PATRICK REYNTIENS
CATALOGUE OF STAINED GLASS

PREFACE BY SIR ROY STRONG
INTRODUCTION BY FRANCES SPALDING
AFTER THOUGHT BY PATRICK REYNTIENS

LIBBY HORNER

Sansom & Company

First published in 2013 by Sansom & Company Ltd
81G Pembroke Road, Bristol, BS8 3EA

www.sansomandcompany.co.uk

e: info@sansomandcompany.co.uk

ISBN: 978-1-908326-48-5

British Library-Cataloguing-in-Publication Data
A catalogue record for this book is available from the British
Library

Designed and Typeset by Libby Horner
Printed and bound in the UK by
Charlesworth Press, Wakefield

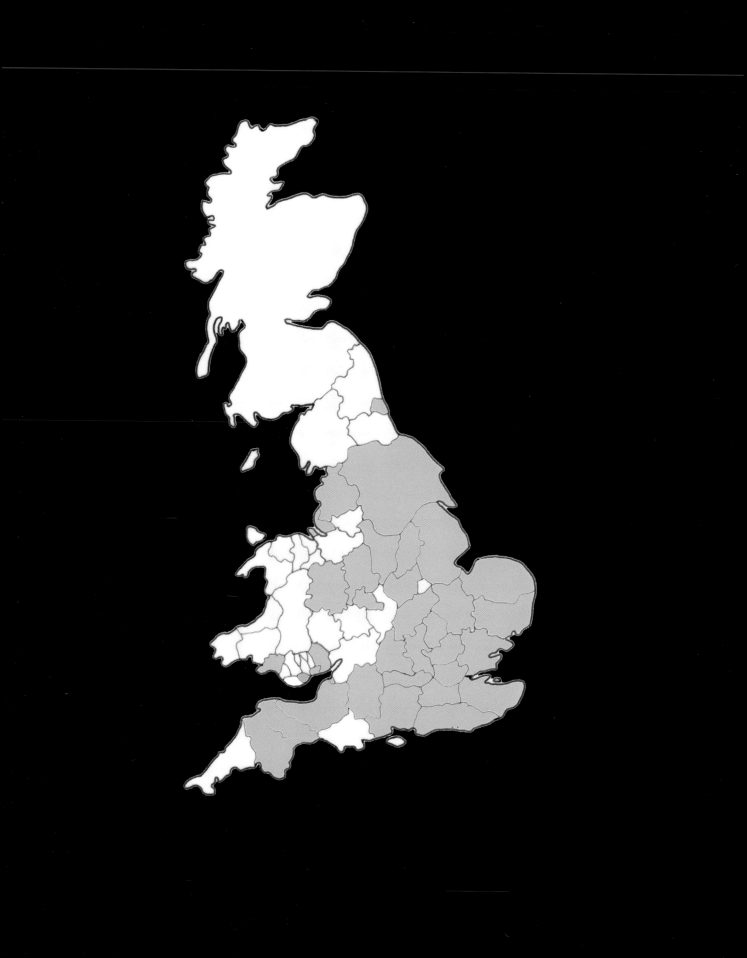

CONTENTS

Author's note	8
Acknowledgements	9
Explanatory notes	10
Glossary	11
Recurring themes and symbolism	12
Index of churches, buildings and museums	16
Preface by Sir Roy Strong	18
Introduction by Frances Spalding	19
Works in Britain – England	21
Bedfordshire	22
Berkshire	24
Buckinghamshire	34
Cambridgeshire	40
Derbyshire	54
Devon	58
Essex	64
Hampshire	66
Hertfordshire	76
Kent	84
Lancashire	90
Leicestershire	94
Lincolnshire	96
London (Greater London)	100
Merseyside	130
Norfolk	144
Northamptonshire	146
Nottinghamshire	154
Oxfordshire	164
Shropshire	186
Somerset and Bristol	188
Staffordshire	194
Suffolk	196
Surrey	202
Sussex	206
Tyne and Wear	212
West Midlands	214
Wiltshire	220
Yorkshire	226
Works in Britain – Wales	245
Cardiff	247
Gwent	249
Monmouthshire	251
West Glamorgan	253
Works abroad	255
Canada	257
Germany	257
Ireland	263
New Zealand	269
South Africa	270
United States of America	270
Autonomous panels	275
Panels designed by other artists	276
Panels designed by Reyntiens	278
Limited edition and Goldmark Gallery series	317
Tabulated biography	331
Bibliography	339
Red herrings	346
After Thought by Patrick Reyntiens	348

AUTHOR'S NOTE

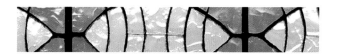

I first met Patrick Reyntiens in November 2007 when he kindly agreed to be interviewed about Frank Brangwyn for a film and catalogue I was making of the latter's forays into stained glass. I was struck then by the enthusiasm, energy, imagination, knowledge and intellect of the man. The following year the Goldmark Gallery commissioned Charles Mapleston and me to make a film about John Piper and we visited Patrick a number of times for that venture. It was whilst making the film and visiting Coventry, Liverpool, Aldeburgh, Sanderson and other venues that I began to fully appreciate just how important Patrick Reyntiens was in translating Piper's often pretty sketchy designs for stained glass, and that Piper's windows would not have been as successful and important as they are without Reyntiens' input. Piper frequently expressed his indebtedness to his colleague in letters to clients.

When the Piper film was launched at the Goldmark Gallery, together with Frances Spalding's excellent book about John and Myfanwy Piper, serendipity played a part. Patrick was unable to attend but his son John did and left with a copy of the film. Having watched the DVD he decided to pay tribute to his father's work by commissioning Charles and me to make a film leading to many more meetings and interviews with Patrick which we enjoyed tremendously because he has a wicked sense of fun. It was at this time that I began cataloguing Reyntiens' work and a basic version of this book was added to the DVD (*From Coventry to Cochem. The Art of Patrick Reyntiens*) as a PDF file. Having got that far I knew I wouldn't be satisfied until I'd written as comprehensive a catalogue as possible.

I have tried to be accurate in my recording of events and not to rely on word of mouth, hearsay or vague reminiscences. If mistakes have occured I apologise. Hopefully all major works have been included, although Patrick insists I have missed out a 'monkey' window in Christ Church, Oxford.

The compilation of this book has truly been a labour of love since it has been entirely self-funded. My poor little car and I have visited every church and museum where there is work by Reyntiens in England, Wales and Ireland. I was also fortunate in attending the dedication of the beautiful windows at St Martin's, Cochem, Germany but missed out on the Derix studio panel and much as I'd have loved to visit Christchurch, Johannesburg and Washington DC the bank balance said NO.

I hope the book will inspire people to visit Reyntiens' windows and to really look at them and marvel at the prodigous and exemplary output and I hope that the catalogue will provide a platform upon which future assessment of Reyntiens' work can be based.

Patrick Reyntiens and the author, 16 May 2011

ACKNOWLEDGEMENTS

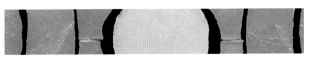

One of the joys of compiling a catalogue such as this is the opportunity to travel, visit so many beautiful churches and museums and meet so many enthusiastic and knowledgeable people who encouraged me in my endeavours, appreciating the huge influence Reyntiens has had on the history of stained glass.

In true democratic fashion I list my acknowledgements in alphabetical order, reserving a special mention for a chosen few. Apologies if I have inadvertently omitted anyone.

I am very grateful to the following:
Canon Colm Acton, Jackie Adams, Natalie Adams, Michael Archer, Revd Graeme Arthur, Heather Ault, Revd Philip Ball, Revd Brendan Bailey, Mike Bailey, June Bangs, Sister Patricia Bell, John Bethell, Frederick Birkhill, David Blackmore, Revd Bill Burleigh, Paula Boughton, Sir Roger du Boulay, Revd Christopher Boulton, Revd Chris Bull, Father Bernard Boylan, Father George Bowen, Dr Martin Brett, Revd Viv Bridges, Beverley Brown, Mr & Mrs Buckberry, Revd Chris Bull, Claire Bunce, Bill Burleigh, Revd Dr Mark Butchers, Revd Edward Cain, Revd Frank Carvill, Jackie Chalmers, Susan Chapel, John Chetwood, Fiona Ciarán, Pamela Clark, Revd Alexandra Clarke, Brian Clarke, Chloë Cockerill, Lesley Colby, Terry Comer, Mgr Peter Cookson, Di Copas, Father Jonathan Cotton, Elody Crimi, Allan Crocker, Sharon Crofts, Revd Grant Crowe, Canon John Cunningham, Judith Curthoys, Ernest Dale, the late Andrew Dalton, Professor Edward Davis, Dr Maggi Dawn, Nicky Denny, Wilhelm Derix, Diana Dillon, Gilly Dobson, Mary Donaghey, Eunice and Chris Doswell, Philippa Dowdell, Terence Duffy, Julian Dutnall, Simon Edsor, Chris Emmott, Sophie Farrant, Roddy Fisher, Brenda Flack, Sarah Flathar, Neil Fletcher, Stephen Forge, Mac Forsyth, Father Peter Foulkes, Revd Roy Goodhew, Debbie Goodson, Revd Andrew Gorham, Mari Gosling, Rachel Gough, Father Philip Gregory, Jacquie Grieve, Father Nigel Griffin, Father Simon Griffiths, Jimmy Guy, Tony Haigh, Father Paul Harrison, Revd Peter Hart, Revd David Hobden, Claire Hanlon, Rosemary Harris, Father Paul Harrison, Revd Peter Hart, Revd Nigel Hartley, Penny Hatfield, Revd David Henson, David Hillier, Revd Father Roderick Hingley, Mrs Hunt, Charlotte Hodgson, Revd Dr Stephen James and Sue James, Caroline Jarvis, Sister Barbara Jeffery, Stuart Jones, Barbara Judd, Clare Kavanagh, Revd Gary Keith, Maria Kelly, Mgr Jack Kennedy, Michael Kersey, Revd Carol Kimberley, David Kirby, Father Varghase Konthuruthy, Dipika Kulkarni, Revd Nigel Lacey, Elizabeth Lakey, Benjamin Longden, Angela Lord, Alex Low, Revd Canon Anthony Lynett, Kay Macaree, Charlotte Manley, Elizabeth Mann, Charles Mapleston, Revd Roger Marsh, Simon Martin, Tricia Maughan, Sharon Maurice, Tom Mayberry, Revd Coralie McClusky, Jean McGinley, Father Peter McGuire, William McWilliam, Father Sean Melody, Dr Mark Miller, Father David Mills, Revd Mike Mills, Revd Gerard Mitchell, Peter Moran, Revd Stephen Morgan, Sarah Murray, Diane Ney, Kerry Nickels, Judy Noakes, Tony Northen, Sarah Norris, Marie O'Hara, Yvonne Owen, Anne Padget, Michael Parry, Revd Alan Partridge, Jig Patel, Marcus Peel, Suzanne Philipps, Derek Pierce, Patrick Pike, Saffron Pinegar, Father Christopher Posluszny, Marian Povey, Revd Canon Tony Powell, Dr Robert Proctor, Revd Wendy Pugh, Monica Purdue, Ken Ransley, Dr John Rawlinson, Lesley Read, Revd Paul Reynolds, Helen Richardson, Miriam Richardson, Father Terence Richardson, Dr Clare Rider, Sarah Robertson, Revd Rosalind Rutherford, Sister Attracta Ryan, Henrietta Ryan, Alex Sainsbury, Emelie Salford, Suzanne Sandford, Wendy Sawyer, Polly Seviour, Idwal Sheen, Maria Simson, Jenny Smith, Revd Janet Spicer, Revd Kate Stacey, Freddie Stockdale, Revd Canon Dr David Stone, Sir Tatton Sykes, Sam Talbot, Revd Kim Taplin, Jane Teal, Olivia Temple, Andrew Todd, Father Dennis Touw, Father Jeremy Trood, Dr Tony Trowles, Father John Tuohy, Niamh Tyrrell, Catherine Vaux, Charlotte Villiers, Paul Walker, Revd Dr Ian Wallis, Christine Whitehouse, Revd John Wigram,

Vanda Wilkinson, Revd Ralph Williamson, Andrew Willson, Debbie Woods, Professor Gregory Woods, Penelope Wrong, Father Philip Ziomek

Will Schenck, Elizabeth Stazicker and Sarah Robertson of the Stained Glass Museum, Ely were all most hepful in sorting out details of works in the Museum. Terry Bloxham not only showed me the works in storage at Blythe House but also devoted a day to finding records for me at the Victoria and Albert Museum. Heather Ault and staff at the Wiltshire Heritage Museum allowed me to leaf through their records and photograph the Piper/ Reyntiens panel. William Hlowatzki and staff at The Clay & Glass, Canada conducted a search on my behalf for Reyntiens' works.

The staff in Archival Centres were wonderfully helpful and resourceful, including Nigel Lutt at Bedford & Luton Archives, Sarah Charlton at the Centre for Buckinghamshire Studies, Gill Shapland at Cambridge Archives, Cressida Williams at Canterbury Cathedral Archives, Paul Beattie and Karen Millhouse at Derbyshire Record Office, Jane Harris and Carol Linton at Hampshire Record Office, Carol Futers at Hertfordshire Archives and Local Studies, Archives of the Institute of Our Lady of Mercy, Leeds, Dr Meg Whittle at Metropolitan Cathedral of Christ the King, Liverpool, Archives Department, Eleanor Winyard at Northamptonshire Record Office, Len Smithurst at Norfolk Record Office, Stuart Jones at the Diocese of Norwich, Canon A Dolan at Nottingham Diocesan Archives, Nottinghamshire Archives and Southwell & Nottingham Diocesan Record Office, Lynda Haynes at Oxfordshire History Centre, Heritage & Arts, Tim Knebel at Sheffield Archives, Surrey History Centre, Nigel Wilkins at English Heritage, Swindon, Margaret Moles at Wiltshire Archives. And a special mention for Ahilan Sooriasgaram at the RIBA Library.

I am tremendously grateful to Clare and Niels Cross and Graham Horner for proof-reading the counties and autonomous panels as and when the sections were completed and to Hugh Newsam for painstakingly proof-reading the book in its present format.

I thank the Reyntiens family for their support and Patrick himself for giving me leave to compile this catalogue, for some wonderful meals, for Theocritus recitals, for much hilarity and laughter, for transporting me into a different world, inspiring and educating me and for agreeing to write the postcript (renamed by the man himself an After Thought).

Sir Roy Strong and Frances Spalding have done me the honour of writing the Preface and Introduction and I cannot find words to express my gratitude.

Shortly before I was due to self-publish Dr John Sansom of Sansom & Company saw the completed manuscript and design and expressed the wish to become involved – absolutely thrilling news for me and I hope that his faith in my book is not misplaced!

EXPLANATORY NOTES

Maps: The county maps are all to the scale of approximately 1:800 000. In each case the county town is named together with the locations of Reyntiens' work. Motorways are in blue, major A roads in green. The map of the UK shows county boundaries in 1995 (prior to the introduction of unitary authorities).

Postcode: The postcodes are included for satnav navigation purposes and do not imply a postal address.

Listing: The listing grades and dates are those provided by English Heritage and CADW.

General: This provides a basic history of the building and any other details. The literature section immediately following refers to the building as a whole, not specific windows.

Date: Previous books and magazines have put forward a variety of dates for the works. I have attempted to gain accurate dates from faculties and Parochial Church Council Minutes etc, but in some instances this has not been possible – partly because many of the windows are considered too recent for the papers to be released. Reyntiens himself has produced such a large body of work that his memory of dates is unsurprisingly hazy.

Size: Sizes are given in metric and Imperial, height before width. It has not always been possible to measure the windows, and where they have been measured the sizes are approximate.

Studies: There are few extant studies and cartoons. Reyntiens' cartoons are in general a mixture of paint and collage with no indication of lead lines.

Literature: References to books by Martin Harrison, June Osborne and Frances Spalding and the AISG website recur frequently and have therefore been abbreviated in the text to Harrison, 1982; Osborne, 1997; Spalding, 2009 and AISG
The full references are
Harrison Martin, 'Introduction', in Compton Ann (Ed), *John Piper painting in coloured light*, Kettle's Yard Gallery, 1982, unpaginated
Osborne June, *John Piper and Stained Glass*, Stroud: Sutton Publishing, 1997
Spalding Frances, *John Piper Myfanwy Piper. Lives in Art*, Oxford: Oxford University Press, 2009
Artists in Stained Glass, *Patrick Reyntiens Individual Glass Panels*, 7 November 2008, http://www.aisg.on.ca

Abbreviations:
AISG = Artists in Stained Glass
BSMGP = British Society of Master Glass Painters
CBRN = *The Catholic Building Review*, Northern Edition, Ormskirk: Fides Publications Ltd
CBRS = *The Catholic Building Review*, Southern Edition, Ormskirk: Fides Publications Ltd
CCC = Christ Church, Oxford
DAC = Diocesan Advisory Committee
NADFAS = National Association of Decorative and Fine Arts Societies
PCC = Parochial Church Council
SGC = St George's Chapel, Windsor
TGA = Tate Gallery Archives
b = bottom
c = centre
l= left
r=right
t=top

Notes: Cross references to works included in the catalogue and important personalities are marked in red.

Photography: Unless otherwise stated, all photographs are by the author, Charles Mapleston and The Reyntiens Trust

Typography: Text in Berlin Sans FB, Helvetica, Times New Roman and Veneer.

Patrick Reyntiens and Anne Bruce at Burleighfield House
Reyntiens Trust archives

GLOSSARY

Many of these definitions have been taken, appropriately enough, from Reyntiens' book *The Technique of Stained Glass*, London: B T Batsford Ltd, 1967.

Aciding - process of etching the 'flash' off antique glass.

Alla prima painting - the painting is completed while the paint is still wet. Strictly defined, an alla prima painting would be started and finished in one painting session.

Antique glass - molten glass (metal) is placed on the end of a blow-pipe and blown into a muff, a cylindrical form about 7in in diameter and 13-14 inches long. This is then cut and flattened producing a sheet 21-23 inches long.

Badgering - badger hair brushes are soft and flexible and are used for softening outlines.

Cames - fine lead bars used between pieces of glass. H-shaped sections hold two pieces of glass together and U-shaped sections are used for borders.

Cartoon - working drawing or painting, usually full-sized.

Collage - coloured papers cut to shape and stuck on to study or cartoon. Also papier collé - from the French 'pasted paper', a type of collage

Dalle-de-verre - French term for one-inch-thick glass, literally 'paving stone of glass'.

Enamel - powder of coloured frit (ceramic composition fused to form glass and granulated) which can be diluted as used for painting on glass. Fixed by firing between 550C and 750C.

Etched glass - acid-resistant wax is applied to certain areas of flashed glass for protection, whilst the remainder is treated with hydrochloric acid which eats away the surface thereby exposing the coloured layers beneath. Tiffany used this process instead of applying stain or enamel to glass.

Firing - paint is fused to glass by being placed in a kiln and fired at a temperature of 1300-1500F.

Flashed glass - traditionaly two or more coloured layers of glass are rolled together whilst still molten to produce a single sheet. Nowadays clear glass with a skin of colour on one side is etched, immersed in hydrofluoric acid and white lines appear where 'flashed' because the colour does not go all the way through.

Glass - a fluid, composed of sand (silica), soda ash, potash, limestone, lead oxide, borax and boric acid. Coloured glass is made by the addition of metallic oxides to a batch of glass:
Cobalt oxide or copper in the form of curpric oxide yields blue glass
Iron oxide = greenish colour
Manganese oxide = violet
Gold, copper or selenium = red
Coke, coal or carbonaceous oxides = amber
Manganese, cobalt and iron = black
Uranium = yellow

Kiln-formed glass - this involves melting cut or crushed glass together in a kiln until it becomes a single piece and shaping the glass with moulds.

Leading - strips of lead came milled to specific sizes which hold the glass together providing support and also a design element.

Mandorla - *vesica pisces* (fish-bladder) shaped aureola surrounding the figure of Christ or the Virgin Mary emphasising both the divinity and humanity. The term relates to the almond shape, 'mandorla' being the Italian for almond.

Painted glass - black lead paint is generally used and can be applied with brushes or a variety of different implements.

Plated glass - sandwiching layers of glass together to produce specific colours.

Predella - the painting or sculpture along the frame at the bottom of an altarpiece. They are significant in art history because the artist had more freedom from iconographic conventions than in the main panel; they could only be seen from close up. Predella were rare by the middle of the 16th century.

Quarries - pieces of glass cut into regular geometric shapes, sometimes square, rectangular or circular but most frequently diamond shaped, creating a 'diaper' pattern.

Scumble - soften colours or outlines by rubbing.

Silver stain - the process was discovered in the early 14th century and the stain is composed of silver nitrate and gamboge gum and comes in various colours, from pale yellow to a rich orangey-amber.

Slumping - melting glass into a mould or shape.

Stained glass - as a material stained glass is glass that has been coloured by adding metallic salts during its manufacture. The coloured glass is crafted into stained-glass windows in which small pieces of glass are arranged to form patterns or pictures, held together (traditionally) by strips of lead and supported by a rigid frame. Painted details and yellow stain are often used to enhance the design. The term stained glass is also applied to windows in which the colours have been painted onto the glass and then fused to the glass in a kiln.

Strapwork - stylised representation of strips or bands.

Striations - marks on antique glass, like scratches, making the glass more brilliant and crystalline in effect.

Templates - shapes, cut out of tracing paper, paper, or thin glass corresponding to the exact size of a piece of glass required.

Tracery - shapes in the head of a Gothic window.

Reyntiens' art materials in his kitchen

RECURRING THEMES AND SYMBOLISM

The symbolism in general relates to Christianity.

Alpha and Omega (A and Ω). These are the first and last letters of the Greek alphabet and in *Revelations* 1:8 it states 'I am Alpha and Omega, the beginning and the ending, saith the Lord'. They are used as Christian symbols to symbolise Christ or God, often combined with a cross or chi-ro (combination of X and P).

Clifton College, Bristol; St George, Taunton, Somerset

Annunciation. The annunciation (from the Latin *Annuntiatio nativitatis Christi*) refers to the moment when the angel Gabriel appeared to the Virgin Mary and announced that she would give birth to the Son of God and that she should name the child Jesus which means 'Saviour' (*Luke* 1:26-35). It has been a popular theme in Christian art and especially in Roman Catholic Marian art. Such works usually contain a dove and Madonna lilies either in a vase or held by the angel Gabriel and the Virgin Mary usually has her hands raised, open, palm outwards which signifies acceptance. In Medieval art Mary often held a distaff to represent the activity of women.

St Peter's, Tewin, Hertfordshire; St Mary the Virgin, Turville, Buckinghamshire; St Peter & St Paul, Northampton; Minster and Cathedral Church of St Mary the Virgin, Southwell, Nottinghamshire; St Mary's, Stoke St Mary, Somerset; Abbey Church of St Laurence, Ampleforth, Yorkshire
Reyntiens produced an autonomous panel on this theme

Apocalyptic Beasts or Tetramorph. The symbols of the four evangelists ('people who proclaim good news') are taken from *Ezekiel* 1:5-10 and *Revelations* 4: 6-8, the four living winged creatures which drew the throne chariot of God. The animals were probably chosen as the mightiest of various forms of animals, so man is the king of creation in the image of the Creator, the lion is the king of beasts, the ox is the king of domesticated animals and the eagle is the king of birds. Matthew is represented by a man, Mark by a Lion, Luke by an Ox and John by an Eagle. They symbolise Christ's birth, death, resurrection and ascension and were generally shown surrounding the figure of Christ with the man top left, the lion top right, the ox bottom left and the eagle bottom right which order also reflects the medieval idea of the 'nobility' of the beasts.

St George, Taunton, Somerset; Hospital of St John the Baptist, Lichfield, Staffordshire; All Hallows, Wellingborough, Northamptonshire

Ascension of Christ. This is the belief that 40 days after the Resurrection Jesus was taken up to heaven in his resurrected body, in the presence of eleven of his apostles (*Luke* 24:50-53). The Ascension implies Jesus' humanity being taken to Heaven. Many ascension scenes have two parts, Heaven being seen above with the earth below. The ascending Jesus is often shown blessing the people below with his right hand signifying that he is blessing the entire Church.

Frances Bardsley School for Girls, Romford, London; St Andrew's, Scole, Norfolk; Minster and Cathedral Church of St Mary the Virgin, Southwell, Nottinghamshire; St Martin's, Cochem, Germany

Aureole. This is the radiance of luminous cloud which is shown round sacred figures in art. When it encircles the head it is called a halo or nimbus. When covering the whole body it is usually oval or elliptical, but is sometimes circular, quatrefoil or vesica pisces. One form of the latter is the mandorla which is formed from two intersecting circles and signifies the cloud on which Christ

ascended to heaven. The mandorla is often painted in concentric circles which are darker towards the centre in accordance with Apophatic theology and the writings of Dionysius the Areopagite – one cannot depict the sheer brilliance of pure holiness except through darkness.

Eton College, Windsor, Berkshire; Heathfield School, Ascot, Berkshire; St Michael & All Angels, Marden, Kent; St Lawrence College, Ramsgate, Kent; St Mary the Virgin, Shipton-under-Wychwood, Oxfordshire; St George, Taunton, Somerset; Hospital of St John Baptist, Lichfield, Staffordshire; Abbey Church of St Laurence, Ampleforth, Yorkshire; Cathedral Church of St Marie, Sheffield, Yorkshire

Christ Pantocrator/Christ in Majesty. This refers to Christ the Almighty or All-Powerful relating to the omnipotent Christ. The iconography of the Pantocrator which is mainly found in Eastern Orthodox art differs from that of Christ in Majesty which is found in Western Catholic art. Pantocrator is usually a half-length image with Christ holding the New Testament in his left hand and blessing with his raised right hand. Christ in Majesty is usually seated on a throne, is full length and facing forwards and often flanked by other sacred figures.

St Michael & All Angels, Marden, Kent; St George, Taunton, Somerset; Hospital of St John Baptist, Lichfield, Staffordshire

Colours. Colours have an emotional impact on one's senses and have symbolic overtones. The colours used in stained glass are therefore of huge importance. Basil Spence associated green with youth as in green shoots bursting forth, red with age, middle life he regarded as a kaleidoscope of colours, whilst old age with a richness of experience and wisdom he associated with deep purple, blue, silver and gold.

Black - death
Blue - heaven, eternity, water. As one of the most expensive pigments available to painters, ultramarine ground from lapis lazuli was usually reserved for painting the clothing of the Virgin Mary.
Brown – earth, autumn, humility
Gold – God and eternity
Green - youth, hope and resurrection, rebirth, earth, the world. Dark green represents God's creativity and green is the colour of the Trinity. In medieval art emerald green was symbolic of life, productivity and rebirth.
Grey - the 'Valley of The Shadow', gloom and depression, immortality of the soul
Orange - the colour of fire, also symbolises 'the inescapable grace of God'
Red - age, danger, eternity, war, blood of martyrdom, passion, the Holy Spirit, hell fire and damnation.
Purple - as a combination of red and blue this symbolizes the blood of martyrdom and the power of the spirit, the resurrection implicit in the Crucifixion
White – purity and perfection and death
Yellow – sun, light, gold and also treachery and deceit

Crucifixion. Jesus was arrested after The Last Supper and sentenced by Pontius Pilate. He was flogged, mocked by Roman soldiers as 'the King of the Jews', clad in purple and made to wear a crown of thorns, and then made to walk to the Crucifixion site bearing his cross (the events of the journey are represented in the Stations of the Cross, see St John Fisher, Morden, London). At Golgotha he was crucified and hung between two thieves. His torment lasted six hours during which time the sky was blackened for three hours and the earth quaked. Symbols found in Crucifixion paintings often include the sun and the moon;

black birds, symbols of discord and strife; anemones which were reputed to have sprouted from the blood of Christ on Calvary; dandelions which were a symbol of grief and thistles, a symbol of sorrow and sin. Jesus' death is seen by Christians as a sacrifice on behalf of mankind, to atone for our sins and make salvation possible.

St Andrew's, Scole, Norfolk; Royal Surrey County Hospital, Guildford, Surrey; Abbey Church of St Laurence, Ampleforth, Yorkshire; St Martin's, Cochem, Germany

Dante. Reyntiens' work is influenced by his knowledge of Dante's writing and philosophy, from the winking eyes at the close of the *Paradiso*, to the *Primum Mobile*, angelic orders and inversion.

All Saints, Basingstoke, Hampshire; St Lawrence College, Ramsgate, Kent; Metropolitan Cathedral of Christ the King, Liverpool, Merseyside; St Mary the Virgin, Shipton-under-Wychwood, Oxfordshire; St George, Taunton, Somerset. Reyntiens also made an autonomous panel, *Male Figure in a Wooded Landscape*

Dove. A dove is a symbol of peace, innocence, hope, the soul and the Holy Ghost and is the attribute of many saints. It is frequently found in Christian art, especially scenes related to the Annunciation, Baptism of Christ (the Holy Spirit descended upon Jesus at his baptism like a dove - *Matthew* 3:16), Pentecost and Trinity. In early Christian art doves represented the twelve apostles and seven doves encircling a cross represent the seven gifts of the Holy Spirit – wisdom, understanding, counsel, fortitude, knowledge, piety and fear of the Lord. Noah sent out a dove from the ark to determine whether the waters had abated and the dove returned with an olive branch in its beak (*Genesis* 8:11). Jesus's parents sacrificed doves on his behalf after his circumcision (*Luke* 2:24).

Southport, Lancashire; St Alban, Romford, London; St Bartholomew's, Nettlebed, Oxfordshire; Holy Family, Clifton College, Bristol; St Mary's, Stoke St Mary, Somerset; Cathedral Church of St Marie, Sheffield, Yorkshire

Eye. The eye represents the all-seeing eye of God, the window of the soul and the light of the body. God the Father was sometimes depicted as an eye within a triangle.

All Saints, Basingstoke, Hampshire; St Michael & All Angels, Marden, Kent; Christopher Grange, Knotty Ash, Merseyside

Foliate Head. The foliate head or Green Man is a pagan symbol which was adopted by the church to represent life and fertility and the regenerative force of Christ. It usually involves a man's face surrounded by leaves with possibly branches escaping from the nostrils, mouth or eyes. It was a favourite motif of Piper.

Rayne House, London; Wessex Hotel, Winchester, Hampshire; Ipswich School, Ipswich
Reyntiens made an autonomous panel to Piper's design titled *Four Seasons*

Gerard Manley Hopkins. Reyntiens is a great admirer of the poems of Gerard Manley Hopkins who read classics at Balliol College, Oxford, became friends with Walter Pater and admired Christina Rossetti, John Ruskin and the Pre-Raphaelites. In an effort to overcome his homoerotic tendencies he decided to become a Catholic and consulted with John Henry Newman. In time he became a Jesuit. In his poetry Hopkins sought linguistic purism and his 'sprung rhythm' was influenced by Old English. 'That nature is an Heraclitean Fire and the Comfort of the Resurrection' appears to have been a particular favourite of Reyntiens.

St Lawrence College, Ramsgate, Kent; All Saints, Lowesby, Leicestershire

God the Father. From the 12th century onwards God was usually depicted enthroned and holding each end of the horizontal bar on which Christ was crucified, whilst a dove hovers above. He is also depicted holding a book with the symbols alpha and omega. Sometimes he has a triangular halo signifying the Trinity.

Bishop's Lodging, Peterborough, Cambridgeshire

Jacob's Ladder. Jacob's Ladder was dreamt of by Jacob during his flight from Esau (*Genesis* 28: 10-19). The ladder is usually depicted with angels ascending and descending and became a symbol of the Virgin Mary in the Middle Ages, representing the alliance of heaven and earth. It is one of the Instruments of the Passion. It can be seen as a means of self-improvement, gaining a higher place on the ladder by virtue of goodness.

Dellow Centre, London; Cathedral Church of St Mary the Virgin, Southwell, Nottinghamshire; Derix Glasstudios, Germany

Lamb of God, Agnus Dei. In *John* 1: 29, John the Baptist saw Jesus and said 'Behold the Lamb of God, which taketh away the sins of the world'. The sacrificial lamb is a symbol of Christ, often shown with a cruciform halo, cross-staff, chalice or banner of the Resurrection. In early Christian art the twelve apostles were shown as sheep surrounding the Lamb of God.

All Saints, Odiham, Hampshire; Holy Family, Southport, Lancashire; St Gregory the Great, South Ruislip, London; St Andrew's, Scole, Norfolk; St Bartholomew's, Nettlebed, Oxfordshire; Abbey Church of St Laurence, Ampleforth, Yorkshire

Lily or Madonna lily. The lily is a symbol of the Virgin Mary and a number of saints including Catherine of Siena. It represents purity and chastity and is the flower of Easter. Christ referred to the lilies of the field as a symbol of simplicity and purity (*Matthew* 6:28).

St Peter's, Goytre, Monmouthshire

Mandorla. See 'aureole'

Musical instruments. These are emblems of joy. In Christian art King David, as composer of the *Psalms* and musician at the court of King Saul, is often shown with a harp or lyre; the 24 Elders of the Apocalypse played stringed instruments such as harps, lyres, lutes or viols; whilst angels announce the Last Judgement with trumpets, relax with harps and other stringed instruments and have been known to accompany the Virgin Mary and child or other saints with portative organs.

Minster Church of St Andrew, Plymouth, Devon; St Michael & All Angels, Marden, Kent; Hospital of St John Baptist, Lichfield, Staffordshire; Cathedral Church of St Marie, Sheffield, Yorkshire; Sledmere House, Sledmere, Yorkshire
Reyntiens produced a series of autonomous panels as musical homages to various composers

Pentecost. Pentecost falls on the 7th Sunday after Easter and commemorates the descent of the Holy Spirit on the Apostles as described in *Acts* 2:1-31 when they received the ability to speak in all languages: 'And suddenly there came a sound from heaven as of a rushing mighty wind, and it filled all the house where they were sitting. And there appeared unto them cloven tongues like as of fire, and it sat upon each of them. And they were all filled with the Holy Ghost, and began to speak with other tongues, as the Spirit gave them utterance.' Twelve scrolls in scenes of Pentecost symbolize the gospels translated into twelve languages. Reyntiens frequently depicts red and yellow Pentecostal flames in his work, signifying that everything is infused by God's Holy Spirit.

St Lawrence College, Ramsgate, Kent; Holy Family, Southport, Lancashire; St John the Baptist, Ilford, London; St Mary the Virgin, Shipton under Wychwood, Oxfordshire; Clifton College,

Bristol; St George, Taunton, Somerset; St Mary's, Stoke St Mary, Somerset; Abbey Church of St Laurence, Ampleforth, Yorkshire; Cathedral Church of St Marie, Sheffield, Yorkshire; St Mark's Church, Sheffield, Yorkshire; St Martin's, Cochem, Germany

Pillar of Cloud and Pillar of Fire. During the exodus of Israelites from Egypt they were guided by the manifestation of a divine presence in the form of cloud and fire as described in *Exodus* 13:21 'And the Lord went before them by day in a pillar of a cloud, to lead them the way; and by night in a pillar of fire, to give them light; to go by day and night'. The Persians and Greeks used smoke and fire as signals in their marches and the commander of an Egyptian foray was termed 'A flame in the darkness at the head of his soldiers'. God was presenting himself as the leader of the Israelites by his actions.

All Saints, Hinton Ampner, Hampshire; St George, Anstey, Hertfordshire; St Lawrence College, Ramsgate, Kent

Resurrection. This is the belief that Christ returned to life on the Sunday (Easter Sunday) following the Friday (Good Friday) on which he was executed. He appeared to many people over the next 40 days (see *Supper at Emmaus*) before he ascended to heaven to sit at the right hand of God.

Holy Family, Southport, Lancashire; St Andrew's, Scole, Norfolk; St Mary's, East Knoyle, Wiltshire; St Martin's, Cochem, Germany

Christ's Resurrection is also symbolised by a long white flag bearing a red cross; an egg; a lion in medieval bestiaries because the cubs are born dead and only come to life three days later when their father breathes on them; the phoenix rising from its own ashes; swallows arriving in spring. Butterflies also symbolise life, death and resurrection.

St George, Anstey, Hertfordshire; St Bartholomew's, Nettlebed, Oxfordshire

Rose window. These were considered to be symbols of eternity and perfection because of the geometry. The paths which lead to the centre are akin to the paths which lead to enlightenment.

Christ Church, Flackwell Heath, Buckinghamshire; St Lawrence College, Ramsgate, Kent; All Hallows, Wellingborough, Northamptonshire

River of Life. In *Revelations* 22:1 John writes: 'He shewed me a pure river of water of life, clear as crystal, proceeding out of the throne of God and of the Lamb'. The River of Life represents healing, transcendence, renewal and peace. It probably refers back to the first Eden where a river watered the garden and so is Paradise regained, a place of redemption.

Charing Cross Hospital Chapel, London; Christ's College, Christchurch, New Zealand

St Martin of Tours. St Martin could be considered one of the first 'conscientious objectors', having decided that his religious faith prevented him from being a full-time soldier. He was imprisoned and later discharged after which he became a monk at the first ever monastery in Gaul, at Ligugé. He was made Bishop of Tours in 372. The most popular representation of Martin is when he cut his cloak in half to clothe a beggar at Amiens, after which Christ appeared to Martin in a dream wearing the portion of the cloak he had given away.

St Martin's, Sandford St Martin, Oxfordshire; St Martin's, Cochem, Germany

St Paul. Paul (originally named Saul) was a Jew and brought up as a Pharisee who persecuted the early Christians with torture and ultimately death if they refused to deny their faith and notably took part in the stoning of St Stephen, holding the cloaks of the mob. Travelling to Damascus he experienced a vision of Christ which caused him to convert to the Christian faith, be baptised and bring the Christian faith to the Gentiles. He retired for three years of contemplation before returning to Damascus where he was hounded out by the Jews, moving instead to Jerusalem. He travelled widely spreading the Gospel and almost half the books in the New Testament are due to his authorship. On a trip to Rome he was shipwrecked off the island of Malta. He is believed to have been beheaded in Rome at Tre Fontane. He was probably small, bald and bandy legged and is generally portrayed with a long face and beard and deep-set eyes. His emblems are a sword and a book.

Thorpe Tilney Hall, Timberland, Lincolnshire; St Paul's, Pishill, Oxfordshire; St Martin's, Cochem, Germany
Reyntiens produced a series of autonomous panels on the theme of Life of St Paul 'From the Baroque'

St Peter. Peter was originally called Simon but was renamed Cephas (Peter) by Christ. He and his brother Andrew were both fishermen. Peter became the leader of the apostles, was told by Christ that he would be the rock on which his church would be built and was given the keys to heaven. He was crucified head-downwards and is often represented by a cockerel because of his denial of the Lord.

St Peter's, Babraham, Cambridgeshire; St Theodore of Canterbury, Hampton-upon-Thames, London

Supper at Emmaus. In *Luke* 24:13-32 the story is recounted whereby Cleopas and another disciple met the resurrected Jesus but did not recognise him until they sat down to supper together and broke bread, a reference to the Eucharist.

St Bernadette's, Lancaster, Lancashire; St Theodore of Canterbury, Hampton-upon-Thames, London; Cathedral Church of Saints Peter and Paul, Llandaff, Cardiff; St Martin's, Cochem, Germany

Symbols of the Stigmata. The stigmata indicate the Holy Wounds inflicted on Christ during his Crucifixion, on the hands and feet from nails and on the side from a lance.

All Saints, Misterton, Nottinghamshire; Nuffield College, Oxford; St Mary's, East Knoyle, Wiltshire

T S Eliot. Reyntiens was a great admirer of the poems of Thomas Stearns Eliot, in particular 'Little Gidding' and 'Four Quartets' for which Eliot won the Nobel Prize for Literature. T S Eliot was born in the USA but became a naturalised British citizen in 1927. For a time he taught at Highgate School in north London where one of his pupils was the young John Betjeman. Eliot was also a publisher, playwright, and social and literary critic.

St Lawrence College, Ramsgate, Kent; All Saints, Lowesby, Leicestershire

Transfiguration. The transfiguration is described in *Luke* 9:28-36 and the other Gospels. Jesus took Peter, John and James to a mountain to pray and as Jesus prayed he was metamorphosed into a shining light. God announced 'This is my beloved Son: hear him' a fact witnessed by Moses the law-giver and Elijah (Elias) the prophet who were with Jesus. The mountain can be seen as a metaphor, a bridge between heaven and earth, the eternal and the temporal with Jesus as the link.

Good Shepherd, Borough Green, Kent; Cowley Fathers School, Cowley, Oxfordshire; St Leonard's, St Leonards-on-Sea, Sussex

Tree of Jesse. From the 11th century onwards the genealogy of Christ has been portrayed by a tree springing from the loins of Jesse, father of King David, with Christ or the Virgin Mary at the top and other ancestors in the branches – 'And there shall come forth a rod out of the stem of Jesse, and a Branch shall grow out of his roots' (*Isaiah* 11:1). Jesse was usually depicted as a large

prone figure with his head on an ornate cushion at the base of a painting or window, the tree or vine springing from his side or navel. A design could fit equally well into vertical or horizontal compositions and artists could delight themselves with all the intertwining branches upon which the descendants would be placed. David is usually depicted with a harp and Solomon holds a model of his temple. The Virgin Mary is usually included below the figure of Jesus.

The genealogy according to *Matthew* is as follows

1	2	3
Abraham	David	Jechonias
Isaac	Solomon	Salathiel
Jacob	Roboam	Zorobadel
Judas	Abia	Abuid
Phares	Asa	Eliakim
Esrom	Josaphat	Azor
Aram	Joram	Sadoc
Aminadab	Ozias	Achim
Naasson	Joatham	Eluid
Salmon	Achaz	Eleazar
Booz	Ezekias	Matthan
Obed	Manasses	Jacob
Jesse	Amon	Joseph
David	Josias	Christ

Prophets also tend to be added

Isaiah	Joel	Nahum
Jeremiah	Amos	Habakkuk
Ezekiel	Obadiah	Zephaniah
Daniel	Jonah	Hagga
Hosea	Micah	Zechariah
		Malachi

Others sources add Elijah, Elishah, Balaam, Samuel, Nathan, Moses and Methuselah.

All Saints, Odiham, Hampshire; Holy Family, Southport, Lancashire; Holy Trinity, Lyne; Surrey

Tree of Life and Tree of Knowledge. The Tree of Life is a popular motif in many religions symbolizing renewal and peace as well as evolution and may be a synonym for a sacred tree. As such it has pagan origins and is closely related to *Foliate Heads*. The Tree of Life connects all forms of creation and the Tree of Knowledge connects heaven to the underworld and both are part of a world or cosmic tree. The trees are mentioned in *Genesis*, *Psalms*, *Isaiah*, *Ezekiel*, and in the final vision in St John's *Revelations* 22:2 the Tree of Life 'bare twelve manner of fruits, and yielded her fruit every month: and the leaves of the tree were for the healing of all nations'.

St Giles of Provence, Totternhoe, Bedfordshire; St Mary, Fawley, Buckinghamshire; St Andrew, Much Hadham, Hertfordshire; Charing Cross Hospital Chapel, London; St John the Baptist, Ilford, London; Ripon College, Cuddesdon, Oxfordshire; St Bartholomew's, Nettlebed, Oxfordshire; Christ's College, Christchurch, New Zealand; National Episcopalian Cathedral, Washington DC, USA
Reyntiens produced an autonomous panel titled *Tree of Life*

Trinity. The number three is sacred to many religions. In Christianity it represents the three-in-one of Father, Son and Holy Ghost which used to be depicted in symbolic form as three fish, three rings or two triangles.

Minster Church of St Andrew, Plymouth, Devon; St Lawrence College, Ramsgate, Kent; Holy Family, Southport, Lancashire; All Saints, Lowesby, Leicestershire; Metropolitan Cathedral of Christ the King, Liverpool, Merseyside; St Bartholomew's, Nettlebed, Oxfordshire; Holy Trinity, Lyne, Surrey

Virgin Mary. The Virgin Mary was the mother of Jesus. The key doctrines regarding her are the virgin birth of Jesus, assumption, immaculate conception, perpetual virginity and dormition. The ancient depictions of Mary are of a crowned and sceptred queen; later the image of the Madonna and child became more popular, with Mary cradling her baby, feeding Him or adoring Him; and depictions of the Nativity crept in (*Adoration of the Magi*). The principal sites of Marian pilgrimage are Walsingham in Norfolk, Lourdes in France, Fatima in Portugal, Loreto in Italy, Czestochowa in Poland and Guadalupe in Mexico. The 13th century prayer, 'The Litany of Loreto', lists the various attributes by which Mary is known, including Madonna Lilies, the Chosen Vessel, a sword piercing her soul (Simeon said to Mary 'A sword shall pierce through your own soul also', *Luke* 2: 35, Ivory Tower, the burning bush of Moses, the Mystic Rose or Rose without a thorn, the unspotted mirror of purity, the serpent and the flowering rod of Aaron (in medieval times the serpent was placed under the feet of Mary), the Light of Heaven, the Golden Gate and an Enclosed Garden. As noted above she is generally clad in blue.

Robinson College, Cambridge; Minster Church of St Andrew, Plymouth, Devon; St Mary's, Hound, Hampshire; Holy Family, Southport, Lancashire; St Alban, Romford, London; St Ambrose, Speke, Merseyside; Minster and Cathedral Church of St Mary the Virgin, Southwell, Nottinghamshire; Clifton College, Bristol; St Mary's, Stoke St Mary, Somerset; Abbey Church of St Laurence, Ampleforth, Yorkshire; Cathedral Church of St Marie, Sheffield, Yorkshire

Walled Garden and Tower. Medieval enclosed gardens were a symbol of purity, the womb, privacy and secrecy and the protection afforded by women. They generally had narrow entrances. St Barbara was locked in a tower to protect her virginity, said tower reputedly lit by three windows representing the Trinity. She was impregnated by divine intervention as was the Virgin Mary who is also represented by a walled garden or tower, especially in scenes of the Annunciation or Immaculate Conception.

Minster of St Andrew, Plymouth, Devon; Holy Family, Southport, Lancashire; All Saints, Lowesby, Leicestershire; Clifton College, Bristol

Reyntiens and John Piper inspecting glass, c1960
Reyntiens Trust archives

INDEX OF CHURCHES, BUILDINGS AND MUSEUMS

Aldeburgh, Suffolk, St Peter & St Paul (p197)
Ampleforth, Yorkshire, Abbey Church of St Laurence (p228)
Anstey, Hertfordshire, St George (p77)
Ascot, Berkshire, Heathfield School (p25)

Babraham, Cambridgeshire, St Peter's (p41)
Basingstoke, Hampshire, All Saints (p67)
Bledlow Ridge, Buckinghamshire, St Paul (p35)
Borough Green, Kent, Good Shepherd (p85)
Brentwood, Essex, Sion Community (p65)
Bristol, Somerset and Bristol, Clifton College (p189)

Cambridge, Churchill College (p42)
Cambridge, Robinson College (p46)
Chichester, Sussex, Pallant House Gallery, on loan to St
Richard's Hospital (p207)
Christchurch, New Zealand, Christ's College (p269)
Cochem, Germany, St Martin's (p257)
Coventry, West Midlands, Coventry Cathedral of St Michael
(p215)
Cowley, Oxfordshire, Cowley Father's School (p165)
Cuddesdon, Oxfordshire, Ripon College Chapel (p221)

Derby Cathedral Church of All Saints (p55)
Devizes, Wiltshire, Wiltshire Heritage Museum (p215)

East Knoyle, Wiltshire, St Mary's (p223)
Ednaston, Derbyshire, St Mary's Nursing Home (p57)
Ely, Cambridgeshire, Ely Stained Glass Museum (p50)

Fawley, Buckinghamshire, St Mary (p36)
Flackwell Heath, Buckinghamshire, Christ Church (p37)

Goring Heath, Oxfordshire, Oratory Preparatory School (p166)
Goytre, Monmouthshire, St Peter's (p251)
Guildford, Surrey, Royal Surrey County Hospital (p203)

Hinton Ampner, Hampshire, All Saints (p70)
Hound, Hampshire, St Mary's (p71)
Hucknall, Nottinghamshire, Holy Cross (p155)

Ipswich, Suffolk, Ipswich School (p199)

Jarrow, Tyne and Wear, St Paul's (p213)
Johannesburg, South Africa, Unicorn House (p270)

Keighley, Yorkshire, Malsis School (p235)
Knotty Ash, Merseyside, Christopher Grange (Catholic Blind
Institute) (p131)

Lancaster, St Bernadette's (p91)
Leyland, Lancashire, St Mary of the Assumption (p92)
Lichfield, Staffordshire, Hospital of St John Baptist (p195)
Liverpool, Merseyside, Metropolitan Cathedral of Christ the King
(p133)
Llandaff, Cardiff, Cathedral Church of Saints Peter and Paul
(p247)
Lowesby, Leicestershire, All Saints (p95)
Lyne, Surrey, Holy Trinity (p204)

Marden, Kent, St Michael & All Angels (p86)
Misterton, Nottinghamshire, All Saints (p156)
Much Hadham, Hertfordshire, St Andrew (p80)

Nettlebed, Oxfordshire, St Bartholomew's (p167)
Newport, Gwent, St Woolos Cathedral (p249)
Northampton, St Peter & St Paul (p147)
Nottingham, The Good Shepherd (p157)

Odiham, Hampshire, All Saints (p73)
Ontario, Canada, Canadian Clay and Glass Gallery (p257)
Oundle, Northamptonshire, Oundle School (p148)
Oxford, Christ Church (p169)
Oxford, Nuffield College (p178)

Peterborough, Cambridgeshire, Bishop's Lodging (p52)
Pishill, Oxfordshire, St Paul's (p181)
Plymouth, Devon, Minster Church of St Andrew (p59)

Ramsgate, Kent, St Lawrence College Chapel (p88)

St Leonards-on-Sea, Sussex, St Leonard's (p208)
Sandford St Martin, Oxfordshire, St Martin's (p182)
Scole, Norfolk, St Andrew's (p145)
Sheffield, Yorkshire, Cathedral Church of St Marie (p237)
Sheffield, Yorkshire, Mylnhurst Preparatory School (p238)
Sheffield, Yorkshire, St Mark's Church (p240)
Shipton-under-Wychwood, Oxfordshire, St Mary the Virgin (p183)
Sledmere, Yorkshire, Sledmere House (p242)
Southport, Merseyside, Holy Family (p139)
Southwell, Nottinghamshire, Minster and Cathedral Church of St
Mary the Virgin (p159)
Speke, Merseyside, St Ambrose (p141)
Stoke St Mary, Somerset and Bristol, St Mary's (p190)
Swansea, West Glamorgan, St Mary's (p253)

Taunton, Somerset and Bristol, St George (p192)
Taunusstein, Germany, Derix Glasstudios GmbH & Co (p262)
Telford, Shropshire, St Leonard's (p187)
Tewin, Hertfordshire, St Peter's (p82)
Timberland, Lincolnshire, Thorpe Tilney Hall (p97)
Totternhoe, Bedfordshire, St Giles of Provence (p23)
Turville, Buckinghamshire, St Mary the Virgin (p38)

Washington DC, United States of America, National Episcopalian
Cathedral, Cathedral Church of St Peter and St Paul (p270)
Waterford, Ireland, Church of the Sacred Heart (p263)
Waterford, Ireland, St Joseph and St Benildus (p266)
Wellingborough, Northamptonshire, All Hallows (p152)
Winchester, Hampshire, Wessex Hotel (p75)
Windsor, Berkshire, Eton College (p26)
Windsor, Berkshire, Windsor Castle (p32)
Wolvercote, Oxfordshire, Church of St Peter (p184)
Wolverhampton, West Midlands, St Andrew's (p218)

GREATER LONDON

City of London, Bakers' Hall (p102)
City of Westminster, Mayfair, May Fair Theatre (p102)
City of Westminster, Mayfair, The George Club (p102)
City of Westminster, St Margaret's (p104)
City of Westminster, Sanderson, Morgans Hotel Group (p106)
London Borough of Ealing, Southall, St Anselm (p108)
London Borough of Hammersmith and Fulham, Charing Cross Hospital Chapel (p108)
London Borough of Hammersmith and Fulham, London Oratory School (p110)
London Borough of Havering, Romford, St Alban (p110)
London Borough of Havering, Romford, The Frances Bardsley School for Girls (p114)
London Borough of Hillingdon, South Ruislip, St Gregory the Great (p116)
London Borough of Merton, Morden, St John Fisher (p117)
London Borough of Redbridge, Ilford, St John the Baptist (p119)
London Borough of Richmond upon Thames, Hampton-upon-Thames, St Theodore of Canterbury (p121)
London Borough of Richmond upon Thames, Saint Margaret's, St Margaret of Scotland (p122)
Royal Borough of Kensington and Chelsea, Holland Park, No 58 (p123)
Royal Borough of Kensington and Chelsea, Kensington, Rayne House (p123)
Royal Borough of Kensington and Chelsea, South Kensington, Victoria and Albert Museum (p124)
London Borough of Tower Hamlets, Spitalfields, Dellow Centre (Providence Row) (p128)

PREFACE

Brilliant, quirky, opinionated but hugely informed and lovable there is no one quite like Patrick Reyntiens. His energy, even in his later eighties, is prodigious. There can be no doubt but that the alliance of him with the painter John Piper must rank as one of the most contradictory and fruitful in twentieth-century British art. Unlike Gilbert and Sullivan, however, it did not end in tears but endured steadily from its inception in 1954 to Piper's death in 1991. This superb catalogue rights what has been until now an imbalance for we see the stained glass, which was their distinctive and majestic contribution to the decorative arts in this country during the second half of the century, through the eyes of Patrick Reyntiens their maker rather than those of John Piper their designer. This was a rare strange aesthetic marriage between an older and a younger man. It was one which called for the bestowal of confidence each on the other. The results speak for themselves in the amazing flood of stained glass which we find scattered across the churches of England, monuments to Reyntiens' ability to transmute the painter's sketches into a medium which endowed them with a rich luminosity. This catalogue is an extraordinary achievement, truly what the author says it is: 'a labour of love.' It will never be superseded.

I first met Patrick Reyntiens when he was Head of the Central School from 1976-86. They could not have chosen a better person at that time to hold the post, for it was the era which witnessed so many of the old disciplines thrown out of art school education. He stood by them all backed by his formidable knowledge of the whole of the Western European cultural tradition. In that sense he is both by family descent and aesthetic vision more European than Piper. In that too his Catholicism would play a part.

This is a monumental catalogue but the decision to deal with the works, which are many, under geographical location may make it a little difficult to detach those both designed and executed by Patrick Reyntiens himself from those that were the result of a joint enterprise with Piper. I commend to the reader searching out those wholly by Reyntiens. They are quite idiosyncratic and as hugely accomplished as any produced by the team. They leave one in no doubt as to the significant place Reyntiens occupies in the history of post-war British art.

ROY STRONG

Sir Roy Strong being interviewed by the author for the Reyntiens film, *From Coventry to Cochem*, September 2010

INTRODUCTION

There is a whole world of fascination in this astonishing compendium. Here, laid out in full for the first time, is the prodigious output of the stained-glass maker and designer Patrick Reyntiens. It is a book that invites us to travel in his wake around much of Britain and to some places abroad, as we look through the images that here record the vast range of commissions he has fulfilled.

Rarely has a catalogue made such absorbing reading. Alongside relevant illustrations, Libby Horner supplies detailed information on each project. We are offered concise details about the building, the commission, the making and content of the stained glass, as well as in almost all cases a list of available literature. All this is beautifully done. There is much in this book that will deepen our knowledge not only of Reyntiens' achievement but also church history and the complex negotiations that often surround the commissioning of stained glass. There is also the fascination of Reyntiens' all-important working relationship with John Piper, which both triggered Reyntiens' early career and involved him, over many years, with a whole range of commissions, including the great Baptistry window in Coventry cathedral and the huge, magnificent lantern that crowns Liverpool's Catholic cathedral of Christ the King. The work Reyntiens did with Piper was always the fruit of mutual collaboration: even at the cartoon stage, the design was rarely fully fixed, but open to alteration as the work proceeded, for it was Piper's habit, when handing over an initial drawing or completed design to a craftsperson, to respect, fully, the specialist's experience and understanding of his or her medium. Reyntiens supplied not only technical knowledge but also, on occasion, ideas. It was he who had suggested that a burst of glory might work at the heart of Coventry's Baptistry window, and his controlling presence is felt in every one of its 198 panels. His erudition, technical agility and exuberance are even more immediately evident in those works which he both designed and created; and never more so than in his Puginesque Great West window for Southwell Minster with its tiers of angels rising up in a dense hymn of praise.

A grave atmosphere is something we associate with many churches, and this is deliberate. The habit of tinting glass a pale green or yellow, in order to modify daylight, goes back many centuries, and its impact on the psychology of the visitor is noticeable. It is, I think, rightly claimed in this book that subdued light makes the mind more contemplative. It also changes the mood of a building, and the eight discreetly low-toned, abstract

windows down the south aisle of the famous church that sits alongside Westminster Abbey, St Margaret's, make it one of the most successful (and mind-altering) achievements in the Piper/Reyntiens list. In his own work, as both designer and maker, Reyntiens has frequently referred back to the commissions on which he and Piper collaborated. The versatility and expressive range which they explored together has continued to influence his approach to stained glass. His skills, protean energy, his cultivated interests, which have flowed over into his book and exhibition reviews, as well as his mercurial humour – all have made him not only famous but also a much admired national treasure.

But to understand the significance of his achievement we need to be reminded how dull much stained glass was in the hundred years before Reyntiens began his career. There had been very little experiment; much had been executed in a predictable and familiar vein. War memorial windows produced in the 1920s all too often disappoint, while stereotypical saints from that period, as Piper observed, stand 'bored on their pedestals against pink or green seaweed or ivy-leafed backgrounds'. Anything more personal and expressive was at that time abhorred.

Reyntiens' achievement belongs to a renaissance in stained glass. It was triggered, no doubt by an array of things, not least by the windows of Evie Hone, by the impact of the Liturgical movement in Europe on church building, liturgy and stained glass, and by the example of the Art Sacré movement in France. The destruction caused to many of our cities during wartime eventually led to a period of bold innovation in church architecture, partly stimulated by the work of Le Corbusier. We can see the extent to which Reyntiens benefitted from this climate. One example is his work for the 1960s building, the Church of the Good Shepherd in Thackeray's Lane, Woodthorpe, Nottingham. At the time this was built, the conventionally religious interior was being rejected in favour of a new austerity which, at its best, produced a radiant simplicity. That Reyntiens could respond to the needs of a great variety of places of worship, from great medieval buildings to inner-city churches with a centralised Eucharistic space tells us much about the responsiveness and sympathies of this man and his prodigious imagination. He has gifted our architectural heritage through his handling of light and colour, through his enrichment of many sacred spaces, and he is rightly honoured by the publication of this book.

FRANCES SPALDING

Frances Spalding being interviewed by the author for the John Piper film, *An Empty Stage*, March 2009

Clockwise: Reyntiens in France; Reyntiens, Anne Bruce and Henry Moore; Reyntiens teaching at Pilchuk, USA, Reyntiens at Central St Martin c1976, Reyntiens at home 2010

'I think my best invention's myself!'

Reyntiens in interview, 2003

WORKS

IN

BRITAIN

-

ENGLAND

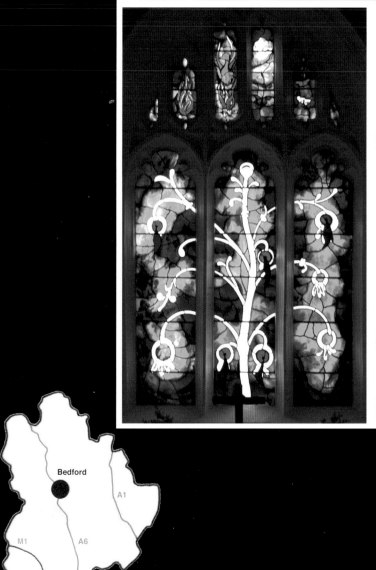

Totternhoe, St Giles of Provence, Church Road, LU6 1RJ

Listing: Grade I (26 September 1967) #1159758

General: The church is built of the local Totternhoe limestone and the chancel dates from the 14th century, the porch and tower from the 15th century whilst the nave and aisles are 16th century in the Perpendicular style. There are some pieces of medieval glass in the south aisle windows, including a Star of David.

Title: *Tree of Life*

Date: 1968-1971

Location and Size: 3-light east window, approximately 229x134cm (90x52 3/4in)

Designer: John Piper

Glass Painter and Maker: Patrick Reyntiens

Installation: January 1970 by E Hooker (St Albans) Ltd, at a cost of £89 (the fixing element of this was paid for by Piper)

Cost: In November 1970 Reyntiens quoted £1,000 for the work

Commemoration and Donor: The window was donated by William Pratt of Tring in memory of his wife Rosina and his parents, Walter John and Hannah Pratt who lived at Church End Farm, Totternhoe.

Dedication: 9 May 1971 by the Bishop of Bedford, The Right Reverend J H T Hare

Documentation: TGA 200410/2/1/10/1-28; Bedford & Luton Archives, P58/0/6; P58/32/6; P58/32/7

Literature: Harrison, 1982, unpaginated; Cowen Painton, *A Guide to Stained Glass in Britain*, London: Michael Joseph Ltd, 1985, p74; Osborne,1997, p105, 108, 175; *Stained Glass Windows and Master Glass Painters 1930-1972*, Bristol: Morris & Juliet Venables, 2003, p83; Spalding, 2009, p418, 419; *St Giles' Church, Totternhoe. Visitor's Guide*, undated, unpaginated

Reproduced: Osborne, 1997, p103

Notes: The Finance and Church Fabric Committee learned on 4 November 1968 that an elderly parishioner (William Pratt) wished to donate a stained glass window to the church and later in the month the PCC were divided, some people thinking that no stained glass should be added, others that the east window should be glazed as well as the north sanctuary window and the window above the side altar in the south aisle. In February 1969 the Annual Parochial Church Meeting and Meeting of Parishioners were informed that the elderly person's parents were buried in the churchyard and that the donor would provide in his will a 'certain sum of money to be held in trust, the interest from which to be used for maintenance of the Fabric and Churchyard as necessary'. On 24 March the Reverend Harold Handley told the PCC that the donor would donate £750 for the window and then a further £1,000 in his Will for maintenance. Four days later the Church Fabric Committee recommended the installation of an east window to include the coats of St Giles and St Alban and symbols of the Resurrection, together with further stained glass in the north chancel, for which a total of £408 had been quoted. It was felt that perhaps, given the value of the donation, a higher standard of workmanship would be advisable, and to this end advice was sought from members of the St Albans Diocesan Advisory Committee who visited the church on 27 May. The group appeared to agree that a single high quality window

would be preferable to a number of less worthy windows and one of the members, Sir Gilbert Inglefield, suggested contacting Piper. In his letter to Piper Inglefield stated that 'some well meaning parishioner' of St Giles had left money for a window in the church and that 'a fearful sketch has been submitted by an artist of woeful Victorian tastes!' – he rather hoped Piper could do something better – and suggested three emblems, one of St Giles, another of the Diocese of St Albans and perhaps a symbol of the Resurrection ('Phoenix, Peacock, Butterfly?') in the central light. Piper visited the church, expressed interest, but did not submit a quote. On 10 January 1970 the artist met the parishioner, William Pratt, Handley and Inglefield at the church and by February the vicar was able to report that Piper had agreed to prepare a design for the east window to replace the plain transparent diamond panes. An enthusiastic letter from the Vicar dated 19 June 1970 indicates that the design was completed and the PCC approved the design on 22 June with the exception of Mrs Acton who felt that the dark blue might perhaps be too dark. Unfortunately no-one seems to have considered showing the design to Mr Pratt, who, 'self taught' and intimidated by and unable to communicate with the vicar, asked a friend (Sheila Navey) to write to Piper personally. With the aid of divine intervention Handley finally visited Pratt on 16 July and showed the old man the design. A faculty was gained prior to the next PCC meeting on 28 September. A site meeting was held late November when Handley noted that 'to the astonishment of us, me in particular, Mr Reyntiens concluded the site discussions by saying that he would not be fixing the windows as it was outside his terms of reference'. The vicar was understandably worried at the escalating costs and the frailty of his parishioner who was anxious that he would never see 'his' window, which is presumably why Piper himself paid for the installation. The window shows a pale yellow Tree of Life (gold 'antique' glass) spreading across the mullions with pomegranate-looking red fruits on a mottled blue background - or alternatively a spreading vine, since the legend over the side altar reads 'I am the vine, you are the branches'. A Tree of Life also features in the 17th century chair to the left of the altar and one of the roof bosses is of a pomegranate, a symbol of eternal life. At the time the vicar described the window as 'The Tree of Life with the five wounds' based on the placing of the red fruits. As suggested by Inglefield, symbols of the Resurrection are found in the tracery - fire, butterflies and a phoenix.

In March 1971 Sheila Navey informed Piper that she had taken Pratt to see 'his' window: 'When he at last gazed upon it he was quite speechless but obviously delighted … he said you had made an old man happy by helping him to make a great wish reality and keep a promise made to his mother.'

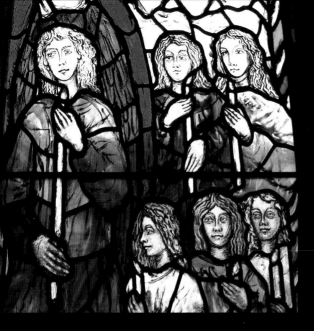

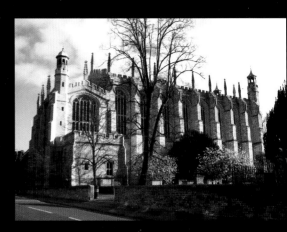

M4

Reading

Windsor

Eton

A34

A33

Ascot

Ascot, Heathfield School, Chapel of the Ascension, London Road, SL5 8BQ

General: Heathfield School is an all-girls independent boarding school which moved from 132-133 Queen's Gate, London, to Ascot in 1899. The stucco villa was designed in 1868 by Alfred Smith. The chapel may be by J Harold Gibbons c1903-1904 and the non-Reyntiens stained glass windows were designed by Louis Davis (1861-1941) in the Arts and Crafts style and were made by James Powell and Sons. Reyntiens' cousins, Audrey, Elizabeth and Ann Fellowes (Head Girl) were pupils at Heathfield in the 1930s. The latter became Sister Veronica Ann and remained in close contact with the School.

Literature: Tyack Geoffrey, Bradley Simon and Pevsner Nikolaus, *The Buildings of England, Berkshire*, London: Yale University Press, 2010, p136

The following details are applicable to both windows:
Designer and Glass Painter: Patrick Reyntiens

Glass Maker: John Reyntiens

Title: *Mary Knight Memorial* window

Date: 1996

Location and Size: 3-light window, chapel south aisle, 153x151cm (60x59in)

Inscription: signed and dated b.r.: 'Reyntiens 96'

Study: Presented to Mary Knight by the School

Commemoration: A plaque under this window reads: 'THIS WINDOW WAS INSTALLED IN APPRECIATION/OF MARY KNIGHT'S GENEROUS CONTRIBUTION/TO EVERY ASPECT OF LIFE AT HEATHFIELD/SCHOOL 1973-1996 AS A MEMBER OF STAFF/AND DEPUTY HEADMISTRESS'.

Literature: *Heathfield Magazine The*, 'Headmistress's Letter', 1996, p12

Notes: In terms of the surroundings this window is far more successful than the later one and Reyntiens has incorporated some of the diamond shaped glass seen in the other windows, even copying the scumbled effect. The theme is Candlemas and shows the Virgin Mary and Child in the centre surrounded by angels with candles, almost like a processional. The colours are subdued - white, red, purple, blue and brown.

Title: *Centenary window*

Date: 1999

Location and Size: 3-light window, chapel south aisle (nearest altar), 153x151cm (60x59in)

Inscription: signed and dated b.r.: 'Reyntiens 99'

Studies: Cartoon, Reyntiens Trust

Dedication: 9 May 1999 (the exact centenary day)

Literature: *Heathfield Magazine The*, 'Headmistress's Letter', 1999, p11

Notes: Christ displaying the five wounds and surrounded by yellow flames and a white mandorla is seen in the central light flanked by softly coloured angels in white, blue and yellow in the left and right lights, the three of them apparently surrounded by a plaited vortex in much bolder blues, green, red and purple. Below multitudinous faces gaze upwards at the spectacle, including that of Eleanor Beatrice Wyatt who founded the school in 1899. The chapel is Arts and Crafts in style and this window does not sit easily amongst such decoration.

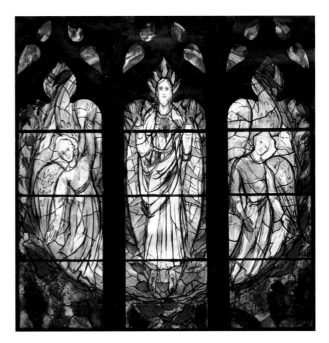

Opposite: Detail of Mary Knight Memorial window

Above: Cartoon of *Centenary window*

Below: *Centenary window*

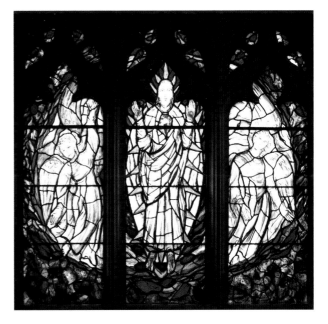

Windsor, Eton College Chapel, SL4 6DW

Listing: Grade 1(11 April 1950) #1290278 (this listing is for the whole complex)

General: Eton College dates from the 15th century, the foundation stone of the Chapel being laid by Henry VI in 1441. Huge though the chapel is, the original plan was for it to extend into what is now Keate's Lane (the proposed west end being marked by a plaque on the wall). The glass in the chapel was destroyed by a bomb during World War 2. The original east window was by Thomas Willement together with the first two windows on the north and south sides of the chapel, the remaining windows being designed by Michael O'Connor. The school broached the subject of replacement glass in 1946, and considering Willement and O'Connor to be first rate artists, desired a similarly renowned figure to design the east window, although the Provost, Sir Henry Marten, observed that 'stained glass windows … are rather a gamble'. Hugh Easton appeared to be the favourite but in June 1949 the Fellows decided on Evie Hone much to the dismay of the Dean of York who thought it would be 'disastrous' to employ Hone – 'her style, her vision, her craft would wage perpetual war with the architecture'. Hone's striking east window, the *Last Supper and Crucifixion*, was in place by April 1952 at which point she was asked to provide designs for the flanking windows, which she did, but her health was deteriorating and she died 13 March 1955. The problem remained – what to do with the two windows nearest the boldly coloured east window, and then the three others on the north and south sides of the chapel respectively.

Literature: *Modern Stained Glass*, Arts Council, 1960-1961, unpaginated; Harrison, 1982, unpaginated; Cowen Painton, *A Guide to Stained Glass in Britain*, London: Michael Jospeh Ltd, 1985, p75; Reyntiens Patrick, *The Beauty of Stained Glass*, London: Herbert Press, 1990, p194 ; *Spectator The*, Harrod Tanya, 'Talking about angels', 18/25 December 1993, p85; Pevsner Nikolaus and Williamson Elizabeth, *The Buildings of England, Buckinghamshire*, London: Penguin books, 1994 (1960), p112, 307; Osborne, 1997, 49-62, 172; *Stained Glass Windows and Master Glass Painters 1930-1972*, Bristol: Morris & Juliet Venables, 2003, p83; *BSMGP*, '"C R Wyard, Aspects of 20th-Century Stained Glass": BSMGP International Conference 2008', Vol XXXII, 2008, p127; Spalding, 2009, p353, 359-362

Reproduced: Reyntiens Patrick, *The Technique of Stained Glass*, London: B T Batsford Ltd, 1967, p137

Film: Pow Rebecca, *Rather Good at Blue. A Portrait of Patrick Reyntiens*, HTV West, 2000

The following details are applicable to all eight windows:
Date: 1955-1964 (production time 1959-1964)

Size: 5-light windows, 1067x457cm (420x180in)

Designer: John Piper

Glass Painter and Maker: Patrick Reyntiens

Technical supervisor: Derek White

Assistant: David Kirby

Architect in charge: Sir William Holford, Holford & Partners

Installation: Goddard and Gibbs

Cost: Piper was paid £1,000 for each window. Reyntiens charged £13/sq ft

Donors: War Damage Commission; Appeal Fund; David H Wills

Documentation: TGA 200410/2/1/3/1-79. Eton College Archives Coll/P8/21 and 29; Coll/P9/19, 20, 22, 24 part 2, 25a, 169; MISC/F/176; MISC/F/176/19; Eton College 1958/Contract for remaining Eight Stained Glass Windows; Eton College 1959 College Chapel Windows; COLL/B/SF96/2 and 6; COLL/CHA/4/1; COLL/B/SF14/5 and 6; B4.5.11pt1 (1947-1960)

Notes: The Head Master, Robert Birley, wanted pictorial glass in the windows at the east end of the nave - parables or biblical stories to give the boys something interesting to look at. Reyntiens wrote to the Bursar in April 1955 asking for images of Hone's window for his lectures and noting that if she had left some sketches for the other windows he would be happy to work from them. At about the same time Robin Arbuthnot recommended Reyntiens. Kenneth Clark noted that he had seen some of Piper's work at the Aldeburgh Festival and considered it 'extremely beautiful'. On 17 October 1955 the new Provost, Sir Claude Elliott, wrote to the architect, Sir William Holford 'the Head Master suggests that we might take our courage in both hands and commission Piper to do the whole eight windows. What do you think of that?' Holford responded that he would feel 'very stimulated'. One of the Masters, Oliver Van Oss, was chosen as the go-between, and wrote to Piper explaining the situation and alerting the artist that 'these big pots – which never boil – are definitely simmering'. Considering that John Betjeman was involved with commissions for Oundle School, Northamptonshire; Nuffield College, Oxford and Wantge, Oxfordshire, it is quite possible that he also had a hand in the proceedings since Van Oss, Paul Betjeman's housemaster, became a lifelong friend, and Betjeman was also in close contact with Kenneth Clark. In November the Vice-Provost, Provost and Head visited Piper's studio and saw the Oundle (Northamptonshire) windows which they considered 'very striking' and Birley felt that Piper was 'practically without competitors'. In July 1956 Piper visited Eton in response to a request from the Provost to submit sketches for the two windows flanking the east window but did not communicate again until March 1957 when he submitted a rough plan of subjects which probably included all eight windows. His subject was *Sacred and Profane Love* but no sketches were included and the theme was vetoed. Birley came to the conclusion that Piper was no draughtsman. In November that year he was asked to prepare a sketch for one of the windows together with a more detailed outline of a plan for the remaining windows, these to be reviewed by the Provost and Fellows in February 1958. At the same time Piper was told that the college would be approaching other artists but would reimburse Piper for his sketches if he was not chosen. Piper asked that he be allowed to submit his ideas before anyone else was contacted. Robin Darwin, Principal of the Royal College of Art was consulted and expressed himself as being slightly nervous about Piper, 'I find his work rather coarse and brutal. But he is, of course, a very fine artist'. The artist appears to have toyed with contrasts, waters of the Flood contrasting with the waters of Baptism and the Fire of Sinai contrasted to the Fire of Pentecost. The Provost decided that the subject matter was to be four miracles and four parables but, according to Reyntiens, Piper could not work out how to formulate the designs. Reyntiens suggested each window should be tree-like with larger pieces of glass in the centre decreasing in size towards the edges and thus becoming more frenetic – a similar device was used in Coventry (West Midlands). Piper's sketches were enthusiastically received at the February meeting and by May he and Reyntiens had been awarded the commission.
Reyntiens requested a legal contract which somewhat surprised the Bursar and staff who were more used to 'gentleman's agreements'. Piper was merely sent a formal letter on 30 July

1958 which stated that he was to be paid £1,000 for each window and that one window should be completed by 1 August 1959, two windows by 1 August 1960, two more windows by 1 August 1961 and the final three windows by 1 August 1962. Reyntiens telephoned the Bursar on 24 March 1959 enquiring when his contract would be ready for signing, although he was already well on the way to completing the first window. His contract was finally signed on 29 May 1959, noting that each window was to be completed within six months of approval being given to Piper's cartoon – this was to prove slightly problematic since Piper did not wish to be more than one cartoon ahead of production since the light changed as each window was added. When his cartoons were ready scaffolding was erected in the chapel and the cartoon viewed by the Provost and Fellows prior to approval being given. In July of that year the Bursar noted that the Fellows rather wanted all the south windows completed before the north windows but that Piper preferred to make the windows in pairs – it was suggested that he design the south window of a pair before the north because this affected the light in the nave. In January 1961 Reyntiens received a stinging letter from the Bursar about the delay in the timetable – the artist was still working on the Coventry window but promised the next Eton window by May and scaffolding was erected. The window was not complete by June and Reyntiens agreed to pay the cost of scaffolding. A new schedule was drawn up: window 4 to be fixed July 1961, window 3 in the autumn, numbers 5, 6, and 7 in 1962 and 8 and 9 early 1963. The College named the east window number 1, with the windows on the north side of the nave numbered 2, 4, 6, 8 and on the south side 3, 5, 7, 9, starting in each case from the East. 'We are hoping that he may improve on this programme, but I am rather sceptical' opined the Bursar in June 1961.

The north aisle of the chancel depicts four miracles, the south aisle four parables. Each window is divided by a transom and Piper depicted the 'problem' below and the 'solution' above. The particular parables and miracles were chosen for the ability with which they could be abstracted. The events are alternately surrounded by a mandorla or a **diamond shaped aureole.** Piper was aided in his iconography by his friend Moelwyn Merchant who was both churchman and academic. The glass was purchased in France and Germany and the colours are deeper in the east to complement Evie Hone's east window, and paler moving westwards where they abut grisaille glass designed by Moira Forsyth. After the first two windows had been completed Biblical references were added and the artists began to sign their work. In January 1959 Piper wrote to the College that in the case of his death 'any cartoons that I have already executed, and that have been approved, should be supervised in the making only by Patrick Reyntiens himself, since he and I have been closely associated and understand each others' methods and intentions, and I would not ordinarily regard the designs as interpretable, or capable of being properly supervised, by another hand' – a fitting tribute to his collaborator.

Pevsner describes the windows as 'powerful, nearly abstract compositions, far more responsive to the 15th century building than Hone's window' and Harrod describes the 'reckless beauty' of the windows. As Osborne points out, not only are the windows a 'fitting foil' to the wonderful east window, but 'they seem to process towards it with a growing sense of climax'.

Name: (2) *Raising of Lazarus* (*John*, 11)

Literature: Osborne, 1997, pxvii, p57-58; Spalding, 2009, 362

Reproduced: Osborne, 1997, p50

Notes: This was the first window to be made and the cartoon was displayed in the School Hall in January 1959. One of the Chaplains complained that in Piper's first sketch for this window the tomb was 'too much a piece of Renaissance architecture'. The Fellows wanted a beckoning hand, they didn't like the Head of Lazarus and objected to the coloured buttons in the border. Birley described the window: 'In the lower half is a tomb with the door most definitely shut. A hand pressed against the door emphasises the finality of it being closed. In the upper half Lazarus is seen emerging from the tomb, a shaft of light falling across his face'. Holford wrote to Piper on 5 September 1959 congratulating him on the first window, 'the colour is superb' but he hoped the more westerly windows would be lighter in tone.

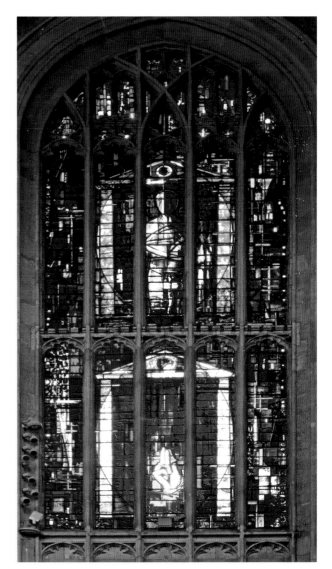

Reproduced by permission of the Provost and Fellows of Eton College

Name: (4) *Stilling of the Waters* (*Matthew* 8: 23-27)

Inscription: bottom of 2nd light from left: 'Matthew 8 23-6/Mark 3 37-9'

Literature: Osborne, 1997, p59, 61

Reproduced: Osborne, 1997, p54

Notes: The cartoon was on view in October 1960 but the window was not fixed until the following summer. The lower half indicates a storm with white flecked waves, the upper half a calm sea, a wonderful fusion of blue and green tones.

Name: (6) *Feeding of the Five Thousand* (*John* 6 and others)

Inscription: bottom of 3rd and 4th lights from left including 'John 6 5-13'

Literature: Harrison, 1982, unpaginated; Osborne, 1997, p61, 111

Reproduced: Osborne, 1997, p55

Notes: The cartoon was complete by February 1962 but the window was not complete until the end of August which earned Reyntiens another reprimand from the Bursar for not 'being business-like'. The lower section shows hands reaching out towards a mandorla containing five loaves and two fish and the upper part shows the baskets of food remaining after the feast. Harrison notes that the loaves and fishes are indicated but not the hungry crowds – although Piper was using symbolic references which lend an almost abstract feel to the windows as a whole, the lack of figures may also be attributable to his relative failure at this form of draughtsmanship.

Reproduced by permission of the Provost and Fellows of Eton College

Reproduced by permission of the Provost and Fellows of Eton College

Name: (8) *Miraculous Draught of Fishes* (*Luke* 5: 3-10)

Inscription: signed b.r.; bottom of 2nd light from left: 'S. Luke 5 1-11'

Commemoration and Donor: The window commemorates a former pupil, Captain Michael Desmond Hamilton Wills MC, Coldstream Guards, killed in North Africa 16 March 1943 and was funded by his brother David H Wills (St Martin, Sandford St Martin, Oxfordshire)

Literature: Harrison, 1982, unpaginated; Osborne, 1997, p62

Reproduced: Clarke Brian (Ed), *Architectural Stained Glass*, London: John Murray, 1979, p175; Compton Ann (Ed), *John Piper, painting in coloured light*, Kettle's Yard Gallery, 1982, unpaginated; Osborne, 1997, p60

Notes: Piper submitted the cartoon in October 1962 and apologised for the darkness of the window round the edges noting that in the making they would remember to lighten the tone. The window was in place by April 1963. The empty nets are indicated in the lower half of the window and the brimful nets in the upper half. The Vice-Provost considered this one of the best windows.

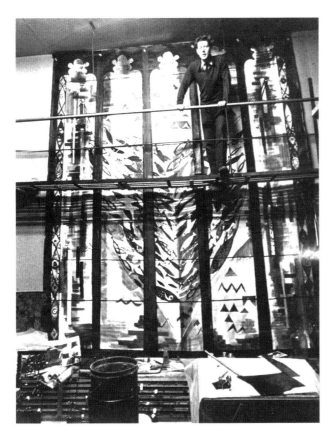

Reyntiens and the cartoon for the *Miraculous Draught of Fishes*
Reyntiens Trust archives

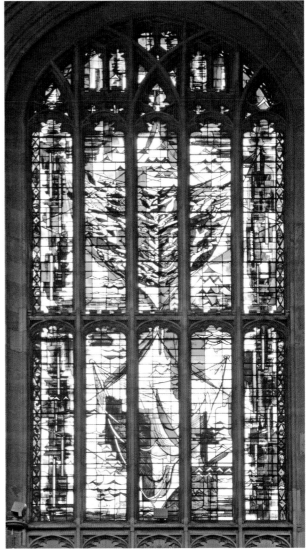

Reproduced by permission of the Provost and Fellows of Eton College

Name: (3) *Light under the Bushel* (*Matthew* 5: 14-16)

Literature: Osborne, 1997, pxvii, p58; Spalding, 2009, p362

Reproduced: Reyntiens Patrick, *The Beauty of Stained Glass*, London: Herbert Press, 1990, p173; Osborne, 1997, p50, 51

Notes: This was the second window to be designed, the cartoon being on view in June 1959 and it was ready to be installed by Easter 1960. The lower half includes a mandorla, the bushel in green and the flicker of a candle flame whilst the upper half contains another mandorla against a sunburst of light.

Reyntiens and Piper choosing glass for *Light Under the Bushel* Reyntiens Trust archives.

Name: (5) T*he House built on Rock and the House built on Sand* (*Matthew* 7: 24-27)

Inscription: bottom of 2nd light from left: 'S. Matthew 7 24-7/S. Luke 6 47-9'

Literature: Osborne, 1997, p58-59

Reproduced: Osborne, 1997, p54

Notes: Piper hoped to start designing the cartoon after April 1960, Reyntiens started work on it in September 1961 and it was completed by December. After viewing the cartoon the College asked for a rock for the house to stand on, a bigger crack in the house built on sand and complained about the white mullion in the top house. The lower half shows a building being destroyed by the elements whilst the top half illustrates a building standing firmly against whatever the weather throws against it.

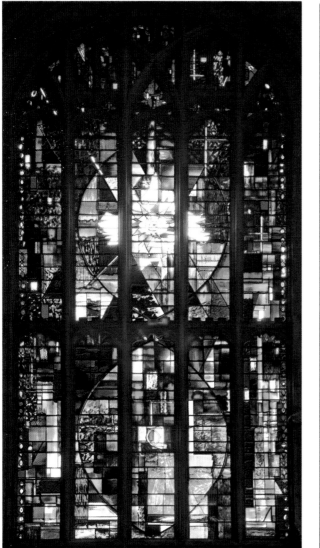

Reproduced by permission of the Provost and Fellows of Eton College

Reproduced by permission of the Provost and Fellows of Eton College

Name: (7) *The Lost Sheep* (*Luke* 15: 4-7)

Inscription: signed b.r.; bottom of 2nd light from left: 'S. Matthew 18.12.13/S. Luke 15.4.5'

Literature: Osborne, 1997, p59-61; Spalding, 2009, p483

Reproduced: Osborne, 1997, p55

Notes: Piper started work on the cartoon in September 1961, completed it by November and the window was in place February 1963. The two halves show a bemused sheep caught in a tangle of undergrowth and a sheep freed thanks to a kindly shepherd on whose shoulders it rests. Apparently, faced with the difficulty of drawing a sheep's head Piper had resorted to purchasing a herd of such animals which he had kept ever since. The Provost wrote to Piper 'I am glad that the sheep looks a complete moron and quite unlike any of the really hardy mountain sheep of Scotland or Cumberland who always know where they are anywhere'.

Name: (9) *The Wheat and the Tares* (*Matthew* 13: 36-40)

Inscription: signed b.r.; bottom of 2nd light from left: 'S. Matthew 13 3-8/S. Mark 4 3-8/S. Luke 8 5-8'

Literature: Osborne, 1997, p61-62

Reproduced: Osborne, 1997, p57

Notes: This was the last window to be fixed, in February 1964. The lower section indicates the spiky tares, a bird and butterflies with more butterflies and golden wheat ears in the upper half. Birley noted that 'The lower half will give an impression of barrenness and futility, the seed falling on stony ground and the thorns choking it; the upper half will show the seed that "did yield fruit that sprang up and increased"'. The Biblical references actually relate to the parable of the sower.

Reproduced by permission of the Provost and Fellows of Eton College

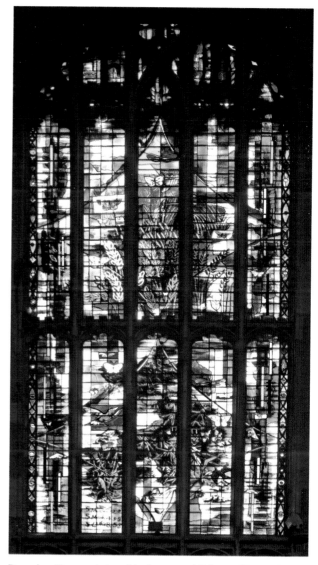

Reproduced by permission of the Provost and Fellows of Eton College

Windsor, Windsor Castle, St George's Chapel, King George VI Memorial Chapel

General: The King George VI Memorial Chapel is a tiny chapel designed by George G Pace with Paul Paget of Seely & Paget, 1967-1969, which fits neatly between the quire and the transept of St George's Chapel. From the exterior the Liturgical Chapel looks like 'a jewel-like shrine, nestling between the great buttresses' (Pace). The design, although modern, perfectly complements the architecture of St George's Chapel, built of pale stone and with recessed windows in the many angled walls. It is the resting place of King George VI (whose body since his death in 1952 had rested in the Royal Vault), his wife Elizabeth (the Queen Mother) and Princess Margaret and is used twice a year, on Accession Day and Coronation Day. The interior is of Clipsham ashlar stonework with a floor of polished Purbeck freestone. The wrought-iron gates are locked and it is impossible to see all the windows but the two most striking are visible. All the windows are abstract and Cowen describes them as 'a relief from all this formality' of the main chapel.

Literature: *Building*, 'King George VI Chapel in St George's Chapel, Windsor', 29 March 1968, p85; *Architectural Review*, 'New Windsor Chapel', February 1970, p153-154

Cost: £2,000 quoted October 1968, **Reyntiens charged £16/sq ft for the glass and £1,000 was paid to Piper 8 July 1969**

Commemoration and Donors: King George VI, donated by the Knights of the Garter in whom King George VI had taken particular interest

Dedication: 31 March 1969 by the Dean of Windsor, Robin Woods

Documentation: SGC CL.22 (1 & 21), TGA200410/2/1/12/21221 5226, 228229, 234, 237, 250

Literature: *Building*, 'King George VI Memorial Chapel, Windsor', 12 September 1969, p102; *Architectural Review*, 'New Windsor Chapel', February 1970, p154; Harrison, 1982, unpaginated; Cowen Painton, *A Guide to Stained Glass in Britain*, London: Michael Jospeh Ltd, 1985, p75; Pace Peter, *The Architecture of George Pace*, London: B T Batsford, 1990, p220; Osborne, 1997, p96, 175; *Stained Glass Windows and Master Glass Painters 1930-1972*, Bristol: Morris & Juliet Venables, 2003, p83; Archer Michael, 'John Piper and the Stained Glass of the King George VI Memorial Chapel 1967-9', in Brown Sarah, *A History of the Stained Glass of St George's Chapel, Windsor Castle*, Windsor: Dean and Canons of Windsor, 2005, p167-169; Neiswander Judith & Swash Caroline, *Stained & Art Glass*, London: The Intelligent Layman Publishers Ltd, 2005, p253; Spalding, 2009, p365; Tyack Geoffrey, Bradley Simon and Pevsner Nikolaus, *The Buildings of England, Berkshire*, Yale University Press, 2010, p664

Reproduced: *Building*, 'King George VI Memorial Chapel, Windsor', 12 September 1969, p102; *Architectural Review*, 'New Windsor Chapel', February 1970, p154; Pace Peter, *The Architecture of George Pace*, London: B T Batsford, 1990, p220; Archer Michael, 'John Piper and the Stained Glass of the King George VI Memorial Chapel 1967-9', in Brown Sarah, A History of the Stained Glass of St George's Chapel, Windsor Castle, Windsor: Dean and Canons of Windsor, 2005, plate XII

The following details are applicable to all four windows:

Title: The windows are unnamed

Date: 1968-1969

Designer: John Piper

Glass Painter and Maker: Patrick Reyntiens
Technical Supervisor: Derek White

Architects in charge: Paul Paget FRIBA of Seely and Paget, architects to St George's Chapel, in association with George G Pace (St Mark's Church, Sheffield, Yorkshire; Llandaff Cathedral Church, Wales)

Notes: The original plan was to have plain or slightly tinted glass in the windows and then Pace considered consulting a flower expert with the thought of including flower motifs. However by August 1968 it was agreed that Piper should be approached. The Queen Mother had aways greatly admired Piper's work and gave him complete freedom as far as the design was concerned. Piper and Reyntiens were authorized to proceed in October that year and Reyntiens had begun work by December at which stage Pace noted that he felt the red tones should be muted somewhat and more lead cames inserted. It is interesting to note that the schedule was quite tight since the windows had to be installed by the date of dedication - so Piper revamped designs which he had worked on with Pace for three windows in the apse of Pershore Abbey between 1962 and 1965 (TGA 200410/2/1/11/83 & 104) and Reyntiens used French and German glass left over from the Coventry (West Midlands) commission.

Location and Size: two 3-light rectangular windows behind stone altar, north, each approximately 305x91cm (120x36in)

Notes: Piper designed these windows to mirror each other. They are abstract, mainly blue ranging from light blue in the other lights to darker blue in the centre emphasising the importance of the altar. There are patches of red and orange glass with smaller insets of purple and green, the whole overlaid with tiny dots of white, yellow, green and pale blue.

Location and Size: single lancet rectangular window to east, approximately 285x22cm (112x8 3/4in) wide

Notes: This window has semi-opaque white glass with areas of turquoise and pale blue, dots of pale blue, green, white and one yellow dot at the top. Judging from Reyntiens' painting, Piper was using marbled paper for his cartoon.

Location and Size: double lancet rectangular window, south east, approximately 300x61cm (118x24in) wide

Notes: The window has semi-opaque white glass with coloured dots in blue, green, white and yellow and painted with marbled effect. Piper has thus decreased the density of colour as the eye moves away from the altar.

Location: single rectangular lancet and 3-light rectangular clerestory windows, south

Notes: These are only visible by the Celebrant. They are a golden yellow, complementing the ceiling of the small sanctuary, with dots in yellow, white, green and blue and painted brush strokes carried out in brown enamel and yellow stain.

Right: one of the 3-light windows behind the altar and
the single lancet window to east

Below: clerestorey lights

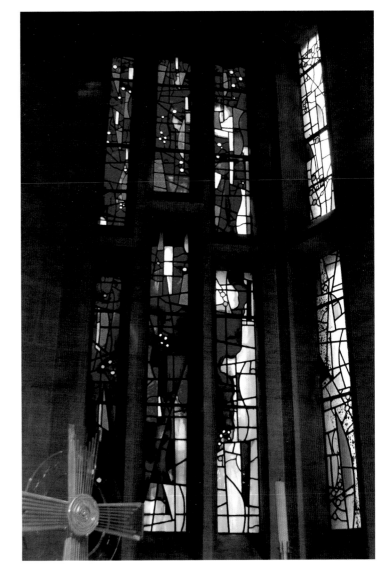

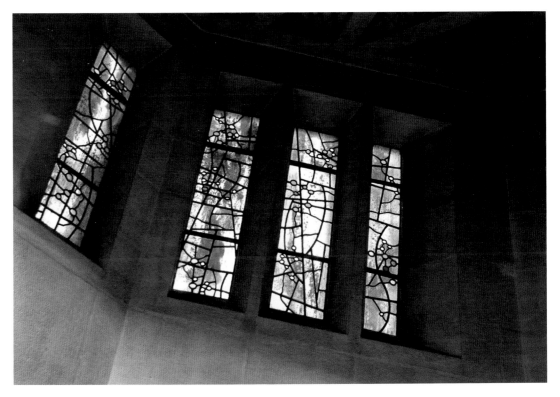

BUCKINGHAMSHIRE

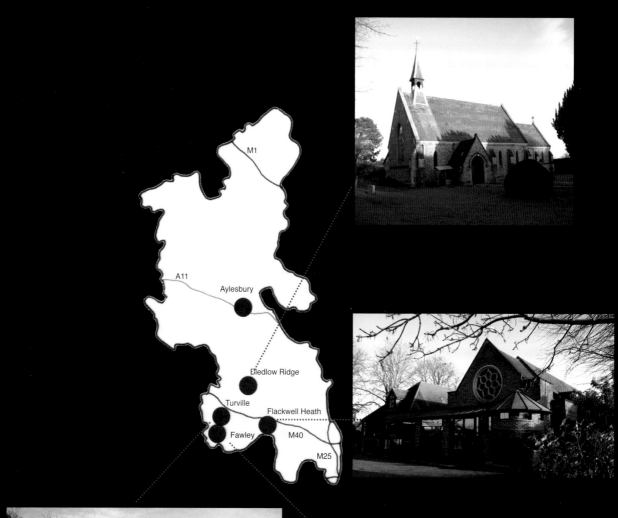

M1

A11

Aylesbury

Bledlow Ridge

Turville

Flackwell Heath

Fawley

M40

M25

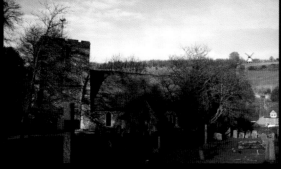

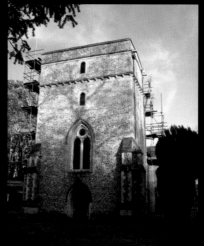

Bledlow Ridge, St Paul, Chinnor Road, HP14 4AX

Listing: Grade II (4 July 1985) #1159852

General: The flint church with Bath stone dressings and slate roofs was designed by D Brandon, is dated 1868, and cost £1,200 to build. The church is very plain inside with whitewashed walls and seating rather than pews.

Title: *Heaven (Chaos to Cosmos)* (in the Register of Services it is referred to as 'Benedicite' window)

Date: 1967-1968

Location and Size: 3-light west window, approximately 355x213cm (140x84in)

Designer: John Piper

Glass Painter and Maker: Patrick Reyntiens

Cost: £2,000

Commemoration and Donor: The postcard states that the window celebrates the 100th anniversary of the church. A plaque next to the window reads: 'THIS STAINED GLASS WINDOW BY PATRICK REYNTIENS/TO THE DESIGN OF JOHN PIPER WAS THE GIFT OF/LOUISE MCMORRAN OF POUND SCOTS BLEDLOW RIDGE/FOR MANY YEARS A CHURCHWARDEN OF THIS PARISH/31ST MARCH 1968'.

Faculty: 27 November 1967

Dedicated: 31 March 1968 by the Lord Bishop of Buckingham

Documentation: TGA200410/2/1/12/152, 158, 162; Centre for Buckinghamshire Studies PR.17.A/2/6; Oxfordshire History Centre, Heritage & Arts, c.1351

Literature: NADFAS, *Nadfas Church Record, St Paul's Church, Bledlow Ridge, Bucks*, 1974; Harrison, 1982; Pevsner Nikolaus and Williamson Elizabeth, *The Buildings of England, Buckinghamshire*, London: Penguin books, 1994 (1960), p183; Osborne, 1997, p76, 100-101, 112, 174; *Stained Glass Windows and Master Glass Painters 1930-1972*, Bristol: Morris & Juliet Venables, 2003, p83; Woollen Hannah, Lethbridge Richard, *John Piper and the Church. A Stained-Glass Tour of selected local churches, in conjunction with the exhibition at Dorchester Abbey from 21 April to 10 June 2012*, 2012, unpaginated

Reproduced: Osborne, 1997, p102; Woollen Hannah, Lethbridge Richard, *John Piper and the Church. A Stained-Glass Tour of selected local churches, in conjunction with the exhibition at Dorchester Abbey from 21 April to 10 June 2012*, 2012, unpaginated; postcard

Notes: In 1967, the incumbent, the Revd A V Diamond, noted that Louise McMorran was ageing and not in good health. She applied for a faculty to reserve a grave space near the large cherry tree in June of that year and obviously wished to give something permanent to the church she had served so faithfully over the years. The west window was suggested and the PCC approved Piper's design which replaced a plain leaded glass window on 25 October 1967. The title, *Chaos to Cosmos*, could refer to the ordering of the world from chaos. This was not Piper's title, apparently he would have preferred *Creation* or *Creation of the World*. The design idea came from the church itself, an uncomplicated building which demanded an uncomplicated response. The design is abstract, predominately blue, with pale and dark circles and squares, white floral shapes (maybe cow-

parsley) and white and red spirals, similar in feeling to the window at St Andrew's, Wolverhampton, West Midlands and one of the windows at All Hallows, Wellingborough, Northamptonshire. The design runs across the mullions. It is rather beautiful, certainly the most exciting aspect of the church and Piper noted that it was amongst the best of the joint Piper/Reyntiens ventures. He declared that there was nothing intentionally representational in the window, no sun or moon or ammonites, whatever people might think.

The *NADFAS* record includes a description taken from a taped recording dated 22 November 1969 between Piper and Revd W B Corfield (who succeeded Revd Diamond in 1968). Piper described the 'pure effect of glaze with simple effects of colour with simple forms. Big forms against little forms, intense colours against more subdued colours and one simple colour against another. This is why I limited it to blues and reds. Indeed one of the most successful things is something you cannot do in a cartoon … and that is the rather bright bits of ultramarine that look rather like a bunch of grapes in the middle of that rather dark background. To me it is very interesting the way that blue radiates and shines. It is a thing that you can only do in glass.'

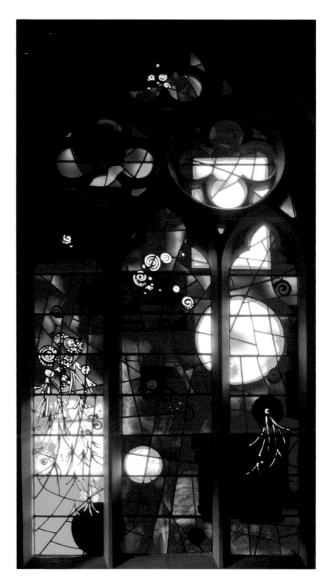

Fawley, St Mary, RG9 6JA

Listing: Grade II* (21 June 1955) #1125702

General: St Mary's is a parish church of flint rubble with stone dressings dating back to the 12th century but most of what one experiences these days dates from the 18th century (financed and possibly designed by by John Freeman of Fawley Court) and 19th century. The pulpit has been attributed to Grinling Gibbons. There are also two 17th century armorial glass panels in the tower which Reyntiens repaired, releaded and added surrounding glass in 1971-1972, the work paid for by Piper and Brown & Sons of Nettlebed (Piper and Brown both being parishioners). The inscription below reads: 'Glass originally in/Fawley Court c.1964/ given by Miss Whitelocke-Lloyd/repaired & set up 1971-72'. Piper is buried in the churchyard.

Literature: NADFAS, *Nadfas Church Record, Fawley, St Mary the Virgin*, 1977 (1973); Tyack Geoffrey, *Fawley Buckinghamshire. A short history of the Church and Parish*, Fawley Parochial Church Council, 1986

Title: *Tree of Life* (*Revelations* 22:2)

Date: 1977-1978

Location: Anthony Hartley memorial window, single lancet on east wall of vestry

Inscription: 'In memory of ANTHONY HARTLEY 1939-1975' inscribed b.l.

Designer: John Piper

Glass Painter and Maker: Patrick Reyntiens

Assistant: David Wasley

Cost: £750

Commemoration and Donors: A plaque adjacent to the window reads: 'In memory of/ANTHONY HARTLEY/1939-1975/The Tree of Life Revelation 22.2/by JOHN PIPER'. The window was commissioned by Dr & Mrs Alan Hartley in memory of their son.

Faculty: 22 November 1977

Documentation: Oxfordshire History Centre, Heritage & Arts, Oxf. Dioc. Papers c.1437

Literature: Harrison, 1982; Tyack Geoffrey, *Fawley Buckinghamshire. A short history of the Church and Parish*, Fawley Parochial Church Council, 1986, p14; Pevsner Nikolaus, and Williamson Elizabeth, *The Buildings of England, Buckinghamshire*, London: Penguin books, 1994 (1960), p325-326; Osborne, 1997, p111, 176; Woollen Hannah, Lethbridge Richard, *John Piper and the Church. A Stained-Glass Tour of selected local churches, in conjunction with the exhibition at Dorchester Abbey from 21 April to 10 June 2012*, 2012, unpaginated

Reproduced: Tyack Geoffrey, *Fawley Buckinghamshire. A short history of the Church and Parish*, Fawley Parochial Church Council, 1986, back cover; Osborne, 1997, p111; Woollen Hannah, Lethbridge Richard, *John Piper and the Church. A Stained-Glass Tour of selected local churches, in conjunction with the exhibition at Dorchester Abbey from 21 April to 10 June 2012*, 2012, unpaginated

Notes: At the PCC meeting dated 25 July 1977 the Revd Basil Wilks showed the council Piper's preliminary design which was 'met with acclaim and admiration by all those present at the meeting'. The design is of a wonderful joyous and colourful Tree of Life, a sinuous green stem laden with a profusion of fruit and flowers set against a blue background. Another faculty dated 8 August 1978 allowed for the vestry to be opened up to the remainder of the church so that visitors could see the window.

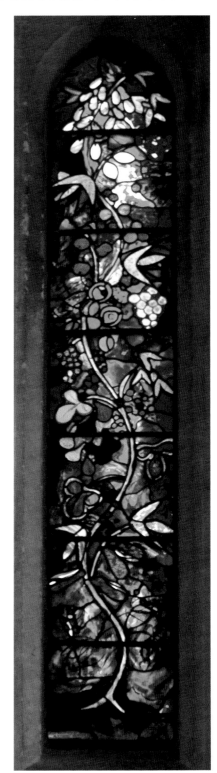

Flackwell Heath, Christ Church, Chapel Road, HP10 9AA

General: In the early 1950s Flackwell Heath expanded rapidly and a small brick and wooden church was chosen for conversion to an Anglican church for the area. The new church was consecrated by Dr Harry Carpenter, Lord Bishop of Oxford, on 31 October 1959.

Literature: NADFAS, *Nadfas Church Record, Christ Church, Flackwell Heath*, undated

Title: *Wootton Memorial window*

Date: 1961

Location and size: Rose west window, approximately 238cm (93 3/4in) diameter

Designer, Glass Painter and Maker: Patrick Reyntiens

Architect in charge: Sebastian Comper

Commemoration and Donors: The plaque below the window reads: 'The above window is given to the Glory of God and in loving memory of Minette Esther & Frank Stone Wootton by their children, 5th November 1961'.

Dedication: 5 November 1961, dedicated at Evensong (Revd V Read vicar)

Documentation: Centre for Buckinghamshire Studies, PR.141/2/5

Literature: Clarke Brian (Ed), *Architectural Stained Glass*, London: John Murray, 1979, p193; *Stained Glass Windows and Master Glass Painters 1930-1972*, Bristol: Morris & Juliet Venables, 2003, p83; NADFAS, *Nadfas Church Record, Christ Church, Flackwell Heath*, undated

Notes: This is an abstract design in rose, blue, grey and stone colours made with old glass.

Turville, St Mary the Virgin, RG9 6QX

Listing: Grade II* (21 June 1955) #1125644

General: The church is in perhaps the most secluded and beautiful part of the Chilterns and is summarily described by Pevsner as mostly medieval but externally all Victorian. It dates from the 12th century, with a 14th century chancel, a west tower of the 16th century and the north aisle dated 1733. It is built of flint with stone dressings, a brick north aisle and tiled roof.

Title: *Annunciation*

Date: 1974-1975

Location and Size: semi-circular lunette in tympanum of walled up door, north side of nave, approximately 43x76cm (17x30in)

Inscription: signed and inscribed on the window: " 'My soul doth magnify the Lord' John Piper/1975"

Designer: John Piper

Glass Painter and Maker: Patrick Reyntiens

Architect in charge: J H Martindale & Son

Commemoration: The plaque below reads: 'By this window/ST MARY'S TURVILLE/commemorates/ST SAVIOUR'S TURVILLE HEATH/1898-1972'

Faculty: 13 May 1975

Documentation: Oxfordshire History Centre, Heritage & Arts, c.1637

Literature: *Chiltern Society's News*, Gayner Richard, 'St Mary's Restored', August 1975; Harrison, 1982; Pevsner Nikolaus and Williamson Elizabeth, *The Buildings of England, Buckinghamshire*, London: Penguin books, 1994 (1960), p698; Osborne, 1997, p111, 176; Joyce Kingsley R, *St Mary the Virgin Turville*, 2002 (1977), p6; Woollen Hannah, Lethbridge Richard, *John Piper and the Church. A Stained-Glass Tour of selected local churches, in conjunction with the exhibition at Dorchester Abbey from 21 April to 10 June 2012*, 2012, unpaginated

Reproduced: Osborne, 1997, p111; Joyce Kingsley R, *St Mary the Virgin Turville*, 2002 (1977), p8; Woollen Hannah, Lethbridge Richard, *John Piper and the Church. A Stained-Glass Tour of selected local churches, in conjunction with the exhibition at Dorchester Abbey from 21 April to 10 June 2012*, 2012, unpaginated; postcard

Notes: The PCC approved the design 11 September 1974. The *Chiltern Society's News* notes that Piper played a major part in the plans for the restored church following the sale of St Saviour's, and 'has presented to the church his design for a stained-glass window' suggesting that this was given gratis. It is a charmingly simple design of a hand holding an Easter lily against a rich blue background, symbolizing the Magnificat of the Virgin Mary.

'One thing about Edinburgh College was that they were still very 19th century and every day of every week you were expected to volunteer, in inverted commas, for life drawing from 6 to 9 every night and you drew and you drew and you drew and you drew until you dropped and then you drew again so that everything was in one's memory and I can draw a muscular man or a beautiful woman in any position at all totally from memory.'

Reyntiens in interview, 2007

CAMBRIDGESHIRE

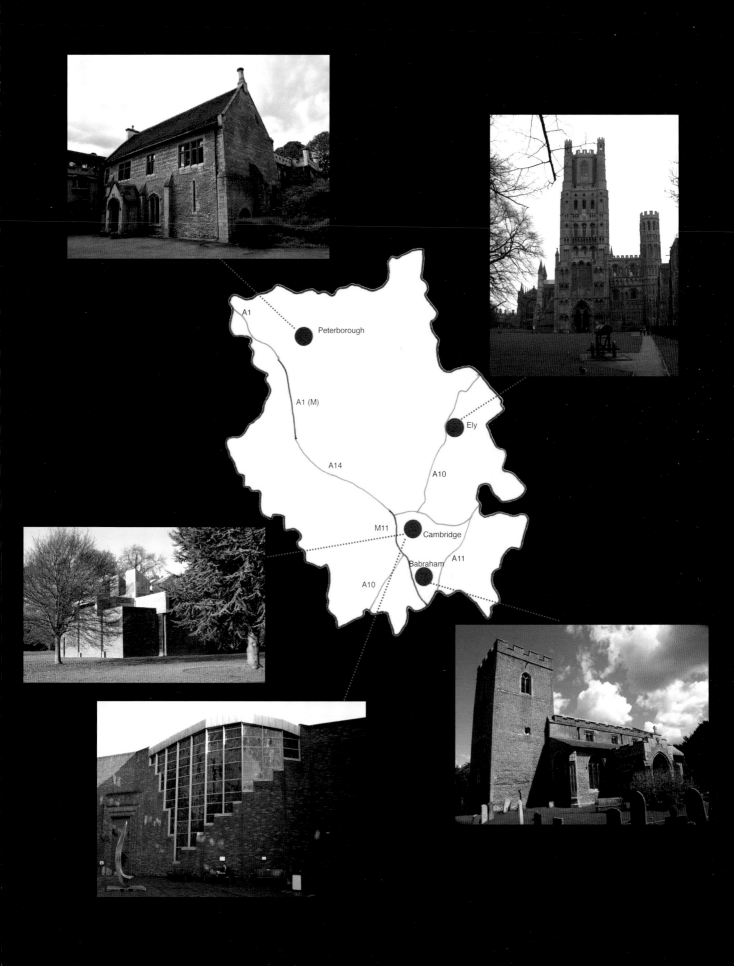

A1

Peterborough

A1 (M)

Ely

A14

A10

M11

Cambridge

Babraham

A11

A10

Babraham, St Peter's, south west of Babraham Hall, High Street, CB22 3AT

Listing: Grade 1 (22 November 1967) #1331111

General: St Peter's is a flint rubble church with clunch and Barnack limestone dressings, slate roofs with pantiles over the chancel, a 13th century stocky square tower, the chancel also being 13th century, the remainder of church mostly 15th century, although there are some lovely fragments of 14th century glass in a north chancel window. The south aisle is raised above floor level and bricked over (covering a vault). There are countless hatchments and monuments to the Adeane family who appeared to dominate every aspect of parish life. The living was the gift of Charles Robert Whorwood Adeane and Babraham Hall was built by Henry John Adeane between 1833 and 1837.

Title: *Emblems of St Peter, Adeane Memorial*

Date: 1962-1966 (design completed January 1964; window delivered 28 January 1966)

Location and Size: 3-light Perpendicular east window, approximately 302x204cm (119x80 1/4in)

Designer: John Piper

Glass Painter and Maker: Patrick Reyntiens

Architect in charge: Marshall Sisson

Cost: £2,100

Commemoration and Donors: The window commemorates Charles Robert Whorwood and Madeline Pamela Constance Blanche Adeane, and was given to the church by their son Sir Robert Adeane.

Documentation: TGA 200410/2/1/11/57, 85, 86, 108, 116, 124, 138, TGA200410/2/1/12/11, 12, 19, 22, 44, 47, 48

Literature: Harrison, 1982; Wright Carolyn, *Exploring Cambridgeshire Churches*, Stamford: Cambridgeshire Historic Churches Trust, 1991, p14; Hicks Carola, *Cambridgeshire Churches*, Stamford: Paul Watkins, 1997, p296-297; Osborne, 1997, p97, 100, 174; Jenkins Simon, *England's Thousand Best Churches*, London: Allen Lane The Penguin Press, 1999, p43; *Stained Glass Windows and Master Glass Painters 1930-1972*, Bristol: Morris & Juliet Venables, 2003, p83; Heard Kate, *Light in the East. A Guide to Stained Glass in Cambridgeshire and The Fens*, Stained Glass Museum, 2004, p10, 14; *St Peter's Church, Babraham*, guidebook, unpaginated

Reproduced: Osborne, 1997, p95, 98, 99; Heard Kate, *Light in the East. A Guide to Stained Glass in Cambridgeshire and The Fens*, Stained Glass Museum, 2004, p14; *St Peter's Church, Babraham*, guidebook, unpaginated

Notes: It would appear from a letter from Robert Adeane to John Piper dated 18 December 1962, that the original idea had been to fill a blocked 15th century rose window but that Piper considered it would be more suitable to fill the east window. Apparently Piper had great difficulties getting the design approved, which possibly accounted for the time taken. But how wonderful that the design was finally accepted – it's a bold and rather jolly window on the theme of St Peter, with a red sailed boat on a green background left referring to his occupation and walking on water (*Matthew* 14: 25-33), yellow and white keys on a blue background centre symbolising his role as keeper of the keys of heaven (*Matthew* 16: 19), and a cockerel on a yellow ground right reminding one of his denial of Christ (*Matthew* 26: 34). In the tracery lights can

be seen the inverted cross on which Peter, in humility, begged to be crucified; the prison chains from which he escaped (*Acts* 12: 7); a fish referring to his job as a fisherman and as a fisher of men (*Luke* 5: 10); and an anchor which relates to the sea (Heard points out that the anchor could represent hope whilst the guidebook suggests that it symbolises The Church, of which Peter was the chief Apostle, and the Ark of Salvation). A cheeky little keyhole at the top links to the keys below. Hicks describes the 'rich palette and graceful lines' of the Piper/Reyntiens collaboration. Heard considers the window the highlight of the church and it certainly adds much needed colour to an over-whitewashed interior.

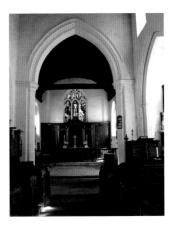

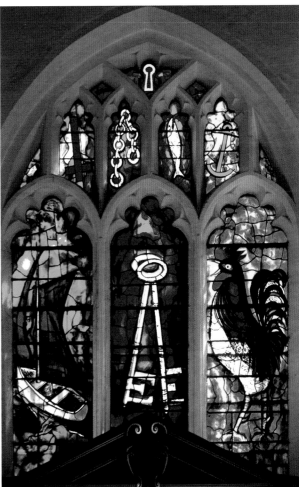

Cambridge, Churchill College Chapel, Churchill College Grounds, Storey's Way, CB3 0DS

Listing: Grade II (30 March 1993) #1331925

General: Churchill College was primarily founded for the study of sciences and engineering and many felt that a chapel was an unnecessary superstitious out-dated and costly addition, most notably Francis Crick who resigned his Fellowship in protest. The wealthy philanthropist Revd Timothy Beaumont offered to fund the building of the chapel to the tune of £30,000 but this did not silence the detractors. The final solution was to build a non-denominational chapel but not in the College complex – it is removed from the campus by the playing fields and sports grounds, does not draw attention to itself and, surrounded by trees, is barely visible from the College. For those interested in the debate I would recommend Mark Goldie's entertaining and authoritative article.

The chapel was designed by Richard Sheppard, Robson and Partners (the architects for the College itself), is dated 1966-1967, built of brown Stamfordstone brick with copper roofing, with floor to ceiling slit windows and its ground plan is that of a Greek Cross. In his foreword to *Cambridge New Architecture*, Pevsner noted that the chapel 'has a serenity inside not before aimed at by the architect'. The hanging cross and standard candlesticks, designed by Keith Tyssen, were gifts from the Goldsmiths' Company, the bell was presented by the Board of the Admiralty and came from *HMS Hermes* which had been launched by Lady Spencer-Churchill, and 100 of Sir Gordon Russell's 'Coventry' chairs were ordered for the interior.

Literature: *churchbuilding*, Sheppard Richard and Canon Duckworth, 'Churchill College Chapel', October 1968, no 25, p23; Pevsner Nikolaus, 'Foreword' in Taylor Nicholas and Booth Philip, *Cambridge New Architecture*, London: Leonard Hill, 1970; Harrison, 1982; *The Chapel at Churchill College, 40th Anniversay Appeal*, 2007; Goldie Mark, *God's bordello: storm over a chapel. A history of the chapel at Churchill College Cambridge*, Cambridge, 2007

Title: *Let there be light' (Genesis* 1: 3), *Sir John Cockcroft memorial*

Date: 1967-1970

Location and Size: eight narrow slit vertical windows in the Chapel, made in glass and set in extruded 'Delta' bronze. The two east windows either side of the altar are composed of two sections each 396x84cm (156x33in) and 396x25.4cm (156x10in); there are two windows on the north and two on the south wall each 396x46cm (156x18in); west wall 2 windows 351x46cm (128x18in).

Designer: John Piper

Glass Painter and Maker: Patrick Reyntiens

Technical Supervisor: Derek White

Architect in charge: Richard Sheppard

Installation: Goddard and Gibbs

Cost: Piper design fee £1,600. Reyntiens contract dated 20 February 1970 in sum of £4,654

Commemoration and Donors: In memory of Sir John Cockcroft. Donations were from Lord Beaumont (mentioned above), the Cockcroft family, John Oriel's family (Oriel was one of the College Trustees and a retired Shell executive), past and present College members and public donations.

Dedication: Sunday 4 October 1970

Documentation: TGA 200410/2/1/1/1-24. Churchill College Archives CCAR/801/2; CCAR/801/2A; CCAR/800/7

Literature: *Presentation of Windows in memory of Sir John Douglas Cockcroft, O.M. First Master of Churchill College Cambridge*, Sunday 4 October 1970; Pevsner Nikolaus, 'Foreword' in Taylor Nicholas and Booth Philip, *Cambridge New Architecture*, London: Leonard Hill, 1970, p7; Osborne, 1997, p96-97, 175; Heard Kate, *Light in the East. A Guide to Stained Glass in Cambridgeshire and The Fens*, Stained Glass Museum, 2004, p28; Goldie Mark, *God's bordello: storm over a chapel. A history of the chapel at Churchill College Cambridge*, Cambridge, 2007, p21, 28; Spalding, 2009, p420-423

Reproduced: Osborne, 1997, p94

Notes: Sir John Cockcroft was not only the first master of the College and the first Chairman of the Trustees but also the driving force behind the plans for the chapel. Cockcroft died 19 September 1967, a mere month before the opening of the Chapel on 15 October 1967. The 40th Anniversary Appeal notes that the chapel 'commanded as great an interest and devotion as any other activity in his remarkable life'. The idea for the Memorial Windows was that of Captain Stephen Roskill and Revd Dr Victor Edward Glencoe Kenna, a Fellow Commoner of the College and a close friend of Piper (they first met when Kenna was curate of St Martin's, the church attended by Piper's parents (Oundle School, Northamptonshire; Coventry Cathedral, West Midlands). According to Henry Thorold Kenna was known in the navy as 'the Black Abbot').

In his 1968 article Sheppard noted that the vertical slit windows were of ordinary sheet glass and painted blue but that it was anticipated in time to have stained glass. Piper was first approached by Revd Kenna in 1967. The artist was in favour of using fibre glass and contacted David Gillespie Associates who had made fibre glass windows to his design for All Saints, Clifton and St Matthew's, Southcote. Lady Cockcroft appears to have been quite a formidable woman and she was against fibre glass, didn't like what was termed 'tiddly-winks' round the edges of the windows (Sheppard was also sceptical) and was not partial to Piper himself. However the Churchill College Chapel Society Trust managed to persuade her in June 1968 to accept the idea of the new material and Piper was so confident that he even suggested having two panels made and fitted at his own expense for the committee to see the effect. Fibre glass had the added advantage of being considerably cheaper – the total package would have been in the order of £1,300. Despite this, in October 1968 Piper was informed that he had been awarded the commission but, on the wishes of Lady Cockcroft, the College would prefer 'conventional' glass. Piper consulted his friend Revd Kenna who suggested drops of blood, but the advice was rejected in favour of a broader symbolism in keeping with the ethos of the building, although some of the dots in the borders could be mistaken for blood droplets. Kenna wrote to Piper noting that 'there are no signs of blood! And without the shedding of blood, there is no remission', most of this underlined once if not twice, so he was obviously not best pleased.

In April 1969 Sheppard acknowledged receipt of Piper's drawings for the windows, 'the colours are rich and sonorous and the radiance in the upper section of each window is exactly placed'

but questioned why the designs were asymmetrical when the chapel itself is very symmetrical, although the entrance is on the diagonal. Piper felt that having the north and south windows different colours would correct the differences in the natural light. He also proposed stained glass for two sets of windows either side of the little committee room overlooking the willows to the west (not commissioned) and reduced his fees slightly because the windows formed a series so work on full sized cartoons would be reduced. His initial suggestion of red for the east windows was changed to lighter shades of blue and green. At first it was anticipated that the windows would have to be made over a number of years as finances allowed, but in May 1969 Sheppard informed Piper that Canon Duckworth had found an anonymous donor which meant that all the windows could be done at once. Piper received the final go ahead in January 1970. The window designs are abstract and integrated into the architecture. The east windows in blue either side of the altar are flanked by narrow windows of dots reminiscent of the edges of the Coventry (West Midlands) window (probably left over tiddly-winks). The west windows are mauve. The other two walls each have a gold and green window (the gold windows being closer to the altar). Each window is abstract but near the top has an egg shape in a lighter, almost transparent, tone. The *Presentation* booklet notes that the windows 'aim to lead us in imagination from the transitory and uncertain nature of our present life to the reality of the world's potential for good, the sole product of the untiring creative mind'. The glass was ordered from St Gobain and Mittinger in 1969 and most of the windows were in place by late July 1970, the gold panels taking longer, Reyntiens explained, because they were 'notoriously difficult to hit off first time'.The windows now have protective glazing on the exterior, presumably as a result of balls from the playing fields finding the wrong mark.

Revd Kenna's 'Argumentum' as he called it, explaining the windows ran thus:

'The East windows, which the congregation face, represent Man's search for Truth and God's revelation. The former springing from the latter but perfected by it. The returned lights include abstracts from the subjects of the other windows which are integral to both Man's search and God's revelation. These are, in the West, the related themes of man's industry and God's creative activity: those north and south flanking the congregation, represent Man's search for beauty and God's response; Man's search for love and God's reply. All windows include symbols of suffering and joy, the concomitants of man's effort.'

Left: Detail of green window

Above: Detail of 'tiddly-winks' in the east of the chapel

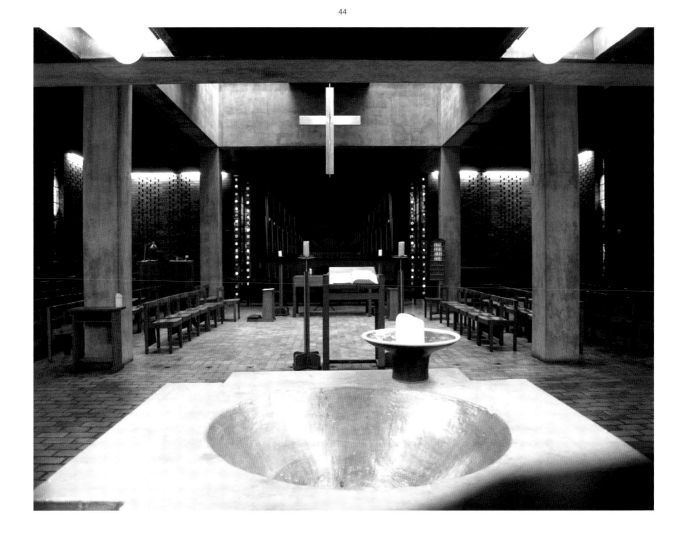

Left: detail of gold window

Above: Interior of the chapel looking east, font in foreground

Right: Gold window

Cambridge, Robinson College, Grange Road, Newnham, CB3 9AN

General: David Robinson was born in Cambridge in 1904, started work aged fifteen and went on to become highly successful in television and radio rentals and horse racing. In 1973 he offered £10 million for a new college and Grange Road was suggested, the residents objecting vociferously. In 1977 he gave an extra £7 million but a further projected gift of £1 million in 1981 did not come to fruition. The College was officially opened in 1981 and the architects were Gillespie, Kidd and Coia, with Yorke Rosenberg Mardall (YRM) appointed executive architects for the project in 1978. Spalding suggests that bearing in mind the problems Churchill College had faced, the Fellows decided not to include a chapel but when Robinson was informed of this decision, he said 'No chapel, no college' - this may be apocryphal. The chapel is non-denominational, of unusual shape and not aligned east-west, *The Guardian* described it as 'looking rather like a thirties cinema, [it] has a bulging wall of stained glass designed by John Piper which seems to burst through its brick container like an over-fed stomach through a zip-up sweater'. Apparently the window facing the quad was to be clear glass but Robinson happened to see a programme about Coventry Cathedral and demanded that the same artist be commissioned - this may also be apocryphal but is a delightful story. Piper also designed the hassocks, the small banners, the wooden cross and candlesticks, a 'Deposition' ceramic wall relief, some altar cloths and advised on the antechapel tiling. Harrison notes that 'the windows … are architectonic in the best sense – that is they relate to their architectural setting in a subtle and sympathetic way, not dominating and yet not being overshadowed by their context'.

Literature: Building, 'A New College for Cambridge', 29 November 1974, Vol CCXXVII, #6860, p55-58; *Architects' Journal*, 'Robinson College, Cambridge', 5 August 1981, Vol 174, #31, p241-261; Architectural Review, Peter Davey, 'Cambridge Castle', August 1981, Vol CLXX, #1014; p81-87; Harrison, 1982; Osborne, 1997, p117, 128-129, 131-132, 176; Spalding, 2009, p453-455

The following details are applicable to both windows:
Date: 1978-1980

Designer: John Piper

Glass Painter and Maker: Patrick Reyntiens

Architects in charge: Isi Metzstein and Andrew McMillan of Gillespie, Kidd and Coia; Yorke Rosenberg Mardall

Cost: In June 1978 when YRM sent Piper drawings of the chapel window it was estimated that the cost of both windows would be £100,000, to which a further £25,000 was later added for the antechapel window. Piper charged 20% of the cost of the two windows, including expenses.

Dedication: 1 November 1981

Documentation: Robinson College Archives, A61025 (1-101); AC1029 (1-39); John Piper Letters 8.14; V1026 (Robinson College Building briefs); VB Unlisted chapel

Notes: The first meeting of interested parties was probably at Piper's house, Fawley Bottom, in January 1978 and it was attended by Reyntiens, Metzstein and Victor Bugg of the Quantity Surveying firm of Davis, Bellfield and Everest. Reyntiens immediately began pestering Bugg for a contract to be drawn up, following which he took slivers of colour from Piper's cartoon, pasted them into an exercise book, flew to Dusseldorf, drove to Hilden and spent £10,000 on glass, then to Waldsassen where

he spent a further £10,000 and then bargained until the total cost was down to £14,000. Nuttgens did the initial glass cutting which was then refined by Reyntiens. According to the latter the painting and aciding (not too much) contrived to 'get the exact nuance of feeling and expression'.

Title: *Light of the World*

Location and Size: chancel window in chapel, irregularly shaped, curved top, stepped base, approximately 1240x890cm (488x350in)

Inscription: '79' in one of lower right panes

Assistants: Joe Nuttgens (Studio Manager), Phil Kenchatt, David Wasley and David Williams

Studies: David Wasley made a trial panel for the window.

Literature: *Crafts*, Martina Margetts, 'A Piper Portfolio', No 36, January/February 1979, p35; *Guardian The*, 'The house that Robinson built', 8 December 1980, p11; *Architects' Journal*, 'Art of the informal', 17 December 1980, Vol 172, No 51, p1183; *Building*, Martin Spring, 'College Collage', 19/26 December 1980, VolCCXXXIX, #7170 , p26; *Architects' Journal*, 'Robinson College, Cambridge', 5 August 1981, Vol 174, #31, p253,255-256; Architectural Review, Peter Davey, 'Cambridge Castle', August 1981, Vol CLXX, #1014, p83; Harrison, 1982; Scarfe Norman, *Cambridgeshire. A Shell Guide*, London: Faber and Faber Limited, 1983, p104; Angus Mark, *Modern Stained Glass in British Churches*, London & Oxford: Mowbray, 1984, p34; *Sunday Telegraph The*, Faulkes Sebastian, 'Romantic vision of a pagan believer', 1 July 1984, p17; Cowen Painton, *A Guide to Stained Glass in Britain*, London: Michael Joseph Ltd, 1985, p79; *Cambridge Evening News*, 'Generous knight dies in seclusion', 12 January 1987; Morris Elizabeth, *Stained and Decorative Glass*, Baldock: Apple Press Ltd, 1988, p95; Reyntiens Patrick, *The Beauty of Stained Glass*, London: Herbert Press, 1990, p194; Osborne, 1997, p128-129; Raguin Virginia Chieffo, *the history of stained glass. The Art of Light Medieval to Contemporary*, London: Thames and Hudson Ltd, 2003, p277; Heard Kate, *Light in the East. A Guide to Stained Glass in Cambridgeshire and The Fens*, Stained Glass Museum, 2004, p10, 28; Neiswander Judith & Swash Caroline, *Stained & Art Glass*, London: The Intelligent Layman Publishers Ltd, 2005, p258; Spalding, 2009, p453-455

Reproduced: Architects' Journal, 'Art of the informal', 17 December 1980, Vol 172, p1183; *Architects' Journal*, 'Robinson College, Cambridge', 5 August 1981, Vol 174, #31. p250, 255; *Architectural Review*, Peter Davey, 'Cambridge Castle', August 1981, Vol CLXX, #1014, p86, 87; Angus Mark, *Modern Stained Glass in British Churches*, London & Oxford: Mowbray, 1984, p35; Morris Elizabeth, *Stained and Decorative Glass*, Baldock: Apple Press Ltd, 1988, p81 (design), 96; Osborne, 1997, p131; *Cornerstone*, RS, '… but then there was John Piper', Vol 25, No 4, 2004, p57; Spalding, 2009, plate 75

Notes: In July 1978 Reyntiens declared himself ready to start work on this window and estimated that he could complete by August 1980 but YRM sent out a schedule in October 1978 stipulating that the window should be completed by March 1980 at the latest - it would appear that Reyntiens' adhered to his own schedule. He considers the window Piper's greatest achievement as a stained glass designer. The window was technically difficult to make because it is both stepped and curved. It is also unsuccessful because it is almost impossible to see the entire window at the same time, being obscured by a curtain wall and

a pillar – the architects' fault, not the glass designer or maker. The sunlight filters from the left and the dripping wisteria-looking plants on the right are reminiscent of some of Tiffany's work. The 'Light of the World' is the large sun top left. Piper described the window as 'a great circulating light penetrating and dominating all nature' and noted that as usual his designs were 'interpreted by Reyntiens' studio at Beaconsfield with their usual sensibility and brio', the last word being underlined. The reviews of the window were somewhat derogatory, but usually because of the architecture: a 'giant billowing stained glass window ... strangely strident' (*Architects' Journal*, 5 August 1981) and the window 'bulges outwards in a curiously amorphous manner' (*Building*, 19-26 December 1980), whilst the *Architectural Review* decided that the window was 'not Piper's best work; it lacks the resonance of deep colour that made him a major twentieth-century stained-glass artist'.

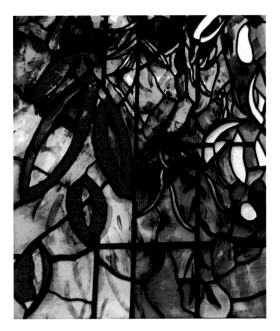

Below: *Light of the World*

Right: detail of window

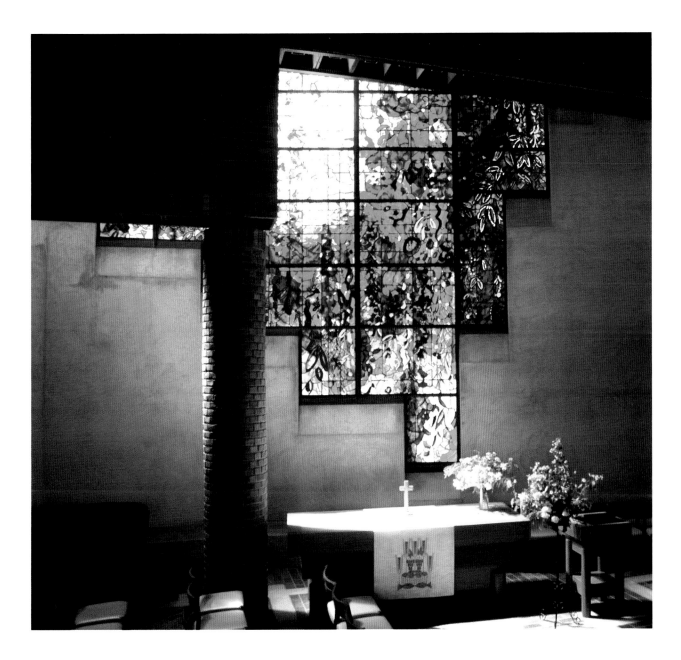

Title: *Epiphany (Adoration of the Magi)*

Location and Size: rectangular window in Allier antechapel, approximately 101.8x114cm (39 3/4x45in)

Assistant: David Wasley

Literature: Harrison, 1982; Scarfe Norman, *Cambridgeshire. A Shell Guide*, London: Faber and Faber Limited, 1983, p104; *House and Garden*, Levi Peta, 'Springboard from Piper and Reyntiens: or the brave new world of the stained-glass designers', April 1983, p147; Angus Mark, *Modern Stained Glass in British Churches*, London & Oxford: Mowbray, 1984, p36; Reyntiens Patrick, *The Beauty of Stained Glass*, London: Herbert Press, 1990, p196; *BSMGP*, Ferrell Ginger, 'New Work Graham Jones', Autumn/Winter 1994, p11; Moor Andrew, *Architectural Glass Art. Form and technique in contemporary glass*, London: Mitchell Beazley, 1997, p130; Osborne, 1997, p92, p129, 131-132; Heard Kate, *Light in the East. A Guide to Stained Glass in Cambridgeshire and The Fens*, Stained Glass Museum, 2004, p28; Spalding, 2009, p455

Reproduced: Compton Ann (Ed), *John Piper painting in coloured light*, Kettle's Yard Gallery, 1982, front cover; *House and Garden*, Levi Peta, 'Springboard from Piper and Reyntiens: or the brave new world of the stained-glass designers', April 1983, p146; Angus Mark, *Modern Stained Glass in British Churches*, London & Oxford: Mowbray, 1984, p37; Morris Elizabeth, *Stained and Decorative Glass*, Baldock: Apple Press Ltd, 1988, p5, 97; Reyntiens Patrick, *The Beauty of Stained Glass*, London: Herbert Press, 1990, p174; Moor Andrew, *Architectural Glass Art. Form and technique in contemporary glass*, London: Mitchell Beazley, 1997, p130; Osborne, 1997, p130; Heard Kate, *Light in the East. A Guide to Stained Glass in Cambridgeshire and The Fens*, Stained Glass Museum, 2004, p28; Spalding, 2009, plate 76

Notes: The YRM schedule of October 1978 specified that this window should be completed by mid June 1980. Bugg visited Reyntiens' studio in November 1979 and reported to Piper that 'the completed small window is a tremendous achievement - you must be very pleased'. The antechapel is a very dark and meditative space. Piper's design was inspired by the Romanesque tympanum at Neuilly-en-Donjon, France (he had painted the window c1969). The window glows with gold, emerald, deep red and blue colours. In his book, Reyntiens notes that this was an extremely difficult window to make from a technical point of view, adding that 'no painter keeps to the possibilities of stained glass better than John Piper, yet at the same time no painter stretches his executive interpreter more cruelly'. Red and blue glass have been inversely etched and layers of glass 'plated' together to create two-tone effects. The upper part of the window portrays the Virgin and Child and the Magi offering gifts, flanked by two trumpeting angels and with two green monsters (the beats of paganism) at their feet. The lower part of the window which is in greens shows Adam and Eve on the left, and the Last Supper on the right. Graham Jones (titling the work *Journey of the Magi*) noted that this window was a great inspiration for him when making the Poets' corner window in Westminster Abbey. Scarfe considers the window 'a little masterpiece'.

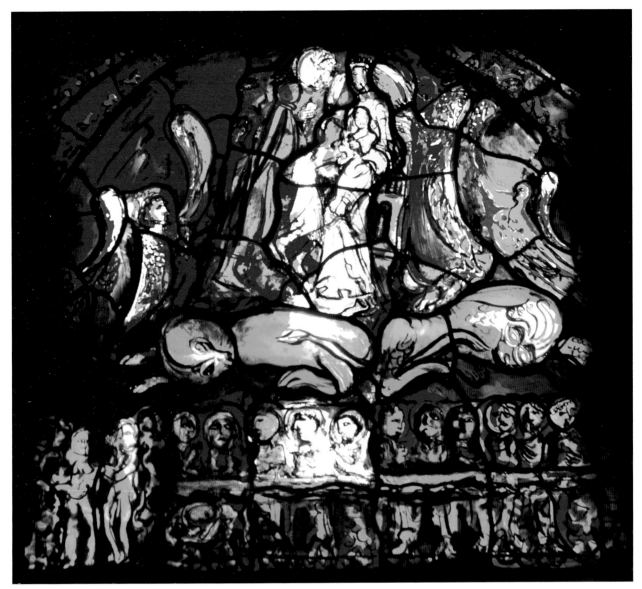

Above: *Epiphany*
Opposite: Detail from *Light of the World*

Ely, Ely Stained Glass Museum, South Triforium, Ely Cathedral, CB7 4DL

Title: *Experimental Panel* (ELYGM:L2003.8)

Provenance: Given by Piper to his friend Justin Blanco-White, on loan to the Museum since 2003 from White's daughter Dusa McDuff

Date: c1956

Size: 152x109cm (43x59 ½")

Designer: John Piper

Glass Painter and Maker: Patrick Reyntiens

Documentation: Ely Stained Glass Museum archives

Literature: Ayers Tim, Brown Sarah, Neiswander Judy, *The Stained Glass Museum Gallery Guide*, Lowestoft: The Stained Glass Museum, 2004, p41; Spalding, 2009, p399

Reproduced: *British Artist Craftsmen*, Smithsonian Institution, 1959-1960, #157; Ayers Tim, Brown Sarah, Neiswander Judy, *The Stained Glass Museum Gallery Guide*, Lowestoft: The Stained Glass Museum, 2004, p41

Exhibited: The panel is on permanent display in the Museum; *British Artist Craftsmen*, Smithsonian Institution, 1959-1960, #157 (titled *Abstract Design*). *An Exhibition of GLASS or Glass-making as a creative art through the ages*, Temple Newsam House, Leeds, 6 October – 12 November 1961, # 202, p60, lent by Piper

Notes: Piper's wife Myfanwy had known Justin Blanco-White from her teenage years, and Blanco-White became the couple's architect of choice. At one stage Blanco-White expressed the desire to own one of Piper's stained glass panels and was presented with this piece - an anthology of all the effects and techniques available to the glass-maker. It is an abstract multi-coloured work with a suggestion of bright light in the centre and a row of dots to the right.

Below: *Experimental Panel*
Photograph courtesy of Ely Stained Glass Museum

Title: *Temptation of St Antony* (ELYGM:1999.1)

Provenance: Purchased by the Keatley Trust for the Museum in 1999, with the kind assistance of Sarah le Marchant of Bruton Gallery Ltd

Date: 1984

Size and Medium: 98.7x89cm (38.9x35in), acid etched, stained, painted and plated stained glass panel with rounded top

Inscription: signed and dated b.c.: 'Reyntiens 84'

Designer, Glass Painter and Maker: Patrick Reyntiens

Literature: Reyntiens Patrick 'Visions of Classical Life', *Patrick Reyntiens, Glass Painted and Stained, Visions in Light*, Bruton Gallery, 1985, p33; Stamp Gavin, 'Patrick Reyntiens and the Ovid Glass Panels', *Patrick Reyntiens, Glass Painted and Stained, Visions in Light, Bruton Gallery*, 1985, p3; *Green Book The, A Quarterly Review of the Visual and Literary Arts*,Grimshaw Rosalind, 'Patrick Reyntiens. Visions of Classical Life. Metamorphoses', Autumn 1985, p9; Ayers Tim, Brown Sarah, Neiswander Judy, *The Stained Glass Museum Gallery Guide*, Lowestoft: The Stained Glass Museum, 2004, p44

Reproduced: Patrick Reyntiens, *Glass Painted and Stained, Visions in Light, Bruton Gallery*, 1985, cover, p4, 16, 17; Ayers Tim, Brown Sarah, Neiswander Judy, *The Stained Glass Museum Gallery Guide*, Lowestoft: The Stained Glass Museum, 2004, p44; *Register of Artists and Craftsmen in Architecture*, Patrick Reyntiens, undated

Exhibited: The panel is on permanent display in the Museum; *Patrick Reyntiens, Glass Painted and Stained, Visions in Light*, Bruton Gallery, Bruton, Somerset, 1985, #9

Notes: St Antony of Egypt (251-356) renounced the world at the age of twenty and became an ascetic, living in complete solitutude from 286-306. Reyntiens describes him as a late-classical phenomenon and certainly his thought was influenced by Plato and Origen. The panel represents the temptations, demons and erotic visions which tormented St Antony when he lived as a hermit but which he resisted through prayer. Reyntiens appears to have linked the torments with the hallucinations (similar to those produced by LSD) experienced by those suffering from ergotism (synonymous with St Anthony's Fire) caused by a fungus on rye and other cereals. Ergotism is often linked to witchcraft. Various mottled, ugly-faced, bird-toed creatures swirl in a coloured labyrinth, sucked into an unfathomable dark vortex. There is almost a suggestion of the gangrenuos symptoms of the illness in the lividly spotted red figure in the centre. Stamp considers that the vivid blue and red colours recall the windows at Chartres. The subject has been popular with artists since the 10th century, some of the most famous interpretations being those by Hieronymus Bosch, Mathias Grünewald and Salvador Dali but Reyntiens' work probably owes more to the work of Martin Schöngauer where 'fantastic' creatures whirl around the saint.

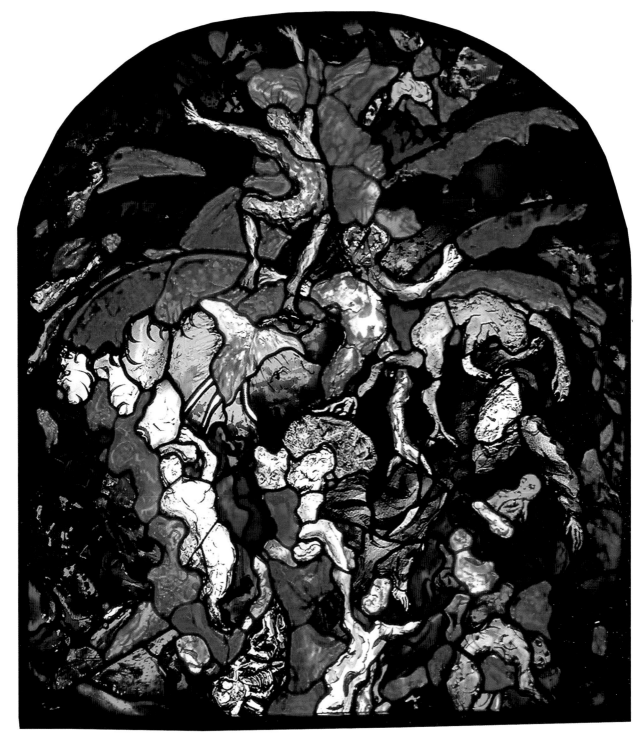

Above: *Temptation of St Antony*
Photograph courtesy of Ely Stained Glass Museum

Peterborough, Bishop's Lodging, The Palace, PE1 1YA

Listing: Grade I (7 February 1952) #1331518

General: The Bishop's house is a Victorian Gothic building including a chapel dating from the mid 13th century. Dr Robert Wright Stopford was appointed Bishop of Peterborough in June 1956 but was unable to take up his duties immediately because of a pre-arranged official visit to the United States and Bermuda. During his absence the Church Commissioners destroyed the Victorian chapel – as the Log Book points out 'this act of desecration was fortunately unnoticed by the Press, who might otherwise have commented adversely on the Bishop's first act as Bishop of Peterborough!' The new chapel was constructed in the oldest part of the house which had not only served as a passage-way to the Victorian chapel but also as a wine cellar. The new chapel was in use after Christmas 1957 and finally completed by Easter 1958. Stopford knew of Reyntiens' work from the windows at Oundle School, Oundle, Northamptonshire which were dedicated when Stopford was Bishop of Fulham (St Margaret's, City of Westminster) The nearby Cathedral is well worth a visit, with its beautiful west front, described as a 'photographer's dream', the painted nave ceiling, windows by Dante Gabriel Rossetti in the south transept and the vaulted ceiling by John Wastell in the 'New Building' dated 1496-1509.

Documentation: Log Book of the Palace Peterborough, 1891-2011 (Palace Library)

Literature: Cowen Painton, *A Guide to Stained Glass in Britain*, London: Michael Jospeh Ltd, 1985, p83; *Stained Glass Windows and Master Glass Painters 1930-1972*, Bristol: Morris & Juliet Venables, 2003, p85

The following details are applicable to all three windows:
Date: 1958

Designer, Glass painter and Maker: Patrick Reyntiens

Title: *Trinity window*

Location and Size: single lancet north window, 102x84cm (40x33in)

Inscription: 'I.N.R.I.' above the crucified Christ

Designer: According to the Log Book, the window was designed by Mrs Stopford.

Glass Painter and Maker: Patrick Reyntiens

Donor: A plaque below this window reads: 'THESE WINDOWS, MADE BY PATRICK REYNTIENS, ARE THE/GIFT OF ROBERT, THIRTY-THIRD BISHOP OF PETERBOROUGH,/AND KATHLEEN HIS WIFE, IN MEMORY OF THOSE WHO/WERE DEAR TO THEM/EASTER 1958'

Literature: *Modern Stained Glass*, Arts Council, 1960-1961, unpaginated; Pevsner Nikolaus, *The Buildings of England, Bedfordshire and the County of Huntingdon and Peterborough*, Harmondsworth: Penguin Books, 1968, p322; *Decorative Arts Society The*, Omnium Gatherum, Horner Libby, 'Patrick Reyntiens' Autonomous Panels. Myth, music and theatre', Journal 35, 2011, p65

Reproduced: Reyntiens Patrick, *The Technique of Stained Glass*, London: B T Batsford Ltd, 1967, p76

Notes: The Norman arch which had previously been the Abbot's entrance was unbricked and made into the Trinity window. The Trinity is represented in the traditional manner by a large enthroned God the Father holding each end of the cross on which is the crucified Christ whilst a dove (Holy Ghost) flutters at the base of the window. The surrounding area is abstract with large blue whorls on either side of the figures. The colours are yellow, blue and green with touches of red on the Christ figure. Pevsner describes the window as 'Expressionist'.

Title: unnamed

Location and Size: east window, single lancet, approx. 214x9cm (86x3 1/2in)

Notes: This is an abstract window in blue colouring with small pieces of yellow and pink.

Title: unnamed

Location and Size: west window, two single lancets, 107x59cm (42x23in)

Designer, Glass Painter and Maker: Patrick Reyntiens

Notes: These are abstract windows in blue and green with a touch of red lower right.

53

Left: West window

Right: East window

Below: *Trinity window*

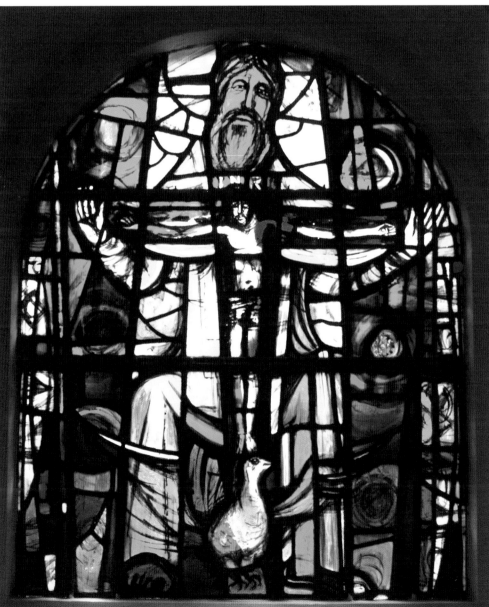

Derby Cathedral Church of All Saints, 18 Iron Gate, DE1 3GP

General: The church of All Saints (it became a Cathedral church of the Diocese of Derby in 1927) possibly dates from the 14th century with the west tower being built between 1510 and 1530. During the 17th century the building deteriorated sufficiently that a new building was required; the architect chosen was James Gibbs (of St Mary-le-Strand and St Martin-in-the Fields fame) so the building is classical in style whilst retaining the tower. A wrought-iron screen was made by a local man, Robert Bakewell, to span the interior in front of the chancel. The eastern extension was designed by Sebastian Comper, a modification of his father Sir Ninian Comper's design. St Katherine's Chapel is outstanding for its simplicity and true religious atmosphere. Monuments include those to Elizabeth of Hardwick ('Hardwick Hall, more glass than wall') and Joseph Wright the artist. The Richards/Reyntiens windows are the only stained glass in the cathedral, the patterned Victorian glass in the nave windows having been replaced by plain glass in keeping with the 18th century interior soon after the Church became a cathedral.

The following details are applicable to both windows:
Date: The windows appear to have been completed by 1962 but were not installed until 1966

Designer: Ceri Richards

Glass Painter and Maker: Patrick Reyntiens

Technical Supervisor: Derek White

Architect in charge: Sebastian Comper

Donor: Anonymous benefactor

Dedication: 26 April 1972 by the Archbishop of Canterbury, Dr Michael Ramsey (the dedication was of the restored Cathedral as a whole)

Documentation: Derbyshire Record Office, D3372/122/1

Literature: *Modern Stained Glass*, Arts Council, 1960-1961, unpaginated; *Derby Evening Telegraph*, 'Derby Diocese's Scheme. £200,000 Cathedral extensions and repairs, Church House redevelopment', 10 February 1966; *Derby Evening Telegraph*, 'Permanent Memorial', 15 November 1971; *Derby Trader*, 'Cathedral reopens for worship on Sunday', 1 March 1972; *Derbyshire Advertiser The*, 'Restored Cathedral Re-Opens on Sunday', 3 March 1972; *Derby Evening Telegraph*, 'Advertisement Feature', 7 March 1972; *Derbyshire Life and Countryside*, 'The restoration of Derby Cathedral', May 1972, p50-51; Mallender Margaret A, *The Great Church. A Short History of the Cathedral Church of All Saints Derby*, Mallender, 1977, p33; Reyntiens Patrick, *The Beauty of Stained Glass*, London: Herbert Press, 1990, p197; Pevsner Nikolaus, revised by Williamson Elizabeth, *The Buildings of England, Derbyshire*, Harmondsworth: Penguin Books, 2002 (1953), p169; Lansberger James, *Derby Cathedral, official guide*, Derbyshire Countryside Ltd, 2002, unpaginated; *Stained Glass Windows and Master Glass Painters 1930-1972*, Bristol: Morris & Juliet Venables, 2003, p84; *BSMGP*, '"C R Wyard, Aspects of 20th-Century Stained Glass": BSMGP International Conference 2008', Vol XXXII, 2008, p127

Reproduced: *Derbyshire Life and Countryside*, 'The restoration of Derby Cathedral', May 1972, p49

Notes: When the extensions to the cathedral were being planned the Provost, Very Revd R A Beddoes, having seen works by Richards based on Debussy's *La Cathedrale Engloutie*, felt that the building would benefit from stained glass designed by the artist. In 1962 a cathedral appeal notes that the windows 'promise to be of exceptional merit'. The windows are held in frames of architectural bronze, an integral part of the design, and they represent the ancient struggle between darkness and light, and the gold and blue reflect the colours of the Bakewell Screen. Both windows are abstract with broad sweeps and arcs overlying a geometrical grid. Reyntiens notes that the windows are classical, round-headed arches which suited Richards' modern style of painting, and anyway Richards, unlike Piper, had no sympathy for the Gothic. The windows are described by Mallender as 'startling' and by various papers of the time in the following terms: 'in a building redolent of classical elegance and poise, they introduce a rugged theme of spiritual combat crowned by heavenly reward. Their vivid blues and yellows, with smoky undertones of black and grey, are in striking contrast to the new decorative scheme'. Richards and Reyntiens also collaborated on *La Cathedrale Engloutie* (Pallant House, Sussex) and the Lady Chapel, Liverpool Metropolitan Cathedral, Merseyside.

Title: *All Souls*

Location: single light east window, north aisle

Reproduced: *Derbyshire Life and Countryside*, May 1972, cover; Lee Lawrence, *The Appreciation of Stained Glass*, Oxford University Press, 1977, p77; Lansberger James, *Derby Cathedral, official guide*, Derbyshire Countryside Ltd, 2002, unpaginated; postcard

Notes: This window indicates the powerful conflict between darkness and light and the soul escaping from its physical limitations. The colours are darker than its companion, the tone more sombre, with greys and dark blues dominating, a broad swirl of yellow across the centre, and gradually lightening towards the top.

Title: *All Saints*

Location: *All Saints*, single light east window, south aisle

Inscription: signed 'Ceri Richards' b.r.

Reproduced: *Derby Evening Telegraph*, Fred Flint, 'Renovations Complete: Cathedral Reopening Sunday', 2 March 1972; Reyntiens Patrick, *The Beauty of Stained Glass*, London: Herbert Press, 1990, p184; Lansberger James, *Derby Cathedral, official guide*, Derbyshire Countryside Ltd, 2002, unpaginated; postcard

Notes: This window expresses the ultimate triumph of light, the soul having attained its singularity. The dominant colour is yellow, with smaller areas in different shades of blue and a discernible vertical strand of white in the centre. The design is busier towards the top. The naming of the window is a reference to the dedication of the Cathedral.

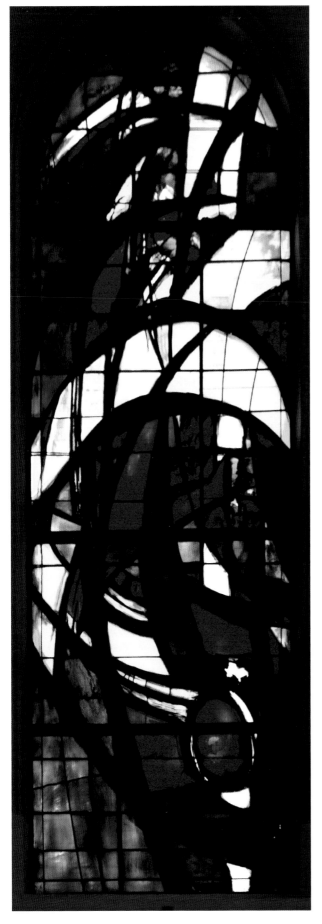

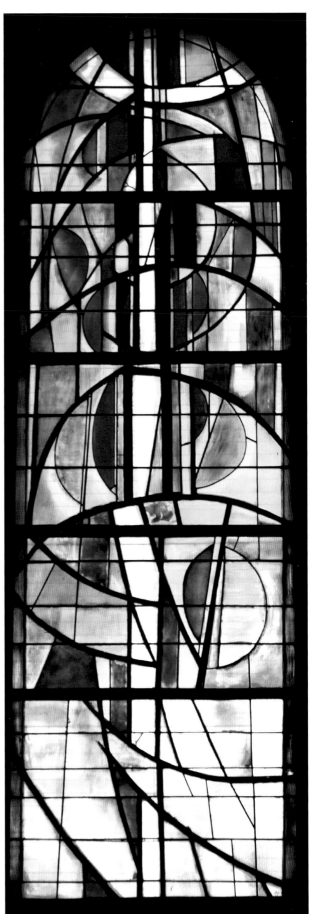

All Souls, Derby Cathedral *All Saints*, Derby Cathedral

Ednaston, St Mary's Nursing Home (RC), Ashbourne, DE6 3BA

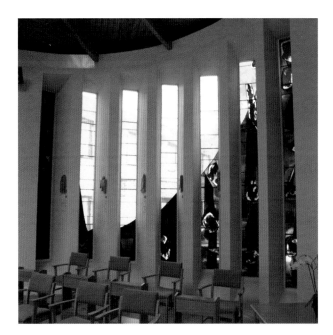

General: The nursing home is run by the Institute of the Sisters of Mercy and managed by lay staff. The unusual top-lit oval chapel was designed by Montague Associates in 1964. It is a concrete structure with copper roofing (subsequently removed) with seven floor to ceiling deeply recessed windows each side of the altar. The windows are splayed so that they are not visible from the entrance and the light is directed towards the sanctuary. Most of the glass is non-opaque, some is antique, some painted – the outside can be seen through the windows, a device used in the Sion Community, Brentwood, Essex (also previously run by the Sisters of Mercy as was Mylnurst, Sheffield, Yorkshire).

Title: *Passion, Death and Resurrection of Christ*

Date: 1964

Location and Size: 7 single lights north and 7 single lights south, each approximately 365x32cm wide (143 3/4x12 1/2in)

Designer, Glass Painter and Maker: Patrick Reyntiens

Architect in charge: Derek Montague

Dedication: A plaque in the entrance to the chapel reads: 'This chapel was blessed and dedicated/to our Lady of Lourdes/by his worship the Bishop of Nottingham/The Right Reverend Edward Ellis, DD, PHD/on 8th July 1964/Deo Gratis/The chapel was designed by/Derek Montague RIBA/and was built by Tyler and Coates Ltd/The windows were designed by/Patrick Reyntiens and represent the/Passion Death and Resurrection of Christ/The Stations of the Cross were given/in memory of the late/Gertrude Trivett and family.'

Above: North lights

Below: South lights

Lower left: Detail

Literature: Pevsner Nikolaus, revised by Williamson Elizabeth, *The Buildings of England, Derbyshire*, Harmondsworth: Penguin Books, 1978 (1953), p47, 207; Clarke Brian (Ed), *Architectural Stained Glass*, London: John Murray, 1979, p193; *Stained Glass Windows and Master Glass Painters 1930-1972*, Bristol: Morris & Juliet Venables, 2003, p84

North lights:
Inscription: 2nd light from altar, north side, 'Reyntiens 64'

Notes: Seen together a vivid yellow triangular form occupies the central area (broader at the top) with a dark blue area to the west, and to the right generally grey with blood red blobs.

South lights:
Notes: Seen together there is a vertical strip of red and grey to the east, followed by a curved yellow area broadening to the west, with an arc of mauve and blue glass above.

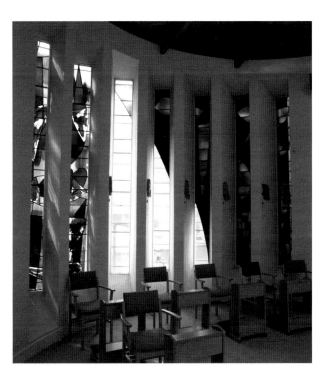

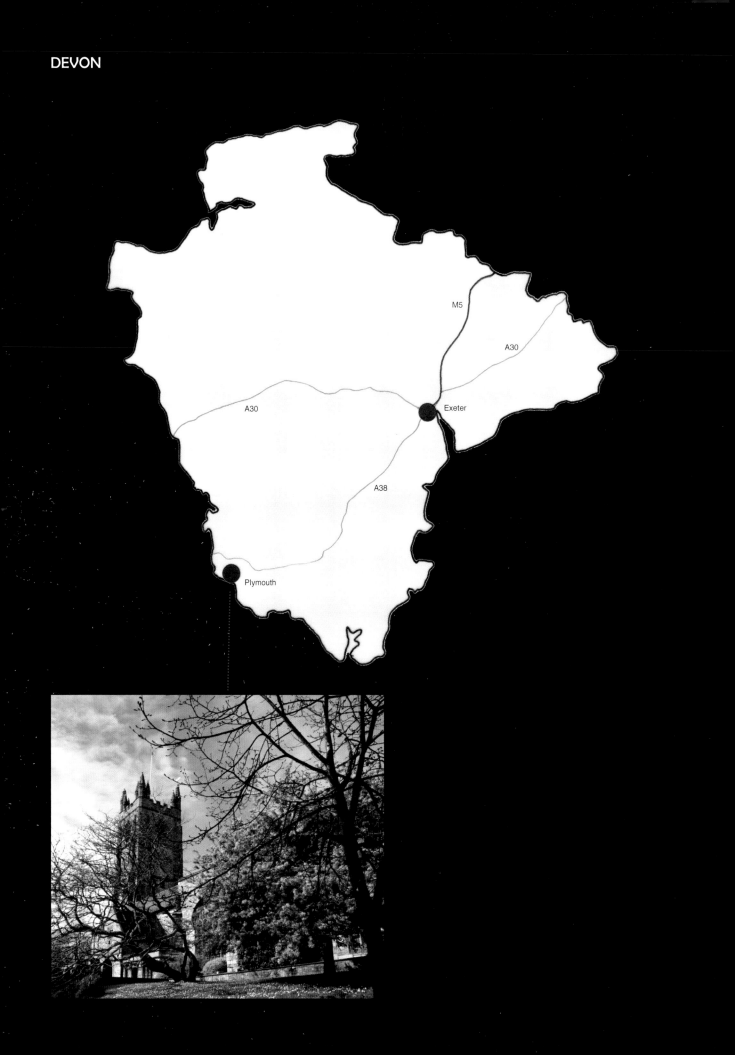

DEVON

M5

A30

A30

A38

Exeter

Plymouth

Plymouth, Minster Church of St Andrew, Royal Parade, PL1 2AD

Listing: Grade I (25 January 1954) #1130012

General: There has probably been a church on this site since the 11th century, dedicated naturally to St Andrew, patron saint of fishermen, but the oldest part of the present building dates to the 14th century. The Minster Church of St Andrew was substantially destroyed by extensive bomb damage in 1941. The following day someone placed a wooden board over the north door on which was written the word 'RESURGAM ('I will rise again'). True to the faith, the minster was rebuilt and reconsecrated by the Bishop of Exeter on St Andrew's day in 1957, the architect being Frederick Etchells.
It was as a result of Piper's work for Oundle School, Northamptonshire that he gained the Plymouth commission. The original idea had been to make the Lady Chapel window first, then the north transept, and that the main east window should be left to last in order to assess the effect of the other five windows. However the first window to be fixed was the west window in the tower, followed by the east window, the north and south aisle east windows and then the east windows in the transepts. In May 1961 Piper was commissioned to design the two transept windows and in August 1963 was officially asked to design the east window and the windows in the Lady Chapel and St Catherine's Chapel. In 1965 he received the impression that the remaining plain glass windows might be filled with stained glass by another maker and virtually threatened to opt out of his remaining obligations if this was the case. Cowen notes that 'one cannot help but wonder what the whole church would look like, filled with their glass!'

Below: Interior of the Minster Church looking towards the *Astor Memorial*

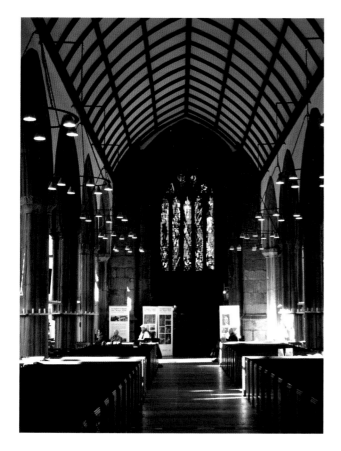

The following details are applicable to all six windows:
Designer: John Piper

Glass Painter and Maker: Patrick Reyntiens

Technical Supervisor: Derek White

Architect in Charge: Frederick Etchells

Installation: Carkeeks

Documentation: TGA 200410/2/1/11/16, 18, 22, 39, 40, 42, 43, 46, 56; TGA 200410/2/1/11/64, 66, 68, 69, 70, 73, 87, 88; TGA200410/2/1/11/101, 102, 103, 105, 106, 110, 117, 118, 120, 121, 145, 146; TGA200410/2/1/12/32, 35, 38, 39, 40, 41, 42, 46, 65, 78, 80,82, 95, 166, 179, 181-183, 186, 188, 208, 240, 243, 245, 253, 254

Literature: *Modern Stained Glass*, Arts Council, 1960-1961, unpaginated; Harrison, 1982; Cowen Painton, *A Guide to Stained Glass in Britain*, London: Michael Joseph Ltd, 1985, p97; Cherry Bridget, Pevsner Nikolaus, *The Buildings of England, Devon*, Harmondsworth: Penguin Books, 1991 (1952), p112, 642; Osborne, 1997, p44-48, 53, 171-172; *Stained Glass Windows and Master Glass Painters 1930-1972*, Bristol: Morris & Juliet Venables, 2003, p84; Spalding, 2009, p353; Corten Anthony G, John Piper and Newport Cathedral, undated, p9; *A Walk around the Church of St Andrew, Plymouth*, unpaginated

Title: *Instruments of the Passion and Cross of St Andrew, Astor Memorial*

Date: 1956-1962

Location and Size: 5-light west window in tower, 457cm (180in) high

Commemoration and Donors: The window is a memorial to William Waldorf, 2nd Viscount Astor, Member of Parliament for Sutton 1910-1919, Lord Mayor of Plymouth 1939-1944 and Freeman of the City. The Astor family paid for the window.

Literature: *Times The*, 'Brilliant Design for Church Window. Mr John Piper's Work on View', 8 November 1957; Betjeman John (Ed), *Collins Guide to English Parish Churches*, London: Collins, 1959 (1958), p142; Harrison, 1982; Osborne, 1997, p45, 53; Spalding, 2009, p354; *A Walk around the Church of St Andrew, Plymouth*, unpaginated; *The Minster Church of St Andrew, Plymouth. The Windows*, unpaginated

Reproduced: Reyntiens Patrick, *The Technique of Stained Glass*, London: B T Batsford Ltd, 1967, facing p65, p78; Osborne, 1997, p43; *A Walk around the Church of St Andrew, Plymouth*, unpaginated; *Church of St Andrew. Plymouth*, unpaginated; *The Minster Church of St Andrew, Plymouth. The Windows*, unpaginated (line drawing); postcard

Notes: Piper received a letter from the architect Frederick Etchells in November 1956 stating that he and the Revd Prebendary W H Alan Cooper felt the window in the west ought to have a fine splash of colour since the powerful afternoon sun required this. Piper's design was submitted early in 1957. The window is part abstract, part symbolic and influenced by Chartres and Bourges cathedrals. It illustrates the Instruments of the Passion with the ladder, reed and spear representing St Andrew's cross together with all the symbols of the Crucifixion. Reading from top to bottom and left to right, the Instruments are as follows:

Crown of Thorns, Pillar and Scourges, Five Wounds, Lantern of the Betrayal, Hand Plucking Hair; Pincers, Spitting Jew, Dice, Malchus' Ear; St Veronica's Handkerchief, Nails, Crowing Cock; Hammer, Smiting Hand, Christ's Loincloth, Thirty Pieces of Silver; Chalice, Seamless Robe, Kiss of Judas, Pestle and Mortar, Spice Boxes. The sun and moon in eclipse and the sponge moistened with vinegar are shown in the tracery. Harrison describes the colours as Romanesque, red and blue dominating the other colours and notes that this was the first window where Piper designed a unified scheme for the entire window, disregarding the individual lights.

Title: *Four Elements, Lady Nancy Astor Memorial*

Date: 1960-November 1965

Location: 6-light east window in sanctuary

Cost: Piper charged £1,000 for the design. In August 1963 Reyntiens quoted £13/sq ft, raised to £16/sq ft in November. Reyntiens estimated the window to be 192 sq ft so Reyntiens charge would be £3,088.

Commemoration: The window is a memorial to Lady Nancy Astor, Britain's first woman MP who represented Plymouth Sutton from 1919 to 1945

Literature: Osborne, 1997, p45, 48; *A Walk around the Church of St Andrew, Plymouth*, unpaginated; *The Minster Church of St Andrew, Plymouth. The Windows*, unpaginated

Reproduced: Osborne, 1997, p46; *A Walk around the Church of St Andrew, Plymouth*, unpaginated; *Church of St Andrew. Plymouth*, unpaginated; *The Minster Church of St Andrew, Plymouth. The Windows*, unpaginated (line drawing); postcard

Notes: Early in 1960 the church considered the possibility of glazing the east windows and the designs were promised for Easter 1961 although it appears from correspondence with the Prebendary that sketches were not received until late that year. The window shows the four elements – air, fire, earth and water – in a semi-abstract fashion with green water at the bottom, a pebble beach indicating earth, red flames at the top encircling a mandorla of white heat, and air is symbolised by blue glass surrounding all. The window symbolises God's purpose for the world, everything striving upwards from the original green slime.

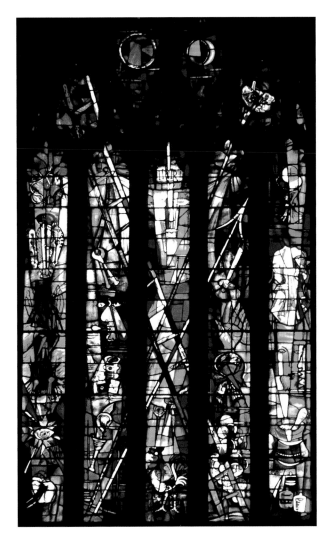

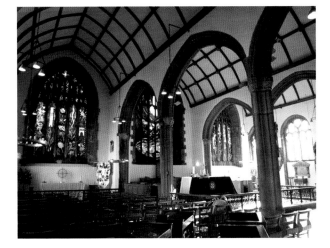

Title: *Litany of Loreto (Symbols of the Virgin)*

Date: 1963-1966

Location: 5-light east window in Lady Chapel (north aisle)

Cost: In August 1963 Piper quoted £1,000 for the design and Reyntiens quoted £13/sq ft, raised to £16/sq ft in November. Reyntiens estimated the window to be 172 sq ft so his charge would be £2,752.

Literature: Osborne, 1997, p48; *A Walk around the Church of St Andrew, Plymouth*, unpaginated; *The Minster Church of St Andrew, Plymouth. The Windows*, unpaginated

Reproduced: *A Walk around the Church of St Andrew, Plymouth*, unpaginated; *Church of St Andrew. Plymouth*, unpaginated; *The Minster Church of St Andrew, Plymouth. The Windows*, unpaginated (line drawing); postcard

Notes: In his letter to Piper dated 8 December 1961 the Prebendary suggested that the cross of St Andrew could be added to the design. The window shows all the symbols of the Virgin Mary based on the 13th century prayer, 'The Litany of Loreto', which lists the various names by which the Virgin Mary is known. Moving from left to right, the first light contains Madonna Lilies, the Chosen Vessel and a sword piercing her soul (Simeon said to Mary 'A sword shall pierce through your own soul also', *Luke* 2: 35); the second light shows Mary as an Ivory Tower (a symbol of virginity) with the burning bush of Moses below; in the centre the Mystic Rose or Rose without a thorn and the unspotted mirror of purity; to the right the serpent and the flowering rod of Aaron (in medieval times the serpent was placed under the feet of Mary); and finally Mary as the Light of Heaven, the Golden Gate and an Enclosed Garden (another symbol of virginity).

Title: *St Catherine*

Date: 1963-1966 (negotiations begun 1960)

Location: 5-light east window in St Catherine's Chapel (originally Lady Chapel) (south aisle)

Cost: In August 1963 Piper quoted £1,000 for the design and Reyntiens quoted £13/sq ft raised to £16/sq ft in November. He estimated the window to be 172 sq ft so his charge would be £2,752.

Donors: £500 from Yeadon family

Literature: Osborne, 1997, p48; *A Walk around the Church of St Andrew, Plymouth*, unpaginated; *The Minster Church of St Andrew, Plymouth. The Windows*, unpaginated

Reproduced: Reyntiens Patrick, *The Beauty of Stained Glass*, London: Herbert Press, 1990, p196; *A Walk around the Church of St Andrew, Plymouth*, unpaginated; *Church of St Andrew. Plymouth*, unpaginated; *The Minster Church of St Andrew, Plymouth. The Windows*, unpaginated (line drawing)

Notes: When St Andrew's was damaged the congregation were cared for by the daughter church of St Catherine hence the change in name of the chapel. Piper's original sketch did not apparently include a reference to the saint, the Prebendary daring 'to suggest that the wheel of St Catherine might be imposed over the whole of the south window'. Piper submitted sketches for this window in December 1963 and a year later suggested revising the design. However in December 1965 the vicar Revd John K Cavell suggested that the wheel was perhaps too dominant and could be interlaced with St Andrew's Cross, and noted that the Parochial Church Council wanted more saints and martyrs, suggesting Bishop Patterson, Bishop Hannington, St Boniface, St Budoc, John Wesley, George Hughes, Richard Hooker and Miles Coverdale, with St Peter, St Nicholas, St Paul, St Sidwell, St Petroc and the Crown of Life in the tracery, which would have been quite an undertaking for one window. Piper responded that his theme was 'the price paid by the Church as she stands in the midst of the world, and that this was in sympathy with the travail of the Creation which is suggested in the centre window'. The following January Piper was told that if he wanted to treat the window in a new way a theme of Reconciliation might be apt since this was the 25th anniversary of the destruction of the church by the Germans.
The final design shows St Catherine's Wheel (one of the tortures to which she was subjected was being broken on a wheel), together with the cross of St Andrew and symbols of the Four Evangelists – St Matthew top left, St Luke top right, St Mark bottom left and St John bottom right. The symbols of various martyrs are shown in the tracery including St Boniface of Crediton (who converted the Germans and Dutch to Christianity), St Sidwell of Exeter, St Margaret, St Lawrence, St Nicholas, St Peter and St Paul. The red background may symbolise purification by fire.

Opposite page left: *Instruments of the Passion and Cross of St Andrew, Astor Memorial* and three of the east windows
Opposite page right: *Four Elements, Lady Nancy Astor Memorial*
Left: *Litany of Loreto (Symbols of the Virgin)*

Title: *Dr Harry Moreton Memorial*

Date: 1961-1967

Location: 4-light east window in St Philip's chapel (north transept)

Cost: In June 1962 Piper estimated £3,000 for the two transept east windows

Commemoration and Donors: The adjacent plaque reads: 'TO THE GLORY OF GOD/The window in this chapel was given/in remembrance of George Harry Moreton/Mus Doc died 8 September 1961 aged 97. Also/of his wife Mary died 5 October 1951 aged 88/ and of their son Cecil Harry 2nd Lieut RGA/Killed in action at Quéant, France/17 September 1918 aged 19 ½ years'. Moreton was the organist and choirmaster from 1885 until three years before he died, an amazing total of 73 years. Donations in memory of Moreton, £1000 from the family

Literature: Osborne, 1997, p48; *A Walk around the Church of St Andrew, Plymouth*, unpaginated; *The Minster Church of St Andrew, Plymouth. The Windows*, unpaginated

Reproduced: Osborne, 1997, p47; *A Walk around the Church of St Andrew, Plymouth*, unpaginated; *Church of St Andrew. Plymouth*, unpaginated; *The Minster Church of St Andrew, Plymouth. The Windows*, unpaginated (line drawing)

Dedication: 4 October 1967 by Dr Clifford Martin (former Bishop of Liverpool and previously Vicar of St Andrews)

Notes: The transept windows were added to the equation in 1961 shortly before Prebendary Cooper left to become Provost of Bradford. The Prebendary noted that Moreton's daughter Ethel hoped that the window might bear some reference to St Cecilia (patron saint of musicians) or St Caedmon (noted for his songs and poetry) or both, but finally accepted that the design would be largely abstract. Ethel wrote to Piper on 25 August 1964 suggesting a theme of 'Inspiration', with 'waves of sound' translated into 'rays of colour radiating through clouds from the top of the window, through the deep blue of early morning, merging into the gold of mid-day, and fading into the pinks and oranges and finally indigo of night'. The final design which was approved 1 August 1966 incorporates, fittingly enough, two images of the earliest known drawings of harps, placed centrally against a gold background, the latter being executed in silver-nitrate stain and symbolising inspiration. The leading is almost grid like. The harp is connected with David and the *Psalms*.

Above: *Dr Harry Moreton Memorial*
Below: *St Catherine*

Title: *Creation and Trinity*

Date: 1961-1968

Location: 3-light east window in St Thomas' Chapel (south transept)

Cost: In June 1962 Piper estimated £3,000 for the two transept east windows

Donor: Anonymous donation in memory of an only son killed in World War 2

Literature: Osborne, 1997, p48; *A Walk around the Church of St Andrew, Plymouth*, unpaginated; *The Minster Church of St Andrew, Plymouth. The Windows*, unpaginated

Reproduced: *A Walk around the Church of St Andrew, Plymouth*, unpaginated; *Church of St Andrew. Plymouth*, unpaginated; *The Minster Church of St Andrew, Plymouth. The Windows*, unpaginated (line drawing)

Notes: The family had no specific idea of the symbols to be included. The window design was submitted 1 August 1966 and approved with the proviso that the hand was rather too delicate. The window has a large white Hand of God extending from the left light into the central light surrounded by a theme of creation with swirling green, blue and white fish (a symbol of Christ) and doves (a symbol of the Holy Spirit). The design is delightfully naïve and the theme and colour links with the East window.

Below: *Creation and Trinity*

Photographs reproduced with permission of the Minster Church

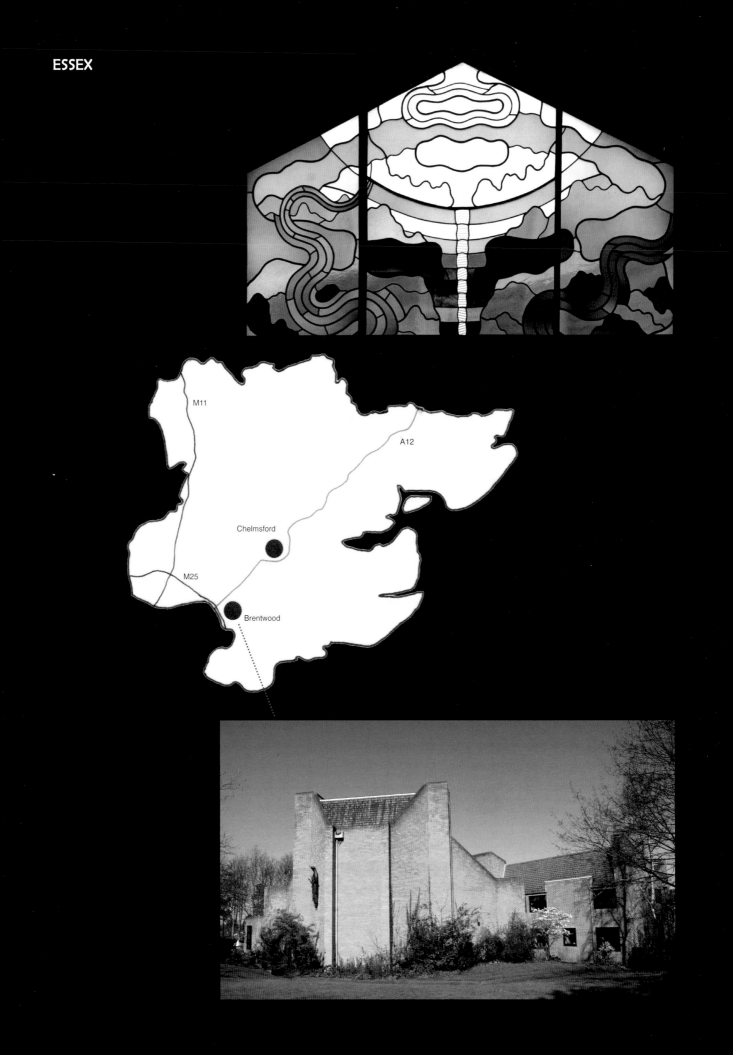

M11

A12

Chelmsford

M25

Brentwood

Brentwood, Sion Community (RC), Sawyers Hall Lane, CM15 9BX

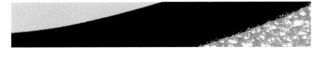

General: The Sisters of Our Lady of Mercy first settled in Brentwood in 1876 and between 1972 and 1974 their new Convent was built to the designs of John Newton and Len Greaves. The Convent, consisting of chapel, refectory, work rooms, library, reading rooms, sick bay, 36 study bedrooms, kitchen, laundry, garage and boiler house is built of load-bearing brickwork with pre-fabricated timber roof trusses on all roofs. The landscaping is an integral part of the design, creating a peaceful environment. Bettley describes the 'complex roof-line and zigzag walls to the residential wings' as creating 'an almost Gothic effect'. The Sisters of Our Lady of Mercy moved from the building in 1989.

Title: unnamed

Date: 1975-76

Location and Size: 2 sanctuary windows, each approximately 540x93cm (212 1/2x36 1/2in); 2 nave windows each approximately 300x91cm (118x35 3/4in). Window opposite altar approximately 87x140cm (34 1/4x55in).

Opposite: Window above the shrine to Our Lady

Designer, Glass Painter and Maker: Patrick Reyntiens

Above: The garden seen through one of the sanctuary windows

Assistant: Ray King

Below left: One of the nave windows

Architect in charge: John Newton and Len Greaves of Burles Newton & Partners

Below right: One of the sanctuary windows

Literature: *CBRS*, 'New Convent for the Sisters of Mercy, Brentwood', 1974, p120; *CBRS*, 'Convent of Mercy, Brentwood for the Sisters of Mercy, Brentwood', 1975, p182; *Building*, 'Convent of Mercy, Brentwood', 23 April 1976, p83; Bettley James, Pevsner Nikolaus, *The Buildings of England, Essex*, London: Yale University Press, 2007 (1954), p174

Dedication: The altar of the chapel was consecrated on 29 October 1976 by the Bishop, assisted by the Vicar General, Monsignor Creede, and Canons Petry and Grady. The event also commemorated the centenary of the Brentwood foundation of the Sisters.

Documentation: A note on the Consecration written by John Newton, in the Archives of the Institute of Our Lady of Mercy, Leeds.

Notes: Reyntiens designed a complete scheme for the church, of abstract shapes and generally muted colours. There are two floor to ceiling narrow windows either side of the sanctuary, almost identical, executed in opaque white, grey, blue and pink glass and opaque glass. Two further almost identical windows are at opposite sides of the main body of the irregularly shaped chapel – these are in clear, blue and grey glass and may represent Christ on the Cross. The soft colouring and clear glass unite interior and exterior, allowing one to see the trees and flowers outside (a device used to a lesser extent at St Mary's Nursing Home, Ednaston, Derbyshire). The window above the shrine to Our Lady, opposite the altar, is brighter which is fitting because it receives less light – grey, white, lemon and ribbed glass with inserts of beautiful antique glass. It may symbolise heaven and earth and the universe. There are two very small triangular windows at the side of this window. Ray King, a student at Burleighfield at the time, helped with the very complicated glass cutting (Reyntiens remarks on King's skill in cutting and leading in *The Beauty of Stained Glass*, p205) and described the 'beautiful sinuous shapes that were kind of veils flowing over in these designs' (interview with the author).

HAMPSHIRE

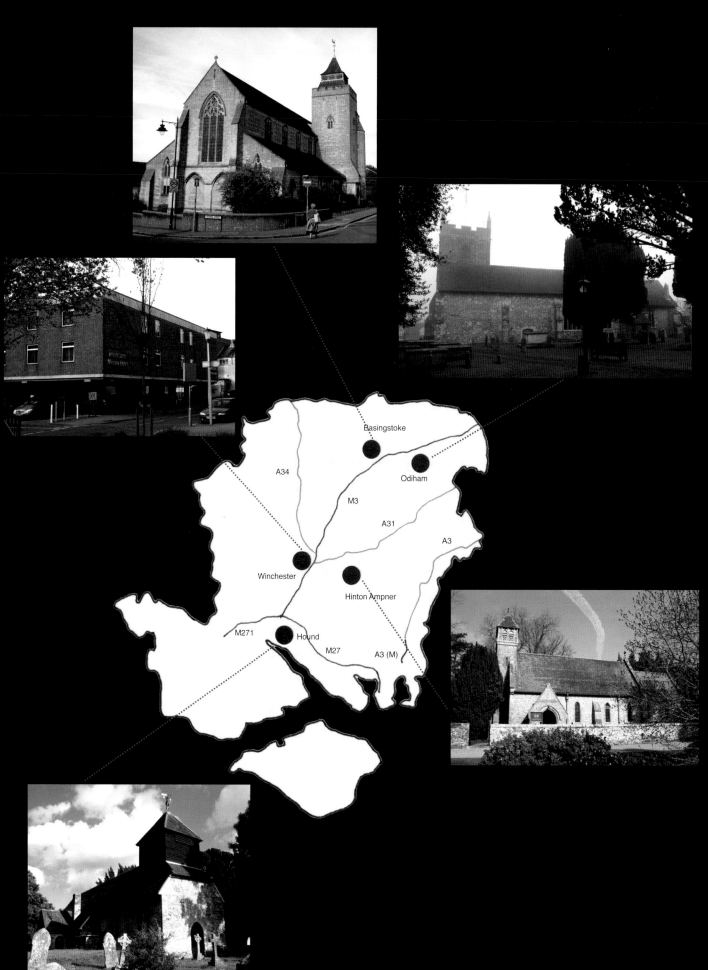

Basingstoke

A34

M3

Odiham

A31

A3

Winchester

Hinton Ampner

M271

Hound

M27

A3 (M)

Basingstoke, All Saints, Southern Road, RG21 7NP

General: The church, of Chilmark stone, was built between 1915 and 1917 to cater for the growing population of Basingstoke and the architect was Temple Moore employing his 14th century Gothic style. The church boasts a *Head of Christ* by Dame Elizabeth Frink (1983) and an icon in the Lady Chapel by Reyntiens' daughter Edith (whom Bullen and friends name Elizabeth) which is included in the faculty for the west window, 1989. The icon represents the *Harrowing of Hell*. The east window was made by Burlison and Grylls.

The following details are applicable to all three windows:
Designer: Cecil Collins

Glass Painter and Maker: Patrick Reyntiens

Architect in charge: Martin Caroe

Film: Mapleston Charles, Horner Libby, *From Coventry to Cochem, the Art of Patrick Reyntiens*, Reyntiens/Malachite, 2011

Title: *Angel windows*

Date: 1985

Location and Size: two 2-light windows at west ends of the north and south aisles, each approximately 330x100cm (130x39 1/2in)

Cost: estimated in February 1985 to be £2,000 for Collins' design, £4,600 for the windows and £150-180 for installation

Faculty: 16 May 1985

Dedication: November 1985, unveiled by Rt Hon Lord Denning, with Cecil Collins preaching the sermon.

Documentation: Hampshire Record Office, 21M65/F1985/29

Literature: John Pearce and Revd Elizabeth George, *All Saints Church Basingstoke. A Guide*, 1998, unpaginated; Bullen Michael, Crook John, Hubbuck Rodney and Pevsner Nikolaus, *The Buildings of England, Hampshire: Winchester and the North*, London: Yale University Press, 2010 (1968), p88, 159; *All Saints' Church in the Basingstoke Team Ministry*, leaflet

Reproduced: *BSMGP*, Swash Caroline, 'Peter Young', Autumn/Winter 1992, p8; John Pearce and Revd Elizabeth George, *All Saints Church Basingstoke. A Guide*, 1998, unpaginated; *All Saints' Church in the Basingstoke Team Ministry*, leaflet

Notes: The angel windows replace plain glass windows. The two windows are almost identical and depict angels with a sun above, symbolizing the Godhead. Each angel holds a circle containing a heart and an eye, suggesting the angel as a channel of Divine vision. They are made with silver stain producing a deep yellow colour, which Bullen and friends describe as 'electric, glaringly golden'. The Revd Dr Arthur Keith Walker, vicar of the church, wrote a letter dated 9 February 1985 which explains the symbolism of the windows: 'The form focusses upon the heart and the heart is echoed in the face of the angel. The form of the angel is like that of a Guardian of the Sacred Mysteries. It echoes with that of a priest celebrating the Eucharist, holding patten or chalice. We are reminded of the words of Meister Eckhardt: "The eye with which I see God is the same eye with which God sees me". Immediately above the angel's head we have the fire and light of God in Trinitarian shape. The Feast of Pentecost gives us the most obvious scriptural reference. The eye is drawn up through a section of unknowingness, that inevitably separates the uncreated majesty of God from all creatures (*Isaiah* 55: 8,9). Even here something of the reality of God can be discerned in the small Trinitarian flame shape. Above this we have the majesty of God symbolized by a shape which is both sun and flower (*Malachi* 4: 2; Psalm 84: 11 etc). The illimitable reality of God is suggested by the flames that glow above the sun/flower shape. The colour is gold, which, as you know, is the traditional symbol of God and eternity. The style of the design is classical which befits an object meant to assist devotion in a public place'. Walker also suggests that the angels become a chorus and have a connection to one another and notes that Collins looked upon the four angels as four secrets, discovered by those who linger in the church – 'there is a theological importance in this observation'.

Title: *Mystery of the Holy Spirit*

Date: 1986-1988

Location and Size: west window, approximately 660x320cm (260x126in)

Cost: estimated June 1987 at £46,000

Donors: Arts Council gave £1,000

Faculty: 5 January 1989. The petition for the faculty was filed 19 June 1987 and the delay in granting it was partly due to abandoned plans for a new church hall. However the church was authorised by letter to proceed with the windows on 10 September 1987.

Dedication: May 1988, unveiled by Lord Roskill

Documentation: Hampshire Record Office, 21M65/F1989/1

Literature: John Pearce and Revd Elizabeth George, *All Saints Church Basingstoke. A Guide*, 1998, unpaginated; Bullen Michael, Crook John, Hubbuck Rodney and Pevsner Nikolaus, *The Buildings of England, Hampshire: Winchester and the North*, London: Yale University Press, 2010 (1968), p88, 159; *All Saints' Church in the Basingstoke Team Ministry*, leaflet

Reproduced: John Pearce and Revd Elizabeth George, *All Saints Church Basingstoke. A Guide*, 1998, unpaginated; *All Saints' Church in the Basingstoke Team Ministry*, leaflet

Notes: Revd Walker had worked closely with Dean Walter Hussey for some time which explains his desire to seek out works of art for his church. The congregation of All Saints leans towards a Catholic strain of Anglicanism. At the Parochial Church Council on 15 June 1986 Walker proposed that a faculty be sought for the west window; this was seconded by Francis Drake, and there were 32 votes for, none against, with one abstention. In a letter accompanying the Petition for Faculty, Walker wrote that 'the design shows God the Holy Spirit as the central face, which is also a sun with concentric circles of influence radiating outwards through the heavens. The first three circles contain heart shapes suggesting the gospel truth that God is love. Some of the hearts have eyes because love is personal and God is personal. These images relate to the seeing hearts in the small windows present already in the West wall. The hearts in the second circle are flames at the same time as hearts, since God is depicted also as the sun and carry overtones of light and fire, well known biblical images for the Spirit of God. The seventh circle contains stars, suggestive of the Empyrean. The circles of angels are the heavenly beings accompanying God, messengers of his will, depicted frequently in the Bible'. He noted that the window is male, so the design is predominantly circular, the feminine balancing the masculine, and the 'Holy Spirit is that Person of the Blessed Trinity most associated with the Feminine principle. Not all the wheeling circles are contained in the outer frame' because God is illimitable. However the Diocesan Advisory Committee (DAC) was not as entranced by the design as the PCC and advised Walker on 14 July that they were 'not happy with the overall effect of the blaze of yellow. Further, it was felt that the initial impression given by the design was that of a sun god rather than a Christian image'. Walker was not about to give up on his beautiful window and sought out the views of Professor John Bowker, Regius Professor of Divinity, Trinity College, Cambridge. Bowker considered the design 'profoundly and un-confusingly Christian'. Following a request from Walker, Reyntiens wrote to him 17 July 1987: 'The DAC uses the phrase "a blaze of yellow" but in fact this could hardly be said to be a description of the window as such since 75% of the area is white. ... there are many 'whites available' in the actual medium of glass. They vary from greys to green-tinted whites and moreover there are degrees of transparency and translucency, brought about by aciding and painting on the glass, which can ring the most subtle changes'.

On the matter of design he added that 'from an artistic point of view the concentric circles of angels have been used many times in the past – in poetry, Dante's *Paradiso*, in art Correggio's dome at Parma Cathedral ... the sun-burst is seen in Durer's Apocalypse engravings and has been used in Coventry Cathedral ... and in St Peter's, Rome'. Walker responded to the DAC on 22 July 1987 explaining that the design was born out of deep meditation in the church, Collins having visited many times. As he sat there contemplating, Collins felt that the church had an atmosphere of spiritual happiness and 'the element of gold is wonderfully appropriate to express god and spiritual serenity'. Walker observed that the window was designed for this particular church and that 'God is light; God is love; God is personal. We are told also that angels exist and that they are emissaries of God and sing his praises. All these notions are biblical and orthodox'. In another letter he noted of Collins and Reyntiens that 'their friendship and aesthetic and religious sympathies make them an ideal team'.

The window shows a mesmeric face of God as the Holy Spirit which is also a sun, surrounded by concentric circles with hearts, stars, eyes and angels in flight which Bullen describes as 'all symbolic of the Holy Spirit and an affirmation of mystic love'. It is truly magical when the setting sun shines through. Reyntiens states that Collins 'knew an enormous amount about the spirituality of colour' (interview with the author). In designing the window, Collins had in mind the words in the gospel at the Baptism of Christ: 'He saw the Spirit of God descending like a dove to alight upon him' (*Matthew* 3: 16) and light from the window does appropriately catch the Head of Christ as sculpted by Frink.

Above: *Head of Christ* by Dame Elizabeth Frink

Opposite: Detail of *Mystery of the Holy Spirit* window and the west end of the church with the flanking angel windows.

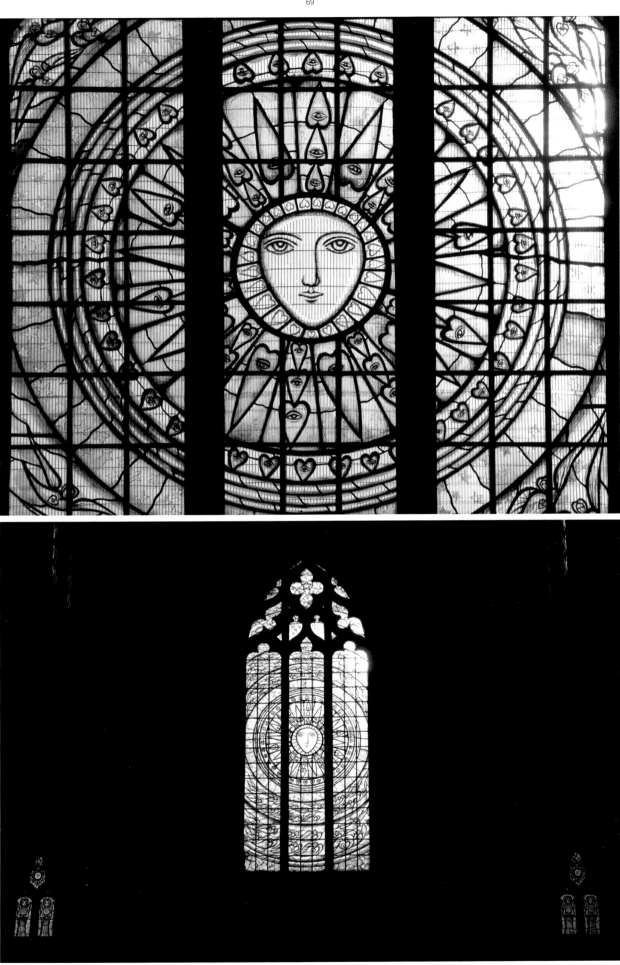

Hinton Ampner, All Saints, Hinton Ampner House, Bramdean, Nr Alresford, SO24 0LA

Listing: Grade II* (5 December 1955, amended 19 December 1983) #1155865

General: The parish church, constructed of squared flintwork with stone dressings and with a plain tile roof, has a Saxon floor plan and a13th century chancel but most of the fabric was restored in the early 19th century and in 1879 by C N Tripp. The church is listed by virtue of its memorials – nearly all commemorating the Stewkeley family.

Literature: Dutton Ralph, *Hinton Ampner. A Hampshire Manor*, National Trust, 2010 (1968), p24; *Stained Glass Windows and Master Glass Painters 1930-1972*, Bristol: Morris & Juliet Venables, 2003, p84

Title: *Pillar of Cloud* (left) and *Pillar of Fire* (right)

Date: 1969

Location and Size: two 19th century single lancet windows in sanctuary, east end, each lancet approx. 325x50cm (128x19 3/4in)

Inscription: signed and dated bottom of right hand lancet: 'Reyntiens 69'

Designer, Glass Painter and Maker: Patrick Reyntiens

Architect in charge: P R Sawyer

Donor: Ralph Dutton, the last Lord Sherborne and owner of Hinton Ampner House, commissioned the windows.

Faculty: 15 July 1969

Documentation: Hampshire Record Office, 21M65/196F/14; 40M80/PP2; 40m80/PW3

Literature: Clarke Brian (Ed), *Architectural Stained Glass*, London: John Murray, 1979, p193; Cowen Painton, *A Guide to Stained Glass in Britain*, London: Michael Jospeh Ltd, 1985, p113; Bullen Michael, Crook John, Hubbuck Rodney and Pevsner Nikolaus, *The Buildings of England, Hampshire: Winchester and the North*, London: Yale University Press, 2010 (1968), p88, 338; Greeves Lydia, 'Introduction' in Dutton Ralph, *Hinton Ampner. A Hampshire Manor*, National Trust, 2010 (1968), p9

Below: Interior of the church
Right: *Pillar of Cloud and Pillar of Fire*

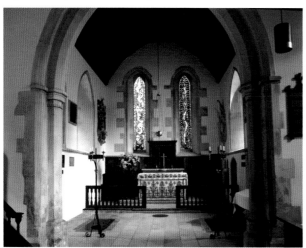

Notes: At the Parochial Church Council meeting on Monday 18 November 1968 Mr Dutton asked for approval for a plan he had to improve the Church, explaining that 'it was something he would very much like to do, and it would be no expense to the village at all'. This included new east windows which needed renewing and which Dutton described as being 'filled with glass of exceptional crudity'. The idea was unanimously approved. The windows are rather exceptional and unusual and represent the pillars of cloud and fire which led the Israelites out of Egypt (*Exodus* 13: 21-22). In each window a tapering triangle, signifying the Trinity, forms the structure upon which the clouds or fire rise. In the left hand window the base of the triangle is red, with swirling clouds ascending, the area outside the pictorial element being pale blue. The right hand window is very dramatic, red flames scrambling over a dark blue ground, the area outside being almost black. The area round the triangles is formed of small pieces of glass joined by dots reminiscent of a chemical molecular model.

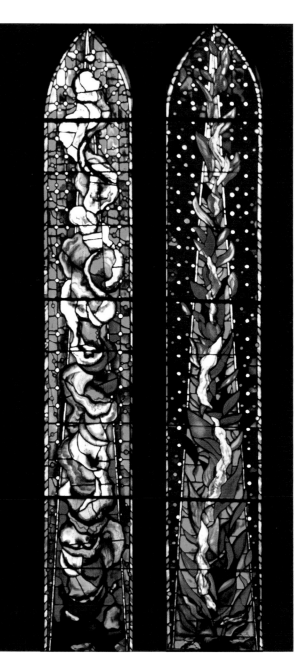

Hound, St Mary's, Hound Road, Netley Abbey, Southampton SO31 5FS

Listing: Grade II* (5 December 1955) #1322693

General: St Mary's is a delightful, simple 13th century church in Early English style with a 15th century timbered bell turret at the west end. Reyntiens described the church as a 'unique little building, intrinsically a powerhouse of spirituality and a venue for private prayer'. Since the settlement developed at nearby Netley the church has, fortunately, been unaltered – by the same token, it was rarely used and by 1998 had fallen into such a state of disrepair that the Diocese decided to make the church redundant. Luckily a group of local residents formed the registered charity, 'Friends of St Mary's, Hound' and have succeeded in maintaining the church and its unique window.

Title: *Virgin and Child*

Date: 1958-1959

Location and Size: 3-light east window, approximately 207x169cm (81 1/2x66 1/2in)

Inscription: signed in right hand light: 'Reyntiens'

Designer, Glass Painter and Maker: Patrick Reyntiens

Architect in charge: Robert Bostock & Partners

Studies: A photograph of the study is in Hampshire Record Office, 2/M65/202F/20

Cost: Estimated at £270 in Petition dated 12 November 1958

Commemoration and Donors: The central light is in memory of Agnes Mary Sellex who died 30 November 1957, wife of Major G W Sellex MBE, MC. The left light is in memory of Reginald Bartlett and the right light was an anonymous gift. Funds were also raised through public subscription.

Faculty: 2 January 1959

Dedication: Sunday 21 June 1959

Documentation: Hampshire Record Office, 21M65/202F/20; 133M83/PW22; 133M83/PZ9/54

Literature: *Hound Chronicle The*, June 1959; Pevsner Nikolaus, Lloyd David, *The Buildings of England, Hampshire and the Isle of Wight*, Harmondsworth, Penguin Books, 1967, p59, 298; Clarke Brian (Ed), *Architectural Stained Glass*, London: John Murray, 1979, p193; *Stained Glass Windows and Master Glass Painters 1930-1972*, Bristol: Morris & Juliet Venables, 2003, p84; Baden Fuller Kate, *Contemporary Stained Glass Artists. A Selection of Artists Worldwide*, London: A&C Black Publishers Ltd, 2006, p49; BSMGP, '"C R Wyard, Aspects of 20th-Century Stained Glass": BSMGP International Conference 2008', Vol XXXII, 2008, p127; *Decorative Arts Society The, Omnium Gatherum*, Horner Libby, 'Patrick Reyntiens' Autonomous Panels. Myth, music and theatre', Journal 35, 2011, p65

Reproduced: Baden Fuller Kate, *Contemporary Stained Glass Artists. A Selection of Artists Worldwide*, London: A&C Black Publishers Ltd, 2006, p49; *Decorative Arts Society The, Omnium Gatherum*, Horner Libby, 'Patrick Reyntiens' Autonomous Panels. Myth, music and theatre', Journal 35, 2011, back cover, p62; greetings card

Notes: When it was decided to replace the original geometrical patterned glass the architect Bostock suggested contacting

Reyntiens. Writing to the vicar, Revd A J Beach, the Registrar observed that whilst he had 'no great experience of painted drawings of this nature' he felt that the study was 'rather a rough state and generally the coloured drawings that are submitted are in a much more finished condition'. However his misgivings were unfounded and in the introduction to *Hampshire and the Isle of Wight* the authors note that with respect to stained glass 'no church in the C20 idiom need be referred to, but the excellent stained glass by Patrick Reyntiens at Hound' and Reyntiens himself considers it the best work he ever accomplished. Pevsner notes that 'the colouring bears only a partial relationship to the figures and is to a large extent composed as if the design were abstract. But the figures are strongly representational, with firm facial expressions and delicately composed hands and robes'. In *The Hound Chronicle* the writer observed that 'the more I look at it the more I am convinced that it is beautifully conceived in subject, design and colour … it looks as if it had always been in the church, and at the same time has all the marks of originality'. Angels flank the Virgin Mary who holds the baby Jesus, at the same time traditional and yet original because the child is gesticulating. It is a stunning window, beautifully framed by the ancient chancel arch. The colours are rich, mainly blue, mauve and green with small touches of yellow and red. Reyntiens is quoted in Fuller's book as saying that the window has strong spiritual overtones and that his design changed considerably during execution – 'the Christ child opened His arms, becoming more welcoming to the congregation'. In execution the design became less traditional and more abstract.

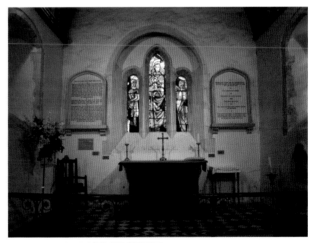

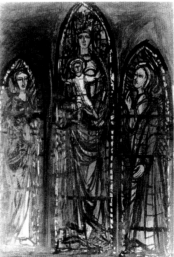

Left: Study for window

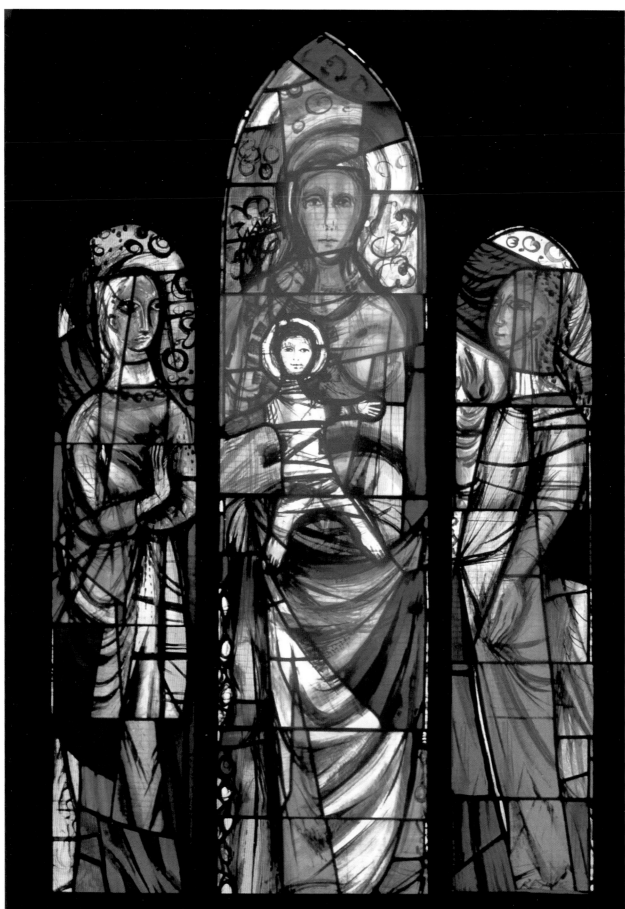

Virgin and Child, Hound

Odiham, All Saints, Church Street, RG29 1ND

Listing: Grade I (24 November 1961) #1092160

General: The church dates from the 13th and 14th centuries and is built of flint with stone rubble, local malmstone dressing and some brickwork, with a red tiled roof. The tower was largely rebuilt in the 17th century and the four pinnacles are 19th century. Under the influence of the Camden Society, the interior of the church was re-ordered in the 19th century by Henry Woodyer and the main east window reduced in size. In 1858 the plain glass in the three east windows was replaced by stained glass in memory of Colonel Charles William Short who lived in the Bury House – only the stained glass in the south chapel remains (probably Hardman under Woodyer's supervision) – the other two subsequently being replaced by Reyntiens' glass. The church owns one of the twelve remaining hudds in the country – basically a small shelter under which the priest would stand in inclement weather when officiating at the graveside. Bullen et al describe the windows as 'strikingly original works'.

Literature: Spruce Derek, *The Church in the Bury. A Thousand Years of All Saints, Odiham*, Odiham Parochial Church Council, 2001; *Stained Glass Windows and Master Glass Painters 1930-1972*, Bristol: Morris & Juliet Venables, 2003, p84; Bullen Michael, Crook John, Hubbuck Rodney and Pevsner Nikolaus, *The Buildings of England, Hampshire: Winchester and the North*, London: Yale University Press, 2010 (1968), p88

The following details are applicable to both windows:
Date: 1968-1969

Designer, Glass Painter and Maker: Patrick Reyntiens

Architect in charge: Robert Bostock

Title: *Adoration of the Lamb*

Location and Size: 3-light east window of antique glass, approximately 375x206cm (148x80in)

Cost: Estimated at £1,500 in petition for faculty dated 10 June 1968

Donor: Anonymous memorial gift in memory of parents.

Faculty: 9 July 1968

Documentation: Hampshire Record Office, 21M65/275F/25

Literature: Clarke Brian (Ed), *Architectural Stained Glass*, London: John Murray, 1979, p193; Spruce Derek, *The Church in the Bury. A Thousand Years of All Saints, Odiham*, Odiham Parochial Church Council, 2001, p73; Spruce Derek, *Illustrated Guide to the Church of All Saints*, 2006, back page; Bullen Michael, Crook John, Hubbuck Rodney and Pevsner Nikolaus, *The Buildings of England, Hampshire: Winchester and the North*, London: Yale University Press, 2010 (1968), p422

Reproduced: Patrick Reyntiens, *Glass Painted and Stained, Visions in Light*, Bruton Gallery, 1985, p30; greetings card

Notes: Bostock suggested replacing the east window glazing which he felt was in poor condition and of inferior design. In a letter dated 5 June 1968 to Dr A Phillips, the Registrar noted that 'I find the explanation of how the glass is to be inserted although complicated clearer to understand than the design but the passages in *Revelations* might have been written for 20th century illustrations whether beautiful examples or not'. The window shows the Lamb of God centre within a triangle symbolizing the Holy Trinity, surrounded by the emblems of the four Evangelists with the innumerable company of the Saints below, as described in the epistle for All Saints' Day (*Revelations* 7: 9-17). It is composed of strong diagonals of coloured glass (mainly blue and green with yellow colouring in centre) bearing no relationship to the images. Bullen and friends describe the window as 'an advanced semi-abstract idiom then still rare in England, but firmly established in Germany'.

Whilst working on this window Reyntiens suggested that the south east and north east windows should be modified by removing the uninteresting decorative glass on the two outer lights in each window and replacing them with antique glass of a bluish hue to harmonise with the remnants of 19th century glass in the windows either side of the east window.

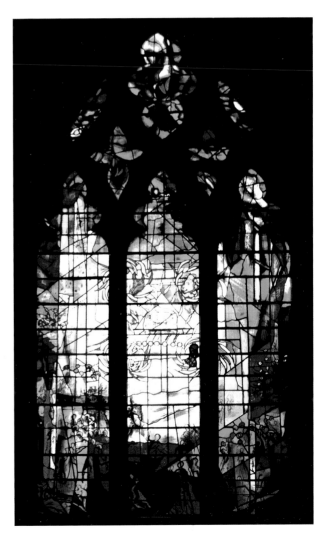

Title: *Tree of Jesse*

Location and Size: 3 light east window in Lady Chapel (north chapel), approximately 375x206cm (148x80in)

Cost: Estimated at £800 in petition for faculty dated 17 July 1969

Commemoration and Donor: In memory of Caroline Hilda Chamberlain of The Bury House, Odiham, 1872-1967. Anonymous donation.

Faculty: 12 August 1969

Documentation: Hampshire Record Office, 21M65/275F/26

Literature: Clarke Brian (Ed), *Architectural Stained Glass*, London: John Murray, 1979, p193; Spruce Derek, *The Church in the Bury. A Thousand Years of All Saints, Odiham*, Odiham Parochial Church Council, 2001, p73; Bullen Michael, Crook John, Hubbuck Rodney and Pevsner Nikolaus, *The Buildings of England, Hampshire: Winchester and the North*, London: Yale University Press, 2010 (1968), p422

Notes: The window has a Tree of Jesse in the central panel with the Virgin Mary hovering above, branches and streaks of light spreading into outer lights which are otherwise pale green with large medieval-inspired borders. There is a sunburst in the tracery lights. Unusually this Tree of Jesse does not include all the forebears.

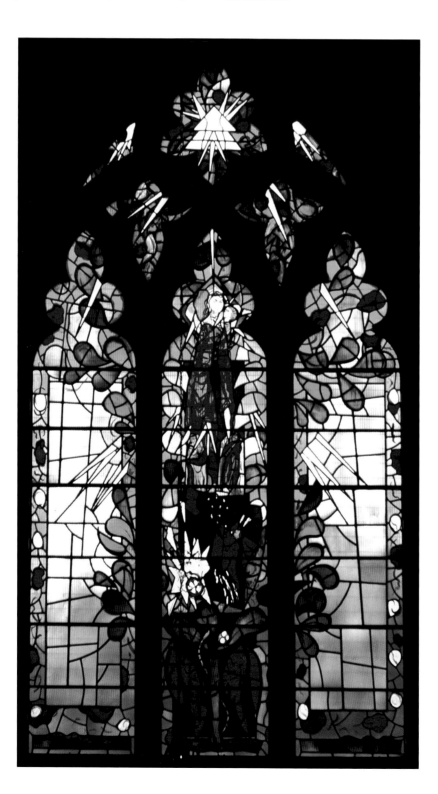

Winchester, Wessex Hotel, Paternoster Row, SO23 9LQ

General: The hotel was designed by Fielden and Mawson (with Lionel Brett) from 1961-1963. Pevsner and Lloyd consider the building a triumph of design.

Title: *Foliate Heads*

Date: 1964

Location and Size: stained glass and fibreglass screen divided into 12 panels, each back lit, opposite the main entrance. Each panel measures 62x62cm (24 1/2x24 1/2in)

Designer: John Piper

Glass Painter and Maker: Patrick Reyntiens and David Gillespie

Literature: Pevsner Nikolaus, Lloyd David, *The Buildings of England, Hampshire and the Isle of Wight*, Harmondsworth, Penguin Books, 1967, p691; Harrison, 1982, unpaginated; *House and Garden*, Levi Peta, 'Springboard from Piper and Reyntiens: or the brave new world of the stained-glass designers', April 1983, p147; Osborne, 1997, p81-83, 173; *Stained Glass Windows and Master Glass Painters 1930-1972*, Bristol: Morris & Juliet Venables, 2003, p84; Spalding, 2009, p366; Bullen Michael, Crook John, Hubbuck Rodney and Pevsner Nikolaus, *The Buildings of England, Hampshire: Winchester and the North*, London: Yale University Press, 2010 (1968), p675

Reproduced: Osborne, 1997, p82

Notes: The panels feature Piper's favourite foliate heads against a background varying from dark blue to black. Spalding considers the panels disappointing. Osborne notes that the faces are U shaped and surrounded by vegetation and perhaps symbolise the 12 months of the year, although, if so, it is difficult to discern where spring, summer, autumn and winter appear.

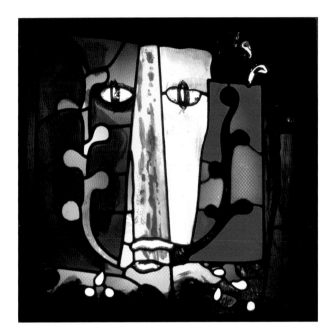

Above: One of the panels
Below: The twelve panels in the entrance hall

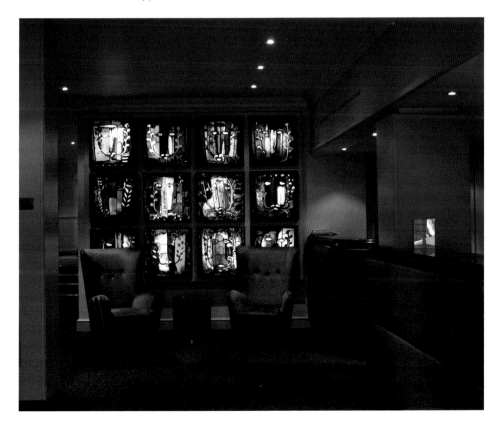

HERTFORDSHIRE

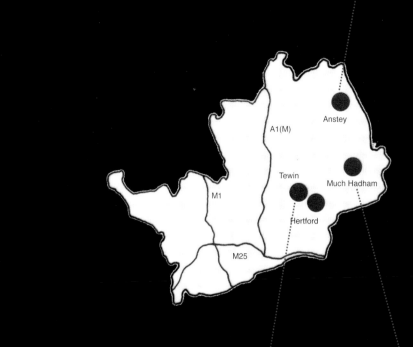

Anstey

A1(M)

Tewin

Much Hadham

M1

Hertford

M25

Anstey, St George, SG9 0BY

Listing: Grade 1 (22 February 1967) #1101870

General: The church of flint rubble with stone dressings is built on an artificial mound marking the meeting place of two ley-lines, a place of pagan worship. The origins of the church are late 12th century, rebuilt over the centuries, with the top of the tower and south porch added in the 15th century. The church was restored by William Butterfield 1871-1872 and repaired by Sir Arthur Blomfield in 1907. Inside there's a cornucopia of delights including the Norman font decorated with Mermen holding their tails, 14th century choir stalls with wonderful carved misericords, a medieval iron bound chest and 13th and 14th century graffiti.

Title: *398th Bomb Group Memorial*

Date: 1997-2000

Location and Size: 3-light Perpendicular window in south aisle, approximately 335x244cm (132x96in)

Inscription: signed in right hand light: 'Reyntiens 2000'

Designer and Glass Painter: Patrick Reyntiens

Glass Maker: John Reyntiens

Study: Preliminary sketch, Reyntiens Trust, signed by the artist b.r. Cartoon, Reyntiens Trust. Although the basic concept remained the same throughout the design stage it is interesting to note subtle changes in colour. The planes on the cartoon are merely unmarked paper shapes.

Cost: Preliminary sketch, August-December 1997, £600 paid for by Lady du Boulay. Full size cartoon, glass painting, leading, firing, installation etc £12,000.

Commemoration and Donors: The window commemorates all 296 members of the 398th Bomb Group who lost their lives in combat. The UK based Friends of the 398th commissioned the window which was financed through contributions from the UK and USA.

Documentation: Correspondence in private collection

Dedication: 11 June 2000 (Pentecost Sunday), dedicated by the Bishop of St Albans and unveiled by HRH The Duke of Gloucester

Literature: *One More Peek. June 2006. Big Friends and Little Friends*, Friends of the 398th, 2006, unpaginated; *St George's Church Anstey*, undated; *St George's Church Anstey, a brief guide*, undated

Reproduced: postcard

Film: Pow Rebecca, *Rather Good at Blue. A Portrait of Patrick Reyntiens*, HTV West, 2000; Mapleston Charles, Horner Libby, *From Coventry to Cochem, the Art of Patrick Reyntiens*, Reyntiens/Malachite, 2011

Below left: Preliminary sketch

Below right: Full size cartoon

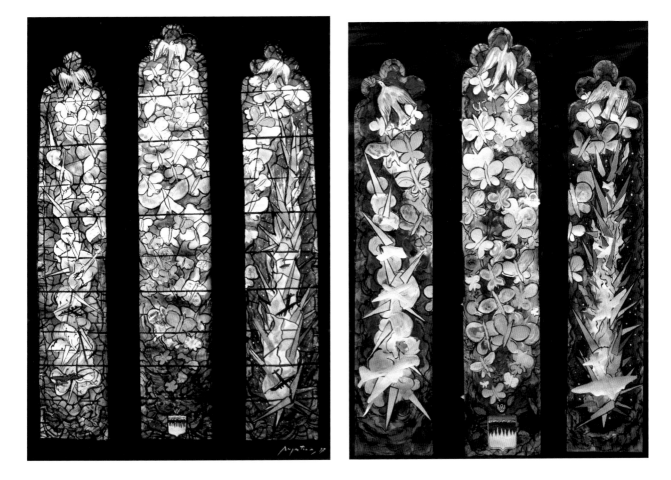

Notes: The American Air Force 398th Bomb Group was despatched to England in April 1944 and stationed at Nuthamstead in Hertfordshire (8th AF Station 131) which they speedily nicknamed 'Mudhamstead'. Their task was to operate against strategic objectives in Germany. In the year they were in the UK they flew 6,419 sorties and lost 58 B-17's, including two during their final mission on 25 April 1945 – the last aircraft shot down in the war over Europe. 296 of the Group lost their lives, including ten who died when their aircraft crashed into the mound, narrowly missing St George's church. The veterans began holding reunions in the UK which always included a service of commemoration in St George's. From this developed the idea of a stained glass window to honour the 398th and thank them for their assistance during the war. The project was masterminded by one of the churchwardens, Sir Roger du Boulay and he contacted John Piper, with whose work he was familiar, in the late 1970s. Piper agreed to design a window and stated that Reyntiens would make it for him, quoting a price of between £5,000 and £10,000, which was more than the Friends could raise at the time. The veterans began visiting the site on a biennial basis and by 1996 sufficient funds had been raised to once again contemplate a memorial window. Since by this time Piper was dead (1903-1992), Sir Roger contacted Reyntiens who agreed to design a window. The pair first met in May 1997 and judging by their correspondence they immediately formed a good working relationship, Sir Roger describing their on-site talks and debates as 'all highly enjoyable and ceaselessly constructive'. The concept for the window was in reality a joint one. Since many of the airmen were either agnostic or Jewish it was considered necessary to avoid overt Christian symbolism and they agreed on the *Old Testament*, basing the iconography on the journey of the Israelites out of Egypt with the Pharaoh's army being engulfed by the Red Sea indicated at the bottom of the central light. The left panel depicts the Pillar of Smoke in *Exodus* which led the Israelites by day – the bombers flew by day. The right panel depicts the Pillar of Fire which led the Israelites by night, symbolising here the destructive forces of war. The silvery white butterflies in the central light are symbolic of flight and the transformation of the soul after death whilst the golden butterflies scattered across the three lights represent the Cross. The B-17 Flying Fortresses, marked with 398th Triangle W identification and red wing tips, fly through the Pillars – five planes ascend whilst only four descend since on average one in every five aircraft failed to return. The two aircraft at the bottom are numbered, two of the eight or so which survived the war and returned to the USA. The Squadron badges (which Reyntiens regarded as latter day gargoyles) are included and Reyntiens inscribed on the wings of the butterflies the name of every single airman who was killed. He explains that 'the act of reading from one name to another to another builds up your understanding of what it must have been like for each of those individuals to have lost their lives doing their duty in the way that war demands. And so it's a very decorative window but it has a secret warning behind it and the more you look at the window the more you realise the sacrifice of those Americans far from home who gave their lives for greater peace in the world.'

There is also a stone memorial to the 398th next to the Woodman Inn at Nuthamstead (the Inn itself is full of memorabilia and worth a visit).

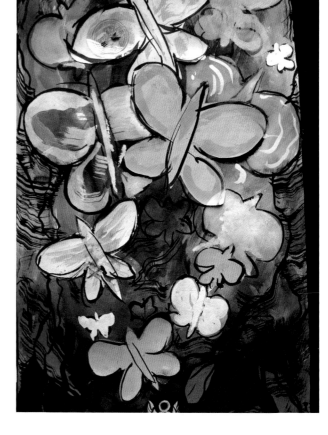

Above: Painted and collage butterflies on the cartoon, together with one of the squadron badges drawn on to tracing film. The badge designs were made into rubber stamps which were coated with lead paint before being stamped on to the glass.

Below: Detail of one of the finished butterflies.

Opposite page: *398th Bomb Group Memorial*

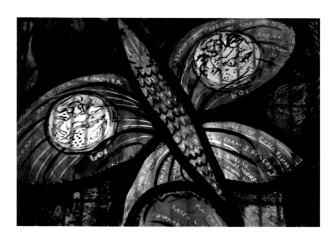

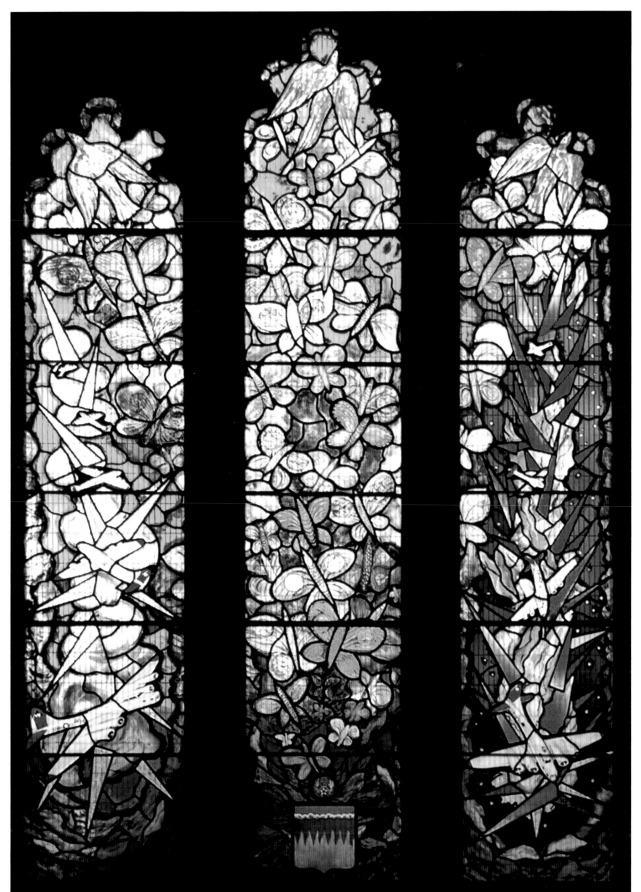

Much Hadham, St Andrew (CofE and RC), Church Lane, SG10 6DH

Listing: Grade I (22 February 1967) #1289691

General: Much Hadham is a very attractive village with a great mixture of house styles, all very well heeled. The large parish church of flint with Barnack stone dressing, and a slate roof, dates back to the 13th century with much 15th century work. The tower boasts a typical 'Hertfordshire spike', a lead-covered spire. There is some 15th century stained glass, Burlison and Grylls work in east window, glass by Selwyn Image and dozens of cheerful kneelers made by the parishioners. The west doorway has label stops of a king and a queen by Henry Moore dated 1953. The Henry Moore Foundation is nearby at Perry Green, SG10 6EE.

Title: *Tree of Life*

Date: 1994-1995

Location: 3-light Perpendicular west window in tower

Inscription: Signed by Patrick Reyntiens b.l. and by John Reyntiens b.r.

Designer and Glass Painter: Patrick Reyntiens

Glass Maker: John Reyntiens

Architect in charge: Martin Caroe, Caroe & Partners, London

Studies: Reyntiens Trust inscribed b.r.: 'Reyntiens 94'; private collection inscribed 'Reyntiens '94'

Above: Henry Moore, *Trees V: Spreading Branches*, 1979, etching and aquatint in three colours
Below left: Sketch, private collection
Below right: Sketch, Reyntiens Trust. This is the design which was chosen.

Cost: estimated £25,000-26,000 when petition sent

Commemoration and Donors: The floor plaque (made by David Dewey) at the entrance to the tower records: 'THE TREE OF LIFE from an etching by Henry Moore OM, CH, depicted in the West Window by Patrick Reyntiens marks the friendship and common vision of Michael McAdam and Patrick Dolan which in 1984 led to the shared use of this church by the Anglican and Roman Catholic congregations of St Andrew's and Holy Cross. UT UNUM SINT. ANNO DOMINI 1995'. £30,000 was raised by public subscription. The PCC paid for stonework repair to the west window, amounting to £12,000.

Faculty: 17 February 1995

Dedication: 30 July 1995 by Robert Runcie (previously Archbishop of Canterbury and co-incidentally, as Bishop of St Albans, the man who instituted the Rector)

Documentation: Hertfordshire Archives and Local Studies, DSA2/1/1096/263

Literature: *Much Hadham Parish Magazine*, June 1994, unpaginated; *Much Hadham Parish Magazine*, November 1994, unpaginated; *A Guide to the Parish Church of St Andrew, Much Hadham, Hertfordshire*, 1997 (1986), p16

Reproduced: A *Guide to the Parish Church of St Andrew, Much Hadham, Hertfordshire*, 1997 (1986), p17; postcard

Film: Mapleston Charles, Horner Libby, *From Coventry to Cochem, the Art of Patrick Reyntiens*, Reyntiens/Malachite, 2011

Notes: The Catholic community of Holy Cross, Much Hadham used to worship in a Nissen hut in a field belonging to the local butcher, Mr Roberts. When the latter died he left the field to the Catholics who then developed the land, gained money and wished to build their own church. To do this they had to knock down the Nissen hut and were invited by Revd Michael McAdam of St Andrew's to share his church. The two communities got on so well and since there were a number of other places of worship in the area they agreed to continue sharing. In 1984 the PCC of St Andrew entered into a legal agreement with the Catholic congregation whereby both communities would worship in the church and share the financial costs of the upkeep of the building. In the meantime Patrick Dolan, a prominent member of the Catholic community, had approached his friend Henry Moore with the prospect of obtaining a design which could be used for a stained glass window in the projected Catholic church, and was given the etching and aquatint *Trees V: Spreading Branches*, 1979, a beautiful etching of a willow tree. After ten years of amicable sharing and to commemorate the retirement of the much loved McAdam, it was agreed that the Moore etching should be made into a stained glass window in the west tower replacing the post 1945 clear glass. The driving force behind the window was Penelope Wrong who liaised with the church authorities and the artist and his son. This was the first window in which the father/son team of Patrick and John Reyntiens collaborated. The lower part of the window is based on the aforementioned etching which measures 16.8x20.6cm. This had to be photographically enlarged and then painted. Reyntiens produced two studies, one in which the mullions were superimposed on to the original design and one in which the design was in effect cut into three parts so that none of the design was lost – the latter was chosen. On 10 September 1994 and again on 29 January 1995 the PCC agreed unanimously to the project. In November 1994 a fund raising 'Pate and Plonk Lunch' was organised so that the communities could view the design. English Heritage was also approached for their views. The tree only fitted the lower part of the window and in a letter dated 10 November 1994, English Heritage stated: 'We feel that the design for the upper window, above Moore's tree, appears unsympathetic. The random design creates disharmony and competition with Moore's branches below, and the junction between the two elements is particularly

uncomfortable. Alternatives could be considered, including a very simple large pane glazing pattern which could extend the sky background colour upwards'.
In the event Reyntiens used blue and green glass, carrying on the soft blue of the aquatint. In painting this glass he had to ensure that he did not produce anything too expressionist which might detract from the Moore tree below. Leading was another problem because the artist did not want to damage the integrity of the original design, and in fact it is so well devised as to be almost invisible. The tree is grey glass overlaid with blue and acid etched; the beige colouring of the background was created with light yellow enamel. The glass is German and Reyntiens particularly admired the subtlety and range of their grey glass. This is thought to be the only stained glass window in the world based on a Henry Moore design. Unfortunately an unadulterated vision of the window is impossible from the nave because of the placing of the organ.

Left: Henry Moore, label stop below west window

Below: *Tree of Life* photographed from the bell-ringers' loft

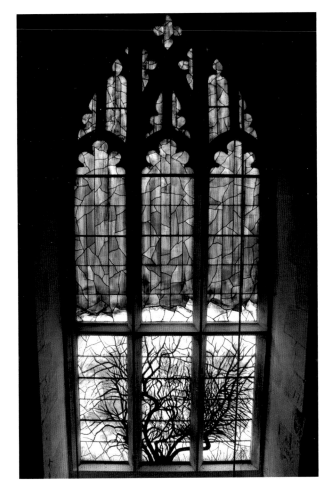

Tewin, St Peter's, Churchfield Road, AL6 0JF

Listing: Grade I (24 November 1966) #1341477

General: St Peter's is an attractive church dating back to the 11th century with a solid 15th century buttressed west tower, a catslide roof on the south side and a timber framed south porch. The church is built of flint rubble on a brick plinth with stone and tile dressings and tiled roof. The east window was designed by Harry Ellis Wooldridge and made by James Powell and Sons. Healey noted the 'blues and citric yellows' of Reyntiens' glass.

Literature: Healey R M, *A Shell Guide to Hertfordshire*, London: Faber and Faber, 1982, p165 ; Pevsner Nikolaus, 2nd edition revised by Cherry Bridget, *The Buildings of England, Hertfordshire*, Harmondsworth: Penguin Books, 1977 (1953), p360; NADFAS, *Record of Church Furnishings, St Peter's, Tewin, Herts*, 1985

The following details are applicable to all four windows:
Date: 1962-1963

Designer, Glass Painter and Maker: Patrick Reyntiens

Cost: estimated at £200-300 in petition dated 29 November 1962

Commemoration and Donors: A plaque adjacent to the Annunciation window reads: 'THE EAST WINDOW AND LANCETS/ARE IN MEMORY OF/CEDRIC LANE-ROBERTS C.V.O., MS/OF THIS PARISH'. The windows were donated by the brother of Dr Lane-Roberts, Allun Arbuthnot Lane-Roberts, his sister-in-law Madge Lane-Roberts, and Mrs Edith Jean Ritchie.

Faculty: January 1963 (for all four windows)

Dedication: 3 July 1963

Documentation: Hertfordshire Archives and Local Studies, DSA2/1/239/10; D/P106 8/8

Literature: Healey R M, *A Shell Guide to Hertfordshire*, London: Faber and Faber, 1982, p165; NADFAS, *Record of Church Furnishings, St Peter's, Tewin, Herts*, 1985

Notes: All four windows were previously glazed with plain glass. Negotiations about the windows were underway by January 1962, if not earlier and in October of that year the St Albans Diocesan Advisory Committee approved the designs which were also reviewed by the Central Council for the Care of Churches. The PCC held a meeting on 25 November and the decision to carry out the works was unanimous, although it would appear that Reyntiens had already begun work. The four windows were in place by September 1963 but since the faculty had expired on 24 July the PCC had to apply for another faculty to add the explanatory plaque.

Title: *Annunciation*

Location: double lancet 15th century window, east end of south aisle

Literature: *St Peter's Church, Tewin, A Visitor's Guide*, 2009, unpaginated

Reproduced: *St Peter's Church, Tewin, A Visitor's Guide*, 2009, unpaginated

Notes: The window represents the moment when the angel Gabriel informed Mary that she would give birth even though she

was a Virgin. Mary, in blue and with a blue halo, is depicted on the left with her hands raised, palms facing outwards. Gabriel with a yellow halo is in the right lancet, his right hand raised in blessing whilst his left holds a Madonna lily with gold leaves. A dove flutters above him. The colours are mainly blue, green, yellow and white and the window is similar in style to the *Annunciation* window at Ampleforth College, Yorkshire.

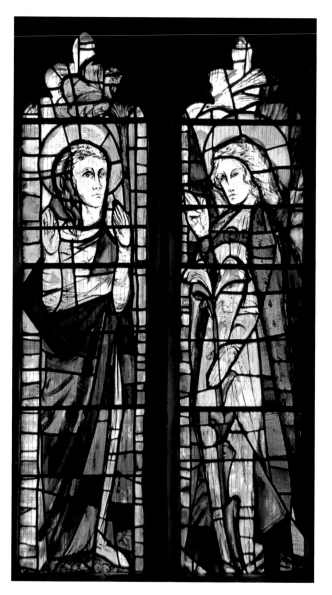

Title: unnamed

Location and Size: single lancet, south aisle, 118x26cm (42 1/2x10 1/4in)

Notes: The design is abstract in blue, yellow, green and clear glass.

Title: unnamed

Location and Size: single lancet, south aisle, 118x26cm (42 1/2x10 1/4in)

Inscription: signed b.r.: 'Reyntiens 62'

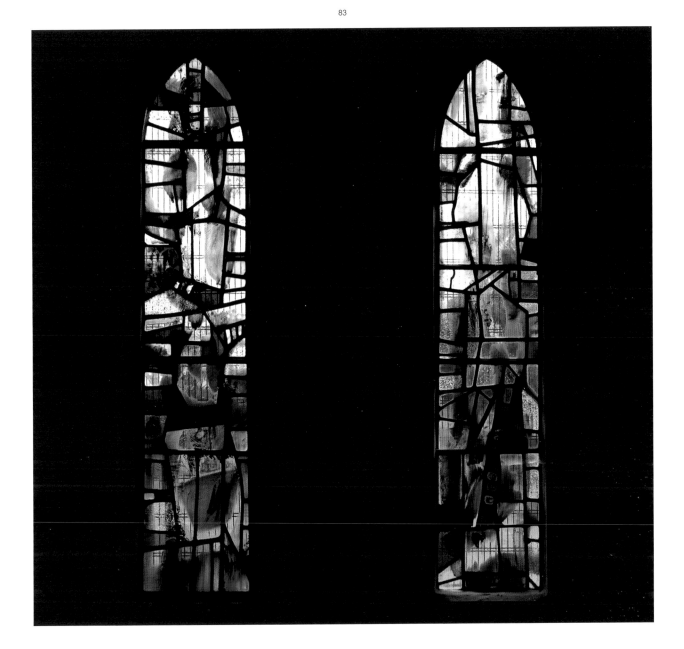

Above: South lancet windows
Right: West window

Notes: The design is abstract in blue, yellow and clear glass. One of these lancets was wrecked in September 1972 and renewed by the artist by February 1973.

Title: unnamed

Location and Size: 2-light rectangular window, west end of south aisle, approximately 125x125cm (49 1/4x49 1/4in)

Notes: The design is abstract in blue, grey and clear glass with brush marks creating the figure 8 on each light. This was probably the last window to be installed and may not have been in place for the dedication.

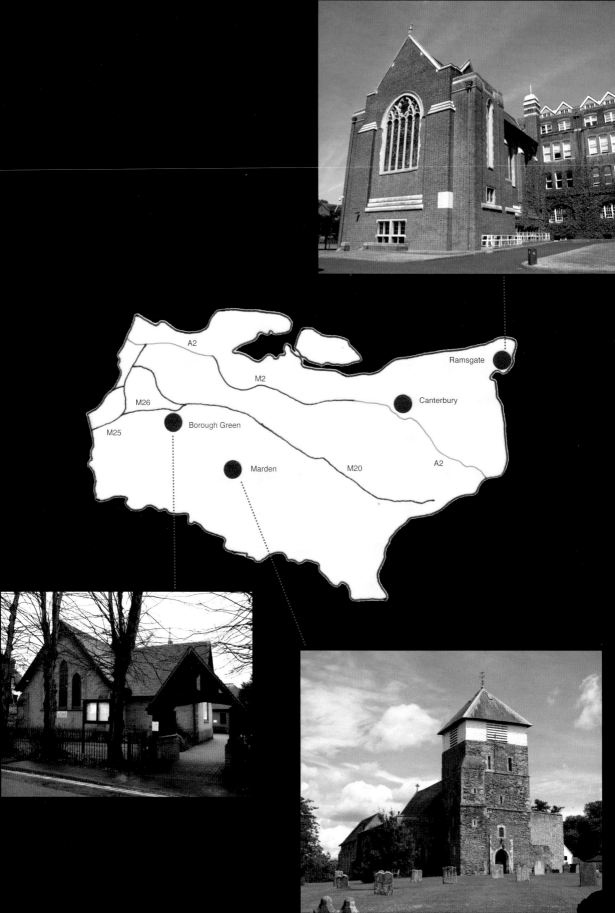

A2

M2

M26

M25

Ramsgate

Canterbury

Borough Green

Marden

M20

A2

Borough Green, Good Shepherd, Quarry Hill Road, TN15 8RF

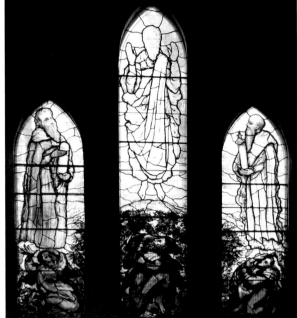

General: The Good Shepherd is a red brick building dating from the turn of the 20th century, the foundation stone having been laid by Emmeline St Maur, the Viscountess Torrington, on January 9th 1906.

Date: 1986-1987

Title: *Transfiguration*

Location and Size: 3-light east window, approximately 287x265cm (113x104 1/4in)

Inscription: signed and dated b.r.: 'Reyntiens 1986-7'

Designer, Glass Painter and Maker: Patrick Reyntiens

Notes: Reyntiens was inspired by the trees outside the church and decided on the theme of Transfiguration. In the summer and autumn the light shimmers through the window in a mystical manner. The figures of Saints Peter, James and John at the bottom of the window amongst autumn looking leaves are darker to emphasise their earthboundness, whilst the window becomes lighter as one ascends, some of the colours being almost acidic. Christ is shown in the central light with Moses on the left in pink and holding a scroll, Elijah on the the right in pale blue and holding a flask.

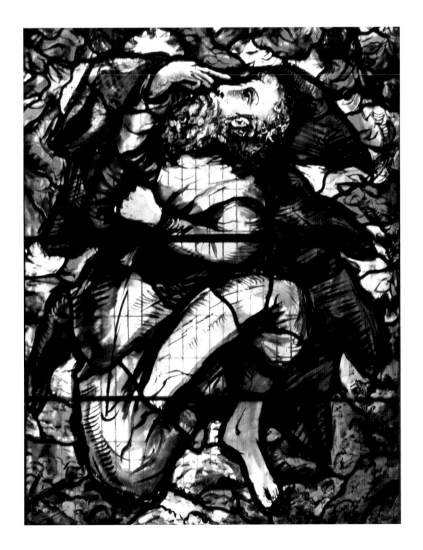

Marden, St Michael & All Angels, Church Green, TN12 9DR

Listing: Grade I (23 May 1967, amended 23 May 1987) #1054804

General: In his introduction to *North East and East Kent*, Newman states that 'the only furnishings of note are two very recent stained glass windows, one of 1962 at Marden by Patrick Reyntiens, and the sincere and tender window designed for Tudeley by Marc Chagall in 1967'. Marden is an attractive village with a delightful church dating back to 1200 with additions in the 13th, 14th and 15th centuries and restoration in 1868. The church is generally composed of random ragstone, sandstone and puddingstone with tiled roofs to nave and chapels, a leaded roof to the north aisle, and a tower with a weather boarded belfry and pyramidal slated roof.

Literature: Newman John, *The Buildings of England, West Kent and the Weald*, Harmondsworth: Penguin Books, 1969, 117, 399; Hughes Pennethorne, *Kent Shell Guide*, London: Faber & Faber, 1969, p110; Newman John, *The Buildings of England, North East and East Kent*, London: Penguin Books, 1998 (1969), p120; *Stained Glass Windows and Master Glass Painters 1930-1972*, Bristol: Morris & Juliet Venables, 2003, p84

The following details are applicable to all 3 windows:
Date: 1962-1963

Designer, Glass Painter and Maker: Patrick Reyntiens

Installation: Cliff White (the window was supplied in kit form and Mr White assembled it in a fortnight – only one small piece of glass is missing from the east window).

Donor: A wooden commemorative panel below the north chancel lancet reads: 'IN GRATITUDE TO GOD/these windows were given by/WILLIAM DAY, CHURCHWARDEN/1962'. William Day, who lived at The Thorn, Marden, retired as the People's Warden in April 1962 due to ill health.

Faculty: 8 January 1963

Dedication: Easter Sunday, 14 April 1963 by the Bishop of Dover, Lewis Evan Meredith

Documentation: Kent History and Library Centre P244/25/A/4/1; P244/6/B/12; P244/8/A/8. Marden Heritage Centre.

Title: *Christ in Majesty*

Location and Size: 3-light east window, approximately 319x218cm (125 1/2x86in)

Literature: Newman John, *The Buildings of England, West Kent and the Weald*, Harmondsworth: Penguin Books, 1969, p399; Gosling Mari, *The Parish Church of St Michael and All Angels*, Marden, 2009

Notes: On 24 November 1958 a Deed was signed by which William Day established a fund for the maintenance and repair of the church, titled the 'William Day Marden Church Maintenance Fund'. The fund was worth £2,935 3s 10p. Whether the money for the windows came out of the Trust Fund is unknown. The incumbent at the time, an uncommunicative man, Revd Cecil George Eagling chose Reyntiens as the designer. On 15 July 1962 an Extraordinary Meeting of the PCC was held so that the vicar could explain the position regarding the East window and obtain permission to go ahead with its installation. The window replaced plain glass and illustrates the vision of St John in the first chapter of the *Book of Revelations*. Christ is seated centre,

his hand raised in blessing, his mouth speaking the Word of Life, whilst his hand holds the Book of Life. One side of his face is in shadow which represents the sin of the world, whilst the other side reflects the Glory of God. He is enclosed by a fine red line of a mandorla, and also a brilliant turquoise aureole. On the left is the Angel with the trumpet from the *Book of Revelation* and on the right is the Archangel Michael (to whom the church is dedicated) with a lance, conquering the dragon. There are flames below Christ's feet, and in the tracery above, a cross left and a dove right. The colours are symbolic, blue representing Heaven, green the World, and the blood red circle symbolises eternity. The window is glorious with its really strong almost violent colours including lots of black and blood red, and quite jagged shapes which Newman considers in the style of Graham Sutherland. Apparently at the time about half the congregation loved the window, but the 'ladies in hats' hated it, and the proportion of love/hate has remained roughly constant!

Title: untitled

Location and Size: north chancel single lancet, approximately 228x53.5cm (89 3/4x21in)

Inscription: signed and dated b.r. 'Reyntiens 62'

Literature: Newman John, *The Buildings of England, West Kent and the Weald*, Harmondsworth: Penguin Books, 1969, p399; Gosling Mari, T*he Parish Church of St Michael and All Angels, Marden*, 2009

Notes: Installation and donor as for east window. The mainly abstract lancet has the same strong colours as the east window, with white sword marks striking out from the centre, possibly symbolising Christ's wounds, and there are ten green eyes. The chancel windows are deeply recessed and can only be seen from the sanctuary.

Title: untitled

Location: south chancel single lancet, approximately 228x53.5cm (89 3/4x21in)

Literature: Newman John, *The Buildings of England, West Kent and the Weald*, Harmondsworth: Penguin Books, 1969, p117, 399; Gosling Mari, *The Parish Church of St Michael and All Angels*, Marden, 2009

Notes: Installation and donor as for east window. The design is pretty much as for north chancel, possibly some drops of Christ's blood on left hand side and again the ten green eyes.

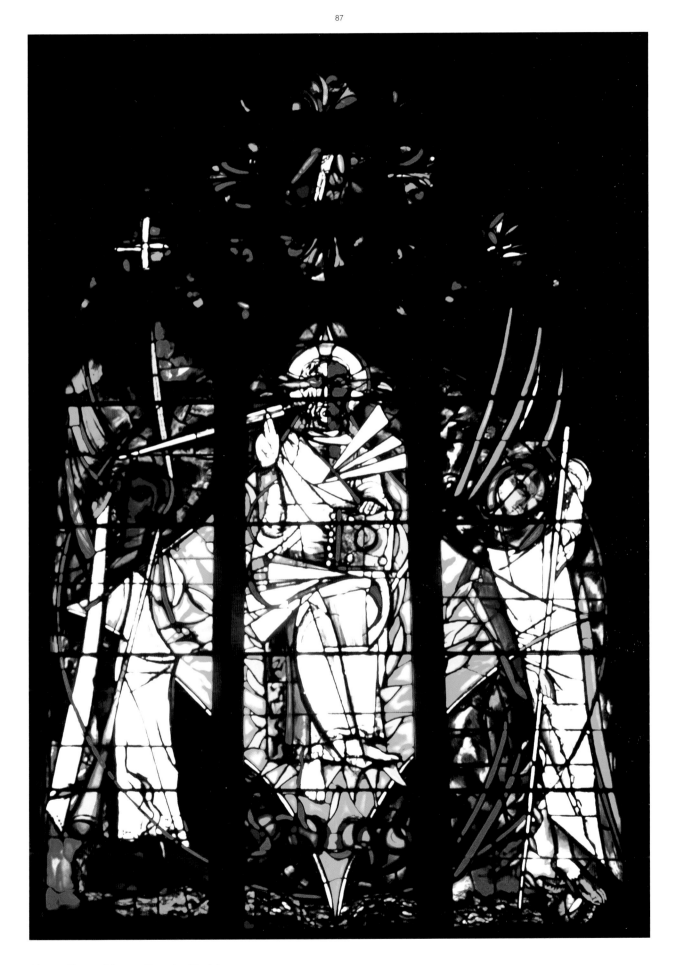

Above: *Christ in Majesty*. Opposite: North lancet

Ramsgate, St Lawrence College Chapel, College Road, CT11 7AE

Listing: Grade II (4 August 1999) #1388303

General: St Lawrence College is an independent, co-educational, day and boarding school for ages 3-18. The chapel and library were designed by Sir Aston Webb as a memorial to old boys who died during World War 1. The library is on the ground floor with the chapel above which gives the building an imposing height from the outside. The building materials are brown brick with stone dressings and a Westmorland slate roof.

Date: 1981

Title: *Let there be Light*,

Location: 5-light south window in French, German and English glass

Designers: John Piper and Patrick Reyntiens

Glass Painter and Maker: Patrick Reyntiens and David Wasley

Commemoration and Donors: The adjacent plaque reads: 'SOUTH WINDOW/Donated by Old Lawrentians, Council, Friends, Staff & Pupils./Designed by John Piper and Patrick Reyntiens./To Commemorate the Headmastership of/Canon R. Perfect, M.A., (1938-69)/and to mark/Centenary Year 1979/Dedicated by the Rt. Rev &/Rt. Hon. The Lord Coggan, P.C., D.D.,/29th June 1981.' The window is also a memorial to Lawrentians who died in both World Wars (another plaque commemorates the 120 old boys and chaplains who died during World War One). Finances were gained by public donations.

Dedication: 29 June 1981 by Lord Coggan, former Archbishop of Canterbury, Visitor to the College and a personal friend of Canon Perfect

Documentation: TGA 200410/1/1/3184 (description of window by Reyntiens dated 27 February 1981)

Literature: *Lawrentian The*, Binfield John H, 'The Memorial Window – An Appreciation', Summer Term 1981, p18-25; *Lawrentian The*, 'College Notes', Summer Term 1981, p6; Binfield John H, *St Lawrence College: The Chapel Windows*, 1984, unpaginated; Osborne, 1997, p121, 177 (titled *The Firmament*)

Reproduced: Osborne, 1997, p121; *Lawrentian The*, Binfield John H, 'The Memorial Window – An Appreciation', Summer Term 1981, cover, p5, 6, 19, 21, 23

Notes: The original window was plain glass and since the chapel faces south (not east) the light was blinding. The College asked for a window on the theme of the risen Christ in Glory, above the cross. Piper designed the central tracery light which was made by David Wasley, one of Reyntiens' assistants. The figure of Christ, inspired by a 12th century carving in the Church of Beaulieu, Charente Inférieure, France, represents Christ as creator, saviour and judge.
The stars in the tracery and the remainder of the window were designed and made by Reyntiens. The window took ten days to install. At first sight Reyntiens' design appears abstract, but as usual with the artist, involves much complex iconography. The perfect form of a circle represents God and since the shape has no beginning or end it also denotes eternity. Three rings symbolise the Trinity of Father, Son and Holy Spirit, and there is also a second trinity of circles from the halo on Piper's figure, Reyntiens' circles and the white circle in the blue rectangle at the base. The circular theme is also echoed in the ceiling ribs of the chapel and the rose window at the north end. The concentric

circles also represent the ancient view of the universe, the earth being the deep blue circle in the centre (French glass), the four stars indicating north, south, east and west and allied to Christ being the 'bright star of dawn'. Surrounding this the dark green sphere of fixed stars (the orb of creation), then the clear ring of the Primum Mobile and beyond that the light green sphere of the Heavens (German glass), sprinkled with yellow angels' wings or Pentecostal tongues of fire. Binfield suggests that the lead 'is not employed to hold oblong pieces of glass in place but is part of a creative activity', citing the fact that the divisions in the glass resemble spokes of a wheel which become more frenetic as one reaches the outer part of the window, reflecting the rotating motion of the universe. The Pentecostal flames are echoed in the clamps at the four compass points which form a Celtic cross. Flames can also be seen in the Pillar of Smoke on the left hand side which led the Israelites by day and the Pillar of Fire on the right which led them by night (*Exodus* 13: 21) – the upward movement on the left and the downward trajectory on the right suggest, to Binfield, 'a circular, two-way communication with God'. The fire imagery was inspired by Gerard Manley Hopkins' poem *That Nature is an Heraclitean Fire and the Comfort of the Resurrection* and T S Eliot's *Four Quartets*, in particular *Little Gidding*. The motifs at the bottom of the window symbolise *Old Testament* sacrifices. The fire on the left hand side symbolises the story of Cain and Abel (*Genesis* 4) whereby God appreciated Abel's sacrifice of one of his finest beasts but was not impressed by Cain's offering. In envy Cain then killed his brother and became an outcast. The flames rise to Heaven. The sacrifice of Abraham (*Genesis* 22) is illustrated in the second light. Abraham was ordered by God to kill his son Isaac and was about to commit the deed when the Lord, delighted with this show of faith, told him to withstand and look around him whereupon Abraham saw a one-eyed ram caught in a thicket, which was sacrificed in Isaac's stead. The curl of the ram's horn can be easily seen as can the one dark green eye (the colour of God's creativity). The central lancet shows a round wafer on a blue tableau above a green hill – the bread and the world are one. Abraham appears again in the fourth light, when he was known as Abram and had rescued his nephew Lot (*Genesis* 14). He met Melchizedek, the Priest-King of Salem or Jerusalem, and willingly gave up a tenth of his war spoils. As a result he was blessed by the King and given bread (the white ovals) and water from the green chalice, representing the Body and Blood of Christ. The right hand light illustrates *I Kings* 18 where Elijah proves that his God is the true God and that Baal does not exist. The followers of the latter could not set their sacrificial bullock alight, but even though Elijah doused his bullock with water, the Lord still answered his prayer and set the beast alight – the flames descend from Heaven. Binfield considers that the four sacrifices 'depict man's religious progress: from giving humble thanks to God, through severe tests of faith, to a recognition of the Priest-King, and to direct communication with God. Their stories are filled with the multitude of human life, from sinner to saint'. The window is joyful, the colours clear but not strident or overwhelming, mainly shades of blue and grey with white and flashes of yellow, and the window can be appreciated on a variety of levels. White opaque English glass was stained to create the yellows in the window.

Title: *President's window, Pentecost*

Date: 1982

Location and Size: rose north window in gallery, 396cm (156in) diameter

Designer, Glass Painter and Maker: Patrick Reyntiens

Commemoration: The plaque over the door leading to the Vestry reads: 'PRESIDENT'S WINDOW/This plaque commemorates the completion of the President's Rose Window – Whitsuntide 1982./Window designed and made by Patrick Reyntiens.'

Literature: *Lawrentian The*, Binfield John H, 'The President's Window', Summer Term 1982, p11-15; Binfield John H, *St Lawrence College: The Chapel Windows*, 1984, unpaginated

Reproduced: *Lawrentian The*, Binfield John H, 'The President's Window', Summer Term 1982, cover, p9, 10, 12, 14; *House and Garden*, Levi Peta, 'Springboard from Piper and Reyntiens: or the brave new world of the stained-glass designers', April 1983, p147

Notes: As noted above, the rose window echoes the circular motion of Reyntiens' design for the south window. Rose windows represent the sun, with the spokes being the sun's rays and the added connotation of wheels of fortune. The circular shape again represents eternity and God. The cloven tongues of Pentecostal flames radiate from the centre of the window, gloriously asymmetrical, suggesting the 'rushing mighty wind' of *Acts* 2: 2. Even the cross is boldly tilted, and the symmetry is broken even more by five white spears of light reminding one of Christ's stigmata, the sharp ends of the spears protected by green leaves representing regeneration. The green is echoed by green apples in the outer edge of each petal, pierced by a red stripe indicating suffering. The background deep blue harks back to the blue earth in the centre of the Memorial window. In his design for the window Reyntiens was inspired by Giotto's representation of St Francis of Assisi. In the Upper Church of San Francesco at Assisi there is a series of 28 frescoes illustrating the life of the saint, originally attributed to Giotto but now disputed. One of these shows the *Stigmatization of St Francis*. In this a six winged seraph floats diagonally top right, like the cross in the rose window, and five shafts of light travel from the stigmata to the saints body, like the white lines in the rose window. A church with a rose window is shown lower right. Giotto's *St Francis of Assisi Receiving the Stigmata* (Louvre, #309) is a very similar composition although the church has a lunette rather than a rose window. St Francis loved Brother Wind and Brother Fire, both of which can be seen in this design, and he heard the tongues of all nations united in the Spirit, represented by the pink cloven tongues.

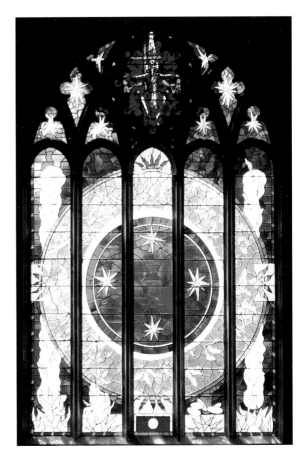

Above: *Let there be Light*

Below: *President's window, Pentecost*

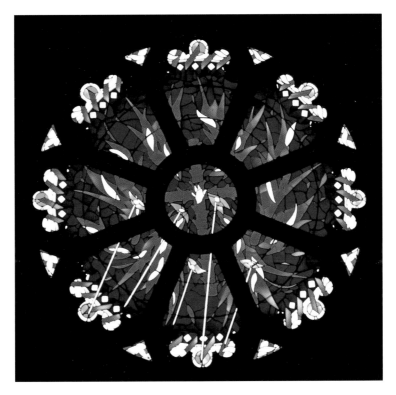

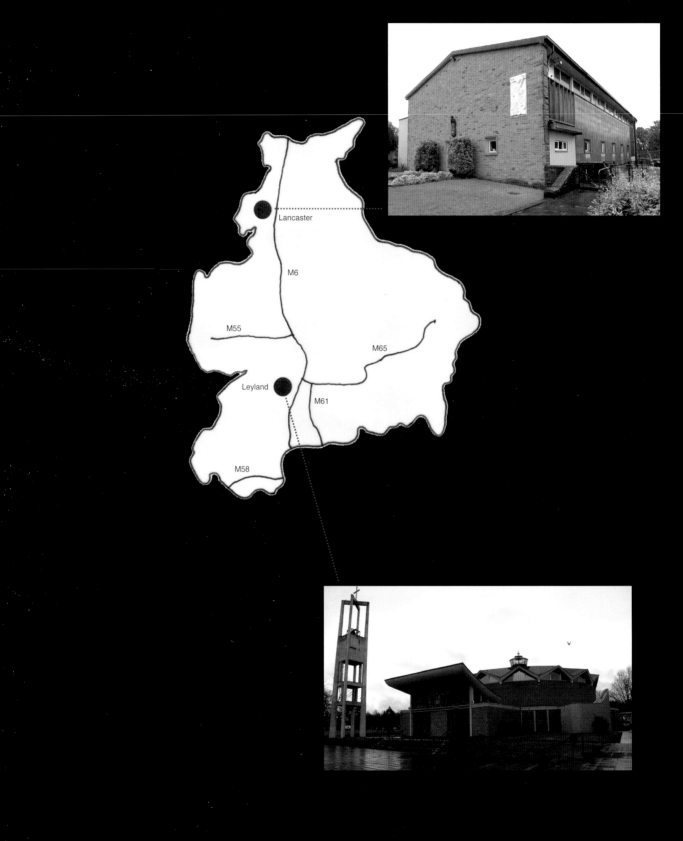

Lancaster, St Bernadette's Church (RC), 120 Bowerham Road, LA1 4HT

General: The church was designed by Mellor, Waterhouse and Brook in 1958, built of stone with a copper roof and based on Roman basilicas. The landmark free-standing tower had to be removed at a later date and the internal layout of the church has changed over the years. On 9 July 1958 Tom Mellor (TGA 200410/2/1/11/26) wrote to Piper asking how soon he could contemplate undertaking £1,000 worth of window and how long it would take. Presumably Piper felt that that it was not possible to make a window for that sum of money and produced a sketchy mural instead on slatted white boards showing Christ in Glory flanked by angels – it hangs behind the altar. The baptistry font is surrounded by a beautiful aquatic looking mosaic by Emma Biggs and Tessa Hunkin of Mosaic Workshop.

Date: 1991

Title: *Christ at Emmaus*

Location and Size: chapel, 67.5x82cm (26 1/2x32 1/4in), plated glass

Inscription: signed b.r.: 'Reyntiens 91'

Designer, Glass Painter and Maker: Patrick Reyntiens

Notes: The window shows Christ centre with a diamond shaped turquoise halo and the disciples either side. Christ's gaze is mesmeric. The background is divided vertically into 5 panels, alternating blue and green, the blue areas marked by white dots and the two green areas having floating bowls with Pentecostal flames. The table in the foreground is a light yellow-green with a golden cup. The window is very powerful, appearing three-dimensional and absolutely glows in the dark with an almost fluorescent light.

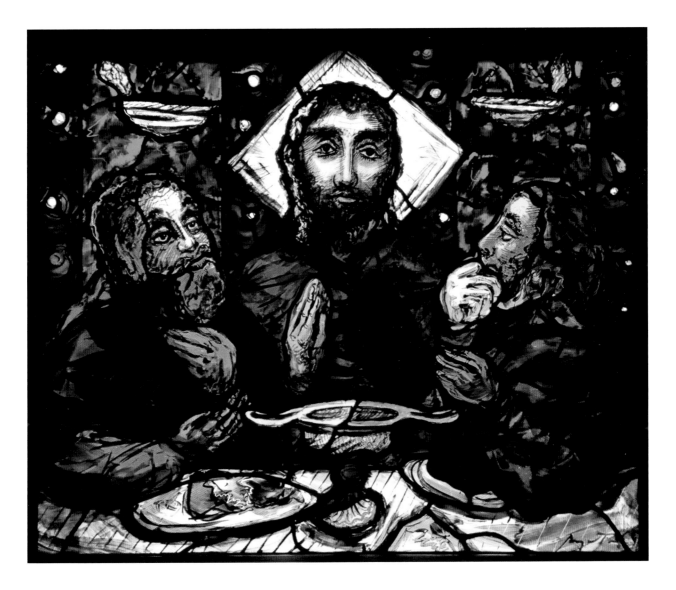

Leyland, St Mary of the Assumption (RC), Broadfield Drive, PR25 1PD

Listing: Grade II (25 September 1998) #1376616

General: The church was founded by Benedictine monks who first came to the area in 1845 from Ampleforth. Abbot Byrne of Ampleforth retired to Leyland in 1963 and lived there as a curate for fifteen years and there is still a very strong link with the Abbey (Abbey Church of St Laurence, Ampleforth, Yorkshire). Church planning began in 1959 and the church was designed 1962-1964 by the Polish architect Jerzy Faczynski (of Weightman and Bullen) (St Ambrose, Speke, Merseyside). It is circular in plan, seats 1,000 people around a central altar, and the materials are pink brick and reinforced concrete with copper covered roofs. The nave's drum rests on fourteen Y shaped concrete piers. Proctor regards the church as a 'thought-provoking treasure-trove of post-war religious architecture, art and design' noting the interesting bronze Stations of the Cross by Arthur Dooley, crucifix and ceramic frieze over the entrance by Adam Kossowski (St Ambrose, Speke, Merseyside), tabernacle by Robin McGhie and tapestry reredos in the Blessed Sacrament Chapel designed by the architect and made by the Edinburgh Tapestry Company.

Date: 1963-1964

Title: *First Day of Creation*

Location and Size: 36 panels of dalle-de-verre curtain walling each 244x152cm (8x5ft). The glass is 6.4cm (2.5in) thick.

Designer: Patrick Reyntiens

Technical Supervisor: David Kirby

Architect in charge: Jerzy Faczynski

Dedication: The church was consecrated and dedicated 4 April 1964 by Archbishop Beck of Liverpool

Literature: CBRN, 'St Mary's Church, Sacristy and Priory, Leyland, Lancs', 1962, p40; *CBRN*, 'St Mary's Priory Church, Sacristy and Priory, Broadfield Drive, Leyland, Lancs', 1963, p38; *Builder The*, 'St Mary's Priory Church, Leyland, Lancashire', 2 May 1964, p1062; *churchbuilding*, Corbould Edward O.S.B., 'St Mary's Priory Church, Leyland', October 1964, no 13, p5, 8 (this article contains a description by Reyntiens of the dalle-de-verre); Little Bryan, *Catholic Churches since 1923*, London: Robert Hale, 1966, p219-221; Harrison Martin, 'Notes', *Glass/Light*, London, 1978, #39; Clarke Brian (Ed), *Architectural Stained Glass*, London: John Murray, 1979, p193; Cowen Painton, *A Guide to Stained Glass in Britain*, London: Michael Jospeh Ltd, 1985, p131; *Twentieth Century Architecture*, Harwood Elaine, 'Liturgy and Architecture: The Development of the Centralised Eucharistic Space', No 3, 1988, p66; *Stained Glass Windows and Master Glass Painters 1930-1972*, Bristol: Morris & Juliet Venables, 2003, p84; Martin Christopher, *A Glimpse of Heaven. Catholic Churches of England and Wales*, Swindon: English Heritage, 2006, p203; Baden Fuller Kate, *Contemporary Stained Glass Artists. A Selection of Artists Worldwide*, London: A&C Black Publishers Ltd, 2006, p49; Procter Robert, http://www.c20society.org.uk/botm/archive/2008/st-marys-leyland-ne; Hartwell Clare, Pevsner Nikolaus, *The Buildings of England, Lancashire: North*, Yale University Press, 2009, p62, 423; *Decorative Arts Society The, Omnium Gatherum*, Horner Libby, 'Patrick Reyntiens' Autonomous Panels. Myth, music and theatre', Journal 35, 2011, p66, 69

Reproduced: *Builder The*, 'St Mary's Priory Church, Leyland, Lancashire', 2 May 1964, p1061, 106; *CBRS*, 1964, p32; *churchbuilding*, Corbould Edward O.S.B., 'St Mary's Priory

Church, Leyland', October 1964, no 13, p3, 5, 6, 7; Little Bryan, *Catholic Churches since 1923*, London: Robert Hale, 1966, fig 40 (a) and (b); *Twentieth Century Architecture*, Harwood Elaine, 'Liturgy and Architecture: The Development of the Centralised Eucharistic Space', No 3, 1988, p76; Martin Christopher, *A Glimpse of Heaven. Catholic Churches of England and Wales*, Swindon: English Heritage, 2006, p203; Baden Fuller Kate, *Contemporary Stained Glass Artists. A Selection of Artists Worldwide*, London: A&C Black Publishers Ltd, 2006, p48; *Decorative Arts Society The, Omnium Gatherum*, Horner Libby, 'Patrick Reyntiens' Autonomous Panels. Myth, music and theatre', Journal 35, 2011, p66

Film: Mapleston Charles, Horner Libby, *From Coventry to Cochem, the Art of Patrick Reyntiens*, Reyntiens/Malachite, 2011

Notes: The glasswork undertaken here was the precursor to the Lantern Tower at Liverpool Metropolitan Cathedral and therefore is of great importance. It was the first time panels of this size had been made in this country and the artist noted that 'the internal coffering was partly utilitarian ... and partly aesthetic'. Reyntiens, who admits to being influenced by Leger and Manessier at Audincourt and other French churches, wanted the windows to be subtle in colouring and not distract the congregation. Every panel is unique. He chose the theme, *First Day of Creation*, and a passage from the Bible 'applied to Our Lady on the Feast of the Immaculate Conception' (*Proverbs* 8). He wanted the design to flow like the world revolving and the greens and blues symbolise water and the womb (Baptism and the Virgin birth). There are also flashes of red and white glass. Harrison considers this one of the most important works in 20th century stained glass whilst Hartwell describes the work as 'very beautiful in colours and shapes'.

Above: Interior of the church
Below and opposite: Details of the panels

LEICESTERSHIRE

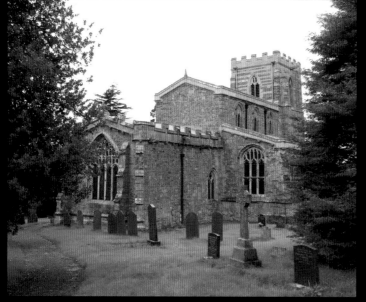

Lowesby, All Saints, Church Hill, LE7 9DD

Listing: Grade II* (29 December 1966) #1295216

General: The church is built of ironstone with limestone dressing, and is partially 13th century with restoration work in 1859. The interior is attractive with double chamfered arches, sculpture, a font possibly dating from the 13th century, a wooden roof dating from 1859 and chancel south and east windows by Ward Hughes dated 1881 and 1897. Sir Keith and Lady Nuttall went to live in Lowesby Hall in 1935. During the 1920s and 1930s Nuttall ran the construction and civil engineering firm Edmund Nuttall Limited (now BAM Nuttall Limited) which was founded by his grandfather James Nuttall in Manchester in 1865. The firm was responsible for such high profile works as the Manchester Ship Canal (1894), the Liver Building in Liverpool (1911) and the Queensway Tunnel under the Mersey (1932). Nuttall served in the Royal Engineers during World War 2, was badly injured during the retreat to Dunkirk in 1940 and died in 1941, his wife Gythar marrying Colonel Edward Kirkpatrick in 1942.

Title: *23rd Psalm*

Date: 1977

Location and Size: 3-light west window in south aisle, approximately 261x155cm (102 3/4x61in)

Inscription: signed and dated in right lancet: 'Reyntiens 77'. On white glass in central light: 'Beside the waters/of comfort/Keith Nuttall Gythar/Kirkpatrick/Edward Kirkpatrick' and family crest and motto 'Aut Num Quam Tentes Aut Perfic'.

Designer, Glass Painter and Maker: Patrick Reyntiens

Commemoration and Donor: The window commemorates Nuttall, Gythar and her second husband Kirkpatrick. The donor was Sir Nicholas Keith Lillington Nuttall of Lowesby Hall, the son of Nuttall and Gythar.

Documentation: correspondence in church archives

Literature: *Leicester Mercury*, 'Memorial window splendid addition to church of All Saints', 30 December 1977; Pevsner Nikolaus, revised by Williamson Elizabeth, *The Buildings of England, Leicestershire and Rutland*, Harmondsworth: Penguin Books, 1984 (1960), p47, 296

Reproduced: *Leicester Mercury*, 'Memorial window splendid addition to church of All Saints', 30 December 1977

Notes: In the introduction to *The Buildings of England* Williamson notes that 'no other churches need singling out, and among furnishings only the stained glass of 1977 by Reyntiens at Lowesby'. At first sight the bold and dramatically coloured window appears to be almost abstract with the uncomfortable addition of an altar and 400 year old chalice and candlesticks at the bottom of the central light which one imagines must have been at the insistence of the donor (this window faces Lowesby Hall and the candlesticks were given by the Nuttall family). However Reyntiens wrote some compendious notes about the religious significance of this window, which indicate the wide and varied influences with which he juggled and the depth of religious symbolism. Since there was already one window in the church which dealt with the *23rd Psalm* in a traditional 19th century manner, Reyntiens sought inspiration in a 15th century French manuscript illumination in which 'themes of immanence and transcendence are intermingled'. His use of colour is symbolic. The dominant orange, the colour of fire, also symbolises 'the inescapable grace of God'; green is the colour of hope, red

a symbol of the Holy Spirit and martyrdom, blue represents Eternity and grey the 'Valley of The Shadow'. The window as a whole represents the three paths to heaven, Tranquillity in the centre, Heroism on the left and Suffering on the right. Reyntiens considers the *23rd Psalm* to be an expression of the providence of God and His omniscience, and has woven the idea of the body and blood of Christ into the altar and accoutrements, the figure of Christ being faintly discernible in the wafer (Cathedral Church of St Marie, Sheffield, Yorkshire). The waters of salvation (also symbolising the village brook) flow round the altar and are subsumed in the fire below the altar and the thin bands round the sides of the window. Above the altar is an enclosed garden, a symbol of the Virgin Mary, with sheep in the fold of the good shepherd/the Saviour who also guards the only entrance and exit to the garden. The three lakes represent the three theological virtues: Faith (with a rock central), Hope (an anchor) and Charity (figure of bounty). The 'circle of encounter with the Saviour' is superimposed on this ellipse, reflecting the shapes of the bread and wine below. The left red path is that of the righteous, a veritable Red Sea which ascends easily from the bucolic English/ Leicestershire landscape (including the hunt, Lady Nuttall being a 'keen rider to hounds') to the stars above. The right hand path however represents the Valley of the Shadow with death and destruction, the glass shapes and jagged leading indicating the inherent violence. In the tracery can be seen the Godhead and Holy Trinity represented by a triangle. The window also makes a passing reference to alchemy in that the garden is shaped like an alchemist's flask and the 'successive colours of the empyrean – each an opening, or act of initiation to a higher realm of consciousness' refer to alchemy. The seven superimposed circles of the central light relate to the Hindu centres of the human body, at the base the Coat of Arms, then navel, heart, throat, mouth, eyes and forehead (seat of wisdom) - somewhat unusual symbolism for a Protestant church. As if all this were not enough Reyntiens also quotes various literary references including Isaiah (empty cisterns on the right), the vision of Ezekiel, T S Eliot's *Four Quartets*, Herbert Crawshaw, Henry Vaughan, Thomas Traherne, Gerard Manley Hopkins' *That Nature is a Heraclitean Fire and of the Comfort of the Resurrection*, the opening of William Langland's *William's Vision of Piers Plowman* (tower of salvation on left and deep fosse on right), and John Bunyan's *Pilgrims Progress*. Reyntiens likes to compare his work to gourmet pastimes and I'm inclined to think that this represents a seven course banquet topped with rather too much double cream.

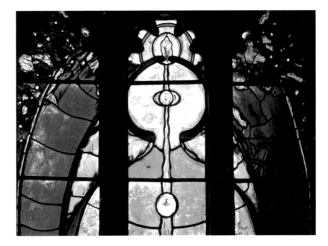

Opposite page: *23rd Psalm* window
Above: Detail of the window

LINCOLNSHIRE

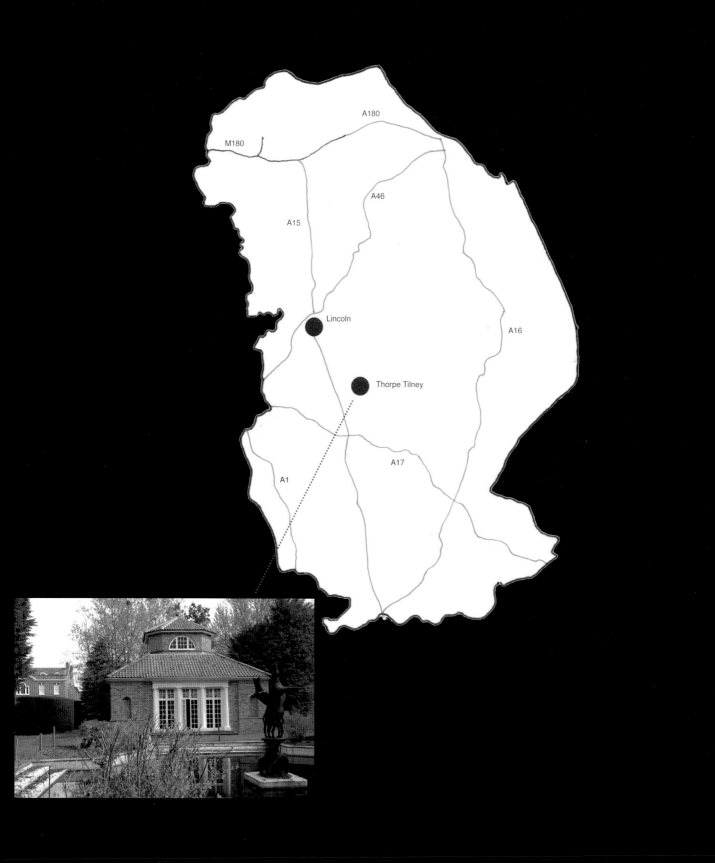

Timberland, Thorpe Tilney Hall, LN4 3SL

Listing: Grade II (23 November 1951) #1205610

General: The Hall is a country house dating from 1740 but much restored and altered in the 1980s. It is built of red brick with ashlar dressings and the roof is slate. The plans for the garden pavilion were first mooted in 1975 and evolved from a changing room for the adjacent swimming pool to a joint changing room and small concert hall for the presentation of operas, the final design being based on the Temple of Castor and Pollux, Rome. Freddie Stockdale formed the Pavilion Opera company, London's premier touring chamber opera, in 1981 and the group has given over 2,000 performances in 24 countries, in addition to its charitable educational trust which takes opera to schools in deprived areas. Reyntiens referred to the pavilion as 'that Bath House'!

Literature: Thorold Henry, *Lincolnshire Houses*, Wilby: Michael Russell (Publishing) Ltd, 1999, p173-175

Title: *Life of St Paul*

Date: 1977-1980 (installed May 1980)

Location and Size: Four semi-circular windows in octagonal turret of garden pavilion, each approximately 100x200cm (39 1/2x78 3/4in). Flashed glass was ordered from Germany.

Designer: John Piper

Glass Painter and Maker: Patrick Reyntiens

Assistant: David Wasley

Architect in charge: Francis Johnson

Cost: £12,000 of which £4,000 design fee for Piper and £8,000 to Reyntiens for glass, making and installing

Documentation: Architect's drawings and notes in pavilion entrance; correspondence in private collection

Literature: *Berks and Bucks Countryside*, Coomer Norman, 'Exciting new future for Beaconsfield school', Vol 20, No 157, September 1980, p18; Harrison, 1982, unpaginated; Cowen Painton, *A Guide to Stained Glass in Britain*, London: Michael Jospeh Ltd, 1985, p134; Pevsner Nikolaus, Harris John, 2nd edition revised by Antram Nicholas, *The Buildings of England, Lincolnshire*, Harmondsworth: Penguin Books, 1990 (1964), p87, 767; Osborne, 1997, pxviii, 117, 119-120, 176; Thorold Henry, *Lincolnshire Houses*, Wilby: Michael Russell (Publishing) Ltd, 1999, p175

Reproduced: *Berks and Bucks Countryside*, Coomer Norman, 'Exciting new future for Beaconsfield school', Vol 20, No 157, September 1980, p18 (Wasley with part of a panel); Osborne, 1997, p118, 119 (*Stoning of St Stephen* and *St Paul shipwrecked on Malta*)

Notes: The lunettes were commissioned by the owner of the house, Freddie M Stockdale, who attended Eton College, Berkshire and sat opposite the parable windows for three years. During a meeting with Revd Henry Croyland Thorold, the squarson of Marston, Stockdale noted that he would have dearly loved to commission Piper to design windows based on the life of St Paul for his pavilion, and was delighted when Thorold announced that Piper was still very much alive and visiting him the following week (Thorold was also a product of Eton; Christ Church, Oxford and Cuddesdon College, Oxfordshire and was acquainted with Piper because of his topographical and architectural interests – he wrote the *Shell Guide to Lincolnshire*). Stockdale gained his introduction to the artist who accepted the commission in January 1977, describing it as a 'delightful proposal' and noting that 'your clear, wide-horizoned Fen light makes the whole idea doubly exciting'. Piper finally produced some rough sketches in June 1978 but admitted he was unhappy with the colour and wondered whether to base each window on a single colour depending on the aspect. In January 1979 he was thinking about starting the full size cartoons and was still busy with them in June of that year when he thanked Stockdale for the idea of a pedimented building in the background of the *Execution* panel – making a pleasant contrast to the semi-circular window.

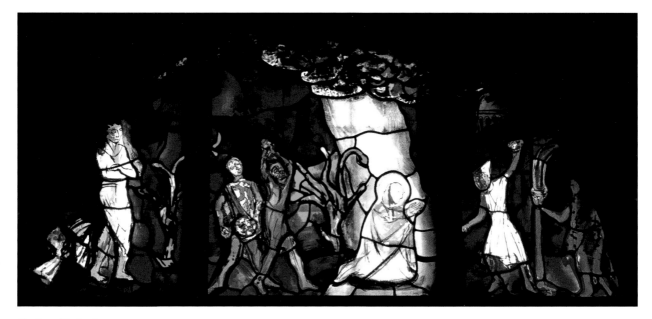

Stoning of St Stephen

This was one of the first jobs undertaken at Reyntiens' Old School Church studio. The lunettes illustrate four Biblical themes from the *Life of St Paul*: *Stoning of St Stephen* (*Acts* 7: 57-58), *Conversion of St Paul* (*Acts* 9: 3-6), *St Paul shipwrecked on Malta* (*Acts* 28: 1-6) and the *Execution of St Paul*. There is something very theatrical about the figures and settings, in keeping with the operatic use of the building. In the *Stoning of St Stephen* the yellow clad figure of the saint kneels in the centre of the panel, a white shower of light descending upon him from a turbulent sky, whilst the stone throwing men are demonic in red and white (one looking like a member of the Ku Klux Klan) – Paul (Saul) stands to one side, a ghostly figure. The *Conversion of St Paul* shows Paul and his Damascene experience – he lies on the ground, a black horse rearing up behind him and blinding rays of light from heaven when Jesus questioned 'Saul, Saul, why persecutest thou me?' The third panel, *St Paul shipwrecked on Malta* illustrates the scene when Paul lit a fire and was bitten by a poisonous snake but did not suffer. Paul and the fire are central, with some willowy figures to the right, the dark shape of a boat in the background and a lurid green sky above, the sun/moon obscured by a yellow cloud. The fourth lunette, *Execution of St Paul*, is strikingly dramatic with Paul's head centre on a yellow ground, the three fountains of 'Tre Fontane Abbey' in Rome springing up left, right and centre (probably symbolizing Faith, Hope and Charity), a blue coloured temple behind and the hand of God pointing downwards.

Above: Interior of pavilion looking up to balcony

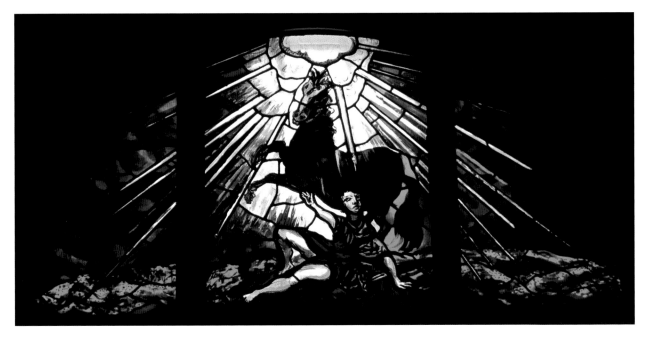

Conversion of St Paul

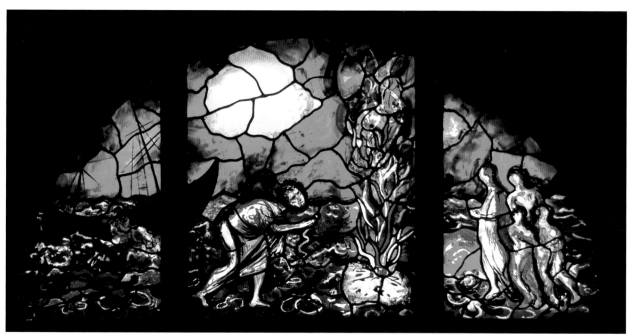

Above: *St Paul Shipwrecked on Malta*

Below: *Execution of St Paul*

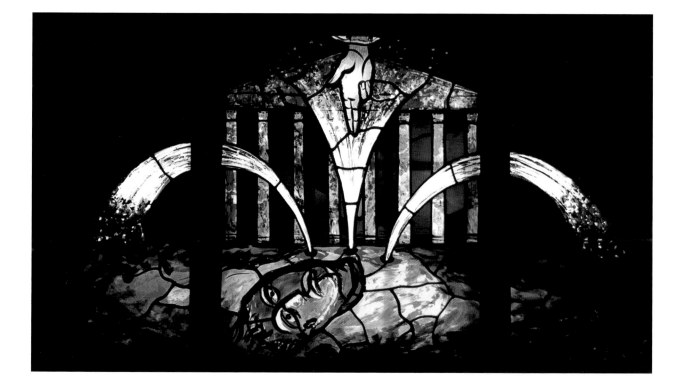

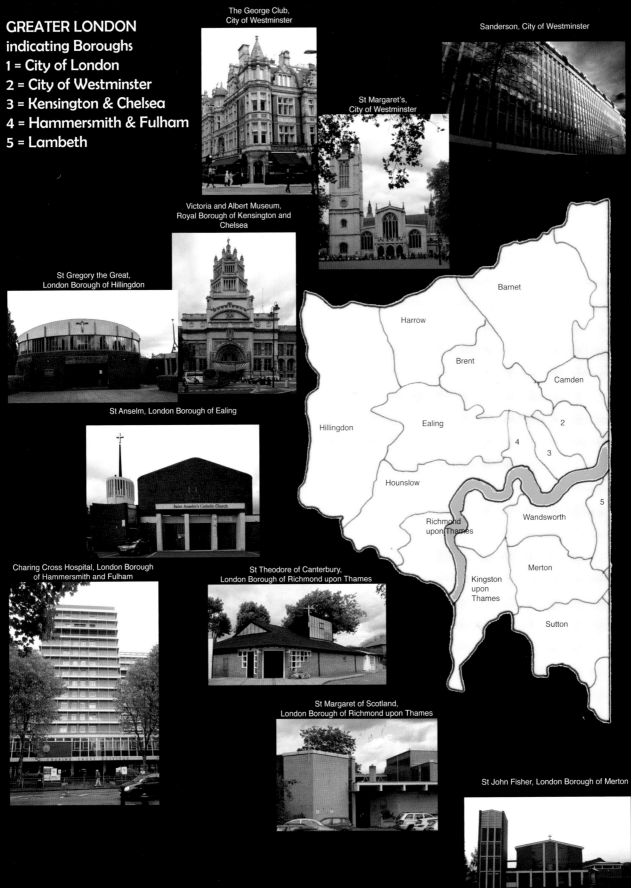

GREATER LONDON
indicating Boroughs
1 = City of London
2 = City of Westminster
3 = Kensington & Chelsea
4 = Hammersmith & Fulham
5 = Lambeth

The George Club,
City of Westminster

Sanderson, City of Westminster

St Margaret's,
City of Westminster

Victoria and Albert Museum,
Royal Borough of Kensington and
Chelsea

St Gregory the Great,
London Borough of Hillingdon

St Anselm, London Borough of Ealing

Charing Cross Hospital, London Borough
of Hammersmith and Fulham

St Theodore of Canterbury,
London Borough of Richmond upon Thames

St Margaret of Scotland,
London Borough of Richmond upon Thames

St John Fisher, London Borough of Merton

Barnet

Harrow

Brent

Camden

Hillingdon

Ealing

2

4

3

Hounslow

5

Richmond
upon Thames

Wandsworth

Kingston
upon
Thames

Merton

Sutton

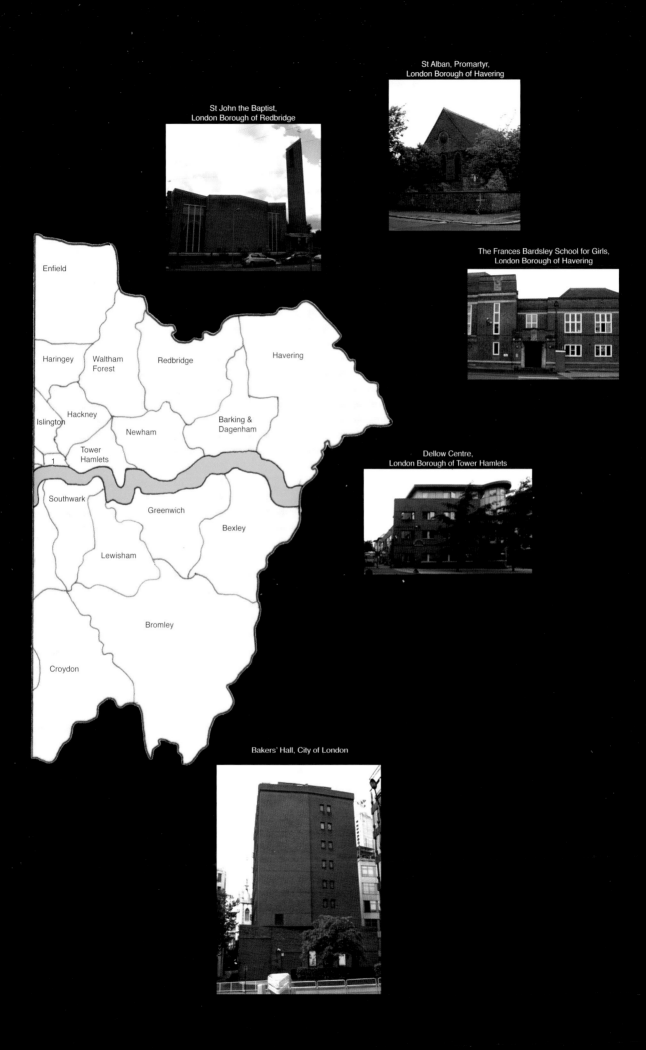

St Alban, Promartyr,
London Borough of Havering

St John the Baptist,
London Borough of Redbridge

The Frances Bardsley School for Girls,
London Borough of Havering

Enfield

Haringey

Waltham
Forest

Redbridge

Havering

Hackney

Islington

Newham

Barking &
Dagenham

Tower
Hamlets

1

Southwark

Greenwich

Bexley

Lewisham

Bromley

Croydon

Dellow Centre,
London Borough of Tower Hamlets

Bakers' Hall, City of London

CITY OF LONDON
Bakers' Hall, 9 Harp Lane, EC3R 6DP

General: Bread has always been a staple of diets and bread in the olden sense meant necessities in general. In Egypt the word for bread is the same as the word for life and a companion is someone with whom one shares bread (from the Latin *panis*). The Worshipful Company of Bakers is the second oldest guild in London and is known to have existed in 1155 AD although it was probably formed prior to this date. The Company has been situated on Harp Lane since 1506. The third hall was bombed on 29 December 1940 and again in June 1942. Construction on the fourth hall began in October 1960 and the building was opened in October 1963. There is an unusual fragment of pre-reformation stained glass in the vestibule which shows the company's shield including the triple crown of Pope Clement. The Saint's iconography of two anchors is still included in the armorial bearings (he was martyred by being thrown into the sea with an anchor round his neck) together with sheaves of corn, scales and two bucks representing buckwheat. Piper toyed with these symbols when producing his design ideas.

Title: *Great Fire of London, 1666*, *Fire in Thames Street, 1715*, *First Night of the Blitz, 1940*

The following details are applicable to all three windows:
Date: 1967-1969 (installed mid June 1969)

Location and Size: Three rectangular windows on east wall of the Livery Hall, each 229x100cm (90x39in) - the windows are recessed 15cm (6in) within the frame.

Designer: John Piper

Glass Painter and Maker: Patrick Reyntiens

Architect in charge: Trehearne & Norman, Preston & Partners

Documentation: TGA200410/2/1/12/160, 168, 172, 177, 185, 189, 190, 192-193, 195-196, 200, 202-203, 205, 210, 213, 214, 232

Literature: Harrison, 1982; *House and Garden*, Levi Peta, 'Springboard from Piper and Reyntiens: or the brave new world of the stained-glass designers', April 1983, p147; Bradley Simon and Pevsner Nikolaus, *The Buildings of England, London 1: The City of London*, London: Penguin Books, 1997, p146, 379; Osborne, 1997, p97, 100, 175; *Stained Glass Windows and Master Glass Painters 1930-1972*, Bristol: Morris & Juliet Venables, 2003, p85; Spalding, 2009, p365; Bakers' Hall flier, undated

Reproduced: Osborne, 1997, p99 (*First Night of the Blitz, 1940*); Bakers' Hall flier, undated

Notes: A former Master of the company, John M Roberts, first wrote to Piper in 1967 concerning the possibility of designing some stained glass windows for the hall. Roberts suggested a topic of 'the progression of corn to bread at the hands of the Bakers' Company' including perhaps corn sheafs, hands on dough, loaf-shapes and scales and the fact that the building was destroyed by fire three times during its history. Piper duly submitted sketch designs but in February 1968, Roberts noted that Mr Collinson, the Clerk, confessed 'to some disappointment and had hoped for something more original and exciting'. The following month the Committee informed Piper that they didn't like the coats of arms or the scales, but they did like the ears of corn and the green colouring of an anchor and they most certainly approved of the flames. By April Piper had altered the designs so that ears of corn were suggested within the flames and sparks had been added which would delight the Underwarden, Mr Savage, whose idea it had been. When the windows were in place Roberts wrote in gratitude to Piper, noting that the Beadle had become something of an historian and in showing visitors the windows 'has already decided which window represents which fire, even to the point of internal evidence as to the direction in which the wind was blowing at the time'! From left to right the windows represent the *Great Fire of London, 1666* which started in Thomas Farriner's bakery shop in nearby Pudding Lane on 2 September and raged for three days; *Fire in Thames Street, 1715* and *First Night of the Blitz, 1940*. The windows have red, yellow and gold flames on a blue background with rings and crescents, perhaps representing sparks of fire or patisserie and look absolutely stunning when the blinds are pulled down behind and the lights turned off - they glow and dance like the fires they represent.

CITY OF WESTMINSTER
Mayfair, May Fair Theatre, May Fair Hotel, Stratton Street, W1J 8LT

Title: *Dorephos sixty-four*

Date: 1970-1971

Designer: John Piper

Glass Painter and Maker: Patrick Reyntiens

Literature: Harrison, 1982; Osborne, 1997, p175, 184

Notes: Apparently this revolving light in the theatre foyer was an abstract geometrical design but unfortunately the installation is not extant.

CITY OF WESTMINSTER
Mayfair, The George Club, 87-88 Mount Street, W1K 2SR

Title: *Bacchanalian Feast*

Date: 2001

Location: internal backlit picture window

Designer and Glass Painter: Patrick Reyntiens

Glass Maker: John Reyntiens

Note: The George Club was founded by Mark Birley who commissioned the panel which illustrates an idyllic Glyndebourne style picnic on a green mound surrounded by sea and with a distant landscape.

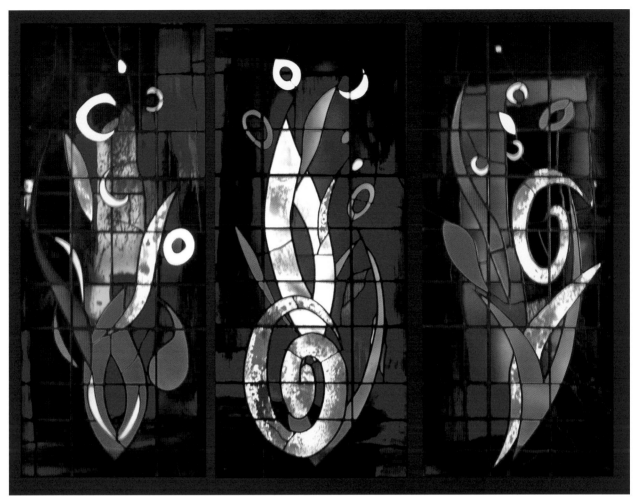

Above: Bakers' Hall windows, left to right - *Great Fire of London, 1666*; *Fire in Thames Street, 1715*; *First Night of the Blitz, 1940*
Below: *Bacchanalian Feast*. Photograph courtesy Reyntiens family

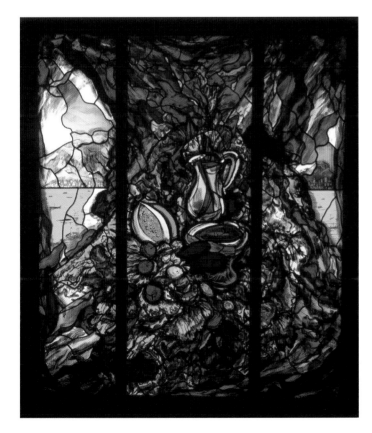

CITY OF WESTMINSTER
St Margaret's, SW1P 3PA

Listing: Grade I (24 February 1958) #1226286

General: St Margaret's, dedicated to St Margaret of Antioch, is known as the parish church of the House of Commons. It was founded by Benedictine monks in the 11th century but has been extensively rebuilt and restored over the centuries and in the 18th century was encased in Portland stone. The interior was overhauled by Sir Gilbert Scott in 1877. Much of the Victorian glass was lost as a result of bomb damage in World War 2 and was temporarily replaced with white obscured bathroom glass. The church boasts a good selection of monuments and glass – the east window has Gothic-Renaissance transitional Flemish stained glass commemorating the marriage of Henry VIII to Catherine of Aragon, west windows by Clayton and Bell 1882 and 1888, south aisle west window by Henry Holliday 1882, and two north windows by Edward Frampton 1888 and 1891. In 1972 St Margaret's ceased to be a parish church and was placed under the care of the Dean and Chapter of Westminster.

Title: *Spring in London*

Date: 1963-1967

Location and Size: five triple lancet (#s705-709) and 3 triple lancet half windows (#s 702-704) in south aisle of nave, the full length windows being approximately 535x244 cm (210 1/2x96in). I have followed the NADFAS numbering allocation, #702 being the most easterly. The glass was ordered from England, France and Germany.

Designer: John Piper

Glass Painter and Maker: Patrick Reyntiens

Assistant: Derek White

Cost: about £13,000 which included Piper's fee of £1,500

Commemoration and Donors: The contemporary slate plaques below the windows read as follows: window 704 'This window was given in memory of/CANON WILLIAM HARTLEY CARNEGIE/ Rector of this Church 1913-36 & of MARY ENDICOTT his wife,/by his five daughters, Frances, Mary, Kathleen, Jocosa & Rachel, January 1967'; window 705 'This window was given in happy memory of/PETER KEMP-WELCH/1907-1964/by his family'; window 706 'THE WINDOWS IN THIS SOUTH WALL/designed by John Piper and executed by Patrick Reyntiens/were dedicated by the Bishop of London on the 15th January 1967/ to replace those destroyed by enemy action between 1940 and 1942; window 707 'This window was given in memory of/CLARENCE GEORGE EUGENE FLETCHER/for many years a member of the congregation and/a teacher in the Sunday School of St Margaret's'; window 708 'This window was given in memory of/ RICHARD RYLANDES COSTAIN Kt. CBE/1902-1966. Fellow of the Institute of Building'. The windows were erected with money from the War Damage Commission (£3,740 9s 5d) and donations from various families.

Faculty: 28 April 1966 (work to be completed within 12 months of faculty date)

Dedication: Sunday 15th January 1967 by the Bishop of London, Robert Stopford - previously Bishop of Peterborough (Bishop's Lodging, Peterborough, Cambridgeshire) and Bishop of Fulham (Oundle School, Oundle, Northamptonshire)

Documentation: St Margaret's Church, Westminster, Parochial Church Council Minute Book; St Margaret's Westminster Vestry Minute Book; TGA200410/2/1/11/95, 97, 112, 113, 114, 115, 119, 123, 126, 128, TGA200410/2/1/12/107, 154, 175, 201, 211, TGA200410/2/1/13/1, 2, 3, 4, 10, 11, 12, 19, 20, 24, 30, 31, 35, 38, 41, 45, 63, 67, 70, 71

Literature: Harrison, 1982; Cowen Painton, *A Guide to Stained Glass in Britain*, London: Michael Joseph Ltd, 1985, p144; NADFAS, *Nadfas Church Record, St Margaret's Westminster Abbey*, 1993, window numbers 702-709; Moor Andrew, *Architectural Glass Art. Form and technique in contemporary glass*, London: Mitchell Beazley, 1997, p114-115; Osborne, 1997, p94, 95, 174; Bradley Simon and Pevsner Nikolaus, *The Buildings of England, London 6: Westminster*, London: Yale University Press, 2003, p92, 209; *Stained Glass Windows and Master Glass Painters 1930-1972*, Bristol: Morris & Juliet Venables, 2003, p85; Neiswander Judith & Swash Caroline, *Stained & Art Glass*, London: The Intelligent Layman Publishers Ltd, 2005, p258; *St Margaret's Church A Souvenir Guide*, Dean and Chapter of Westminster, 2006, p14; Spalding, 2009, p419-420

Reproduced: NADFAS, *Nadfas Church Record, St Margaret's Westminster Abbey*, 1993, window numbers 702-709; Moor Andrew, *Architectural Glass Art. Form and technique in contemporary glass*, London: Mitchell Beazley, 1997, p114; Osborne, 1997, p93; *BSMGP*, Caroline Swash, 'On Contemporary Glass', Vol XXIII, 1999, p67; Neiswander Judith & Swash Caroline, *Stained & Art Glass*, London: The Intelligent Layman Publishers Ltd, 2005, p258, 259; *St Margaret's Church A Souvenir Guide*, Dean and Chapter of Westminster, 2006, p14,15; Spalding, 2009, plate 67, *It's time to help, St Margaret's Church Appeal*, 2009; postcard

Notes: At the Parochial Council Meeting on 8 July 1963 the Rector, Canon Michael S Stancliffe, noted that the War Damage Commission would give £3,740 9s 5d to replace stained glass damaged during the war. The Council decided to commission one modern window to replace the clear glass in the south aisle and it was agreed that Piper should be approached. Wasting no time Stancliffe wrote to Piper on the 10th July explaining the position. By 3 December Stancliffe had met Piper twice and the artist was of the opinion that the five full length windows should be replaced with pale coloured glass which would allow in a maximum of light from outside. He also admired the east window and did not want to create a clash, and the colours of 'green, grey-green, pale yellow and near-white' were chosen in consultation with Reyntiens (Osborne p96). On 13 May 1964 Stancliffe announced that it was an 'all or nothing' situation and that Piper would design glass for the five windows at a cost of about £7,000. By 22 July

the Rector was able to show the Council Piper's sketches which were approved subject to some reservations about the colours being too vivid. On 29 September Piper himself addressed the Council, overcame their fears and suggested replastering the south aisle wall, after which the committee resolved to go ahead with glazing all eight windows in the south aisle. By 28 June 1965 Piper's sketches had been approved by the Diocesan Advisory Committee and Piper was proceeding with detailed drawings. The estimate of cost had risen to £13,000 by July 1966. Stancliffe wrote to Piper in September 1966 to announce that the first window (one of the smaller ones) had been installed but was rather troubled by the amount of grey and hoped this would be less prominent in future windows. The design of all the windows is similar, delicately and subtly coloured abstract forms in pale blue, green, orange, yellow, grey and white and continues into the tracery, the outer edges having dotted borders. The design and colouring is similar to that used in Malsis School, Keighley, Yorkshire. The windows form a unified whole but do not dominate the architectural background, and were probably inspired by French 15th century churches which have 'an atmosphere of serenity, a French light, analogous to that of the Loire, the banks of the Seine and the Ile de France' (quote from Maurice Denis in Spalding p419). Reyntiens considers this the finest work he and Piper achieved because the tonality and cubist abstraction was just right for the setting, not competing in any way with the very baroque heraldry and memorials. Moor describes the windows as 'shocking in their unflinching modernity'. One summer tourist in 1967 observed that 'I suppose that glass is the oldest in the church' which exemplifies how well it fits in.

Opposite: Detail of one of the windows

Below: The south aisle showing the five triple lancet windows

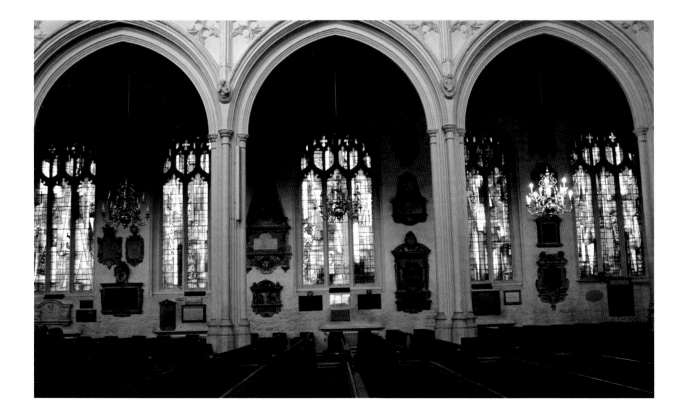

CITY OF WESTMINSTER
Sanderson, Morgans Hotel Group, 52 Berners Street, W1T 3NG

Listing: Grade II* (23 January 1991) #1248457

General: The new headquarters and showroom of Arthur Sanderson and Son were built 1957-1960 to celebrate their centenary and were designed by Reginald Uren of Slater, Moberly and Uren. The building has a reinforced concrete frame clad with Portland stone, aluminium and curtain glass walling, fairly typical of the era. It is currently a boutique hotel belonging to the Morgans Group and with bizarre interiors by Philippe Stark, and unfortunately the Piper/Reyntiens window (which is opposite the entrance) is hidden behind a curtain.

Title: *Abstract Composition of Biomorphic Forms*

Date: 1959-1960

Location and Size: main staircase hall, 640x975cm (252x383.9in)

Designer: John Piper

Glass Painter and Maker: Patrick Reyntiens

Technical Supervisor: Derek White

Assistant: David Kirby

Architect in charge: Reginald Uren

Study: collage of coloured paper, 57x77cm (property of John Reyntiens)

Literature: *Modern Stained Glass*, Arts Council, 1960-1961, unpaginated; Harrison, 1982; *House and Garden*, Levi Peta, 'Springboard from Piper and Reyntiens: or the brave new world of the stained-glass designers', April 1983, p147; *Working With Light. A look at contemporary STAINED GLASS in architecture*, Andrew Moor Associates and Derix Glass Studios, April 1987, unpaginated; Cherry Bridget and Pevsner Nikolaus, *The Buildings of England, London 3: North West*, Yale University Press 2002 (1991), p88, 634; Osborne, 1997, p64-66, 172; *Stained Glass Windows and Master Glass Painters 1930-1972*, Bristol: Morris & Juliet Venables, 2003, p85; Harwood Elaine, *England. A Guide to Post-War Listed Buildings*, London: B T Batsford, 2003 (2000), p608; Neiswander Judith & Swash Caroline, *Stained & Art Glass*, London: The Intelligent Layman Publishers Ltd, 2005, p258; Spalding, 2009, p365-366; *Decorative Arts Society The, Omnium Gatherum*, Horner Libby, 'Patrick Reyntiens' Autonomous Panels. Myth, music and theatre', Journal 35, 2011, p65

Reproduced: Reyntiens Patrick, *The Technique of Stained Glass*, London: B T Batsford Ltd, 1967, p79; Compton Ann (Ed), *John Piper painting in coloured light*, Kettle's Yard Gallery, 3 December 1982 – 9 January 1983, unpaginated (Piper with cartoon); *BSMGP*, Spring 1986, cover; *Working With Light. A look at contemporary STAINED GLASS in architecture*, Andrew Moor Associates and Derix Glass Studios, April 1987, unpaginated; Osborne, 1997, p65

Film: Mapleston Charles, Horner Libby, *From Coventry to Cochem, the Art of Patrick Reyntiens*, Reyntiens/Malachite, 2011

Notes: According to Osborne, Ivan Sanderson of Arthur Sanderson & Sons, initially asked Epstein for a sculpture but he declined on grounds of age, so Sanderson turned to Piper for some iconic art work. Osborne also states that the plan for

the showrooms was not finalised and that the area opposite the main entrance was redesigned to accommodate a wall of stained glass. According to Michael Parry, archivist at Sanderson, Ivan Sanderson directly commissioned Piper subsequent to 'Painting into Textiles', an *Ambassador* exhibition held in late 1953. The showroom was opened in February 1960 and the window design featured on the cover of *The Ambassador*. This was Piper's first secular stained glass work. The design has been described as a row of semi-abstract plants, although Reyntiens compares it to a firework display which is probably fairly apt since Piper was very keen on fireworks and it has an energy and flamboyance reminiscent of pyrotechnical displays. The panel is artificially lit from behind, and is divided diagonally in a visual sense by a delicate staircase. The panel was technically quite difficult to make. Reyntiens had to black out his studio, paint the back of the work with a colour identified by the interior designers and buy specific lighting so that he could replicate the conditions of the window in situ. The pieces of glass are very large and great care had to be taking in firing and cooling. Techniques involved badgered paint, dripped paint, coarse brushes, and using rubber latex to lift the ground.

Spalding considers the window 'of questionable success', citing the artificial lighting and staircase which were out of the control of the artists, but also considering 'the end result hard and unsatisfying, the colours poorly coordinated and the whole curiously empty of feeling'. Seeing the window puts Reyntiens in the mood for a double gin and tonic!

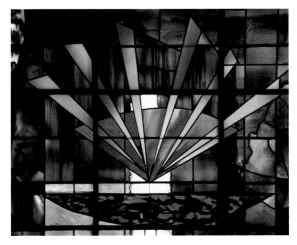

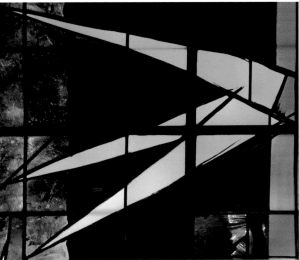

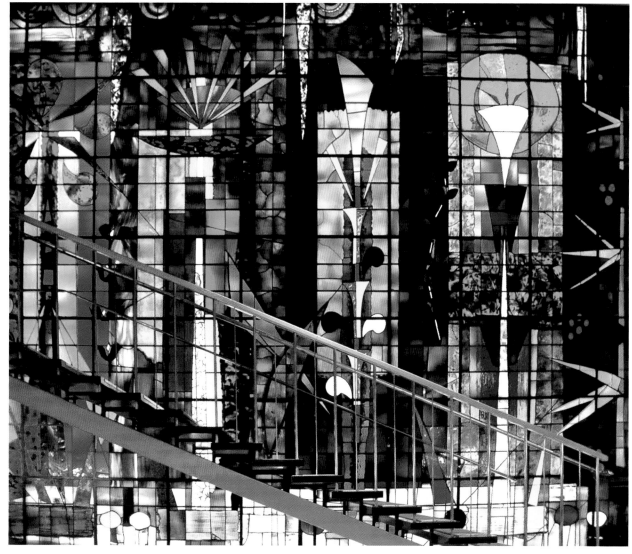

Above: Abstract Composition of Biomorphic Forms
Below: John Piper's study from which Reyntiens worked, emphasising his tremendous input into the finalisation of the design process.
Photograph courtesy of John Reyntiens
Opposite: Details of the window

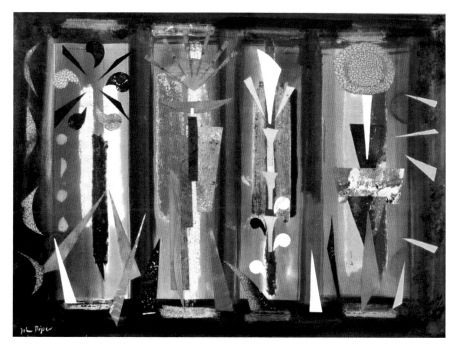

LONDON BOROUGH OF EALING
Southall, St Anselm (RC), The Green, UB2 4BE

General: The first St Anselm's church was formed in 1906 and occupied a tithe barn from the Tudor Manor House. The second church incorporated St Anselm's school, the third church was built as the school increased in size and the present church, buiult 1965-1966, is the fourth reincarnation, not on the same site but still on The Green. The church is slightly fan shaped and was designed to seat 600-700 people with further space in the gallery. There is a glorious profusion of modern stained glass, in the Blessed Sacrament chapel, the Lady chapel and the Baptistry – none of which are by Reyntiens, although various sources indicate that the Baptistry is by Reyntiens together with an east window (there is no east window).

Literature: *CBRS*, 'New Presbytery, Church and Parish Rooms, Southall, Middlesex', 1964, p36

Title: unnamed

Date: c1971

Location and Size: ten small lights in west of church above gallery, the smaller ones measuring approximately 105x25cm (41 1/4x9 3/4in), opaque and painted glass

Designer, Glass Painter and Maker: Patrick Reyntiens

Architect: Burles Newton & Partners

Literature: *CBRS*, 'New Presbytery, Church and Parish Rooms, Southall, Middlesex', 1964, p36; Clarke Brian (Ed), *Architectural Stained Glass*, London: John Murray, 1979, p193; Cherry Bridget and Pevsner Nikolaus, *The Buildings of England, London 3: North West*, London: Penguin Books, 1991, p192; *Stained Glass Windows and Master Glass Painters 1930-1972*, Bristol: Morris & Juliet Venables, 2003, p85

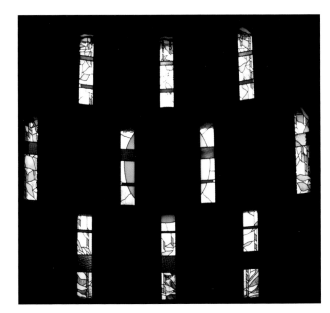

Notes: The lights are in three tiers with 3 lights at the top, then four and three. Reyntiens has treated them as a whole, with a large opaque blue-white sun/moon in the centre and abstracted leaf and twig forms in the outlying lights, all in yellow, green and white, with purple horizontal bands, a simple but effective design. The initial design shown on p39 of the *CBRS* does not indicate windows in the west elevation.

LONDON BOROUGH OF HAMMERSMITH AND FULHAM
Charing Cross Hospital Chapel, Fulham Palace Road, W6 8RF

General: Charing Cross Hospital is part of Imperial College Healthcare NHS Trust. The hospital includes a day-surgery unit and the West London Neuroscience Centre. Maggie's Cancer Centre, the first of its kind in England, opened in 2008. The chapel is on the ground floor in the south wing. The works belong to Imperial College Healthcare Charity Art Collection.

Literature: Harrison, 1982; Cowen Painton, *A Guide to Stained Glass in Britain*, London: Michael Joseph Ltd, 1985, p146; Cherry Bridget and Pevsner Nikolaus, *The Buildings of England, London 3: North West*, London: Penguin Books, 1991, p241; Baden Fuller Kate, *Contemporary Stained Glass Artists. A Selection of Artists Worldwide*, London: A&C Black Publishers Ltd, 2006, p6; Spalding, 2009, p418

The following details are applicable to both backlit windows:
Designer: John Piper

Glass Painter and Maker: Patrick Reyntiens

Architect in charge: Ralph Tubbs

Title: *River of Life*

Date: 1977-1978

Location and Size: right hand side of entrance, single light, approximately 260x124cm (102 1/4x48 3/4in)

Cost: £2,000 (of which £500 paid to Piper for the design)

Donors: The plaque below the window reads: 'THE RIVER OF LIFE/DESIGNED BY JOHN PIPER/MADE BY PATRICK REYNTIENS/DONATED BY THE LEAGUE OF FRIENDS OF CHARING CROSS HOSPITAL/1978'

Documentation: Stockdale correspondence (Piper mentions that Reyntiens is finishing the window January 1978)

Literature: Osborne, 1997, p112, 176

Reproduced: Osborne, 1997, p114

Notes: The *River of Life* shows a red pot from which blue and red streams flow and fish swim. The border is pale turquoise with yellow dots. Children delight in looking for all the hidden fish in the window. The River of Life and Tree of Life appear in consecutive verses in *Revelations* 22:1-2.

Title: *Tree of Life*

Date: 1981

Location and Size: left hand side of entrance, single light, approximately 260x124cm (102 1/4x48 3/4in

Cost: In April 1981 Piper requested Reyntiens' backing to raise the cost of the second window from £2,000, which would only leave him with a design fee of £500 for which he felt unable to work.

Donors: The plaque below the window reads: 'THE TREE OF LIFE/DESIGNED BY JOHN PIPER/MADE BY PATRICK REYNTIENS/DONATED BY THE LEAGUE OF FRIENDS OF CHARING CROSS HOSPITAL/1981'

Documentation: TGA 200410/1/2

Literature: Cherry Bridget and Pevsner Nikolaus, *The Buildings of England, London 3: North West*, London: Penguin Books, 1991, p241; Osborne, 1997, p112, 176

Reproduced: Osborne, 1997, p114

Notes: The *Tree of Life* has a red trunk with branches bearing a profusion of colourful fruit including pears, figs, mottled apples, round red apples, grapes and plums together with various birds including a lovely pink specimen. The border is red with blue dots. Piper obviously used a fair amount of marbled paper which Reyntiens had to reproduce in glass. Cherry considers the *Tree of Life* 'especially delightful in its flowing forms and naïve Chagall-like detail'. It is a joyous window.

Above Right: *River of Life*

Below Right: *Tree of Life*

Below: Detail of *Tree of Life*

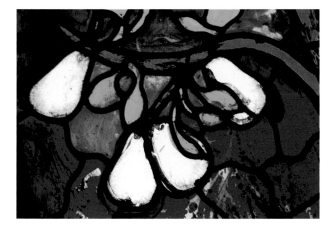

LONDON BOROUGH OF HAMMERSMITH AND FULHAM
London Oratory School Chapel (RC), Seagrove Road, SW6 1RX

General: The School is a Catholic, voluntary aided secondary school. Harrison considered the windows amongst the most important in the 20th century.

The following details are applicable to all windows:
Date: 1968-1970

Designer, Glass Painter and Maker: Patrick Reyntiens

Architect in charge: David Stokes and Partners

Literature: Harrison Martin, *Glass/Light*, 'Notes', London, 1978; Clarke Brian (Ed), *Architectural Stained Glass*, London: John Murray, 1979, p193; *Leadline 1990, Patrick Reyntiens & the Burleighfield Experience*, Goodden Ted (Ed), Prest Cedar, 'Burleighfield', 1990, p19; Cherry Bridget and Pevsner Nikolaus, *The Buildings of England, London 3: North West*, London: Penguin Books, 1991, p239; *Stained Glass Windows and Master Glass Painters 1930-1972*, Bristol: Morris & Juliet Venables, 2003, p85

Title: *two sanctuary windows*

Reproduced: Clarke Brian (Ed), *Architectural Stained Glass*, London: John Murray, 1979, p196, 197

Notes: Apparently these windows were so recessed that they were barely visible. The windows were almost identical, with what looked like a large opaque beaker filled with cloud shapes in pink, gold and green. At the top of each window was an almost rectangular shape with grey horizontal bars encircling a blue pool (reversed in the second window). At the beginning of the 1990s it was decided that the chapel was too small for requirements and a new one was designed. The Reyntiens' sanctuary windows were set into concrete mullions and when the chapel was tunred into a fitness centre the cost of saving the windows was considered too great. As a result the windows do still exist but have unfortunately been bricked in on both sides.

Title: *west clerestory window*

Notes: At the same time as the sanctuary windows were blocked in, the clerestory windows were removed and are stored in the basement of the school.

LONDON BOROUGH OF HAVERING
Romford, St Alban, Protomartyr, Kings Road, RM1 2SS

General: Since his appointment as parish priest at St Alban's, the energetic Reverend Father Roderick S P Hingley (Tel: 01708 473580) has enriched the rather dull Victorian Gothic church (built 1890) with works of art by artists of international standing, including a *Christus Rex* by Peter Eugene Ball (Southwell Minster, Nottinghamshire), Stations of the Cross by Charles Gurrey, a painted chancel ceiling by Mark Cazalet, two acolyte tapers by Alex Brogden and a Portland stone bench by John Pitt. Father Hingley has a passion for glorifying God with the visual enrichment of the church and chose Reyntiens as the stained glass designer after seeing the angel windows at Southwell and the Life of Mary windows at Stoke St Mary, Somerset. Unsurprisingly the church has won numerous DAC Design Awards and is well worth a visit – one is unlikely to see such a profusion of masterpieces in any other parish church in the country. The church is not a listed building.

The following details are applicable to all windows:
Designer and Glass Painter: Patrick Reyntiens

Glass Maker: John Reyntiens

Architect in charge: Nicholas J Rank

Documentation: Chelmsford Record Office, A12572 Box 34

Literature: Gardom Anne, *Surprised by angels, St Alban, Promartyr, Romford*, http://www.trushare.com/0138NOV06/21Reviews.htm, November 2006

Title: *Pilgrimage window*

Date: 2002

Location and size: single lancet, baptistry window, west end, approximately 300x67cm (118x26 1/4in)

Inscription: signed and dated b.r.: 'Reyntiens 2002'

Cost: £9,000

Faculty: 8 February 2002

Dedication: Sunday 28 July 2002, nearest Sunday to the Feast of St James, patron saint of pilgrims

Reproduction: Gardom Anne, *Surprised by angels, St Alban, Promartyr, Romford*, http://www.trushare.com/0138NOV06/21Reviews.htm, November 2006

Notes: The window replaced a coloured glass window and is mainly blue and green with a spot or two of gold. It illustrates the pilgrimages taken by the congregation in the preceding ten years, with the premier shrine in England of Our Lady of Walsingham in the centre. Other shrines featured are the chapel of St Peter-On-The-Wall, Bradwell, Essex (1992); the Three Major Holy Places of Ireland (1993); a Celtic pilgrimage to the Shetlands and Orkney (1995); a 'Principality Pilgrimage' to holy places in Wales (1997); 'Saints of the North' pilgrimage (1999); 'Cradle of Christianity'

pilgrimage to Lindisfarne (2000) and 'Principality Pilgrimage Two' to the Island of Twenty Thousand Saints (2001). Father Hingley and some of the parishioners are shown at the base of the window. At the top of the window is the scallop shell of St James of Compostela which often features as the shell of baptism in many Medieval and Renaissance paintings and since one's pilgrimage begins at Baptism the blue water cascading down represents baptism, neatly uniting the theme of the window with the font below, the cover of which is decorated with a golden dove by Siegfried Pietzsch. The window is also inscribed: 'Thanne long en folk/to yoon on pilgrimage/Chaucer The Canterbury Tales'.

Title: *Seven-Fold Gifts of the Holy Spirit*

Date: 2003-2004

Location and Size: rose window, west end (above *Pilgrimage window*), approximately 120cm (47 1/4in) diameter

Inscription: signed and dated by the artist

Study: *Original cartoon*, 120cm diameter, inscribed 'Reyntiens 2003', private collection. It was considered that this work was too brightly coloured and would overshadow the *Pilgrimage window*. The design is similar to the final design but with more flaring red flames, a rather angry looking dove, and the three rings symbolising the Holy Trinity are placed round the bird's beak and on the wing tips. *Final study*, photograph in Chelmsford RO (study signed 'Reyntiens 2003').

Cost: Artist's estimate April 2003 - £5,523

Donor: Anonymous gift

Faculty: 19 May 2003

Dedication: 30 May 2004, Whit Sunday/Pentecost

Notes: The rose window which replaced an existing coloured glass window is composed of a harmony of blues and greens distributed in seven parts round the window, the light and dark blues circling round a dove, symbolic of the Holy Spirit, which appears to descend into the church and hover over the font. The seven-fold gifts of the Holy Spirit are indicated by red tongues of lightning and three yellow rings symbolise the Holy Trinity. The small areas of red make an arc of memory to the proposed sanctuary windows. In the explanation of the windows (faculty papers) it explains that 'the play of the "arc of memory" is of vital psychological and, obliquely, of *spiritual importance*, since this small on-site reiteration gives a trigger towards the employment of *affective memory*, which is one of the greatest helps towards a fully developed, mature and rounded Christian life.' The colours were chosen so that they did not dominate the *Pilgrimage window* below.

Above: Original cartoon and final design for rose window
Left: *Pilgrimage window*

Title: *Angel windows*

Date: 2002-2004

Location and Size: five single lancet windows in sanctuary, the three east windows are approximately 236 and 219x70cm (93 and 86 1/4x27 1/2in), the flanking lancets approximately 207x65cm (81 1/2x25 1/2in).

Inscription: east windows signed and dated; south lancet signed and dated b.l.: 'Reyntiens 2003' and north lancet b.r.: 'Reyntiens 2003'

Study: The rather sketchy studies for the five lancets are illustrated on the appeal leaflet dated May 2002. Cartoons, Reyntiens Trust.

Cost: £33,000

Donors: Public subscription

Faculty: 16 September 2002

Dedication: Sunday 26 September 2004, Sunday next to Feast of St Michael and All Angels

Literature: *The Parish Church of Saint Alban, Promartyr, Romford, Essex*, appeal leaflet, May 2002; Cranfield Nicholas, *Vision of glory for the citizens of Romford*, http://www.churchtimes.co.uk/content.asp?id=29809, December 2006

Reproduction: Gardom Anne, S*urprised by angels, St Alban, Promartyr, Romford*, http://www.trushare.com/0138NOV06/21Reviews.htm, November 2006; Cranfield Nicholas, *Vision of glory for the citizens of Romford*, http://www.churchtimes.co.uk/

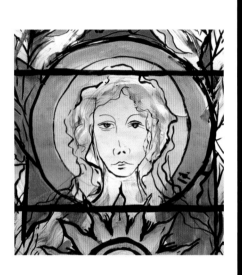

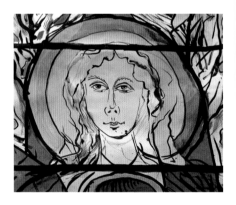

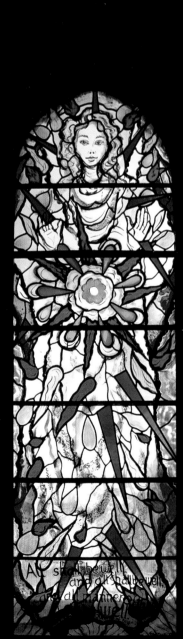

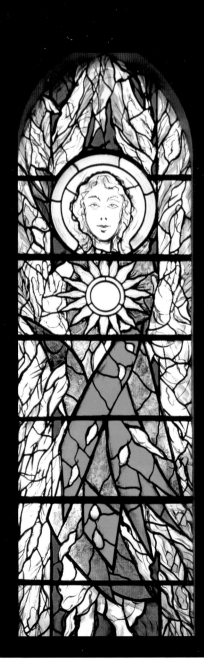

Above top: Cartoon, left hand side angel of the Eucharist, a portarit of the artist's daughter Lucy

Above: Cartoon, right hand side angel of the Eucharist, a portrait of the artist's wife Anne Bruce

Right: North lancet in sanctuary, three east windows and south lancet in sanctuary

Notes: The windows replace ordinary tinted glass windows. There are three lancets at the east end of the church with single lancets on the south and north sides of the sanctuary. The theme of the windows is angelic, the three main windows are brightly coloured, a lot of green with red backgrounds, continuing the red colour of the reredos panels. The red is symbolic, the colour of sacrifice, blood and fire. The outer lancets are more subdued, opaque white, blue and yellow, so that any light shining through them does not alter the colouring of the main windows. The three angels on the east wall bear symbols associated with the teaching on The Mass. The central lancet has an angel holding a crucifix which 'reminds us of the total Sacrifice of Jesus Christ upon The Cross for the salvation of mankind. It is a reminder of Jesus Christ The Supreme and Eternal High Priest, who offered Himself to death so that we might live'. The angel on the left is the angel of the Eucharist and holds the Host which looks like a monstrance, with the sacred monogram 'i h s' inside, to the right another angel of the Eucharist holds a chalice of the Blood of Christ. One part of the chalice rim is of a slightly different yellow, a 'Piperesque' touch! A quotation from the *Epistle to the Hebrews* 5:6 is inscribed along the base of these three windows: 'Thou art a priest for ever after the order of Melchizedek'. The north and south lancets, also with angel figures, are based on the emblem of St Alban, a red rose. The south window indicates fire surrounded by the rose and includes a quotation from T S Eliot: 'and the fire and the rose are one/Little Gidding/Four Quartets T S Eliot'. The north lancet indicates the rose surrounded by fire and includes a quotation from Mother Julian of Norwich: 'All shall be well/and all shall be well, and all manner of things/shall be well/Mother Julian of Norwich'.

The Chancellor, after reading the faculty petition observed that 'this is one of the most inspiring and exciting stained glass window projects which I have been privileged to approve'.

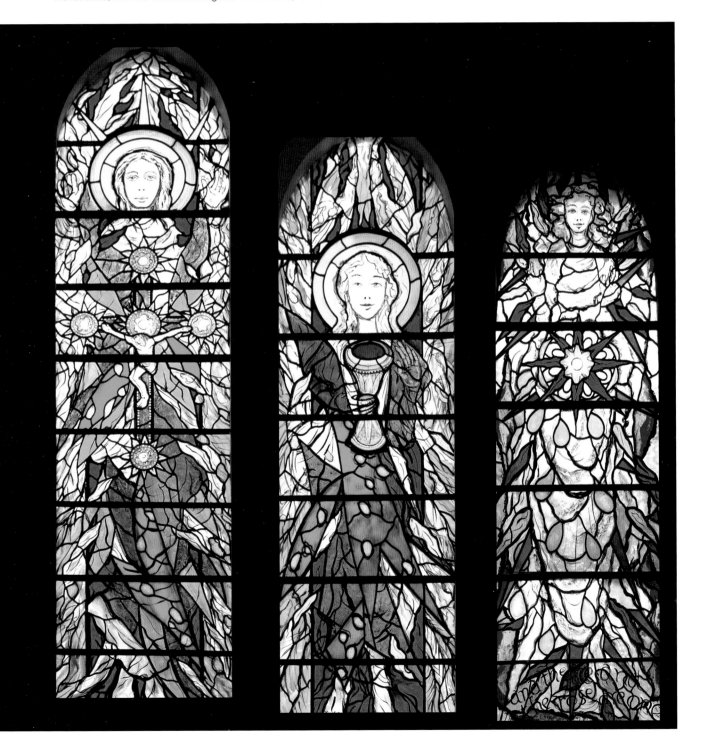

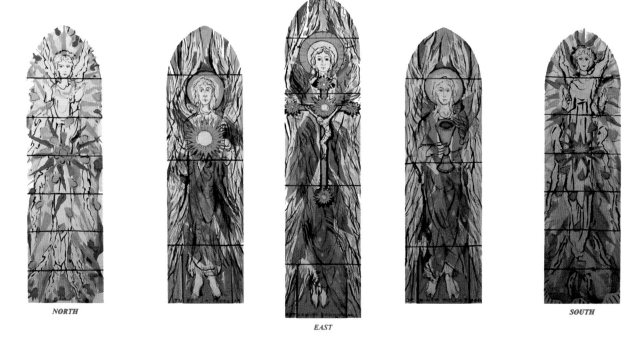

NORTH

EAST

SOUTH

Above: studies for the five sanctuary lights as shown on the appeal
leaflet dated May 2002

LONDON BOROUGH OF HAVERING
Romford, The Frances Bardsley School for Girls, Brentwood Road, RM1 2RR

General: The Frances Bardsley School is a non-denominational comprehensive girls' school specialising in the visual arts. The original school, the Romford County High School for Girls, was founded in 1906 by Frances Beatrice Bardsley, a supporter of the Suffragette movement who wanted to provide quality education for local girls.

Title: *Centenary window*

Date: 2006

Location and Size: main staircase of old building, approximately 206x115cm (81x41in)

Inscription: signed and dated b.r.: 'Reyntiens 2006'

Designer and Glass Painter: Patrick Reyntiens

Glass Maker: John Reyntiens

Study: Illustrated on a postcard sold in aid of The Centenary Appeal

Donors: Public subscription and funds were raised in school by the sale of paper 'flames'

Dedication: 6 October 2006 (centenary of foundation date)

Literature: Gardom Anne, Surprised by angels, St Alban, Promartyr, Romford, http://www.trushare.com/0138NOV06/21Reviews.htm, November 2006; Order of service at dedication of window, 6 October 2006

Notes: The indefatigable Father Hingley (St Alban, London Borough of Havering) is the Chairman of Governors and Link-Governor for Art and Design at the school and so it is hardly surprising that they turned to Reyntiens for their centenary window. The design is of flickering Pentecostal flames, each one unique, just as each pupil in the school is unique. The three larger flames in the centre which are reminiscent of quills remind one that 'the pen is mightier than the sword' and at the top left Christ's feet disappear into the clouds. They are accompanied by the inscription 'POST XL DIES' referring to the Ascension of Christ forty days after the Resurrection (Southwell Minster, Nottinghamshire). The window also includes school mottos: 'Gladly learne and gladly teche' from the Prologue to Chaucer's *Canterbury Tales*, 'we toil not for time but for eternity' and 'we work not for school but for life' from the memorial to the first Headmistress in the school library. The window is mainly yellow with added touches of grey, green and blue. Reyntiens described the design as 'one of memory and of aspiration … the flames are the individual student's potential and possible creation of their own identity and talent'. Regarding Christ's feet he observed that 'Christians will understand this reference, but, at the same time, pupils of other Faiths will not be offended by the overt pressure of any particular structure of belief, in this day and age the latter is most important'.

The Stained glass window - Reyntiens

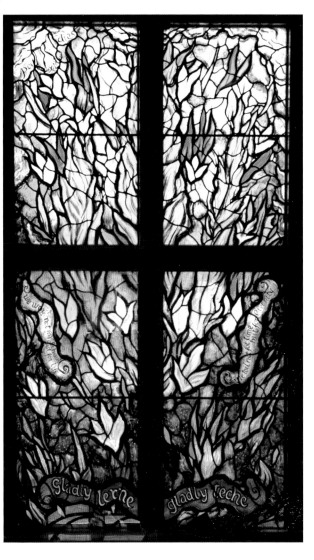

Above left: Study for the *Centenary window*

Above right: *Centenary window*

Below: Details of the window

LONDON BOROUGH OF HILLINGDON
South Ruislip, St Gregory the Great (RC), 447 Victoria Road, HA4 0EG

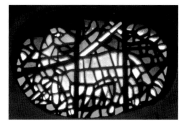

General: The church was designed by Gerard Goalen who also designed The Good Shepherd, Nottingham and it was this latter commission which enabled him to set up in private practice and design churches such as this one. The church was built 1965-1967 and is oval shaped. Reyntiens' windows were originally the only stained glass but one of the priests felt that more colour was required and a number of dalles-de-verre windows were made by the monks at Buckfast Abbey.

The following details are applicable to both windows:
Date: 1965-1967

Designer, Glass Painter and Maker: Patrick Reyntiens

Architect in charge: Gerard Goalen

Dedication: 16 March 1967 by Cardinal Heenan

Documentation: Westminster Diocesan Archives, Heenan papers, Council of Administration meetings, ref HE1/C23(a)

Literature: CBRS, 'Church of St Gregory the Great, South Ruislip, Middlesex', 1965, p44; CBRS, 'Church of St Gregory The Great, Victoria Road, South Ruislip, Middlesex', 1967, p36

Notes: The designs for the stained glass windows were approved in principle 15 December 1965

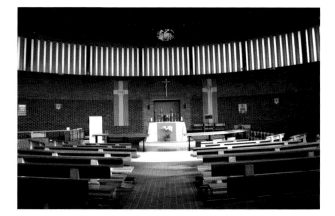

Title: *Lamb of God*

Location: oval stained glass east window above altar, dalle-de-verre

Literature: *Twentieth Century Architecture*, Harwood Elaine, 'Liturgy and Architecture: The Development of the Centralised Eucharistic Space', No 3, 1988, p67; Cherry Bridget and Pevsner Nikolaus, *The Buildings of England, London 3: North West*, London: Penguin Books, 1991, p87, 347

Reproduced: CBRS, 'Church of St Gregory The Great, Victoria Road, South Ruislip, Middlesex', 1967, p39

Notes: The window is placed high above the altar and the image is suitably simple and direct, a blue lamb with a green cross against a red and green background.

Title: *Baptistry*

Location and Size: Baptistry, six panels of curved glass, each approximately 343x61cm (135x24in), dalle-de-verre

Literature: Cherry Bridget and Pevsner Nikolaus, *The Buildings of England, London 3: North West*, London: Penguin Books, 1991, p87, 347

Notes: The Baptistry is a very small round space with the font in the centre and Reyntiens' glass forming a semi-circle on the outer wall creating a beautiful soft light in the room. There are large blue and yellow waves of glass on the outer edges with a pale blue diamond in the centre, the seven Sacraments inscribed on circles within: 'Eucharist/Anointing/Baptism/Penance/Confirmation/Holy Orders/Marriage'

From top to bottom:
View of interior with *Lamb of God; Lamb of God; Baptistry*

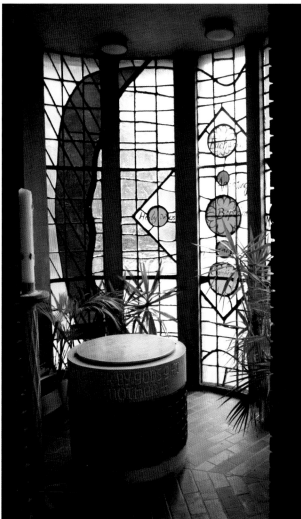

LONDON BOROUGH OF MERTON
Morden, St John Fisher (RC), 207 Cannon Hill Lane, SW20 9DB

General: The church was designed by F G Broadbent & Partners and built in 1962 and Canon O'Donnell had always hoped that it could be made more colourful. By 1982 the funds were available and Father Colm Acton, in consultation with his parishioners and the architect Michael Hattrell, devised a plan for re-ordering the church.

Literature: CBRS, 'Canon Hill Church of St John Fisher', 1962, p82

Title: *Stations of the Cross*

Date: c1984

Location and Size: 14 windows on north side, Stations 1-12 measure approximately 62x45cm (24 1/2x17 3/4in) and Stations 13 and 14 measure approximately 56x45cm (22x17 3/4in)

Inscription: Station 14, b.r.: 'Reyntiens 84'

Designer, Glass Painter and Maker: Patrick Reyntiens

Assistant: David Williams (described as colleague and co-artist by Reyntiens)

Architect in charge: Michael Hattrell

Literature: *CBRS*, 'Canon Hill Church of St John Fisher', 1962, p82; *Church Building*, 'Re-ordering of St John Fisher, Morden. Roman Catholic Diocese of Southwark', Whitsun 1985, p47; *Church Building*, Reyntiens Patrick, 'Re-ordering of St John Fisher, Morden. Roman Catholic Diocese of Southwark', Whitsun 1985, p48

Reproduced: *Church Building*, Reyntiens Patrick, 'Re-ordering of St John Fisher, Morden. Roman Catholic Diocese of Southwark', Whitsun 1985, p1 (8th Station), 48 (12th Station)

Notes: The stained glass has been placed inside the old plain glass with light boxes below to illuminate the panels at night. Reyntiens decided to make the panels figurative with each panel being 'distinct and readable as a particular event'. The background to the Stations is alternately dull green and dull grey-purple and Reyntiens colour coded the dramatis personae, so 'The Innocent, the Man-God, God-Man, the Victim, is always in white'. The Virgin 'coadjutor and co-sufferer' is in blue. The tormentors are scarlet red and are 'specially painted in a lacerated, almost flayed or enorché style' to symbolise a soul divided against itself in torment. The cross is red, with the exception of Station 14, where the three crosses on the hill are pale green and pink. Reyntiens cleverly rotated the cross in a cart-wheel through the Stations, creating a rhythm. The spectators are grey, brown, green and pale blue. In Station 4 one bystander carries a child, Reyntiens suggesting that this may symbolise hope. Simon of Cyrene is a burgundy coloured figure. In Station 6, Veronica wipes the face of Jesus, the handkerchief is amusingly shown as a large white flag bearing the imprint of Christ's face. By Station 8 where Jesus speaks to the daughters of Jerusalem, He has recovered sufficiently to stand upright, a willowy figure. Station 12 is more classical in format and symmetrical and with the mauve background really rather beautiful. Stations 13 and 14 are simpler in style and work better, the former having the addition of two yellow slashes of colour, and the latter with a predominantly mauve background. In general the leading 'meanders' across the glass, slowly and eloquently.

Below: Interior showing *Stations of the Cross* 6-10

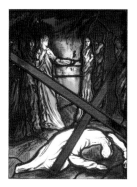

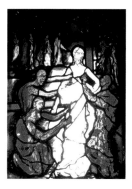

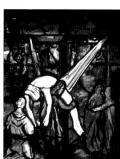

St John Fisher, Morden, *Stations of the Cross 1-14*, reading left to right, top to bottom

LONDON BOROUGH OF REDBRIDGE
Ilford, St John the Baptist (RC), Wanstead Park Road, Cranbrook, IG1 3TS

General: The church is modern and unusual in that it is wider than it is deep.

The following details are applicable to both windows:
Date: 1967

Location and Size: West windows, armoured glass, each approximately 638x345cm (251x136in)

Designer and Glass Maker: Patrick Reyntiens

Architect in charge: Butles, Newton and Partners

Dedication: 3 March 1967. The first Mass was performed the same day by the Bishop of Brentwood and Bishop Butler

Documentation: church archives

Literature: *CBRS*, 'St John The Baptist Church, Wanstead Park Road, Ilford, Essex', 1967, p84; *Berks and Bucks Countryside*, Coomer Norman, 'Exciting new future for Beaconsfield school', Vol 20, No 157, September 1980, p18; Cherry Bridget, O'Brien Charles and Pevsner Nikolaus, *The Buildings of England, London 5: East, London*: Yale University Press, 2005, p97, 338; *Decorative Arts Society The, Omnium Gatherum*, Horner Libby, 'Patrick Reyntiens' Autonomous Panels. Myth, music and theatre', Journal 35, 2011, p67

Notes: Reyntiens devised a scheme for all the glazing in the church with a view to modifying the light streaming into the interior, although the entire scheme was not carried out either due to lack of funds or a disagreement with the parish priest at the time - it is worth noting that in his recommendations to the church Reyntiens appeared to be dictating the symbolic and religious content. For the two deeply recessed sanctuary windows, hidden from the congregation most of the time, he suggested the theme of solomonic pillars on either side of the Temple Sanctuary together with the idea of the cloud by day and the fire by night. The colours were to be gold on a blue background, which would presumably have given a rich contemplative feel to the sanctuary platform. For the twin windows on the presbytery side of the sanctuary he suggested the two tables of stone of the old Law, containing the Ten Commandments, the tables to be on a blue background to match the sanctuary. For the three windows above the confessionals he chose the theological virtues, faith represented by a light in white colours, hope represented by a branch in green and charity represented by a flame in red. He proposed that the baptistry windows, removed from the body of the church, should be 'entirely leafy and spring green. On a blue background as the rest of the church'. The two large west windows facing the road presented, he admitted, the most difficult problem, because of their sheer size (they are floor to ceiling and occupy perhaps 2/3rds of the wall opposite the sanctuary). He proposed a 'wall of glass, opaque, white, showing the four doors of Paradise'. Perhaps because Reyntiens was not commissioned to design and make the other windows (which are still plain glass) he developed a more radical approach to the two main windows. *The Buildings of England* authors obviously greatly admire these 'striking' and 'bold semi-abstract' windows which employ two similar designs in very subtle pale colours, mainly shades of grey, yellow, turquoise and opaque white. The designs are rather Art Deco looking and unpainted. I think they are absolutely glorious but whether the colours and design stimulate religious feeling is another matter.

Below: Interior of church showing on left *Closed Paradise, Tree of Knowledge* and on right *Closed Paradise, Tree of Life*

Title: *Closed Paradise, Tree of Knowledge*

Location: south side of west wall

Notes: The theme of this window was 'the tree of knowledge of good and evil' to which the parish priest at the time, by way of explanation, added 'You are not to eat. For the day you eat of it you must surely die'. There is a pale yellow tree centre which opens into leaves/flames overlapping a half moon shape. The five barred doors either side are coloured green, yellow and grey.

Title: *Closed Paradise, Tree of Life (Terrestrial Paradise)*

Location: north side of west wall

Reproduced: Reyntiens Patrick, *The Beauty of Stained Glass*, London: Herbert Press, 1990, p214; *Decorative Arts Society The, Omnium Gatherum*, Horner Libby, 'Patrick Reyntiens' Autonomous Panels. Myth, music and theatre', Journal 35, 2011, p66

Notes: The theme of this window was 'below the doors of Paradise, with flames issuing from them, would have the tree of life' to which the parish priest at the time added 'Eat of this tree and live for ever'. There is a tree of life centre against a green background, enclosed at the top by a half moon and guarded either side by five barred doors radiating with little yellow Pentecostal flames. Unfortunately some of the glass is broken.

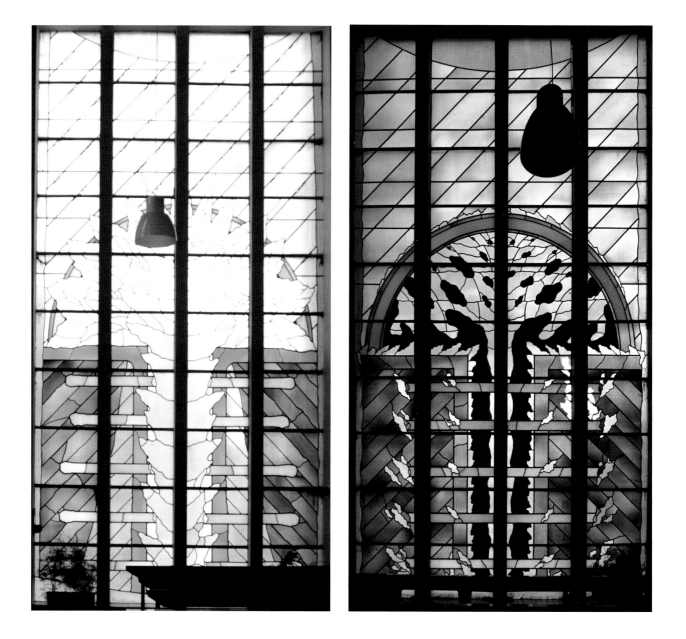

LONDON BOROUGH OF RICHMOND UPON THAMES
Hampton-upon-Thames, St Theodore of Canterbury (RC), 110 Station Road, TW12 2AS

General: The church, opened in 1986, is a cleverly designed and constructed low-budget edifice by the architect Austin Winckley (St Margaret, London Borough of Richmond upon Thames) – the budget was a mere £80,000. The site is limited and the altar placed at a diagonal to the congregation, facing Jerusalem. All four windows are small but beautifully formed gems.

The following details are applicable to all four windows:
Date: 1986

Designer, Glass Painter and Maker: Patrick Reyntiens

Architect in charge: Austin Winckley

Title: *Supper at Emmaus*

Location and Size: opposite the altar, plated and painted glass, approximately 38.5x56cm (15 1/4x22in)

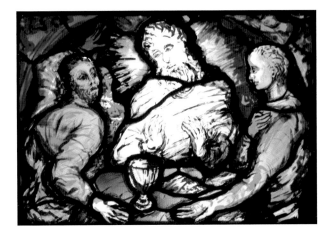

Notes: Reyntiens would appear to have been influenced by Caravaggio's painting of the same name, in the attitudes of the men, the green colouring and the tinges of red and white drawing one's eye into the middle of the work. The window is almost entirely green, the attention being centred on Christ who is a white clad figure with the bread and the wine on the table highlighted in red. Christ is flanked by the two disciples, both men startled by the revelation that they are seated with Jesus, their hands almost touching in the foreground, creating a frame to the image and reminding one of Michelangelo's famous painting in the Sistine Chapel where the hand of God gives life to Adam.

Title: *Tabernacle*

Location and Size: 2 narrow vertical slits left and right of the Tabernacle, each approximately 104x10cm (41x4in)

Inscription: signed and dated b.r. of right light: 'Reyntiens 86'

Notes: Flowers are painted on abstract blobs of pink, brown, white and red glass (the latter symbolising the grapes of Gethsemane). It has been suggested that the twisting upward motion of the leadlines recalls the DNA structure.

Title: *Penitence*

Location and Size: Confessional, approximately 33x53cm (13x21in)

Notes: Perhaps the most attractive of the windows, this one is rarely seen. It shows St Peter, head in hand, weeping, following his betrayal of Christ. His other hand is raised towards his ear so that he can block out the crow of the cockerel. The latter, top left, is a wonderful belligerently red-headed bird, silhouetted against the dawn. There is some beautiful antique purple glass.

Above from top to bottom: *Supper at Emmaus*; *Penitence* and detail of *Penitence*

Left: *Tabernacle* and detail of same

LONDON BOROUGH OF RICHMOND UPON THAMES
Saint Margaret's, St Margaret of Scotland (RC), 130 St Margaret's Road, TW1 1RL

Listing: Grade II (5 May 1999) #1387183

General: The church, commissioned by Father Sidney Dommerson, was designed between 1968 and 1969 by Austin Winckley (of Williams and Winckley) in modernist style and following the liturgy of the New Churches Research group. This was the first church Winckley, himself a Catholic, designed (St Theodore of Canterbury, London Borough of Richmond upon Thames). The church itself is diamond shaped with opaque clerestory glazing, constructed with Forticrete concrete block walls, with steel trusses supporting flat roofs. A gilded crucifix by Stephen Sykes hangs above the altar, a memorial from the parishioners to Father Dommerson who died a few days before the building was finally completed. Cherry describes Reyntiens' windows as 'excellent' and Harrison considers them to be amongst the most important 20th century stained glass.

Literature: *CBRS*, 'St Margaret of Scotland, East Twickenham', 1966, p48; Harrison Martin, 'Notes', *Glass/Light*, London, 1978, #39; Clarke Brian (Ed), *Architectural Stained Glass*, London: John Murray, 1979, p193; Cherry Bridget and Pevsner Nikolaus, *The Buildings of England, London 2: South*, Harmondsworth: Penguin Books, 1983, p540; Angus Mark, *Modern Stained Glass in British Churches*, London & Oxford: Mowbray, 1984, p60; Cowen Painton, *A Guide to Stained Glass in Britain*, London: Michael Joseph Ltd, 1985, p141; Harwood Elaine, *England. A Guide to Post-War Listed Buildings*, London: B T Batsford, 2003 (2000), p572; *Stained Glass Windows and Master Glass Painters 1930-1972*, Bristol: Morris & Juliet Venables, 2003, p85

Reproduced: Angus Mark, *Modern Stained Glass in British Churches*, London & Oxford: Mowbray, 1984, p61

The following details are applicable to both windows:
Date: c1969-1970

Designer, Glass Painter and Maker: Patrick Reyntiens

Architect in charge: Austin Winckley

Literature: Martin Christopher, *A Glimpse of Heaven. Catholic Churches of England and Wales*, Swindon: English Heritage, 2006, p213

Title: *Triumph of Christ (Second Coming or Parousia)*

Location: rectangular clerestory window above altar, facing south

Literature: *CBRS*, 'St Margaret's Church, 130 St Margaret's Road, East Twickenham', 1969, p34

Reproduced: Clarke Brian (Ed), *Architectural Stained Glass*, London: John Murray, 1979, p195

Notes: The design is abstract, reminiscent of a fried egg but probably symbolising the sun, cosmos and universe. Blue, dark grey, yellow and clear glass are used. Angus states that the window symbolizes Christ dispelling the darkness; the bright light shines out forcing the clouds to roll back. 'Once this theme is contemplated upon, the work has a depth of meaning'. Cowan titles it *Christ Breaking Into the World*, so perhaps the egg analogy is apt!

Title: *Baptistry*

Location: Baptistry
Reproduced: Clarke Brian (Ed), *Architectural Stained Glass*, London: John Murray, 1979, p194; Harwood Elaine, *England. A Guide to Post-War Listed Buildings*, London: B T Batsford, 2003 (2000), p573

Notes: The window is a thin sliver of glass, the height of the building. The design is abstract with a vertical stripe overlaid with cloud forms, in clear ribbed glass, and a mixture of blue, grey and white glass. Martin thinks the window is a 'representation of St Margaret of Scotland' but does not attribute it to Reyntiens, merely noting that it used to be in the 'cardboard cathedral' as the previous prefabricated hut was affectionately known, in which case the date is earlier.

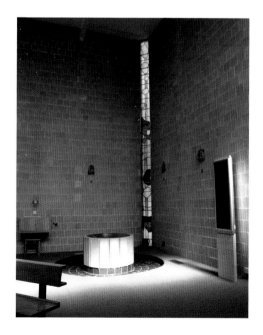

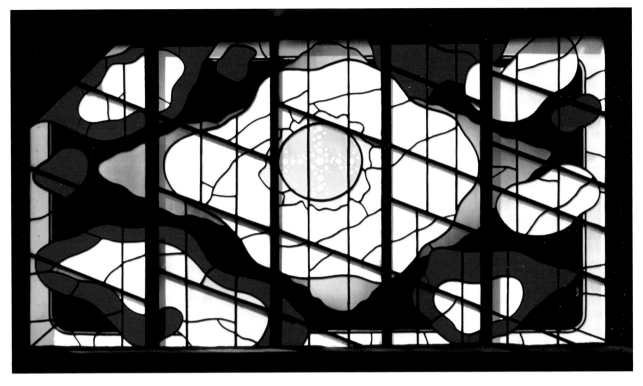

Above: *Triumph of Christ*

Left: Interior of the church with *Triumph of Christ* and interior of church showing the font and Baptistry window

ROYAL BOROUGH OF KENSINGTON AND CHELSEA
Holland Park, No 58, private chapel

Title: unnamed

Date: 1970

Designer, Glass Painter and Maker: Patrick Reyntiens

Architect in charge: Williams & Winckley (St Theodore of Canterbury and St Margaret of Scotland, London Borough of Richmond upon Thames)

Literature: *Stained Glass Windows and Master Glass Painters 1930-1972*, Bristol: Morris & Juliet Venables, 2003, p85

Notes: It is not known whether the work is extant.

ROYAL BOROUGH OF KENSINGTON AND CHELSEA
Kensington, Rayne House

Title *Four Seasons*

Owner: Private collection

Date: 1981

Designer: John Piper

Glass Painter and Maker: Patrick Reyntiens

Cost: In the TGA letter dated 14 April 1981 Piper states that he will support Reyntiens' charge of £2,000 for this panel

Documentation: TGA 200410/1/2

Literature: Osborne, 1997, p124, 177

Reproduced: Osborne, 1997, p126

Notes: A landscape panel of the Four Seasons, Winter, Spring, Summer and Autumn, represented by foliate heads. Each head is divided in two vertically, so the predominant colours move from almost black to red, black with yellow and blue, yellow, blue, yellow, yellow with black and back to predominantly black, so the design has symmetry.

ROYAL BOROUGH OF KENSINGTON AND CHELSEA
South Kensington, Victoria and Albert Museum, Cromwell Road, SW7 2RL

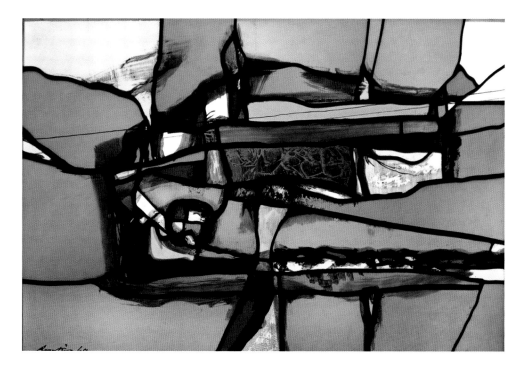

Title: *Beckett's Bones I* (C.7-1973)

Provenance: Given to the Museum by Reyntiens (delivered November 1972)

Date: 1960

Size and Medium: 51x76cm (20.1x29.9in), stained and painted glass

Inscription: signed and dated b.l.: 'Reyntiens 60'

Designer, Glass Painter and Maker: Patrick Reyntiens

Documentation: V&A Register; V&A Nominal file MA/1/R716

Exhibited: *Patrick Reyntiens*, The Arthur Jeffress Gallery, London, 10 January-27 January 1961, #11

Notes: This is a semi-abstract panel with beige, light grey, lemon and white areas surrounding a tomb-like shape with added blue tones in which a shroud-like body lies, presumably Beckett, connecting with what Reyntiens described as 'Becket's glassy bones'. The wonderful marking on some of the glass gives the impression of rocks and stone and Reyntiens aimed to indicate 'the idea of something laid bare after being hidden for many years – and not much of it left as in a Saxon tomb for instance'. In a letter to the Museum, Reyntiens notes that 'the piece of glass is one of two entitled *Beckett's Bones*. Professor Sam Truman[?] of the Royal College possesses the other … the connection with Sam Beckett also is inherent in the spelling of the title … I think it may be one of the most delicate pieces of lead-work attempted – but the cutting is fairly straight forward.'

Title: *Brittany Beach Scene* (C.74-1981)

Provenance: Purchased from Reyntiens when living at The Old School Church, Beaconsfield

Date: c1965 (the purchase note gives the date as 1965)

Size and Medium: 120x160cm (47.2x63in), painted and stained glass

Designer: John Piper

Glass Painter and Maker: Patrick Reyntiens

Cost: £2,300

Documentation: V&A Register

Literature: *Glass/Light*, The Royal Exchange, 18 July-12 August 1978, #37; *Das Bild in Glas*, Hessisches Landesmuseum Darmstadt, 1979, p150; Osborne, 1997, p63-64, 172

Reproduced: Osborne, 1997, p64

Exhibited: Permanently exhibited in Gallery 222 by Exhibition Road Entrance; *Glass/Light*, The Royal Exchange, London, 18 July-12 August 1978, #37; *Das Bild in Glas*, Hessisches Landesmuseum Darmstadt, 1979, # 99

Notes: A number of panels were made from the gouache and collage landscapes which Piper created in Brittany and North Wales in the early 1960s (Autonomous Panels) The panel is semi-abstract, mainly blue-green glass with a tiny house at the top above some yellow squiggles (possibly representing seaweed), two large red and white shapes, and some blue squiggles.

Below: *Beckett's Bones 1*

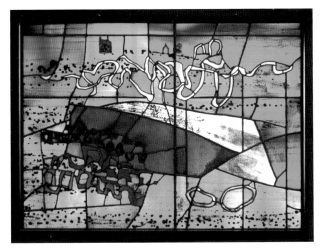

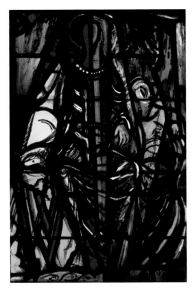

Top: *Brittany Beach Scene*
Above: *Christ between St Peter and St Paul*
Below: *Cross*, artist's impression of colours

Title: *Christ between St Peter and St Paul* (C.77-1981)

Provenance: Purchased from John Piper's studio in 1981

Date: 1955-1960

Size and Medium: 85.5x58.5cm (33 3/4x23in), stained glass panel, coloured and acid-etched flashed glass, with paint and silver stain

Designer: John Piper

Glass Painter and Maker: Patrick Reyntiens

Cost: £2,000

Documentation: V&A Register

Literature: *John Piper*, London: Tate Gallery, 1983, p115; Osborne, 1997, p179; *Decorative Arts Society The, Omnium Gatherum*, Horner Libby, 'Patrick Reyntiens' Autonomous Panels. Myth, music and theatre', Journal 35, 2011, p68

Reproduced: *mural art today*, Victoria and Albert Museum, London, 1960, #3 titled *Variation on a French Sculpture*

Exhibited: Permanently exhibited in Sacred Silver and Stained Glass Gallery, Room 83, case S5; *mural art today*, Victoria and Albert Museum, London, 1960, #3 titled *Variation on a French Sculpture*; *John Piper painting in coloured light*, Kettle's Yard Gallery, Cambridge, 3 December 1982-9 January 1983, #3 (lent by the Victoria and Albert Museum); *John Piper*, The Tate Gallery, London, 30 November 1983-22 January 1984 (lent by the Victoria and Albert Museum), #117

Notes: This is a semi-abstract image of the seated Christ in the centre flanked by St Peter and St Paul and executed in beautiful, jewel-like colours. The Tate catalogue notes that it is based on a gouache of 1955 after a Romanesque tympanum at Aulnay in France and that it is the larger of two similar works (Autonomous Panels).

Title: *Cross* (C.48-1976)

Provenance: Given to the Museum by Reyntiens in March 1976

Date: 1966

Size and Medium: 153x93cm (60.2x36.6in), translucent and obscured glass

Designer, Glass Painter and Maker: Patrick Reyntiens

Documentation: V&A Register; V&A Nominal file V&A MA/1/R716

Literature: Harrison Martin, 'Introduction', *Glass/Light*, London, 1978, #39

Reproduced: Harrison Martin, 'Introduction', *Glass/Light*, London, 1978, plate 39; *House and Garden*, Levi Peta, 'Springboard from Piper and Reyntiens: or the brave new world of the stained-glass designers', April 1983, p147

Exhibited: Building Centre (exhibition of Reyntiens' work), London, 1966; *Glass/Light*, The Royal Exchange, London, 18 July-12 August 1978, #39

Notes: The panel was made for the exhibition of the artist's work at the Building Centre in 1966. Harrison notes that the work 'is particularly interesting for its date, as it was conceived with no knowledge of contemporary German work'. A cross with blue,

green and red blobs dripping from it divides the panel into four almost equal parts, whilst the work is also divided horizontally into approximate thirds, the upper and lower sections being backed by large white shapes.

Title: *Herbin's Tomb* (C.49-1976)

Provenance: Given to the Museum by Reyntiens in March 1976

Date: 1968

Size and Medium: 243.3x274.7cm (95 3/4x108in) (outside frame) composed of 6 panels, translucent and obscured glass

Designer, Glass Painter and Maker: Patrick Reyntiens

Documentation: V&A Register; V&A Nominal file MA/1/R716

Literature: *Leadline 1990, Patrick Reyntiens & the Burleighfield Experience*, Goodden Ted (Ed), 1990, p7

Reproduced: Neiswander Judith & Swash Caroline, *Stained & Art Glass*, London: The Intelligent Layman Publishers Ltd, 2005, p259

Notes: When Reyntiens was working with Ceri Richards (*La Cathedrale Engloutie*, Pallant House, Sussex; Liverpool Metropolitan Cathedral, Merseyside; Derby Cathedral Church of All Saints) he read *L'art non-figuratif non-objectif* which was written by the Belgian Auguste Herbin in 1949 outlining his colour theories and his compositional system based on the structure of letters. Disagreeing with the thesis, Reyntiens issued his riposte in the form of this panel. Three of the panels are in blue, black and white, the other three in brown with white and red cloud shapes. Ted Goodden noted that the Museum 'purchased a large stained glass diptych of Patrick's. It was damaged in the move from Loudwater to Beaconsfield and my first job as a journeyman apprentice (50 pounds a week) was to restore this work'. Some of the glass had cracked and Goodden cracked some more in stripping the lead so they had to remove some Antique glass and replace it with English glass (plated) and replace some black glass. Goodden found his task impossible and finally Reyntiens told him to '"just roll one sheet over another until the hills and valleys correspond". Focussed on the template rather than the glass itself, this had never occurred to me. I was dumbstruck, like the Zen student clobbered on the head by the master's staff – this was a moment of satori. "An artist must be resourceful", Patrick said matter-of-factly'. Reyntiens charged for glass and labour in restoring the panel. The artist told the Museum he hoped to have the work completed by July 1977 but when the packers came to collect the work in August they noted another crack and the panel was delivered in this state.

Title: *Model of Baptistry window, Coventry Cathedral* (C.63-1976)

Provenance: Given to the Museum by John Piper

Date: 1958-1959

Size and Medium: total size: 366.4x218.5cm (144.3x86in) made to the scale 1 1/2inches to a foot, larger part 193x218.5cm (76x86in), smaller part 173x218.5cm(68 ¼x86in) - two part model of the entire window, wood and stained glass

Inscription: various scratched number marks on small glass panels

Designer: John Piper

Model Painter and Maker: Patrick Reyntiens

Documentation: V&A Register; V&A Nominal File MA/1/P1383

Literature: Harrison, 1982; *John Piper*, The Tate Gallery, London, 30 November 1983-22 January 1984, p115; Campbell Louise, *To build a Cathedral, Coventry Cathedral 1945-1962,* Warwick: University of Warwick, 1987, p55; Campbell Louise, *Coventry Cathedral. Art and Architecture in Post-War Britain*, Oxford: Clarendon Press, 1996, p174; Osborne, 1997, p71, 179; Spalding, 2009, p374; Breward Christopher & Wood Ghislaine (Ed), *British Design from 1948: Innovation in the Modern Age*, V&A Publishing, 2012, p94

Reproduced: *John Piper*, The Tate Gallery, London, 30 November 1983-22 January 1984, p115; Campbell Louise, *To build a Cathedral, Coventry Cathedral 1945-1962,* Warwick: University of Warwick, 1987, p13, 54; Campbell Louise, *Coventry Cathedral. Art and Architecture in Post-War Britain*, Oxford: Clarendon Press, 1996, plate XV; *Burlington Magazine The*, Spalding Frances, 'John Piper and Coventry, in war and peace', CXLV, July 2003, p496; Breward Christopher & Wood Ghislaine (Ed), *British Design from 1948: Innovation in the Modern Age*, V&A Publishing, 2012, p93

Exhibited: *John Piper*, Baukunst, Cologne, September 1965; *Metamorphosis, Figure into Abstract*, Herbert Art Gallery, Coventry, 3 September-2 October 1966, #47 (lent by the artist); *John Piper painting in coloured light*, Kettle's Yard Gallery, Cambridge, 3 December 1982-9 January 1983, #4 (lent by Victoria and Albert Museum); *John Piper*, The Tate Gallery, London, 30 November 1983-22 January 1984, #118 (lent by the Victoria and Albert Museum); *To build a Cathedral, Coventry Cathedral 1945-1962,* University of Warwick, 1987, #108 (lent by the Victoria and Albert Museum); *British Design from 1948: Innovation in the Modern Age*, Victoria and Albert Museum, 2012, #1.77

Notes: The model was made after the initial drawings but before the cartoon stage and constitutes the only trial design made in glass for any Piper commission. The leads are randomly placed and bear no resemblance to Piper's designs for the final work. The model was used by Piper so that he could finalise the cartoons for the window (Coventry Cathedral, West Midlands). In a letter to the Museum dated 17 June 1976 Piper notes that it was kind of the V&A 'to arrange for Philadelphia to borrow the Coventry model'.

Title: *Panel for Baptistry window, Coventry Cathedral* (C.10-1976)

Provenance: Patrick Reyntiens; purchased by Lord Beaumont of Witley; donated by latter to Museum

Date: 1962

Size and Medium: 125.1x50.4cm (49.3x19.8in) painted glass

Designer: John Piper

Glass Painter and Maker: Patrick Reyntiens

Documentation: V&A Register; V&A Nominal file MA/1/B866

Literature: Harrison Martin, 'Introduction', *Glass/Light*, The Royal Exchange, London, 1978, #36; Osborne, 1997, p179

Reproduced: Martin Harrison, 'Introduction', *Glass/Light*, The Royal Exchange, London, 1978, plate 36

Exhibited: *Modern Stained Glass*, Arts Council, 1960-1961, #12 (see Bibliography for venues); *Glass/Light*, Royal Exchange, London, 18 July 1978-11 August 1978, #36. *Pleasure of Peace: Light, Art and Design in Britain1939-1968*, The Sainsbury Centre for Visual Arts, 1 February 1999-18 April 1999 and Brighton Museum and Art Gallery, 1 May 1999-20 June 1999.

Notes: The panel was made for the Baptistry window but Piper and Reyntiens were asked at short notice by the Arts Council to provide a panel for the Exhibition. They submitted this panel and Reyntiens made a replacement for Coventry. The panel, in shades of blue with black paint, is abstract in design although there almost appears to be a skull on the left hand side. In a letter to Lord Beaumont dated 24 March 1971 Reyntiens noted that 'the circumstances of this panel are ... that in the early part of 1962 Feb or so we were asked to contribute something to an Arts Council exhibition – it could have been November 61 and this glass was due to go in to the cathedral (top half: there was quite a gap between the top going in and the bottom half) so we pushed the panel into the Arts Council show and proceeded to make a replica which is now in the cathedral ... probably the painting isn't quite so good in the cathedral'. Reyntiens seemed to think the panel was then exhibited at All Hallows, London Wall. He felt it would look best in a light-box placed back to front with the glassy side to the viewer, otherwise it would 'look drab and lacklustre when the light is not on'.

Right: *Model of Baptistry window, Coventry Cathedral*
Far right: *Panel for Baptistry window, Coventry Cathedral*

LONDON BOROUGH OF TOWER HAMLETS
Spitalfields, Dellow Centre (Providence Row), Chapel, 82 Wentworth Street, E1 7SA

General: In 1857 Father Daniel Gilbert decided to start a refuge for homeless people in the East End of London and asked the Sisters of Mercy in Wexford, Ireland for their help. The Providence Row Night Refuge opened on 7 October 1860 and by 1861 had moved to a larger site on Crispin Street near Spitalfields Market. It offered a welcome alternative to the workhouse, families were kept together, the Sisters of Mercy opened a school, and parents were helped in whatever way possible to find a way out of homelessness. During the late 19th century the order provided lodging to the 'destitute from all parts, without distinction of creed, colour and country'. The current Dellow Centre was opened on 17 April 1994. The chapel is now used as a meeting room.

Title: unnamed

Date: 1993

Location and Size: south bow window, 3rd floor of building, 375x335cm (147 1/2x132in)

Inscription: signed and dated b.c.: 'Reyntiens 93/15:XII:93'

Designer and Glass Painter: Patrick Reyntiens

Glass Maker: Bernard Becker & Partners Studio, E2 6HN

Literature: BSMGP, 'New Work', Spring/Summer 1994, p9; Cherry Bridget, O'Brien Charles and Pevsner Nikolaus, *The Buildings of England, London 5: East*, London: Yale University Press, 2005, p420; Neiswander Judith & Swash Caroline, *Stained & Art Glass*, London: The Intelligent Layman Publishers Ltd, 2005, p260

Reproduced: BSMGP, 'New Work', Spring/Summer 1994, p9; Neiswander Judith & Swash Caroline, *Stained & Art Glass*, London: The Intelligent Layman Publishers Ltd, 2005, p260, 261

Notes: The design suggests the protective form of the Virgin Mary and incorporates a version of Jacob's Ladder. In the BSMGP article Reyntiens is quoted as saying that 'it was inspired by a medieval engraving of man looking out of the universe. The dark area around the bottom suggests the millstones of discomfort contrasting with the apotheosis of a dove flying up in the God head in the middle. Quiet colours of grey, cold greens, blues and yellow stain were used as the light changes so much during the day, anything more intense would be too jarring and busy'. The dove is painted into the central yellow flame. The colours are indeed very subtle and the glass round the edge of the design is plain and semi opaque, thinly painted, giving a soft grey tone. The article also notes that every piece of glass was slumped into shape and that 'the effortless appearance belies the care that went into the alla prima painting and firing to achieve the curve'.

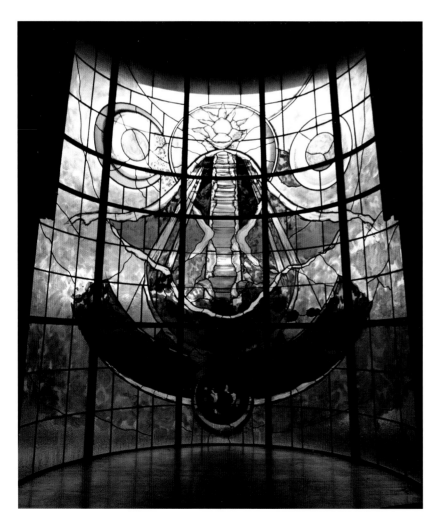

Left: Window

Right: Buildings seen through the window

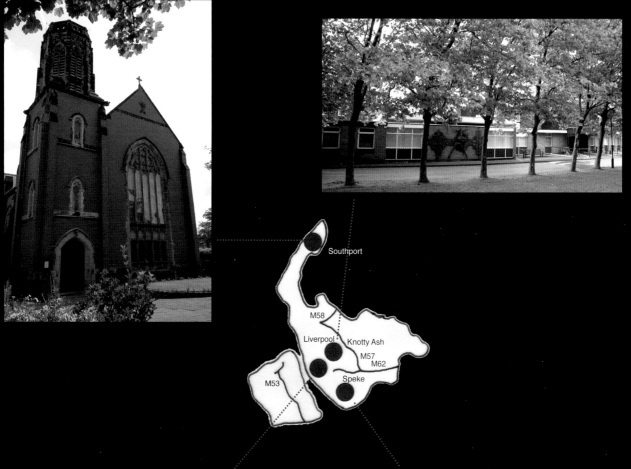

Southport

M58

Liverpool · Knotty Ash

M57
M62

M53

Speke

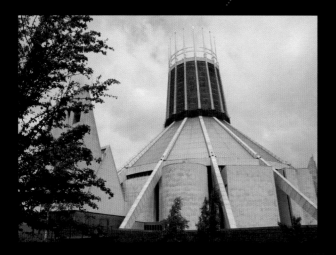

Knotty Ash, Christopher Grange (Catholic Blind Institute), Youens Way, L14 2EW

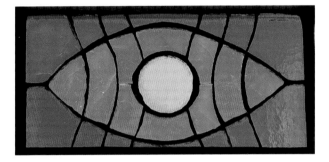

General: The 'Catholic Blind Asylum' was founded in 1841 by The Very Revd Dr Thomas Youens, and remains the only centre for the Catholic blind in England and Wales. The Sisters and Daughters of Charity have been involved in the organisation of the Centre since 1871. In 1969 work was begun on the new purpose built centre for rehabilitation and residential care of the visually impaired and physically disabled and the building was opened by His Eminence Cardinal Heenan on 12 October 1972. Robert Brumby who made the Lady statue for the Metropolitan Cathedral designed a sculpture of St Christopher which is on the exterior of the building by the main entrance and Jean and Rhys Powell made ceramic plaques for the interior. The name Christopher Grange pays tribute to the then General Secretary of the organisation T J Christopher Taylor and his father W E Taylor who had both been supporters of the Charity.

Title: unnamed

Date: 1969-1972

Location and Size: Chapel, clerestory windows, dalle-de-verre, each set of three measuring 50x279cm (19 1/2x110in). Two sets of three each side of the altar, 5 sets of three on the three remaining walls.

Designer and Maker: Patrick Reyntiens

Architect in charge: Roy Croft of Croft Cooper Partnership

Commemoration and Donors: The windows are in memory of Miss C R Sanders, Mr & Mrs W Williams, Mr & Mrs J O'Brien, K & J Kingston and Mr & Mrs T Dinneen. They were paid for by public subscription, including £150 from Reyntiens himself.

Literature: *CBRN*, 'Christopher Grange, West Derby, Liverpool', 1969, p411; *Catholic Blind Institute & St Vincent's School for the Blind and Partially Sighted, Annual Report & Statement of Accounts 1969-1970*, unpaginated; *Christopher Grange Centre for Adult Blind*, 1972, unpaginated; *Stained Glass Windows and Master Glass Painters 1930-1972*, Bristol: Morris & Juliet Venables, 2003, p85; Pollard Richard, Pevsner Nikolaus, *The Buildings of England, Lancashire, Liverpool and the South-West*, London: Yale University Press, 2006, p437

Reproduced: *Christopher Grange Centre for Adult Blind*, 1972, unpaginated

Notes: The south facing chapel, a large square space, occupies a central position in the complex. It was designed to meet the liturgical requirements of the 2nd Vatican Council, and a glass spire in the roof lights the central altar. Reyntiens' windows, with their yellow/orange colouring, complement the honey coloured wooden ceiling and lend a warm atmosphere to the space. All the panels contain an eye shape traversed by six curved leads, but every set of three is different in the way the colours are used. The middle three panels on the long walls have a central circle like a pupil, making the eye analogy more obvious. The eye symbolizes God the Father, whilst three eyes together could symbolize the Trinity. The orange colouring represents the inescapable grace of God.

Above: Detail of one of the 'eye' panels
Below: Chapel interior showing clerestory windows

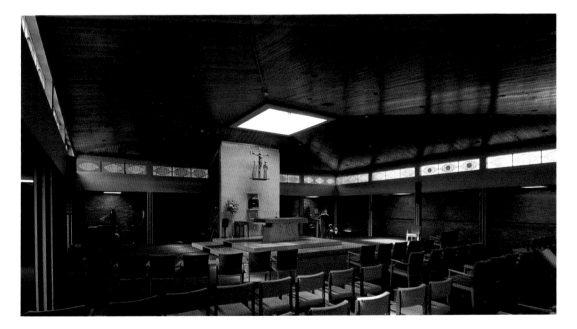

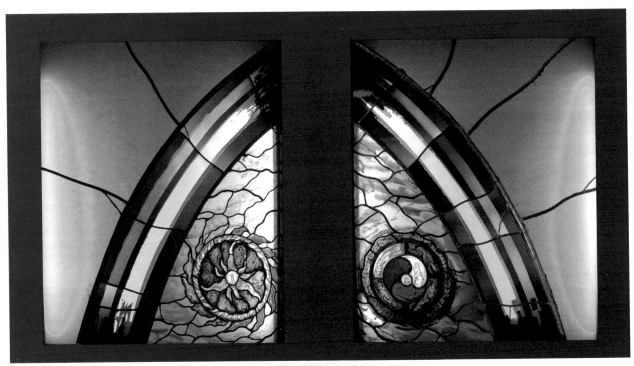

Title: unnamed

Date: 1969-1972

Location and Size: 'Market Place', 5 back-lit panels in dalle-de-verre, each measuring 117x71cm (46x28in)

Designer and Maker: Patrick Reyntiens

Technique: devised by Charles Broome

Literature: *Christopher Grange Centre for Adult Blind*, 1972, unpaginated; *Stained Glass Windows and Master Glass Painters 1930-1972*, Bristol: Morris & Juliet Venables, 2003, p85

Notes: The 'Market Place' is a communal area. The five panels are all variations on a theme, abstracts in red, yellow, orange, almost gold tones, with circles and rectilinear forms on a grid background balanced against curving lines created from the glass being used end on, thus creating a three dimensional surface and one which is tactile for the visually impaired to appreciate. Some of the glass is bonded, other parts are leaded,

Title: unnamed

Date: c1978-1979

Location and Size: Visual Rehabilitation Centre, Entrance hall, two back-lit panels, 136x113cm (53 1/2x44 1/2in)

Designer, Glass Painter and Maker: Patrick Reyntiens

Notes: The panels are almost identical. A three coloured rainbow, representing the Trinity and a link between heaven and earth, arches from one to the other, the outer area being plain opaque glass, the area below the rainbow in blue-green glass linked by undulating leads giving the impression of a sea, each containing a painted almost circular medallion, denoting eternity and God because of its perfect shape. In the left hand side is a sun within a sun (relating to the triskele in the adjacent panel) with Christ in the centre (Christ also being known as the Sun of Righteousness) all in yellow and orange tones, surrounded by mythical figures representing drama and the theatre, holding masks, lyres etc, executed in blues and greens. On the right hand panel Christ is in the centre of the medallion surrounded by a triskelion or tomoe of red, yellow and blue with lounging figures painted thereon. Actually a tomoe (a Japanese family crest) consists of revolving commas with their heads together, forming a perfect circle – Reyntiens' commas are distorted due to the central image. A circle of brown, yellow, ochre and green with more lounging figures encloses this shape; the whole contained within a blue watery circle.

Above: Visual Rehabilitation Centre panels
Left: One of the 'Market Place' panels
Right: 'Market Place' and panels

Liverpool, Metropolitan Cathedral of Christ the King (RC), Mount Pleasant, L3 5TQ

Listing: Grade II* (14 March 1975, amended 7 February 1994) #1070607

General: Liverpool has the largest Catholic population of any city in England and yet was the last to have a Catholic cathedral. Work first started on the cathedral in 1933 to a design by Sir Edwin Lutyens. Only the crypt had been started when work ceased because of World War 2. After John Carmel Heenan became Archbishop of Liverpool in 1957 he held an architectural competition which stipulated that the new building should relate to the completed crypt, be built within five years, cost no more than £1 million (1959 prices), be capable of seating 2,000 people and relate to the new liturgy of the Second Vatican Council. The competition was judged in 1960 and Sir Frederick Gibberd was chosen as architect (with his partner Jack Forrest) and 'Paddy's Wigwam', as it is affectionately known, was built between 1962 and 1967. Gibberd chose a circular plan with a central altar and peripheral chapels, the structure of concrete with ceramic mosaic and Portland stone cladding and an aluminium roof. The interior is a wonderful magical theatrical space, which, despite its modernity, breathes the air of deep contemplation which medieval cathedrals must have inspired in their day. There are countless treasures including a crucifix by Elizabeth Frink, two windows by Margaret Traherne and the Chapel of the Blessed Sacrament by Ceri Richards (see below).

Heenan transferred from Leeds and noted that 'to come from Yorkshire was not necessarily a passport in favour of Lancashire'! Despite his misgivings he became hugely popular in the city and it was a shame in a sense that he was appointed Archbishop of Westminster in 1963, leaving Archbishop Beck to oversee the completion of the cathedral.

In May 1967 Reyntiens wrote to Piper that he was 'terribly proud to have done that tower and the rest of the cathedral with you. I hope you feel happy about the whole work, which, considering all the difficulties that had to be overcome, was a great success'.

Consecration: of building 13 May 1967 by Bishop Harris, of high altar 14 May 1967 (Whit Sunday) in the presence of the Papal Legate

Literature: *Architect and Building News The*, Scott Keith 'Liverpool Cathedral – a criticism', 31 August 1960, p266-267; CBRS, Monsignor Cyril Taylor, 'Liverpool's New Metropolitan Cathedral', 1960, p212; CBRS, Rt Revd George Andrew Beck, Bishop of Salford, 'Design, Price and Value', 1960, p215; *CBRN*, 'Metropolitan Cathedral of Christ the King, Liverpool. The Final Design', 1961, *p38,40; CBRN*, 'Metropolitan Cathedral of Christ the King, Liverpool', 1962, p38,40; *CBRN*, 'Metropolitan Cathedral of Christ the King, Liverpool', 1964, p38; *CBRN*, 'Foreword by The Most Reverend George Andrew Beck, Archbishop of Liverpool', 1967, p23; *Studies in Church History: The Church and The Arts*, Tarn John Nelson, 'Liverpool's Two Cathedrals', Blackwell Publishers: Oxford, 1992, p539-541, 556-569; Heenan John C, *A Crown of Thorns. An Autobiography 1951-1963*, London: Hodder and Stoughton, 1974, p207, 280-307; *Stained Glass Windows and Master Glass Painters 1930-1972*, Bristol: Morris & Juliet Venables, 2003, p85

Reproduced: *CBRN*, 'Foreword by The Most Reverend George Andrew Beck, Archbishop of Liverpool', 1967, p25, 28, 33

Film: Heckford Michael, *Crown of Glass*, Shell Film Unit, 1967; Burder John, *Great Artists Rediscovered: John Piper, John Hutton*, John Burder Films, c1967; Pow Rebecca, *Rather Good at Blue. A Portrait of Patrick Reyntiens*, HTV West, 2000; Mapleston Charles, Horner Libby, *An Empty Stage. John Piper's romantic vision of spirit, place and time*, Goldmark/Malachite, 2009; Mapleston Charles, Horner Libby, *From Coventry to Cochem, the*

Art of Patrick Reyntiens, Reyntiens/Malachite, 2011

Title: *Holy Trinity*

Date: 1963-1967

Location and Size: Lantern Tower, dalle-de-verre, 16 bays each approximately 23.9x4.3M (70x14ft), a total of 12,500 sq ft of glass

Designers: John Piper and Patrick Reyntiens

Glass Maker: Patrick Reyntiens

Technical Supervisor: David Kirby

Architect in charge: Sir Frederick Gibberd and Jack Forrest

Studies: Henley Town Hall was hired and rolls of drawing paper 23.9x3.6M (70x12ft) were laid down. Piper and Reyntiens painted (in water colour, gouache and powder colour) the full size cartoons for each of the sixteen bays of the tower, working on three bays at a time.

Cost: £84,500 (of which £21,760 for glass, ordered from France and Germany)

Documentation: TGA 200410/2/1/7/1-27

Literature: *CBRN*, 'Metropolitan Cathedral of Christ the King Liverpool', 1963, p38; Little Bryan, *Catholic Churches since 1923*, London: Robert Hale, 1966, p224-225; Reyntiens Patrick, *The Technique of Stained Glass*, London: B T Batsford Ltd, 1967, p13, 175; *Studio International*, Piper John, 'The Liverpool Lantern', Volume 173, Number 890, June 1967, p294-295; Gibberd Frederick, *Metropolitan Cathedral of Christ the King Liverpool*, London: The Architectural Press, 1968, p59, 68-74; Heenan John C, *A Crown of Thorns. An Autobiography 1951-1963*, London: Hodder and Stoughton, 1974, p307; Lee Lawrence, Seddon George, Stephens Francis, *Stained Glass*, London: Mitchell Beazley, 1976, p17, 158; Clarke Brian (Ed), *Architectural Stained Glass*, London: John Murray, 1979, p193; West Anthony, *John Piper*, London: Secker & Warburg, 1979, p151, 154; Harrison, 1982, unpaginated; *John Piper*, Tate Gallery, London, 1983, p128; Stamp Gavin, 'Patrick Reyntiens and the Ovid Glass Panels', *Patrick Reyntiens, Glass Painted and Stained, Visions in Light*, Bruton Gallery, 1985, p3; Cowen Painton, *A Guide to Stained Glass in Britain*, London: Michael Joseph Ltd, 1985, p150; *John Piper in Wales*, p15; Morris Elizabeth, *Stained and Decorative Glass*, Baldock: Apple Press Ltd, 1988, p95; *Twentieth Century Architecture*, Harwood Elaine, 'Liturgy and Architecture: The Development of the Centralised Eucharistic Space', No 3, 1988, p68-69; *Studies in Church History: The Church and The Arts*, Tarn John Nelson, 'Liverpool's Two Cathedrals', Oxford: Blackwell Publishers, 1992, p560; Osborne, 1997, p85-91, 97, 174; Lewis David, *The Churches of Liverpool*, Liverpool: Bluecoat Press, 2001, p36; Harwood Elaine, *England. A Guide to Post-War Listed Buildings*, London: B T Batsford, 2003 (2000), p100; *The Metropolitan Cathedral of Christ the King, Liverpool. Authorised Cathedral Guide*, 2005, p14; Martin Christopher, *A Glimpse of Heaven. Catholic Churches of England and Wales*, Swindon: English Heritage, 2006, p204-206; Pollard Richard, Pevsner Nikolaus, *The Buildings of England, Lancashire, Liverpool and the South-West*, London: Yale University Press, 2006, p112, 255; Altet Xavier Barral I, *Stained Glass Masterpieces of the Modern Era*, London: Thames & Hudson, 2007, p67; *BSMGP*, '"C R Wyard, Aspects of 20th-Century Stained Glass": BSMGP International Conference 2008', Vol XXXII, 2008, p128; Spalding,

2009, p423-428; *Guardian The*, Bell Julian, 'Seeing the Light', 13 June 2009; *Oldie The*, McEwen John, 'DVD Reviews', February 2010, p74

Reproduced: Little Bryan, *Catholic Churches since 1923*, London: Robert Hale, 1966, fig48; Reyntiens Patrick, *The Technique of Stained Glass*, London: B T Batsford Ltd, 1967, frontispiece; *Studio International*, Piper John, 'The Liverpool Lantern', Volume 173, Number 890, June 1967, p294-295; Gibberd Frederick, *Metropolitan Cathedral of Christ the King Liverpool*, London: The Architectural Press, 1968, p59, 70, 71, 75; Heenan John C, *A Crown of Thorns. An Autobiography 1951-1963*, London: Hodder and Stoughton, 1974, facing p257; Lee Lawrence, *The Appreciation of Stained Glass*, Oxford University Press, 1977, p92; Compton Ann (Ed), *John Piper painting in coloured light*, Kettle's Yard Gallery, 1982, unpaginated; Morris Elizabeth, *Stained and Decorative Glass*, Baldock: Apple Press Ltd, 1988, p95; *Twentieth Century Architecture*, Harwood Elaine, 'Liturgy and Architecture: The Development of the Centralised Eucharistic Space', No 3, 1988, p68; *Studies in Church History: The Church and The Arts*, Tarn John Nelson, 'Liverpool's Two Cathedrals', Oxford: Blackwell Publishers, 1992, colour plate 8; Osborne, 1997, p88, 90, 91; Lewis David, *The Churches of Liverpool*, Liverpool: Bluecoat Press, 2001, cover , p36, 37; *The Metropolitan Cathedral of Christ the King, Liverpool. Authorised Cathedral Guide*, 2005, p14, 15; Martin Christopher, *A Glimpse of Heaven. Catholic Churches of England and Wales*, Swindon: English Heritage, 2006, p206; Spalding, 2009, p426, plates 68, 69

Notes: In his 'criticism' of the competition winners, Keith Scott pondered how the glass in the tower would be executed: 'one thinks in vain for the name of a British artist who is technically capable of handling the job'. According to Heenan it had been expected that the lantern glass would be supplied by the monks at Buckfast Abbey, but a visit to Coventry persuaded Heenan that Piper and Reyntiens should be offered the commission, to which Gibberd, himself a Coventry man, wholeheartedly agreed. Piper was offered the commission but could not work out how to deal with the window. Reyntiens observed that he had been reading Dante's *Inferno*, where there is a description of the Trinity, three great eyes of different colours winking at each other. Apparently there was a five minute pause before Piper commented, 'Pity Dante didn't tell you what to do with the rest of the cathedral!' The final design has three areas of white glass within the primary colours of red, yellow and blue with touches of orange, green and violet in the transitional areas, providing the complete spectrum. Yellow faces north to compensate for the lack of warm light from that direction, red faces south-west and blue south-east. The two artists were declared joint designers with a fee of £2,000 each. In December 1963 Piper demanded amendments to the proposed contract (for which they had already been paid £750) because the artists were concerned that someone else might be asked to complete their designs which would interfere with the integrity of their artistic vision. The final contract was dated 3 February 1964. Taylor Woodrow, the builders of the cathedral, erected a special studio near Reyntiens' home at Loudwater in Buckinghamshire measuring 22x12M (70x40ft) and fitted out with overhead cranes, oil fired central heating to ensure a continuous regular heat, and special tables (designed by Reyntiens) on which the panels could be cast and glazed. The design was transferred to polythene sheets and the glass placed on top of this. Each dalle-de-verre measured 25x30cm (9.8x11.8in), was 3cm (1.2in) thick and weighed 4.5kg (10lbs). Polystyrene blocks were used to support the glass prior to adding an industrial epoxy resin which was developed specially by Shell Petroleum. The epoxy mix was squeezed through a plastic bag. Strands of fibre glass (rovings) were then coated in epoxy and laid on top of the resin before a second coating of resin was applied – so the fibre glass was embedded to reinforce the structure in the same way that steel is used to reinforce concrete. Within hours the glass panels would be set and the polystyrene could be removed. Reyntiens started work at 4am every day and was joined by his team of assistants at 8am. All the glass was complete in 18 months. 156 panels were made, each one 365.8cm (12ft) wide and varying in height

from 182.9-304.8cm (6-10 ft). Each panel contained about 100 pieces of glass, none of which were painted. The total weight of the tower lantern is over 2,000 tons. At the time it was the largest ever religious stained glass commission.
Gibberd noted that: 'One of the most impressive aspects of the story of the Liverpool glass is that art ceased to be the exclusive and esoteric activity of a superior being, the artist. Everyone became involved in the design: the contractor, the consulting engineer, the architect, the quantity surveyor and a host of specialist technicians; the stained glass artists, on their part, became concerned with such technical problems as the properties of building materials, and industrialised building techniques.'
West observes that although critics tend to ignore the point 'there is nothing more stimulating to an artist than success, and Piper's knowledge that the Liverpool lantern had come off beyond his greatest expectations as one of the milestone achievements of modern English stained-glass design' launched him into a 'joyously creative period'.

Title: unnamed

Date: 1964-1967

Location and size: Entrances to peripheral chapels and subsidiary chapels, coloured glass, 2.5cm (1in) thick, epoxy resin and dalle de verre, vertical windows 22m (70 ft) high

Designers: John Piper and Patrick Reyntiens

Glass Maker: Patrick Reyntiens

Technical Supervisor: David Kirby

Cost: £30,895 (of which £10,250 for glass)

Documentation: TGA 200410/2/1/7/1-27

Literature: CBRN, 'Metropolitan Cathedral of Christ the King Liverpool', 1963, p38; Gibberd Frederick, *Metropolitan Cathedral of Christ the King Liverpool*, London: The Architectural Press, 1968, p67-68, 74; Lee Lawrence, Seddon George, Stephens Francis, *Stained Glass*, London: Mitchell Beazley, 1976, p17; Cowen Painton, *A Guide to Stained Glass in Britain*, London: Michael Joseph Ltd, 1985, p150; Jenkins David Fraser, John Piper in Wales, Davis Memorial Gallery, Welshpool, 1990, p15; *Studies in Church History: The Church and The Arts*, Tarn John Nelson, 'Liverpool's Two Cathedrals', Oxford: Blackwell Publishers, 1992, p560; Harwood Elaine, *England. A Guide to Post-War Listed Buildings*, London: B T Batsford, 2003 (2000), p100; *Stained Glass Windows and Master Glass Painters 1930-1972*, Bristol: Morris & Juliet Venables, 2003, p85; Martin Christopher, *A Glimpse of Heaven. Catholic Churches of England and Wales*, Swindon: English Heritage, 2006, p204-206; Pollard Richard, Pevsner Nikolaus, *The Buildings of England, Lancashire, Liverpool and the South-West*, London: Yale University Press, 2006, p112, 255, p358

Reproduced: Heenan John C, *A Crown of Thorns. An Autobiography 1951-1963*, London: Hodder and Stoughton, 1974, facing p320; Lee Lawrence, Seddon George, Stephens Francis, *Stained Glass*, London: Mitchell Beazley, 1976, p17; *Studies in Church History: The Church and The Arts*, Tarn John Nelson, 'Liverpool's Two Cathedrals', Oxford: Blackwell Publishers, 1992, p565; *The Metropolitan Cathedral of Christ the King, Liverpool. Authorised Cathedral Guide*, 2005, p2, 16, 17, 18; Martin Christopher, *A Glimpse of Heaven. Catholic Churches of England and Wales*, Swindon: English Heritage, 2006, p205; Spalding, 2009, plate 69

Notes: In March 1964 the two artists agreed to design the glass for the 'nave' at an additional design cost of £2,000 each and a contract was signed in October 1965. Gibberd's office

sent a letter to Reyntiens in 1965 noting that the chapels would be decorated at a later stage but wondering if Reyntiens could suggest a neutral tone of Claritude's 'Claricast' as a temporary measure. In the main body of the building each chapel is treated as an autonomous entity, a fact highlighted by the brilliant blue and red borders devised by Piper and Reyntiens at the entrance to each chapel. The clerestory is a band of blue, purple, mauve and green with flecks of red. The same colour scheme, omitting red, is used for the vertical windows. The east and west porches are glazed in red which Gibberd found too great a contrast. Reyntiens observed that Piper's genius for theatrical design came to the fore in this building, creating a composite religious décor. The comparative darkness has a contemplative and spiritual resonance.

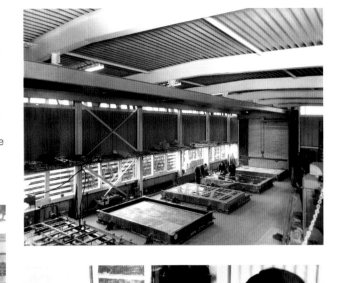

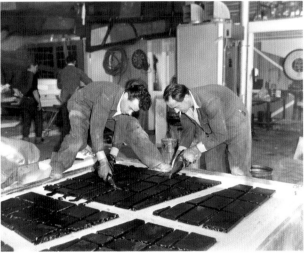

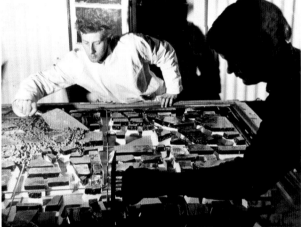

Top right: the Loudwater studio. Above: squeezing the epoxy mix between the dalles-de-verre. Right: Reyntiens working on a panel. Photographs courtesy of David Kirby. Below: *Holy Trinity*, Lantern Tower. Reproduced by kind permission of the Dean of the Metropolitan Cathedral, Canon Anthony O'Brien

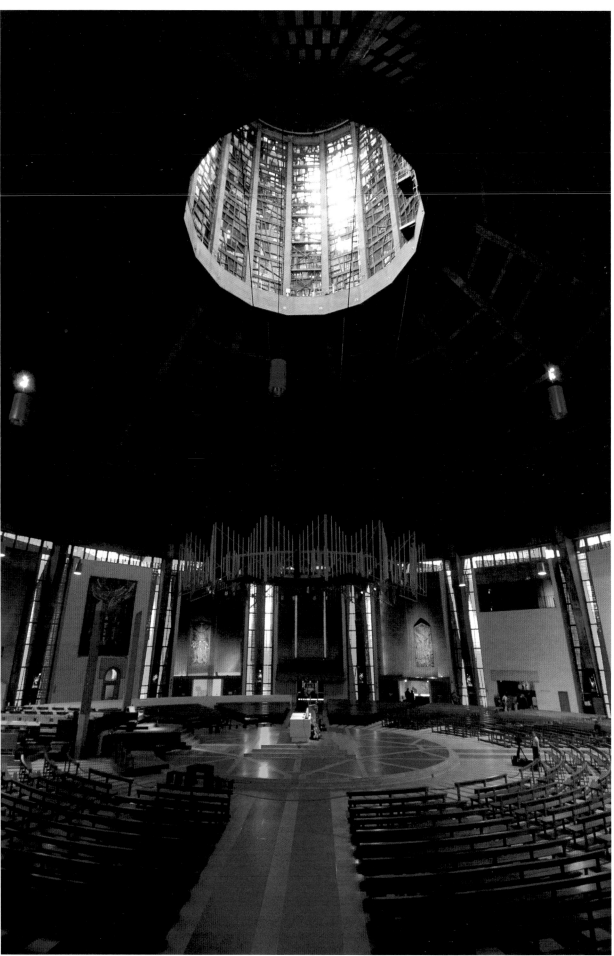

Title: unnamed

Date: 1964-1967

Location: East and West Apses either side of the Blessed Sacrament Chapel, dalle-de-verre

Designers: John Piper and Patrick Reyntiens

Glass Maker: Patrick Reyntiens

Reproduced: *The Metropolitan Cathedral of Christ the King, Liverpool. Authorised Cathedral Guide*, 2005, p21

Notes: There are two rows of sixteen rectangular lights in each area, on the northern side the main colour is green becoming lighter towards the centre with the addition of yellow and white glass, on the southern side the main colour is red fading to salmon pink and pale blue in the centre. Gibberd would have preferred the colouring to be symmetrical – i.e. both green or both red based.

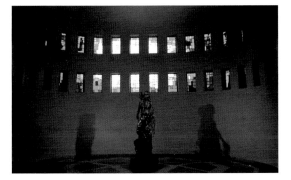

Above: One of the windows in the Children's Chapel and the Chapel of the Holy Oils
Reproduced by kind permission of the Dean of the Metropolitan Cathedral, Canon Anthony O'Brien

Title: unnamed

Date: 1964-1967

Location: Children's Chapel (St Anne's Chapel), dalle-de-verre

Designers: John Piper and Patrick Reyntiens

Glass Maker: Patrick Reyntiens

Notes: There are four horizontal windows arranged in portrait fashion on the east side of the chapel with almost identical glazing. Each window has a green background and contains three circles, the central one lemon coloured, and the outer ones orange. There is one further window in the gallery above.

Title: unnamed

Date: 1964-1967

Location: Chapel of the Holy Oils (St George and the English Martyrs), dalle-de-verre

Designers: John Piper and Patrick Reyntiens

Glass Maker: Patrick Reyntiens

Notes: The details are similar to the Children's chapel but the background colour is red-brown with a yellow eye central and turquoise green ones on the outside. There is one further window in the gallery above.

Left: Interior showing the entrances to peripheral chapels
Above: West Apse with sculpture of *Abraham* by Sean Rice and a light from the East Apse
Reproduced by kind permission of the Dean of the Metropolitan Cathedral, Canon Anthony O'Brien

Title: unnamed

Date: 1966-1967

Location: 2 large triangular windows either side of the altar in the Blessed Sacrament Chapel (Lady Chapel) - the windows are in two sections, each the shape of an isosceles triangle, 1006x488cm (33x16ft)

Designer: Ceri Richards

Glass Painter and Maker: Patrick Reyntiens

Technical Supervisor: Derek White

Studies: The full size cartoons were prepared jointly by Richards and Reyntiens

Literature: *John Piper, Ceri Richards*, Marlborough Fine Art Ltd, London, April 1967, unpaginated; Gibberd Frederick, *Metropolitan Cathedral of Christ the King Liverpool*, London: The Architectural Press, 1968, p117-121; Cowen Painton, *A Guide to Stained Glass in Britain*, London: Michael Joseph Ltd, 1985, p150; *Studies in Church History: The Church and The Arts*, Tarn John Nelson, 'Liverpool's Two Cathedrals', Oxford: Blackwell Publishers, 1992, p562; Harwood Elaine, *England. A Guide to Post-War Listed Buildings*, London: B T Batsford, 2003 (2000), p100; *Stained Glass Windows and Master Glass Painters 1930-1972*, Bristol: Morris & Juliet Venables, 2003, p85; *The Metropolitan Cathedral of Christ the King, Liverpool. Authorised Cathedral Guide*, 2005, p22; Martin Christopher, *A Glimpse of Heaven. Catholic Churches of England and Wales*, Swindon: English Heritage, 2006, p206

Reproduced: Gibberd Frederick, *Metropolitan Cathedral of Christ the King Liverpool*, London: The Architectural Press, 1968, p119; *Studies in Church History: The Church and The Arts*, Tarn John Nelson, 'Liverpool's Two Cathedrals', Oxford: Blackwell Publishers, 1992, p562; *The Metropolitan Cathedral of Christ the King, Liverpool. Authorised Cathedral Guide*, 2005, p22

Notes: Richards designed the windows, tabernacle and reredos for this, the largest of the peripheral chapels. The Cathedral Committee were distinctly unenthusiastic about Gibberd's choice of Ceri Richards. The design is abstract with free flowing curves and carried out in yellows and blues, 'suggesting a mysterious infinity of cool space' (Gibberd). Harwood notes that the gentler tones contrast with the vivid colours in the main body of the building. Meanwhile Tarn rather witheringly observes that: 'The best that can be said is that the three items relate thematically and in colour to one another and give the chapel some identity. But the lasting impression is one of self-consciousness.' Richards and Reyntiens had previously collaborated on the panel *La Cathedrale Engloutie* (Pallant House, Chichester, Sussex) and Derby Cathedral of All Saints.

Blessed Sacrament Chapel
Reproduced by kind permission of the Dean of the Metropolitan Cathedral, Canon Anthony O'Brien

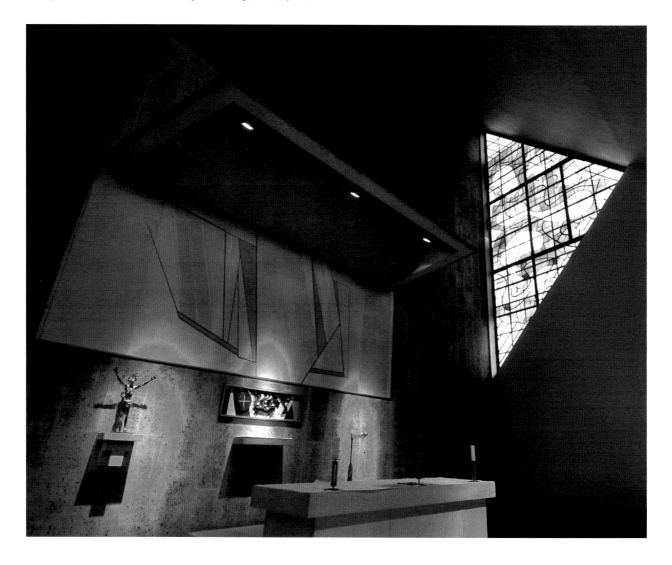

Southport, Holy Family (RC), Brompton Road, PR8 6AS

General: There are five windows on each side of the nave.

The following details are applicable to all three windows:
Designer, Glass Painter and Maker: Patrick Reyntiens

Literature: Hartwell Clare, Pevsner Nikolaus, *The Buildings of England, Lancashire: North*, Yale University Press, 2009, p623

Title: *Jesse window*

Date: 1974-1975

Location and Size: north aisle, 3 light window, approximately 305x160cm (120x63in)

Cost: Design, glass and assembly estimated at £800 by Reyntiens in 1974 (not including fixing and scaffolding)

Commemoration and Donors: The plaque below reads: 'THIS JESSE WINDOW, BY PATRICK REYNTIENS, WAS GIVEN BY THE PEOPLE OF/HOLY TRINITY PARISH IN 1975,/IN MEMORY OF/THE REVEREND JAMES FAULKNER,/PARISH PRIEST HERE 1947-1972/MAY HE REST IN PEACE'. Funds were raised through public subscription without recourse to parish funds.

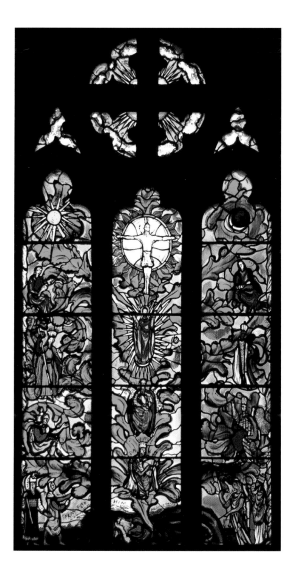

Documentation: Metropolitan Cathedral of Christ the King, Liverpool, Archives Department, Diocesan Finance & Development, X Files, Box 26, Parish No 116

Notes: On 28 February 1974 the Revd Edward K Taylor wrote to the Council of Administration noting that his parishioners wished to commemorate the late Revd James Faulkner and it was decided that a stained glass window would be suitable especially since there was an odd number of stained glass windows in the church. Reyntiens had already submitted a sketch for a Jesse window which was considered appropriate for a church dedicated to the Holy Family. The design was approved by the Fine Arts Commission. In this window Jesse can be seen at the bottom of the central light (inscribed 'JESSE') whilst at the top is a crucified Christ backed by a sun with the Virgin Mary below and various prophets resting in the large fronds. The inscriptions help identify some of the characters and places. At the bottom of the left hand light two hillocks are inscribed 'MORES MONS' and 'CARMEL', the two figures are labelled 'AARON' (he is depicted with his rod) and 'HOMO'. In the central light the lower figure is a crowned 'DAVID' playing his harp and above him 'SOLOMON' perhaps holding the Seal of Solomon. In the right hand light 'MELCHIZADEK' is identified, King of Salem or Jerusalem and a high priest (referred to in *Hebrews*, *Psalm* 110 and *Genesis* 14:18) who dispenses justice, hence the figure of Lady Justice at his side, holding scales and a sword and inscribed 'MULIER'. Across the left and central lights is inscribed the dedication: 'PRAY FOR HIM/ IN MEMORY OF REV JAMES FAULKNER PP here 1947-72'. At the top of the left and right lights the sun and a sliver of moon represent the three hours of darkness which covered the land during the crucifixion. A sun and clouds can be seen in the tracery and the colours are mainly blue and green with some red and yellow.

Left: *Jesse window*

Title: *Resurrection of God*

Date: 1975-1976

Location and Size: west end of south aisle, 3 light window, approximately 305x160cm (120x63in)

Inscription: signed b.r. of central light: 'Reyntiens/76'

Donors: The plaque below the window reads: 'THIS RESURRECTION WINDOW/BY PATRICK REYNTIENS/WAS GIVEN IN 1976 BY/JOSEPH AND MARY ROBINSON/OF THIS PARISH/Pray for them'

Documentation: Metropolitan Cathedral of Christ the King, Liverpool, Archives Department, Diocesan Finance & Development, X Files, Box 26, Parish No 116

Notes: The Revd Taylor wrote to the Council of Administration on 8 September 1975 concerning this window, noting that Reyntiens had submitted a sketch which Canon Ormsby of the Fine Arts Commission considered would result in 'a beautiful, devotional and educative work of art'. The design was approved on 22 September 1975. The Christ figure occupies the central light with right arm raised, his head resting on the Lamb of God with a triangular halo above (representing the Trinity), his feet almost touching his own dead body. Blue and green ribbons of land and water create almost a circle round his body, possibly symbolising an enclosed garden, representing the Virgin Mary, whilst the

other lights are filled with the waters of salvation trickling through green bands of countryside in which are illustrated scenes from Christ's Life. There are numerous inscriptions. In the left hand light 'EMAUS' indicates that the scene shows the Supper at Emmaus. Other inscriptions in this area include 'ET APERITI SUN …', 'PRAECED' and 'CHRISTUS SPES MEA' (Christ my hope). Above this 'ANGELICOS TESTE' (the angelic witness) reminding the faithful that angels unite heaven and earth and this union is expressed in the coming of Christ. Another inscription appears to read 'DIC OBIS MARIA QUID VIDISII IN VIA' and above that 'B BONI'. In the central light 'DUELLO' below the body of Christ and 'MOR SET VITA' above referring to the resurrection. On the large figure of Christ 'SUDARIUM ET VESTE' and in the halo 'CHRISTUS IMM [?] EN PATRI'. In the right hand light 'my love and my [?]', 'be not faith but believing', and further up 'it is the LORD', 'PISCES', 'VOS IN GALILEA' and '[?]xit christus spes mea' referring generally to the miraculous catch of fishes. God the Father and angels are found in the tracery. The colouring is generally white, green and blue with splashes of yellow.

Below: *Resurrection of Christ*
Right: *Assumption of the Blessed Virgin Mary*

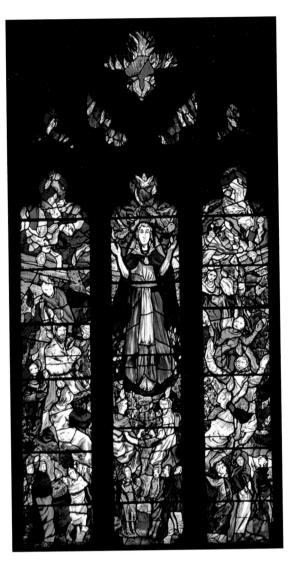

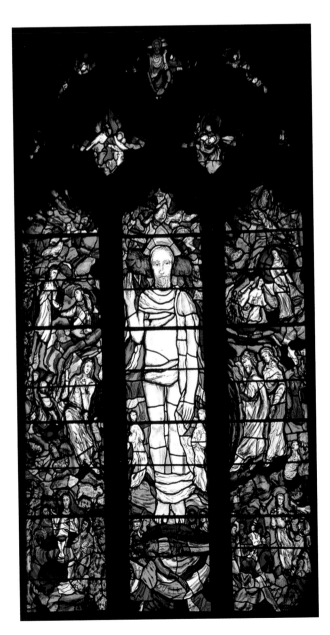

Title: *Assumption of the Blessed Virgin Mary*

Date: 1977

Location and Size: west end of north aisle, 3 light window, approximately 305x160cm (120x63in)

Designer, Glass Painter and Maker: Patrick Reyntiens

Commemoration and Donor: The plaque below reads: 'IN EVER GRATEFUL MEMORY/OF MY DEVOTED WIFE/MARY ROBINSON R.I.P/DIED 18TH FEBRUARY 1976/ Pray for her'

Documentation: Metropolitan Cathedral of Christ the King, Liverpool, Archives Department, Diocesan Finance & Development, X Files, Box 26, Parish No 116

Notes: On 4 February 1977 Revd Taylor wrote to Revd Vincent Burrowes of the Council of Administration, noting that Joseph Robinson wished to donate another window to the church as a gift to God and in memory of his late wife. Taylor felt sure that 'this latest project of his [Reyntiens] will be a fine work of art, orthodox, devotional and instructive'. He received approval five days later for this 'very impressive work of art', with the proviso that 'we assume that the figure of Our Lady will be more clearly "Our Lady" in the final work'. A Marian figure in the central light is surrounded by a profusion of other figures and flickering Pentecostal flames. The colours are blues, green, orange, purple and yellow. A red dove pointing downwards and a starburst are depicted in the tracery.

Speke, St Ambrose (RC), Heathfield Avenue, L24 7RS

Listing: Grade II (16 November 2007)

General: St Ambrose was the first Roman Catholic church in England completed to a rectangular plan with a free-standing altar, and the Catholic Building Record considered that 'the unique planning of the interior is likely to set a new pattern for church building in this country'. The church, built between 1959 and 1961 is built of reinforced concrete clad in brown brick whilst the campanile is clad with stock brick. Little describes the church as an 'important rectangular work', with slender concrete piers dividing the congregational space from an aisle behind the sanctuary and both sides of the nave. The high altar stands clear of the east wall with communion rails in a square. Lighting is from arched clerestory windows set with central panels of yellow and orange with clear surrounds. The ceiling vaulting is inset with pyramidal acoustic panels. The Stations of the Cross are by Adam Kossowski and Our Lady painting and triptych are by Jerzy Faczynski (St Mary of the Assumption, Leyland, Lancashire).

Literature: *CBRN*, 'Church of St Ambrose, Speke, Liverpool', 1961, p42; Little Bryan, *Catholic Churches since 1923*, London: Robert Hale, 1966, p219

The following details are applicable to both windows:

Title: *Marian Themes*

Date: 1975-1977

Location and Size: rectangular windows on north and south sides of Lady Chapel, each approximately 190x302cm (74 3/4x119in)

Designer, Glass Painter and Maker: Patrick Reyntiens

Architects in charge: Alfred Bullen and Jerzy Faczynski of Weightman and Bullen

Cost: estimated by Reyntiens June 1975 as £1,700-1,800

Documentation: Metropolitan Cathedral of Christ the King, Liverpool, Archives Department, Diocesan Finance & Development, X Files, Box 39, Parish No 185

Notes: In June 1975 the incumbent, Revd J Flynn, received a letter from the Council of Administration concerning his proposal to install two stained glass windows in the Lady Chapel. The Council were not averse to the project, provided that funds could be made available, but were concerned at the rise in vandalism and wondered whether the money might prove not to have been well spent. They advised sending the design to the Fine Arts Commission. The images have been described as 'cartoon style'. Unfortunately, perhaps due to the weight of the glass and the lack of saddle bars, both windows are sagging and bulging.

Title: *Marian Shrines, Lourdes and Paris*

Date: 1976

Location: south side of chapel

Inscription: signed and dated b.r.: 'Reyntiens 76'

Notes: On 11 February 1858 the 14-year-old Bernadette Soubirous claimed a beautiful lady appeared to her in the remote Grotto of Massabielle near Lourdes. The lady, who appeared 18 times in total, later identified herself as "the Immaculate Conception" and the faithful believe her to be the Blessed Virgin Mary. Bernadette declared that the apparition wore a white veil and a blue girdle, she had a golden rose on each foot and held a rosary of pearls. By 1859 thousands of pilgrims were visiting Lourdes and these days over five million pilgrims visit the town each year. The Sanctuary of Our Lady of Lourdes and the Basilica of St Pius X , the river and grotto are all shown on the right side of the window. Notre Dame and Notre Dame de la Medaille Miraculeuse (in the Rue du Bac) appear on the left side of the window (together with the Eiffel Tower). In 1830 Catherine Lebouré, a novice of the Daughters of Charity claimed the Virgin Mary appeared to her and instructed the girl to make healing medals. In February 1832 a cholera epidemic broke out in Paris, claiming more than 20,000 lives. The Sisters began distributing medals and many cures were reported with the result that the medals were proclaimed 'miraculous'. The colours in the window are very bright, the design almost abstract with images painted on the glass. In the top part of the window concentric curves, rather like a Michelin man, probably indicate clouds.

Title: *Marian Shrines, Fátima*

Date: 1977

Location: north side of chapel

Inscription: signed and dated b.r.: 'Reyntiens 77'

Notes: On 13 May 1917 ten year old Lúcia dos Santos and her cousins Jacinta and Francisco Marto were herding sheep near Fátima, Portugal. Lúcia claimed she saw a brilliant apparition of a woman surrounded by bright light. In further appearances the woman (who called herself 'The Lady of the Rosary' and was recognised as the Virgin Mary) told the children to do penance and Acts of Reparation, and to make sacrifices to save sinners. The children wore tight cords around their waists, beat themselves with stinging nettles and abstained from drinking water on hot days. The Virgin Mary was due to appear again on 13 October and promised a miracle which would convince unbelievers – this became known as the 'Miracle of the Sun'. About 70,000 people flocked to the Cova da Iria and Lúcia told everyone to look at the sun which then appeared to perform a dance, spinning and rotating and changing colour. This story is illustrated in the window, with the brilliant apparition lower left, and the dancing sun top right, its rays breaking through the mist and enveloping the countryside. Beautiful strong red and orange colours predominate.

Interior of church looking west

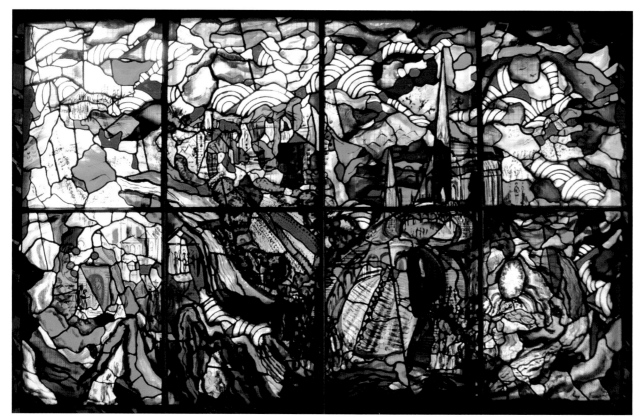

St Ambrose, Speke
Above: *Marian Shrines, Lourdes and Paris*
Below: *Marian Shrine, Fátima*

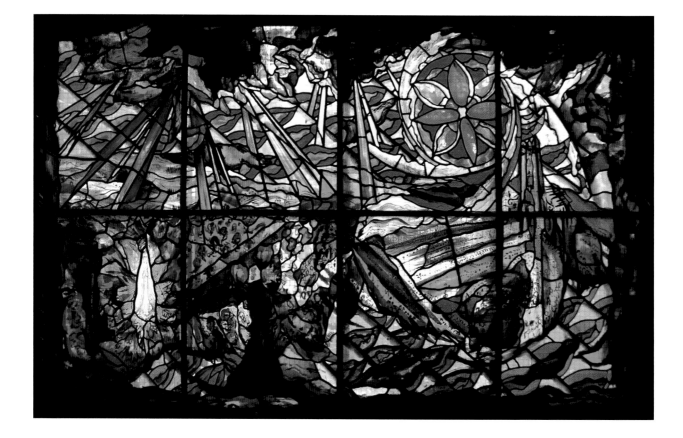

'The technical freedom of John Piper was enormous and I learnt a lot about it. When he wanted to splash something he just used to take it into the yard and splash it and if he wanted to do something really odd he used to fill the bath with water and then put various oil colours on top and then flick them around until they were right and then drop a piece of paper on them you see. When it was dry he would pull the plug and say "Myfanwy the bath needs cleaning".'

Reyntiens in interview, 2007

Light transmitted from *All Things Bright and Beautiful, Constance Elizabeth Chapman memorial window*, All Hallows, Wellingborough

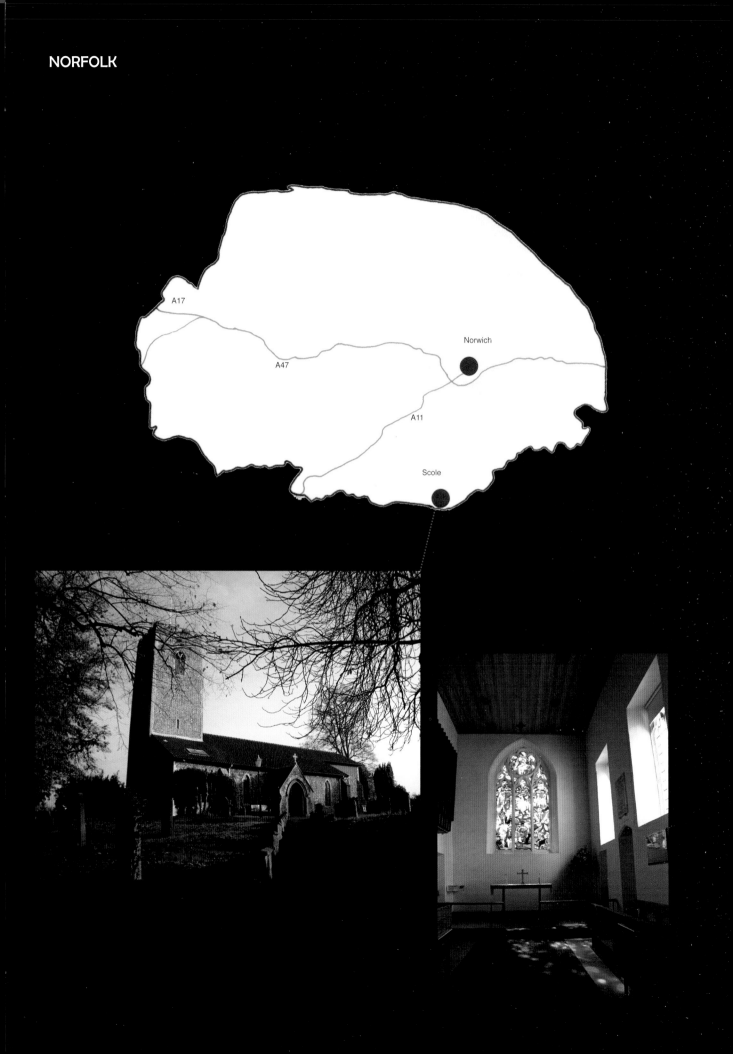

NORFOLK

A17

A47

A11

Norwich

Scole

Scole, St Andrew's, Norwich Road, IP21 4DY

Listing: Grade II* (7 December 1959) #1156145

General: St Andrew's is a flint church with stone dressings dating back to the 14th and 15th centuries but much restored in 1874. The east window was plain glazed until the late 1890s when it was replaced with stained glass in memory of W C Curteis. On 7 January 1963 during one of the coldest winters on record an arsonist set the church ablaze. The conditions were dreadful, slates and molten lead dropped from the roof, the smoke was so thick that firemen had to smash windows to get inside the church and once there had to use breathing apparatus and yet because of the cold the water the firemen used was freezing on their uniforms and the ground. The entire contents of the sanctuary and chancel, including the east window, were destroyed together with the chancel arch, the 15th century hammer-beam roof and most of the pews.

Title: *The Past, The Present and The Future*

Date: 1964

Location and Size: 3-light east window, approximately 396x183cm (156x72in)

Inscription: signed and dated bottom of right hand light: 'Reyntiens 64'

Designer, Glass Painter and Maker: Patrick Reyntiens

Architect in charge: Peter Codling of Fielden & Mawson

Cost: £950.00 (not including installation) price quoted October 1963

Faculty: 2 August 1963 (as part of general furniture and fittings)

Dedication: church re-consecrated on 17th September 1964 by Rt Revd Eric Cordingly, Bishop of Thetford

Documentation: Norfolk Record Office DN/CSP/29/3/1 and /2; DN/FCP/109

Literature: Cowen Painton, *A Guide to Stained Glass in Britain*, London: Michael Jospeh Ltd, 1985, p153; Harrod Wilhelmine, *The Norfolk Guide*, Bury St Edmunds: The Alastair Press, 1988 (1958), p146; Pevsner Nikolaus and Wilson Bill, *The Buildings of England, Norfolk 2: North-West and South*, London: Yale University Press, 2002 (1962), p632; *Stained Glass Windows and Master Glass Painters 1930-1972*, Bristol: Morris & Juliet Venables, 2003, p85; Earl Chris, *St Andrews Church, Scole, Norfolk. A history of Scole and its Church*, 2007, p13; Mortlock D P and Roberts C V, *The Guide to Norfolk Churches*, Cambridge: Lutterworth Press, 2007 (1981 and 1985), p245

Notes: Following the fire in 1963 Reyntiens was commissioned by the Rector, Revd Hugh Edward Lutwyche Clements, to design a new east window. A letter from the Architects to Clements dated 7 October 1963 states that Reyntiens had provided a sketch of the window. At first glance the window appears to be abstract but in fact there are recognisable symbols and images, and Reyntiens stated that he 'purposefully refrained from making the figures anything other than mnemonic ciphers as it is the impact of the trait I wish to emphasise. Detail and colour are individually expressed and fused together into an expressive whole'. The bottom of the window represents the past (the *Old Testament*) with a brazen fiery serpent created by Moses at the command of the Lord on the left (*Numbers* 21: 8-9) forecasting the Crucifixion, Jonah being vomited out of the whale's mouth (*Jonah* 2: 10) with

three smaller fish circling, forecasting the resurrection and on the right Elijah being swept up into heaven by a chariot of fire and horses of fire (*II Kings* 2: 11) forecasting the Ascension of Christ. The middle section of the window represents the present (*New Testament*) with the Resurrection indicated by a figure rising into the light, flanked by the Crucifixion left and the Ascension right, both with three figures in attendance. The tracery represents the future (Apocalypse) with the Lamb of God in the sexfoil, facing north but with its head facing south, a crozier laid across its shoulder. The heads of the multitude are seen beneath. The remainder of the tracery is purely decorative. The window is vividly coloured with bright oranges and reds dominating, sandwiched together, also green and turquoise, almost heraldic and clashing colours.

Mortlock and Roberts describe the window as 'a tumultuous composition, with dark reds and greens predominating' and Harrod terms it 'exciting'. When the sun shines the play of colours on the walls and floor is superb.

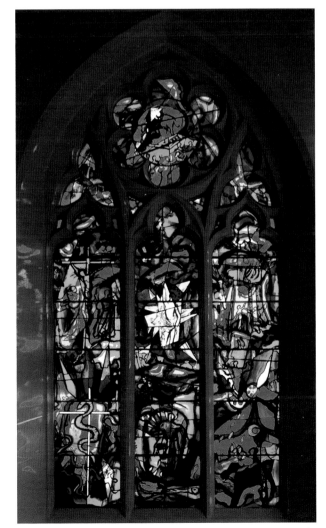

NORTHAMPTONSHIRE

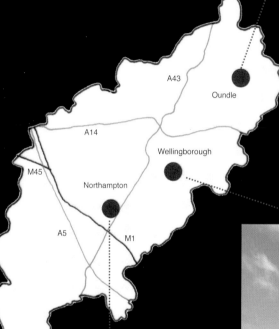

A43

Oundle

A14

Wellingborough

M45

Northampton

A5

M1

Northampton, St Peter & St Paul, Park Avenue South, Abington, NN3 3AB

Listing: Grade II* (19 January 1952) #1189663

General: The church is known as 'the church in the park' being situated in the beautiful Abington Park. Although the original church dates from the 12th century (the lower part of the Tower is a surviving relic) and served as a place of worship for the Manor House and its staff, in 1823 a storm destroyed the nave and aisles. This part of the church was rebuilt, rather unusually, with a flat ceiling and without columns and with timber window frames and tracery. A large gallery was added in 1922. The pulpit, with huge tester above, is perhaps from the workshop of Grinling Gibbons. The east window is by Heaton, Butler and Bayne (1862). The church is aligned about 11 degrees north of true east.

Date: 1980-1982

Title: *Annunciation*

Location and Size: 3-light east window, Lady Chapel, approximately 185x140cm (73x55in)

Inscription: In right hand light: b.r.: 'John Piper'; left of this 'IN MEMORY OF A/BELOVED WIFE AND MOTHER/MURIEL KATHLEEN JARMAN/WHO DIED IN HER 57th/YEAR ON 19 MARCH/1980 AND IS/INTERRED IN THE CHURCHYARD/THIS WINDOW WAS GIVEN BY/HER HUSBAND AND FAMILY'; above this 'REYNTIENS/WASLEY/1982'

Designer: John Piper

Glass Painter and Maker: Patrick Reyntiens and David Wasley

Commemoration and Donors: In memory of Muriel Kathleen Jarman, donated by her husband and family.

Dedication: 17 July 1982 (the anniversary of Muriel Jarman's birthday) at a private ceremony.

Documentation: Northamptonshire Record Office, Church of St Peter and Saint Paul, Abington (Parish Magazine), 1p/280/5 (August 1982)

Literature: Harrison, 1982, unpaginated; Osborne, 1997, p121, 124, 177; Langley John D, *A Short History and Guide To the Parish Church of St Peter and St Paul, Abington*, 4th edition, 2000, p8

Reproduced: Osborne, 1997, p123; Langley John D, *A Short History and Guide To the Parish Church of St Peter and St Paul, Abington*, 4th edition, 2000, p8

Notes: The window was commissioned by E W 'Pat' Jarman who had always admired Piper's work and thought it would be fitting if he designed a window for Abington 'to the greater glory of God and in thankfulness for a wonderful life'. He was delighted with the result, especially the 'atmospheric' blue. Piper overcame the difficulty he had in interpreting what would normally form a 2-light window, by adapting a painting by Botticelli (or his circle) in the Uffizi. The angel Gabriel, clad in red, flies upwards in the left hand light, whilst the Virgin Mary, also unusually in red, looks rather uncertain on the right. Between them is a yellow pot of lilies which Reyntiens has encased in leading almost like a tree trunk, and at the top of the window the trunk branches sideways into feathery falling leafed branches.

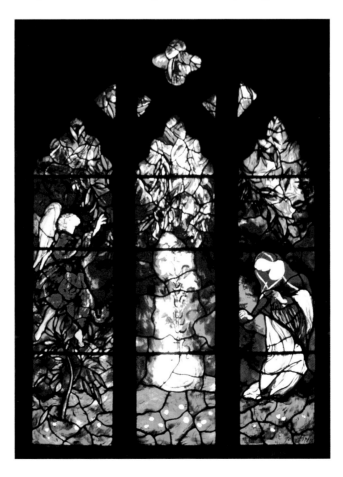

Oundle, Oundle School Memorial Chapel, Milton Road, Northamptonshire

Listing: Grade II* (7 June 1974) #1039825

General: Oundle is currently a co-educational independent day and boarding school with entry at 11, 13 or into the sixth form. Sir William Laxton (c1500-1556), eight times Master of the Grocers' Company and Lord Mayor of London, left his estate to the Grocers' Company to re-energise the grammar school he had attended in Oundle. In the 1870s the Company expanded the school further but it was really the appointment of Frederick William Sanderson as Headmaster in 1892 which transformed it into a first class public school. One of Sanderson's great aims was to build a new chapel for the school and the project was launched in 1917. It was to be a memorial to the old boys who died during World War 1, but Sanderson himself died a month before the foundation stone was laid in July 1922, so it became his memorial as well. The chapel was designed by Arthur Conran Blomfield in a 15th century Perpendicular style, of coursed limestone ashlar with clay tile roofs and cost £42,000. A Sanderson Memorial Fund was then established to buy furniture and fittings for the chapel and the last remaining money in the fund paid for the Piper/Reyntiens windows. There is a delightful series of windows dated 1949 depicting the *Seven Ages of Man* by Hugh Easton in the ambulatory behind the apse. The aisle windows, west end of the nave and the west porch were all designed by Mark Angus of Bath and installed 2002-2005.

Title: *The Way, The Truth, The Life*; *The True Vine, The Living Bread, The Water of Life (Baptism and Regeneration)*; *Christ the Judge, The Teacher and The Good Shepherd*

Date: 1953-1956

Location and Size: three 3-light windows in apse (east), plated, flashed, etched, stained and painted glass, **approximately 450x205cm (177x81in)** with central window slightly taller and wider

Designer: John Piper

Glass Painter and Maker: Patrick Reyntiens

Installation: Messrs G King & Son (Lead Glaziers) Ltd, Norwich

Studies: Oundle School own a number of studies and sketches for the windows

Cost: The windows were paid for with the remaining £3,800 in the Sanderson Memorial Fund. Piper's fee was £1,000 and Reyntiens quoted £10/sq ft of glass, total area being about 225 sq ft. Reyntiens' contract was for £2,800.

Commemoration: 400th anniversary of the founding of the school

Dedication: 26 May 1956 by Dr Robert Wright Stopford, Bishop of Fulham (a former member of staff and housemaster at Oundle, Bishop's Lodging, Peterborough, Cambridgeshire; St Margaret's, City of Westminster) in the presence of the Queen Mother.

Documentation: TGA 200410/1/1/3184; TGA 200410/2/1/11/3-15, 21; TGA9315.1; TGA9315.2; TGA200410/1/1OUN/OXF

Literature: Caudwell Hugo, *The John Piper Windows Executed for Oundle School Chapel by Patrick Reyntiens*, 1956; *Country Life*, Caudwell Hugo, 'New Windows at Oundle', 2 August 1956, p248; *BSMGP*, 'News and Notes', Volume 12, No 2, 1957, p92; *Modern Stained Glass*, Arts Council, 1960-1961, unpaginated; Pevsner Nikolaus, 2nd edition revised by Cherry Bridget, *The*

Buildings of England, Northamptonshire, Harmondsworth: Penguin Books, 1973 (1961), p71, 365; Harrison Martin, *Glass/Light*, The Royal Exchange, 1978, unpaginated; Clarke Brian (Ed), *Architectural Stained Glass*, London: John Murray, 1979, p79; Harrison, 1982, unpaginated; *House and Garden*, Levi Peta, 'Springboard from Piper and Reyntiens: or the brave new world of the stained-glass designers', April 1983, p147; Ingrams Richard and Piper John, *Piper's Places. John Piper in England & Wales*, London: Chatto & Windus, The Hogarth Press, 1983, p177; Reyntiens Patrick, 'Fawley in the Fifties', London, 1983; Cowen Painton, *A Guide to Stained Glass in Britain*, London: Michael Joseph Ltd, 1985, p67, 161; Morris Elizabeth, *Stained and Decorative Glass*, Baldock: Apple Press Ltd, 1988, p94; Reyntiens Patrick, *The Beauty of Stained Glass*, London: Herbert Press, 1990, p194; Bender Rodney, 'The Painter in Glass 19th and 20th Centuries', in Lloyd Alison (Ed), *The Painter in Glass*, Dyfed: Gomer Press, 1992, p38; *Spectator The*, Harrod Tanya, 'Talking about angels', 18/25 December 1993, p85; Lycett Green Candida (Ed), John Betjeman. Letters Volume Two: 1951 to 1984, London: Methuan, 1995, p65; Campbell Louise, *Coventry Cathedral. Art and Architecture in Post-War Britain*, Oxford: Clarendon Press, 1996, p170, 172; Osborne, 1997, pxv, p38-44, 52, 171; Raguin Virginia Chieffo, *the history of stained glass. The Art of Light Medieval to Contemporary*, London: Thames and Hudson Ltd, 2003, p276; *Stained Glass Windows and Master Glass Painters 1930-1972*, Bristol: Morris & Juliet Venables, 2003, p85; *Burlington Magazine The*, Spalding Frances, 'John Piper and Coventry, in war and peace', CXLV, July 2003, p494; Neiswander Judith & Swash Caroline, *Stained & Art Glass*, London: The Intelligent Layman Publishers Ltd, 2005, p238, 253; *BSMGP*, '"C R Wyard, Aspects of 20th-Century Stained Glass": BSMGP International Conference 2008', Vol XXXII, 2008, p127; Spalding, 2009, p349, 351-354; Woollen Hannah, Lethbridge Richard, John Piper and the Church. A Stained-Glass Tour of selected local churches, in conjunction with the exhibition at Dorchester Abbey from 21 April to 10 June 2012, 2012, unpaginated

Reproduced: *Country Life*, Caudwell Hugo, 'New Windows at Oundle', 2 August 1956, p248; Reyntiens Patrick, *The Technique of Stained Glass*, London: B T Batsford Ltd, 1967, p40, 107; Lee Lawrence, *The Appreciation of Stained Glass*, Oxford University Press, 1977, p48; Compton Ann (Ed), *John Piper painting in coloured light*, Kettle's Yard Gallery, 1982, unpaginated; *House and Garden*, Levi Peta, 'Springboard from Piper and Reyntiens: or the brave new world of the stained-glass designers', April 1983, p146; Cowen Painton, *A Guide to Stained Glass in Britain*, London: Michael Joseph Ltd, 1985, p162; Morris Elizabeth, *Stained and Decorative Glass*, Baldock: Apple Press Ltd, 1988, p95; Reyntiens Patrick, *The Beauty of Stained Glass*, London: Herbert Press, 1990, p195; Lloyd Alison (Ed), *The Painter in Glass*, Dyfed: Gomer Press, 1992, p66; Osborne, 1997, p42; Raguin Virginia Chieffo, *the history of stained glass. The Art of Light Medieval to Contemporary*, London: Thames and Hudson Ltd, 2003, p276; Neiswander Judith & Swash Caroline, *Stained & Art Glass*, London: The Intelligent Layman Publishers Ltd, 2005, p252; Spalding, 2009, plate 49

Film: Burder John, *Great Artists Rediscovered: John Piper, John Hutton*, John Burder Films, c1967; Pow Rebecca, *Rather Good at Blue. A Portrait of Patrick Reyntiens*, HTV West, 2000; Mapleston Charles, Horner Libby, *An Empty Stage. John Piper's romantic vision of spirit, place and time*, Goldmark/Malachite, 2009; Mapleston Charles, Horner Libby, *From Coventry to Cochem, the Art of Patrick Reyntiens*, Reyntiens/Malachite, 2011

Exhibited: Trial lancet of *The Good Shepherd* was exhibited at the Grocers' Hall and Phaidon Press, 1954

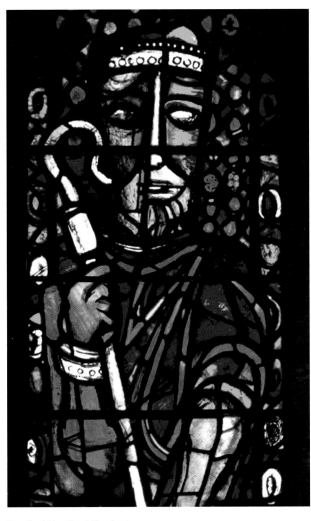

Detail of *The Good Shepherd*

Notes: Frederick Sanderson's successor, Graham Stainforth, wanted the chapel east window replaced and the Trustees of the Sanderson Memorial Fund were given the responsibility of choosing an artist. Major Leonard Dent, a past Master of the Grocers' Company, was appointed a Trustee by Stainforth and became the prime mover and shaker behind the windows. Initially Stainforth favoured Hugh Easton who had designed the ambulatory windows, but Easton declined the commission. Peter White was also asked to submit a design which he duly did for the central window in December 1953 (White was the son-in-law of Hugo Caudwell, a Modern Language teacher at the school). Meanwhile John Betjeman, who was a Liveryman of the Grocers' Company and who employed Dent's daughter Anita as his secretary, suggested that Piper be approached for a design even though he had never worked in this medium previously. (Betjeman was also involved with commissions for Eton College, Berkshire and Nuffield College, Oxford). Dent duly wrote to Piper on 19 May 1953 asking if he was interested in submitting designs. Piper thought of making the glass himself at the Royal College of Art but Betjeman pointed out to Piper that he already had too many projects on the go, and suggested approaching young Reyntiens (Wantage, Oxfordshire; *Heads of two Kings*, Autonomous Panels). This was the beginning of a remarkable partnership. It is clear from Reyntiens' article about Fawley that Piper had already produced five designs for the three windows, each design about 66x61cm (26x24in) and Reyntiens felt that 'what Stravinsky has done in relationship to music ... these designs have accomplished in relationship to stained glass'. Piper's designs were submitted to the Grocers' Company and approved of by Dent, Stainforth and Fred Drake, another Trustee. Dent displayed the designs in the cellars where he could show them to the converted including Stephen Glanville and Philip Frere, without horrifying other members of the Court. One of the panels, *The Good Shepherd*, was made as a trial piece at a cost of £200 and installed on the first floor of the Company's building – it was completed by 18 June 1954. Betjeman described the windows as 'awe-inspiring, reverent, and magnificent' noting that 'I believe that if the windows are completed they will make Oundle a place of pilgrimage'. The Governors gave their go-ahead the following month. 'The Young Man' as Stainforth and the others referred to Reyntiens then ruffled a few feathers by demanding a legal contract, which was rather alarming to those used to gentleman's agreements. A contract was finally signed later in the year.

The windows had to be completed and installed by March 1956 to be ready for the 400th anniversary celebrations which gave Reyntiens 15 months in which to finish the other eight lights. Each lancet is dominated by a more than life-size figure of Christ. The symbolism of the figures and their attributes (the majority from the Gospel of St John) was the suggestion of the Revd Victor Kenna, a friend of Piper (Churchill College, Cambridge; Coventry Cathedral, West Midlands). The figure in *The Way* holds a star, in the next light with a largely red background *The Truth* holds a tau cross whilst *The Life* holds a shield. The central figures are more dominant, *The True Vine* in gold and with a glorious pink clad leg holds a silver chalice, *The Living Bread* holds a wafer and *The Water of Life* in greens and blues holds a bowl. *The Judge* holds a flail, *The Teacher* a rod and *The Good Shepherd* a long silvery crook. Reyntiens noted that the head of the Shepherd was in the same proportion and characteristics as the head of the Holy Shroud in Turin.

The lights for the right hand window were completed first, followed by the left hand window and finally the central lights. The windows were installed shortly before the summer term, boarded up, and seen by the public for the first time on 26 May 1956. In his notes on the commission Dent observed that 'much of the credit for the success of the windows is due to him (Reyntiens) for all the skill and artistic sensitivity he displayed in giving birth in glass to Piper's magnificent designs'.

The windows are glorious, breath-taking, beautifully coloured and have an immediacy and life about them which was somehow never quite repeated in Piper's work, as if they were the culmination of his many years of studying and admiring stained glass. The figures are strangely enigmatic though, they stare beyond the viewer.

Caudwell observes that 'the tall figures of Christ have the majesty and poetry of the great verses of *Isaiah* and *The Revelation*'. In the *Country Life* article Caudwell observes that Reyntiens has 'applied the greatest originality, and indeed new technique, to rendering Piper's characteristic texture and calligraphy', noting the 'flashing' and plating of glass, and finishes that 'it is a rare and complete collaboration of artist and technician that has produced, at first trial, work unsurpassed in this medium'. Reyntiens describes the figures as the result of Picasso visiting the angels of Bourges and getting on very well together and thinks that the faces were influenced by Picasso's *Les Demoiselles d'Avignon*. He felt the general aura of the windows suggested a combination of *Psalms* 93 and 97. Pevsner considered the windows one of only four modern works of art worth mentioning in the county, the others being Evie Hone's stained glass at Wellingborough parish church (All Hallows, Wellingborough, Northamptonshire), and Graham Sutherland's *Crucifixion* and Henry Moore's *Virgin*, both at St Matthew's, Northampton. As Martin Harrison notes in his introduction to the *Glass/Light* exhibition, 'English stained glass had a largely undistinguished history until John Piper's first windows, for Oundle School'. The Queen Mother considered the windows 'the most exciting thing she had seen for years'!

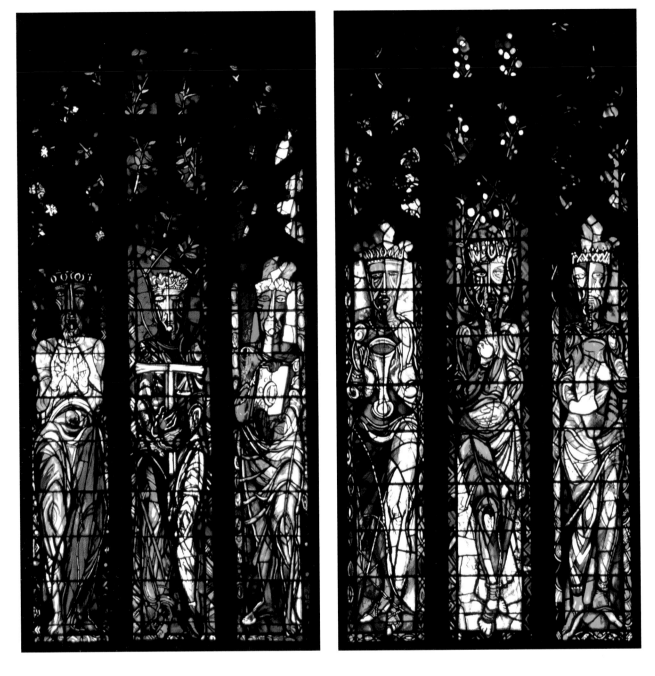

From left to right: *The Way, The Truth, The Life*; *The True Vine, The Living Bread, The Water of Life*; *Christ the Judge, The Teacher, The Good Shepherd*; detail of *The True Vine*

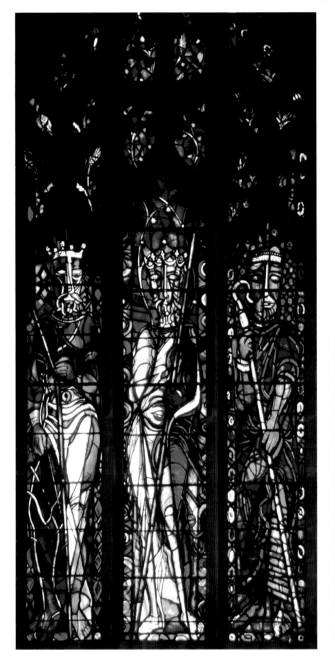

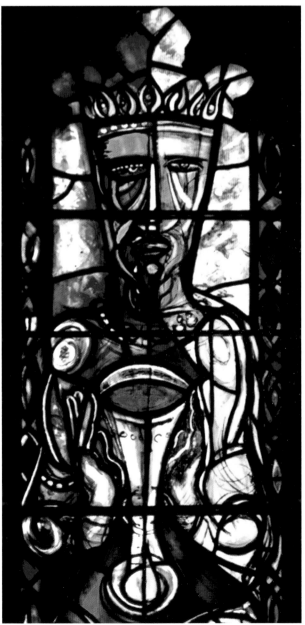

Wellingborough, All Hallows, The Church on the Market Square, NN8 4PA

Listing: Grade I (23 September 1950) #1371761

General: All Hallows dates from the 12th and 14th centuries and is built of squared coursed ironstone and limestone ashlar with a lead roof. Screens between the nave and chancel have attached figures after designs by Sir Ninian Comper. The south aisle west window was designed by Evie Hone in 1955 and much admired by Pevsner. There is also a window in the Lady Chapel dated 1962 by Jean Barillet depicting St Crispin (patron saint of shoes on which much of the town's wealth was based). The four figures on the pillars and the Rood screen date from about 1919 and were made after designs by Sir Ninian Comper.

Literature: Pevsner Nikolaus, 2nd edition revised by Cherry Bridget, *The Buildings of England, Northamptonshire*, Harmondsworth: Penguin Books, 1973 (1961), p72, 452; Harrison, 1982, unpaginated; Osborne, 1997, p74-76, 173; *Stained Glass Windows and Master Glass Painters 1930-1972*, Bristol: Morris & Juliet Venables, 2003, p86; Berrill Shirley, *Wellingborough Parish Church, All Hallows, guide*, 2012

The following details are applicable to all three windows:
Designer: John Piper

Glass Painter and Maker: Patrick Reyntiens

Title: *Beasts of the Evangelists (Old and New Testament Prophets), Helena Wells Chapman memorial window*

Date: 1960-1961

Location and Size: 4-light window at west end of north aisle, approximately 365x250cm (143 3/4x98 1/2in)

Commemoration and Donor: Helena Wells Chapman paid for by her sisters Millicent and Constance Chapman – the plaque below the window reads as follows: 'IN DIAM/MEMORIAM/ SORORIS AMABILIS/HELENA WELLS CHAPMAN/HAEC FENESTRA/POSITA EST/MCMLXI'

Literature: Pevsner Nikolaus, 2nd edition revised by Cherry Bridget, *The Buildings of England, Northamptonshire*, Harmondsworth: Penguin Books, 1973 (1961), p452; Cowen Painton, *A Guide to Stained Glass in Britain*, London: Michael Joseph Ltd, 1985, p163; Berrill Shirley, *Wellingborough Parish Church, All Hallows, Notes on the Stained Glass Windows*, 1995, unpaginated; Osborne, 1997, p74-76; Harwood Elaine, *England. A Guide to Post-War Listed Buildings*, London: B T Batsford, 2003 (2000), p608

Notes: The Chapmans were a wealthy local family who owned a box and cardboard factory in the town. The choice of Piper and Reyntiens may have been influenced by the vicar at the time Canon Matthew Methuen Clarke who had been curate at St Matthew's, Northampton when Hussey was the incumbent and had developed a love of fine art. The window represents the Symbols of the Evangelists – the four winged living creatures which drew the throne-chariot of God (*Ezekiel* 1) together with visions of the Old Testament Prophets. The left hand light, subtitled 'Law with Grace', bears the words 'S MATTHEW' and 'MOSES', the tracery and background to the upper half of the window is blue, with red in the lower part. Matthew is shown as an angel. The two Tablets of the Law are shown, one broken by Moses when he was enraged at the sight of the Children of Israel worshipping a Golden Calf, the other whole. Stones are also indicated in the traceries, representing the hardness of man's heart and the rock-like solidity of the Love of God. The second light, 'Strength with Sweetness' contains the words 'S MARK' and 'JUDAH', the tracery and background to the upper part of the window is yellow, the lower part purple/pink. Mark is indicated by a lion. The symbol of the vine is often used in relation to the House of Judah and vine leaves also indicate the goodness of God. The next light, 'Power with Love', has the words 'S LUKE' and 'AARON', the tracery and background is green (symbolizing the first domesticated animal), with blue below. Luke is represented by a bull, and the rod of Aaron which had miraculous powers is shown with almond blossom. The final light, 'Knowledge with Faith', has the words 'S JOHN' and 'ELIJAH', the tracery and background is red, with blue below. John is represented by an eagle, and since Elijah ascended to heaven in a chariot drawn by horses of fire, the wheels and red flames are depicted.
The colouring and weightiness of the images correspond well with its counterpart, the Evie Hone window in the south aisle.

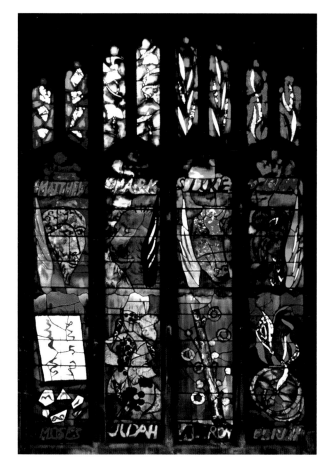

Left: Beasts of the Evangelists (Old and New Testament Prophets)

Title: *Our Lady of the Mystic Rose*

Date: 1963-1964

Location: 13th century rose window in the tower (west end)

Donor: The window was paid for by the Arts Council of Great Britain and the Contemporary Art Society

Documentation: TGA 200410/8/1 (where Piper dates the window as 1967)

Literature: Pevsner Nikolaus, 2nd edition revised by Cherry Bridget, *The Buildings of England, Northamptonshire*, Harmondsworth: Penguin Books, 1973 (1961), p452; Cowen Painton, *A Guide to Stained Glass in Britain*, London: Michael Joseph Ltd, 1985, p163; Berrill Shirley, *Wellingborough Parish Church, All Hallows, Notes on the Stained Glass Windows*, 1995, unpaginated; Osborne, 1997, p76; Berrill Shirley, *Wellingborough Parish Church, All Hallows, guide*, 2012, unpaginated

Notes: The rose window is in primary blue and red, the red representing the 'Mystic Rose' and blue being the colour of the Virgin Mary. Unfortunately, without climbing into the bell ringers' loft, the window is only visible through the glass above the wooden doors to the tower.

Title: *All Things Bright and Beautiful, Constance Elizabeth Chapman memorial window*

Date: 1969

Location and Size: , 3-light south window in Lady Chapel, unpainted, approximately 472x208cm (186x82in)

Inscription: b.l.: 'John Piper 1969' and 'Patrick Reyntiens 69/ Derek White, John D[?] Charles Broome 1969'

Assistants: Derek White, John D[?], Charles Broome

Commemoration and Donor: The slate plaque below the window reads: 'This window/in memory of Constance Chapman/ and given by her sister Millicent/was designed by John Piper and/made by Patrick Reyntiens/1969'

Literature: Pevsner Nikolaus, 2nd edition revised by Cherry Bridget, *The Buildings of England, Northamptonshire*, Harmondsworth: Penguin Books, 1973 (1961), p452; Cowen Painton, *A Guide to Stained Glass in Britain*, London: Michael Joseph Ltd, 1985, p163; Berrill Shirley, *Wellingborough Parish Church, All Hallows, Notes on the Stained Glass Windows*, 1995, unpaginated; Osborne, 1997, p76, 100, 112; Spalding, 2009, p419

Reproduced: Osborne, 1997, p75

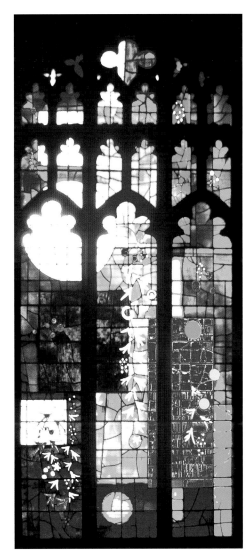

Notes: The hymn, *All Things Bright and Beautiful*, was Constance Chapman's favourite. The design lives up to its title, being both bright and beautiful, a joyous abstract, predominantly blue in colour with rectangles of red and green and falling leaf and flower forms and circles with a large white moon upper left. Piper used similar motifs at St Paul, Bledlow Ridge, Buckinghamshire and All Hallows, Wolverhampton, West Midlands. The Wellingborough flier notes that the window is 'unique' and 'highly controversial' and that when questioned about the symbolism, Piper responded 'It is what you make it to be'. The colouring empathises with the brightness of the Barilett window in the same chapel, and creates wonderful patterns on the floor when the sun shines through.

Top right: Our Lady of the Mystic Rose
Right: *All Things Bright and Beautiful*

NOTTINGHAMSHIRE

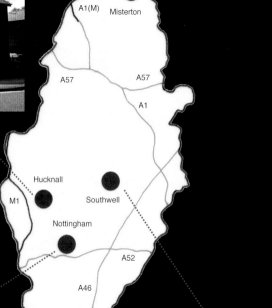

Misterton

A1(M)

A57

A57

A1

Hucknall

M1

Southwell

Nottingham

A52

A46

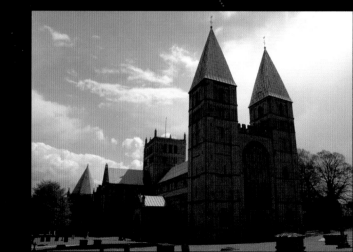

Hucknall, Holy Cross Parish (R.C.), Watnall Road, NG15 7NJ

General: The church, designed by architects Reynolds and Scott, was opened in 1960. It is built on a reinforced concrete foundation with a portal frame construction designed to allow for mining subsidence, exterior materials being red brick with reconstituted stone dressings and a slate roof. The church was designed to seat 300 people and the estimated cost in 1957 was £24,500 plus fittings. For an unprepossessing looking building it certainly contains some remarkable stained glass, the east window (in a strangely peppermint green painted sanctuary) being the work of Joseph Nuttgens in 1959 and the Baptistry window the work of his son Joseph in 2002.

Literature: *CBRS*, 'Proposed Church of the Holy Cross, Hucknall, Nottinghamshire', 1957, p118; *CBRS,* 'Proposed Church of The Holy Cross, Hucknall', 1958, p150; *CBRS*, 'Church of The Holy Cross, Hucknall, Nottinghamshire', 1960

Title: unnamed

Date: 1960

Location and size: Lady Chapel, a band of 6 rectangular windows clerestory on west wall, 7 rectangular windows on north wall and 6 rectangular windows on east wall, each window measuring approximately 36x30cm (14x12in)

Designer, Glass Painter and Maker: Patrick Reyntiens

Architect in charge: Reynolds and Scott

Dedication: 11 February 1960 by His Lordship the Bishop of Nottingham

Literature: *CBRS,* 'Church of The Holy Cross, Hucknall, Nottinghamshire', 1960, p164; *Modern Stained Glass*, Arts Council, 1960-1961, unpaginated; Williamson Elizabeth, Pevsner Nikolaus, *The Buildings of England, Nottinghamshire*, Harmondsworth: Penguin Books, 1979 (1951), p150; *Stained Glass Windows and Master Glass Painters 1930-1972*, Bristol: Morris & Juliet Venables, 2003, p86; www.grasshopper-hosting. co.uk/Diocese/02_Admin/AHP/Finalreport(PDF)NottinghamWestD eanery/Nottingham, Holy Cross

Notes: The panels are placed high in the walls and are all abstract, the west windows are mainly blue-green, the north windows predominantly blue and mauve with a heart and cross in the central panel, whilst the the east panels are in blue, green and mauve colours.

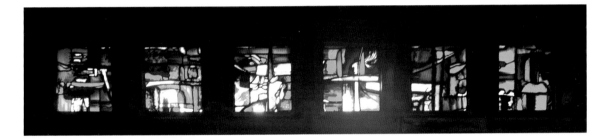

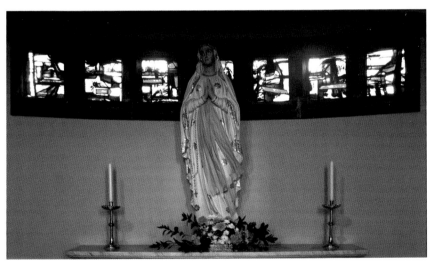

From top to bottom: East windows, North windows, west windows

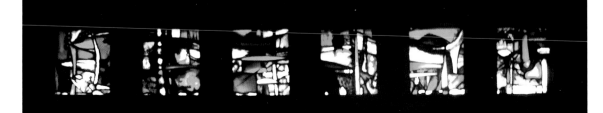

Misterton, All Saints, Church Street, DN10 4AH

Listing: Grade I (1 February 1967) #1302717

General: All Saints dates back to the 13th century with additions in successive centuries and is built of ashlar with ashlar dressings and coursed squared rubble with lead roofs. Following a storm in 1824 the north aisle and tower were rebuilt and a 30.5m (100ft) broach spire added, an unusual feature in this district. Some good gargoyles are to be found on the north side of the church, whilst inside there is more interesting stone carving, 15th century glass, a window by Charles Eamer Kempe and another by Kempe and Walter Ernest Tower.

Title: *Symbols of the Stigmata*

Date: 1960-1965, installed 9 August 1965

Location and Size: 3-light east window of north chapel (Holy Cross chapel), approximately 200x157cm wide (78 3/4x61 3/4in)

Designer: John Piper

Glass Painter and Maker: Patrick Reyntiens

Cost: The legacy amounted to £750, Reyntiens' invoice dated 7 April 1965 was for £390

Commemoration and Donor: The adjacent plaque reads: 'This glass is given/In Memory of her Mother/ ANNA MARIA/by ELEONORE SABINA'. The donor was Miss Eleonore S English.

Faculty: 23 June 1965

Dedication: Sunday 7 November 1965 by the Bishop of Southwell

Documentation: TGA 200410/2/1/11/47, 49; TGA 200410/2/1/11/65, 82, 94, 100, 130, TGA200410/2/1/16/1, 2, 4, 6, 13, 14, 16. Nottinghamshire Archives and Southwell & Nottingham Diocesan Record Office - faculty PR/16,582/12 (also recorded as DR/1/1/2/8825)

Literature: Williamson Elizabeth, Pevsner Nikolaus, *The Buildings of England, Nottinghamshire*, Harmondsworth: Penguin Books, 1979 (1951), p179; Harrison, 1982, unpaginated; Osborne, 1997, p97, 174; *A Guide to & Tour of the Parish Church of ALL SAINTS, Misterton*, 2006, p5

Reproduced: Clarke Brian (Ed), *Architectural Stained Glass*, London: John Murray, 1979, p179; Osborne, 1997, p94; *Stained Glass Windows and Master Glass Painters 1930-1972*, Bristol: Morris & Juliet Venables, 2003, p86

Notes: Piper received a letter from Revd Geoffrey Frank Blackmore in December 1960 stating that the church had been left a legacy for stained glass and he very much wanted a window which would add substantially to the church, not some cheap effort from Church furnishers. He also noted that, having initially trained as an architect, he was moved to ordination after reading Piper's *Buildings and Prospects*. By 1962 Blackmore had succeeded in persuading his two wardens that Piper should be commissioned to design the window. In October that year Blackmore suggested the symbols of martyrdom, the Lamb of God and the *Book of Revelation*: 'These are they which are come out of great tribulation and have washed their robes in the blood of the Lamb'. He added that St Catherine's Wheel was a good circular motif. On 28 August 1963 the solicitor for the executors gave permission for the window and the Advisory Committee approved the design 18 May 1965. In the event Piper

designed a green Tree of Life in the shape of a cross on a dark blue background, with the hands, feet and central bleeding heart in white with red wounds. The colours are bold and dramatic. On 28 August 1965 an enthusiastic Blackmore wrote to Piper that 'the window looks marvellous in the morning light and casts great pools of colour out over the altar and the floor. I am sure I have never seen the great doctrines of our faith so clearly and wonderfully stated.'

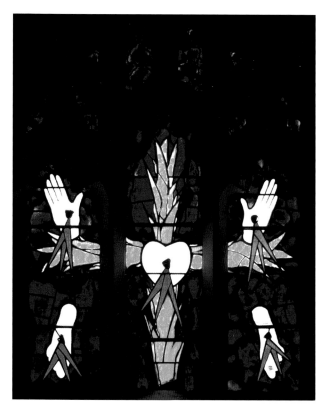

Nottingham, The Good Shepherd (R.C.), Thackerays Lane, Woodthorpe, NG5 4HT

Listing: Grade II* (25 September 1998) #1376603

General: Father Bernard Mooney had admired Gerard Goalen's design for Our Lady of Fatima in Harlow and approached him to design this church which won an award from the Royal Institute of British Architects in 1966 (the plaque is visible at the church entrance), although Williamson prosaically terms it 'typical of its date'. It was built between 1962-1964, at a cost of £70,000 (the cost being met by the parishioners), with the stained glass forming an integral part of the design. The building materials are concrete and brick and the interior space, which can seat 600 people, is an elongated hexagon, the centralised plan relating to the liturgy of the Second Vatican Council. Traditional orientation was not considered necessary (the church is orientated about 10 degrees east of north). The church is unmissable, not only for its uncompromising modern structure but also the 30.5m (100ft) high spire topped by a 244cm (8ft) cross. The contract period of 21 months was delayed by two months due to the harsh winter of 1962-1963 but the building was completed one month before the opening ceremonies. As with many (almost experimental) reinforced concrete buildings of the 1960s made with rapid-hardening cement, the reinforcement has rusted and cracked the concrete extensively. More than £430,000 has been spent repairing the building, with a further £250,000 worth in the pipeline. The church also boasts a delightful set of minimalist carved stone Stations of the Cross by Nicholas Mynheer (c2001).

Literature: CBRS, 'Church of The Good Shepherd, Thackeray's Lane, Woodthorpe, Nottingham', 1961, p178

Title: Biblical Trees

Date: 1962-1964

Name, Location and Size: The Tree of the Cross behind the altar, two walls at an angle to each other creating three 4-light arched windows, each wall 6400x7100cm (2520x2795in); Tree of Good and Evil and Tree of Life on either side of the sanctuary, rectangular, 6400x7100cm (2520x2795in); Burning Bush above the entrance on the southern apex of the nave, two rectangular windows at an angle to each other, 6400x3400cm (2520x1339in), all dalle-de-verre

Designer and Maker: Patrick Reyntiens

Technical Supervisor: David Kirby

Architect in charge: Gerard Goalen (St Gregory the Great, London Borough of Hillingdon)

Installation: William Woodsend Ltd

Dedication: 23 July 1964 by Archbishop Beck of Liverpool (Father Mooney celebrated his Silver Jubilee on the same day)

Literature: CBRS, 'Church of The Good Shepherd, Thackeray's Lane, Woodthorpe, Nottingham', 1961; CBRS, 'Church of the Good Shepherd, Thackeray's Lane, Woodthorpe, Nottingham', 1963, p174; Nottinghamshire Guardian, 20 July 1963; CBRS, 'Church of The Good Shepherd, Thackeray's Lane, Woodthorpe, Nottingham', 1964; Nottinghamshire Guardian, 18 April 1964; Architect & Building News, 'Church, Nottingham', 23 September 1964, p583, 586; CBRS, 'Church of The Good Shepherd, Thackeray's Lane, Woodthorpe, Nottingham', 1964, p142; churchbuilding, Corbould Edward O.S.B., 'St Mary's Priory Church, Leyland', October 1964, no 13, p8; Architecture East Midlands, Stone John, 'Roman Catholic Church of the Good Shepherd, Woodthorpe', No 10, October/November 1966; Little

Bryan, Catholic Churches since 1923, London: Robert Hale, 1966, p216; Williamson Elizabeth, Pevsner Nikolaus, The Buildings of England, Nottinghamshire, Harmondsworth: Penguin Books, 1979 (1951), p38, 58; Twentieth Century Architecture, Harwood Elaine, 'Liturgy and Architecture: The Development of the Centralised Eucharistic Space', No 3, 1988, p66-67; Harwood Elaine, England. A Guide to Post-War Listed Buildings, London: B T Batsford, 2003 (2000), p182; Martin Christopher, A Glimpse of Heaven. Catholic Churches of England and Wales, Swindon: English Heritage, 2006, p200-201; Powell Kenneth, Notttingham Transformed. Architecture and Regeneration for the New Millenium, London: Merrell Publishers Ltd, 2006, p33; www.grasshopperhosting.co.uk/Diocese/02_Admin/AHP/Finalreport(PDF)NottinghamEastDeanery/Nottingham,Woodthorpe,theGoodShepherd (2010); Dale Ernest, A History of the Parish of The Good Shepherd Woodthorpe, 2011, p9, 10, 13, 15, 17, 25, 29, 35; Telegraph The, 'The Angel Awards: The Good Shepherd, Woodthorpe, Nottinghamshire', 17 September 2011; Church of the Good Shepherd, Woodthorpe, Nottingham, undated, unpaginated; Church of the Good Shepherd, undated, unpaginated

Reproduced: Architect & Building News, 'Church, Nottingham', 23 September 1964, p585-587; CBRS, 'Church of The Good Shepherd, Thackeray's Lane, Woodthorpe, Nottingham', 1964, p145; Little Bryan, Catholic Churches since 1923, London: Robert Hale, 1966, fig 45(a); Harwood Elaine, England. A Guide to Post-War Listed Buildings, London: B T Batsford, 2003 (2000), p183; Stained Glass Windows and Master Glass Painters 1930-1972, Bristol: Morris & Juliet Venables, 2003, p86; Martin Christopher, A Glimpse of Heaven. Catholic Churches of England and Wales, Swindon: English Heritage, 2006, p201; Powell Kenneth, Notttingham Transformed. Architecture and Regeneration for the New Millenium, London: Merrell Publishers Ltd, 2006, p32; Dale Ernest, A History of the Parish of The Good Shepherd Woodthorpe, 2011, p20-21; Church of the Good Shepherd, Woodthorpe, Nottingham, undated, unpaginated; Church of the Good Shepherd, undated, unpaginated

Notes: The client, Father Mooney, and the Nottingham Roman Catholic Diocesan Trustees, asked for external walls of dalle-de-verre in the nave and sanctuary, but unfortunately the cost would have been prohibitive, so the architect provided for stained glass in the sanctuary area and above the entrance with a system of obscure glass set in louvered concrete mullions elsewhere. The interior of the church is bathed in blue light by the Reyntiens' windows which changes as the sun and clouds move across the sky. The windows are all abstract, not quite symmetrical, and for dalle-de-verre some of the pieces of glass are surprisingly small. The theme is of trees. The two windows in the sanctuary area combine the New Testament Tree of the Cross, Tree of the Mustard Seed and the vine and branches together with the stigmata of Christ and the Crown of Thorns in red. The glass here, in dark green and a range of blue tones, is darker than in the remaining windows so that the high altar does not lose prominence and the green branches slither outwards like octopus legs. In the architect's notes (quoted in the excellent guidebook) Goalen says the windows 'give the feeling that the whole sanctuary is an arbour – reflecting the structural theme of the building, and completing the most important of the three arbours that Peter suggested to Christ should be built on Mount Tabor, "one for thee, one for Moses, and one for Elijah"'. The trees of the Old Testament, the Tree of Good and Evil and the Tree of Life are featured on the walls to the left and right of the sanctuary. The glass is lighter here, pale green, a range of blues and some red dots, with a bias of horizontal undulating lines. Above the entrance the colours are again blue and green with some mauve tones and Harwood says that the windows are 'not only of

exceptional quality in their own right, but strengthen the numinous, organic experience of the church' and Reyntiens is quoted in the Corbould article as stating that 'the window over the entrance door is the nearest thing I have got in my search for spontaneity, fluidity and yet colour and tone discipline, all coalescing into a unified experience'. One would have perhaps expected a Burning Bush to include some red and orange colouring but not so in this case. Williamson notes that the simplicity of the church is 'relieved by a glorious display of glass by Patrick Reyntiens', whilst Stone observes that the glass is 'less convincing when seen from outside'.

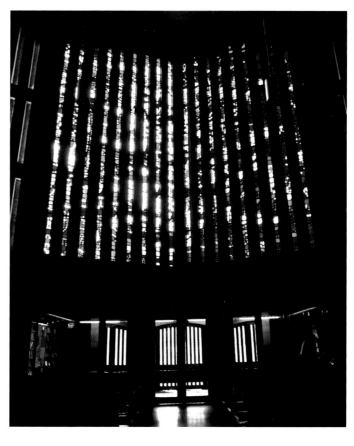

Bottom left: *Tree of Good and Evil*
Bottom Right: *Tree of Life*
Right: *Burning Bush*
Facing page: *Tree of the Cross*

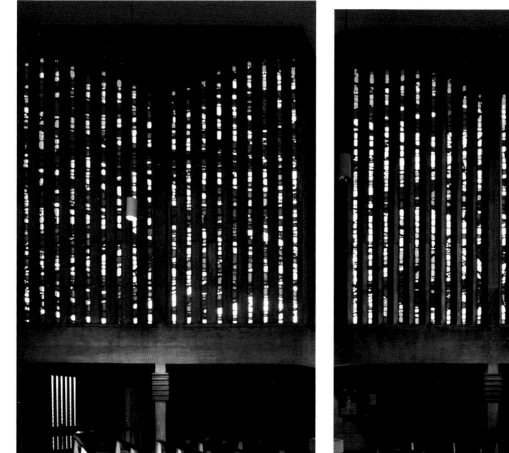

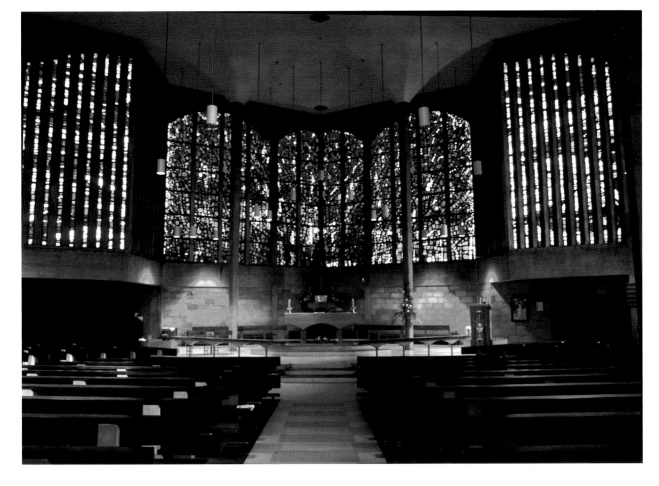

Southwell, Minster and Cathedral Church of St Mary the Virgin, Church Street, NG25 0JR

Listing: Grade I (11 August 1961) #1374853

General: Southwell Minster is one of the most beautiful of English religious establishments surrounded by lawns and chestnut trees which add to the grace and serenity. The west end of the Minster and the transept dates from the 12th century, the east end beyond the crossing has been dated 1235-1250 and the Chapter House is dated 1290-1300. The north porch is worth noting for the blind arcading, the seven orders of moulding round the Norman arched doorway and the three windows above the porch which lit the sacrist's room. The Chapter House reveals a glorious profusion of wonderful carved stone, faces, flowers, beasts, with baskets of stone carving at the entrance. The Perpendicular west window was added in the 15th century and glazed in plain green and yellow in the 19th century. In 1711 the western spires were struck by lightning which damaged the building as far as the western tower. Luckily in the 1840s the new Ecclesiastical Commissioners' body charged Ewan Christian with the task of restoring the Minster to its former glory, which he did with great sensitivity. More recent additions include a red altar frontal by John Piper in St Oswald's Chapel, the furniture in the Choir from the workshops of Robert 'Mousey' Thompson (Ampleforth Abbey, Yorkshire) and four works by Peter Eugene

Ball – *Christus Rex* at the east end of the nave (St Alban Promartyr, London Borough of Havering), a *Pieta* in the South Transept, *Ecce Homo* in the North Quire aisle and *Christ* in the Chapel of Christ the Light of the World.

Title: *Angel windows*

The following details are applicable to all 6 windows:
Date: 1995

Location and Size: 6 single lancet windows on right hand side of Chapter House Passage, approximately 60x51cm (23 1/2x20in)

Designer and Glass Painter: Patrick Reyntiens

Glass Maker: John Reyntiens

Architect in charge: Martin Stancliffe

Literature: *Southwell Minster. The Cathedral and Parish Church of the Blessed Virgin Mary. The Cathedral Companion*, undated, p12

Film: Mapleston Charles, Horner Libby, *From Coventry to Cochem, the Art of Patrick Reyntiens*, Reyntiens/Malachite, 2011

Notes: These exquisite little windows mirror the angels in the Great West window. In each the top half of a robed female angel is shown, with a large halo and holding a sphere in which a Biblical episode in portrayed. Each angel is unique and the faces are mesmeric, calm and beautiful. Reyntiens has added some medieval inspired borders and filled the background with an impression of mille-fleurs which perfectly reflects the range of botanical species shown in the stone carvings. From the Minster towards the Chapter House they are as follows:

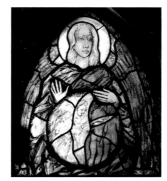

Name: *Adam and Eve being expelled from the Garden of Eden*

Inscription: signed and dated b.r. 'Reyntiens 95'

Notes: A blue clad angel holds a sphere in which the nude brown figures of Adam and Eve are expelled by an angry looking yellow angel on the left, one blade of yellow crossing into the right hand side like a sword.

Name: *Jacob wrestling with the Angel*

Inscription: signed and dated b.r. 'Reyntiens 95'

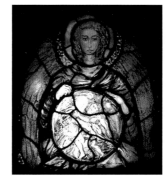

Notes: A brownish clad angel holds a yellow, grey and brown orb in which Jacob and the angel can be seen wrestling.

Name: *Annunciation*

Inscription: signed b.r.: 'Reyntiens 95'

Notes: The sphere held by this red clad angel shows the angel with the Virgin Mary, a lily on the right hand side.

Name: *Bethlehem*

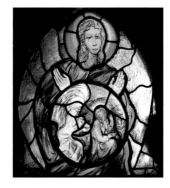

Inscription: signed and dated b.r. 'Reyntiens 95'

Notes: A green clad angel holds one hand up in blessing. The orb shows Joseph and Mary holding the baby Jesus.

Name: *Garden of Gethsemane*

Inscription: signed and dated b.r. 'Reyntiens 95'

Notes: An angel with a red ringed halo and a green cloak holds a sphere depicting Christ in agony in the garden of Gethsemane together with the angel who came to strengthen him.

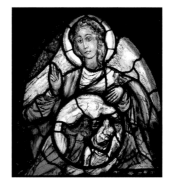

Name: *Ascension of Christ*

Inscription: signed and dated b.r. 'Reyntiens 95'

Notes: An angel in grey holds one hand up in blessing. The orb shows Christ's feet disappearing into the clouds illustrating the Ascension of Christ forty days after the Resurrection (Frances Bardsley School, London Borough of Havering).

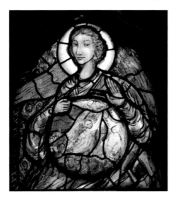

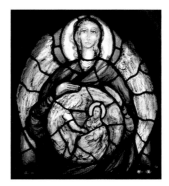

From top to bottom:
Adam and Eve being expelled from the Garden of Eden
Jacob wrestling with the Angel
Annunciation
Bethlehem
Garden of Gethsemane
Left: *Ascension of Christ*

Title: *Angel window*

Date: 1996

Location and Size: 7-light Great West window, approximately 2499x1737cm (984x684in)

Designer and Glass Painter: Patrick Reyntiens

Glass Maker: Keith Barley, Barley Studio, York

Architect in charge: Martin Stancliffe

Studies: Apparently there was some resistance to the idea of stained glass in the west window and Reyntiens was charged with producing seven roundels symbolising Acts of Creation which would give the powers that be some indication of what the window would look like. These roundels are each 36.5cm (14 1/4in) diameter and are permanently exhibited in the nearby Minster Centre, Church Street. They represent *Creation of Light*, *Vaults of Heaven*, *Dry land appearing out of the waters*, *Day and Night*, *Birds and Fish*, and *Living Creatures on the Earth*. A seventh panel showing Adam and Eve was broken.

Dedication: 7 July 1996

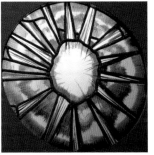
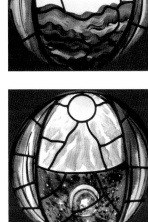
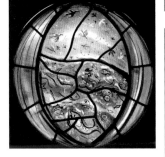
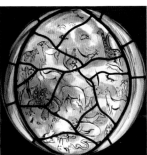

From top to bottom: Studies, *Creation of Light*, *Vaults of Heaven*, *Dry land appearing out of the waters*, *Day and Night*, *Birds and Fish*, and *Living Creatures on the Earth*
Right: Predella showing angels ministering to Christ in the wilderness and Christ in agony in the Garden of Gethsemane

Literature: *Spectator The*, Harrod Tanya, 'Talking about angels', 18/25 December 1993, p86; *BSMGP*, Barley Keith, 'Southwell Minster: The Great West Window', 1996, Issue 2, p14; Neiswander Judith & Swash Caroline, *Stained & Art Glass*, London: The Intelligent Layman Publishers Ltd, 2005, p260 (titled *Angels in Heaven*) Baden Fuller Kate, *Contemporary Stained Glass Artists. A Selection of Artists Worldwide*, London: A&C Black Publishers Ltd, 2006, p52; Dixon Philip and Coats Nigel, *Southwell Minster, A History and Guide*, undated, p41; *Southwell Minster. The Cathedral and Parish Church of the Blessed Virgin Mary. The Cathedral Companion*, undated, p5, 7; *Southwell Minster, The Great West Window*, undated, unpaginated

Reproduced: *BSMGP*, Barley Keith, 'Southwell Minster: The Great West Window', 1996, Issue 2, p14; Baden Fuller Kate, *Contemporary Stained Glass Artists. A Selection of Artists Worldwide*, London: A&C Black Publishers Ltd, 2006, p51; *Southwell Minster, A History and Guide*, undated, p40, 41

Film: Mapleston Charles, Horner Libby, *From Coventry to Cochem, the Art of Patrick Reyntiens*, Reyntiens/Malachite, 2011

Notes: The original concept of a window full of angels as beings of light was that of the Minster's architect, Martin Stancliffe. Reyntiens describes the window as 'a great gathering of angels, enjoying being with God; just all joy and worship'. The window is both medieval in tradition and yet contemporary – 'a reminiscence, not a parody or a pastiche, of what might have been there in the early 16th century' (Fuller). Tiers of angels ascend into Heaven diminishing in size as they go up, the colours generally muted and the design in keeping with the age of the original 15th century window, although the colour and activity becomes more hectic as one ascends giving a feeling of majesty like the finale of a triumphant piece of music. Reyntiens notes that his choice of colouring may have been influenced by the work he and Piper did at St Margaret's, City of Westminster and also explains that medieval pilgrimage churches have dark glass and when one enters one's eyes have to adapt to the subdued light which makes the mind more contemplative. In contemporary churches the light is often quite bright and Reyntiens wanted to recreate the sense of spirituality. He observed that the tracery forms three interlocking arches and so much of the symbolism involves the Trinity. He hired a local hall near his house in which to make the cartoons in charcoal and Indian ink – this took him about three months. He then took these to Keith Barley's studio and according to Reyntiens, Barley asked how long it would take to paint the glass - Reyntiens replied 'about six weeks'. There was a stunned silence, Barley expecting the response to be more like six months.

At the bottom of the window are predella illustrating interventions by angels: from left to right, an angel expelling Adam and Eve from the Garden of Eden (*Genesis* 3), Jacob wrestling with the angel (*Genesis* 32), an angel telling Tobias what to do with his monstrous fish (*Tobias* 6), the classic Annunciation scene with a central lily (*Matthew* 1, *Luke* 1), angels ministering to Christ in the wilderness, the devil sloping off to the right (*Matthew* 4: 11), Christ in agony in the Garden of Gethsemane, his disciples asleep and an angel strengthening him (*Luke* 22: 42-45) and finally the angel appearing to the two Marys at the sepulchre (*Matthew* 28, *Luke* 24).

The large angels above the predella hold spheres which represent the Seven Acts of Creation: from left to right, the creation of light, the vault of the heavens, dry land appearing out of the waters, day and night, the birds and the fish, living creatures and finally human beings (see under Studies). Their huge wings above their heads draw one's eye up the window to the next tier where there are pairs of smaller angels holding books, trumpets, a harp, a pipe organ and a stringed instrument. Above these are more angels, the 2nd, 4th and 6th with wings outstretched representing the Trinity. In the next tier of lights there are four small and three larger panels. The smaller windows contain angels holding spheres of pure energy. The left hand larger panel has an angel holding Christ on the cross which is also a tree of life and a lily referring to the Annunciation. The central panel shows the Virgin Mary (to whom the Minster is dedicated) dressed in a very simple manner compared to the glorious host of angels and holding seven red Sorrows of Mary. She is supported by two angels at her shoulders whilst above her the Spirit of God descends in a cloud bearing the inscription in Hebrew 'I am who I am'. The border of the panel is green representing Jacob's ladder. On the right an angel holds the emblems of the Holy Spirit, a dove descending and tongues of fire. The angels in the top of these larger panels represent the Trinity. Above this are yet more angels playing musical instruments, others balance on wheels of fire (*Ezekiel* 1), there is the Eye of God and then at the very top the Godhead with the Hand of God below and the letters alpha and omega (the Beginning and the End), the Blood of Christ in a red chalice and the dove of the Holy Spirit, again reinforcing the theme of Trinity. There are actually two windows, the interior painted window and an exterior clear glass window with identical leading, thus protecting the inner window from the elements. Harrod cites Reyntiens' influences as being as diverse as Dante's *Paradiso*, Alasdair MacIntrye's *After Virtue* and Andrei Tarkovsky's film *Nostalghia*.

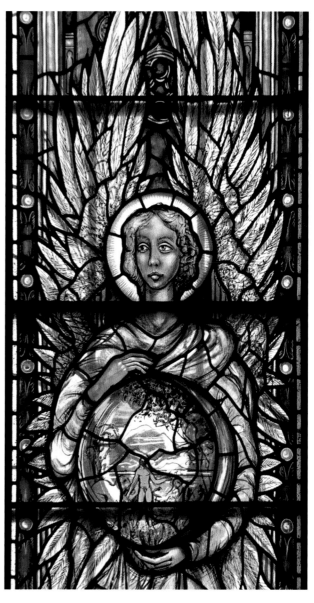

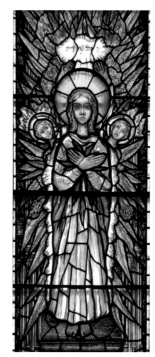

Above: Angel holding a sphere depicting the creation of man
Far left: Angel window
Left: Virgin Mary

Right: Detail of tracery

Below: Angels in the second tier, the central one
holding the emblems of the Holy Spirit, a dove
descending and tongues of fire

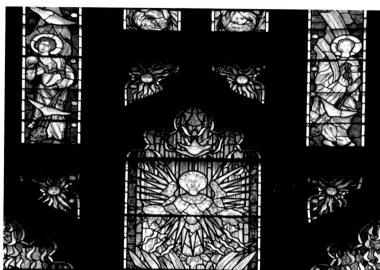

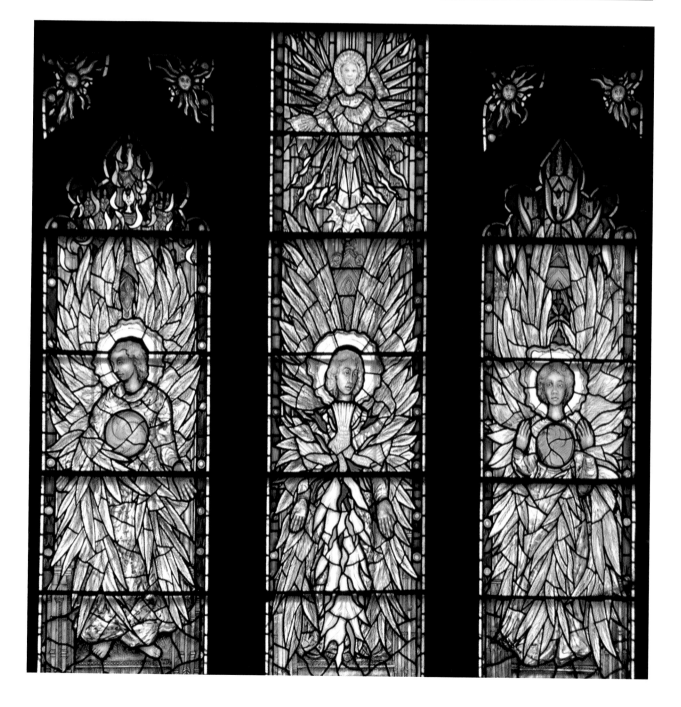

OXFORDSHIRE

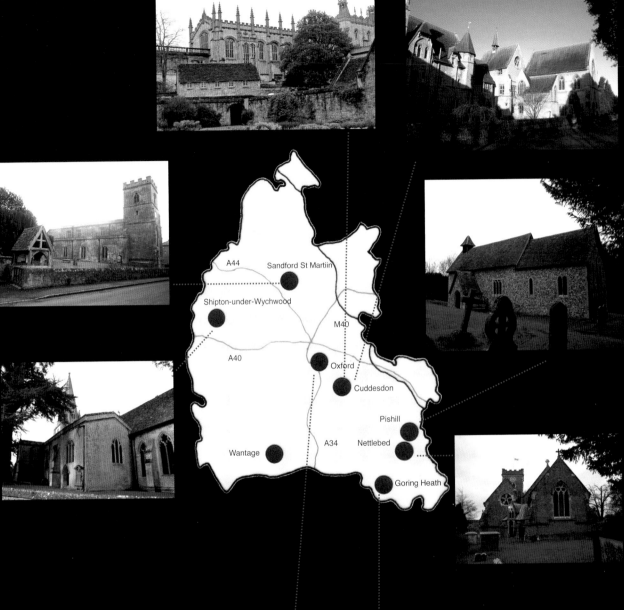

A44
Sandford St Martiin

Shipton-under-Wychwood

M40

A40

Oxford

Cuddesdon

Pishill

A34 Nettlebed

Wantage

Goring Heath

Cowley, Cowley Fathers' School, Cowley Road Church of England Secondary School Library

Date: 1976

Title: *Transfiguration*, autonomous panel

Designer, Glass Painter and Maker: Patrick Reyntiens

Literature: Harrison Martin, 'Notes', *Glass/Light*, London, 1978, #39

Reproduced: Clarke Brian (Ed), *Architectural Stained Glass*, London: John Murray, 1979, p198

Notes: Harrison considers this work to be amongst the best 20th century stained glass. The panel has three wreaths in green colours at the base, with above a slightly ovoid sun in clear glass (with figures), opaque white and yellow. To the right of this and slightly overlapping is a cloud and lightning. Areas of clear glass give glimpses of the courtyard beyond. Unfortunately this school no longer exists and it is not known whether the panel is extant.

Cuddesdon, Ripon College Chapel, OX44 9EX

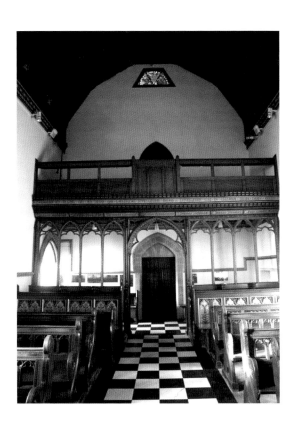

Listing: Grade II* (19 January 1973) #1047715 (this listing is for the College complex as a whole)

General: Formerly known as Cuddesdon Theological College, the Anglican college founded in 1853 by Bishop Samuel Wilberforce, was designed by G E Street in 1852 in his role as Diocesan Architect for Oxford. All the buildings are tall and narrow and ecclesiastical looking, built of coursed limestone rubble with ashlar dressings. The chapel dates from 1874-1875 and is on the first floor with a hall below. It is late 13th century in style on a traditional college chapel plan and the other windows are all by Clayton and Bell.

Title: *Tree of Life*

Date: 1964

Location and Size: west window above gallery, approximately 99x76cm (39x30in)

Designer: John Piper

Glass Painter and Maker: Patrick Reyntiens

Literature: Sherwood Jennifer and Pevsner Nikolaus, *The Buildings of England, Oxfordshire*, Harmondsworth: Penguin Books, 1974, p564; Osborne, p105, 173

Notes: The chapel was redecorated in 1964 under Piper's guidance. The small window is trapezoidal and depicts a bright red Tree of Life against a blue background – the first time Piper used such a motif for stained glass and one which was to become a favourite.

Right: Interior of chapel and *Tree of Life* window

Goring Heath, Oratory Preparatory School Chapel (RC), Reading, RG8 7SF

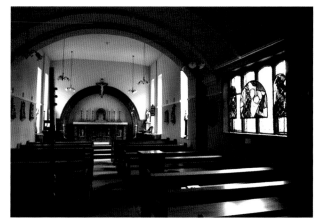

General: The Oratory Preparatory School is an independent day and boarding school for boys and girls aged 3-13. The Oratory Schools were the inspiration of Cardinal John Newman who wished to create a Catholic version of English public schools. Having been located for many years in the Caversham area, in 1946 the Preparatory School moved to The Old Ride, a large house in Branksome, Bournemouth. Christopher Maude became Headmaster in 1958 until his retirement in 1968. Maude's son died in a fire and the window was designed to commemorate the tragedy. When the school moved to its current premises in 1968 part of the window was reinstalled in the new chapel. Apparently there were three smaller areas of stained glass but presumably these did not fit the new setting and were discarded or lost. The chapel, which is south facing, was previously a billiard room to which an extension was added to form the sanctuary.

Title: *Thomas Maude Memorial Window*

Date: 1964

Location and Size: 3-light window in chapel, ecumenical south, opposite main entrance and mounted in front of plain quarry glass, the central light measures 77.5x91.5cm (30 1/2x36in), the outer lights 77.5x37.5cm (30 1/2x14 3/4in)

Designer, Glass Painter and Maker: Patrick Reyntiens

Commemoration and Donors: The plaque below the window reads: 'THESE WINDOWS/Designed by Patrick Reyntiens/ WERE GIVEN TO THE ORATORY PREPARATORY SCHOOL/ BY THE PARENTS OF THE BOYS THEN IN THE SCHOOL/In Memory of THOMAS MAUDE/who Died on 12 June 1963. Aged 2 Years.'

Literature: Clarke Brian (Ed), *Architectural Stained Glass*, London: John Murray, 1979, p193; Angus Mark, *Modern Stained Glass in British Churches*, London & Oxford: Mowbray, 1984, p112; *Stained Glass Windows and Master Glass Painters 1930-1972*, Bristol: Morris & Juliet Venables, 2003, p84

Notes: The central light shows a small child (Thomas) holding his arms up to a female figure (the Virgin Mary). Red markings and two red horn shapes would appear to indicate fire but the two figures are not consumed by the fire and smoke - Mary saves the child. The figures are surrounded by abstract green, blue and clear glass shapes and one area is painted black with criss crosses imitating the quarry glass behind. The right and left hand lights similarly reflect the diamond shaped quarries, both are abstract in clear, blue, green and black painted glass, the right hand light having additional streaks of red.

Above: Interior of Chapel with windows on right

Below: Thomas Maude Memorial Window

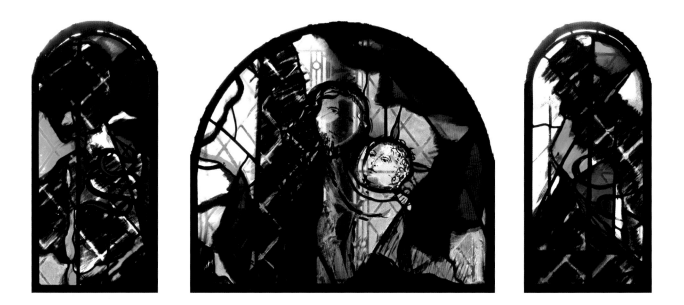

Nettlebed, St Bartholomew's, High Street, Nettlebed, RG9 5DA

Listing: Grade II (13 February 1985) # 1369329

General: St Bartholomew's is a grey and red brick church (Nettlebed was a centre of brickmaking from the 14th century) with stone window surrounds designed by Henry Hakewill 1845-1846. Harrison describes both Piper windows as 'bringing patches of intense colour and interest into an otherwise drab brick Victorian church'.

Literature: Sherwood Jennifer and Pevsner Nikolaus, *The Buildings of England, Oxfordshire*, Harmondsworth: Penguin Books, 1974, p374, 714; NADFAS, Record of Church Furnishings, St Bartholomew's, Nettlebed, Oxfordshire, 1978; Harrison, 1982, unpaginated; Osborne, 1997, p108-109, 175

local churches, in conjunction with the exhibition at Dorchester Abbey from 21 April to 10 June 2012, 2012, unpaginated

Notes: The window replaced geometrically patterned Victorian stained glass which was removed and placed in windows which had hitherto been clear glass. The design was approved by the PCC on 23 June and again on 8 December 1969. The left hand light shows fish on a red ground, the central light has a slim yellow Tree of Life with red fruits on a blue background, and the right hand light shows butterflies on a green ground (symbols of the Resurrection). The tracery is traditional with a triangle, Lamb of God and a dove. It seems rather odd that Piper didn't make the left light blue as a suitable background for the fish and place the red in the centre since it is a dominating colour.

Title: *Dr Williamson Memorial Window*

Date: 1969-1970

Location and Size: 3-light east window of chancel, approximately 297x155cm (117x61in)

Inscription: signed and dated left hand lancet: 'Patrick Reyntiens 70'

Designer: John Piper

Glass Painter and Maker: Patrick Reyntiens

Study: There is a photograph of the study in Oxfordshire History Centre

Cost: Approximately £1,000. The Memorial Fund had raised £1,280 by June 1969 at which point the committee suggested the money be devoted to a memorial east window.

Commemoration and Donors: A plaque on the south chancel wall reads: 'The east window of this church/was given in memory of/Robin Williamson/by the many who knew him as/Doctor, Counsellor and friend/during the years he served/Nettlebed and neighbouring parishes 1946-1969/He was greatly loved'. The window was donated by parishioners and friends

Citation: 2 July 1970 (for some reason a Faculty was never issued)

Documentation: Oxfordshire History Centre, Heritage & Arts, c.1905

Literature: NADFAS, *Record of Church Furnishings, St Bartholomew's, Nettlebed, Oxfordshire*, 1978; *Crafts*, Martina Margetts, 'A Piper Portfolio', No 36, January/February 1979, p36; Sherwood Jennifer, *A Guide to the Churches of Oxfordshire*, Oxford: Robert Dugdale, 1989, p124; Osborne, 1997, p108, 186; Neiswander Judith & Swash Caroline, *Stained & Art Glass*, London: The Intelligent Layman Publishers Ltd, 2005, p253; Woollen Hannah, Lethbridge Richard, *John Piper and the Church. A Stained-Glass Tour of selected local churches, in conjunction with the exhibition at Dorchester Abbey from 21 April to 10 June 2012*, 2012, unpaginated

Reproduced: NADFAS, *Record of Church Furnishings, St Bartholomew's, Nettlebed, Oxfordshire*, 1978; *Crafts*, Martina Margetts, 'A Piper Portfolio', No 36, January/February 1979, p36; Osborne, 1997, p106, 107; Woollen Hannah, Lethbridge Richard, *John Piper and the Church. A Stained-Glass Tour of selected*

Below: Dr Williamson Memorial Window

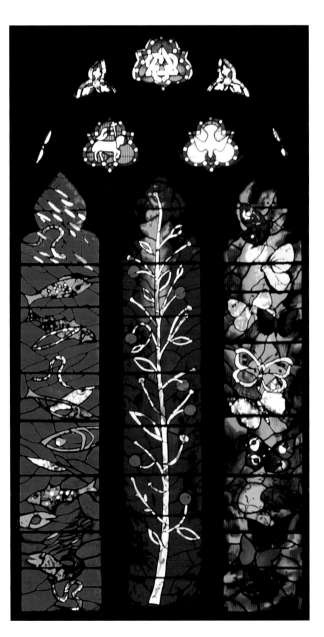

Title: *Tree of Life, Peter Fleming Memorial Window*

Date: 1974-1976

Location and Size: 2-light window at west end of south aisle, approximately 175x97cm (69x38in)

Inscription: signed by both artists: 'Patrick Reyntiens' left and 'John Piper/76' right

Designer: John Piper

Glass Painter and Maker: Patrick Reyntiens

Cost: £800

Commemoration and Donor: The plaque reads: 'THIS WINDOW/IS IN MEMORY OF/PETER FLEMING/WRITER, TRAVELLER, SOLDIER/1907-1971'. The window was commissioned by Fleming's widow, the actress Celia Johnson.

Faculty: 28 May 1975

Documentation: Oxfordshire History Centre, Heritage & Arts, c.1905

Literature: NADFAS, *Record of Church Furnishings, St Bartholomew's, Nettlebed, Oxfordshire*, 1978; *Crafts*, Margetts Martina, 'A Piper Portfolio', No 36, January/February 1979, p37; Ingrams Richard and Piper John, *Piper's Places. John Piper in England & Wales*, London: Chatto & Windus. The Hogarth Press, 1983, p174; Angus Mark, *Modern Stained Glass in British Churches*, London & Oxford: Mowbray, 1984, p54; Sherwood Jennifer, *A Guide to the Churches of Oxfordshire*, Oxford: Robert Dugdale, 1989, p124; Osborne, 1997, p109; Ayers Tim, Brown Sarah, Neiswander Judy, *The Stained Glass Museum Gallery Guide*, Lowestoft: Richardson Printing, 2004, p41; Woollen Hannah, Lethbridge Richard, *John Piper and the Church. A Stained-Glass Tour of selected local churches, in conjunction with the exhibition at Dorchester Abbey from 21 April to 10 June 2012*, 2012, unpaginated

Reproduced: NADFAS, *Record of Church Furnishings, St Bartholomew's, Nettlebed, Oxfordshire*, 1978; Angus Mark, *Modern Stained Glass in British Churches*, London & Oxford: Mowbray, 1984, p54; Osborne, 1997, p110; Woollen Hannah, Lethbridge Richard, *John Piper and the Church. A Stained-Glass Tour of selected local churches, in conjunction with the exhibition at Dorchester Abbey from 21 April to 10 June 2012*, 2012, unpaginated

Notes: Fleming had admired the Dr Williamson window and after his death Celia Johnson thought it would be good to commemorate Fleming's life in similar fashion. The PCC unanimously approved the design on 13 May 1974. Piper's original idea was a Tree of Life, at which point Johnson said 'Of course he was very fond of birds – even though he did shoot an awful lot of them' (quoted in Ingrams). Piper described his thinking behind the design as follows:
'THE TREE. The mystery of perpetual regeneration in growth towards heaven. Expansion of life and constant victory over death. Life expands in colour and richness, birds in branches. THE WORLD: In quatrefoil at the top, the world in space. Peter Fleming was a world traveller.'
The window shows a Tree of Life with a hawk, a pheasant, a cardinal bird and an owl with the sun and moon in the tracery, all set against a mottled blue background. Piper has cleverly used the central mullion as the trunk for his tree. Peter Fleming was an adventurer and travel writer and an alumnus of Eton College, Berkshire and Christ Church College, Oxford and in his articles for *The Spectator* used the pseudonym 'Stricks' which is a dialect word for an owl. His brother Ian was also a writer. Margetts describes the window as being 'of exceptional technical complexity'.

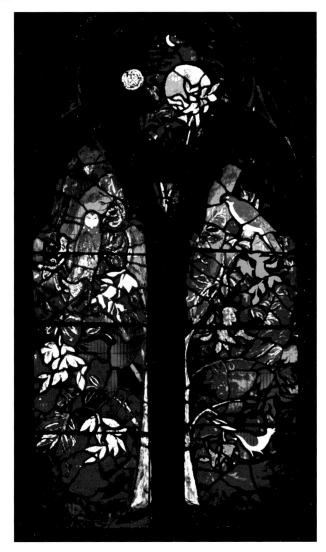

Above: *Tree of Life, Peter Fleming Memorial Window*
Below: Detail of window

Oxford, Christ Church, Great Hall, St Aldates, OX1 1DP

Listing: Grade I (12 January 1954) # 1198760 as The Great Quadrangle

General: Christ Church is both the grandest Oxford College and an Anglican Cathedral, and the latter has been described as the 'smallest, shyest and squarest of English cathedrals' (Batsford and Fry, *The Cathedrals of England*, 1934). The College was originally founded in 1525 by Thomas Wolsey as Cardinal College, but he fell from favour and his property was confiscated by Henry VIII who re-founded the college in 1532 as King Henry VIII's College. Following the dissolution of the monasteries the college was renamed Christ Church and the church became the cathedral for the newly created diocese of Oxford. The Hall, on the south side of the Great Quadrangle, is the largest pre-Victorian College Hall in the city and was built as part of Wolsey's grand design on which he spent between £20,000 and £25,000. When the Cathedral clock strikes the hour, the clock in the Tom Tower stands at five minutes past the hour – this is because the Cathedral keeps Oxford time, not Greenwich Mean Time – a charming anachronism. The College counts amongst its alumni 13 Prime Ministers and 11 Viceroys of India.

Title: *Memorial Windows*

Date: 1980-1984

Location: Eleven 4-light windows on north and south sides of the Dining Hall, each window divided horizontally by a heavy stone transom

Designer, Glass Painter and Maker: Patrick Reyntiens

Assistant: David Williams and Edith Reyntiens

Cost: £10,000 on signing contract, 36 monthly payments of £1,085 starting 5 May 1981, £3,500 on completion, subject to retention of £1,250 for one year

Commemoration: The south windows commemorate 20 Deans of the College between 1689 and 1969 together with portrait medallions of 10 notable people connected with the House. The north windows commemorate a further 36 distinguished members of the House.

Documentation: CCC Hall and Hall windows; CCC Hall Windows 1983; CCC Windows DEFG

Literature: *Country Life*, Dunlop Ian, 'Alice in Stained Glass. The Reyntiens Windows at Christ Church, Oxford', 15 November 1984, p1468-1469; Stamp Gavin, 'Patrick Reyntiens and the Ovid Glass Panels', *Patrick Reyntiens, Glass Painted and Stained, Visions in Light*, Bruton Gallery, 1985, p2; Trevor-Roper Hugh, *Christ Church Oxford. The Portrait of a College*, Governing Body of Christ Church, p12; *Spectator The*, Harrod Tanya, 'Talking about angels', 18/25 December 1993, p85; Baden Fuller Kate, *Contemporary Stained Glass Artists. A Selection of Artists Worldwide*, London: A&C Black Publishers Ltd, 2006, p52; *Christ Church Oxford, Guide to College and Cathedral*, p4

Notes: The Great Hall is accessed from the staircase on the east. There is a large window above the dais at the west end, and eight windows on the north and south sides of the hall numbered S1-S8 and N1-N8 reading east to west, all of which are the same size except for S7 and N8 which are in alcoves and much taller. There was no coherent scheme to the windows, eleven were green windows of inferior quality decorated with flowers and trees, the other five windows were heraldic and golden-yellow. The College began debating what to do about

the windows in 1971 and moved into action in 1980 under the guidance of Dr John Mason, Curator of the Common Room and the College Librarian. Reyntiens wrote a report on the state of the windows and a possible solution in March of that year, the York Glaziers Trust were consulted in May and Goddard and Gibbs submitted a proposal in September. Reyntiens must have worked his magic because he was given the commission. His designs had to relate to the Late Medieval character and pattern of the Burlison & Grylls heraldic windows installed by the architect G F Bodley in the late 19th century. The artist told the Dean that he would design windows 'in the style of 1588 had the breach with Rome never occurred. The result is a combination of Tudor strap-and-quarry work, peppered with mottos and escutcheons with baroque borders of the utmost subtlety' (Fuller). Reyntiens separated his colours allowing the eye to move across the surface without becoming bored and varied the position of the diagonal straps. Despite the fact that the windows are set high in the walls and cannot be viewed intimately, the academics, being academic, became over concerned about minute details of heraldic badges and portraits. Reyntiens appeared to take umbrage, probably because he had a heavy workload and was also Head of Fine Art at the Central School of Art and Design at the time, and the resulting correspondence was somewhat acrimonious. The College had 12 months in which to notify Reyntiens about faulty workmanship or changes required but sometimes used this opportunity to complain about portraits which they had ignored at the cartoon stage. The College itself wrote copious letters to the College of Arms requesting heraldic details, to descendants of alumni and various institutions requesting portraits or likenesses. The windows are highly successful – Harrod notes how Reyntiens set out to 'honour and employ the language of the 19th century' and Dunlop considers that Reyntiens was more successful than Bodley in combining the portraits and heraldic devices against a background of 'strap and quarry' design. He also notes that the windows have been 'achieved by an almost microscopic attention to detail'. Despite the background aggression the Dean wrote a fulsome letter to Reyntiens after the last window was installed declaring that 'my purpose in writing in this triumphalist vein is to ensure that you are aware of the House's gratitude and admiration'.

Below: Interior of Great Hall

Above: Detail from window S5

Below: Window N1 by Burlison and Grylls

Below right: Window S2

Images, badges and names inserted in each window design are described from top left to top right, then bottom left to bottom right.

S2 – Reyntiens was informed of mistakes in this window and S3 in January 1983 but 'repudiated liability'. The window was installed 28 September 1982 and includes the words 'dominus mihi adiutor' across the strapwork, a medallion of 'MATTH LEE', Henry VIII monogram, cardinal's hat (signifying Wolsey), medallion of 'JOHN GUISE'; Arms of Dean 'HENRY ALDRICH 1689-1710', Arms of Dean 'FRANCIS ATTERBURY 1711-1713', Arms of Dean 'GEORGE SMALRIDGE 1713-1719' and Arms of Dean 'HUGH BOULTER 1719-1724'. Dr Matthew Lee (1695-1755) was both a student and a college benefactor and his money (over £20,000) helped set up the Matthew Lee Readership, pay for cadavers and build the Christ Church Anatomy School (1766-1767). General John Guise (d1756) was inspired during his time at the college by the polymath Dean Aldrich. Guise became an officer in Marlborough's army and left his collection of drawings and Old Masters to the college. Aldrich (1647-1710) was a theologian, philosopher and architect of All Saints, Oxford and three sides of the Peckwater Quadrangle at Christ Church. He entered the College in 1662 and was also Vice-Chancellor of Oxford University 1692-1695. Atterbury (1663-1713) studied at the college and became a tutor. He was a man of letters and a politician but was such a failure as Dean that he was appointed Bishop of Rochester instead. Smalridge (1666-1719) studied at the college and was a tutor, greatly influencing the young John Wesley. He was Bishop of Bristol from 1714-1719. Boulter (1672-1742) attended the college before moving to Magdalene College. He succeeded Smalridge as both Dean and Bishop of Bristol and was appointed Church of Ireland Archbishop of Armagh, Primate of all Ireland, in 1724, a post he held until his death.

S3 – The window was installed 29 June 1982 and includes the words 'dieu et mon droit' across the strapwork, a medallion of 'THOMAS PERCY', Henry VIII monogram, cardinal's hat, medallion of 'JOSEPH BANKS'; Arms of Dean ' WILLIAM BRADSHAW 1724-1733', Arms of Dean 'JOHN CONYBEARE 1733 -1756', Arms of Dean 'DAVID GREGORY 1756-1767' and Arms of Dean 'WILLIAM MARKHAM 1767-1777'. The poet Thomas Percy (1729-1811) studied at the college before becoming Bishop of Dromore. Sir Joseph Banks (1743-1820) studied natural sciences at the college but left without graduating. He is known as a naturalist and botanist, accompanied Captain James Cook on his first voyage to South America, New Zealand and Australia (1768-1771) and became President of the Royal Society in 1778. It is to Banks that we owe the pre-eminence of the Royal Botanical Gardens, Kew. Bradshaw (1671-1732) attended New College, Oxford and held the post of Bishop of Bristol from 1924 until his death. The theologian Conybeare (1692-1755) studied at Exeter College, Oxford and was also Bishop of Bristol from 1750. Gregory (1695-1767) studied at Christ Church and became the first Professor of Modern History and Languages at the College. Markham (1719-1807) studied at Christ Church and became the Archbishop of York.

Reproduced: *Country Life*, Dunlop Ian, 'Alice in Stained Glass. The Reyntiens Windows at Christ Church, Oxford', 15 November 1984, p1468

S4 – The window was installed 6 April 1982 and includes the words 'dominis mihi adiutor' across the strapwork, a medallion of 'HENRY HALLAM', Henry VIII monogram, cardinal's hat, medallion of 'CANNING'; Arms of Dean 'LEWIS BAGOT 1777-1783', Arms of Dean 'CYRIL JACKSON 1783-1809', Arms of Dean 'CHARLES HALL 1809-1824' and Arms of Dean 'SAMUEL SMITH 1824-1831'. Henry Hallam (1777-1859) graduated from the college in 1799 and is remembered as an historian. Charles John Canning, 1st Earl Canning (1812-1862) studied at the college, gaining a first in classics and a second in mathematics. He became Governor-General of India 1856-1962 and was Viceroy from 1858-1862. He and his wife Charlotte kept a photographic record of the Indian population which was published in eight volumes between 1868 and 1875 as *The People of India*. His father George Canning is commemorated in window N3. Bagot (1740-1802) studied at the college before becoming Canon and then Dean. He was an English cleric who also held the post of Bishop of Bristol (1782), Bishop of Norwich (1783) and Bishop of St Asaph (1790). The cleric Jackson (1746-1819) was Canon of Christ Church before becoming Dean. His devotion to the college led him to refuse the Bishopric of Bristol in 1799 and the primacy of All Ireland in 1800. Hall (1763-1827) studied at the college and remained within it becoming Regius Professor of Divinity, a post he resigned from upon becoming Dean. In 1924 he was appointed Dean of Durham. Samuel Smith (1765-1841) studied at the college and was a tutor there before becoming incumbent of Daventry. He returned in 1807 as Canon before becoming Dean.

172

S5 – The window was installed 26 January 1982 and includes the words 'dominus illuminatio mea' across the strapwork, a medallion of 'ALICE LIDDELL' (when she was 10 years old), Henry VIII monogram, cardinal's hat, a medallion of 'LEWIS CARROLL' (Charles Dodgson); Arms of Dean ' THOMAS GAISFORD 1831-55', Arms of Dean 'HENRY LIDDELL 1855-91', Arms of Dean 'FRANCIS PAGET 1892-1901' and Arms of the See of Oxford for 'THOMAS STRONG 1901-1920'. Alice Liddell (1852-1934) was a daughter of Dean Liddell. Charles Lutwidge Dodgson (1832-1898) was a student at the college and remained there as a maths tutor until his death. He befriended Alice and to entertain her and her sister he invented stories (*Alice's Adventures in Wonderland* and *Through the Looking Glass*) published under the pseudonym Lewis Carroll. Some of the fantastical characters and creatures from the stories are also to be found in the window – these are taken from the wonderful illustrations by John Tenniel. Gaisford (1779-1855) was both student and tutor at the college. In 1811 he became Regius Professor of Greek at the University, was curator of the Bodleian Library in Oxford and also found time to take orders. Henry George Liddell (1811-1898) gained a double first at the college, was ordained in 1838, was Headmaster of Westminster School from 1846-1855, and was also Vice Chancellor of Oxford University. The Right Revd Francis Paget was a student at the college and also held the post of Regius Professor of Pastoral Theology at the University and was Bishop of Oxford 1901-1911. Thomas Strong Banks was a student and lecturer at the college. He was also Vice-Chancellor of the University 1913-1917, Bishop of Ripon 1920-1925 and Bishop of Oxford 1925-1937.

Reproduced: *Country Life*, Dunlop Ian, 'Alice in Stained Glass. The Reyntiens Windows at Christ Church, Oxford', 15 November 1984, p1468, 1469 (Alice Liddell and Lewis Carroll medallions); *Patrick Reyntiens, Glass Painted and Stained, Visions in Light*, Bruton Gallery, 1985, p27 (Alice Liddell medallion); Baden Fuller Kate, *Contemporary Stained Glass Artists. A Selection of Artists Worldwide*, London: A&C Black Publishers Ltd, 2006, p50

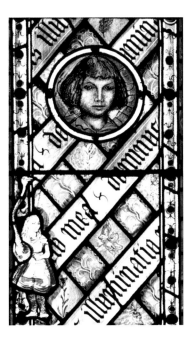

Details from window S5, showing Alice Liddell, Charles Dodgson and Tenniel illustrations

S6 – This was the first window to be installed on 27 October 1981. Reyntiens was informed of deficiencies in the window on 23 October 1982 just before the 12 month deadline but he chose not to respond. The words 'dominus mihi adiutor' are placed across the strapwork, a medallion of 'WALTON', Henry VIII monogram, cardinal's hat, medallion of 'AUDEN'; floriated initials for 'HENRY WHITE 1920-34', Arms of the See of Durham for 'ALWYN WILLIAMS 1934-39', floriated initials for 'JOHN LOWE 1939-59' and floriated initials for 'CUTHBERT SIMPSON 1959-69'. Sir William Turner Walton (1902-1983) became an undergraduate at the college at the age of 16 but despite his musical prowess failed both Greek and algebra and left without a degree. At Oxford he became friends with Sacheverell Sitwell and the family became his patrons. His first work *Façade* accompanied poems by Edith Sitwell. Wystan Hugh Auden (1907-1973) studied English Literature at the college before becoming a teacher, although he is remembered as a poet. In 1946 he became an American citizen although he frequently returned to Oxford where he was Professor of Poetry from 1956-1961. Henry Julian White (1859-1934) was a biblical scholar. Alwyn Terrell Petre Williams (1888-1968) attended Jesus College, Oxford where he gained a triple first. He was ordained and taught at Winchester College, becoming Headmaster in 1924, a post he held until being made Dean of Christ Church. He was later Bishop of Durham (1939-1952) and Bishop of Winchester (1952-1961). The Very Reverend Professor John Lowe (1899-1960) was Canadian and studied at the University of Trinity College, Toronto before becoming Rhodes Scholar at Oxford in 1922. He returned to his alma mater, holding the position of Dean of Divinity 1933-1939, at which point he returned to Oxford. He was also Vice-Chancellor of Oxford University 1948-1951. The Very Reverend Cuthbert Aikman Simpson (1892-1969) was another Canadian, born in Nova Scotia. He became Canon of Christ Church and Regius Professor of Hebrew at the University in 1954.

N2 –The window was installed 11 January 1983 and includes the words 'dominus mihi adiutor' across the strapwork, a medallion of 'JOHN WESLEY', Henry VIII monogram, cardinal's hat, medallion of 'CH WESLEY'; Arms of 'SOUTH 1651', Arms of 'WAKE 1673', Arms of 'LONGLEY 1812' and Arms of the See of Chichester for 'BELL1901'. Mason had suggested including the Wesley brothers in the hopes of attracting Wesleyan pilgrims. John Wesley (1703-1791) and his younger brother Charles (1707-1788) both attended the college, both were Anglican clerics and evangelical theologians. Fellow students mocked their methodical lives, hence the term Methodists. They sailed to Savannah, Georgia in 1735 and were greatly influenced by the piety of Moravian settlers on the boat. Following their return to England they began open air preaching round the country. John formed societies, organised chapels, commissioned preachers and started orphanages. Charles is chiefly remembered for his hymns. At one stage the College were very concerned about one of the colours in Dr South's badge. Dr Robert South (1634-1716) matriculated from the college in 1651, became public orator to the University from 1660-1677 and was made Canon of the college in 1670. William Wake (1657-1737) studied at the college, took orders, was appointed Canon to the college in 1693, became Bishop of Lincoln in 1705 and was Archbishop of Canterbury from 1716-1737. Charles Thomas Longley (1794-1868) was educated at Oxford University, ordained in 1818 and was Headmaster at Harrow from 1829-1836. He was then successively Bishop of Ripon, Bishop of Durham, Archbishop of York and lastly Archbishop of Canterbury from 1862-1868. George Kennedy Allen Bell (1883-1958) read theology at the college and from 1910-1914 was a student minister and tutor. He was Dean of Canterbury from 1925-1929 when he was made Bishop of Chichester. He was the leader of the Ecumenical Movement and a stalwart supporter of the underdog and disadvantaged.

N3 – In January 1983 Mason complained that the 'eagle displayed' in the cartoon was not quite correct. The window was installed 12 April 1983 and includes the words 'dieu et mon droit' across the strapwork, a medallion of 'C C PINCKNEY', Henry VIII monogram, cardinal's hat, medallion of 'Wm PENN'; Arms of 'MANSFIELD 1723', Arms of 'CANNING 1788', Arms of 'PORTAL1912' and Arms of 'CHERWELL 1921'. Charles Cotesworth Pinckney was born in South Carolina but schooled in England and read science and law at the college. He returned to America, was a lawyer, planter, soldier and statesman and twice ran as the Federalist Party Presidential candidate. William Penn (1644-1718) spent much of his life in Ireland where his father had been given estates by Oliver Cromwell. He studied at Christ Church but was expelled because of his Quaker beliefs. He tried various employments to no avail before emigrating to America with other Quakers in 1677. He was a champion of democracy and religious freedom and the founder of the State of Pennsylvania. William Murray, 1st Earl of Mansfield was accepted at the college in 1723. He became a barrister and politician and from 1756-1788 was Lord Chief Justice, in which role he reformed English law. George Canning (1770-1827) was a brilliant student and orator who wished to enter politics despite his impoverished background and sought the patronage of the Tory party under William Pitt the Younger. He held the post of Foreign Secretary twice and was Prime Minister for a mere 119 days, dying in office. Wyndham Raymond Portal, 1st Viscount Portal (1885-1949) was educated at the college before embarking on a successful military career. He then became a politician, was the last Chairman of the Great Western Railway and President of the Olympic Games in 1948. The physicist Frederick Alexander Lindemann, 1st Viscount Cherwell (1886-1957) was born in Germany and attended Berlin and Sorbonne Universities. In 1919 he was made Professor of Experimental Philosophy at the University and Director of the Clarendon Laboratory. He acted as a scientific advisor to Winston Churchill who used to comment that the 'Prof's brain is a beautiful piece of mechanism'!

Reproduced: *Patrick Reyntiens, Glass Painted and Stained, Visions in Light*, Bruton Gallery, 1985, p26

N4 – The cartoon for this window was approved in March 1983 subject to revised portraits of Gladstone and Salisbury, the deletion of the KG abbreviation on the latter's medallion, and a reduction of the black elements in the borders. The window was installed 28 June 1983 and includes the words 'dominus mihi adiutor' across the strapwork, a medallion of 'GLADSTONE', Henry VIII monogram, cardinal's hat, medallion of 'SALISBURY', Arms of 'WELLESLEY 1778', Arms of 'LIVERPOOL 1788', Arms of 'PEEL 1806' and Arms of 'DALHOUSIE 1829'. William Ewart Gladstone (1809-1898) read Classics and Mathematics at the college. He was a Liberal politician, four times Chancellor of the Exchequer and four times Prime Minister and was known as GOM – Grand Old Man (or as Disraeli would have it God's Only Mistake). Robert Arthur Talbot Gascoyne-Cecil, 3rd Marquess of Salisbury (1830-1903) read mathematics at the college but was awarded an honorary 4th class degree by virtue of his nobility. He was a Conservative politician and three times Prime Minister, alternating the role with the GOM. Richard Wellesley, 1st Marquess Wellesley (1760-1842) studied at the college. He was an Anglo-Irish politician who held the post of Lord Lieutenant of Ireland twice. Robert Banks Jenkinson, 2nd Earl of Liverpool (1770-1828) studied at the college. Upon graduation he immediately went into politics, winning the seat of Rye in 1990 but was too young to take his seat. He became Prime Minister at the tender age of 42 and was Britain's longest serving PM (1812-1827). Sir Robert Peel (1788-1850) graduated from the college with a double first in classics and mathematics. He was Prime Minister twice (1834-1835 and 1841-1846) and is probably best remembered for creating the modern police force (Peelers). He is also credited with developing the Tamworth pig. The Scottish statesman James Andrew Broun-Ramsay, 1st Marquess of Dalhousie (1812-1860) entered the college in 1829 and scraped through with a pass degree. He held the post of Governor General of India from 1848-1856 and was both the country's saviour and destroyer, modernising and centralising the administration which led indirectly to the Indian Rebellion of 1857.

N5 – Various defects were found with the cartoon in June 1983. The window was installed 27 September 1983 and includes the words 'dominus illuminatio mea' across the strapwork, a medallion of 'EINSTEIN', Henry VIII monogram, cardinal's hat, medallion of 'LOCKE'; Arms of 'WILLIS 1637', Arms of 'ACLAND 1834', Arms of 'GARROD 1876' and Arms of 'OSLER 1905'. The German born theoretical physicist Albert Einstein (1879-1955) scarcely requires an introduction although few may realise that he was the first German-Jewish academic to take up a post at the college. The initiative was that of Frederick Lindemann, (see N3 above) and Einstein spent three periods at the college between May 1931 and June 1933. John Locke (1632-1704) studied at the college and is known as the Father of Classical Liberalism. As well as being an influential philosopher he was also a learned physician and saved the life of his patron the 1st Earl of Shaftesbury. The four personalities commemorated below were all notable physicians. Thomas Willis (1621-1675) graduated from the college in 1642 and held the post of Sedleian Professor of Natural Philosophy at the University from 1660 until his death. He was a founding member of the Royal Society and conducted pioneering research into the anatomy of the brain, nervous system and muscles. Sir Henry Wentworth Dyke Acland (1815-1900) studied at the college and returned in 1845 as Lee's Reader in Anatomy. He held the post of Regius Professor of Medicine from 1858-1894, was also curator at the Bodleian and a fellow of the Royal Society. He helped establish the Oxford University Museum and he and Dean Liddell revolutionised the study of art and archaeology. Sir Archibald Edward Garrod (1857-1936) studied natural sciences at the college. He was also appointed Regius Professor of Medicine at the University, was a Fellow of the Royal Society, but his main claim to fame was his research into the inherited diseases of metabolism. The Canadian Sir William Osler (1849-1919) was one of the four founding Professors of Johns Hopkins Hospital, Baltimore, USA. He was appointed Regius Professor of Medicine at Oxford in 1905 and was a Fellow of Christ Church. He was the first educator to take students out of the lecture halls and into hospitals.

Reproduced: *Country Life*, Dunlop Ian, 'Alice in Stained Glass. The Reyntiens Windows at Christ Church, Oxford', 15 November 1984, p1469

N6 – The window was installed 10 January 1984, includes the motto 'dominus mihi adiutor' across the strapwork, a medallion of 'FEILING', Henry VIII monogram, cardinal's hat, medallion of 'HARROD'; Arms of 'BUSBY 1626', floriated initials for 'HOOKE 1658', floriated initials for 'BUCKLAND 1825' and Arms of 'STUBBS 1844'. The historian Sir Keith Graham Feiling (1884-1977) was educated at Balliol, Oxford but was tutor and lecturer in Modern History at Christ Church from 1911-1928. He was Chichele Professor of Modern History at All Souls, Oxford from 1946-1950. The economist Sir Henry Roy Harrod (1900-1978) was educated at New College, Oxford but became a Fellow and tutor in Economics at Christ Church. He is best remembered as the biographer of John Maynard Keynes. The Reverend Dr Richard Busby (1606-1695) was educated at the college and was Headmaster of Westminster School from 1638 until his death. A brilliant teacher, he was also noted for administering corporal punishment and once boasted that he had personally caned 16 bishops! The polymath Robert Hooke (1635-1703) was one of Busby's boys. His passion for science was kindled when studying in Oxford and he became the first Curator of Experiments at the Royal Society in 1662, a position he held for over 40 years. He was also Surveyor to the City of London and Professor of Geometry at Gresham College, London. The Very Reverend Dr William Buckland was a geologist and palaeontologist who studied at Corpus Christi College, Oxford, was ordained, but his chief love was fossils. He was created Canon at Christ Church in 1825. He was an unofficial curator of the Ashmolean Museum, kept exotic animals in his house, carried out his field work in his academic gown and specialised in zoophagy – the eating of all manner of animals, including, it is reputed, the heart of Louis XIV! William Stubbs (1825-1901) studied at the college and held the post of Regius Professor of Modern History at the University from 1866-1884 and various ecclesiastical posts including Bishop of Oxford (1889-1901) but these were a distraction from his role as a pre-eminent historian.

N7 – The cartoon was submitted in November 1983. The window was installed 28 March 1984 and includes the words 'dieu et mon droit' across the strapwork, a medallion of 'TAVERNER', Henry VIII monogram, cardinal's hat, medallion of 'RUSKIN', Arms of 'SIDNEY 1568', Arms of 'HAKLUYT 1570', Arms of 'BURTON 1599' and Arms of 'OTWAY 1669'. John Taverner (c1490-1545) became the first Organist and Master of the Choristers at the College in 1526, appointed by Wolsey. He left in 1530 following Wolsey's fall from favour and dedicated his life to composing. John Ruskin (1819-1900) read 'Greats' at the college and won the Newdigate prize for poetry in 1839. He was a renowned writer, art critic, social thinker, philanthropist and talented draughtsman. In 1869 he was appointed as the first Slade Professor of Fine Art at the University. Sir Philip Sidney (1554-1586) was educated at the college and became one of the most famous courtiers and poets of the Elizabethan age. Richard Hakluyt (c1552-1616) studied at the college where his passion for reading about journeys and voyages and looking at maps and globes began. His seminal publication was *The Principal Navigations, Voiages, Traffiques and Discoueries of the English Nation.* He urged the colonisation of what was to become the state of Virginia, USA. Robert Burton (1577-1640) spent most of his life in Oxford, first at Brasenose College and then as a fellow of Christ Church. He is best remembered for his book *The Anatomy of Melancholy.* Thomas Otway (1652-1685) went up to the college in 1669 but left in 1672 without a degree. He was a restoration dramatist best known for his play *Venice Preserv'd* (1682).

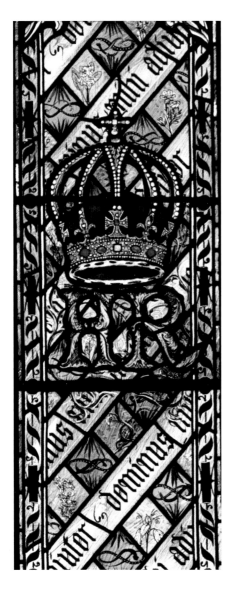

Left: Henry VIII monogram
Above: Cardinal's hat
Right: Window N7

Photographs by Ralph Williamson, with thanks to Christ Church, Oxford

Oxford, Nuffield College Chapel, 1 New Road, OX1 1NF

Listing: Grade II (30 March 1993) #1278775

General: The graduate College founded in 1937 by the motorcar manufacturer Lord Nuffield and specialising in Social Sciences, was designed by Harrison, Barnes and Hubbard between 1949 and 1960. The patron forced the architects to give the college a traditional flavour. Although it had originally been intended to include a large chapel, in the climate of austerity in the post war years it was decided instead to convert a couple of attic rooms in the south range of buildings. The chapel was the inspiration of Dame Margery Perham, an expert in African Studies who was appointed as the first official and only woman Fellow of Nuffield College in 1939. Perham happened to live near John Betjeman (Eton College, Berkshire; Oundle School, Northamptonshire; Wantage, Oxfordshire) who suggested she contact Piper. By coincidence the architect Thomas Barnes had attended Epsom College (as had Piper) and Barnes' brother was Piper's solicitor. Perham contacted Piper on 23 October 1958 noting that 'apart from the seating, colouring, hangings, altar and cross there is little more to be done, though we would be able to commission, I think, one work of art by way of a picture or statue'. Piper did indeed advise on the furniture and fittings and chose the wall colouring, the chequer board flooring, and designed the simple pews and wooden candlesticks. The reredos and cross were the design of John Hoskin and the golden curtain behind the altar was woven by students at the Royal College of Art. The first mention of stained glass windows was in December 1959 but it was not until the following December that Piper began work on the cartoons. Together with the five rectangular Piper/Reyntiens windows these are indeed rich fittings for a loft conversion! The nave and chancel windows are all deeply recessed so that the liturgical west window is the only one visible. The chapel is actually aligned north-south.

The following details are applicable to all five windows:
Date: 1959-1961

Designer: John Piper

Glass Painter and Maker: Patrick Reyntiens

Architect in charge: Thomas Barnes

Cost: Piper appears to have received a mere £250 for his work. Reyntiens quoted £12/sq ft for glass in January 1961, making a total of £600.

Dedication: The chapel was dedicated 13 December 1961 by Dr Harry Carpenter, Bishop of Oxford

Documentation: TGA200410/2/1/11/; TGA200410/1/1OUN-OXF

Literature: Sherwood Jennifer and Pevsner Nikolaus, *The Buildings of England, Oxfordshire*, Harmondsworth: Penguin Books, 1974, p66, 236; Harrison, 1982, unpaginated; Osborne, 1997, p78-80, 97, 173; Harwood Elaine, *England. A Guide to Post-War Listed Buildings*, London: B T Batsford, 2003 (2000),p370; *Stained Glass Windows and Master Glass Painters 1930-1972*, Bristol: Morris & Juliet Venables, 2003, p86; Spalding, 2009, p414; *A Guide to Nuffield College Chapel*, 2012

Title: *Symbols of the Stigmata*

Location and Size: 3-light liturgical west window, 112x187cm (44x73 1/2in)

Inscription: b.r.: 'John Piper/Reyntiens/Del 1961 Del'

Literature: Osborne, 1997, p79; Spalding, 2009, p414; *A Guide to Nuffield College Chapel*, 2012

Reproduced: Osborne, 1997, p78; *A Guide to Nuffield College Chapel*, 2012

Notes: Christ's heart is in the central light with a hand and foot in the outer lights, the shapes painted on, not outlined in lead, and the background abstract. The colours are shades of grey and beige, some opaque, some transparent, with burgundy for the wounds.

Below: Chapel Interior 2012

Images reproduced with the kind permission of the Warden and Fellows of Nuffield College

Title: unnamed

Location and Size: 2-light liturgical north nave, 112x112cm (44x44in)

Inscription: b.r.: '1961 John Piper Del/Reyntiens'

Reproduced: Osborne, 1997, p79; *A Guide to Nuffield College Chapel*, 2012

Notes: The design for this window is abstract, mainly geometrical shapes, a vertical line of rectangles against a blue background, in the left light red, gold and grey colours; in the right light red, green and grey.

Title: unnamed

Location and Size: 2-light liturgical south nave, 112x112cm (44x44in)

Inscription: b.r.: '1961 John Piper Del/Reyntiens Del'

Reproduced: *A Guide to Nuffield College Chapel*, 2012

Notes: This is a similar design to the other nave window, but the background colour is pale brown and largely transparent, with blue, green and yellow colours in the left hand light; blue, red and gold in the right hand light.

Title: unnamed

Location and Size: 2 light liturgical north chancel, 112x112cm (44x44in)

Inscription: b.r.: 'John Piper del 1961/Reyntiens del'

Notes: The design for this window is abstract with sharper shaped shards of glass and more diagonal movement than the nave windows. The glass is mainly transparent, much painted over, with insertions of light and dark blue and rich cream.

Title: unnamed

Location and Size: 2 light liturgical south chancel, 112x112cm (44x44in)

Inscription: b.r.: 'John Piper Del 1961/Reyntiens del'

Notes: This is similar in design to the other chancel window but with gold, brown and rich cream colours.

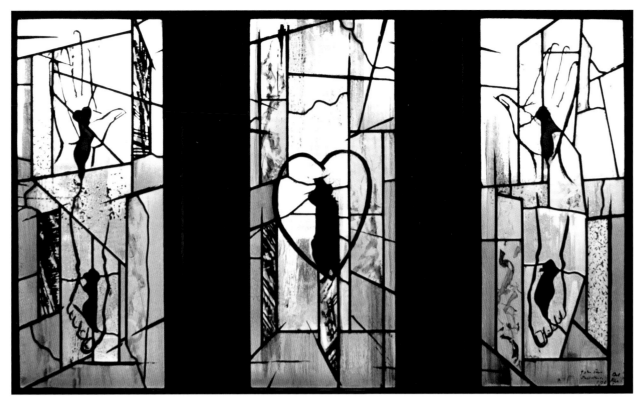

Above: Nuffield College Chapel, *Symbols of the Stigmata*

Below: Chapel Interior 1960s

Pishill, St Paul's, Church Hill, RG9 6HH

Listing: Grade II (11 December 1985) #1194362

General: St Paul's is a wonderful old T-shaped church with box pews, dating back to the 13th century but with much restoration in 1854 for Revd C E Rucke-Keene. It is built of flint rubble with limestone dressings with a gabled old tile roof. The reredos by Powell & Sons is dated 1873.

Date: 1968

Title: *Emblems of St Paul (the Sword and the Gospel), Philip James Hall Memorial Window*

Location and Size: south chancel, approximately 125x27cm (49x10 ½ in)

Inscription: signed 'PR:DW ' b.l. and 'John Piper/68' b.r.

Designer: John Piper

Glass Painter and Maker: Patrick Reyntiens and David Wasley

Commemoration and Donors: The plaque reads: 'PHILIP JAMES HALL/1886-1967/THIS WINDOW/IS ERECTED BY HIS FRIENDS'. The donors were members of the congregation.

Literature: Sherwood Jennifer and Pevsner Nikolaus, *The Buildings of England, Oxfordshire*, Harmondsworth: Penguin Books, 1974, p374, 732; Harrison, 1982, unpaginated; Sherwood Jennifer, *A Guide to the Churches of Oxfordshire,* Oxford: Robert Dugdale, 1989, p159; Osborne, 1997, p100, 175; Humphries Michael, *Pishill Church, Pishill, Henley-on-Thames, Oxon. A Brief History*, 2011, p6; Woollen Hannah, Lethbridge Richard, *John Piper and the Church. A Stained-Glass Tour of selected local churches, in conjunction with the exhibition at Dorchester Abbey from 21 April to 10 June 2012*, 2012, unpaginated

Reproduced: Osborne, 1997, p37; *Stained Glass Windows and Master Glass Painters 1930-1972*, Bristol: Morris & Juliet Venables, 2003, p86; Woollen Hannah, Lethbridge Richard, *John Piper and the Church. A Stained-Glass Tour of selected local churches, in conjunction with the exhibition at Dorchester Abbey from 21 April to 10 June 2012*, 2012, unpaginated

Notes: The window includes the emblems of St Paul, his hands holding a book, set against a cross shape of a red sword, with a dark blue background with white stars and scattered green leaves. Osborne notes that the book is set in front of the sword, possibly indicating that the pen is mightier. The red of the cross could symbolise the Passion and the deep blue of the background, Heaven.

Sandford St Martin, St Martin's, Ledwell Road, OX7 7AG

Listing: Grade II* (27 August 1956) #1052510

General: The church dates from the 13th to the 15th centuries with restorations by G E Street in 1856. It is built of local grey limestone and marlstone rubble with limestone-ashlar dressings and Stonesfield-slate and sheet-metal roofs. Fragments of medieval glass are preserved in the south aisle windows, and there is a rare example of the Royal Arms of Queen Elizabeth 1 painted on wood.

Title: *St Martin of Tours*

Date: 1972-1973

Location and Size: single lancet window, east window of north aisle, approximately 193x26cm (76x10in)

Inscription: Signed and dated b.r.: 'John Piper/Patrick Reyntiens 1973'

Designer: John Piper

Glass Painter and Maker: Patrick Reyntiens

Installation: Cotswold Casement Engineering Ltd

Cost: £350.00

Commemoration and Donor: The window marked the 700th anniversary of the consecration of the church in 1273. The cost of the design was paid for by David Wills, the Sept-Centenary Fund paid £150 for execution and £35 per day for installation.

Citation: 6 June 1973

Dedication: July 1973

Documentation: TGA 200410/2/13/35, 39; Oxfordshire History Centre, Heritage & Arts, PC229

Literature: Harrison, 1982, unpaginated; Elrington C R (Ed), *The Victoria History of the County of Oxford*, Volume 11, London: Oxford University Press, 1983, p180; Sherwood Jennifer, *A Guide to the Churches of Oxfordshire*, Oxford: Robert Dugdale, 1989, p164; Osborne, 1997, p110-111, 176; *St Martin's Church, Sandford St Martin. A guide to the Church and Churchyard*, Sandford St Martin PCC, 2009, p6; Woollen Hannah, Lethbridge Richard, *John Piper and the Church. A Stained-Glass Tour of selected local churches, in conjunction with the exhibition at Dorchester Abbey from 21 April to 10 June 2012*, 2012, unpaginated

Reproduced: Osborne, 1997, p103; *St Martin's Church, Sandford St Martin. A guide to the Church and Churchyard*, Sandford St Martin PCC, 2009, p6; Woollen Hannah, Lethbridge Richard, *John Piper and the Church. A Stained-Glass Tour of selected local churches, in conjunction with the exhibition at Dorchester Abbey from 21 April to 10 June 2012*, 2012, unpaginated; postcards

Notes: The owner of Sandford Park, David H Wills (of the tobacco company W D & H O Wills), paid for one of the Eton College Chapel (Berkshire) windows in memory of his brother and wrote to Piper asking for help with his parish church. The PCC approved various stages of the design on 29 December 1972, 6 February 1973 and 27 March 1973. The window was probably completed by the first week in July 1973. There are two interpretations of the design; one being that St Martin's hands

appear at the top of the lancet holding a red cloak decorated with blue circles and preparing to cut said cloak with a sword; the other being that the first hand is God's indicating that St Martin should divide his cloak. The beggar, with whom St Martin is to share the cloak, holds out a hand at the bottom of the lancet – the hands in each case are ghostly white.

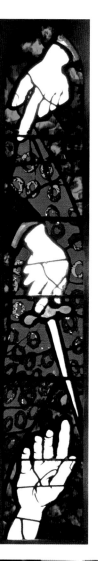

Left: *St Martin of Tours* window

Below: Interior of church with Piper/Reyntiens window on left

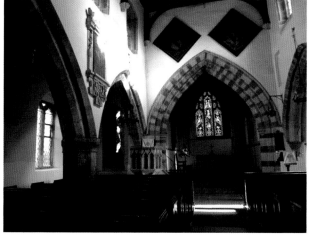

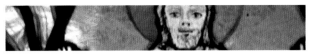

Shipton-under-Wychwood, St Mary the Virgin, Church Street, OX7 6BP

Listing: Grade I (27 August 1956) #1182700

General: The church dates from the early 13th century to 15th century with restorations by G E Street in 1859. It is built of rubble with freestone dressings, with a leaded roof to nave and aisles and stone slate to chancel. The west window is by Morris and Co and the octagonal font and stone pulpit are both thought to be 15th century.

Title: *Millennium Window*

Date: 2004

Location and Size: 3-light rectangular window, western end of south aisle, approximately 234x150cm (92x59in)

Inscription: signed and dated b.r.: 'Reyntiens 2004'

Designer and Glass Painter: Patrick Reyntiens

Glass Maker and Installer: John Reyntiens

Study: There is a photograph of the study in the Oxfordshire History Centre. There appears to be no significant difference between the study and the final window.

Commemoration and Donors: The window commemorates the Millennium and was made possible by a legacy from Desmond Bagguley and other donations from parishioners

Dedication: 31 October 2004

Documentation: Oxfordshire History Centre, Heritage & Arts, PAR235

Reproduced: greetings card

Notes: The window illustrates the parable of the sower from *Matthew* 28: 19: 'Go ye therefore, and teach all nations, baptizing them in the name of the Father, and of the Son, and of the Holy Ghost'. It indicates the hazards of sowing where the soil is doubtful, and the yellow tongues could be interpreted as wheat ears and also Pentecostal flames. The world is shown by a blue circle with tiny fish swimming in the oceans and the scattered green trees symbolize the fecundity of the world. Christ is depicted within a pink mandorla, 'his countenance was like lightning, and his raiment white as snow' (*Matthew* 28: 3). The outer edges of the window contain half circles mostly composed of clear glass. The spheres may be related to Dante's writings. There are more green leaves and yellow flames in the tracery.

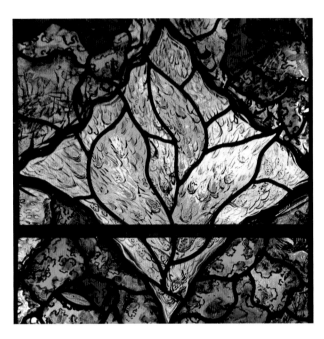

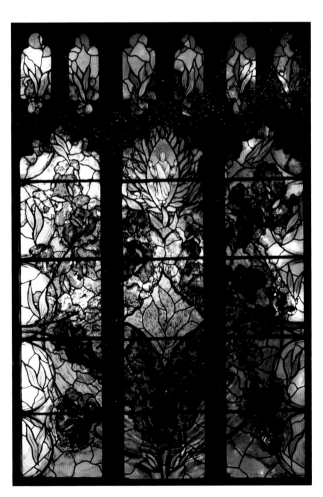

Right: Detail of window and *Millennium Window*

Wantage

Date: c1953

Glass Painter: Patrick Reyntiens

Literature: Spalding, 2009, p350

Notes: A window by John Francis Bentley in a church in Wantage was broken and John Betjeman, a friend of Reyntiens' in-laws, contacted the young artist. Reyntiens successfully painted a small piece of pink glass to replicate the broken pane. Betjeman was most impressed, introduced Reyntiens to John Piper and the rest, as they say, is history. I have been unable to identify which church was involved. Betjeman was also instrumental in gaining the commissions for Oundle School, Northamptonshire and Nuffield College, Oxford and may have improved Piper's chances with Eton College, Berkshire. Betjeman and Piper used to embark on 'church-crawling' adventures together and were involved with the Shell County Guides.

Wolvercote, Church of St Peter, First Turn, Upper Wolvercote, OX2 8AQ

Listing: Grade II (12 January 1954) #1047300

General: The west tower dates from the 14th century but the remainder of the church was rebuilt in 1860 by the Oxford architect Charles Buckeridge in coursed limestone rubble with limestone dressings. The original Stonesfield stone slates were replaced by reconstituted stone slates in 1977. One of the south chancel windows contains early 14th century geometric grisaille glass thought to have come from Merton College, Oxford.

Title: *Palm Sunday window, Bellamy Memorial*

Date: 1975-1976

Location and Size: 2-light window at west end of south aisle, approximately 107in wide

Inscription: signed by the artist b.r.: 'John/Piper'

Designer: John Piper

Glass Painter and Maker: Patrick Reyntiens

Assistant: David Wasley

Installation: Michael Stockford and Dr Desmond Walshaw

Commemoration and Donors: Alderman C.J.V Bellamy and his wife left £1,000 for a memorial window which should relate to the text 'suffer the little children to come unto me' (they were childless). A plaque below the window reads as follows: In memory of Clement James Victor Bellamy, Alderman,/and Maud Emma his wife, who in 1976 gave this window/designed by John Piper and made by Patrick Reyntiens./The Piper window/ was restored in memory of/Peter Nicholson/1968-2011/*Filius carissimus*'.

Dedication: 29 June 1976 (St Peter's day) by the Rt Revd Peter Walker, Bishop of Dorchester, followed by the Annual Festival which included an exhibition in the church of Piper's art

Documentation: Oxfordshire History Centre, Heritage & Arts, pamphlet OXFO 283 WOLV

Literature: *Wolvercote Parish Magazine*, January 1974; *Wolvercote Parish Magazine*, June 1975; *Ambit, Wolvercote Parish Magazine*, May 1976; *Ambit, Wolvercote Parish Magazine*, August 1976; Harrison, 1982, unpaginated; Angus Mark, *Modern Stained Glass in British Churches*, London & Oxford: Mowbray, 1984, p106; Osborne, 1997, p111, 176; Woollen Hannah, Lethbridge Richard, *John Piper and the Church. A Stained-Glass Tour of selected local churches, in conjunction with the exhibition at Dorchester Abbey from 21 April to 10 June 2012*, 2012, unpaginated

Reproduced: Angus Mark, *Modern Stained Glass in British Churches*, London & Oxford: Mowbray, 1984, p107; Osborne, 1997, p115; Woollen Hannah, Lethbridge Richard, *John Piper and the Church. A Stained-Glass Tour of selected local churches, in conjunction with the exhibition at Dorchester Abbey from 21 April to 10 June 2012*, 2012, unpaginated

Notes: Alderman Bellamy bequeathed money for the proposed window which became available following the death of his wife who died aged 93 and was buried on 14 December 1973. The District Church Council initially considered some traditional designs from a number of studios to replace the east window in the north aisle before it was suggested Piper should be contacted. The artist visited the church, decided that the fabric of the window was not in a good state and offered instead to design a window for the south aisle. The June 1975 issue of the Parish magazine reported that the PCC had approved the design. In August 1976 *Ambit* noted that Piper had given an interview to Radio Oxford in which he said that it would have been difficult to illustrate the title of the window so they considered two ways in which children responded to Jesus – the young boy who gave his lunch of loaves and fishes and those who greeted Jesus enthusiastically on Palm Sunday (*John* 12:13). The latter was chosen and 'we managed to persuade the executor that it would be alright to have a triumphal entry into Jerusalem with just hands waving palms – all sorts of hands obviously, different classes and creeds and types and colours of race, all the people are, and that just is the subject and

that's all the subject is'. The parish outing on Whit Monday 1976 visited Reyntiens' studio to see the work in progress. Various changes were suggested including the green arm and hand which links both lights. The design shows hands on a blue ground with two palm fronds which meet in the cinquefoil at the top. Apparently the children's hands were those of Piper's sons. In his dedication of the window the Bishop of Dorchester described the window as 'a priceless gift from day to day. And why? Because of its freshness and delight – and because too, being what it is, and evocative as it is (and how evocative are those hands) it

can open our eyes, give us a glimpse, evoke our own response – liberate us, that is to say, into an ounce of gladness.' Woollen's guide notes that 'the window is full of activity with the hands crossing over between the two main lights creating the feeling of excitement and anticipation that the inhabitants of Jerusalem must have experienced.'

The window was initially protected on the exterior by plastic sheeting but this sandwiched heat behind the glass causing some movement. In 2011 the window was cleaned, one section was removed and restored and it is now protected by wire mesh.

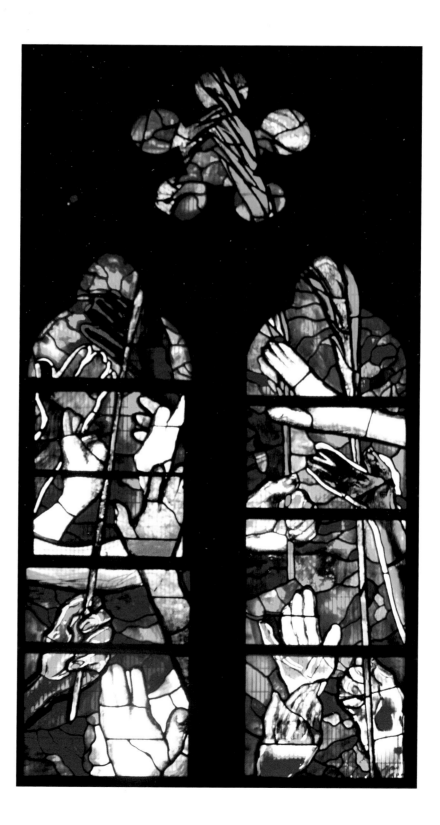

SHROPSHIRE

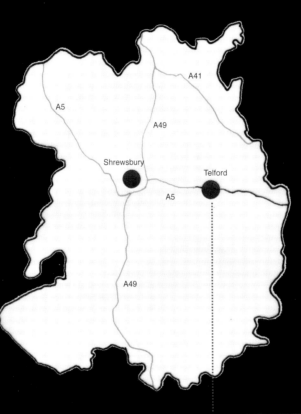

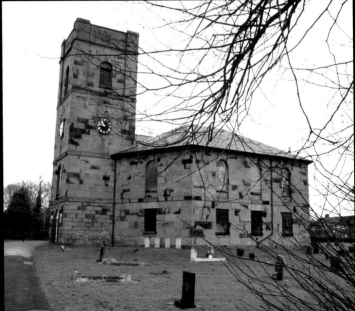

Telford, St Leonard's, Church Road, Dawley, TF4 2AS

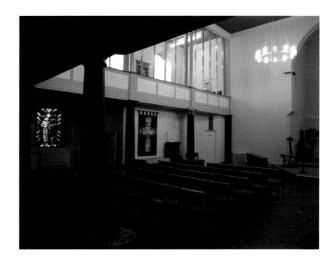

Listing: Grade II* (26 March 1968) #1367391

General: St Leonard's is one of only three churches in England designed by Thomas Telford and is dated 1805. The church is an unusual elongated octagon in plan, built in sandstone with stone and iron columns, rectangular and Georgian windows, a hipped slate roof and a large west tower. The church is rectangular inside with sacristies in the adjacent triangles and galleries on three sides of the nave. Telford's design was based on the fact that he wished 'to correct what appeared to be inconvenient and faulty in the general construction of churches. For instance, the very extended oblong form seemed to be inconvenient because in this way a considerable number of the pews were removed to a very great distance from the pulpit.' In a move long predating Vatican 2, Telford hoped that 'the attention will be drawn to the body of the church which is meant to appear as one great and undivided apartment' (quoted in Brice, p2 regarding Telford's design for St Mary's, Bridgnorth)

Title: *Christ Saving Peter on Lake Galilee*

Date: 1965

Location and Size: north west end of nave, approximately 179x125cm (70 1/2x49in)

Above: View of the interior with Reyntiens' window

Below: *Christ Saving Peter on Lake Galilee*

Inscription: b.r.: 'Reyntiens '65'

Designer, Glass Painter and Maker: Patrick Reyntiens

Donors: The stained glass in the church dates from the 20th century and all are memorial windows – Hill and Brice state that this one is in memory of Gladys Cope although it might be in memory of the Windsor family.

Literature: Hill Revd Roger, *A Telford Church. St Leonard's, Malinslee, a history and guide*, 1980, unpaginated; Brice Alan, *St Leonard's Malinslee, Bicentenary 2005, A Telford Church*, 2006, p7; Newman John and Nikolaus Pevsner, *The Buildings of England, Shropshire*, Yale University Press, 2006, p78, 647

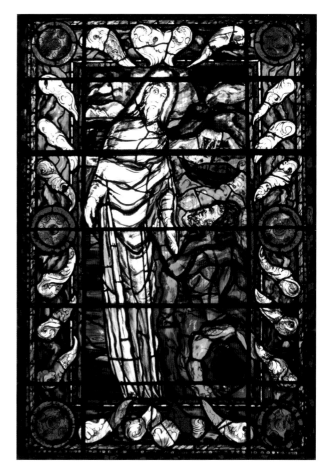

Notes: Newman feels that there are only two windows in Shropshire worth mentioning, this and one by Alan Younger dated 1981 at Newport. He describes the window as 'psychologically powerful, in style influenced by Chagall'. The window is based on *Matthew* 14:22-33 where, following the feeding of the 5,000, Jesus sent his disciples by boat to the other side of Lake Galilee whilst he prayed alone. Unfortunately a storm arose and Jesus walked across the water to rescue his friends. Peter went to meet Jesus but was afraid and sank in the water before Jesus rebuked him with the words 'O thou of little faith, wherefore didst thou doubt?' and rescued him. A white willowy Christ on the left holds out his hand to Peter whose body vaguely emerges from the green and blue of the sea. The image is surrounded by a wide border containing scrolls and roundels in keeping with the classical nature of the church.

SOMERSET AND BRISTOL

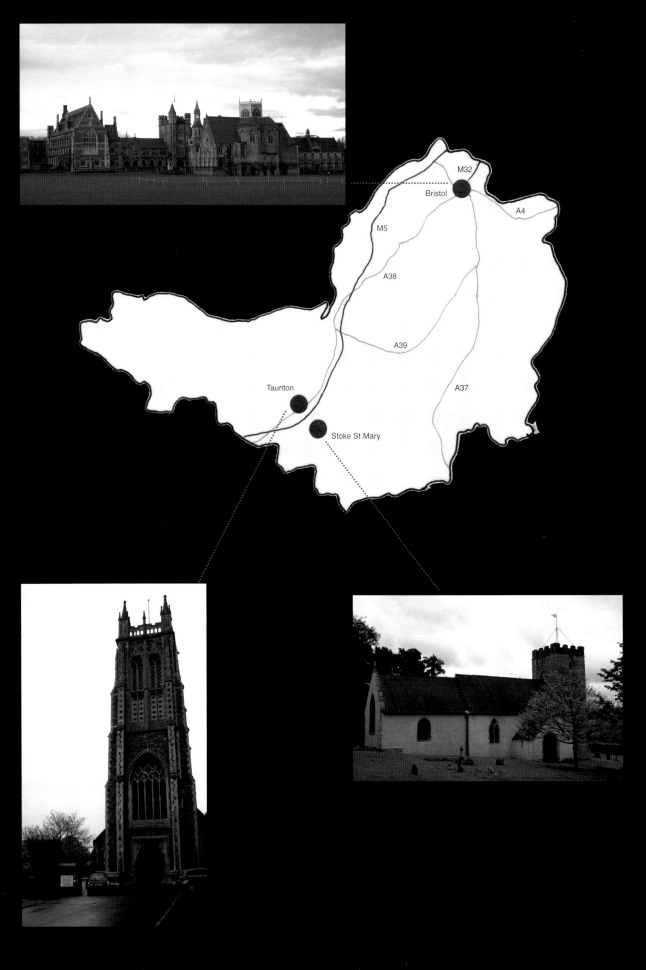

M32

Bristol

M5

A38

A39

A37

Taunton

Stoke St Mary

Bristol, Clifton College Chapel, 32 College Road, Clifton, Avon, BS8 3JH

General: Set in what John Betjeman described as 'the handsomest suburb in Europe', Clifton College is an independent day and boarding school for girls and boys aged 3-18. The large chapel is unusual in shape, with a short nave opening into a multi angled area with a high ceiling and lantern culminating with a chancel and apsidal east end.

Title: *Centenary Window*

Date: 1964

Location: 2-light north window in nave

Designer, Glass Painter and Maker: Patrick Reyntiens

Commemoration: The window celebrates the centenary of the College

Literature: Clarke Brian (Ed), *Architectural Stained Glass*, London: John Murray, 1979, p193; *Stained Glass Windows and Master Glass Painters 1930-1972*, Bristol: Morris & Juliet Venables, 2003, p84

Notes: The left hand light includes the symbols for alpha and omega over an open book which symbolises wisdom and knowledge, a tortoise and looking glass which symbolise prudence and self-knowledge - the glass may also be the unspotted mirror of purity, a symbol of the Virgin Mary. A tower with three yellow windows symbolises courage and fortitude, but could also be interpreted as the Ivory Tower or the Golden Gate, also symbols of the Virgin Mary. The right hand light includes a sheathed sword indicating temperance and mercy, scales symbolising justice and the burning bush of Moses symbolising piety and fear of the Lord. In the tracery are Pentecostal flames and a dove symbolising the Holy Spirit and peace.

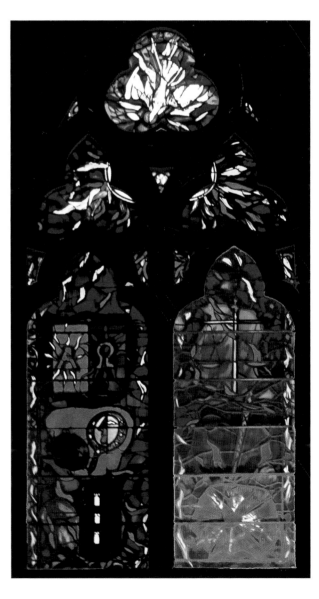

Stoke St Mary, St Mary's, TA3 5BY

Listing: Grade II* (25 February 1955) #1177216

General: St Mary's is a delightful little country parish church in a large churchyard with daffodils and cherry trees lining the path from the gate to the north porch. The church, built of rubble, partly roughcast, with Ham stone dressings, dates from the 13th century with fenestration mainly from the 15th century and a south aisle added in 1864. When Reyntiens designed the first window one of the parishioners pointed out that it would be good to see coloured glass in the window opposite the north entrance. Reyntiens then came up with a scheme which portrayed the life of the Virgin Mary in the three south aisle windows and the west window at the end of the aisle. The latter window illustrated the *Dormition of the Virgin Mary* and Reyntiens considered it one of the best colour designs he'd ever made. In the event only two more windows were commissioned which is rather a shame because the white light from the west window mars the beauty of the stained glass. On the other hand the design was predominantly purple, blue and black and it was felt that it would darken the church too much.

The following details are applicable to all three windows:
Designer and Glass Painter: Patrick Reyntiens

Glass Maker: John Reyntiens

Film: Mapleston Charles, Horner Libby, *From Coventry to Cochem, the Art of Patrick Reyntiens*, Reyntiens/Malachite, 2011

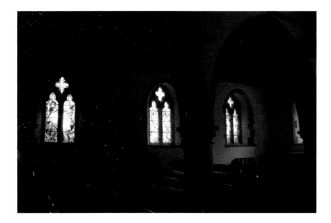

Title: *Childhood of the Virgin Mary, Millennium Window*

Date: 2000-2001

Location and Size: 2-light window at east end of south aisle (St Anne's Chapel), approximately 190x83.5cm (74 3/4x33in)

Studies: cartoon, Reyntiens Trust

Donors: The window was commissioned by Stoke St Mary Church Committee and Stoke St Mary Millennium Committee

Dedication: Sunday 10 September 2000

Film: Pow Rebecca, *Rather Good at Blue. A Portrait of Patrick Reyntiens*, HTV West, 2000

Notes: The window shows the Virgin Mary's parents, St Anne and her husband St Joachim, teaching their daughter to read. Reyntiens reasoned that if Christ was literate he was most probably taught by his mother, and the artist decided that an appropriate text would be Isaiah 7:14: 'Therefore the Lord himself shall give you a sign; Behold, a virgin shall conceive, and bear a son, and shall call his name Immanuel' and he specifically wanted this to appear in the window in Hebrew, so he commissioned a rabbi to write the words on a scroll, which Reyntiens then copied. The rabbi instructed the artist that once he had finished with the scroll he was to bury it in the ground so that its authority would be taken into the world in general. The temple at Jerusalem is depicted at the top of the right hand light with a dove symbolising the Holy Spirit in the quatrefoil. The parishioners wanted to stress the importance of education and also reflect the dawn of a new millenium and the environment.

Title: *Descent of the Holy Spirit*

Date: 2002-2003

Location and Size: 2-light window in south aisle, approximately 190x83.5cm (74 3/4x33in)

Studies: cartoon, Reyntiens Trust

Notes: The design shows crowds of people gathered for Pentecost and the tongues of fire which mark the descent of the Holy Spirit, the colours generally yellow and red tones. There is a dove in the quatrefoil. The delight of this window is that when the porch door is open one can see this vivid work from the path which is a welcoming sight.

Title: *Annunciation*

Date: 2002-2003

Location and Size: 2-light window at west end of south aisle, approximately 190x83.5cm (74 3/4x33in)

Studies: cartoon, Reyntiens Trust

Notes: A white angel Gabriel floats across the centre of the window to inform a blue clad Mary on the right that she will have a child although a virgin. The colours are generally blue-green and a dove can be seen in the quatrefoil.

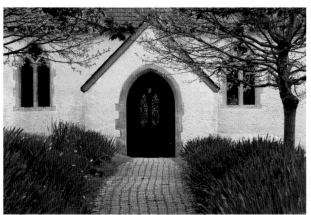

Left: Interior showing the three south aisle windows
Above: The *Descent of the Holy Spirit* window framed by the porch
Opposite page: *Childhood of the Virgin Mary*, *Descent of the Holy Spirit*, *Annunciation* (completed windows above and cartoons below)

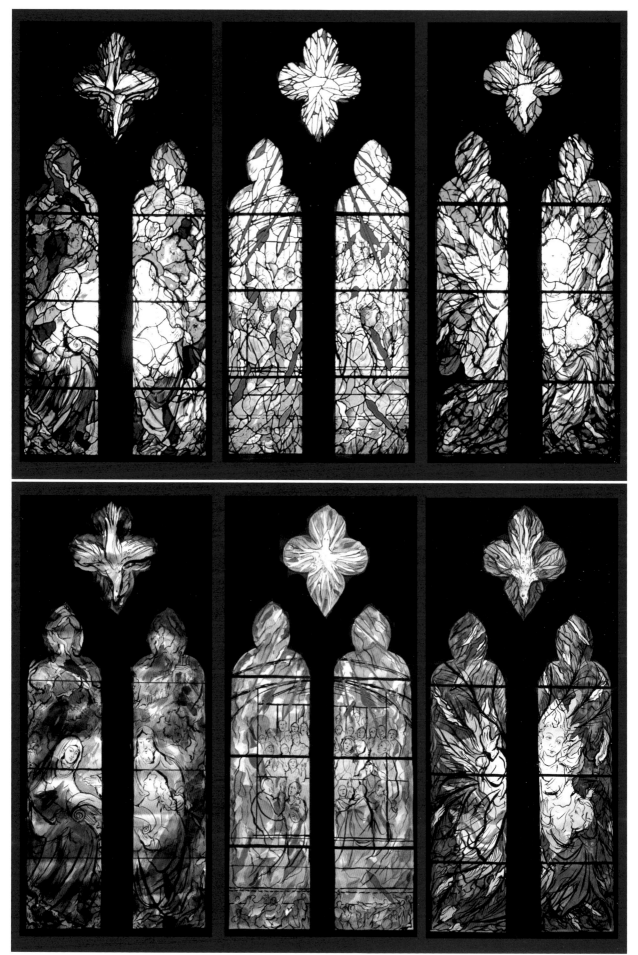

Taunton, St George (RC), Billet Street, TA1 3NN

Listing: Grade II* (4 July 1975) #1231201

General: The church, designed by Benjamin Bucknell, dates from 1860 and is built in an early 14th century style in red rubble with ashlar dressings, with a large west tower and equally large Decorated style west window. The sanctuary was redecorated and arranged according to contemporary liturgical requirements in 1970 at which stage the roofs were relaid with asbestos slates.

Literature: Storer Patrick Anthony, *A History of St George's Catholic Church, Taunton*, 1990

Title: *Christ in Majesty*

Date: 2009-2010

Location and Size: 5-light west window, approximately 1372x772cm (540x304in)

Designer and Glass Painter: Patrick Reyntiens

Glass Maker: John Reyntiens

Study: Reyntiens Trust (Reyntiens did not make a full size cartoon for this window)

Dedication: 20 April 2010 by Rt Revd Decland Lang, Bishop of Clifton (150th Anniversary Celebration)

Literature: *CBRS*, 'St George's Church, Taunton', 1970, p82

Film: Mapleston Charles, Horner Libby, *From Coventry to Cochem, the Art of Patrick Reyntiens*, Reyntiens/Malachite, 2011

Notes: Reyntiens designed the window to empathise with the Gothic revival architecture in theme, colouring and use of lead lines and wanted a large figure which could be seen and read from as far away as the sanctuary. The figure is Christ Pantocrator, the Almighty, based on the description in *The Epistle Of Paul The Apostle To The Colossians* 1:15-20. The Pantocrator has been a central figure of Eastern Orthodox and Eastern Catholic art since the 7th century and is always depicted fully frontal. Unusually Reyntiens' figure has both hands raised perhaps to symbolise both blessing and teaching, and consolidating this imagery Christ has an open book on his lap representing 'Christ the Teacher'. The book bears the alpha and omega symbols. In the traditional fashion Christ is bearded, his hair centrally parted and his head is surrounded by a halo – Reyntiens painted the face in 15 minutes. He has added elements of the Western 'Christ in Majesty' imagery, placing the seated figure within a mandorla which is in turn placed within a circle, and has included the symbols of the Four Evangelists. The blue ground within the mandorla could indicate earth with the surrounding green sphere probably representing the heavens, with yellow and blue angel wings or Pentecostal tongues of fire scattered around. Beneath the feet of Christ are skulls which indicate that death has been eliminated. The yellow circles in the tracery are a combination of kiln formed glass and acid etched glass. The window was made from a small study, not a full size cartoon, and contains about 8,000 pieces of glass, all fired at least twice, and took two years to make.

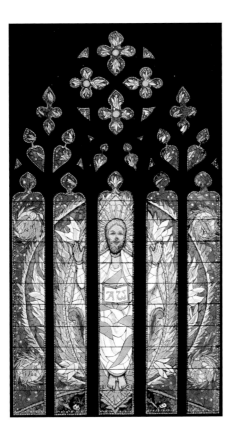

Left: Study, photograph courtesy Reyntiens Trust

Below: Interior of church looking west

Opposite: *Christ in Majesty*

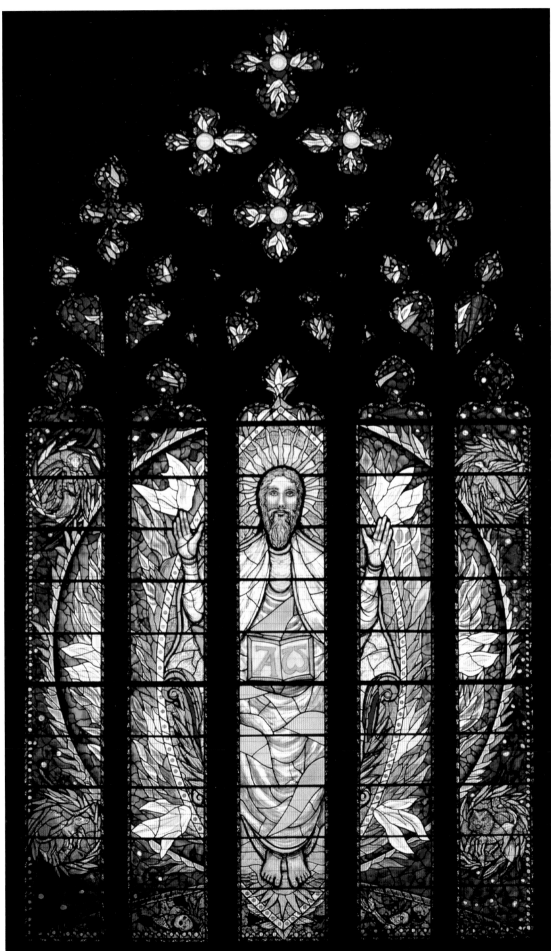

STAFFORDSHIRE

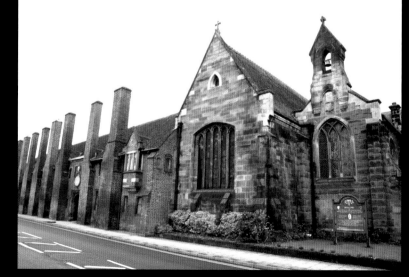

Lichfield, Hospital of St John Baptist (Chapel of St John Baptist without the Barrs), St John Street, WS13 6PB

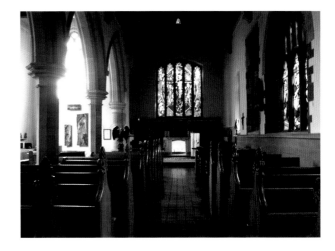

Listing: Grade I (5 February 1952) #1218231

General: St John's Hospital was founded in 1135 by Bishop Roger de Clinton and staffed by Augustinian Canons to offer hospitality to pilgrims visiting the shrine of St Chad in the cathedral. The name of the establishment is explained by the fact that it was situated outside the city gates or 'barrs'. In 1495 the Hospital was re-founded as a free grammar school and an Almshouse for 'thirteen honest poor men upon whom the inconveniences of old age and poverty, without any fault of their own, have fallen'. It was at this time that the distinctive building with the eight prominent chimney stacks was built. The chapel was extended in 1829 and restored in 1870.

Title: *Christ in Majesty*

Date: 1984

Location and Size: 5-light east window, approximately 360x285cm (141x112in)

Designer: John Piper

Glass Painter and Maker: Patrick Reyntiens

Donor: The window was paid for by the Trustees and a bequest from Samuel Hayes, a former resident.

Dedication: June 1984

Literature: *Sunday Telegraph The*, Faulkes Sebastian, 'Romantic vision of a pagan believer', 1 July 1984, p11; Osborne, 1997, p140-142, 178; Spalding, 2009, p486; Williams Canon Roger, *St John's Hospital LICHFIELD*, Ziggurat Design, undated, p17, 22,25

Reproduced: Osborne, 1997, p138; ; Williams Canon Roger, *St John's Hospital LICHFIELD*, Ziggurat Design, undated, p7, 10-11, 22-25; postcard

Notes: This was the last window on which Piper and Reyntiens collaborated and Piper was quoted in the *Sunday Telegraph* article as saying: 'His accountant told him he couldn't afford to work with me any more – or some such thing'. The window replaced one of plain white quarry glass, and Piper's inspiration was Romanesque sculptures in the Dordogne and Saintogne areas of France and specifically a window at Beaulieu in the Dordogne. Christ is depicted with his arms outstretched within a red bordered mandorla and flanked by two green angels blowing trumpets with the sun and moon above them and a slightly offset Mercian Cross. Surrounding the mandorla is green glass and the symbols of the evangelists at the four corners. Faulkes described the window as 'a work of alarming power' and noted that at the time one older observer said: 'Of course I like it – everything that is except the design and the colour'!

Above: Interior of chapel

Below: *Christ in Majesty*

Opposite page: Statue of St John above entrance

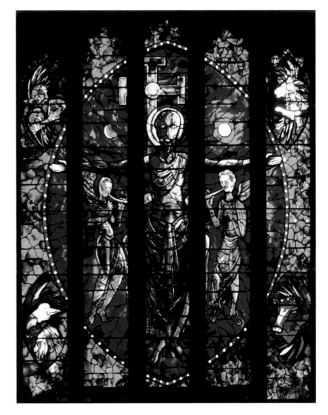

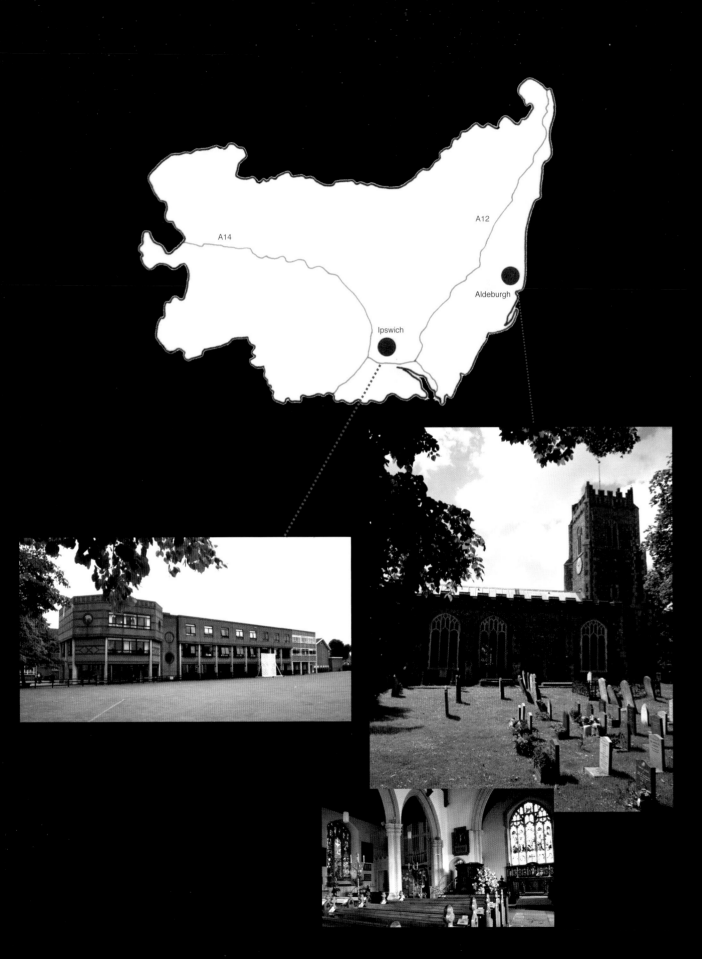

SUFFOLK

A14

A12

Aldeburgh

Ipswich

Aldeburgh, St Peter & St Paul, Victoria Road, IP15 5DY

Listing: Grade II* (27 February 1950) #1269731

General: St Peter & St Paul's is a flint and pebble building with ashlar dressings and some brick, mainly dating from the 16th century, with restorations in 1870-1871 by Henry Perkin and 1891 by E F Bishop. The church faces the sea and is inextricably linked to the sea. The tall west tower dates from the 14th century and was constructed as a seamark and watchtower to give warnings of the 'Dunkirkers', Lowland pirates. In February each year the church holds a special Seafarer's service and in the 1530s ship auctions were held in the church. The octagonal font, which is placed beneath the Britten Memorial window, dates from 1320, and one face survived the butchering of reformation zealots. A number of well-known personalities have graced the interior including the poet George Crabbe who is commemorated with a bust by Thomas Thurlow; Elizabeth Garrett Anderson who was not only the first female doctor but also the first female mayor in Britain; and of course Edward Benjamin Britten (1913-1976). Britten was a composer, conductor and pianist who, together with his partner, the tenor Sir Peter Neville Luard Pears, and the librettist Eric Crozier, founded the Aldeburgh Festival in 1948. Britten also wrote the *War Requiem* for the consecration of Coventry Cathedral and his opera *Peter Grimes* is based on Crabbe's poem *The Borough*.

Literature: NADFAS, *Record of Church Furnishings, St Peter and St Paul, Aldeburgh, Suffolk*, 2006

Title: *Benjamin Britten memorial*

Date: 1979-1980

Location and Size: , 3-light Perpendicular window in north aisle, 370x189.5cm (145 3/4x74 1/2in)

Designer: John Piper

Glass Painter and Maker: Patrick Reyntiens

Assistants: Joseph Nuttgens, David Williams

Installation: Wm C Reade Ltd

Cost: about £5,000 including installation, Piper's design was a gift to the church

Commemoration and Donors: Benjamin Britten. The window was paid for by a public appeal fund organised by a Town Council committee under the Chairmanship of Mrs L Gifford.

Faculty: 25 April 1979 (DR3847)

Dedication: 6 June 1980 by the Bishop of St Edmunsbury and Ipswich at the opening service of the 33rd Aldeburgh Festival

Documentation: *Parish Log Book*, June 1980

Literature: *Berks and Bucks Countryside*, Coomer Norman, 'Exciting new future for Beaconsfield school', Vol 20, No 157, September 1980, p18; Harrison, 1982, unpaginated; Angus Mark, *Modern Stained Glass in British Churches*, London & Oxford: Mowbray, 1984, p50; *Sunday Telegraph The*, Faulkes Sebastian, 'Romantic vision of a pagan believer', 1 July 1984, p17; Cowen Painton, *A Guide to Stained Glass in Britain*, London, Michael Jospeh Ltd, 1985, p186; Haward Birkin, *Nineteenth Century Suffolk Stained Glass*, Suffolk: Boydell Press, 1989, unpaginated; Mortlock D P, *The Popular Guide to Suffolk Churches, No 3 East Suffolk*, Cambridge: Acorn Editions, 1992, p2; Osborne, 1997,

p120-121, 176; Blythe Ronald, *The Parish Church of St Peter & St Paul, Aldeburgh, Suffolk*, 1998 (1957), p14-15; Jenkins Simon, *England's Thousand Best Churches*, London: Allen Lane The Penguin Press, 1999, p640; NADFAS, *Record of Church Furnishings, St Peter and St Paul, Aldeburgh, Suffolk*, 2006; Spalding, 2009, p486

Reproduced: *Berks and Bucks Countryside*, Coomer Norman, 'Exciting new future for Beaconsfield school', Vol 20, No 157, September 1980, p18 (Williams working on Burning Fiery Furnace); Compton Ann (Ed), *John Piper, painting in coloured light*, Kettle's Yard Gallery, 1982, unpaginated; Angus Mark, *Modern Stained Glass in British Churches*, London & Oxford: Mowbray, 1984, p51; Osborne, 1997, p122-123; Blythe Ronald, *The Parish Church of St Peter & St Paul, Aldeburgh, Suffolk*, 1998 (1957); *Cornerstone*, RS, '… but then there was John Piper', Vol 25, No 4, 2004, p47; Neiswander Judith & Swash Caroline, *Stained & Art Glass*, London: The Intelligent Layman Publishers Ltd, 2005, p255; NADFAS, *Record of Church Furnishings, St Peter and St Paul, Aldeburgh, Suffolk*, 2006; Spalding, 2009, plate 77; postcards

Film: Mapleston Charles, Horner Libby, *An Empty Stage. John Piper's romantic vision of spirit, place and time*, Goldmark/ Malachite, 2009

Notes: The window replaced a plain glass window next to the organ and choir vestry. John and Myfanwy Piper were close friends of Britten and Pears. Piper had created stage sets for Britten's operas and Myfanwy had written librettos so it is unsurprising that Piper should have been called upon to design the memorial window. The design represents three Parables written for church performances (the librettos for these three works were by William Plomer). The left hand light depicts *The Prodigal Son* (1968) and the actual image of the father and son is based on Rembrandt's painting of the same title dated 1668-1669 now in The Hermitage, St Petersburg. On the right hand side is the *Burning Fiery Furnace* (1966) (*Daniel* 3: 12-28) where Shadrach, Meshach and Abednego were thrown into a furnace for refusing to worship a golden image of King Nebuchadnezzar but emerged unscathed because of their faith. The design is taken from a Romanesque capital at Autun designed by the wonderful sculptor Giselbertus. The central light, *Curlew River* (1964) is based on a Japanese Noh play titled *Sumidagawa* in which a mother seeks her son by the side of a river only to discover that he has died and been buried on the opposite bank. On a tour of the Far East in 1956, Britten and Pears saw the play in Tokyo. For the first 20 minutes they found the performance tedious but when the central character took the stage, a crazed woman played by a tall man in a white mask, they were transfixed. Eventually, Britten composed his own version of the tale, *Curlew River*, with Pears playing the woman. The left and right lights are in hot colours, mainly red, yellow and purple and the archway above the prodigal son reflects that of the furnace, giving the work a symmetry. The central light is much cooler, a river winding its way through a green background, with the white curlew (also seen by many as a dove) pointing downwards and some mauve coloured bamboo leaves at the base. Cowan feels that the 'dove-like curlew seemingly gives birth to the whole lancet with its natural forms'. Mortlock considers it as the most striking window in the church, 'its dark and vibrant colour acts like a magnet as soon as one enters' and Haward describes the window as 'exceptional col & outstanding modern SG'. This was one of the first major projects Reyntiens undertook at his Old Church School studio.

Interior of the church with the *Benjamin Britten memorial* window on left shown on opposite page.

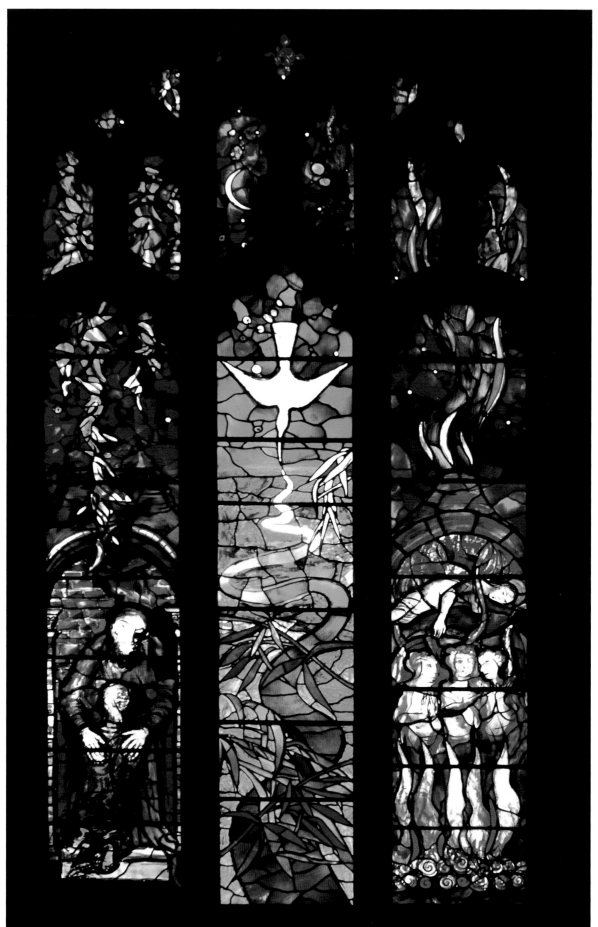

Benjamin Britten memorial window, Aldeburgh

Ipswich, Ipswich School, Henley Road IP1 3SG

General: Ipswich School is a co-educational, independent day and boarding school for children aged 3-18. It was founded during the 14th century and its first Charter was granted by Henry VIII when the school was located in the town centre. It moved to its new site opposite the arboretum of Christchurch Park in 1852. Former pupils include the artists Sir Edward Poynter, Charles Keene and Edward Ardizzone.

The following details are applicable to all four windows:
Date: 1980-1981

Size: 105cm diameter (41 1/4in)

Designer: John Piper

Glass Painter and Maker: Patrick Reyntiens

Assistant: David Wasley

Architect in charge: Birkin Haward of John Slater & Haward, Ipswich

Documentation: School Library, *Pages from Practice Nov 78 to June 81*, compiled by Birkin Haward at the request of the Headmaster, Dr John M Blatchly

Literature: Harrison, 1982, unpaginated; *House and Garden*, Levi Peta, 'Springboard from Piper and Reyntiens: or the brave new world of the stained-glass designers', April 1983, p147; Osborne, 1997, p124-125, 177; *Times The*, Wasley David, 27 March 2002

Notes: The library is at one end of the concrete framed, brick clad building designed by Haward. According to Wasley, Haward's own home with its two storey hall decorated with his cherished collection of stained glass cartoons was the inspiration for the library and his decision to commission Piper to unify the octagonal faces of the library balcony. Haward (an authority on stained glass) appears to have toyed with various ideas for the circular windows including abstracts, school emblems, copies of round windows at Amiens, Chartres, Lausanne, Lincoln, Notre Dame and Washington DC before sketching a Piperesque foliage head accompanied by the notes 'seasons/ages of man/mythological history of East Anglia, the Green man (ref carvings in churches) … spring light blue green yellow, summer brighter blue red (?) green, autumn red brown cols on sun image, winter colder black blue white'. He refers to the book by C J P Cave, *Roof Bosses in Medieval Churches*, which happened to be a favourite of Piper. In November 1980 Piper responded to a letter from Haward in which he stated that he would be unable to start designing the windows until the following spring, he felt the Seasons rather than the Arts would be a suitable subject and that he would discuss the windows with Reyntiens, who was responsible for leading and adjustments. By July 1981 Piper had completed two full sized cartoons and was progressing with work on *Summer* and *Spring*. The foliate heads represent the four seasons, four elements and four ages of man. They are situated so that they make the most of the appropriate seasonal light.

Title: *Spring*

Location: north east roundel

Inscription: signed and dated b.r.: 'John Piper/1981'

Commemoration: The window is dedicated to Roger James John Cooper (1957-1980), an alumnus of the School.

Literature: *Listener The*, Dodd Philip, 'Fertile Imaginings' 15 Nov 1990, p25

Reproduced: *Listener The*, Dodd Philip, 'Fertile Imaginings' 15 Nov 1990, p25; Osborne, 1997, cover, p127

Notes: This window represents spring, the Greek element earth and youth and receives the early morning light. Pink lips, a yellow nose and pale mesmeric eyes peer out from green foliage overlaid with narrow curving branches, with purple and red colours creeping into the borders. Dodd felt that the green man image evoked a 'naïve bucolic past'.

Below: Looking across the library towards *Summer* foliate head

Title: *Summer*

Location: south east roundel

Commemoration: The window is dedicated to Allan Harry Leggett (1908-1987), Governor and Benefactor of the School.

Reproduced: Osborne, 1997, p127

Notes: This window represents summer, air and adulthood and is lit before noon. The face is blue with pink lips and is overlaid and surrounded by flowers in purple and pink with the addition of some yellow and green glass.

Title: *Autumn*

Location: south west roundel

Commemoration: The window is dedicated to Patrick John Bills (1961-1980), an alumnus of the School who died in the Rocky Mountains.

Reproduced: Osborne, 1997, p127

Notes: This roundel represents autumn, fire and adulthood and is lit during the afternoon. A blue and mauve coloured face is overlaid with red and yellow flame like shapes.

Title: *Winter*

Location: *Winter*, north west roundel

Literature: Harrison, 1982, unpaginated; Osborne, 1997, p127

Reproduced: Osborne, 1997, p127

Notes: This roundel represents winter, water and old age and receives less sun. In the cold winter of 2009/2010 it seemed to come into its own according to the librarian. It is arguably the most beautiful of the roundels, with, appropriately enough, a certain maturity about the design which is carried out in an array of blue and green with the lips being dark red.

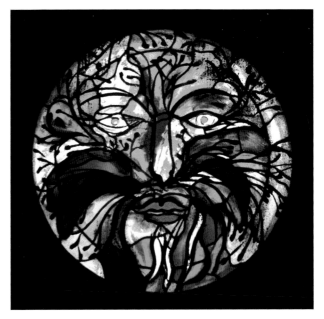

'As Fragonard said in the 18th century, if you are professional you can do something very quickly and if you're not professional you might as well just not try and that's true of all sorts of things and especially glass painting.'

Reyntiens interview April 2010

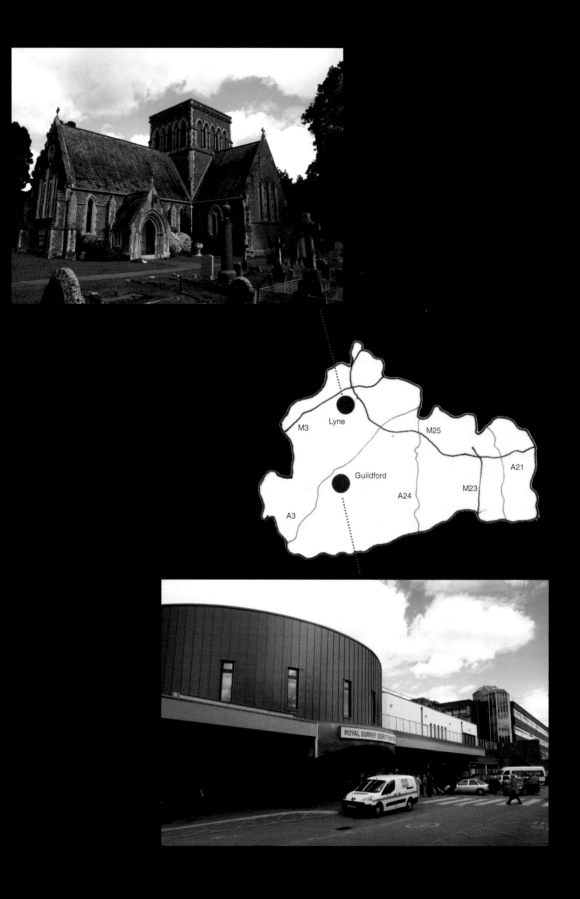

Guildford, Royal Surrey County Hospital, Chapel, Egerton Road, GU2 7XX

Title: *Geoffrey Lavis Memorial Window*

Date: 1990

Location and Size: antechapel, two semicircles each 57cm (22 1/2in) radius either side of flask shape 133 cm (52 1/4in) diameter, 153 cm (60 1/4in) tall, mounted on to plain glass window

Inscription: Below the panels are three biblical quotations, the left hand one in Latin, the central one in English and the right hand one in Greek. The central one is from *Proverbs* 8: 22-35: 'The LORD possessed me in the beginning of his way, before his works of old. I was set up from everlasting, from the beginning, or ever the earth was. When there were no depths, I was brought forth; when there were no fountains abounding with water. Before the mountains were settled, before the hills was I brought forth: While as yet he had not made the earth, nor the fields, nor the highest part of the dust of the world. When he prepared the heavens, I was there: when he set a compass upon the face of the depth: When he established the clouds above: when he strengthened the fountains of the deep: When he gave to the sea his decree, that the waters should not pass his commandment: when he appointed the foundations of the earth: Then I was by him, as one brought up with him: and I was daily his delight, rejoicing always before him; Rejoicing in the habitable part of his earth; and my delights were with the sons of men. Now therefore hearken unto me, O ye children: for blessed are they that keep my ways. Hear instruction, and be wise, and refuse it not. Blessed is the man that heareth me, watching daily at my gates, waiting at the posts of my doors. For whoso findeth me findeth life, and shall obtain favour of the LORD.'

Designer, Glass Painter and Maker: Patrick Reyntiens

Architect in charge: D F Oakley

Commemoration: Geoffrey Lavis

Dedication: 19 October 1990

Notes: The panels appear to symbolise the creation of the world, illustrating the Biblical quotation. The right hand panel is composed of dark blobs of colour like a rich soil. The mainly blue left hand panel has successive circles splattered with little explosions and stars. The central flask (hinting at medicine) is surrounded by a pale blue circle like water, with dark red and brown shapes at the base of the flask moving into green hills and animals (including an elephant and a cheeky cat) with a crucified Christ just below the neck of the bottle and a Godlike figure faintly discernible in the white glass at the top around which the waters of salvation flow.

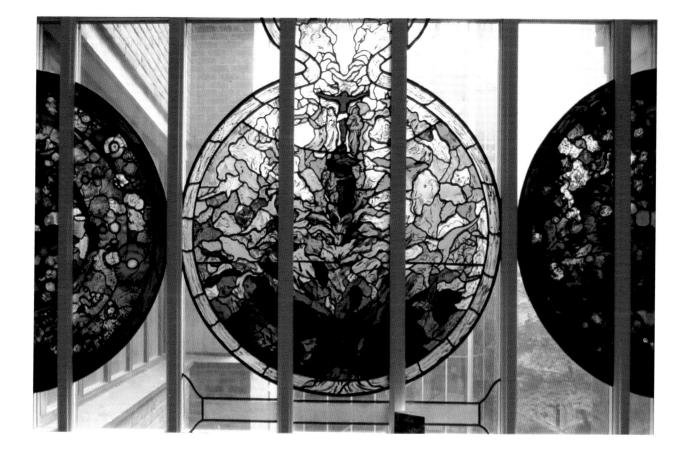

Lyne, Holy Trinity, Lyne Lane, KT16 OAJ

Listing: Grade II (30 September 1986) #1242378

General: The church was designed by F J H Francis in 1849 in 13th century Gothic style and built in coursed stone with ashlar dressings and slate roof.

Title: *Jesse Tree*

Date: 1983-1985 (installed 25-26 February 1985)

Location and Size: 3-light south window, south transept, approximately 399x317.5cm (157x125in)

Inscription: signed b.r.: '1983/Reyntiens'

Designer, Glass Painter and Maker: Patrick Reyntiens

Cost: estimated at £1,500 in 1983

Commemoration and Donor: The plaque below the window reads: 'These windows are in memory of/JAMES ALEXANDER/IRENE EVANGELINE/and/PETER GEORGE ALEXANDER BORTHWICK'. The window was commissioned by Sir John Borthwick.

Dedication: Sunday 30 June 1985 by Bishop St John Pike who was vicar of the parish before the then incumbent, Revd Barry Olsen. The event was celebrated by a flower festival on the theme of stained glass and the Borthwick family were present.

Documentation: Surrey History Centre, 7463/1/3/5 (Parish newsletters); 1861/Box 3 Folder 1

Notes: The original Early English style window was filled with white glass. Reyntiens was contacted in 1983 and on 7 April submitted a précis of his ideas for a 'tree of life' with the suggestion of a Jesse Tree. He wrote as follows: 'The background to the window is of 13thC vessica and roundel design, the colouring is predominantly blue and green and white. Over this background the Jesse Tree is in light green (this type of Jesse tree has been made in medieval times notably at Wells [over the high altar] and York Minster [1/2 way up on the RH Aisle, nave]. There is more white included in the design than meets the eye at first glance'. He intended the colouring to be 13th century as in the Canterbury glass and also Chartres, Bourges and Le Mans. The vicar at the time Rt Revd St John S Pike was sent a letter from the Diocese of Guildford on 7 June noting that in view of the large size of the window, the horizontal saddle bars should be more closely spaced than shown on Reyntiens' drawing, and that the arched bars in the apex of each of the three lancets should be horizontal, but they were sure the new window 'will be an enhancement of your church'. A tree of life spreads rather like a triffid from the central light into the outer lights – the design is not quite symmetrical. It is intertwined with white vessica piscis shapes which are sprinkled with silver looking circular clamps containing trefoils. The tree is a lovely clear green against a mainly dark blue abstract background with some touches of red and yellow. There are no figures within the tree.

Title: unnamed

Date: 1989-1990 (installed shortly before Easter 1990)

Location and Size: 2-light west window, south transept, approximately 259x117 (102x46in)

Inscription: signed b.r.: 'Reyntiens 89'

Designer, Glass Painter and Maker: Patrick Reyntiens

Donor: Borthwick family

Documentation: Surrey History Centre, 7463/1/3/5 (Parish newsletters)

Notes: The October/November newsletter described the window as follows: 'Two angels with flaming wings hold shields bearing the coats of arms of the Borthwick family and the family of the late Hon Mrs Irene Evangeline Borthwick, the Wise family. A triangle in the small trefoil window above is a symbol of God, the Holy Trinity'. The angels are dressed in flaming red and stand on bright green grassy swards.

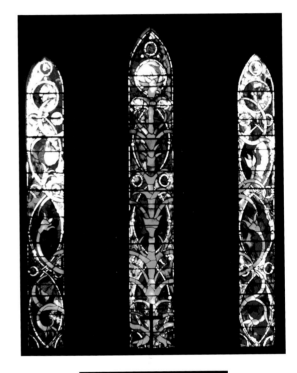

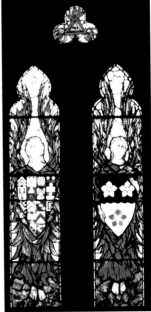

'Religions 2,000 years ago used to treat the butterfly as it came out of its chrysalis as a symbol of the human soul. I suppose they'd treat the caterpillar as a symbol of the human body, I'm not sure. But it still seems to me, I mean sorry Mr Dawkins, but it is almost a miracle, a squishy nasty wobbly little sausage on 16 legs could suddenly curl up and turn into a hard cocoon and wait six weeks and the cocoon opens and a butterfly comes out. Totally extraordinary.'

Reyntiens in interview, 2010

SUSSEX

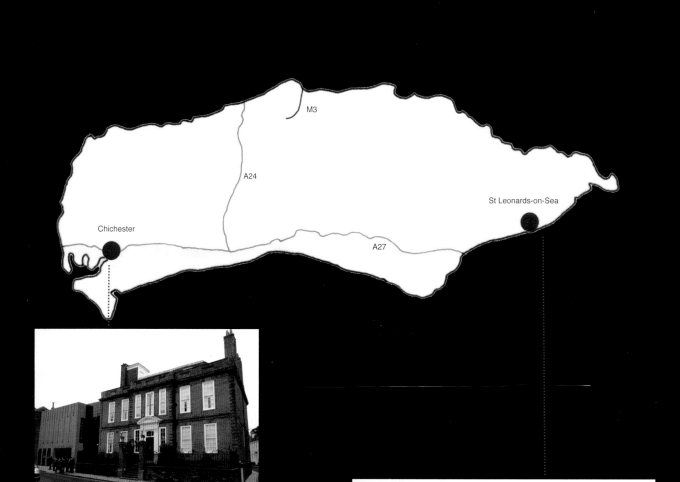

Chichester

A24

M3

A27

St Leonards-on-Sea

Chichester, Pallant House Gallery, 9 North Pallant, PO19 1TJ (on loan to St Richard's Hospital, Spitalfield Lane, Chichester, PO19 6SE)

Title: *Le Cathedrale Engloutie III (The Sunken Cathedral)* (CHCPH 0071)

Provenance: Purchased by Dean Walter Hussey from the Arts Council exhibition; Hussey bequest, Chichester District Council (1985)

Date: 1960

Size and Medium: 132x76cm (52x29.9in), stained glass panel, acid etched and painted. The panel is backlit.

Inscription: 'Ceri Richards' b.l.

Designer: Ceri Richards

Glass Painter and Maker: Patrick Reyntiens

Literature: *The Painter in Glass*, Catalogue of Works, Swansea Festival Exhibition, 1992, p20

Reproduced: *Modern Stained Glass*, Arts Council, 1960-1961, #16

Exhibited: *Modern Stained Glass*, Arts Council, 1960-1961, #16; *The Painter in Glass*, Catalogue of Works, Swansea Festival Exhibition, 1992, #52

Notes: This panel marked the first collaboration between Richards and Reyntiens and according to the latter Richards' inspiration was his lithograph printed in 1959 at the Curwen Press. Richards' motivation was Debussy's prelude for solo piano *Le Cathédrale Engloutie* (1910) which was based on a Breton myth in which a cathedral submerged off the Island of Ys occasionally rose from the sea, and sounds could be heard of bells, chanting, organ playing etc. Between 1957 and 1962 Richards painted a number of works based on the Debussy music. 'Debussy is a visual composer' Richards wrote, 'his sounds and structures are derived from a visual sensibility. He gives me a feeling of the sounds of nature, as Monet does'. The sunken cathedral is represented by small yellow, white and orange lights in the centre, surrounded by a violent mesh of lead lines, with a calm sea above in four green/blue rectangles. The panel was commissioned for the Arts Council exhibition of which the selectors were the Very Reverend Walter Hussey, John Piper and David Thomas and the panel was designed to show the effects possible in painting and aciding. The work has been on loan to St Richard's Hospital since 1997 and is placed in the chapel facing the entrance. Reyntiens and Richards later collaborated on stained glass for Derby Cathedral and the Lady Chapel, Liverpool Metropolitan Cathedral, Merseyside.

Photograph by Anthony McIntosh

St Leonards-on-Sea, St Leonard's, The Marina, TN38 0BE

Listing: Grade II (25 September 1998) #1376621

General: The church was designed by Sir Giles and Adrian Gilbert Scott 1953-1956 and was built of buff brick with cream stone dressings. The church is on a north-south axis presumably so that it faces the sea, or maybe due to site limitations. Steps lead up to the main entrance above which is an imposing tower (completed 1961) containing an illuminated cross which can be seen miles out to sea. The interior has a distinct nautical air: the high arches reflect the hull of a boat; the marble floor of the sanctuary represents fish found on the coast (linking the fact that Christ was represented as a fish); marble loaves and fishes bordered by scallop shells can be found beyond the communion rail, the lower part of the walls are clad with green Hornton stone finished with a wave pattern; the pulpit takes the form of a Galilean boat and was made in the fishing village of Ein Gev in Galilee and the lectern is an ex ship's binnacle.

In January 1956 Rev Canon Cuthbert Griffiths sent Piper a letter asking if it was possible for him to design twenty-one panels for the new church, stating that Gilbert Scott wanted figures. Maybe this was the reason Reyntiens inherited the commission since Piper was not noted for his figure drawing.

The following details are applicable to all nine windows:
Date: 1957

Designer, Glass Painter and Maker: Patrick Reyntiens

Architect in charge: Sir Giles and Adrian Gilbert Scott

Documentation: TGA 200410/2/1/11/1. Church archives (note from Reyntiens dated 28 July 1959)

Literature: *Modern Stained Glass*, Arts Council, 1960-1961, unpaginated; *Stained Glass Windows and Master Glass Painters 1930-1972*, Bristol: Morris & Juliet Venables, 2003, p86; *Decorative Arts Society The, Omnium Gatherum*, Horner Libby, 'Patrick Reyntiens' Autonomous Panels. Myth, music and theatre', Journal 35, 2011, p65; *St Leonard's Parish Church, St Leonards-on-Sea. A Short Guide*, undated, unpaginated; *Windows in St Leonard's Parish Church*, undated, flier

Reproduced: *Windows in St Leonard's Parish Church*, undated, flier

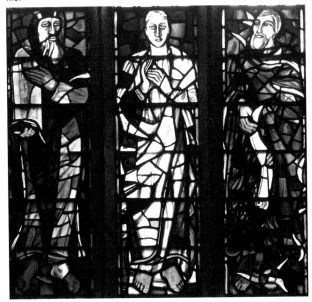

Title: *Transfiguration*

Location: 3-light chancel window, liturgical south

Donor: War Damage Commission grant

Notes: The window represents the miracle of the Transfiguration mentioned in the *Gospels* where Jesus spoke with Moses and Elijah and which established Christ as the link between heaven and earth. The characters are finely drawn and have commanding faces. Christ stands in the centre in white robes, his clean-shaven face shining like the sun (*Matthew* 17: 2) – he has no symbolic attributes. He is flanked by Moses on the left, the biblical prefiguration of Christ and the lawgiver – he is carrying the Commandments. Rays of light shine from his temples. The prophet Elijah stands on the right hand side, with spokes of the chariot of fire by which he ascended to heaven indicated lower right (*II Kings* 2: 11).

Title: *Old and New Testament Characters*

Location: eight double rectangular panels liturgical north and south of nave

Notes: This was one of Reyntiens' earliest personal commissions, from the architects themselves, who warned the artist that they had already ordered plain glazing, with the result that the panels are placed in the middle of otherwise plain diamond leaded double lancet windows. The subjects were chosen by Canon Griffiths in consultation with his PCC and Reyntiens. The artist explained that the biblical characters represent 'not what they looked like, which we don't know, but their character' and their characters presumably teach us lessons. All the acutely observed faces are different and alive and it is interesting to compare them with the contemporary blank staring faces Piper drew for Oundle School, Northamptonshire. On the liturgical north side, in chronological order (moving towards the altar) the characters are from the *Old Testament*:

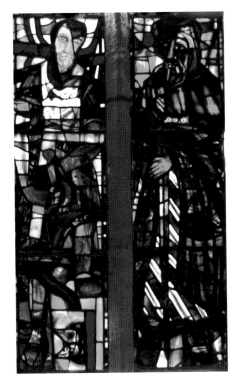

Noah and Abraham. The shipbuilder Noah is seen with the tools of his trade, a set square and brace and bit, whilst his foot rests on a carpenter's bench. The raven and the dove which Noah sent out from the ark to discover dry land (*Genesis* 8: 7-11) are shown at the bottom of the panel. Noah was faithful and obedient and very patient (it took him 120 years to build the ark). Abraham is portrayed as a soldier, possibly referring to his valiant efforts to recover his nephew Lot after which he was blessed by Melchizedek (*Genesis* 14). Abraham was courageous and God stood by him despite his weaknesses.

Samuel and David. Samuel was judge, prophet, a leader of Israel and anointed the first two Kings of Israel, Saul (*1 Samuel* 10) and David (*1 Samuel* 16: 13). He is depicted as an old man and the white horn of oil with which David was anointed can be seen above his arm. Unsurprisingly the next panel shows David as he appears in *1 Samuel* 16: 12, 'he was ruddy, and withal of a beautiful countenance, and goodly to look at', dressed in his shepherd's clothing with the typical hat used to keep away flies. One of his legs is clad as a warrior, he holds the sword of Goliath, and round his waist is a pouch holding a slingshot and stones (tiny blobs of blue glass on the left) with which he overcame the giant (*I Samuel* 17: 49-51). At his feet is his adversary's head and above his own head the star of Bethlehem indicating that Jesus will be born of his line. David was strong, courageous, had faith in God and was loyal to Saul.

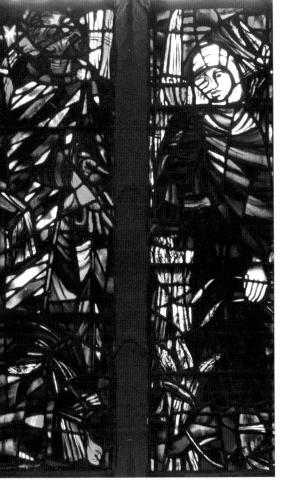

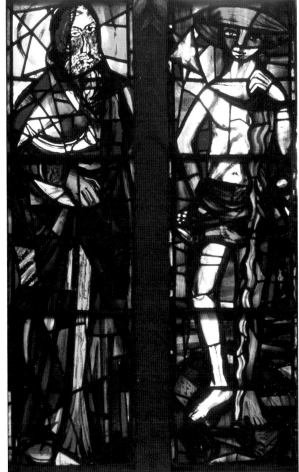

Joseph and Ruth. Joseph is portrayed in his famous coat of many colours, a wonderful creation, which was given to him by his father Jacob because he was the favourite child. The panel also refers to Joseph's ability to interpret dreams – he told his brothers that their sheaves of corn bowed to his and that the sun, moon and stars made obeisance to him (the corn and star are shown at the top) (*Genesis* 37). Of course this came to pass when he rose to be one of the most powerful men in Egypt. Joseph suffered, worked hard, loved his family and forgave his brothers their wrongs. Ruth was a native of Moab but steadfastly refused to leave her mother-in-law Naomi and travelled to Bethlehem with her where she gleaned barley until evening – she is shown here barefooted in the field, her hand wiping her tired face. She married the owner of the field, Boaz, and their child Obed was the father of Jesse. Ruth shows that selfless love (as she showed for Naomi) is a virtue and the *Book of Ruth* also engages with redemption in the way that Boaz, the kinsman redeemer, saved Ruth and Naomi.

Opposite page:
Left: *Transfiguration*
Right: *Noah and Abraham*
This page:
Left: *Joseph and Ruth*
Right: *Samuel and David*

Nehemiah and Daniel. Nehemiah learned that the walls of Jerusalem had collapsed and the gates burned and asked permission from King Artaxerxes to go and mend same (*Nehemiah 1* and *2*). He is depicted with his hands resting on a broken column. Whilst in Jerusalem he purified the Jewish community, abolished usury and helped Ezra promulgate the laws of Moses. Despite scepticism that he could rebuild the walls and much antagonism to his rule, his faith carried him forward successfully. The last of the *Old Testament* characters is the prophet and interpreter of dreams, Daniel, whose book, appropriately enough, is the last of the Major Prophets in the *Old Testament*, 'But thou, O Daniel, shut up the words, and seal the book, even to the time of the end' (*Daniel* 12: 4). He is depicted holding a scroll. Daniel is a forerunner of the Messiah, whose escape from death could be compared to the resurrection of Jesus.

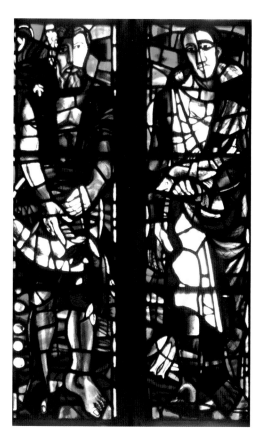

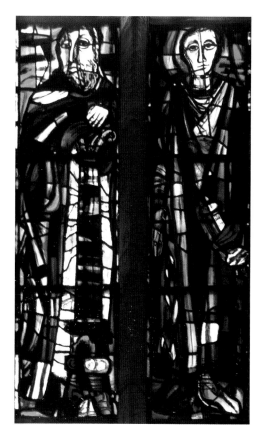

Left: *Nehemiah and Daniel*
Above: *Peter and Andrew*
Below: *Matthew and Barnabas*

On the liturgical south side are characters from the *New Testament*. The original order, as envisaged by Reyntiens was St Peter, St Andrew, St Paul, St Barnabas turning away from Paul, the centurion, St Matthew, St John the Divine and St Mary Magdalene, but the order of the middle four was inadvertently changed in placing the windows. Moving away from the altar:

Peter and Andrew. The brothers Peter and Andrew were both fishermen and apostles. Peter holds a basket and the five large white shapes to his left may represent the five loaves in the miracle of the feeding of the 5,000 (*John* 6: 4-13), whilst the cockerel on his shoulder reminds one of his denial of the Lord. Andrew has fish in his hands and at his feet.

Matthew and Barnabas. Matthew was a tax-collector before he became an apostle and evangelist and he is depicted with a money bag slung over his shoulder and his account bag in his hand. Barnabas, shown splendidly attired in a blue striped cloak, owned land which he sold and gave the money to the apostles. He became an apostle himself and, together with Paul, undertook the 'first missionary journey'. His name means 'man of encouragement' and this is his chief attribute – without him there might not have been a *New Testament*, which is probably why he is depicted with a book and pen.

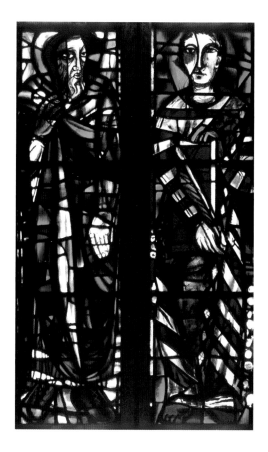

Centurion and Paul. The next figure is a centurion, sword in hand. The episode referred to is from *Matthew* 8. Jesus arrived at Capernaum where the centurion begged for his servant to be healed. Jesus commended him for his faith. After the apostle Paul was shipwrecked off the island of Melita (Malta) the local population built a fire for the cold and wet survivors. A viper rose from the fire and fastened on Paul's hand but he shook it off with no ill effects. The locals were amazed and decided Paul must be a god (*Acts* 28: 1-6). The yellow flames of the fire can be seen lower left and the viper rising up.

John and Mary Magdalene. The viper in this panel relates to the apostle John being challenged by a high priest of Diana at Ephesus to drink a poisoned cup. He blessed the cup and the poison rose up in the form of the viper. In keeping with traditional representations of Mary Magdalene, the repentant sinner, the saint is shown with red hair and holding a pot of ointment with which she will anoint Christ's body at the tomb. In contrast to all the other figures she moves sideways and has a certain voluptuousness about her. This panel is above the balcony where a few years back a fire started, causing some damage to the window. According to one of the parishioners the panel was restored by a previous student of Reyntiens.

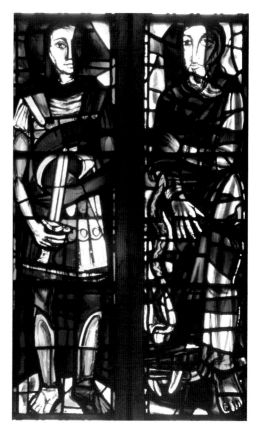

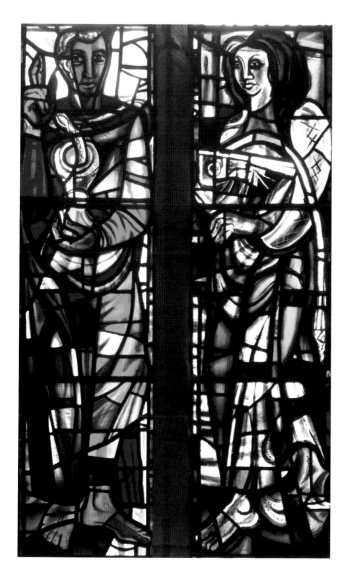

Above: *Centurion and Paul*
Left: *John and Mary Magdalene*

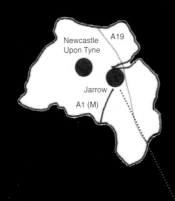

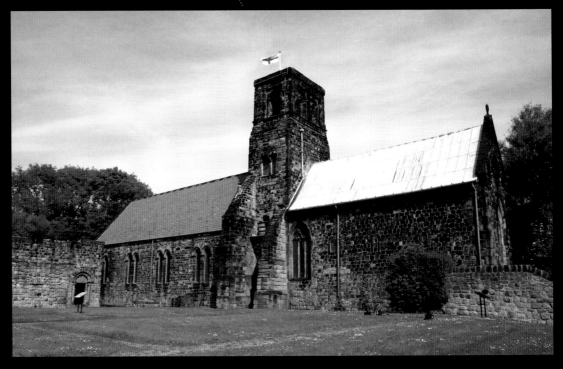

Jarrow, St Paul's Church, Church Bank, NE32 3DZ

Listing: Grade 1 (18 January 1949, amended 26 February 1985) #1025198

General: Benedict Biscop (628-689), a Northumbrian, was a very influential monk, scholar and patron of the arts. In 674 he was given seventy hides of land by King Egfrith of Northumbria for the foundation of a monastery at Wearmouth (St Peter's). For this Biscop brought Frankish stonemasons to England as well as European glassmakers and other craftsmen and these men in turn taught the English their crafts. In 682 Egfrith gave Biscop more land at Jarrow for a sister monastery, St Paul's. Benedict also collected books from the Continent and built up a world-famous library. One of his pupils was the Venerable Bede whose *History of the English Church and People* is a seminal work. One of the churches was demolished in 1782 and a new church built which was in need of attention by 1852 at which point George Gilbert Scott was brought in to design another church and repair the Saxon chancel and Norman tower. Between 1963 and 1978 the archaeologist Dr Rosemary Cramp and her team from Durham University discovered evidence of glass-working on the site – and one round window of coloured glass, abstract in design, holds the accolade of being the oldest stained glass in Europe. The glass was made from sand and soda-lime, colouring agents were derived from metal oxides and it was made by the cylinder-blown method. Since glass was a rarity in buildings in the 7th century it is fitting that Biscop should be commemorated in a window by the foremost stained glass designer of the 20th century. Biscop became patron saint of Sunderland when the town received its city status.

Title: *Benedict Biscop window*

Date: 1985 (installed)

Location and Size: , single lancet, north side of chancel, approximately 159x37cm (62 1/2x14 3/4in)

Designer: John Piper

Glass Painter and Maker: Patrick Reyntiens

Commemoration and Donors: The window commemorates the 1300th anniversary of the church and was a gift from the JUNO Charity Trust.

Dedication: 21 May 1985 in the presence of H.R.H. the Princess of Wales

Documentation: TGA 200410/2/1/5/1-22

Literature: Osborne, 1997, p133, 136, 178; Jenkins Simon, *England's Thousand Best Churches*, London: Allen Lane The Penguin Press, 1999, p173; Spalding, 2009, p 490; Dry Mavis and Smart Revd Ian Hunter, *The Royal Ancient & Monastic Parish Church of St Paul*, undated, p10, 15

Reproduced: Osborne, 1997, p3; Dry Mavis and Smart Revd Ian Hunter, *The Royal Ancient & Monastic Parish Church of St Paul*, undated, p16; postcard

Notes: In September 1981 Rt Hon Lord Fletcher sent Piper Dr Cramp's suggestions for the memorial window which noted that it should not be 'a replica of a Saxon image, but it should be consonant with the imagery, iconography, and basic geometry of Anglo-Saxon art' and that a non-figurative window could include the Jarrow cross and Biscop's initials. Piper was probably also sent photographs of Saxon stone-carving and various booklets relating to the settlement, together with Jarrow lectures, since

these all form part of the Tate Archive. The Norman window incorporates the Jarrow Cross with the initials BB below, the form and decoration of the letters taken from the *Leningrad Bede Manuscript*. The cross itself is white (through which the light of Christ always shines) but with a marbled effect so that it looks like stone, and is outlined with a green border signifying the earth, against a blue background (representing heaven) with curving red and yellow lines like Pentecostal flames.

WEST MIDLANDS

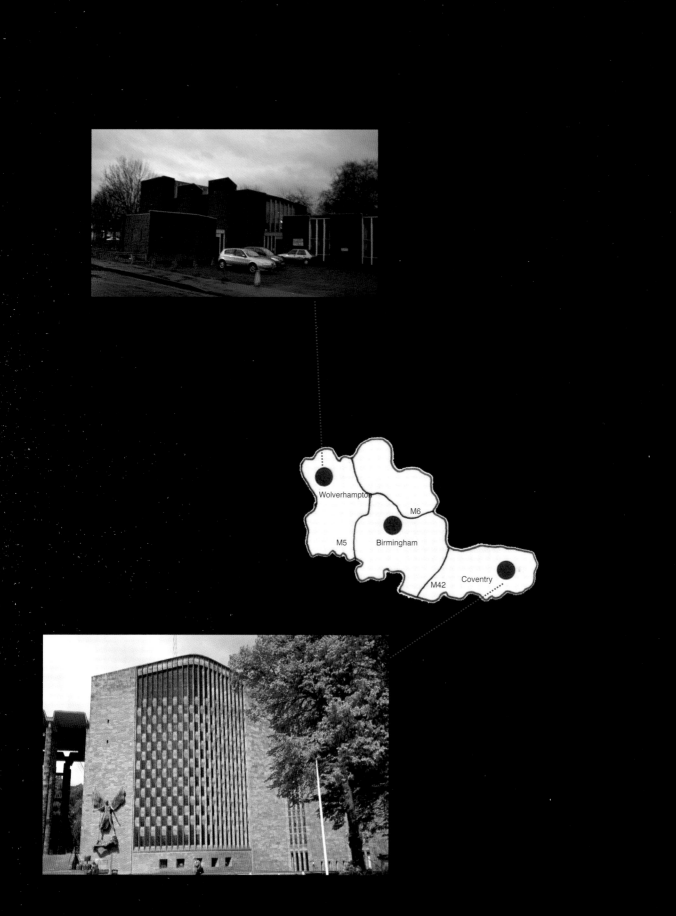

Wolverhampton

M6

M5 Birmingham

M42 Coventry

Coventry Cathedral of St Michael, 1 Hill Top, CV1 5AB

Listing: Grade 1 (29 March 1988) #1342941

General: The Cathedral was designed by Sir Basil Spence and is built at right angles to the old cathedral which was destroyed on 14 November 1940 as a result of German bombing. The new cathedral is built of red sandstone with green slate cladding to the chapels and a concrete roof. Spence's motto was 'Only the very best will do for God' so the building represents a veritable treasure trove of artistic talents – Epstein's sculpture of *St Michael and the Devil* on the exterior wall, entrance plate glass engraved with angels by John Hutton, stained glass aisle windows by Lawrence Lee, Geoffrey Clarke and Keith New, stained glass in Lady Chapel by Einar Forseth, stained glass in Chapel of Unity by Margaret Traherne, bronze eagle book rest on lectern by Elizabeth Frink, tapestry by Graham Sutherland, altar cross and crown of thorns by Geoffrey Clarke and chairs by Gordon Russell. In 1959 John Summerson was asked whether 'Basil Spence's new cathedral … will turn out to be a religious building or only the country's most striking pavilion of religious art of the century' and he responded 'It will assuredly be the biggest consecrated Odeon in the Anglican communion'. (quoted in Harwood's article, p59)

Title: *Light of the Holy Spirit*

Date: 1957-1961 (Piper's contract was dated 25 October 1957)

Location and Size: Baptistry window, plated, stained and painted glass from Germany and France and ordinary traffic light glass, approximately 2190x1800cm **(862x708 3/4in)**

Inscription: signed by both artists b.r.: 'John Piper/Patrick Reyntiens'

Designer: John Piper

Glass Painter and Maker: Patrick Reyntiens

Technical Supervisor: Derek White

Assistant: David Kirby

Studies: See panels in Victoria and Albert Museum, Royal Borough of Kensington and Chelsea; *Maquette*, 108.5x73cm (43x28 3/4in), chalk,watercolour and gouache, dated 1957. A gift to Brian Clarke from his friend and mentor John Piper (see below, photograph courtesy of Brian Clarke). Literature: *BSMGP*, Crichton-Miller Emma, 'The Great Glass Elevator', Vol XXXIV, 2010, p134. Reproduced: *Burlington Magazine The*, Spalding Frances, 'John Piper and Coventry, in war and peace', CXLV, July 2003, p496.

Cost: In 1955 Piper quoted £15/sq foot which amounted to £25,680, beyond the funds at the time. By 1957 Spence had found sufficient money and contacted Piper again who quoted just under £16/sq ft in May 1957 bringing the total to £27,000. Reyntiens' quoted a fee of £12/sq ft as his part of the overall cost (£22,250). Piper was paid £4,750 for the design and supervision.

Documentation: TGA 200410/2/1/2/1-39a, 101, 123

Literature: *Modern Stained Glass*, Arts Council, 1960-1961, unpaginated; *Sunday Times The*, Colour Section, 'Coventry Cathedral', 20 May 1962, p8, 16, 17, 18; *BSMGP*, Lowe John, 'Stained Glass at Coventry Cathedral', Vol 13, no 4, 1963, p585-587; Spence Basil, *Phoenix at Coventry. The Building of a Cathedral – by its Architect*, London and Glasgow: Fontana Books, 1964 (1962), p31, 66-67, 136-137; Pevsner Nikolaus and Wedgewood Alexandra, *The Buildings of England, Warwickshire*, Harmondsworth: Penguin Books, 1966, p254; Reyntiens Patrick, *The Technique of Stained Glass*, London: B T Batsford Ltd, 1967, p13, 65, 81, 99; Lee Lawrence, Seddon George, Stephens Francis, *Stained Glass*, London: Mitchell Beazley, 1976, p168; West Anthony, *John Piper*, Secker & Warburg: London, 1979, p148, 151, 154; Harrison, 1982, unpaginated; *John Piper*, Tate Gallery, London, 1983, p18; *Country Life*, Dunlop Ian, 'Alice in Stained Glass. The Reyntiens Windows at Christ Church, Oxford', 15 November 1984, p1468; Angus Mark, *Modern Stained Glass in British Churches*, London & Oxford: Mowbray, 1984, p13; Cowen Painton, *A Guide to Stained Glass in Britain*, London: Michael Joseph Ltd, 1985, p200; Thorold Henry, *Collins Guide to Cathedrals, Abbeys and Priories*, Collins: London, 1986, p68; Campbell Louise, *To Build a Cathedral, 1945-1962*, Coventry Cathedral, University of Warwick, 1987, pxv, 54, 55; Morris Elizabeth, *Stained and Decorative Glass*, Baldock: Apple Press Ltd, 1988, p94; *Independent Magazine The*, Fuller Peter, 'An English Romantic', 10 December 1988; Moor Andrew, *Contemporary Stained Glass. A Guide to the Potential of Modern Stained Glass in Architecture*, London, Mitchell Beazley International Ltd, 1989, p15; Reyntiens Patrick, *The Beauty of Stained Glass*, London: Herbert Press, 1990, p191-192; *Spectator The*, Harrod Tanya, 'Talking about angels', 18/25 December 1993, p85; *Stained Glass*, Volume 90, Number 1, Debora Coombs, 'British Stained Glass', p20-22; Campbell Louise, *Coventry Cathedral. Art and Architecture in Post-War Britain*, Oxford: Clarendon Press, 1996, p170-175; Osborne, 1997, p45, 52, 53,59, 66-73, 89, 172; Herschel-Shorland Cassie, http://www.c20society.org.uk/botm/archive/2002/coventry-cathedral; Raguin Virginia Chieffo, *the history of stained glass. The Art of Light Medieval to Contemporary*, London: Thames and Hudson Ltd, 2003, p277; *Stained Glass Windows and Master Glass Painters 1930-1972*, Bristol: Morris & Juliet Venables, 2003, p86; *Burlington Magazine The*, Spalding Frances, 'John Piper and Coventry, in war and peace', CXLV, July 2003, p494-498; Neiswander Judith & Swash Caroline, *Stained & Art Glass*, London: The Intelligent Layman Publishers Ltd, 2005, p238; Baden Fuller Kate, *Contemporary Stained Glass Artists. A Selection of Artists Worldwide*, London: A&C Black Publishers Ltd, 2006, pix, 1; Altet Xavier Barral I, *Stained Glass Masterpieces of the Modern Era*, London, Thames & Hudson, 2007, p67, 138; *BSMGP*, '"C R Wyard, Aspects of 20th-Century Stained Glass": BSMGP International Conference 2008', Vol XXXII, 2008, p127; Spalding, 2009, p353, 362, 365, 366, 367-376, 379, 402; 'Coventry Cathedral stained glass painter returns to talk about masterpiece', http://www.coventrytelegraph.net/news/coventry-news/2011/06/22/; *Arts & Windows in Coventry Cathedral The*, undated, p9; *Decorative Arts Society The, Omnium Gatherum*, Horner Libby, 'Patrick Reyntiens' Autonomous Panels. Myth, music and theatre', Journal 35, 2011, p65, 70, 73; *Financial Times*, Foyle Jonathan, April 2012, http://www.ft.com/cms/s/2/e4ba737c-8aee-11e1-912d-00144feab49a.html#axzz1tPvZkOeO

Reproduced: *Sunday Times The*, Colour Section, 'Coventry Cathedral', 20 May 1962, p9, 16, 17; Spence Basil, *Phoenix at Coventry. The Building of a Cathedral – by its Architect*, London and Glasgow: Fontana Books, 1964 (1962), plate 7, 18 (exterior), 27; Reyntiens Patrick, *The Technique of Stained Glass*, London: B T Batsford Ltd, 1967, p77, 138; Lee Lawrence, Seddon George, Stephens Francis, *Stained Glass*, London: Mitchell Beazley, 1976, p169; Lee Lawrence, *The Appreciation of Stained Glass*, Oxford University Press, 1977, p92; Clarke Brian (Ed), *Architectural Stained Glass*, London: John Murray, 1979, p175; Thorold Henry, *Collins Guide to Cathedrals, Abbeys and Priories*, Collins: London, 1986, px; Moor Andrew, *Contemporary Stained Glass. A Guide to the Potential of Modern Stained Glass in Architecture*, London, Mitchell Beazley International Ltd, 1989, p14; Campbell Louise, *Coventry Cathedral. Art and Architecture in Post-War Britain*, Oxford: Clarendon Press, 1996, plates XVI, XVII; Osborne, 1997, p72; *Burlington Magazine The*, Spalding Frances, 'John Piper and Coventry, in war and peace', CXLV, July 2003, p497, 498, 500; Neiswander Judith & Swash Caroline, *Stained & Art Glass*, London: The Intelligent Layman Publishers Ltd, 2005, p248, 249; Altet Xavier Barral I, *Stained Glass Masterpieces of the Modern Era*, London, Thames & Hudson, 2007, p148, 149; Spalding, 2009, p375, plate 57; *Oldie The*, McEwen John, 'DVD Reviews', February 2010, p74; *Arts & Windows in Coventry Cathedral The*, undated, p8

Film: Burder John, *Great Artists Rediscovered: John Piper, John Hutton*, John Burder Films, c1967; Pow Rebecca, *Rather Good at Blue. A Portrait of Patrick Reyntiens*, HTV West, 2000; Mapleston Charles, Horner Libby, *An Empty Stage. John Piper's romantic vision of spirit, place and time*, Goldmark/Malachite, 2009; Mapleston Charles, Horner Libby, *From Coventry to Cochem, the Art of Patrick Reyntiens*, Reyntiens/Malachite, 2011

Notes: Hans Juda, editor of the *Ambassador* magazine, suggested Spence see the Piper/Reyntiens windows at Oundle School, Northamptonshire and Provost Howard and Spence visited Piper in 1955. Having gained the commission Piper was asked to submit his final design by November 1957 and this was approved 3 December. Piper consulted his friend Revd Victor Kenna (Churchill College, Cambridge; Oundle School, Northamptonshire) about a design and the latter suggested dividing the window into four sections, the top two symbolising the Ark and Sinai, the lower ones Baptism and Pentecost, the colours of each section to be green, red, yellow and blue. This solution did not appear to meet with instant approval and, according to Reyntiens, Piper could not decide what to do with this rather problematic window which is slightly curved, is composed of nearly 200 lights, 172 of which are of uniform size, recessed into the stone mullions, the sharp profiles of which were designed to convey 20th century stone cutting techniques. The window is like a giant nutmeg grater in which figurative work would have been lost, so the solution had to be abstract. Reyntiens had been reading a book about Bernini who had a similar problem unifying St Peter's in Rome, and his solution was to throw a sunburst at the back of it, rather like an exploding bomb which was apt since the first Cathedral had been bombed. Reyntiens suggested placing the sun up high but Piper decided to place it centrally. Basil Spence remembered things differently, stating that before he had even won the cathedral design competition he envisaged 'a series of lights in bright primary colours', and that later in discussion with Piper they 'decided on a purely abstract design'. In his report for the competition he stated that 'the stained-glass panels would not be too expensive as donations from the public' and 'behind the font the glass is very pale, almost white, with a slight tint of rose and pale blue'. Campbell (1987) quotes Spence as wishing the Baptistry window to represent 'the saints in infancy … the window will be carried out in the clear blue colours of birth and innocence'. At a lecture in Southampton in 1973 Spence declared that 'within the discipline of the stonework I encouraged [Piper] to do a burst of light symbolizing the giving of life and strength to the green and red below' (quoted in Spalding, 2009, fn10, p546).

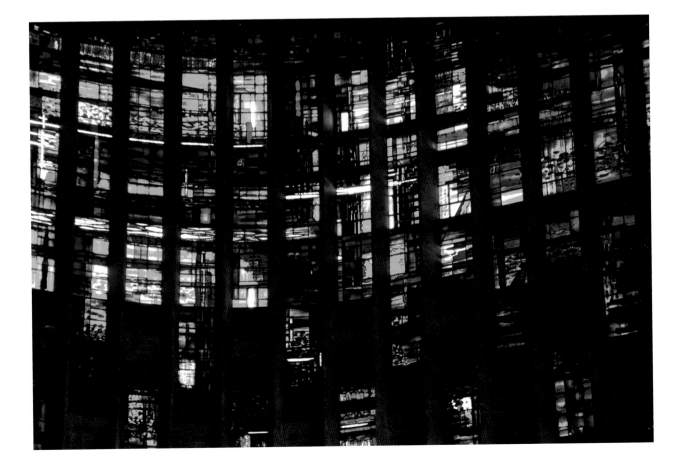

The truth probably lies somewhere between these conflicting claims, but it does indicate the prestige of the window that all concerned wished to assume credit for the inspiration. In 1957 Piper visited many French churches and was influenced by Corbusier's work at Ronchamp, Marguerite Huré at Notre-Dame du Raincy, Leger and Bazaine at Audincourt and Matisse in Vence. Piper and Reyntiens were also inspired by the American Abstract Expressionism exhibited at the Tate in 1956. Piper observed that his heart beat faster whenever he saw blue glass, especially 13th century blue glass as seen at Lincoln, Chartres, Bourges and Le Mans. He regarded the colour as a symbol of infinity, and this may explain the mass of blue at the top of the window, splintered by star-like and comet-like flashes of red and yellow.

In January 1958 Reyntiens wrote to Captain Thurston (Secretary to the Reconstruction Committee) complaining that 'this question of a contract is really too slow for words, and my patience is wearing very thin.' Thurston was obviously shocked by the tone of the letter and complained that he had to deal with large sums of money and numerous contracts and needed to be sure all legalities were covered. In his eleven years dealing with the reconstruction of the cathedral he could not recall 'having received a letter couched in such terms, and certainly not from any of the many artistic or professional gentlemen with whom I have had dealings'. Reyntiens' contract was posted 23 January 1958. At this stage Reyntiens hoped to complete by 31 March 1961 and indeed the windows were installed in May of that year. Reyntiens describes the window as possibly the first where the colour is not a slave to the lead work - it is like a huge painting. A scale model of the window was made (now in the Victoria and Albert Museum, Royal Borough of Kensington and Chelsea) to which Piper referred in producing cartoons for each panel. Reyntiens started with the top of the window and worked downwards, in order that he could experiment and make adjustments as he proceeded to glass closer to the human gaze. He painted every single piece of glass by hand and made the window in three years, never once seeing it complete until it was installed. The installation took two weeks. Piper painted the top of the cartoon with a blue-green wash, overlaid with other colours and Reyntiens mirrored this by obtaining some cheap traffic light glass with which he plated the entire top of the window thereby unifying the colours. The central sun was composed entirely of stained glass – pale yellow, rose and white glass – and the staining had to be done very carefully. It was fired at 500C for 3-4 minutes for the pale stains and slightly longer for the darker stains. Reyntiens decided that the sun should have the simplest break up and painting, a quiet area within the more intricate framework – a device also followed at Eton College, Berkshire and probably influenced by his reading of Dante – the central earth being a still zone surrounded by increasing activity of the celestial spheres, and also the idea that God 'occupies' the centre. Piper wanted some violet and purple glass near the base of the window but Reyntiens persuaded him that brown would look much better. The vertical rows of circles either side of the window were a device copied from 13th century glass to provide a border containing the design. Reyntiens describes the window as representing 'the state of the soul when it has been baptized, of utter unity and innocence and that is the great light in the middle of the window'. Spence recorded that 'it is a staggering design and to my mind a masterpiece'. Dunlop, rather strangely for such an iconic building, thinks 'the interior architecture is of little account without the great Graham Sutherland tapestry on the east wall and the Baptistery window … the glass at Coventry is dominant' – to be fair he was comparing the role of glass in this building and the role of the windows in Christ Church, Oxford, but it does display Reyntiens' range. Angus notes that Coventry was 'a landmark of British stained glass' but that 'with a few exceptions that momentum halted, and the revival never really came'. In *The Independent Magazine* article Piper is quoted as saying that 'I saw Coventry all bust up and I helped to put it back together again' but he gave most of the credit to Reyntiens 'the craftsman and scholar'. Piper considered the cathedral 'rather flimsy and bitty' and thought it needed a greater man than Spence!

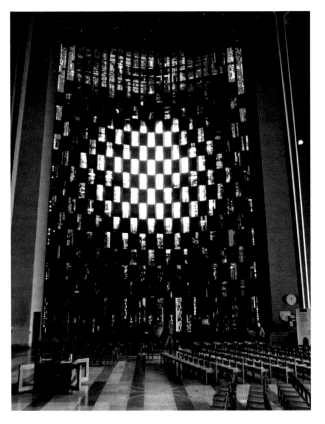

Left: Detail of the top of the window
Above: Baptistry window
Below: Detail of border dots at edge of window, a recurrent theme in Piper/Reyntiens commissions - these have often been referred to as 'tiddly-winks' (Churchill College, Cambridge)

Wolverhampton, St Andrew's, St Andrew's Close, Hunter Street, Whitmore Reans, WV6 0QZ

General: The church was designed by Richard Twentyman of Twentyman, Percy and Partners 1965-1967 to replace an old Victorian sandstone building destroyed by fire in 1964. To deaden traffic noise the church is mainly top lit, apart from the west window placed high in the wall. The church appears bleak from the outside, windowless, but inside has something of the austerity and devotional feeling of Corbusier's Ronchamp.

Title: *Life in the Sea*

Date: 1966-1970

Location and Size: 7-light west window, rectangular in shape, 508x1016cm (180x400in)

Designer: John Piper

Glass Painter and Maker: Patrick Reyntiens

Technical Supervisor: Derek White

Architect in charge: Dick Twentyman

Studies: The half size cartoon (228.6x508cm) was exhibited at *John Piper, Ceri Richards*, Marlborough Fine Art Ltd, London, April 1967

Cost: Estimate November 1966 of £3,500 of which £2,000 for Reyntiens' work.

Documentation: TGA200410/2/1/12/59, 62, 71, 73, 76, 94, 97

Literature: Pevsner Nikolaus, *The Buildings of England, Staffordshire*, Harmondsworth: Penguin Books, 1974, p324; Harrison, 1982, unpaginated; Angus Mark, *Modern Stained Glass in British Churches*, London & Oxford: Mowbray, 1984, p62; Osborne, p76, 112-113, 175; Spalding, 2009, p413

London: John Murray, 1979, p180-181; Angus Mark, *Modern Stained Glass in British Churches*, London & Oxford: Mowbray, 1984, p12, 63; Osborne, 1997, p115; Spalding, 2009, plate 60

Notes: Dick Twentyman, whose brother Tony had known the Pipers since 1947, first contacted Piper in March 1966 suggesting a total cost of £2,500 and a completion within 15 months. The design was approved 2 November 1966. The Vicar wrote the following 'directional thinking' noting that the previous church was destroyed by fire. 'The fire can be represented as both a destroying and life-giving force. It is both purging and inspiring. The Holy Spirit, represented by wind and flame, brought by His light and zeal St Andrew to our Lord, and St Andrew in turn through the Holy Spirit brought his brother Peter to Jesus. We, under the patronage of St Andrew the fisherman, go out through the flame of the Holy Spirit to imitate him in the sea of life. What was a tragedy of fire and flame is turned into magnificent opportunity through the Holy Spirit, The Life-giver'. The final design represents an abstract image of what St Andrew might have seen if he had looked over the side of his boat, using different shades of blue, the whole linked by painted spidery black and white flowing lines, arcs and spirals reminiscent of sea creatures. Angus notes that the blue light pervades the building, reflects on the floor, and that the window is 'surprisingly successful, given its simplicity of colour, and being non-figurative, wonderfully links the life of St Andrew back to early creation and forward to our own experiences of the sea'. Apparently the Archdeacon wanted more fishes! Even on a dull winter's afternoon the beautiful blue shades sing out to one. The loose design is reminiscent of St Paul, Bledlow Ridge, Buckinghamshire and All Hallows, Wellingborough, Northamptonshire. Unfortunately, due to valdalism, the outside of the window had to be protected with Perspex and this has minimised the amount of light filtering into the interior. The solid black areas of painting never allowed light through anyway.

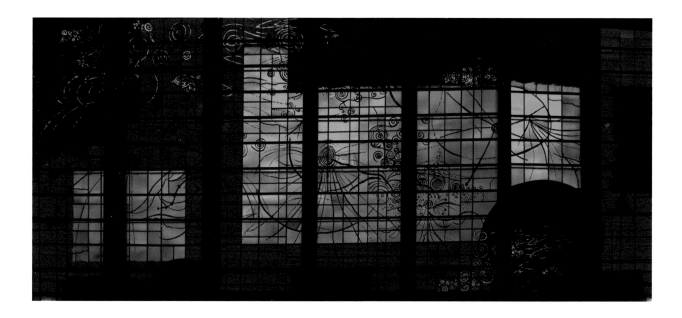

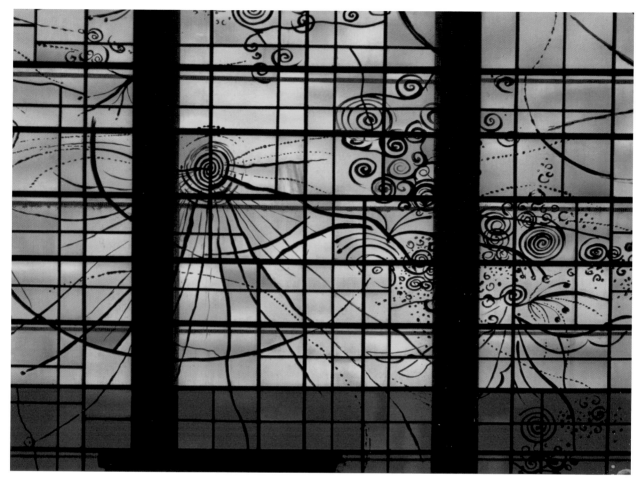

Left: *Life in the Sea*

Above: Detail of window

Below: Interior of the church

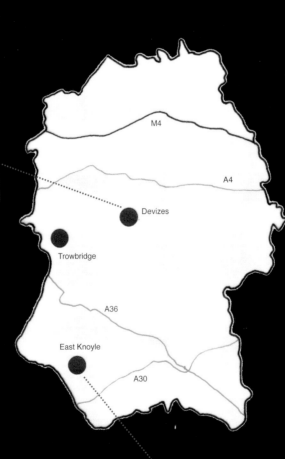

M4

A4

Devizes

Trowbridge

A36

East Knoyle

A30

Devizes, Wiltshire Heritage Museum, 41 Long Street, SN10 1NS

Title: *Archaeological Finds*

Date: 1979-1981

Medium and Size: Stained glass panel, 110.8x119.0cm (43 1/2x47in)

Inscription: 'John Piper' b.r.

Designer: John Piper

Glass Painter and Maker: Patrick Reyntiens

Assistant: David Wasley

Studies: Cartoon, 1981, 110.8x119.0cm (43 1/2x47in), Wiltshire Heritage Museum (DZSWS:2003.1007) purchased for £1,000 in May 1983 with the aid of a grant from the Victoria and Albert Museum Purchase Grant Fund. Bonar Sykes bought the first small study.

Cost: The museum costs were about £800, consisting of £630 for the panel (£75/sq ft) and a further £200-300 for structural works

Donors: Sykes wrote to numerous organisations requesting funding for the project and received £200 from the Walter Guinness Charitable Trust, £200 from Instone Bloomfield Charitable Trust whilst Mr and Mrs Martin Gibb raised about £200 from a rose symposium.

Documentation: Museum Archives Box 128 Ms1359 Piper window; John Piper file

Literature: Harrison, 1982; Ingrams Richard and Piper John, *Piper's Places. John Piper in England & Wales*, London: Chatto & Windus. The Hogarth Press, 1983, p132; *Wiltshire Archaeological and Natural History Magazine The*, 'Inauguration of New Galleries and John Piper Stained Glass Window, 19 June 1982', 1983, Vol 77, p7-9; *Wiltshire Archaeological and Natural History Magazine The*, Sykes Bonar, 'John Piper' in Obituaries, 1994, Vol 87, p168-169; Osborne, 1997, p125, 128, 177; Spalding, 2009, p97, 465

Reproduced: Osborne, 1997, p130; postcard dated 1982

Exhibited: On permanent display in the Museum

Notes: Bonar Sykes, Chairman of the Wiltshire Archaeological and Natural History Society and a friend of Piper asked the artist if he would design a panel for the Museum. Sykes and Professor Stuart Piggott visited Piper, probably in 1979, and Sykes described a wonderfully spontaneous gathering: 'Our preliminary discussion included a suggestion that natural history should be represented: John immediately sketched in a group of woolly-headed thistles. Then, rather tentatively, I suggested a white horse against the downland, or would this be too 'kitsch'? 'Not at all' said John, who promptly cut out a paper white horse and asked us to help place it on his sketch.' By March of that year a cartoon had been prepared which Sykes declared was 'exactly what we were hoping for but even more exciting than we had imagined in anticipation'. Sykes collected the completed window from Reyntiens' studio 9 October 1981. On 19 June 1982 the Museum celebrated its new galleries and acquisition and in his speech Lord Eccles, President of the Society noted that 'Piper's window offers a memorable symbol of Wiltshire. The colours are beautiful and the pattern enchanting. To me it is a fine work of art'. Piper wrote that: 'I have been interested in the archaeology

of Wiltshire since my early teens, and bought Stukeley's *Avebury* and *Stonehenge* and books by Colt Hoare, the Cunningtons and so on, whenever I found them in second-hand bookshops since my twenties. I was delighted to be given the opportunity to include in a window some of the more evident archaeological features of this much-loved area.' These included '*Wiltshire landscape*: the Ridgeway (Neolithic); the devil's den, Marlborough Downs (Neolithic); Avebury/West Kennet Avenue including 'cup and ring' marks on standing stone (Neolithic); Barbury Castle (Iron Age); the Cherhill White Horse; and the woolly-headed thistle. *Devizes Museum artefacts*: amber necklace (Early Bronze Age); pottery (Late Bronze Age).' Piper originally sketched the pots when visiting the Museum with Myfanwy in February 1937. The 'gold' necklace is part of the collection formed by Sir Richard Colt Hoare from his excavations in Wiltshire barrows.

Below: Detail of *Archaeological Finds*

Photographs reproduced with permission of the Wiltshire Heritage Museum

Above: *Archaeological Finds*, Wiltshire Heritage Museum
Below: Detail of reredos, St Mary's, East Knoyle
Opposite page: Detail of cartoon for St Mary's, East Knoyle showing Reyntiens' working methods

East Knoyle, St Mary's, Church Road, SP3 6AE

Listing: Grade I (6 January 1966) #1131168

General: St Mary's is a wonderful rubble stone and dressed limestone church dating back to the 11th century (chancel) with additions over the centuries, restored by Sir Arthur Blomfield in 1876 and the tower was restored by Philip Webb in 1893 (Webb of course re-designed the country house *Clouds* nearby). From 1623-1646 the church also had a famous rector, Dean Christopher Wren, father of the even more famous Sir Christopher Wren. The chancel boasts some unique plasterwork, commissioned by Dean Wren and made by Robert Brockway, together with a stunning Minton mosaic reredos (Blomfield) and an east window by Ninian Comper.

Title: *Resurrection of Christ*

Date: 1999-2000

Location and Size: 3-light window south side of nave between porch and tower, approximately 282x146cm (111x57 1/2in)

Designer and Glass Painter: Patrick Reyntiens

Glass Maker: John Reyntiens

Installation: John Reyntiens and craftsman Tony Sandles, 13-14 July 2000

Studies: Cartoon, Reyntiens Trust

Cost: Reyntiens' 1998 estimate, £14,000

Commemoration and Donors: Millennium window donated by parishioners, £625 was raised by Mrs Robertson, and gifts in memory of Diana Rockingham-Gill were added to the fund

Faculty: Diocese of Salisbury, Advisory Committee Certificate granted 21 September 1999, faculty granted 14 January 2000

Dedication: Saturday 18 November 2000 by the Bishop of Ramsbury, The Right Revd Peter Hullah

Documentation: Wiltshire and Swindon History Centre, 4003/4; 1832/22

Literature: *Parish News, East Knoyle, Sedgehill, Semley*, April 1998, May 1998, July 1998, January 2000, March 2000, June 2000, July 2000, August 2000, November 2000

Reproduced: *Parish News, East Knoyle, Sedgehill, Semley*, August 2000, November 2000 (pen drawings)

Notes: The Resurrection window replaced a plain glass window with 19/20th century diamond quarries. It celebrated the Millennium and was the brainchild of Julian and Lavinia Seymour in 1997. In February 1998 Julian Seymour felt obliged to write to the Parochial Church Council reminding them that a year had passed 'since the subject of the millennium came up and apart from a meeting in the church when the idea of a window was discussed and subsequently approved in principle (the idea of looking into it) by the PCC and followed by a meeting with Mr Haig, the diocesan rep, no progress has been made'. Stung into action the PCC decided on 27 February that the south west window in the nave would be a suitable candidate, that it was not essential for the entire window to be coloured, that the work of students might not be of sufficiently high standard, that the window should look forward to the 21st century and not back to the 19th century, and that ideas and examples of windows

should be presented at the PCC AGM on 22 April. The Seymours arranged a display of recent church windows, offered a donation of £1,000 towards the costs and help with fund-raising. Reyntiens and his son John visited the church on 23 June 1998 and the artist stated that the entire window should be glazed, it should bear relation to the east window and he felt it might be possible to complete the window by the year 2000. In July the PCC asked Haig to talk to the artist. Haig reported back that Reyntiens' estimate was reasonable and suggested that the PCC should explain the doctrinal and liturgical role of the window and then leave the artist to find inspiration. He also advised looking at the work of other artists - accordingly visits to Netley Abbey (St Mary's, Hound, Hampshire), West Grinstead, Devizes (Wiltshire Heritage Museum), Bristol, an exhibition of Norman Adams' work in London and Thomas Denny's studio at Hinton St Mary were arranged. In February 1999 the PCC decided that funds should be made available before a decision was reached, and in March they considered opting for a smaller window. By the end of March Lavinia Seymour announced that £3,000 had been promised to date and it was agreed that Reyntiens should be approached to submit a design at a cost of £500. By 20 April two designs had been submitted, one showing the Virgin Mary (to whom the church is dedicated), the second depicting the Risen Christ, this being the artist's favoured design. Reyntiens was asked to change the hands in the Resurrection design and lighten the edges. His revised design was submitted in August, with the addition of a wren. An appeal letter boosted the funds to £17,685.97 by February 2000, the same month in which the faculty was granted. When the window was in situ the PCC agreed that it was 'good and well accepted'. Writing in the August edition of the Parish News, the Priest in charge, Revd Peter Ridley, sounded more enthusiastic: 'See the window especially when the sun is shining and its many aspects glow and sparkle and reveal its hidden secrets', observing that 'etched into the coloured glass panels, and almost hiding in order to be investigated by us, are seven pictures that remind us of what, according to the four gospels, actually happened on the first Easter Day'.

The central figure is Our Lord Jesus Christ resurrected and with the stigmata, surrounded by white shards of light and an abstract pattern of yellow, white, purple, blue and green glass on which are painted images in a style presaging the windows in St Martin's, Cochem, Germany. The faculty states that the other 'biblical references [are] from the books of *Matthew, Mark, Luke* and *John* and other references, particularly on the *Epistles of St Paul*'.

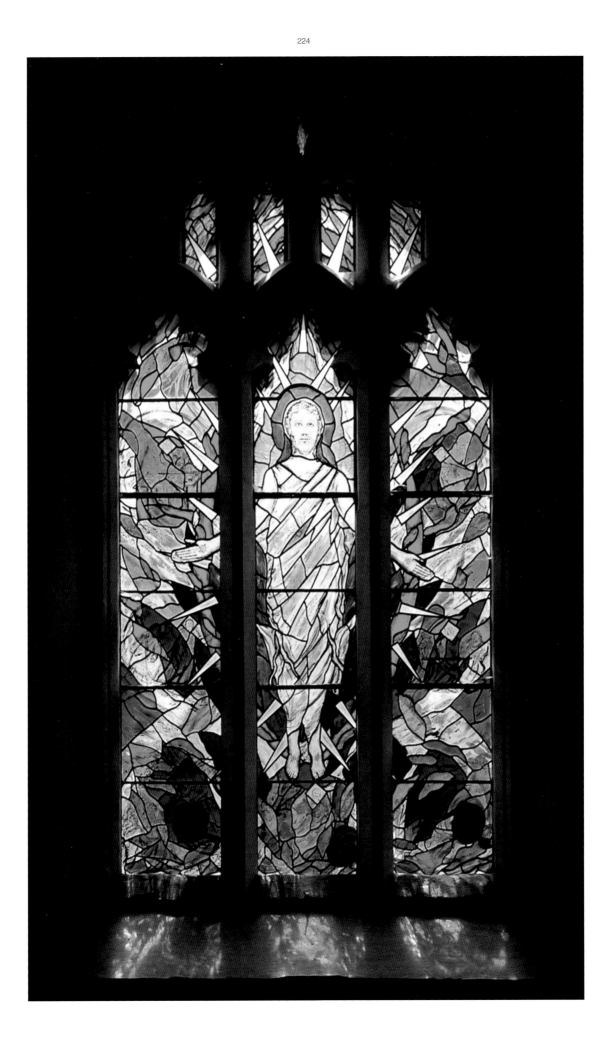

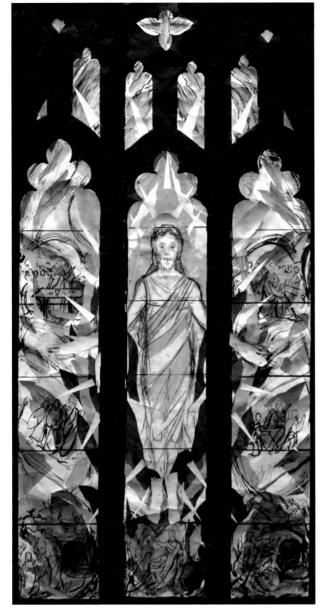

Opposite page: *Resurrection of Christ*

Left: cartoon

Below: Detail of plasterwork

YORKSHIRE

A19

A1 (M)

A65

A59

Keighley

M62

M1

Sheffield

Ampleforth

A64

Sledmere

York

A19

M62

M18

A1 (M)

Ampleforth, Abbey Church of St Laurence (RC), YO62 4ER

Listing: Grade II (9 September 1985) #1315767

General: Ampleforth is a Benedictine Abbey and co-educational independent day and boarding school. In 1803 some Benedictine monks, having fled from France, were given a home east of Ampleforth by Ann Fairfax. The school was founded in 1808 and Reyntiens was himself a pupil at the school in St Edward's House from about 1940-1943. The Abbey (1922-1961) faces west, not east, and was designed by Sir Giles Gilbert Scott who was first contacted by the community in 1919. The site was very limited due to the hillside and the position of the existing buildings – the total length of the Abbey is only 175ft, but what it lacks in length it gains in height, standing imposingly above the grassy swards. It is made of rock-face limestone with ashlar dressings, has a Westmorland slate roof and the windows are early Gothic lancets originally filled with plain pale blue-grey tinted glass. The plan is cruciform with a 4-bay chancel and nave, 3-bay south transept with chapels to east and west and a one bay north transept. The private altars are in the crypt. A notable feature of the interior is the vast collection of Robert 'Mousey' Thompson furniture – he hailed from nearby Kilburn (Southwell Minster, Nottinghamshire).

Literature: Little Bryan, *Catholic Churches since 1923*, London: Robert Hale, 1966; p186, 205-206; *Ampleforth Abbey, Visitors Guide & History*, 2012; *The Christian Heritage of Ryedale. 2000 Years of Living Faith*, Ryedale Christian Community, undated, p10

Film: Mapleston Charles, Horner Libby, *From Coventry to Cochem, the Art of Patrick Reyntiens*, Reyntiens/Malachite, 2011

Title: *Annunciation*

Date: 1961

Location and Size: double lancet above altar in Lady Chapel, approximately 210x112cm (82 1/2x44in)

Designer, Glass Painter and Maker: Patrick Reyntiens

Literature: *Ampleforth Journal*, Father Edward Corbould, 'Ampleforth Abbey Church', 1961, #66, p11; Pevsner Nikolaus, *The Buildings of England, Yorkshire: The North Riding*, London: Penguin Books, 1997 (1966), p62; *Stained Glass Windows and Master Glass Painters 1930-1972*, Bristol: Morris & Juliet Venables, 2003, p86; *Ampleforth Abbey, Visitor's Guide 4*, 2004, p7; *Ampleforth Abbey, Visitors Guide & History*, 2012, p5

Notes: By 1961 it was felt that some colour could usefully be inserted into the Abbey and Father James Forbes who had known Reyntiens as a pupil and was greatly interested in the arts, suggested contacting the artist. The window represents Gabriel informing Mary (a portrait of the artist's wife Anne Bruce) that she would give birth to a child even though she was a virgin. Reyntiens considers his design was influenced by the Scottish colourists; Pevsner describes the work as 'Expressionist'. It is similar in style to the Annunciation window at St Peter's, Tewin, Hertfordshire. Abbot Herbert Byrne, noted for his dry sense of humour observed that: 'I thought the Annunciation was supposed to be good news!'

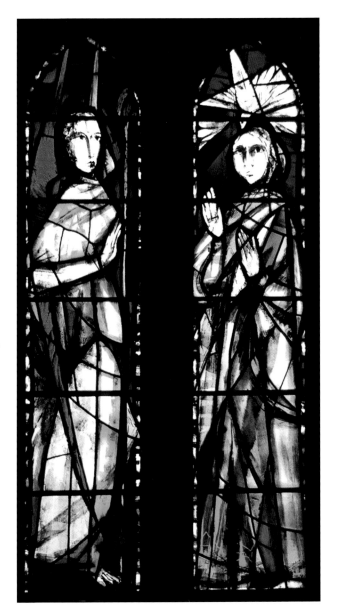

Right: Annunciation

Opposite page: Immaculate Conception, the cartoon above and the completed window below

The following details are applicable to the remaining 13 windows:
Designer and Glass Painter: Patrick Reyntiens

Glass Maker: John Reyntiens

Title: *Immaculate Conception*

Date: 2002

Location and Size: double lancet on north side of the altar in Lady Chapel, approximately 210x112cm (82 1/2x44in)

Inscription: signed in right hand lancet: 'Reyntiens 2002'

Studies: Cartoon, Reyntiens Trust. The egg is more star shaped than in the final version and the foestus is not marked.

Literature: *Ampleforth Abbey, Visitor's Guide 4*, 2004, p7;

Ampleforth Abbey, Visitors Guide & History, 2012, p5

Reproduced: *Ampleforth Abbey, Visitor's Guide 4*, 2004, p6; *Ampleforth Abbey, Visitors Guide & History*, 2012, p6

Notes: Not only is it unusual to find work by the same artist spanning over forty years, but the design of this window is of itself singular. It represents the moment the Virgin Mary was conceived in St Anne's womb (the tiny foetus can be seen in the egg on the left hand side), the glory of the conception being celebrated perhaps by a 'Big Bang' of Creation above, a red ringed circle with sharp rays emanating from it being surrounded by dark blue cloud shapes.

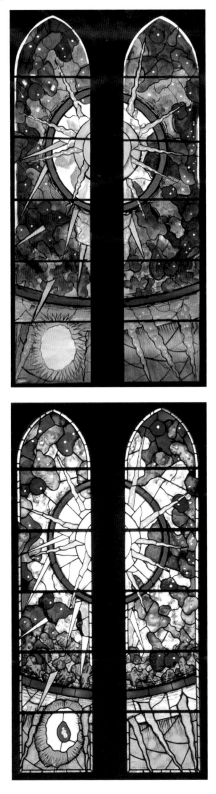

Title: *Life of the Virgin Mary*

Date: 2002-2003

Location and Size: 3 double lancet windows on south side of Lady Chapel, each approximately 210x112cm (82 1/2x44in)

Inscription: signed right hand lancet of *Assumption of Mary into Heaven*: 'Reyntiens'

Studies: Cartoons, Reyntiens Trust

Literature: *Ampleforth Abbey, Visitor's Guide 4*, 2004, p7-8; Martin Christopher, *A Glimpse of Heaven. Catholic Churches of England and Wales*, Swindon: English Heritage, 2006, p165; *Ampleforth Abbey, Visitors Guide & History*, 2012, p5-6

Reproduced: *Ampleforth Abbey, Visitor's Guide 4*, 2004, p6; Martin Christopher, *A Glimpse of Heaven. Catholic Churches of England and Wales*, Swindon: English Heritage, 2006, p165 (*Assumption of Mary into Heaven*, titled *Death of our Lady*); *Ampleforth Abbey, Visitors Guide & History*, 2012, p6

Notes: From left to right the windows are:

Marriage Feast at Cana. The window refers to the sanctity of marriage, God's relation to humans, the values of ordinary human life as made by God, and the intercession of the Virgin Mary. The latter is shown in the left hand light, Jesus on the right turning water into wine at his mother's request. Reyntiens' sense of fun is shown by the dismayed look of the servants with the empty jars, and the delighted look of those with the full jars. In an interview with the author Reyntiens explained that Mary 'looked at the servants and said you are to do exactly what He tells you to do, and in that she said it to every single person on earth, you are to do exactly what He tells you to do, and that was her motto'.

Coming of the Holy Spirit on the Apostles at Pentecost. St Peter with his keys is on the right and the Virgin Mary on the left. The Ampleforth guidebook notes that 'the pairing of two such images owes not a little to the development of the theology of the Church which was implicit in the thinking of the Second Vatican Council'. The Holy Spirit is indicated by yellow flickering flames.

Assumption of Mary into Heaven. Mary is believed to be free of sin and the corruption of death and is therefore shown literally returning to her body, the colours becoming brighter as she ascends towards a brilliant Christ and her body moves from a prone position to upright.

Title: unnamed

Date: 2002-2003

Location: 4 double lancet and 1 triple lancet window in the south transept

Installed: April 2003

Inscription: The eastern lancets are inscribed: 'IN MEMORIAM/ JOSEPH CYRIL BAMFORD/1916-2001/REQUIESCAT IN PACE' and the western lancets are inscribed: 'IN GRATITUDE TO/THE COMMUNITY/OF ST LOUIS ABBEY/U.S.A. – 2003'

Commemoration: The windows commemorate the 200th anniversary of the suppression of the Abbey of Lambspringe near Hildesheim by the Prussian government. The English students at the Laurentian school were sent to Ampleforth.

Donors: Amongst others, Joseph Cyril Bamford (founder of the JCB company) and St Louis Abbey, Missouri (the latter monastery and school was founded by four monks from the community in 1955 and was the idea of Abbot Byrne).

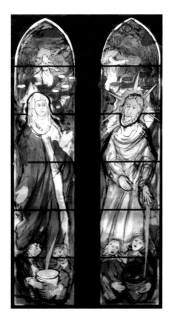

Left hand images: Cartoons

Right hand images: Completed windows

Top to bottom: *Marriage Feast at Cana, Coming of the Holy Spirit on the Apostles at Pentecost, Assumption of Mary into Heaven.*

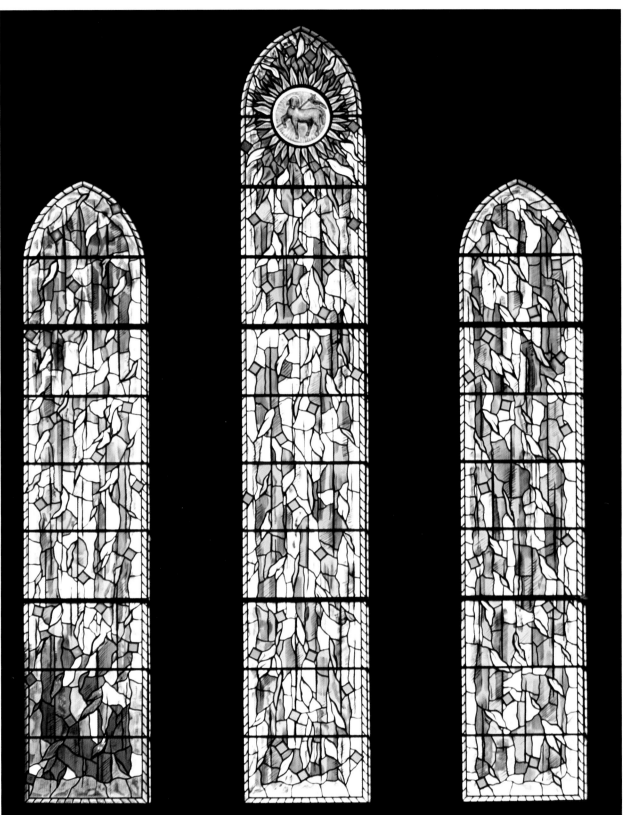

South transept triple lancet window

Dedication: May/June 2003

Literature: *Ampleforth Abbey, Visitor's Guide 4*, 2004, p8; Martin Christopher, *A Glimpse of Heaven. Catholic Churches of England and Wales*, Swindon: English Heritage, 2006, p165; *Ampleforth Abbey, Visitors Guide & History*, 2012, p7

Reproduced: *Ampleforth Abbey, Visitor's Guide 4*, 2004, p8; *Ampleforth Abbey, Visitors Guide & History*, 2012, p7

Notes: When Reyntiens was visiting the Abbey to show the monks the designs for the Lady Chapel windows, he had an idea which he thought would work well for the transept, quickly sketched it, showed it to the monks and persuaded them that this would work beautifully. It is a testament to Reyntiens' ability and the trust the monks placed in him that they agreed to commission the south transept windows which they initially had no intention of replacing. The mainly abstract windows successfully reduce the glare of the morning sun without detracting from the sense of light and space which had been the aim of the architect. Apart from the central Lamb of God, the design is influenced by Cistercian glass which was generally grisaille, and the *Five Sisters* window in York Minster. There are over 1,000 pieces of glass in these beautiful graceful soft lemon and grey coloured windows, the flickering leaves an echo of the Pentecostal flames seen in the Lady Chapel and symbolic of the 'great number beyond all counting' surrounding the throne of the Lamb. Martin describes this glass as 'an abstract representation of the apocalypse inspired by pre-Reformation medieval glass', and mistakenly says that the work was made by Reyntiens' son Richard. In discussing the *Five Sisters* window in his book *The Beauty of Stained Glass* (p64) Reyntiens states they are 'unique both for their scale and for the amazingly intricate and sophisticated interweave of colour and pattern they exhibit from top to bottom … all the time the whole window-surface is gently respiring, palpitating, never completely at rest, the various layers of delicately differentiated tones and near-white colours suggesting a tremulous fibrillation which is never obtrusive yet always present. It is this almost sub-liminal stimulus that constitutes the unique quality of the *Five Sisters*.' He could well have been describing his own windows.

Title: *Du Vivier memorial*

Date: 2003-2004

Location and Size: double lancet window in Holy Cross chapel, approximately 210x112cm (82 1/2x44in)

Inscription: Signed and dated both lancets: 'Reyntiens 04'. At base of window: 'Ubi Caritas Et Amor …' (the whole tag would be 'Ubi Caritas Et Amor Ibi Deus Est')

Studies: Cartoon, Reyntiens Trust

Donor: Du Vivier whose father (Paul du Vivier) and his father's best man were members of Emmargorp (the best man was also the donor's benefactor when he attended Ampleforth).

Literature: *Ampleforth Abbey, Visitor's Guide 4*, 2004, p9; *Ampleforth Abbey, Visitors Guide & History*, 2012, p8

Reproduced: *Ampleforth Abbey, Visitor's Guide 4*, 2004, p7; *Ampleforth Abbey, Visitors Guide & History*, 2012, p7, 8

Notes: One of the ex-students invited to the dedication of the south transept windows was inspired to donate this window which shows the crucifixion and the figures of Mary and John accepting each other as friends, the donor's desire being to celebrate Christian friendship and community. At the bottom of the window is shown a group of Ampleforth students who formed a theatrical group and travelled the country to raise money for the Red Cross in 1940 before going to war themselves. They were directed by John Ryan who created Captain Pugwash and the group were known as Emmargorp (programme in reverse). One of the troupe was George Basil Hume who taught the young Reyntiens rugby and who became Abbot at Ampleforth and later Archbishop of Westminster (hence the angel holding a Cardinal's hat above his head). Reyntiens has used a lot of red in this window, symbolising self-sacrifice.

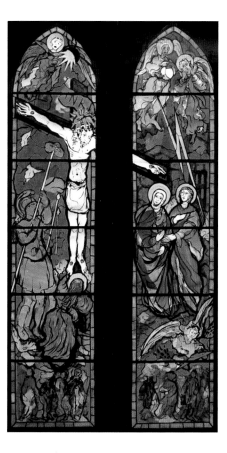

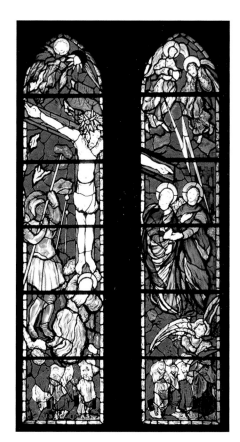

Opposite page: *Du Vivier memorial*, cartoon and window

Above: Detail from cartoon of angel with Cardinal's hat

Right from top to bottom: Transmitted light in Holy Cross chapel and details from cartoons for Memorial chapel, which illustrate the energy of Reyntiens' painting

Title: *Harrowing of Hell*

Date: 2006-2007

Location and Size: 3 double lancet windows in Memorial chapel, each approximately 210x112cm (82 1/2x44in)

Inscription: signed and dated on the right hand side of *Christ in Glory*: 'Reyntiens 2006'

Studies: Cartoons, Reyntiens Trust

Commemoration: Old Boys who died in World War 1

Literature: *Ampleforth Abbey, Visitor's Guide 4*, 2004, p13; *Ampleforth Abbey, Visitors Guide & History*, 2012, p12

Reproduced: *Ampleforth Abbey, Visitor's Guide 4*, 2004, p13

Notes: The windows in this chapel were by three different makers, Robert Hendrie of Edinburgh, James Powell & Son and Joseph Nuttgens – those windows have now been re-installed in the north transept and the south stairs to the crypt, where their pale colouring shows up to greater advantage. The guidebook observes that the pieces of glass are larger in these windows than the earlier ones, and the colouring stronger, symbolizing the 'sense of freedom and release' associated with the theme of regeneration, despite the destruction of the war. From left to right the Reyntiens windows are:

Assumption 1. Skeletons become flesh and blood as they rise, in similar fashion to the Assumption of Mary in the Lady Chapel.

Christ in Glory. Christ, surrounded by a pale blue mandorla, descends to hell.

Assumption 2. The theme is the same as in the first window, with angels giving their blessing at the top.

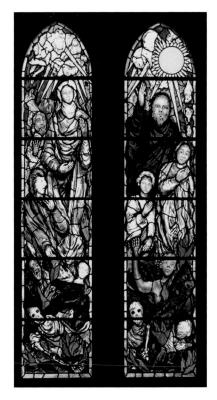

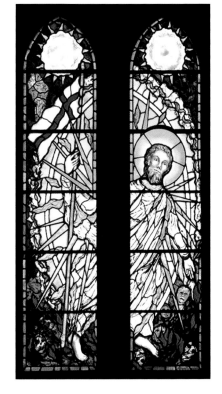

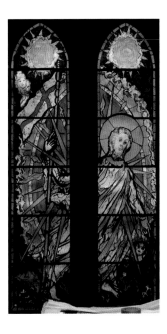

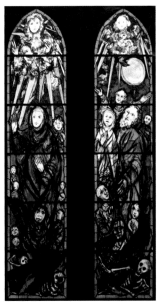

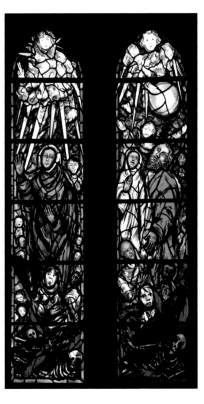

Left hand images: Cartoons

Right hand images: Completed windows

Topt to bottom: *Assumption 1*, *Christ in Glory*, *Assumption 2*

Keighley, Malsis School Chapel, Cross Hills, BD20 8DT

General: The school is an independent co-educational day and boarding preparatory school for ages 4-13. The house was built by the Lund family in 1881 to the designs of Samuel Jackson of Bradford and became a school in 1920. In 1966 John Brunton and Partners designed a novel multi-purpose building which combines an assembly hall, theatre and chapel. On the north side of the chapel an inscription reads: 'Here we shall honour/so long as Malsis stands/the seventeen men from this school/who died in their country's service/Their names are written/in the windows of this chapel/in the book below this stone/and in the hearts/of those that loved them/1939-1945'. The book gives further details of those commemorated.

Title: *World War 1 Memorial*

Date: 1966-1967

Location and Size: 9-light window, ecumenical north, each approximately 297x28cm, stained glass. 8-light window, ecumenical south, each approximately 294x33.5cm, stained glass. Remaining windows (east and 2 narrow strips on north) glazed in antique white reamy glass.

Inscriptions: In each light the man commemorated is inscribed by hand beneath the insignia, with the official dedication (devised by Humphrey Ellis and designed by David Kindersley) nearer the bottom of the window on a blue background. When the windows were installed it was felt that the lettering on some of them was illegible, but on removing a paint film they became legible. For exact wording see Commemoration below.

Designer: John Piper

Glass Painter and Maker: Patrick Reyntiens

Architect in charge: Harry E D Moon, John Brunton and Partners, Leeds

Cost: £1,500 (original contract) increased to £1,700 – this is for design, manufacture and delivery, but not fixing. On 4 July 1966 the architect Harry Moon noted that Reyntiens required an additional 30 shillings/sq ft because Piper's designs entailed more painting than he had originally anticipated. Piper offered to reduce his fee, but when Reyntiens heard of this, he refused to allow it to happen. In total the windows measured 192sq ft so the increase in cost amounted to £288. In January 1967 the architects and Reyntiens agreed on a compromise of £200.

Commemoration: Ecumenical north lights (moving east to west): 'Lewis Booth. Pilot Officer LEWIS ALFRED BOOTH/R.A.F.V.R. 1651 conversion unit/Lost at sea on active service Aged 32'. 'James Crawford. Captain JAMES WOLFENDEN CRAWFORD/ Royal Artillery Medical Corps/Died on active service in India Aged 32'. 'Edward Bairstow. Pilot Officer EDWARD AKEROYD BAIRSTOW/R.A.F.V.R. 12 Squadron Wellington Bombers/Killed in action over Germany Aged 20'. 'Richard Hudson. 2nd Lieutenant RICHARD LAWRENCE HUDSON/East Riding Yeomanry, Royal Armoured Corps/Killed in Action in Belgium Aged 23'. 'John Webber. Sergeant Pilot JOHN WEBBER/R.A.F. 172 Squadron Wellington Bombers/Lost at sea on active service Aged 20'. 'Peter Skirrow. Captain PETER EDWARD SKIRROW/The Duke of Wellington's Regiment/Killed in action in Europe Aged 26'. 'Sydney Baker. Cadet SYDNEY CROFT BAKER/The Merchant Navy/Killed in action in the English Channel Aged 17'. 'Anthony Sagar. Lieutenant ANTHONY DURBER GORDON SAGAR/Royal Artillery/Killed in action in Malaya Aged 22'. 'Rex Butterworth. Flying Officer ERNEST REX BUTTERWORTH/R.A.F. 106 Squadron Lancaster Bombers/Killed in action over the Ruhr Aged 21'.

Ecumenical south lights (moving east to west): 'Joseph Dawson. Flying Officer JOSEPH DAWSON/R.A.F. 609 Squadron Spitfires/Killed in action over Dunkirk Aged 24'. John Dawson. Captain JOHN HINCHLIFE DAWSON/Royal Artillery/Killed in action in Tunisia Aged 24'. 'Howard Wansborough. Sergeant Pilot HOWARD VIVIAN WANSBOROUGH/R.A.F. 99 Squadron Wellington Bombers/Lost at sea on active service Aged 22'. 'Robert Brown. S.B.A. ROBERT HOPE BROWN/Royal Naval Volunteer Reserve/Died on active service Aged 22'. 'Robert Marks. Flight Lieutenant ROBERT ALAN MARKS A.F.M./R.A.F. Bomber Command/Killed on active service at Farnborough Aged 29'. 'Peter Barron. Captain PETER RODERICK MacGREGOR BARRON/Royal Artillery 1st Airborne Division/Killed in action at Arnhem Aged 22'. 'JohnWorswick. Pilot Officer JOHN ALAN WORSWICK D.F.C./R.A.F.V.R. 106 Squadron Lancaster Bombers/Killed in action over Essen Aged 27'. 'Eric Brown/a master at Malsis/Lieutenant GEORGE ERIC TIPLADY BROWN/ The Border Regiment 1st Airborne Division/Killed in action over Arnhem Aged 28'.

Dedication: Chapel, war memorial and four windows dedicated Friday 1 July 1966 by the Archbishop of York, Frederick Donald Coggan

Documentation: TGA200410/2/1/13/6, 7, 8, 9, 14, 15, 16, 18, 21, 22, 23, 26, 28, 29, 32, 33, 34, 37, 44, 46, 47, 48, 50, 51, 52, 53, 54, 55, 56, 57, 58, 59, 60, 61, 62, 65, 66, 68, 71, 76, 78, 79; TGA200410/1/1OUN-OXF

Literature: Harrison, 1982; Osborne,1997, p93, 95, 174; *Stained Glass Windows and Master Glass Painters 1930-1972*, Bristol: Morris & Juliet Venables, 2003, p86; Leach Peter and Pevsner Nikolaus, *The Buildings of England, Yorkshire: West Riding. Leeds, Bradford and the North*, Yale University Press, 2009, p282; Spalding, 2009, p420

Reproduced: Osborne,1997, p93

Notes: In January 1966 Stainforth (Oundle School, Northamptonshire) wrote Piper a letter to say that Bernard Gadney had just retired as headmaster of Malsis School and wondered whether Piper could design an east window for his old school. Gadney wrote to Piper himself in March of that year explaining that the Governors of the school 'wish the boys to worship God in a Chapel which is not only beautiful, but exciting and dramatic'. The new Headmaster, Gerald Watts, supplied Piper with the names of Old Boys who had died during World War 2 together with one master, Eric Brown, who had taught at the school 1937-1939 and was a personal friend of Gadney.

The idea of using symbols to represent the areas of combat in which the young men had been involved was mooted in May 1966. For the Army, infantry would be indicated by a North American buffalo in a defensive ring, armed corps by a charging rhino, sappers by beavers at work, and gunners by a porcupine. Within the Navy battleships would be represented by a spouting whale, cruisers by small whales, destroyers by swordfish, and aircraft carriers (rather bizarrely) by a hippo in a water hole with birds perched on its back. Even more fun went into creating identities for the RAF. Fighter planes became peregrine falcons attacking a stork, bombers became a golden eagle attacking a wolf, coastal planes became an albatross with porpoise in the sea below, path finders not surprisingly were indicated by an owl flying below a full moon, the airborne division became Pegasus flying over open country (the Netherlands) and helicopters a kestrel hovering over long grass out of which a mouse peered nervously. RAF Naval fighters would be turned into falcon swooping on a carrier pigeon, bomber recces into osprey above a ship in the sea, communications and anti-submarine personnel into sea

mews with sharks in the water below, and torpedo bombers into swordfish attacking a rowing boat. It was suggested that the RAMC airborne forces troops would be represented by a man holding a spear and riding a winged horse, with the rider that MoD permission would have to be granted for this symbol since it already appeared on the badge of at least one unit. In the event none of these notions were used – perhaps a pity because the children would have found them fun. Apart from the badges and names, the glass is abstract and lightly coloured in grey, green and pale yellow, reminiscent of St Margaret's, City of Westminster. The lights alternate between Air Force, Army, Merchant Navy and Royal Navy badges.

Without putting too much pressure on Piper and Reyntiens they were then told that the school would appreciate three windows being in place by the time of the dedication, specifically those commemorating Lieutenant Eric Brown, Captain John Dawson and Flying Officer Joseph Dawson who died at Dunkirk and should therefore have additional symbols of a beach and smoke. Designs for four windows were approved in early June 1966 although Watts expressed the opinion that the inscriptions should be higher up so that the saddle bars didn't hide them, the Army symbol should be a little larger and all symbols should be the same height. This left Reyntiens with less than a month to produce the required three windows, although, amazingly enough he completed four before the deadline. Perhaps as a result of the tight schedule the first four windows had to be returned to the studio because the inscriptions were not as requested by Watts and there were spelling mistakes.

North lights

South lights

Sheffield, Cathedral Church of St Marie (RC), Norfolk Row, S1 2JB

Listing: Grade II* (28 June 1973, amended 12 December 1995) #1271205

General: The Gothic revival style church was designed by J G Weightman and M E Hadfield 1846-1850, based on St Andrew, Heckington in Lincolnshire. It is built of ashlar and coursed squared stone with ashlar dressings and steep pitched slate and lead roofs. There is an embarrassment of 19th century stained glass by Augustus Welby Pugin, John Hardman & Co, Wailes of Newcastle, Goddard & Gibbs, Lavers Barraud & Westlake and J F Bentley. Sheffield used to be part of the diocese of Leeds but when the Hallam diocese was created in 1980 this church was chosen as the cathedral church.

Title: *Virgin Mary and Padley Martyrs*

Date: 1982

Location: 3-light south transept west window

Inscription: signed b.r. 'Reyntiens 82'

Designer, Glass Painter and Maker: Patrick Reyntiens

Commemoration: A plaque beneath the window reads: 'THE HALLAM WINDOW/DEDICATED BY/BISHOP GERALD MOVERLEY J.C.D. FIRST BISHOP OF HALLAM/ON/11th SEPTEMBER 1983/TO COMMEMORATE/THE CREATION OF THE DIOCESE OF HALLAM/ON/30th MAY 1980/DESIGNED AND MADE BY PATRICK REYNTIENS O.B.E.'

Dedication: 11 September 1983 by Bishop Gerald Moverley

Documentation: Sheffield Archives, Acc2000/76

Literature: Harman Ruth and Minnis John, *Pevsner Architectural Guides, Sheffield*, London: Yale University Press, 2004, p60; Martin Christopher, *A Glimpse of Heaven. Catholic Churches of England and Wales*, Swindon: English Heritage, 2006, p84; Burleigh Revd Bill and Mather Eileen, *Cathedral Church of Saint Marie Diocese of Hallam. A Simple Guide*, 2003, p5

Notes: The blue-clad Virgin Mary with the baby Jesus on her lap is depicted in the central light with a descending dove above her. Her halo is inscribed. Below her are two angels holding hands and with their free hands pointing upwards towards the Christ-child and down to the signs and symbols of Christ as Eucharist, the chalice, grapes, wheat and figure of Christ within a triangle depicted in the host (wafer) (All Saints, Lowesby, Leicestershire). The host rests on a green chalice flanked by grapes and wheat. '30 MAY 1980', the date the diocese was created, is inscribed either side of the chalice. A broad green mandorla encompasses Mary and the two men depicted in the other lights and Pentecostal flickering red flames, a manifestation of the Holy Ghost, surround all three figures. The men are the Padley Martyrs, Nicholas Garlick and Robert Ludlum, both Catholic priests, who were captured at Padley Hall near Sheffield in 1588 and were hanged, drawn and quartered for their faith. They each hold a palm, the traditional emblem of a martyr. On the left, in a green cope and identified by the inscription in his halo is 'VEN ROBERT LUDLAM'. Above him is an angel playing a harp and below an angel holding a shield bearing the coat of arms of Pope John Paul II who was the Pope at the time when the windows were installed. The motto of Pope John Paul II, 'TOTUS TUUS' ([I am] All Yours), is shown alongside. On the right hand side, in a red cope, is 'VEN NICHOLAS GARLICK', with above him an angel playing pipes and below another angel holding a shield

which bears the arms of Bishop Moverley accompanied by his motto – 'NOVA ET VETERA' (New And Old). The inclusion of the arms is a standard way of showing Catholic allegiance. God and angels are shown in the tracery.

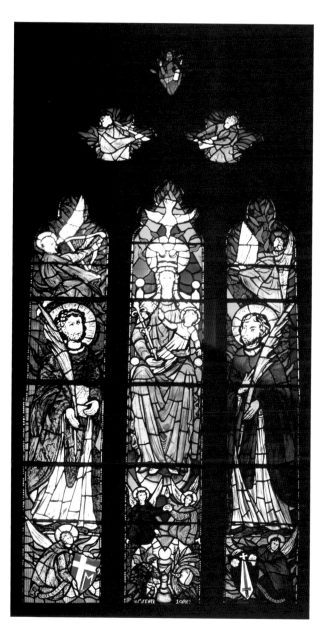

Sheffield, Mylnhurst Preparatory School, Button Hill, Woodholm Road, Ecclesall, S11 9HJ

General: The large Victorian stone house set in six acres of land was built in 1883 for Major William Greaves Blake JP who died in 1904 and is buried in Ecclesall churchyard. After his second wife Rebecca died in 1920 the house was sold to John W Walsh, a member of the Walsh family who owned a large department store in the city. In 1933 he sold the property to the Sisters of Mercy who wished to establish a Catholic school in the area – when the school opened it had seven pupils, by 1962 it had 250 students. The chapel was designed by John Rochford and Douglas Wilkinson in 1960 (Rochford's wife taught at what was then Mylnhurst Convent school and the children of both architects were students there). The chapel is of stone to harmonize with the existing house and has a green Westmoreland slate roof and oak ply panelling in the interior.

Title: unnamed

Date: 1960-1962

Location and Size: Two 4-light rectangular windows either side of the sanctuary approximately 335x212cm (132x84in); three 2-light rectangular opening windows either side of nave approximately 91.5x76cm (36x30in); 3-light window in balcony, west window approximately 275.5x152cm (108x60in)

Inscription: North sanctuary window, b.r.: 'Reyntiens 60'; west window, b.r.: 'P Reyntiens 61'

Designer, Glass Painter and Maker: Patrick Reyntiens

Architect in charge: John Rochford and Douglas Wilkinson

Dedication: 19 June 1962 by The Bishop of Leeds, the Very Revd George Patrick Dwyer

Documentation: Sheffield Archives CA/206/36487; school archives

Literature: *CBRN* 'Mylnhurst Convent Chapel, Sheffield', 1962, p134

Reproduced: *CBRN* 'Mylnhurst Convent Chapel, Sheffield', 1962, p137

Notes: The windows are all abstract and made of plain and painted glass, the glass on the north side being generally lighter in tone than that on the south side. The north sanctuary window is mainly green, grey and purple, and the north nave lights turquoise and grey-green whilst the south sanctuary window is green, butter yellow and purple and the south nave windows blue-grey and yellow. The west window is turquoise, grey and white.

Top right: South sanctuary window

Bottom right: One of the south nave windows

Opposite: West window

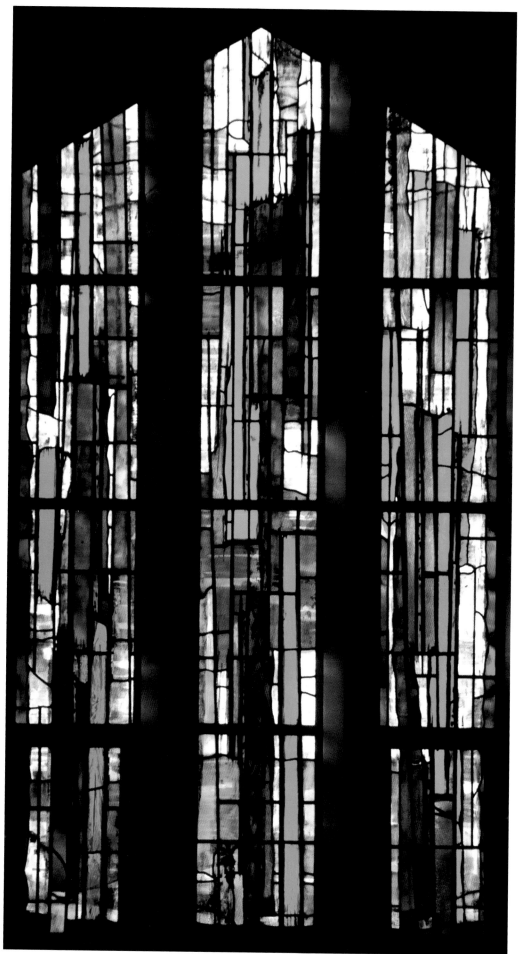

Sheffield, St Mark's Church, Broomfield Road, S10 2SE

Listing: Grade II (28 June 1973, amended 9 December 1999) #1247190

General: The original St Mark's designed by W H Crossland was largely destroyed by an incendiary bomb on 12 December 1940. The church appointed George Pace as architect in 1948 but there were long delays while alternative designs were considered and negotiations took place with the War Damages Commission and the Diocese (which at one point urged the congregation to move into a vacant Baptist church). Eventually all the issues were resolved and in 1960 the Church Council agreed to Pace's final plans and a faculty was sought in December that year. The new church has incorporated the old tower and spire and some of the original walls up to plinth level, although the footprint of the Victorian church was not followed. The church is in a sense striking precisely because it is not striking or pretentious. The exterior looks as if it had always been there, solidly Yorkshire and grounded, its rubble stone weathering well, the long narrow deeply recessed windows clear glazed with heavy lead cames, and the rough slate roofing. In fact the construction is of reinforced concrete with cavity walls, the inner brick wall being plastered. The interior, an irregular hexagon, is filled with light, a large uncluttered area, but with the finest fittings possible, integrated to produce a *gesamptkunstwerk*, something Pace was very eager to achieve. There are two areas of stained glass, the east window on the theme of *Te Deum* by Harry Stammers and the Piper/Reyntiens window. The artists had worked with Pace on two previous occasions, Llandaff Cathedral, South Glamorgan and the King George VI Memorial Chapel, Windsor, Berkshire. Reyntiens observed that in working with Pace, 'one had above all, a sense of being invited by a distinguished and subtle and sensitive mind and heart to co-operate in a genre of architecture and decoration which was of a quality that is almost nowadays non-existent'. (Pace p144, letter to I F C Pace, 1 September 1975)

Literature: Pace Peter, *The Architecture of George Pace*, London: B T Batsford, 1990

Title: *Flames (The Holy Spirit at Work in the World Today)*

Date: 1961-1963

Location and Size: west window, approximately 596x432cm (234x170in)

Designer: John Piper

Glass Painter and Maker: Patrick Reyntiens

Architect in charge: George Pace

Cost: £3,100 was quoted in early 1962, Reyntiens' work coming in at £21 10s/sq ft – Pace said the War Damage Commission would not approve that amount.

Donor: War Damage Commission. In March 1959 the Commission agreed to pay £71,600 (raised later due to increased labour costs) towards the building costs and an additional £7,809 to be spent on stained glass.

Dedication: 8 December 1963 by the Bishop of Sheffield

Documentation: TGA 200410/2/1/1154, 55; TGA 200410/2/1/11/58, 61, 62, 71, 76, 81, 84, 90, 92, 98, 99, 109; Sheffield Archives, St Marks, Broomhill, Parochial Church Council Minutes, Acc2005/121

Literature: *Builder The*, 'St Mark's Church, Sheffield', 23 October 1964, p866; Harrison, 1982, unpaginated; Pace Peter, *The Architecture of George Pace*, London: B T Batsford, 1990, p183; Osborne, 1997, p76-77, 173; Harwood Elaine, *England. A Guide to Post-War Listed Buildings*, London: B T Batsford, 2003 (2000), p66; Harman Ruth and Minnis John, *Pevsner Architectural Guides, Sheffield*, London: Yale University Press, 2004, p250; Spalding, 2009, p364-365; NADFAS, *Record of Church Furnishings, St Mark's, Broomhill, Sheffield, S Yorkshire*, 2010, #710; Pace George G, *St Mark's Church Broomhill Sheffield*, undated, p5-6

Reproduced: Pace Peter, *The Architecture of George Pace*, London: B T Batsford, 1990, p41; Osborne, 1997, p74; *Stained Glass Windows and Master Glass Painters 1930-1972*, Bristol: Morris & Juliet Venables, 2003, p86; Spalding, 2009, plate 55; NADFAS, *Record of Church Furnishings, St Mark's, Broomhill, Sheffield, S Yorkshire*, 2010, #710; Pace George G, *St Mark's Church Broomhill Sheffield*, undated, p5

Notes: Discussions regarding stained glass did not officially commence until November 1961 but by January 1962 it was agreed that Piper would be asked to design the west window on the theme of 'all work to the glory of God' and Harry Stammers would be given the commission for the large east window for which he was paid £3,500. It would appear that the estimate for the west window exceeded the budget and enquiries were made for possible alternative designers/glass makers. However by November 1962 the Piper option appeared to be back on the agenda, because Pace was awaiting design details. His brief to Piper was fairly complicated – the artist was to provide an 'interpretation of Pentecost and the Holy Spirit blessing and guiding the work-a-day world. It is hoped that large easily recognisable emblems referring to the work of the Parish could be incorporated … [which] includes steel, education, hospital (including a teaching hospital), shops and, of course, the domestic work in homes.' Piper obviously decided to concentrate solely on the Pentecostal flames and his design was shown to the Council on 25 January 1963 who noted that 'it had no figuration or representation, but in general was approved'. The design complements Pace's strong geometrical tracery and, being abstract, does not get lost in the branchlike heavy concrete. The architect specifically asked for a dark window so that the congregation would approach the main body of the church through a dark corridor before entering into a light airy space. The dark tones also prevent people seeing the tower of the original church. The base colour of the window is blue, darker round the edges and becoming lighter in the middle with flashes of white, indicating the 'Light of the World'. Red and yellow flames dart upwards. Commenting on the window, Piper wrote: 'The flames, yellow on blue, with their sparks and tongues of red and orange, provide an abstract pattern which I hope will unite and contrast happily with the design of Mr Pace's geometrical tracery'. As Spalding notes, the flames could also reference the fire which previously demolished the building. Piper observed that the Baptistry window at Coventry Cathedral 'has clearly influenced my design for St Mark's in its simplicity and directness of approach. Patrick Reyntiens in his interpretation has also used a technique which was also much influenced by his other masterly interpretations of my cartoons. I hope the rich colour may give pleasure and inspiration'. Unfortunately the window was not completed for the consecration of the new church on 26 September 1963.

Opposite: Interior of the church and the west window

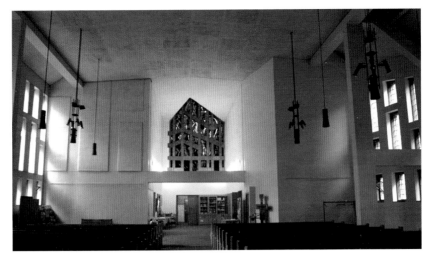

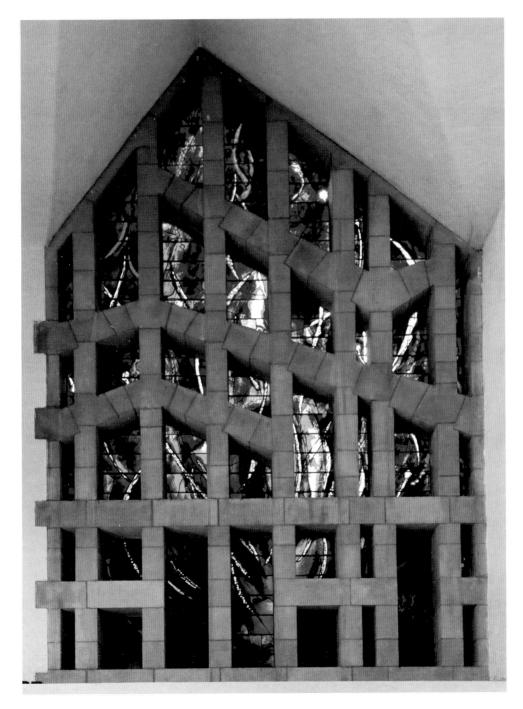

Sledmere, Sledmere House, Chapel of St Mark (RC), YO25 3XG

Listing: Grade I (7 September 1987) #1083802

General: The core of the country house dates from c1751, the main house c1780-1790 designed by Sir Christopher Sykes in consultation with John Carr and Samuel Wyatt. The building was almost completely destroyed by a fire on 23 May 1911, but most of the contents were salvaged including Victorian watercolours of the building from which an exact reproduction was built.
At the same time, 1911, the chapel was added, designed by Walter Brierley. There are five windows in the apse which are alternately stained glass and plain. The armorial window in the entrance is by David Wasley, and Angela, Countess of Antrim, is remembered in the Lily Crucifixion window (west) designed by John Leathwood. The ceiling was painted by Tom Errington and depicts the four winged creatures of the evangelists in the chancel and a variety of birds in the sanctuary.

Literature: *Sledmere*, Norfolk: Jarrold Publishing, 2008

The following details are applicable to all 3 windows:
Date: 1979

Size: approximately 178x92cm (70x36in)

Designer: Angela, Countess of Antrim

Glass Painters and Makers: Patrick Reyntiens and David Wasley

Commemoration and Donor: Designed by the Countess in memory of her brother, Sir Richard Sykes and commissioned by Sir Richard's son, Sir Tatton Sykes

Literature: Pevsner Nikolaus and Neave David, *The Buildings of England, Yorkshire: York and the East Riding*, Yale University Press, 2002 (1972), p696; Sledmere, Norfolk: Jarrold Publishing, 2008, p31

Title: *Sir Richard Sykes memorial, St Hubert*

Location: single lancet north apse window

Inscription: signed b.c.: 'Patrick Reyntiens OBE 1979'. There appear to be two logos, an 'A' and 'M' within a circle b.l. and an 'A' within a 'D' b.c.

Notes: One of Sir Richard's life-long pursuits was the chase. St Hubert, the patron saint of huntsmen, was converted whilst hunting on Good Friday and seeing an image of Christ crucified between the antlers of a stag (depicted at the top of the window). The banner behind him is inscribed: 'd727 St Hubert Bishop of Liege 3rd NOV FEAST DAY'. The saint is shown looking rather like a William Tell character with hunting references around and below him, including a pheasant, guns, a hunting horn, a running dog, a fox with crop behind and riding hat above, a rabbit, horses, fishing, country pursuits in general. Part of a Christian poem by William Cowper is inscribed in the lower part of the window: 'The Stricken Deer William Cowper 1731-1800/I was a stricken deer that/left the herd/Long since with many an arrow/deep infix'd/My panting side was charged,/when I withdrew/To seek a tranquil death/distant shades./There I found by One who/had Himself/Been hurt by archers. In his/side he bore,/And in his hands and feet, the/cruel scars,/With gentle force soliciting/the darts/He drew them forth and heal'd/and bade me live.'

Title: *Sir Richard Sykes memorial, St Mark the Evangelist*

Location: single lancet east apse window

Inscription: signed b.l.: 'Reyntiens 1971' and b.r.: 'David WASLEY PINX MCMLXXI' (I cannot explain the discrepancy between the dates and the death of Sir Richard).

Reproduced: *Sledmere*, Norfolk: Jarrold Publishing, 2008, p31

Notes: The chapel is dedicated to St Mark the Evangelist, and the saint is depicted writing his Gospel with his symbol, a winged lion, lying across the lower part of the window holding a shield with the tag 'AUT VINCERE AUT MORI'. A banner reads: 'IN MEMORIAM – RICHARD MARK TATTON SYKES 7th Baronet/ Born August 24th 1905. Died July 24th 1978'. At the top of the window are circular cloud-like forms, a dove and the hand of God pointing down.

Title: *Sir Richard Sykes memorial, St Cecilia*

Name and Location: single lancet south apse window

Inscription: signed b.r. 'D Wasley/1979'. Long inscription centre right: 'Laboro Adetico/Patrick Reyntiens/OBE/August/1979' and 'These windows in memory of/Richard Sykes have been/designed by his Sister/Angela and erected by his/Son Tatton. They recall his interests/St Hubert, Patron Saint/of the Chase. St Cecilia/Patroness of Music./St Mark to whom this chapel/is dedicated is represented in/the Centre.'

Notes: As noted in the inscription, Sir Richard's other great passion was music. He was a jazz pianist before World War 2, and after the war turned to classical music and became an accomplished organist. This window is dedicated to St Cecilia, who can be seen at the top of the window holding a portative or positive organ, the banner behind her inscribed: '230 AD St Cecilia 22NOV/FEAST DAY'. Three medallions lower right, inscribed 'VALERIAN', 'CECILIA' 'TIBERTIUS', refer to the 5th century legend surrounding Cecilia – she was betrothed to a pagan called Valerian but refused to consummate the marriage because she had already vowed her virginity to God. Both her husband and his brother Tibertius became Christians. Some musical scores are included and named: 'Toccata & Fugue in D Minor J S Bach Adagio Presstissimo', 'Trumpet Voluntary Jeremiah Cl[arke] Trumpets', a piano bears the inscription 'Master of the Keys' and, amusingly, a cat lies on the keyboard – this relates to the well-known jazz tune 'Kitten on the Keys' which Sir Richard used to play. An old fashioned gramophone is featured in the centre and a wireless set on the left is inscribed 'BBC NEWS/AT SIX'. Part of Dryden's song for St Cecilia's day is inscribed upper left: 'Ode in honour of St Cecilia's Day/… At last Divine Cecilia came/Inventress of the Vocal Frame,/The sweet Enthusiast from her/Sacred Shore./Enlarged the former narrow Bounds,/And added Length to solemn sounds,/with nature's Mother Wit and Arts/unknown before./Let old Timotheus yield the Prize,/Or both divide the Crown:/He raised a Mortal to the Skies;/she drew an Angel down./John Dryden 1700'.

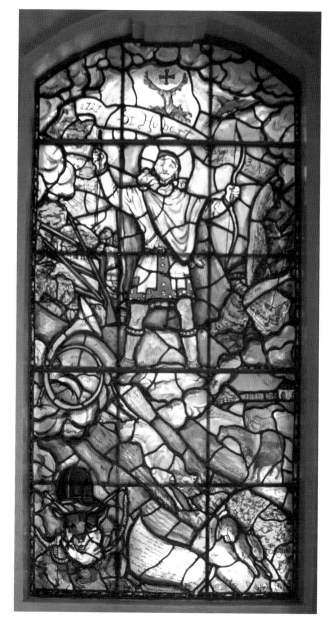

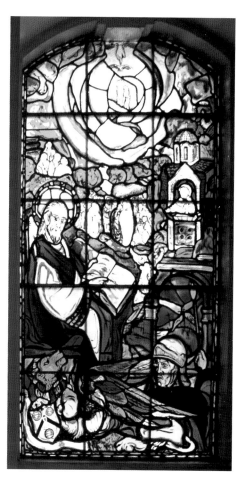

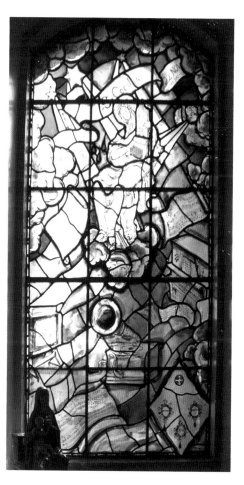

Above: *St Hubert*
Above right: *St Mark the Evangelist*
Right: *St Cecilia*

'Patrick is an educator in the original Greek sense of the word, i.e. he "draws out" from each of his students what is most personal, their unique vision of the world. This is a thing that cannot be done by frointal attack or a rigid course of study. neither can it be done painlessly. Patrick taught indirectly, obliquely, sketchily. He set the stage for learning and left room at the centre for each of his students to occupy. It took nerve to study with Patrick'.

Leadline 1990, Patrick Reyntiens & the Burleighfield Experience,
Goodden Ted (Ed), 'Preface', 1990, p1

WORKS
IN
BRITAIN
–
WALES

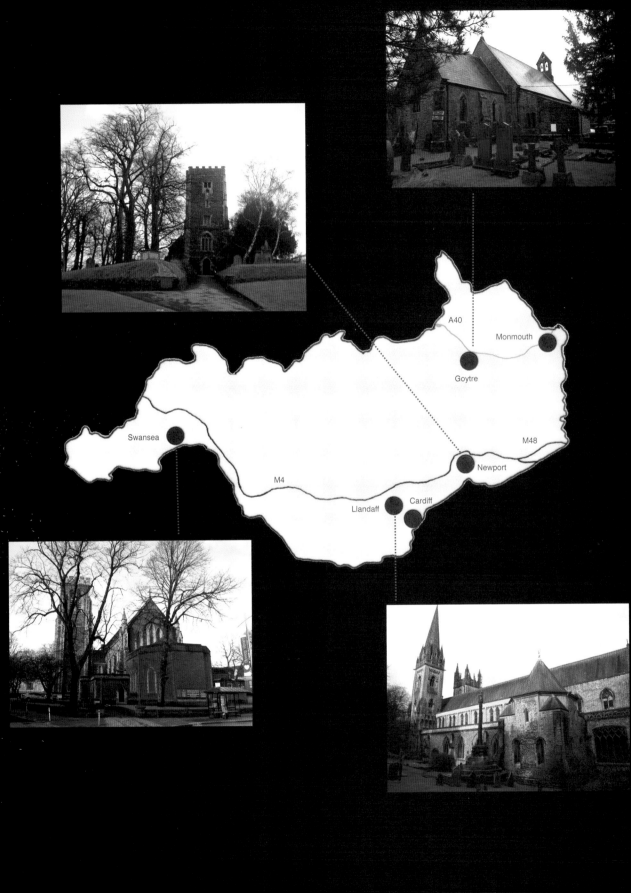

SOUTH-EAST WALES

A40

Monmouth

Goytre

Swansea

M48

M4

Newport

Llandaff

Cardiff

CARDIFF
Llandaff, Cathedral Church of Saints Peter and Paul, Dyfrig, Teilo and Euddogwy, Cathedral Green, CF5 2LA

Listing: Grade 1 (12 February 1952) CADW #13710

General: The Cathedral was founded in the 6th century and the present building started by Bishop Urban in 1120, but as with most cathedrals, the building has been altered, added to and restored over the centuries producing a rather homogenous hotch-potch of styles that come together in quite an attractive manner. The edifice has, to my mind, the feel of a large friendly parish church, although George Pace's parabolic concrete arch, separating the nave from the choir, takes some getting used to. But without the arch one would not have Sir Jacob Epstein's Christ in Majesty, *The Majestas*. Other gems include a triptych by Dante Gabriel Rossetti, some wonderful stone carvings both ancient and modern, stained glass by Silvester Sparrow, a number of windows from Morris & Co, the delightful Lady Chapel with stencilling on walls and ceiling and a *Tree of Jesse* window by Geoffrey Webb, the Welsh Regiment Chapel, a beautifully simple altar by Pace and six Della Robbia ceramic panels designed by Edward Burne-Jones in the Dyfrig Chapel.

Literature: Davies Dr Chrystal, *Around and About Llandaff Cathedral*, Much Wenlock: R J L Smith and Associates, 2006

Title: *Supper at Emmaus*

Date: 1959

Location: 3-light east window and roundel above the Urban arch leading to the Lady Chapel

Designer: John Piper

Glass Painter and Maker: Patrick Reyntiens

Architect in Charge: George Pace (King George VI Memorial Chapel, Windsor Castle, Berkshire, St Mark's Church, Sheffield, Yorkshire)

Cost: £400 to Piper and £600 to Reyntiens (paid January 1960)

Donor: War Damage Commission

Documentation: TGA 20040/2/1/11/28- 32, 34

Literature: *Friends of Llandaff Cathedral, 27th Annual Report*, May 1959-March 1960 Merchant Moelwyn William, 'Supper at Emmaus', p27,28; *Modern Stained Glass*, Arts Council, 1960-1961, unpaginated; Harrison, 1982; Cowen Painton, *A Guide to Stained Glass in Britain*, London, Michael Joseph Ltd, 1985, p224; Thorold Henry, *Collins Guide to Cathedrals, Abbeys and Priories*, Collins: London, 1986, p303; Newman John, *The Buildings of England, Glamorgan*, London: Penguin Books, 1995, p117, 251; Osborne, 1997, p77, 173; *Stained Glass Windows and Master Glass Painters 1930-1972*, Bristol: Morris & Juliet Venables, 2003, p87; Davies Dr Chrystal, *Around and About Llandaff Cathedral*, Much Wenlock: R J L Smith and Associates, 2006, p22; Spalding, 2009, p363-364

Below: *Supper at Emmaus* and roundel seen through Pace's parabolic concrete arch

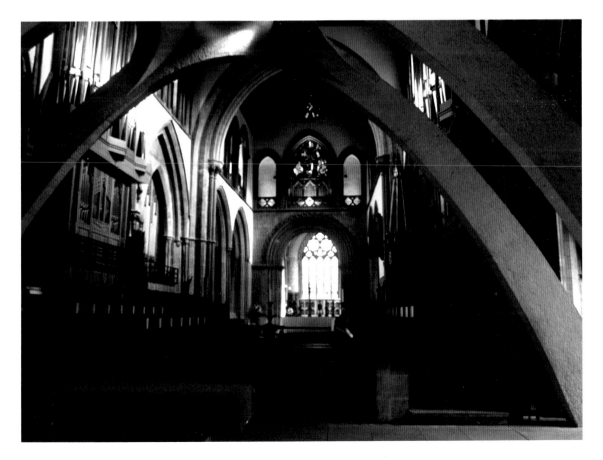

Reproduced: *Friends of Llandaff Cathedral, 27th Annual Report*, May 1959-March 1960, Merchant Moelwyn William, 'Supper at Emmaus', p28; Pace Peter, *The Architecture of George Pace*, London: B T Batsford, 1990, p165; Davies Dr Chrystal, *Around and About Llandaff Cathedral*, Much Wenlock: R J L Smith and Associates, 2006, p21, 22; postcard

Below: *Supper at Emmaus*

Notes: Correspondence relating to the window dates from February 1959 and the cartoon was completed in April of that year. It seems fitting that the Piper/Reyntiens work is above the Urban arch (named after the founder), the oldest part of the Cathedral, a glorious Norman arch with five carved bands and twenty-seven medallions containing eight-petalled flowers. The roundel is abstract. In the *Supper at Emmaus* window, Christ occupies the central panel, his hand raised in both blessing and consecration, with the disciples in the side panels. Merchant described the window as a 'metamorphosis the creative artist alone dare attempt, and this window is a triumph of creation'.

GWENT
Newport, St Woolos Cathedral, Stow Hill, NP20 4AE

Listing: Grade 1 (26 July 1951) #2998

General: Although there may have been a wattle and daub church on the site in about 500AD the earliest recognisable structures are the pillars in the nave and the magnificent Norman arch with its dog-tooth carving. The Lady Chapel was added in the 13th century and Jasper Tudor (Henry VII's uncle) and others restored and extended the church in the 15th century including the western porch and tower. Further restoration was undertaken in 1853. The east end of the Cathedral was designed by Caroe in the early 1960s to increase the accommodation of the building in keeping with its new status of Cathedral (granted in 1949). St Woolos is well worth a visit, beautiful and understated.

Title: unnamed

Date: 1962-1963

Location: Rose window in chancel reredos, east

Designer: John Piper

Glass Painter and Maker: Patrick Reyntiens

Architect in charge: Caroe & Partners (Alban D R Caroe)

Cost: Piper's estimate, January 1963 - £1,000 for design of stained glass and mural, £560 to Reyntiens for making the window

Dedication and Consecration of new building: 18 October 1963 by the Archbishop of Wales

Literature: Reyntiens Patrick, *The Technique of Stained Glass*, London: B T Batsford Ltd, 1967, p99; Harrison, 1982, unpaginated; Thorold Henry, *Collins Guide to Cathedrals, Abbeys and Priories*, Collins: London, 1986, p317; Osborne, 1997, p77, 173; Newman John, *The Buildings of England, Gwent/Monmouthshire*, Harmondsworth: Penguin Books, 2000, p75; Willie Revd Andrew, *St Woolos Cathedral Newport. Illustrated Guide Book*, 2002(1979), p27, 28, 48; *Stained Glass Windows and Master Glass Painters 1930-1972*, Bristol: Morris & Juliet Venables, 2003, p85; Spalding, 2009, p366; Corten Anthony G, *John Piper and Newport Cathedral*, undated, p2-11

Reproduced: Osborne, 1997, p47; Willie Revd Andrew, *St Woolos Cathedral Newport. Illustrated Guide Book*, 2002(1979), p48, 57; *St Woolos Cathedral Newport. The Cathedral Church of the Diocese of Monmouth*, 2012; Corten Anthony G, *John Piper and Newport Cathedral*, undated, cover, p4, 9, 11; postcard

Notes: The window is set within a painted wall, also designed by Piper. As early as 1958 Caroe appeared to have a fairly definite scheme for the east wall: 'The High Altar is set in a splayed recess with semi-circular head of maximum height centred on the rose window, the whole being conceived as a blaze of colour, with glowing stained glass in the rose emphasizing the cross by contrasting hues, and a rich red wall below crossed with gold lines' (quoted in Corten, p3). Piper submitted his estimate of costs and designs for the mural and window in January 1963, but the Chapter claimed the costs were too high, although they clearly had sufficient funds available. They suggested omitting the mural but Piper was understandably dismayed since this was intended as a complete decorative scheme. He even offered to reduce his fee, but Chapter was not to be swayed, and it would appear

that they were actually more concerned about the symbolism of the wall painting. Caroe was also concerned about the Chapter's decision and pointed out that time was of the essence. Piper was finally asked to proceed in April 1963. When the new building was consecrated the *South Wales Argus* described the window and mural as 'one of the most exciting and possibly the one controversial feature' (quoted in Corten, p2). The design of the window is abstract within double cross tracery and executed in silver stain producing gold and yellow tones – Piper stated he wanted 'yellow and warm brown – tones of the 15th century type, silver stain, from palest yellow to rich dark ochres' (quoted in Corten, p5). Newman describes the mural as 'inescapable but puzzling, consisting of a canvas painted to look like 'marbling or like a turbulent, muddy river flecked with red. The whole is framed by a broad, mauve band painted direct on to the plaster of the E wall'. Willie notes that the shape of the mural reflects that of the Norman arch and suggests that the marbling effect is Roman in spirit and that the 'marbling seems to constitute either a chaos, which the cross transcends or a new creation streaming from the cross – or perhaps both'. The mural was painted by Peter Courtier who worked for the Royal Opera House. Piper designed a similar marbled reredos for St Mary's, Swansea, West Glamorgan.

Below: Rose window

Following page: Sanctuary area as seen from the nave

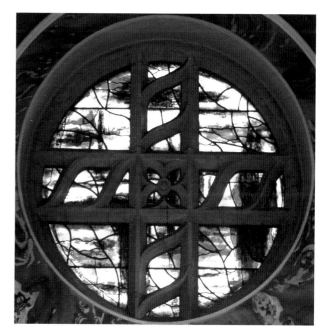

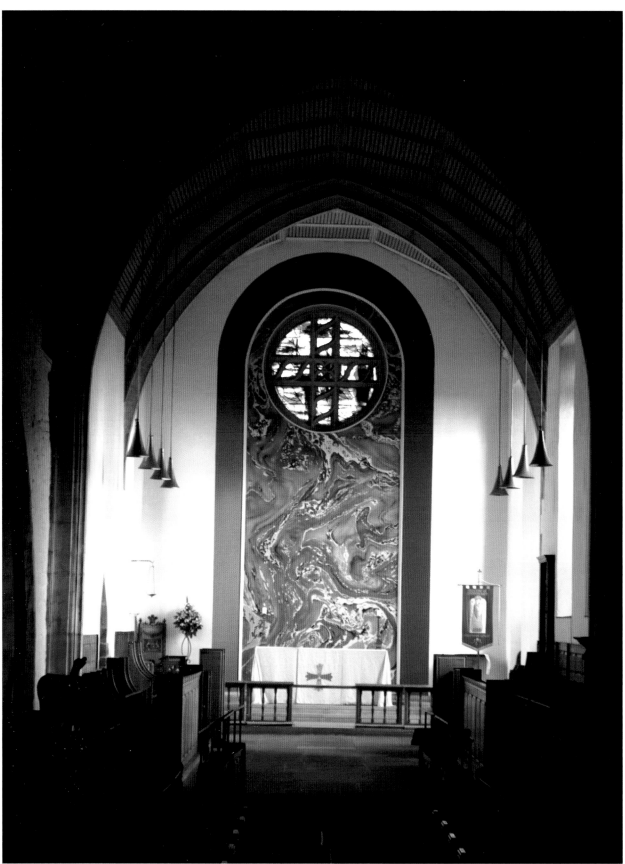

MONMOUTHSHIRE
Goytre, St Peter's, NP7 9DW

Listing: Grade II, 18 November 1980 (CADW Building ID: 2621)

General: The rock-faced stone church with a slate roof was built as a mission church in 1894 and was extended westwards in 1916 at which point Margaret Hamer donated many furnishings and fixtures (including traceried panels and linen-fold panelling) which resulted in the listing. It is somewhat surprising but rather glorious to find four Reyntiens' windows in such a tiny church. The windows are more traditonal than one would expect from the artist, and one is left with the feeling that Reyntiens was given a strict brief from which he could not waver.
Peter Wynford Innes Rees (1926-2008), an alumnus of Christ Church, Oxford, was in the Scots Guards 1945-1948 (at the same time as Reyntiens), became a QC in 1969, was a Conservative MP for Dover and Deal and became Baron Rees of Goytre in Gwent in 1987. In 1969 he married Anthea Wendell. The family home was Goytre Hall, Abergavenny (the ecclesistical parish is Goetre but the village is signposted Goytre).

The following details are applicable to all 4 windows:
Size and Medium: approximately 180x43.5cm (71x17in), stained glass with black lead and coloured paint

Glass Designer, Painter and Maker: Patrick Reyntiens

Architect in charge: Caroe & Partners, Wells

Contractor: John Baker, Weston-super-Mare

Donor: The windows were financed by Baron Rees of Goytre in Gwent

Documentation: Church archives

Title: *St Caradoc*

Date: 1996

Location: Single lancet, chancel north

Inscription: At the top of the window 'SAINT CARADOC OF WALES'; lower left 'REES' together with the family shield bearing three ravens; bottom of window 'To the Glory of GOD and in honour of Saint Caradoc of Wales, a nobleman/of liberal education who was unjustly accused of stealing the king's hounds/He renounced the world and became a humble hermit./ His holiness was such that he became famous throughout Wales./ He died on the 13th of April 1124. This is his feast-day'.

Notes: The Parochial Church Council minutes for 9 May 1966 noted that 'we accept the kind offer of a gift by Lord and Lady Rees of two small stained glass windows. The windows to replace two windows either side of the Chancel one depicting St Cadoc [sic] and the other St Catherine'. The PCC applied for a faculty at this stage and the windows were to be installed within a year. The window depicts the Franciscan monk Caradoc in his brown vestments, holding a blue cross, against a background of dwellings, dogs and daffodils. The 'king' mentioned in the inscription was in fact Rees, or Resus, prince of South Wales. Adjacent to the family shield is a blank space for a memorial to be added to Lord Rees on occasion of his death. The predella depicts images of Caradoc, the king and the hounds together with Caradoc as a hermit.

Above left: *St Caradoc*
Above right: *St Catherine of Siena*

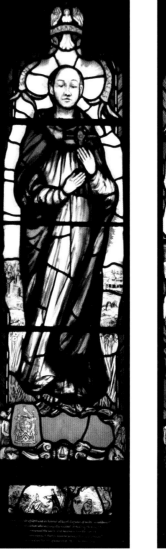
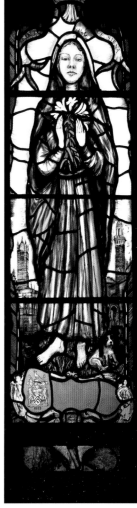

Title: *St Catherine of Siena*

Date: 1996

Location: Single lancet, chancel south

Inscription: At the top of the window 'SAINT CATHERINE OF SIENA'; lower left 'REES' together with the family shield; bottom of window 'To the Glory of GOD and in honour of Saint Catherine of Siena/Born in 1347 of Lapa and Giacomo Benincasa, a dyer. She was instrumental/ in persuading the Pope to move from Avignon to Rome after an absence of /seventy years. She managed this solely by her goodness and holy life/She died in 1380 aged thirty-three years. Her feast day is April 30th.'

Notes: As noted above the PCC approved the window in May 1966. It depicts St Catherine dressed in mauve and green with white lilies (her emblem), three dogs at her feet and towers of churches at her sides. Adjacent to the family shield is a blank space for a memorial to be added to Lady Rees on occasion of her death. Images of churches – possibly Avignon and Rome - are shown in the predella.

Title: *St Joseph*

Date: 1996

Location: Single lancet, sanctuary north

Inscription: 'To the Glory of God/and in memory of/General Thomas Wynford Rees and Rosalie his wife/of Goytre Hall.'

Commemoration: General T W and Mrs Rosalie Rees

Notes: Major-General TW "Pete" Rees (1898-1959) had a daredevil war with the Indian Army in Burma and the novelist John Masters, his 20th chief of staff after Rees had sacked the previous 19, noted that Rees was a polyglot and spoke English, Welsh, "Urdu, Marathi, Pushtu, Burmese, and Tamil. Now he asked me to teach him Gurkhali, and soon he knew enough to cause a look of startled pleasure to cross many a stolid Gurung face." Masters also said of Rees that he had a "rare, personal gentleness and unfailing good manners". In 1926 Rees married Rosalie, only daughter of Sir Charles Innes. The window depicts a sandal clad St Joseph in yellow with a dark red cloak holding a hammer and nails in his hand (indicating his trade of carpenter) and surrounded by foliage. The predella shows Mary and Joseph fleeing Egypt, pyramids in the background – Rees organised the defence of Cairo during World War 2.

Title: *John the Baptist*

Date: 1996

Location: Single lancet, sanctuary south

Commemoration: Rosalie and Richard Brooman White

Inscription: 'To the Glory of God/and in memory of Rosalie daughter of General and Mrs Rees of/Goytre Hall/and of her husband Richard Brooman White of Pennymore, Argyll./Member of Parliament for Rutherglen.'

Notes: The window depicts John the Baptist, clad in traditional skins under a green cloak, holding a long cross and with a shell above his head. St John baptising Christ is depicted in the predella. These predella are very much in the style of Reyntiens' later Limited Edition and Goldmark Gallery autonomous panels.

Above left: *St Joseph*
Above right: *John the Baptist*

Below: Inscription and predella from *St Joseph* window
Right: Rees arms from *St Catherine* window

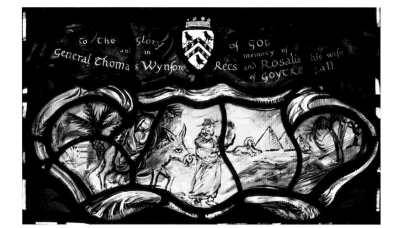

WEST GLAMORGAN
Swansea, St Mary's, St Mary's Square, SA1 3LP

General: There has been a church on the site of St Mary's since about 1328, of which the current building is but one reincarnation, previous structures dating from 1739, another 1879-1882, and a contentious design by Arthur Blomfield of 1896. In February 1941 the Church was extensively damaged by bombing during the Blitz and the current building dates from the 1950s. The rather ordinary exterior gives no clue to the treasures of contemporary stained glass inside, probably the result of the School of Architectural Glass being based at Swansea Metropolitan University. The east window, north chancel windows and St Anne's chapel window were designed by E Liddell Armitage and made by Whitefriars Glass Studio; the chancel windows also by Whitefriars; the Parachute window by Lisa Burkl; the Royal Wedding windows designed by Catrin Jones; the Children's window designed by John Edwards and made at the Glantawe Studios; the Leeson Barlow windows designed by Kuni Kajiwara and made by the Glantawe Studios; the Welsh Guards Falklands Memorial window designed by Rodney Bender; the Helyn Mary Rose Memorial window and Dilys and Morgan Lloyd Memorial windows designed by Colwyn Morris and made at the Glantawe Studios; and the Millennium window designed by Martin Donlin and made by him and staff at the School of Architectural Glass. Piper also designed the reredos (dorsal painting) for the Holy Trinity chapel.

Literature: Padley Kenneth, *Our Ladye Church of Swanesey a History of St Mary's*, The Friends of Swansea St Mary, 2007; Padley Kenneth, *there the heaven espy – a guide to swansea st mary by those who worship in it*, The Friends of Swansea St Mary, 2007, p4-6

The following details are applicable to both windows:

Title: unnamed

Date: 1963-1965

Location and Size: single lancets to north and south of the altar in Holy Trinity chapel (Lady chapel), approximately 264x66cm (104x26in)

Designer: John Piper

Glass Painter and Maker: Patrick Reyntiens

Cost: £900 total, £300 for each window and £300 for dorsal painting

Commemoration and Donors: The plaque beneath the north lancet reads: 'In Loving Memory of/JOHN AND ELIZABETH GRACE STEWART/OF MARY STEWART, AND OLIVE STEWART./THE GIFT OF M GRACE STEWART'.
The plaque beneath the south lancet reads: 'This Window is the GIFT of/MARGARET KIRKLAND, CALEDON./- MUMBLES, SWANSEA -'

Dedication: Wednesday 21 July 1965 by the Bishop of Swansea and Brecon

Documentation: TGA 200410/2/111/23, 89, 96; TGA 200410/2/1/16/3, 5, 7, 8, 10, 11

Literature: Harrison, 1982; Cowen Painton, *A Guide to Stained Glass in Britain*, London: Michael Joseph Ltd, 1985, p226; Newman John, *The Buildings of England, Glamorgan*, London: Penguin Books, 1995, p117, 581; Osborne, 1997, p77-78, 173; Murray Paul & Helen (Eds), *Stained Glass Windows and Master*

Glass Painters 1930-1972, Bristol: Morris & Juliet Venables, 2003, p87; Murray Paul & Helen (Eds), *A Short Guide to the Stained Glass Windows in St Mary's Parish Church Swansea*, 2003 (2001), unpaginated; Padley Kenneth, *Our Ladye Church of Swanesey a History of St Mary's*, The Friends of Swansea St Mary, 2007, p68; Padley Kenneth, *there the heaven espy – a guide to swansea st mary by those who worship in it*, The Friends of Swansea St Mary, 2007, p25-27; Corten Anthony G, *John Piper and Newport Cathedral*, undated, p4

Reproduced: Reyntiens Patrick, *The Technique of Stained Glass*, London: B T Batsford Ltd, 1967, p83; Osborne, 1997, p78; Padley Kenneth, *there the heaven espy – a guide to swansea st mary by those who worship in it*, The Friends of Swansea St Mary, 2007, p25, 26

Notes: In November 1958 Revd Canon H C Williams contacted Piper in the hopes that the artist would design a window for the church. Piper visited the church at some stage and the pair remained in contact, the Canon asking for ideas in July 1963. The two windows are almost identical, described by Reyntiens as 'mood setters'. The design is abstract in varying shades of blue with rings of other colours. Reyntiens had to make extensive use of aciding to interpret Piper's papier collé designs. The windows symbolise the mystery and eternal nature of the Trinity, the circles and blobs remind one of amoeba or planets. The reredos (executed in oil on canvas by Peter Courtier of the Royal Opera House) is painted in a marbled design, similar to that in St Woolos Cathedral, Newport, Gwent. Padley discerns three ghostly white figures within the painting which may represent the Trinity, God the Father, Son and Holy Spirit and takes the view that the painting 'offers insight into God as she is in herself while the windows reflect her activity in the universe'.

Below: Interior of the Holy Trinity chapel showing north and south lancets and dorsal painting

Following page: North and south lancets

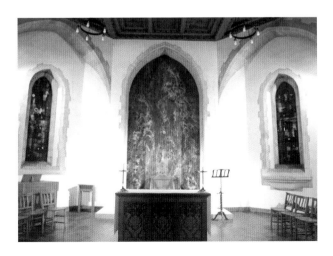

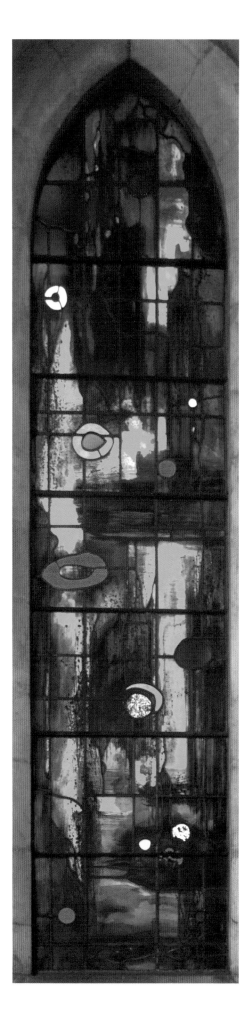
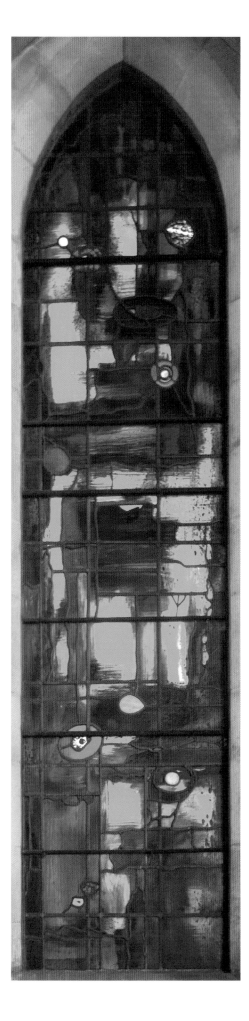

WORKS
ABROAD

Waterloo

Washington D.C.

Waterford

Cochem

Taunusstein

Johannesburg

Christchurch

CANADA
Ontario, Canadian Clay and Glass Gallery, 25 Caroline St North, Waterloo

Title: *Male Figure in a Wooded Landscape*

Provenance: Donated by Artists in Stained Glass; given to AiSG in 1990 when Reyntiens visited Canada

Date: 1983

Size: 28x21cm (11x 8 1/4in), rectangular panel with rounded top

Designer, Glass Painter and Maker: Patrick Reyntiens

Literature: 'Male Figure in a Wooded Landscape', http://www.aisg.on.ca/stained_glass_publications/new_articles/reyntiens.htm, 15 January 2003

Reproduced: 'Male Figure in a Wooded Landscape', http://www.aisg.on.ca/stained_glass_publications/new_articles/reyntiens.htm, 15 January 2003

Notes: Reyntiens wanted to make a panel which 'deliberately dissolved that sense of being a cardboard cut-out figure of homogeneous hue. What unites the figure is the badgering, the hatching, the painting across the colours.' The inspiration was from Dante: 'in the middle years of life I find myself in a dark wood'. It depicts a muscular figure with a ruby coloured torso standing in an abstract coloured wood.
Unfortunately the Gallery can find no reference to this work.

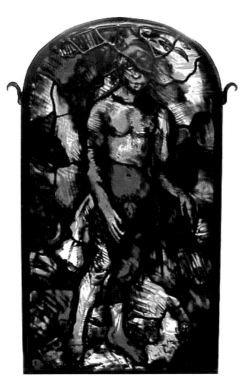

Title: *Designs for Osgoode Hall windows, 130 Queen Street West, Toronto*

Provenance: Donated by Artists in Stained Glass; given to AiSG in 1990 when Reyntiens visited Canada

Notes: Unfortunately the Gallery can find no reference to this body of work.

GERMANY
Cochem, St Martin's

General: The windows were the inspiration of Father Werner Müller who wanted stained glass to rival Chagall. He was advised by Wilhelm Derix of Derix Studios that Graham Jones was the best colourist in the world. In turn, Jones realised that Father Müller wanted figurative Biblical scenes (the exact themes from the *Old and New Testament* were chosen by Father Müller) and decided that the only person who had both the liturgical knowledge and could cope with the painting was Reyntiens. The close cooperation between two artists is very unusual, their abilities are complementary and the two men obviously enjoyed working together. Reyntiens was 84 years young when he began this commission. He drew full size cartoons in the Derix Studios, crawling round the floor in shorts and T-shirt, working with charcoal and Indian ink, his progress being constantly checked and scrutinised by the indefatigable Father Müller, who revelled in the three men rejecting, re-thinking and re-designing. Perhaps, like Basil Spence, Müller's motto is 'Only the very best will do for God' (Coventry Cathedral, West Midlands).

Right: Reyntiens' cartoon for *The Passion and the Resurrection*

Below: Reyntiens painting *The passion and the Resurrection* window, watched by Graham Jones and Father Müller

Photographs courtesy John Reyntiens

Reyntiens then had to paint the designs on the glass which he achieved in a mere three months. The intensity of colour in the glass is due not only to the quality of the glass (from Lamberts, Waldsassen, Germany) but also a considerable amount of plating. The leadwork does not in any way impinge on the designs, in fact it is so spidery that one hardly notices it. As Jones noted after the dedication, 'the beauty is, the figures don't match the colour, that's where the mysticism is'.

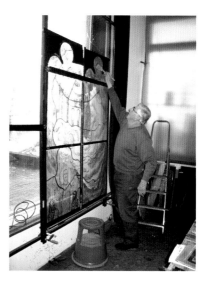

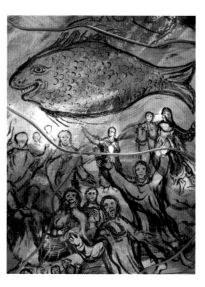

Above: *The Passion and the Resurrection* part painted
Below: Graham Jones and Reyntiens contemplate *Prehistory*
Top right: Reyntiens painting *Basic Themes of Revelation in the First and New Covenant*
Bottom right: Part of the window *Basic Themes of Revelation in the First and New Covenant* prior to leading

Photographs courtesy John Reyntiens

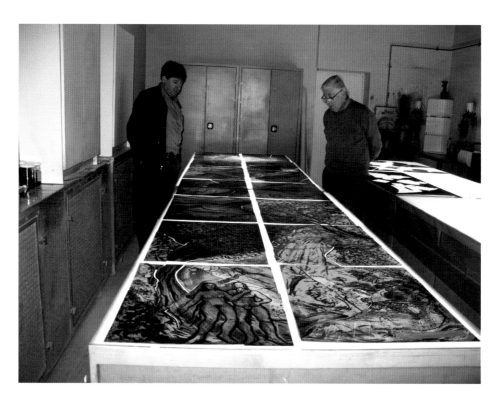

There is a satisfying symmetry and a healing of wounds when one considers that one of Reyntiens' first commissions was for Coventry Cathedral which had been bombed by the Germans. In turn the Americans bombed St Martin's. In Coventry the young Reyntiens collaborated with the older Piper – here he collaborated with the younger artist Graham Jones who grew up in Coventry and passed the Baptistry window every day when he attended art college. Father Müller regards the windows as a sign of reconciliation, and Coventry is not only the world's oldest religious-based centre for reconciliation but also the symbol of Britain's survival after World War 2. At the dedication service Reyntiens quoted from the Lord's Prayer and expressed the hope that with the new windows created by two British artists the two nations had forgiven each other. Several elderly German men started to weep and one in particular thanked Reyntiens whole-heartedly afterwards.

Literature: *Decorative Arts Society The, Omnium Gatherum*, Horner Libby, 'Patrick Reyntiens' Autonomous Panels. Myth, music and theatre', Journal 35, 2011, p65,66, 77

The following details are applicable to all 8 windows:
Date: 2004-2009

Designers: Graham Jones and Patrick Reyntiens

Glass Painter: Patrick Reyntiens

Glass Maker: Derix Studios

Dedication: 8 November 2009 (Remembrance Sunday) by Father Müller.

Literature: *Die neuen Kirchenfester in der Pfarrkirche St Martin, Cochem*, November 2009, unpaginated; *American Glass Guild*, Reyntiens Patrick, 'A letter from Senior Advisor, Patrick Reyntiens', 20 January 2010

Reproduced: *Die neuen Kirchenfester in der Pfarrkirche St Martin, Cochem*, November 2009, unpaginated

Film: Mapleston Charles, Horner Libby, *From Coventry to Cochem, the Art of Patrick Reyntiens*, Reyntiens/Malachite, 2011

Title: *God's spirit is active in His Church*

Location and Size: 2-light window in apse, 12.19x1.52m (40x5ft) (detail below)

Notes: Scenes include the Stoning of St Stephen, descent of the Holy Spirit on the Apostles and the Supper at Emmaus.

Title: *The Passion and the Resurrection*

Location and Size: 3-light central window of apse, 12.19x2.13m (40x7ft) (detail below)

Reproduced: *American Glass Guild*, Reyntiens Patrick, 'A letter from Senior Advisor, Patrick Reyntiens', 20 January 2010; *Decorative Arts Society The, Omnium Gatherum*, Horner Libby, 'Patrick Reyntiens' Autonomous Panels. Myth, music and theatre', Journal 35, 2011, p65

Notes: Scenes include Mary Magdalene meeting the risen Lord, Entry into Jerusalem, Last Supper (including Judas with a sack of money in the corner), Agony in the Garden, Christ Arisen, St Mary Magdalene and the Crucifixion, the latter being inspired by a 15th century cross in Germany.

Title: *The 'I am' words*

Location and Size: 2-light window in apse, 12.19x1.52m (40x5ft) (detail below)

Notes: Scenes include Christ as the Bread of Life, the Light of the World, the Resurrection and the Life, the Way of Truth and the Life, the Door of the Sheep, the Good Shepherd and the True Vine.

Title: *Words of Wisdom*

Location and Size: 2-light window, 12.19x1.52m (40x5ft) (detail below)

Notes: Scenes include 'The Lord is my Shepherd', Adam and Eve and the Songs of Solomon

Title: *Prophets*

Location and Size: , 2-light window, 12.19x1.52m (40x5ft) (detail below)

Notes: Scenes include Jeremiah, Jonah and the Whale, Jonah in Nineveh

Title: *The Patriarchs – The God of Abraham, Isaac and Jacob*

Location and Size: , 2-light window, 12.19x1.52m (40x5ft) (detail top right)

Notes: Scenes include Moses and the Tablets, the Burning Bush and Jacob

Title: *Basic themes of Revelation in the First and New Covenant,*

Location and Size: 2-light window, 12.19x1.52m (40x5ft) (detail below)

Notes: Scenes include Christ rising to Heaven, Moses receiving the Book of Law and St Martin cutting his cloak

Title: *Prehistory*

Location and Size: 2-light window, 12.19x1.52m (40x5ft) (detail opposite)

Notes: Scenes include the Tower of Babel and Adam and Eve in the Garden of Eden. At the top are angel wings and then the flood pours down through the window, with Adam and Eve at the bottom. Apart from the blue flood the colours are green and yellow and Jones regards this as the most satisfying of the windows and the one which definitively points the way forward in glass design.

Die neuen Kirchenfenster für die kath. Pfarrkirche St. Martin

Farbgestaltung:
Graham Jones
London

Figürlichkeit:
Patrick Reyntiens
London

Idee und Konzeption:
Pastor Werner Müller

Umsetzung:
Derix Glasstudios
Taunusstein

Einweihungsgottesdienst
am 8. November 2009 um 10.00 Uhr

gestaltet mit Musik für Chor, Gemeinde, Orgel und Bläser
von der Chorgemeinschaft St. Martin / St. Klaus von Flüe, Cochem, und dem Bläserensemble „Quartettino", Emmelshausen

anschl. Empfang und um 13.00 Uhr thematische Einführung

GERMANY
Taunusstein, Derix Glasstudios GmbH & Co, Platter Strasse 94, D-65232

Title: *Fool's Paradise*

Date: 1986

Size: 280x85cm (110x33 1/2in) in frame 4-5cm (1 ½-2in) wide

Designer and Glass Painter: Patrick Reyntiens

Inscription: signed b.r.

Glass Maker: Derix Studio

Documentation: Letter from Wilhelm Derix to the author, dated 6 February 2012

Literature: *BSMGP*, 'Working with Light', Autumn 1986, p9; *Working With Light. A look at contemporary STAINED GLASS in architecture*, Andrew Moor Associates and Derix Glass Studios, April 1987, unpaginated ; *Moor Andrew, Contemporary Stained Glass. A Guide to the Potential of Modern Stained Glass in Architecture*, London, Mitchell Beazley International Ltd, 1989, p52; *Leadline 1990, Patrick Reyntiens & the Burleighfield Experience* , Goodden Ted (Ed), Moor Andrew, 'Introduction to the Recent Work of Patrick Reyntiens', 1990, p10

Reproduced: Moor Andrew, *Contemporary Stained Glass. A Guide to the Potential of Modern Stained Glass in Architecture*, London, Mitchell Beazley International Ltd, 1989, p52

Exhibited: *Working With Light*, RIBA, organised by Andrew Moor and Bronson Shaw and sponsored by Andrew Moor Associates and Derix Glass Studios, April 1986, Untitled

Notes: Four exhibition windows by Jochem Poengsen, Johannes Schreiter, Bronson Shaw and Patrick Reyntiens were designed and constructed specially for the *Working with Light* exhibition in collaboration with the artists at the Derix Studios near Wiesbaden. In 1985 Reyntiens took a full scale drawing to Derix. They traced it, cut the templates and the glass and etched the glass according to Reyntiens' instructions. The glass was then waxed up on a carrier glass and the artist painted the glass in two layers. Derix then fired the glass in two layers in their kiln, leaded and framed the glass. The glass was manufactured by Lamberts Waldsassen as flash and double flash glass. The panel is a singularly enigmatic work based on Jacob's Ladder with clowns instead of angels either tumbling down or trying to climb a red ladder. At the top are white Ku Klux Klan looking faceless white clowns, the central one of which stands like a God within a halo.

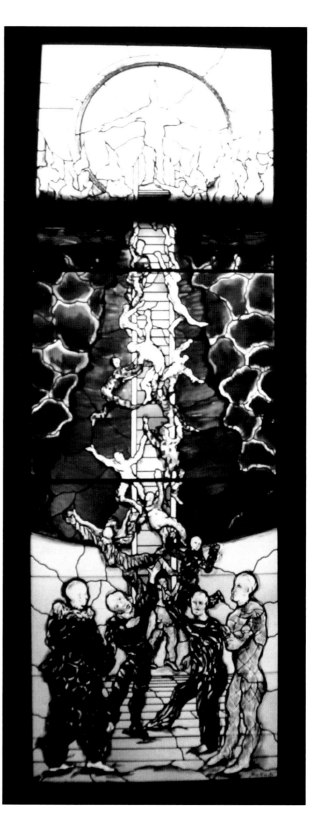

Right: *Fool's Paradise*, photograph courtesy of Derix Studios

IRELAND
Waterford, Church of the Sacred Heart (RC), 21 Richardson's Folly

The following details are applicable to all the windows:
Date: 1967-1969

Designer, Glass Painter and Maker: Patrick Reyntiens

Technical Supervisors: David Kirby (involved in making the stainelss steel reinforcing armatures) and Derek White

Architect in charge: O'Neill Flanagan

Documentation: emails to the author from David Kirby and Father Sean Melody

Literature: *Stained Glass Windows and Master Glass Painters 1930-1972*, Bristol: Morris & Juliet Venables, 2003, p87; Baden Fuller Kate, *Contemporary Stained Glass Artists. A Selection of Artists Worldwide*, London: A&C Black Publishers Ltd, 2006, p49

Notes: This is a complete scheme and the effect is stunning. The glass is not painted.

Title: *Earth, Air, Fire and Water*

Location and Size: alternate walls of the octagonal building, dalle-de-verre, each wall composed of nine panels, each panel approximately 274x132cm (108x52in)

Notes: The 2.5cm (1in) thick glass was glued together with sand-filled epoxy mortar and reinforced with a stainless steel armature and fibreglass rovings. Each window has an identical red cross in the central panel in the middle of a lateral area delineated by a convex curve above and a concave curve below, this area being pale in tone. There are strongly coloured abstract areas above and below, the colouring reflecting the seasons in the sequence of

windows. The south-east window is predominately blue, the south-west window green and purple, north-west orange and red and the north-east window green and blue. In Fuller's book, Reyntiens notes that he became bored with dalle-de-verre – 'too crude a medium to allow the creation of a really sensitive statement, and I consequently never touched it again'.

Title: unnamed

Location: Three areas of clerestory dalle-de-verre windows in ceiling

Notes: The narrow windows form three bands round the ceiling, the colours are mainly green and blue with cloud like forms.

Title: unnamed

Location and Size: Sanctuary, leaded glass on north and south sides, main panel approximately 205cm (80 3/4in) wide

Notes: Abstract cloud forms predominate in clear, blue and grey glass.

Title: *Cross*

Location and Size: Lady Chapel, dalle-de-verre, total size approximately 183x95cm (72x37 1/2in), each arm being 9cm (3 1/2in) wide

Notes: The window has been cleverly designed by the architect to throw a brilliant shaft of white light on the shrine of the Virgin Mary. The glass is white and grey.

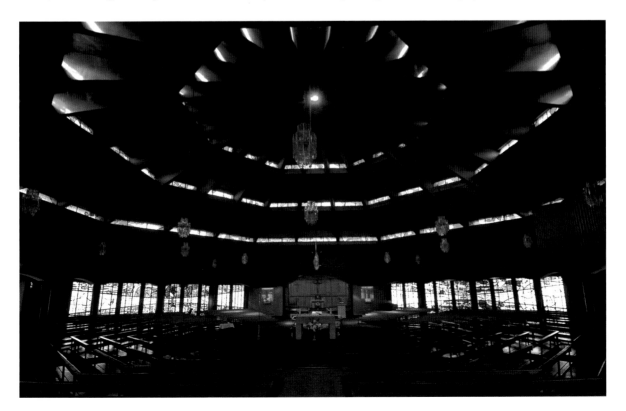

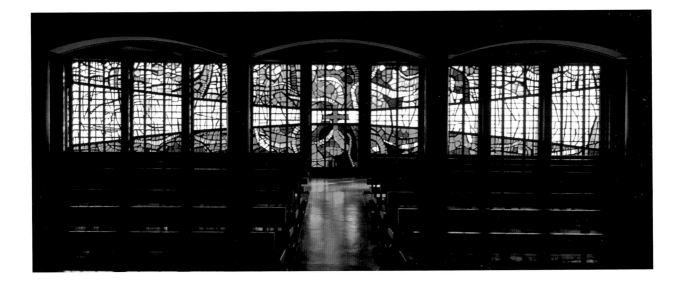

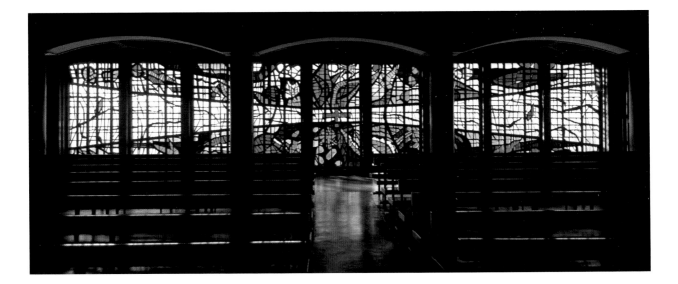

Opposite page, top to bottom: South-east window, south-west window and north-west window
Above: North-east window and sanctuary wall south
Below left: Lady Chapel
Below right: Detail of clerestory

IRELAND
Waterford, St Joseph and St Benildus (RC), Newtown Rd

The following details are applicable to all windows:

Date: 1968

Designer, Glass Painter and Maker: Patrick Reyntiens

Technical Supervisor: David Kirby (involved in making the stainless reinforcing armatures)

Dedication: 19 March 1968 by Most Revd Dr Michael Russell, Bishop of Waterford and Lismore

Literature: *Stained Glass Windows and Master Glass Painters 1930-1972*, Bristol: Morris & Juliet Venables, 2003, p87

Notes: This is a complete scheme. The glass is not painted.

Title: *Bleeding Hearts*

Location and Size: four walls of the building, dalle-de-verre, each wall composed of seven panels, each panel approximately 276x139cm (108 3/4x54 3/4in)

Notes: The 2.5cm (1in) thick glass was set in resin which has since perished and cracked, and the north-west and south-west walls are sagging and bulging, the latter wall actually cordoned off for safety. The windows are abstract, each one unique, with a variation on a bleeding heart at the centre of each panel. The colours are mainly green and blue with touches of red, pink and white.

Title: unnamed

Location: Clerestory window, dalle-de-verre

Notes: The clerestory window encircles the church; the design is abstract and the colours mainly blue, green and brown.

Title: unnamed

Location: Central lantern in roof

Notes: The design is abstract with red Pentecostal flames on a blue background.

Title: unnamed

Location and Size: South wall, south-west chapel, dalle-de-verre, 9-light rectangular window, each light approximately 280x30cm (110 1/4x11 3/4in)

Notes: The window is abstract with acid green leaves against a background of pink, turquoise and dark green.

Title: unnamed

Location and Size: North wall, north-west chapel, dalle-de-verre, 9-light rectangular window, each light approximately 280x30cm (110 1/4x11 3/4in)

Notes: The window is abstract with white tear drops and orange Pentecostal flames on a blue and purple background.

Below: Interior of church
Opposite page, top to bottom: South-east window, south-west window and north-west window

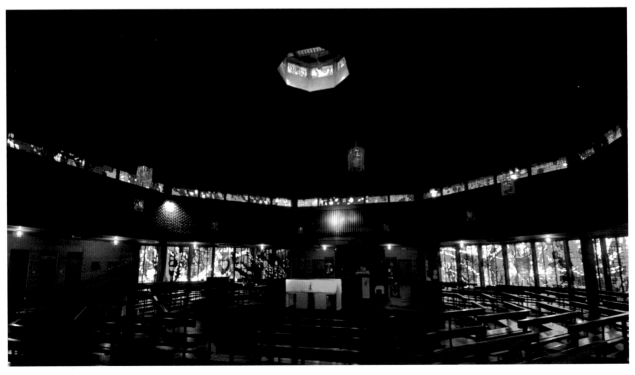

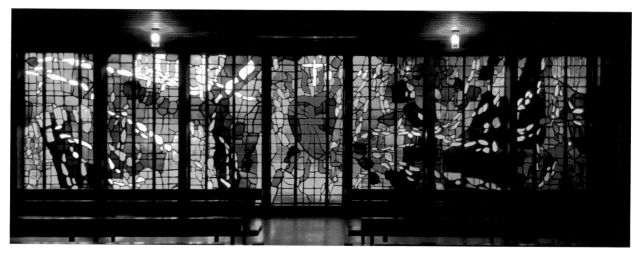

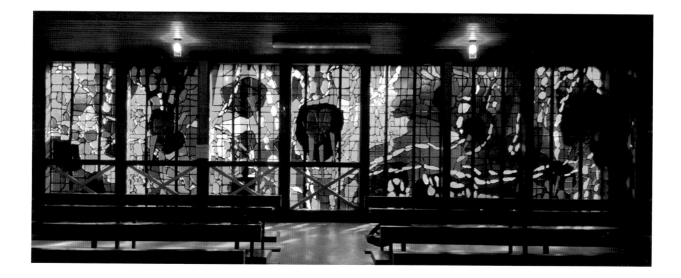

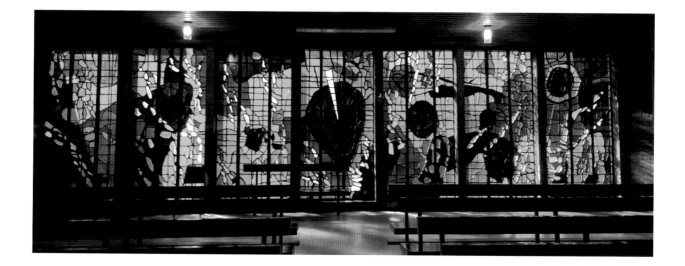

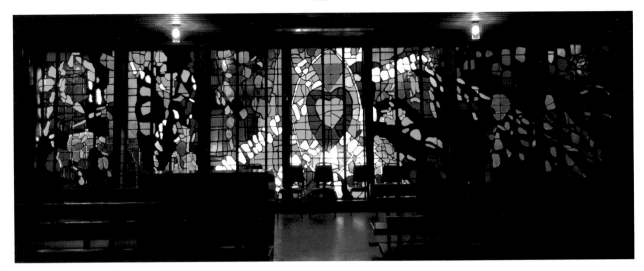

Above: North-east window

Below: South-west chapel window

Right: North-west chapel window

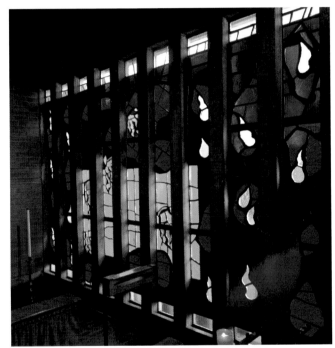

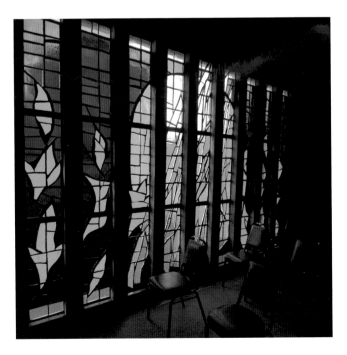

NEW ZEALAND
Christchurch, Christ's College Chapel, Rolleston Avenue

General: Christ's College is an independent Anglican boys school founded in 1850

Title: *The Tree of Life and the River of Life*

Date: 1964-1969

Location and Size: 2-light window south side of nave, 158x107cm (62.2x42.1in)

Designer: John Piper

Glass Painter and Maker: Patrick Reyntiens

Cost: estimated £600 14 April 1966 – paid June 1969 on the basis of £34/sq ft

Commemoration and Donors: The window commemorates Revd Ernest Courtenay Crosse DSO MC MA, Headmaster and Chaplain of the School from 1921-1930. The window was commissioned by the Christ's College Old Boys' Association in July 1966 and was paid for by them with contributions from Canon Crosse's widow Joyce and the family

Faculty: 19 August 1966

Dedication: Sunday 13 July 1969 by Alwyn Keith Warren, Bishop of Christchurch

Documentation: TGA200410/2/1/11/137, TGA200410/2/1/12/16, 18, 24, 27, 43, 45, 86, 111, 197, 227, 230-231, TGA200410/2/1/11/147; Christ's College Archives; Christ's College Old Boys' Association

Literature: Harrison, 1982, unpaginated; *Art New Zealand 37*, Ciarán Fiona, 'The Piper-Reyntiens Window in New Zealand', Summer 1985, p32-33; Osborne,1997, p105 , 174; Ciarán Fiona, *Stained Glass Windows of Canterbury, New Zealand: a catalogue raisonné*, Dunedin: University of Otago Press, 1998, p124; Ciarán Fiona & Teal Jane, *The Stained Glass Windows of Christ's College Chapel*, Christchurch: Christ's College, 2001, #9; *Stained Glass Windows and Master Glass Painters 1930-1972*, Bristol: Morris & Juliet Venables, 2003, p87 (wrongly stating that it is the Cathedral); Spalding, 2009, p418

Reproduced: *Art New Zealand 37*, Ciarán Fiona, 'The Piper-Reyntiens Window in New Zealand', Summer 1985, p32; Ciarán Fiona, *Stained Glass Windows of Canterbury, New Zealand: a catalogue raisonné*, Dunedin: University of Otago Press, 1998, plate 4; Ciarán Fiona & Teal Jane, *The Stained Glass Windows of Christ's College Chapel*, Christchurch: Christ's College, 2001, #9

Notes: Crosse was born in England and educated at Clifton College, Bristol; Balliol College, Oxford and Ely Theological College. He taught at Marlborough College and had a distinguished war record - he was senior Church of England Chaplain to the 7th Division - returning to Marlborough from 1919 to 1920 before taking up the position of Headmaster and Chaplain at Christ's College where his energy and determination made a significant contribution to the school. By 1930 he was exhausted by his efforts and resigned. He became acting headmaster at Waihi School, South Canterbury and assistant curate at Temuka before returning to England in 1932 where he took up the post of chaplain at Shrewsbury College, followed by Headmaster at Ardingly College. From 1944 to 1947 he was a Canon at Chichester Cathedral and in 1946 became the rector at Henley-on-Thames where he met Piper. Crosse died 11 December 1955

in London. The Christ's College Old Boys' Association (CCOBA) first considered the idea of a commemorative window in 1960 and liaised with William Wilson about the possibility. However in November 1964 Crosse's son Simon told Bishop Warren that Piper would be prepared to design a window but that due to work commitments of both himself and Reyntiens, work would not proceed immediately. The negotiations with Wilson ceased at this stage. The following month the CCOBA informed Simon Crosse that they had written to Piper asking for a design and estimate of costs. In 1965 the Secretary of the CCOBA amusingly informed Piper that 'in this hemisphere I need hardly remind you I expect, this wall does not see the sun'. In January 1966 Simon Crosse wondered if Piper could add a swan to the river of life and a seed pod from which the tree of life could sprout. By April 1966 the design had been approved by the Crosse family and was forwarded to the College. The CCOBA approved the design in September by which stage, probably at the suggestion of Bishop Warren, it had been decided that the memorial window should be in the Baptistry – Piper was sent the new templates on 19 January 1967 together with instructions to proceed. Apparently the College authorities had problems obtaining an import licence for the window, the Customs Department taking some convincing that a similar window could not be made in New Zealand. The licence which ended 30 June 1967 had to be extended to 30 June 1969 since the window was not completed – it was sent on 13 March 1969. In a letter to Ciarán dated 4 May 1982, Piper described the subject of the window as a favourite, the symbolism being taken from *Revelation* 22. The left hand light has a red tree with blue leaves against a turquoise ground whilst the right hand light has two red wiggles representing the river against the same turquoise background, the outer edges of each light being purple. The background glass is matted with paint while the scarlet areas of the Tree and River have been left untouched. Ciarán notes that the upward movement of the Tree is balanced by the downward flow of the River and 'in keeping with a theme based on life-giving properties and nourishment, the Tree appears both arterial and vertebral, while the blood-red River seems to teem with fish or droplets' (*Art New Zealand*).

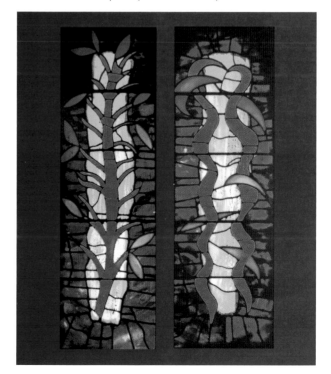

SOUTH AFRICA
Johannesburg, Unicorn House

General: The architect John Fassler was interested in 'New Brutalism' and the work of Marcel Breuer, the setting of a building within an urban framework and close co-operation with artists. The building, designed as the corporate headquarters of Union Corporation, was of precast concrete. Fassler's wife Stephanie had studied for 18 months with Reyntiens.

Date: 1968

Location: Four large decorative west windows in dalle-de-verre

Designer: Patrick Reyntiens

Technical Supervisor: Derek White

Architect in charge: John Fassler & Partners

Literature: *Stained Glass Windows and Master Glass Painters 1930-1972*, Bristol: Morris & Juliet Venables, 2003, p87; http://www.artefacts.co.za/main/Buildings/bldgframes.php?bldgid=360

Notes: The windows are on the ground floor of the building.

UNITED STATES OF AMERICA
Washington DC, National Episcopalian Cathedral, Cathedral Church of St Peter and St Paul, Mount St Alban, 3101 Wisconsin Avenue, Northwest Washington DC 20016

General: The site for the cathedral was chosen by the first Bishop of Washington, Henry Yates Satterlee, on one of the highest points of the city and at that time (1896) a fair distance from the centre. The first architects were the American Henry Vaughan and the English George Bodley and the foundation stone was laid on 29 September 1907. Philip H Frohman became chief architect in the 1920s. The Cathedral building was completed exactly 83 years later.

Literature: Crimi Elody and New Diane, *Jewels of Light. The Stained Glass of Washington National Cathedral*, Washington National Cathedral, 2004, p26-29

Title: *Wings of Courage, Brother Lawrence window, memorial to General Thomas Dresser White*

Date: 1962-1969

Location: 3-light window in nave, north main arcade, Bay 5 (Bettelheim Bay)

Designer, Glass Painter and Maker: Patrick Reyntiens

Technical Supervisor: Derek White

Architect in charge: Philip Frohman

Installation: Dieter Goldkuhle

Studies: Earlier studies included a Biblical Burning Bush for Brother Lawrence's tree, the Air Force Chapel was in the predella, and there were two large white stars in the tracery and vivid white circles in the predella

Commemoration and Donor: The window commemorates General Thomas Dresser White, USAF, and various unnamed donors contributed to the cost.

Dedication: 19 October 1969 by Dean Francis B Sayre

Documentation: Cathedral archives

Literature: *The Cathedral Age*, Winter 1969, p11-12; Clarke Brian (Ed), *Architectural Stained Glass*, London: John Murray, 1979, p193; *Stained Glass Windows and Master Glass Painters 1930-1972*, Bristol: Morris & Juliet Venables, 2003, p87; Crimi Elody and New Diane, *Jewels of Light. The Stained Glass of Washington National Cathedral*, Washington National Cathedral, 2004, p61

Reproduced: *The Cathedral Age*, Winter 1969, cover, p11-12; *Patrick Reyntiens, Glass Painted and Stained, Visions in Light*, Bruton Gallery, 1985, p28; *Stained Glass*, Spring 1985, Volume 80, Number 1, Richard Millard, 'Richard T Feller. Aesthetic Beacon of Washington Cathedral', p33; Crimi Elody and New Diane, *Jewels of Light. The Stained Glass of Washington National Cathedral*, Washington National Cathedral, 2004, p60, 61

Notes: Piper received a letter from Richard T Feller, Clerk of the Works, dated 15 May 1962 about the possibility of designing four stained glass lancets for the Bettelheim Memorial Bay. However by 1968 Reyntiens was in communication with Feller, Dean Sayre and Mrs Katharine Metcalf regarding his design for the *Wings of Courage* window which links the beliefs of two very different men. In 1631 a soldier returning to England passed a bare black tree and realised that in a few months it would have leaves – he wondered if he could transform his life in similar fashion and did so by becoming Brother Lawrence who wrote an influential book, *The Practice of the Presence of God*. General White was Chief of Staff of the U.S. Air Force from 1957 to 1961 but believed that there had to be a saner way to solve problems than by war. A flowering tree with red flowers symbolising the Holy Spirit which *The Cathedral Age* notes 'comes like fire to a man's heart and makes him new' fills the central lancet whilst in the medallion below the soldier Lawrence is shown with the bare tree. The right and left lancets show courageous wings of fire. The left lancet represents man's aspiration and the medallion below shows Moses blessing the Promised Land (*Deuteronomy* 32:49). Aaron and Joshua help Moses who is too old to travel, but has shown

the path for God's people to follow. In the same way it was during General White's tenure that the space mission evolved, a new Promised Land. The right hand lancet indicates mans' needs – his prayer and faith, shown in the medallion by the centurion who asked Jesus to cure his servant (*Matthew* 8:5). According to *The Cathedral Age* the flames above represent 'God's mercy, healing the servant, redeeming history, enfolding the earth with power to live despite her sin. The wondrous shadow of His Providence is suggested by the bright rays from heaven'. In the cinquefoil at the top is a representation of the Air Force Chapel built at Colorado Spring's during General White's time, which 'proclaim[s] that the faith and blessing in the spirit of the leader are shared by all the men throughout the service who, like the soldier of yore, lift up their lives to a more sacred service than any nation may claim and which God alone does bless in eternal glory' (*The Cathedral Age* quoting from Dean Sayre's commentary). The colours are mainly rich dark blues and reds.

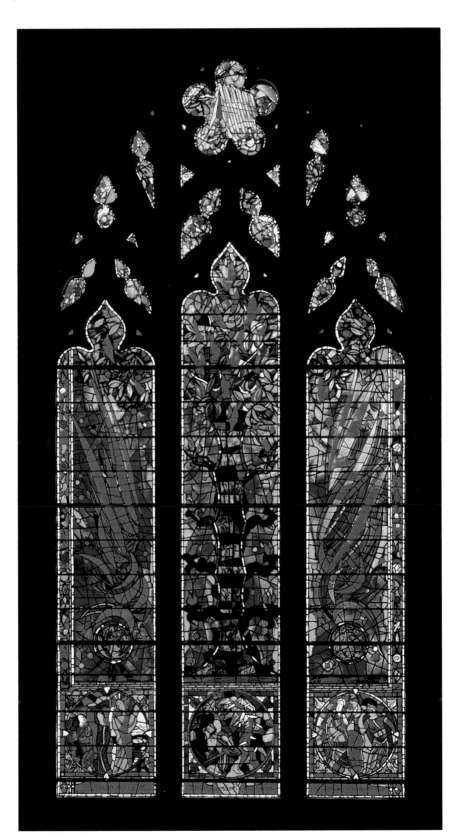

Title: '*Westward, look, the land is bright*', *Sir Winston Churchill memorial window*

Date: 1972-1974

Location: 3-light window in narthex, Churchill porch, balcony level, south wall

Designer: John Piper

Glass Painter and Maker: Patrick Reyntiens

Assistant: Yoshiro Oyama

Architect in charge: Philip Frohman

Installation: Dieter Goldkuhle

Study: Piper presented two designs, both with a golden tree of life against a variegated blue background

Commemoration and Donors: The window is in memory of Sir Winston Churchill. The left and central lancets were the gift of R T Johnstone of Detroit, Michigan who took over as head of the Churchill Memorial Committee in 1969.

Dedication: 29 September 1974 (the porch in the St Paul Tower, given in memory of Churchill, was also dedicated during the service) by Dean Francis B Sayre

Documentation: Cathedral archives

Literature: *Churchill Porch and Window dedication leaflet*, Washington Cathedral, 29 September 1974; Harrison, 1982, unpaginated; *Art New Zealand 37*, Ciarán Fiona, 'The Piper-Reyntiens Window in New Zealand', Summer 1985, p32; Osborne, 1997, p109-110, 176; Crimi Elody and New Diane, *Jewels of Light. The Stained Glass of Washington National Cathedral*, Washington National Cathedral, 2004, p170; Spalding, 2009, p418, 486

Reproduced: Osborne, 1997, p110; Crimi Elody and New Diane, *Jewels of Light. The Stained Glass of Washington National Cathedral*, Washington National Cathedral, 2004, p169; Spalding, 2009, plate 78

Notes: Piper was only persuaded to submit designs by the Cathedral's emissary Katharine Metcalf and the fact that it was a memorial to Churchill. However he was disinclined to design a window on the theme of 'The Defence of Freedom'. His inspiration was from a poem by Arthur Hugh Clough (1819-1861) quoted by Churchill in his World Broadcast, 27 April 1941:

> For while the tired waves vainly breaking,
> Seem here no painful inch to gain,
> Far back, through creeks and inlets waking,
> Comes silent, flooding in the main,
>
> And not by eastern windows only,
> When daylight comes, comes in the light;
> In front the sun climbs slow, how slowly!
> But westward, look, the land is bright.

The Building Committee agreed to offer the commission to Piper in September 1972 and contracts were signed in December of that year. In July 1974 Metcalf visited the Piper family and Reyntiens' studio and reported that the 'blue is very beautiful' and that Piper had just seen the window himself and was delighted with it. It was anticipated that the window would be shipped by air to Dulles mid-September in time to be installed prior to the dedication. A very stylised yellow Tree of Life spreads across the three lights against a blue ground interspersed with little dots of colour.

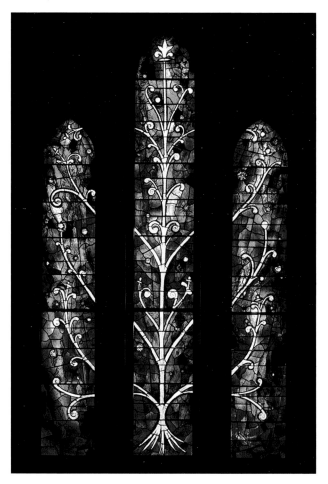

Title: *Servants of God (Peace and Justice), memorial to William Pratt*

Date: 1970-1975

Location: 3-light window in the nave, north main arcade, Bay 4 (National Cathedral Association Bay)

Designer, Glass Painter and Maker: Patrick Reyntiens

Assistant: Yoshiro Oyama

Architect in charge: Philip Frohman

Installation: Washington Art Glass

Commemoration and Donor: The window commemorates William Pratt (1615-1678) and his descendants and the donors were Mr and Mrs Leland Gardner (the latter being a direct descendant). Mrs Gardner pledged money for the window in 1970 at which stage it was determined to offer the commission to Reyntiens.

Dedication: 31 March 1976 by Dean Sayre

Documentation: Cathedral archives

Literature: *Servants of God dedication leaflet*, Washington Cathedral, March 1976 (with description by R T Feller, Clerk of Works); *The Cathedral Age*, Summer 1976, p27; Crimi Elody and New Diane, *Jewels of Light. The Stained Glass of Washington National Cathedral*, Washington National Cathedral, 2004, p61; *BSMGP*, Cormack Peter, 'Crimi Elodi R and Ney Diane, Jewels of Light. The Stained Glass of Washington National Cathedral', Vol XXIX, 2005, p232

Reproduced: *Patrick Reyntiens, Glass Painted and Stained, Visions in Light*, Bruton Gallery, 1985, p29; Crimi Elody and New Diane, *Jewels of Light. The Stained Glass of Washington National Cathedral*, Washington National Cathedral, 2004, p60

Notes: The initial proposition from the Cathedral was to depict Mahatma Gandhi in the left hand lancet with his symbolic spinning wheel, William Penn to be a minor figure. The central lancet was to include Chief Justice John Marshall with a subsidiary figure of Archbishop Stephen Langton, and the right hand lancet was to show Charlemagne with Constantine in a minor role. In February 1972 Reyntiens wrote to Feller that he had decided to unify the window with whites rather than yellow tones since it abutted the red Wings of Courage window. In the same letter to Feller he noted that he had placed Langton in the central light since 18th century clothing would look wrong in a 13th century style window, and that portraits of Marshall, Penn and Constantine were placed in the roundels, each in a different primary colour. Ghandi and Charlemagne were still part of the scheme together with the symbols of a spinning wheel, a Colonel's hat and the Crown Imperial. Reyntiens sharply observed that 'the colour scheme has been extremely carefully balanced to interlock blues, greens, whites and reds and I would not really want it disturbed'. Three months later Reyntiens received an urgent message that, unlike his predecessor, Marshall always wore a plain black robe and not one with orange stripes on the sleeve. In July 1974 Metcalf reported from England that the window would be completed by November and noted that a young Japanese man (Oyama) was helping with the glazing, 'very gifted and certainly meticulous'. The window must have been delivered to Washington by July 1975 because Feller appears to have complained about the illegibility of the inscription and he and Reyntiens agreed that the window should be sent to Dieter Goldkuhle to correct. Reyntiens noted that 'I must admit I felt the somewhat banal inscription on the end of a 14th Century type window needed heavy disguising … I still think the lettering should be a kind of decorative lombardic half-uncial for purely aesthetic reasons'.
William Pratt sailed from England to America in 1663 together with Thomas Hooker, a Puritan preacher and theologian. Having annoyed the Massachusetts church authorities with his even more liberal views, Hooker moved on to Connecticut with a group of followers including Lieutenant Pratt who became a respected citizen in Hartford and founded a large dynasty. The window is traditionally figurative with an abstract background of 'mysterious' blues with flashes of red, yellow and green, a 'resplendent mix of luminous colours' (Feller). It illustrates men who shaped their societies morally, religiously and ethically. In the left lancet is the English Quaker William Penn (who founded Pennsylvania) in traditional black costume holding a Bible in his hand, whilst in the medallion below he is seen signing a treaty with Pennsylvania's Native Americans. At the base of the window is inscribed 'The Heritage of England'. Penn symbolises religious freedom in both England and America. In the central light stands Stephen Langton, Archbishop of Canterbury, in his green chasuble with Episcopal mitre and Papal Pallium, with a symbolic hand of God in benediction above. In the roundel below Langton is seen ensuring that King John signs the Magna Carta in 1215. At the bottom of the light is inscribed '1615 Lt. William Pratt 1678'. On the right is Chief Justice John Marshall of the U.S. Supreme Court, attired in black judicial robes and holding a scroll representing the U.S. Constitution. Marshall reformed the Supreme Court following his appointment in 1801, a position he held for over 35 years. In the medallion two judicial figures stand by the Supreme Court. The bottom of the window bears the inscription 'The Nourishing of America 1633'. A phoenix is seen in the cinquefoil at the top representing the justice of God being renewed and brought back to life by his servants on earth. Cormack considers that with respect to the stained glass in the cathedral 'the sense of inspired architectonic sympathy seems to diminish in much of the later work, beginning with the coarse sub-expressionism of Evie Hone's 1953 window and descending to the banality of Patrick Reyntiens' *Servants of God* window of 1976'.

Photographs of the *Wings of Courage*, *Sir Winston Churchill* and *Servants of God* windows by Ken Cobb, courtesy Washington National Cathedral

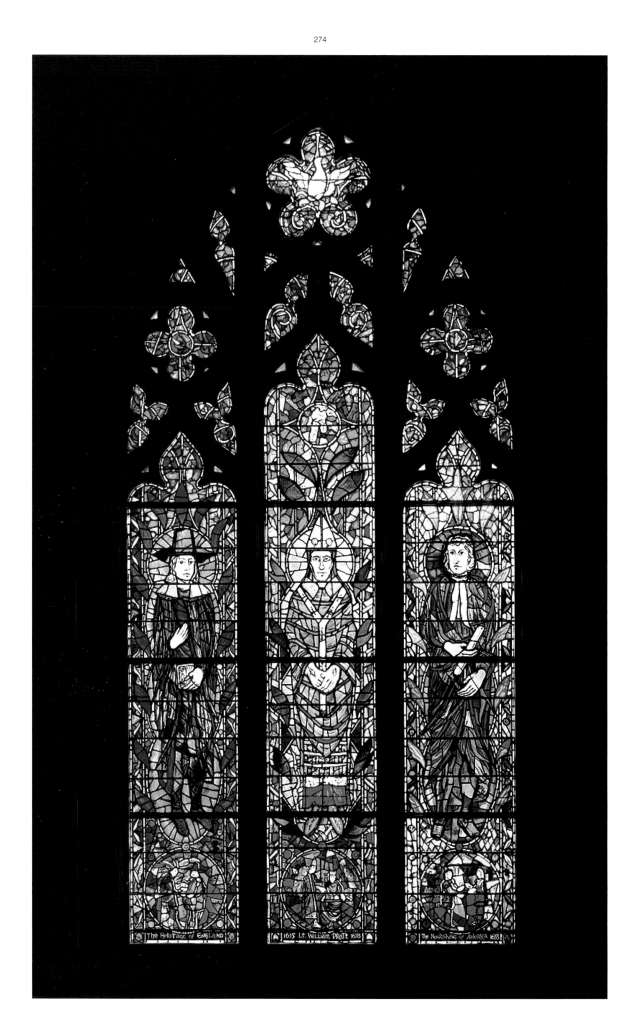

AUTONOMOUS
PANELS

Works designed by Anthony Curtis, John Piper and Philip Sutton, for which Patrick Reyntiens was the Glass Painter and Maker:

ABSTRACT

Date: c1960

Size: 46x39.5cm (18x15.5in)

Designer: Anthony Curtis

Exhibited: *Modern Stained Glass*, Arts Council, London, 1960-1961, #4

ANGLESEY BEACH

Date: 1964

Size: 114.3x162.6cm (45x64in)

Designer: John Piper

Reproduced: *The English Eye*, Marlborough-Gerson Gallery Inc, New York, November-December 1965, #67

Exhibited: *The English Eye*, Marlborough-Gerson Gallery Inc, New York, November-December 1965, #67 (titled *Anglesey*); *John Piper, Ceri Richards*, Marlborough Fine Art Ltd, London, April 1967, #69

Notes: There are a series of round and ovoid forms at the top of the panel with a wide light area below, almost like a playing field, with a strong wide diagonal crossing it.

BENEDICT BISCOP

Owner: Piper Estate

Date: c1981

Designer: John Piper

Literature: Osborne, 1997, p179

Notes: This is a smaller version of the window Piper designed to commemorate Benedict Biscop at St Paul's, Jarrow, Tyne and Wear.

BRITTANY BEACH SCENE 1

Owner: Piper Estate

Date: 1961

Size: 116.8x160cm (46 1/8x63 7/8in)

Designer: John Piper
Literature: Osborne, 1997, p63, 178

Exhibited: *John Piper painting in coloured light*, Kettle's Yard Gallery, Cambridge, 3 December 1982-9 January 1983, #5

BRITTANY BEACH SCENE 2

Owner: Piper Estate

Date: 1961 (Tate dates it 1965)

Size: 115.6x159.4cm (45.5x62.75in)

Designer: John Piper

Literature: Compton Ann (Ed), *John Piper painting in coloured light*, Kettle's Yard Gallery, 1982, unpaginated; *John Piper*, The Tate Gallery, London, 30 November 1983-22 January 1984, p116; Osborne, 1997, p63, 178

Exhibited: *John Piper painting in coloured light*, Kettle's Yard Gallery, Cambridge, 3 December 1982-9 January 1983, #6 (lent by the artist); *John Piper*, The Tate Gallery, London, 30 November 1983-22 January 1984, #120 (lent by the artist)

CHRIST BETWEEN ST PETER & ST PAUL

Owner: Piper Estate

Date: c1955

Size: 49.5x36.8cm (19 1/2x14 1/2in)

Designer: John Piper

Literature: Compton Ann (Ed), *John Piper painting in coloured light*, Kettle's Yard Gallery, 1982, unpaginated; *John Piper*, The Tate Gallery, London, 30 November 1983-22 January 1984, p117

Exhibited: *John Piper painting in coloured light*, Kettle's Yard Gallery, Cambridge, 3 December 1982-9 January 1983, #2 (lent by the artist)

Notes: This is probably a smaller version of the panel in the Victoria and Albert Museum, Royal Borough of Kensington and Chelsea. It is based on a gouache of 1955 after a Romanesque tympanum at Aulnay in France.

ELECT AND THE DAMNED

Owner: Piper Estate

Date: c1960

Size: 128.8x77.5cm (50.75x30.5in)

Designer: John Piper

Literature: *John Piper*, The Tate Gallery, London, 30 November 1983-22 January 1984, p116

Exhibited: *Modern Stained Glass*, Arts Council, London, 1960-1961, #13; *John Piper*, The Tate Gallery, London, 30 November 1983-22 January 1984, #119 (lent by Mrs John Piper)

Notes: This work was specially commissioned by the Arts Council for their exhibition and is a similar size to the individual panels being made for Coventry Cathedral, West Midlands.

FOUR SEASONS

Owner: Piper Estate

Date: 1982

Size: 114.75x160cm (45.25x62.75in)

Designer: John Piper

Documentation: Nominal File MA/1/1383 Victoria and Albert Museum

Literature: Harrison, 1982, unpaginated; Compton Ann (Ed), *John Piper painting in coloured light*, Kettle's Yard Gallery, 1982, unpaginated; *The Painter in Glass, Catalogue of Works*, Swansea Festival Exhibition, 1992, p18; *BSMGP*, Swash Caroline, 'The Painter in Glass', Spring/Summer 1993, p17; Osborne, 1997, p124, 177

Reproduced: *BSMGP*, Autumn 1982 cover; Lloyd Alison (Ed), *The Painter in Glass*, Dyfed: Gomer Press, 1992 p67; T*he Painter in Glass, Catalogue of Works*, Swansea Festival Exhibition, 1992, p14; *BSMGP*, Swash Caroline, 'The Painter in Glass', Spring/ Summer 1993, p16; Osborne, 1997, p126, inside front and back cover

Exhibited: *New British Glass & Vitrail Français Contemporain*, International Stained Glass Centre, Chartres, 1982; *John Piper painting in coloured light*, Kettle's Yard Gallery, Cambridge, 3 December 1982-9 January 1983, #7 (lent by the artist); *The Painter in Glass, Catalogue of Works*, Swansea Festival Exhibition, 1992, #43 (lent by the Artist's Estate)

Notes: The work was made specifically for the 1982 French exhibition with Spring and Summer above Autumn and Winter and was described in the catalogue as 'The Four Seasons represented as foliate heads, symbols of fertility and renewal of life'. Four foliate heads are combined in one panel with top left spring in greens and yellows; top right blue, red and green, joyful and summer-like; lower left autumnal red, grey and golden yellow; and lower right winter is shown in bleached yellow and green shades. The Victoria and Albert Museum considered purchasing this work in 1984, one letter describing the heads as 'painted in brilliant colours and are a further development of the Jack-in-the-Green theme which has interested him all his life'.

HEADS OF TWO KINGS (TWO HEADS)

Owner: Piper Estate

Date: 1954

Size: 56x71cm (28.5x22.5in)

Designer: John Piper

Literature: Harrison Martin, *Glass/Light*, The Royal Exchange, 1978, #35; Harrison, 1982, unpaginated; Compton Ann (Ed), *John Piper painting in coloured light*, Kettle's Yard Gallery, 1982, unpaginated; Reyntiens Patrick, 'Fawley in the Fifties', London, 1983; *John Piper*, The Tate Gallery, London, 30 November 1983-22 January 1984, p115; *The Painter in Glass, Catalogue of Works*, Swansea Festival Exhibition, 1992, p17; Osborne, 1997, p39-40, 171; Spalding, 2009, p351

Reproduced: West Anthony, *John Piper*, Secker & Warburg: London, 1979, fig 96; Lloyd Alison (Ed), *The Painter in Glass*, Dyfed: Gomer Press, 1992, p65; Osborne, 1997, p40

Exhibited: *A Small Anthology of Modern Stained Glass*, Aldeburgh Festival, The Arts Council of Great Britain, 1955, #15; *Glass/Light*, The Royal Exchange, London, 18 July-12 August 1978, #35; *Das Bild in Glas*, Hessisches Landesmuseum Darmstadt, 1979, #98; *John Piper painting in coloured light*, Kettle's Yard Gallery, Cambridge, 3 December 1982-9 January 1983, #1 (lent by the artist); *John Piper*, The Tate Gallery, London, 30 November 1983-22 January 1984, #116 (lent by Mrs John Piper); *The Painter in Glass, Catalogue of Works*, Swansea Festival Exhibition, 1992, #41 (lent by the Artist's Estate)

Film: Heckford Michael, *Crown of Glass*, Shell Film Unit, 1967

Notes: The panel was Piper's first design for stained glass and also marked the first collaboration between the two artists. Having been given some studies of heads by Piper, Reyntiens

worked in Eddie Nuttgens' studio and found his own method of interpreting the design – Reyntiens observed that 'the experience was so vivifying and beautiful that the drawing had to be interpreted into glass; love would find a way'. He returned with the finished panel six weeks later – the relationship the two men built up, that of painter and artist-interpreter, has possibly never been surpassed. The panel shows two crowned heads, one dark blue and yellow, the other red, pink and grey in a semi abstract style. The Tate catalogue notes that 'the technique of the glass is comparatively unrefined, with a variety of thicknesses'. Reyntiens observed that he 'found the technicalities demanded by Piper's presentation highly novel, but not intrinsically impossible. Perhaps it was the freshness and ingenious courage of youth that never considered for a moment that they were impossible' (Swansea Festival).

LIGHT AND DARK FORMS (MUSICIANS?)

Owner: Piper Estate

Designer: John Piper

Literature: Osborne, 1997, p178

STAINED GLASS COMPOSITION

Date: 1964

Size: 83.8x55.9cm (33x22in)

Designer: John Piper

Exhibited: *John Piper, Ceri Richards*, Marlborough Fine Art Ltd, London, April 1967, #70

STILL LIFE WITH CANDLE

Owner: Piper Estate

Designer: John Piper

Literature: Osborne, 1997, p179

NUDE

Date: c1960

Size: 118x35.5cm (46 3/8x14in)

Designer: Philip Sutton

Exhibited: *Modern Stained Glass*, Arts Council, London, 1960-1961, #17

Panels designed, painted and made by Patrick Reyntiens and photographs courtesy Reyntiens Trust (unless otherwise stated):

ABSTRACT 1

Owner: Reyntiens Trust

Size: 106.5x89.5cm (42x35 1/2in)

Literature: *Decorative Arts Society The, Omnium Gatherum*, Horner Libby, 'Patrick Reyntiens' Autonomous Panels. Myth, music and theatre', Journal 35, 2011, p69, 70

Reproduced: *Decorative Arts Society The, Omnium Gatherum*, Horner Libby, 'Patrick Reyntiens' Autonomous Panels. Myth, music and theatre', Journal 35, 2011, p69

Film: Mapleston Charles, Horner Libby, *From Coventry to Cochem, the Art of Patrick Reyntiens*, Reyntiens/Malachite, 2011

Notes: This is an abstract design with a red crescent on the left hand side, the remainder generally rectangular areas of black and white with small green and blue highlights.

ABSTRACT 2

Date: 1988

Inscription: signed b.l.: 'Reyntiens, 88'

Notes: This is a completely random multi-coloured panel with a bright yellow blob top left.

ARCHIMBOLDO

Owner: Reyntiens Trust

Date: 1970

Size: 74x58.5cm (29.1x23in)

Inscription: signed b.r.: 'Patrick Reyntiens 70'

Literature: *Decorative Arts Society The, Omnium Gatherum*, Horner Libby, 'Patrick Reyntiens' Autonomous Panels. Myth, music and theatre', Journal 35, 2011, p73

Reproduced: *Decorative Arts Society The, Omnium Gatherum*, Horner Libby, 'Patrick Reyntiens' Autonomous Panels. Myth, music and theatre', Journal 35, 2011, p72

Notes: This is a strange orange and yellow coloured face with two staring blue eyes and a punk haircut composed of ears of wheat, possibly inspired by the strange images by the Italian painter Giuseppe Archimboldo who created portraits from fruit and flowers – described by Reyntiens as advertisements for organic cooking. The artist produced a series of masks which are slightly African or Indian at a time when he considered he was not being treated fairly and they are perhaps a riposte, a scream against European 'civilisation'.

BECKETT'S BONES 2

Date: c1960

Exhibited: *Patrick Reyntiens*, The Arthur Jeffress Gallery, London, 10 January-27 January 1961, #12

Notes: This is related to the panel of the same name in the Victoria and Albert Museum, Royal Borough of Kensington and Chelsea.

BOSNIA-HERZEGOVINA

General: Reyntiens made five panels dedicated to those killed during the conflict which arose following the break-up of Yugoslavia. The war was territorial, with the Serb forces of the Army of Republika Srpska on one side and the Army of the Republic of Bosnia and Herzegovina (mainly Bosniaks) and the Croation Defence Council (Croats) on the other side. It is estimated that some 100,000-110,000 people died and a further 2.2 million were displaced between April 1992 and December 1995.

Literature: *BSMGP*, Corrin Adelle, 'Images of Myth and Love. An exhibition of stained glass panels by Patrick Reyntiens', Autumn/Winter 1994, p9

PIETA 1

Date: c1994

Exhibited: *Images of Myth and Love. Stained glass panels for the collector and the connoisseur, Patrick Reyntiens. Exhibition of stained glass*, Bernard Becker and Partners, Clerkenwell, London, 16 June – 1 September 1994, #22

PIETA 2

Date: c1994

Exhibited: *Images of Myth and Love. Stained glass panels for the collector and the connoisseur, Patrick Reyntiens. Exhibition of stained glass*, Bernard Becker and Partners, Clerkenwell, London, 16 June – 1 September 1994, #23

BRANAGH AS QUINCE

General: Reyntiens saw Kenneth Branagh acting the part of Peter Quince in *Midsummer Night's Dream*, in Toronto. Branagh was wearing large white Mickey Mouse gloves – and was gesticulating in a wonderfully expressive way which captivated the artist who was inspired to make two panels with different colour themes each consisting of twelve caricatures illustrating Branagh's magnificent miming. The Duke and Duchess of Athens appear in the top left panel, looking decidedly under impressed. The AISG website includes these panels under the heading *commedia dell'arte* series.

Literature: *Decorative Arts Society The, Omnium Gatherum*, Horner Libby, 'Patrick Reyntiens' Autonomous Panels. Myth, music and theatre', Journal 35, 2011, p79

Film: Mapleston Charles, Horner Libby, *From Coventry to Cochem, the Art of Patrick Reyntiens*, Reyntiens/Malachite, 2011

BRANAGH AS QUINCE 1

Owner: Reyntiens Trust

Date: 1990
Size: 71.1x63.5cm (28x25in)

Inscription: signed b.r.: 'Reyntiens 90' and titled b.l.: 'Tribute to Quince'

Literature: AISG, p58 (£12,468)

Reproduced: AISG, p58; *Decorative Arts Society The, Omnium Gatherum*, Horner Libby, 'Patrick Reyntiens' Autonomous Panels. Myth, music and theatre', Journal 35, 2011, p78

Exhibited: *Images of Myth and Love. Stained glass panels for the collector and the connoisseur, Patrick Reyntiens. Exhibition of stained glass*, Bernard Becker and Partners, Clerkenwell, London, 16 June – 1 September 1994, #10 (£2,000), titled *Twelve Quinces*

Notes: The background colours in this panel are yellow and orange.

BRANAGH AS QUINCE 2 (detail right)

Owner: Reyntiens Trust

Date: 1990

Size: 71.1x63.5cm (28x25in)

Inscription: signed 2nd panel bottom row: 'Reyntiens 90' and titled 1st panel bottom row: 'Tribute to Quince'

Literature: AISG p59 (£12,468)

Reproduced: AISG, p59

Exhibited: *Images of Myth and Love. Stained glass panels for the collector and the connoisseur, Patrick Reyntiens. Exhibition of stained glass*, Bernard Becker and Partners, Clerkenwell, London, 16 June – 1 September 1994, #11 (£2,000) titled *Twelve Quinces*

Notes: The background colours in this panel are blue-grey.

CIRCUS CHARACTERS AND COMMEDIA DELL'ARTE

General: In the 1960s Reyntiens created a series of circus panels which were exhibited at the Jeffress Gallery.

Exhibited: *Patrick Reyntiens*, The Arthur Jeffress Gallery, London, 10 January-27 January 1961, #3 (7 works entitled *Circus*) – unidentified

General: In 1990 Reyntiens made a further series of eight panels probably inspired in part by the acrobatic dances which formed part of the *commedia dell'arte*. *Commedia dell'arte* was born in Venice in the 16th century. Reyntiens amusingly compares the actors with those in *East Enders* – both are given a character for life. In the *BSMGP* 1991 article Reyntiens states that the *commedia* dates from Roman Times and the characters are of interest because they are a microcosm of life, and although the costumes may change the situations do not. Reyntiens made eight panels in the initial series, two of which were exhibited at the Becker Gallery. Williams notes that the lead line and the paint intermingle so easily that it is difficult to tell one from the other.

AN ACTOR DIES

Owner: Reyntiens Trust

Date: 1990

Size: 42.5x52.5cm (16.7x20.7in)

Inscription: signed b.r.: 'Reyntiens 90'

Literature: AISG, p61 £3,936)

Reproduced: AISG, p61

Notes: Pierrot collapses on the floor, raising an angry fist, his mask and hat on the boards foreground.

CHARACTER FROM COMMEDIA DELL'ARTE

Date: c1990

Notes: A man with a ruff round his neck touches his lips in contemplation.

CIRCUS 1

Owner: Reyntiens Trust

Date: c1990

Size: 71.1x71.1cm (28x28in) roundel

Literature: AISG, p67 (£13,965)

Reproduced: AISG, p67

Film: Mapleston Charles, Horner Libby, *From Coventry to Cochem, the Art of Patrick Reyntiens*, Reyntiens/Malachite, 2011

Notes: A sad panel with two acrobats throwing themselves up in horror following the fall and death of a trapeze artist.

Literature: *BSMPG*, Williams Rachel, 'Patrick Reyntiens', Spring 1991, p14; Neiswander Judith & Swash Caroline, *Stained & Art Glass*, London: The Intelligent Layman Publishers Ltd, 2005, p260; *Decorative Arts Society The, Omnium Gatherum*, Horner Libby, 'Patrick Reyntiens' Autonomous Panels. Myth, music and theatre', Journal 35, 2011, p79

Exhibited: *Images of Myth and Love. Stained glass panels for the collector and the connoisseur, Patrick Reyntiens. Exhibition of stained glass*, Bernard Becker and Partners, Clerkenwell, London, 16 June – 1 September 1994, #2, *Dance* (£3,000), #3 *A Difficult Feat* (£3,000), *Mexican Jugglers* (£3,000), all 70cm (27 1/2in) diameter, #19 *Endgame*, 43x53cm (17x21in) (£1,800) and #20 *Three Ages*, 43x53cm (17x21in) £1,800). Since the panels have been given different titles over the years I have been unable to identify these works. In the same exhibition #28 was described as *A Sketch-roundel, The Circus* (£500)

Above: *An Actor Dies*
Below: *Circus 1*
Opposite page (top to bottom): *Circus 2, Circus 3*, study for *Circus 3*

CIRCUS 2

Owner: Reyntiens Trust

Date: 1990

Size: 71.1x71.1cm (28x28in) roundel

Inscription: signed t.l.: 'Reyntiens 90'

Literature: AISG p68 (£13,965)

Reproduced: AISG, p68

Film: Mapleston Charles, Horner Libby, *From Coventry to Cochem, the Art of Patrick Reyntiens*, Reyntiens/Malachite, 2011

Notes: Rather in the manner of the Beggerstaff Brothers this shows a ringmaster centre with clowns and a prancing horse background.

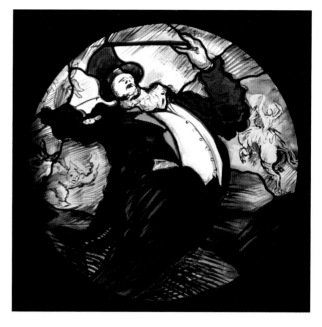

CIRCUS 3/BALANCING ACT

Owner: private collection

Date: c1990

Size: 71.1x71.1cm (28x28in) roundel

Study: Reyntiens Trust

Literature: AISG, p69 (£13,965)

Reproduced: AISG, p69

Exhibited: *Images of Myth and Love. Stained glass panels for the collector and the connoisseur, Patrick Reyntiens. Exhibition of stained glass*, Bernard Becker and Partners, Clerkenwell, 16 June – 1 September 1994, #1 (£3,000) – I believe this is the correct attribution.

Notes: A man centre holds up a child in each hand whilst an acrobat performs on his head.

CIRCUS 4/PIERROT SOLO

Owner: Reyntiens Trust

Date: 1990

Size: 71.1x71.1cm (28x28in) roundel

Inscription: signed b.r.: 'Reyntiens 90'

Literature: AISG, p70 (£13,965); *Decorative Arts Society The, Omnium Gatherum*, Horner Libby, 'Patrick Reyntiens' Autonomous Panels. Myth, music and theatre', Journal 35, 2011, p73

Reproduced: *BSMPG*, Williams Rachel, 'Patrick Reyntiens'', Stained Glass, Spring 1991, p15; BSMGP, Spring/Summer 1993, p18; *Country Life*, 'Living National Treasure: Artist in Glass', 2 June 1994, p59; AISG, p67; *Decorative Arts Society The, Omnium Gatherum*, Horner Libby, 'Patrick Reyntiens' Autonomous Panels. Myth, music and theatre', Journal 35, 2011, p73

Film: Mapleston Charles, Horner Libby, *From Coventry to Cochem, the Art of Patrick Reyntiens*, Reyntiens/Malachite, 2011

Exhibited: *Patrick Reyntiens. Theatre. Commedia Dell'Arte. Circus*, The Fine Art Society, London, 26 November-21 December 1990; *Images of Myth and Love. Stained glass panels for the collector and the connoisseur, Patrick Reyntiens. Exhibition of stained glass*, Bernard Becker and Partners, Clerkenwell, London, 16 June – 1 September 1994, #4 (£3,000) – I believe this is the correct attribution.

Notes: A Pierrot figure with a black mask appears to frighten a grey clad female right whose hair looks like it's had a few volts put through it.

CIRCUS 5

Date: 1990

Size: 71.1x71.1cm (28x28in) roundel

Inscription: signed b.l.: 'Reyntiens 90'

Literature: AISG, p71 (£13,965); *Decorative Arts Society The, Omnium Gatherum*, Horner Libby, 'Patrick Reyntiens' Autonomous Panels. Myth, music and theatre', Journal 35, 2011, p73

Reproduced: *BSMPG*, Williams Rachel, 'Patrick Reyntiens'', Stained Glass, Spring 1991, p15; AISG, p71; *Decorative Arts Society The, Omnium Gatherum*, Horner Libby, 'Patrick Reyntiens' Autonomous Panels. Myth, music and theatre', Journal 35, 2011, p73

Film: Mapleston Charles, Horner Libby, *From Coventry to Cochem, the Art of Patrick Reyntiens*, Reyntiens/Malachite, 2011

Exhibited: *Patrick Reyntiens. Theatre. Commedia Dell'Arte. Circus*, The Fine Art Society, London, 26 November-21 December 1990

Notes: A white clad Pantaloon left and a yellow clad harlequin centre bending over backwards whilst juggling a dish of glasses in one hand and another on his forehead. The harlequin figure is based on Reyntiens' son Dominick who trained as a dancer.

CIRCUS 6

Owner: Reyntiens Trust

Date: c1990

Size: 71.1x71.1cm (28x28in) roundel

Literature: AISG, p72 (£13,965)

Reproduced: *Spectator The*, Harrod Tanya, 'Talking about angels', 18/25 December 1993, p85; AISG, p72

Film: Mapleston Charles, Horner Libby, *From Coventry to Cochem, the Art of Patrick Reyntiens*, Reyntiens/Malachite, 2011

Notes: This roundel shows clowns busking with balloons – a white clad figure centre juggling a ball on his head whilst a pink figure juggles one on her toe left and a red strong man right clenches his fist.

CIRCUS 7

Owner: Reyntiens Trust

Date: c1990

Size: 71.1x71.1cm (28x28in) roundel

Literature: AISG, p73 (£13,965)

Reproduced: AISG, p73

Film: Mapleston Charles, Horner Libby, *From Coventry to Cochem, the Art of Patrick Reyntiens*, Reyntiens/Malachite, 2011

Notes: A delicately coloured, rather beautiful panel showing a clown in multi-coloured pastel shades dancing a jig.

CONFRONTATION

Owner: Reyntiens Trust

Date: 1990

Size: 42.5x48.5cm (16 3/4x20 3/4in)

Inscription: signed t.r.: 'Reyntiens 90'

Literature: AISG, p65 titled Surprise (£5,753)

Reproduced: AISG, p65

Film: Mapleston Charles, Horner Libby, *From Coventry to Cochem, the Art of Patrick Reyntiens*, Reyntiens/Malachite, 2011

Notes: Two clown characters grimacing at each other, the one on the right boasting wonderful purple patterned trousers.

Opposite page (top to bottom): *Circus 4, Circus 5, Circus 6*

This page (top to bottom): *Circus 7, Confrontation, End of the Comedy*

END OF THE COMEDY

Owner: Reyntiens Trust

Date: c1990

Size: 40.6x53.3cm (16x21in)

Literature: AISG, p62 (£3,420)

Reproduced: AISG, p62

Film: Mapleston Charles, Horner Libby, *From Coventry to Cochem, the Art of Patrick Reyntiens*, Reyntiens/Malachite, 2011

Notes: A white clad clown figure appears to be resting (dying) on a plush coloured couch.

GOODBYE PANTALOON

Date: 1989

Size: 43.2x33cm (17x13in)

Inscription: signed left of figure: 'Reyntiens 89'

Literature: AISG, p60 (£3,936)

Reproduced: AISG, p60

Notes: This shows pierrot kneeling, his hands outstretched, above him a fringed curtain.

Above: *Goodbye Pantaloon*
Right: *Gymnasts*

GYMNASTS

Owner: Reyntiens Trust

Date: 1989

Size: 114.3x51.4cm (45x20.25in), rounded top

Inscription: signed b.r.: 'Reyntiens 89'

Literature: *BSMPG*, Williams Rachel, 'Patrick Reyntiens', Spring 1991, p14

Reproduced: *BSMPG*, Williams Rachel, 'Patrick Reyntiens'', Spring 1991, p14

Exhibited: *Patrick Reyntiens. Theatre. Commedia Dell'Arte. Circus*, The Fine Art Society, London, 26 November-21 December 1990

Notes: Three gymnasts balance on top of one another, constructed in cream and beige colours. Reyntiens recalls making four such panels of which three were exhibited.

HARLEQUIN AND PIERROT

Date: c1990

Reproduced: Neiswander Judith & Swash Caroline, *Stained & Art Glass*, London: The Intelligent Layman Publishers Ltd, 2005, p265

Notes: Harlequin stands on one side with crossed arms, looking dreamy, Pierrot at his side, finger on lips.

HARLEQUIN, THE LOVER AND PANTALOON

Date: c1990

Notes: Harlequin stands left in very dandy pose, the lover (sans mask) in 18th century clothing standing to his right and looking equally exquisitely camp, whilst a grumpy old pantaloon leaning on stick stands right pointing a judgemental finger.

HERCULES AS HARLEQUIN

Owner: Reyntiens Trust

Date: 1987-1988

Size: 137.2x78.7cm (54x31in), oval portrait panel

Literature: Moor Andrew, *Contemporary Stained Glass. A Guide to the Potential of Modern Stained Glass in Architecture*, London, Mitchell Beazley International Ltd, 1989, p121; *Leadline 1990, Patrick Reyntiens & the Burleighfield Experience* , Goodden Ted (Ed), Moor Andrew, 'Introduction to the Recent Work of Patrick Reyntiens', 1990, p10; AISG, p20 (£29,818)

Reproduced: Moor Andrew, *Contemporary Stained Glass. A Guide to the Potential of Modern Stained Glass in Architecture*, London, Mitchell Beazley International Ltd, 1989, p121; *Leadline 1990, Patrick Reyntiens & the Burleighfield Experience*, Goodden Ted (Ed), 1990, p14; AISG, p20

Exhibited: *Retrospective Exhibition*, Ontario Crafts Council Gallery, Dundas St, Toronto (17 May – 30 June 1990); *Images of Myth and Love. Stained glass panels for the collector and the connoisseur, Patrick Reyntiens. Exhibition of stained glass*, Bernard Becker and Partners, Clerkenwell, London, 16 June – 1 September 1994, #18 (£6,000). Size quoted as 117x72cm.

Notes: Hercules, seen against a bright abstract background, is a rather dejected looking big beefy figure, parts of his body nude, parts in harlequin costume. Moor astutely observes that 'Reyntiens defies literalism, leaving the viewer to find method in his madness and to patiently wait for the image to assume clarity'. He also notes that many of the pieces of glass in Reyntiens' panels are painted and fired twice to 'achieve different densities of colour'. The AISG website categorises the work as Greek mythology.

PHILOSOPHICAL DISPUTE (#3 of original *commedia dell'arte* series)

Owner: private collection

Date: 1990

Size: 40.6x53.3cm (16x21in)

Reproduced: *BSMPG*, Williams Rachel, 'Patrick Reyntiens', Spring 1991, p14; *BSMGP*, Autumn/Winter 1994, p1; *Country Life*, 'Living National Treasure: Artist in Glass', 2 June 1994, p36; postcard

Exhibited: *Patrick Reyntiens. Theatre. Commedia Dell'Arte. Circus*, The Fine Art Society, London, 26 November-21 December 1990 (sold for £2,600)

Notes: This panel shows two clowns in identical costumes, one lifting his finger towards a sparking light bulb, the other looking grievously concerned.

TOTENTANZ (DEATH DANCE)

Owner: private collection

Date: c1990

Inscription: signed b.r.

Reproduced: *Patrick Reyntiens. Theatre. Commedia Dell'Arte. Circus*, The Fine Art Society, 26 November-21 December 1990; *Stained Glass*, Spring 1995, Volume 90, Number 1, Coombs Debora 'British Stained Glass', p20

Film: Mapleston Charles, Horner Libby, *From Coventry to Cochem, the Art of Patrick Reyntiens*, Reyntiens/Malachite, 2011

Exhibited: *Patrick Reyntiens. Theatre. Commedia Dell'Arte. Circus*, The Fine Art Society, London, 26 November-21 December 1990 (sold for £2,600)

Notes: An orange clad clown figure with a mauve hat appears to dance a jig over a green sword shape. The background is red.

Above: *Hercules as Harlequin*

Below: *Trippin' off the Boards*

TRIPPIN' OFF THE BOARDS

Owner: Reyntiens Trust

Date: 1989-1990

Size: 42.5x34.3cm (16.7x13.5in)

Inscription: signed b.r.: 'Reyntiens 89-90'

Literature: AISG, p63 (£3,936)

Reproduced: AISG, p63; *Decorative Arts Society The, Omnium Gatherum*, Horner Libby, 'Patrick Reyntiens' Autonomous Panels. Myth, music and theatre', Journal 35, 2011, p79

Notes: The panel shows pierrot sneaking stealthily off the stage with the faces of the audience in the background.

CONFRONTATION

General: One wonders what was happening in Reyntiens' private life at this time to occasion these violent panels where the clashing and aggressive colours mirror the antagonism.

Literature: *Decorative Arts Society The, Omnium Gatherum*, Horner Libby, 'Patrick Reyntiens' Autonomous Panels. Myth, music and theatre', Journal 35, 2011, p70

CONFRONTATION 1

Owner: Reyntiens Trust

Date: 1992

Size: 48.3x43.2cm (19x17in)

Inscription: signed t.l.: 'Reyntiens 92'

Literature: AISG, p25 (£5,753)

Reproduced: AISG, p25

Notes: The panel shows the back of a pale yellow figure left with arm upraised facing larger brown man right with arm descending, against a pink, yellow and light red background.

CONFRONTATION 2

Owner: Reyntiens Trust

Date: 1991

Size: 48.3x43.2cm (19x17in)

Inscription: signed l.h.s.: 'Reyntiens 91'

Literature: AISG, p26 (£5,753)

Reproduced: AISG, p26

Notes: A larger yellow figure descends on to a smaller red figure against a cream and green background. There is an almost hallucinatory feel as if the protagonists are falling down a deep void.

CONFRONTATION 3

Owner: Reyntiens Trust

Date: 1992

Size: 48.3x43.2cm (19x17in)

Inscription: signed b.l.: 'Reyntiens 92'

Literature: AISG, p27 (£5,753)

Reproduced: AISG, p27

Notes: This shows a large green running figure against a red, green and brown background.

CONFRONTATION 4

Owner: Reyntiens Trust

Date: 1992

Size: 48.3x43.2cm (19x17in)

Inscription: signed b.c.: 'Reyntiens 92'

Literature: AISG, p28 (£5,753)

Reproduced: AISG, p28; *Decorative Arts Society The, Omnium Gatherum*, Horner Libby, 'Patrick Reyntiens' Autonomous Panels. Myth, music and theatre', Journal 35, 2011, p70, 71

Notes: A forceful image in which a blue man lifts a green figure against a yellow and white background.

CONFRONTATION 5

Owner: Reyntiens Trust

Date: c1992

Size: 48.3x43.2cm (19x17in)

Literature: AISG, p29 (£5,753)

Reproduced: AISG, p29

Notes: Less dramatic than the other Confrontation panels, two pugilists face each other against a background of abstract brown and cream colours.

Oppoisite page: *Confrontation 1*

Above left: *Confrontation 2*

Above right: *Confrontation 3*

Below left: *Confrontation 4*

Below right: *Confrontation 5*

EROTICA

General: Reyntiens explains the panels thus: 'I was a married man, and my wife and I had what they now call global warming for 54 years. It occurred to me that stained glass had a silly reputation of being entirely ecclesiastical', so he decided to change all that in his own inimitable style. However he only produced about eight of these panels because he didn't like flesh tones in glass. The AISG website categorises the works as *Erotica Palestra* and describes them as 'Celebrations of Concupiscence'.

Exhibited: *Images of Myth and Love. Stained glass panels for the collector and the connoisseur, Patrick Reyntiens. Exhibition of stained glass*, Bernard Becker and Partners, Clerkenwell, London, 16 June – 1 September 1994, #30, 31, 32, 33 (each £400), described as expressing the nude in stained glass. I have been unable to identify which panels were exhibited.

Film: Mapleston Charles, Horner Libby, *From Coventry to Cochem, the Art of Patrick Reyntiens*, Reyntiens/Malachite, 2011

EROTICA 1

Size: 45.7x38.1cm (18x15in), portrait oval panel

Literature: AISG, p77 (£4,809)

Reproduced: AISG, p77

Notes: This shows a standing copulating couple, her red hair engulfing the pair.

EROTICA 2

Size: 45.7x38.1cm (18x15in), portrait oval panel

Literature: AISG, p78 (£4,809)

Reproduced: AISG, p78

Notes: This shows a copulating couple, the man holding on to a tree, the woman with flowing red hair.

EROTICA 3

Owner: Reyntiens Trust

Size: 45.7x38.1cm (18x15in), portrait oval panel

Literature: AISG, p79 (£4,809)

Reproduced: AISG, p79

Notes: The panel shows a copulating couple in a frenzy of limbs.

From top to bottom: *Erotica 1, Erotica 2, Erotica 3*

EXPULSION – A STUDY

Exhibited: *Patrick Reyntiens*, The Arthur Jeffress Gallery, London, 10 January-27 January 1961, #14

FIGURE STUDY 1

Exhibited: *Images of Myth and Love. Stained glass panels for the collector and the connoisseur, Patrick Reyntiens. Exhibition of stained glass*, Bernard Becker and Partners, Clerkenwell, London, 16 June – 1 September 1994, #27 (£600)

FIGURE STUDY 2

Exhibited: *Images of Myth and Love. Stained glass panels for the collector and the connoisseur, Patrick Reyntiens. Exhibition of stained glass*, Bernard Becker and Partners, Clerkenwell, London, 16 June – 1 September 1994, #29 (no price listed)

FLORALIA 1

Exhibited: *Patrick Reyntiens*, The Arthur Jeffress Gallery, London, 10 January-27 January 1961, #8

FLORALIA 2

Exhibited: *Patrick Reyntiens*, The Arthur Jeffress Gallery, London, 10 January-27 January 1961, #9

GREECE AND ROME – WRITERS AND MYTHOLOGY

ARGONAUTS

Exhibited: *Patrick Reyntiens*, The Arthur Jeffress Gallery, London, 10 January-27 January 1961, #4

Notes: In Greek mythology the Argonauts accompanied Jason in his quest to find the Golden Fleece. Their vessel was called the Argo named after its builder, Argus.

CATULLUS

General: The poet Gaius Valerius Catullus wrote serious condolences as well as satirical works about friends, politicians and enemies, and erotic poems featuring homosexual activities and his love for a woman he named 'Lesbia'.

Exhibited: I*mages of Myth and Love. Stained glass panels for the collector and the connoisseur, Patrick Reyntiens. Exhibition of stained glass*, Bernard Becker and Partners, Clerkenwell, London, 16 June – 1 September 1994, #26 (£600) titled *From Catullus*. I have been unable to identify which work this is.

CATULLAN DRINKING BOUT

Owner: private collection

Date: c1991

Notes: This shows three figures lounging on couches in the midst of a long liquid session!

TRIBUTE TO CATULLUS

Owner: Reyntiens Trust

Date: 1991

Size: 27x44cm (10 1/2x17 1/4in) irregular shape

Inscription: signed and dated b.l.: 'Reyntiens 91', 'Tribute to Catullus'

Literature: AISG, p23 (£3,154)

Reproduced: AISG, p23

Notes: This shows a rather self-satisfied looking, pale and paunchy woman being propositioned by a muscled tanned figure right.

Below: *Tribute to Catullus*

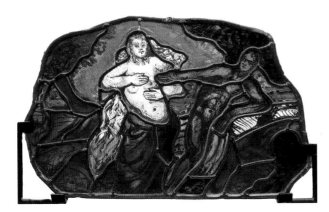

GREEK ANTHOLOGY

Date: 1985-1986

Reproduced: *Leadline 1990, Patrick Reyntiens & the Burleighfield Experience*, Goodden Ted (Ed), 1990, p11

Exhibited: *Retrospective Exhibition*, Ontario Crafts Council Gallery, Dundas St, Toronto (17 May – 30 June 1990)

Notes: Various semi clad figures can be seen lounging on couches.

TWO RECLINING WOMEN

Literature: *Leadline 1990, Patrick Reyntiens & the Burleighfield Experience*, Goodden Ted (Ed), Moor Andrew, 'Introduction to the Recent Work of Patrick Reyntiens', 1990, p9

Exhibited: *Retrospective Exhibition*, Ontario Crafts Council Gallery, Dundas St, Toronto (17 May – 30 June 1990)

HERCULES AND ANTAEUS

General: Reyntiens made eight panels relating to the struggle between Hercules (Greek name Heracles) and Antaeus. Antaeus was the son of Gaia of the Earth from which he drew his strength, but Hercules was advised by Athene to lift Antaeus away from the earth at which point he would lose his strength. Moor notes that the back of Hercules is prominent, drawing the viewer into the contest, and wonders whether Jacob's wrestling with the Angel is a Biblical parallel.

Literature: *Leadline 1990, Patrick Reyntiens & the Burleighfield Experience*, Goodden Ted (Ed), Moor Andrew, 'Introduction to the Recent Work of Patrick Reyntiens', 1990, p9

HERCULES AND ANTAEUS 1

Size: 35.6x30.5cm (14x12in)

Reproduced: *Leadline 1990, Patrick Reyntiens & the Burleighfield Experience*, Goodden Ted (Ed), 1990, p12

Exhibited: *Retrospective Exhibition*, Ontario Crafts Council Gallery, Dundas St, Toronto (17 May – 30 June 1990)

Notes: The large dark brooding shape of Antaeus stands in the foreground with the golden figure of Hercules in the background, apparently leaning on a pole.

HERCULES AND ANTAEUS 2 (STRUGGLE BEGINS)

Size: 35.6x30.5cm (14x12in)

Reproduced: *Leadline 1990, Patrick Reyntiens & the Burleighfield Experience*, Goodden Ted (Ed), 1990, p12

Exhibited: *Retrospective Exhibition*, Ontario Crafts Council Gallery, Dundas St, Toronto (17 May – 30 June 1990)

Notes: Antaeus in the foreground seems to be limbering up whilst in the background we see the golden back of Hercules.

HERCULES AND ANTAEUS 3 (FIRST HOLD)

Owner: Reyntiens Trust

Size: 35.6x30.5cm (14x12in)

Reproduced: *Leadline 1990, Patrick Reyntiens & the Burleighfield Experience*, Goodden Ted (Ed), 1990, p12

Exhibited: *Retrospective Exhibition*, Ontario Crafts Council Gallery, Dundas St, Toronto (17 May – 30 June 1990)

Notes: This shows Hercules quite easily lifting the giant Antaeus over his shoulder. The tan body of the nude god contrasts with the dark brown of the giant and an apple green background.

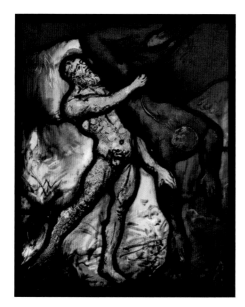

Above: *Hercules and Antaeus 3*
Below: *Hercules and Antaeus 4 or 5*

HERCULES AND ANTAEUS (4 or 5)

Owner: Reyntiens Trust

Size: 35.6x30.5cm (14x12in)

Exhibited: *Retrospective Exhibition*, Ontario Crafts Council Gallery, Dundas St, Toronto (17 May – 30 June 1990)

Notes: Hercules appears to be in the act of lifting the large dark brown body of Antaeus from the ground against a background of abstract greens and browns.

HERCULES AND ANTAEUS 6 (TRIUMPH BEGINS)

Size: 35.6x30.5cm (14x12in)

Reproduced: *Leadline 1990, Patrick Reyntiens & the Burleighfield Experience*, Goodden Ted (Ed), 1990, p13

Exhibited: *Retrospective Exhibition*, Ontario Crafts Council Gallery, Dundas St, Toronto (17 May – 30 June 1990)

Notes: Hercules stands, legs apart, with the body of Antaeus raised on his arms above his head.

HERCULES AND ANTAEUS 7 (TRIUMPH SUSTAINED)

Size: 35.6x30.5cm (14x12in)

Reproduced: *Leadline 1990, Patrick Reyntiens & the Burleighfield Experience*, Goodden Ted (Ed), 1990, p13

Exhibited: *Retrospective Exhibition*, Ontario Crafts Council Gallery, Dundas St, Toronto (17 May – 30 June 1990)

Notes: Hercules is on his knees with the body of Antaeus raised above his head.

HERCULES AND ANTAEUS 8 (CLOSURE)

Size: 35.6x30.5cm (14x12in)

Literature: *Leadline 1990, Patrick Reyntiens & the Burleighfield Experience*, Goodden Ted (Ed), 'Preface', 1990, p1; *Leadline 1990, Patrick Reyntiens & the Burleighfield Experience*, Goodden Ted (Ed), Moor Andrew, 'Introduction to the Recent Work of Patrick Reyntiens', 1990, p9

Reproduced: *Leadline 1990, Patrick Reyntiens & the Burleighfield Experience*, Goodden Ted (Ed), 1990, p13

Exhibited: *Retrospective Exhibition*, Ontario Crafts Council Gallery, Dundas St, Toronto (17 May – 30 June 1990)

Notes: Antaeus has disappeared into the earth and Hercules stands, back to the viewer, in the shade of a tree with a beautiful landscape in the background.

HERCULES AND DEIANEIRA

Notes: Hercules was married to Deianeira. The couple lived in Calydon for a few years, but when Hercules killed a local boy by mistake, they were forced to leave. When they reached the Euenus river they met the Centaur Nessus who tried to rape the beautiful Deianeira after he had carried her across the river, but Hercules killed Nessus with an arrow which had been dipped in the blood of the Hydra. Moor notes the speed of the brushwork which heightens the sense of drama. He continues: 'The figures are moving – there is the electrifying tension of an interrupted narrative, of colour and form in arrested motion, full of ambiguity.' Reyntiens describes the panels as neo-classical and explains that he wanted to gain a depth of colour with an unusual harmonic. He considers a male body as 'like a sunset made of different shapes and sizes and different light and shade' and a female body as 'sunrise, of utter beautiful peace and unity'.

Literature: *Leadline 1990, Patrick Reyntiens & the Burleighfield Experience*, Goodden Ted (Ed), Moor Andrew, 'Introduction to the Recent Work of Patrick Reyntiens', 1990, p10

Exhibited: *Retrospective Exhibition*, Ontario Crafts Council Gallery, Dundas St, Toronto (17 May – 30 June 1990) It is not known which of the two panels was exhibited; *Images of Myth and*

Love. Stained glass panels for the collector and the connoisseur, Patrick Reyntiens. Exhibition of stained glass, Bernard Becker and Partners, Clerkenwell, London, 16 June – 1 September 1994, #9 (£5,000), titled *Hercules and Deianeira*. It is not known which of the two panels was exhibited

HERCULES AND DEIANEIRA 1

Owner: Reyntiens Trust

Size: 61x101.6cm (24x40in), oval landscape panel with hand-gilded frame and verd Antique base

Literature: AISG, p32 (£30,780)

Reproduced: AISG, p32

Notes: This panel is taken from Deianeira's point of view – she sees her husband on the other bank of the river.

HERCULES AND DEIANEIRA 2

Owner: Reyntiens Trust

Size: 61x101.6cm (24x40in), oval landscape panel with hand-gilded frame and verd Antique Base

Literature: Moor Andrew, *Architectural Glass Art. Form and technique in contemporary glass*, London: Mitchell Beazley, 1997, p131; *AISG*, p31 (£30,780)

Reproduced: Moor Andrew, *Architectural Glass Art. Form and technique in contemporary glass*, London: Mitchell Beazley, 1997, p131; *AISG*, p31

Notes: This panel is taken from the point of view of Hercules – he can see Nessus and his wife on the other side of the river. Heracles aims his bow and arrow, the Centaur is collapsing from the blow of the arrow whilst Deianeira falls from his grasp. Moor titles the work *Ulysses*, and notes that Reyntiens' 'lyrical style makes the lead work seem completely integral to the image'.

HERCULES' TWELVE LABOURS

General: Hercules was the son of Zeus, an abiding symbol of masculinity, strength and sexuality. Unfortunately he killed his own children and in order to expiate this sin he had to carry out ten labours. Because he was paid for cleaning the stables and his nephew helped him battle the Hydra, Hercules was set a further two tests, which he successfully accomplished, thereby gaining not only immortality but also Hebe as his wife. Having painted the fine figure of Sean Connery whilst at Edinburgh College of Art, Reyntiens started practising body building and became fascinated by the human body, which may perhaps explain his preoccupation with the nude muscular Hercules in these panels.

Literature: *Decorative Arts Society The, Omnium Gatherum*, Horner Libby, 'Patrick Reyntiens' Autonomous Panels. Myth, music and theatre', Journal 35, 2011, p75

SLAYING THE NEMEAN LION

Owner: Reyntiens Trust

Size: 43.2x38.1cm (17x15in)

Literature: AISG, p46 titled *Nemean Lion* (£4,542)

Reproduced: AISG, p46

Notes: The first Labour of Hercules was to slay the Nemean Lion. The panel shows Hercules strangling the lion in its cave, having discovered that the skin was magically impenetrable. The lion is a rather comical looking character and Reyntiens himself describes him as a 'pussy cat'. Hercules wore the lion skin thereafter as protection.

HERCULES AND THE LERNAEAN HYDRA

Owner: Reyntiens Trust

Size: 43.2x38.1cm (17x15in)

Literature: AISG, p47 titled *Lernaean Hydra* (£4,542)

Reproduced: *AISG*, p47
Notes: The second labour was to slay the nine-headed Lernaean Hydra. The nude Hercules on the right with a large bow takes aim at a blue coloured Hydra, whilst in the background his nephew Iolaus prepares to burn the stumps of the heads to prevent them growing back.

Above: *Hercules and Deianeira 1*
Above right: *Hercules and Deianeira 2*

ARCADIAN STAG

Owner: Reyntiens Trust

Size: 43.2x38.1cm (17x15in)
Literature: AISG, p48 titled *Golden Horned Stag* (£4,542)

Reproduced: AISG, p48

Notes: The third of Hercules' labours was to capture the Golden Hind of Artemis. The panel shows Hercules in the background with his trusty bow, the stag foreground with two large golden antlers.

CAPTURE OF ERYMANTHIAN BOAR

Owner: Reyntiens Trust

Date: 1990

Size: 43.2x38.1cm (17x15in)

Inscription: signed t.l.: 'Reyntiens 90'

Literature: AISG, p49 titled *Erymanthian Boar* (£4,542)

Reproduced: AISG, p49

Notes: The fourth labour was to capture the Erymanthian Boar. The only way to capture the huge ugly rearing red boar was to drive it into snow which is probably symbolised by the pale abstract background to this panel. Hercules can be seen in the background.

Clockwise from below: *Labours of Hercules 1, 2, 3 4*

HERCULES AND THE AUGEAN STABLES

Owner: Reyntiens Trust

Size: 43.2x38.1cm (17x15in)

Inscription: signed t.l.

Literature: AISG, p50 titled Augean Stables (£4,542)

Reproduced: AISG, p50

Notes: The fifth labour entailed cleaning the Augean stables in a single day. This was an humiliating task since the animals produced a lot of dung and the stables hadn't been cleaned for 30 years. Hercules diverted two rivers and succeeded in completing the task. The panel shows the rivers and Hercules in his lion skin.

STYMPHALIAN BIRDS

Owner: Reyntiens Trust

Size: 43.2x38.1cm (17x15in)

Literature: AISG, p51 (£4,542)

Reproduced: AISG, p51

Notes: The sixth labour was to slay the Stymphalian Birds. The birds were reputed to have bronze beaks and metallic feathers and were man-eaters. Hercules destroyed the birds by using loud clappers and then shooting them as they flew away. Hercules is seen here, muscles bulging, holding his bow whilst innocuous looking birds swirl around in the background.

CRETAN BULL

Owner: Reyntiens Trust

Date: 1989-1990

Size: 43.2x38.1cm (17x15in)

Inscription: signed b.c.: 'Reyntiens 90'

Literature: AISG, p52 £4,542); *Decorative Arts Society The, Omnium Gatherum*, Horner Libby, 'Patrick Reyntiens' Autonomous Panels. Myth, music and theatre', Journal 35, 2011, p76

Reproduced: Neiswander Judith & Swash Caroline, *Stained & Art Glass*, London: The Intelligent Layman Publishers Ltd, 2005, p264; AISG, p52; *Decorative Arts Society The, Omnium Gatherum*, Horner Libby, 'Patrick Reyntiens' Autonomous Panels. Myth, music and theatre', Journal 35, 2011, p75

Notes: The seventh labour involved capturing the Cretan Bull which Hercules strangled. This panel shows a back view of Hercules, his massive shoulders bearing the weight of the huge bull whose head and horns are seen on the left. The figure was based on the beautiful back of Ben Johnson, the discredited Olympic sprinter.

Opposite page (top to bottom): *Hercules and the Augean Stables, Stymphalian Birds, Cretan Bull*

This page (top to bottom): *Hercules and the Mares of Diomedes, Girdle of Hippolyta, Capture of the Oxen of Geryon*

HERCULES AND THE MARES OF DIOMEDES

Owner: Reyntiens Trust

Size: 43.2x38.1cm (17x15in)

Literature: AISG, p53 (£4,542)

Reproduced: AISG, p53

Notes: The eighth labour of Hercules was to steal the Mares of Diomedes, wild horses fed on human flesh. Two large horses rear up in the foreground, one white and one black, with the small figure of Hercules in the background.

GIRDLE OF HIPPOLYTA

Owner: Reyntiens Trust

Size: 43.2x38.1cm (17x15in)

Literature: AISG, p54 (£4,542)

Reproduced: AISG, p54

Film: Pow Rebecca, *Rather Good at Blue. A Portrait of Patrick Reyntiens*, HTV West, 2000

Notes: The ninth labour was to obtain the girdle of Hippolyta, Queen of the Amazons. A bronzed Hercules with a long snake of blue round his body (presumably the girdle) is pictured fleeing the banshee like Amazons.

CAPTURE OF THE OXEN OF GERYON

Owner: Reyntiens Trust

Size: 43.2x38.1cm (17x15in)

Literature: AISG, p55 (£4,542)

Reproduced: AISG, p55

Notes: The tenth labour involved obtaining the cattle of the monster Geryon, a many headed winged giant, which is seen here dwarfing Hercules in size. In the foreground Hercules is busy rounding up the famous red cattle. The monster was killed by an arrow dipped in the blood of the Lernaean Hydra.

STEALING THE GOLDEN APPLES OF THE HESPERIDES

Owner: Reyntiens Trust

Size: 43.2x38.1cm (17x15in)

Literature: AISG, p56 (£4,542)

Reproduced: AISG, p56

Notes: The eleventh Labour of Hercules involved stealing the golden apples of the Hesperides. Hercules is portrayed running towards the golden apples which offer immortality, his way blocked by the dragon Ladon.

CAPTURE OF CERBERUS

Owner: Reyntiens Trust

Size: 43.2x38.1cm (17x15in)

Inscription: signed t.l.

Literature: *Artists in Stained Glass, Patrick Reyntiens Individual Glass Panels*, 7 November 2008, http://www.aisg.on.ca, p57 (£4,542)

Reproduced: *Artists in Stained Glass, Patrick Reyntiens Individual Glass Panels*, 7 November 2008, http://www.aisg.on.ca, p57

Notes: The twelfth and last labour was to capture and bring back Cerberus, a three headed dog which guarded the underworld. Hercules had to achieve this feat without the use of weapons and the ever strong god succeeded in throwing the beast over his shoulders. In this panel Hercules is barely visible beneath the huge animal, one of the snarling heads almost jumping out of the frame. The darkness surrounding Hercules is the underworld and the yellow patches at the top of the panel symbolise the world outside.

Above (top to bottom): *Stealing the Golden Apples of the Hesperides, Capture of Cerberus*

Opposite page left: *Niobe's Daughters Killed by Artemis*

Opposite page right: *Biobe's Sons Killed by Apollo*

HOMER'S ILIAD AND ODYSSEY

General: The *Iliad* and its sequel the *Odyssey* are epic poems written about 8BC and attributed to Homer. The *Iliad* tells the story of the ten year siege of Troy (Ilium) by a coalition of Greek states, the conflicts between King Agamemnon and the warrior Achilles, includes Greek legends and foretells the future. The *Odyssey* deals with the adventures faced by the King of Ithaca, Odysseus (Roman Ulysses) on his return home after the wars. It took him ten years to reach Ithaca.

ILIUM

Exhibited: *Patrick Reyntiens*, The Arthur Jeffress Gallery, London, 10 January-27 January 1961, #10

NIOBE'S DAUGHTERS KILLED BY ARTEMIS

Date: 1984

Size: 51.2x82cm (20 1/4x32 1/4in) lunette

Inscription: signed b.r.: 'Reyntiens 84'

Literature: AISG, p44 titled *Appollo [sic] slaying the daughters of Niobe 2* (£10,651)

Reproduced: *Patrick Reyntiens, Glass Painted and Stained, Visions in Light*, Bruton Gallery, 1985, p13; Neiswander Judith & Swash Caroline, *Stained & Art Glass*, London: The Intelligent Layman Publishers Ltd, 2005, p262-263; AISG, p44

Exhibited: *Patrick Reyntiens, Glass Painted and Stained, Visions in Light*, Bruton Gallery, Bruton, Somerset, 1985, #6

Notes: Niobe had seven sons and seven daughters (the Niobids) and made the mistake of boasting to Leto who only had the twins Apollo and Artemis. The twins took their revenge by killing the Niobids. According to the Bridgeman Art Library there may be two copies of this work. With her daughters dying around her, Niobe looks up to the left where Artemis can be seen killing the children with poisoned arrows. The colours are generally blues and purples apart from the yellow nimbus surrounding Artemis.

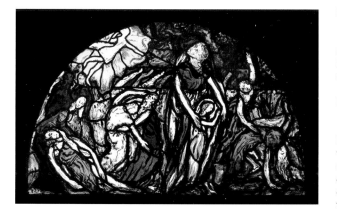

NIOBE'S SONS KILLED BY APOLLO

Owner: Reyntiens Trust

Date: 1984

Size: 51.2x82cm (20 1/4x32 1/4in) acided, stained and painted glass in lead, lunette

Literature: AISG, p43 titled *Appollo [sic] slaying the sons of Niobe 1* (£10,651)

Reproduced: *Patrick Reyntiens, Glass Painted and Stained, Visions in Light*, Bruton Gallery, 1985, p12; AISG, p43; *Register of Artists and Craftsmen in Architecture, Patrick Reyntiens*, undated

Exhibited: *Patrick Reyntiens, Glass Painted and Stained, Visions in Light*, Bruton Gallery, Bruton, Somerset, 1985, #5

Notes: Apollo killed the sons while they were practising athletics. Various nude lean men are seen falling off horses and the colours are generally shades of brown and yellow.

ULYSSES AND CIRCE

Size: 73cm (28 3/4in) roundel

Reproduced: *Patrick Reyntiens, Glass Painted and Stained, Visions in Light*, Bruton Gallery, 1985, p22, 23; *Green Book The, A Quarterly Review of the Visual and Literary Arts*, Grimshaw Rosalind, 'Patrick Reyntiens. Visions of Classical Life. Metamorphoses', Autumn 1985, p10; *BSMGP*, 'current events', Spring/Summer 1993, p6

Exhibited: *Patrick Reyntiens, Glass Painted and Stained, Visions in Light*, Bruton Gallery, Bruton, Somerset, 1985, #14

Notes: Arriving at Circe's shores, some of Ulysses' companions went up to the house where they were greeted kindly and given a magic potion which turned them into wild animals. Luckily one of the party had refused the potion and told Ulysses who quickly despatched himself to the house, refused to drink the potion and threatened Circe with his sword. The couple took each other's right hands as a pledge of good faith and Ulysses requested the return of his companions. The roundel shows Ulysses and Circe clasping hands, whilst on the left her handmaidens mix herbs for the powerful potion and on the right are the wild animals, mainly pigs. There are beautiful blue tones throughout.

ULYSSES AND THE CYCLOPS

Owner: Reyntiens Trust

Size: 68.5x60cm (27x23 1/2in)

Literature: AISG, p40 (£10,651)

Reproduced: *Patrick Reyntiens, Glass Painted and Stained, Visions in Light*, Bruton Gallery, 1985, p19; AISG, p40

Exhibited: *Patrick Reyntiens, Glass Painted and Stained, Visions in Light*, Bruton Gallery, Bruton, Somerset, 1985, #11

Notes: On his return home to Ithaca after the Trojan war, Ulysses and his companions visited the Lotus Eaters and were captured by the Cyclops Polyphemus. They escaped by driving a stake into his eye, which is what is depicted here, a group of men dwarfed by the size of the Cyclops, ramming a pole into the top of his head, whilst the Cyclops' flock of sheep curl up contentedly around the action.

ORPHEUS

General: Reyntiens produced three panels, forming a triptych, illustrating the life of Orpheus who was a musician, poet and prophet in Greek mythology. He was reputed to be able to charm all living things with his music.

ORPHEUS AND THE ANIMALS

Owner: Reyntiens Trust

Size: 91.4x53.3cm (36x21in), panel with rounded top

Literature: AISG, p38

Reproduced: AISG, p38

Exhibited: *Images of Myth and Love. Stained glass panels for the collector and the connoisseur, Patrick Reyntiens. Exhibition of stained glass*, Bernard Becker and Partners, Clerkenwell, London, 16 June – 1 September 1994, #16 (£4,000) titled *He Charms the Animals*

Notes: The panel shows a tiny figure of Orpheus playing his golden lyre and charming the animals in a hilly landscape, the foreground being full of various beasties.

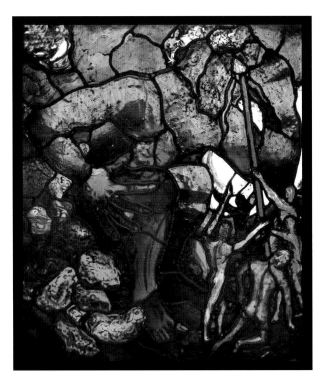

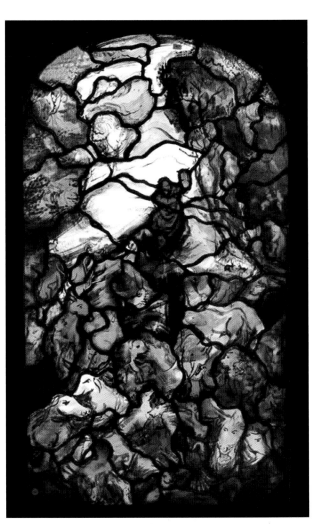

Above: *Ulysses and the Cyclops*

Right: *Orpheus and the Animals*

Opposite page left: *Orpheus Charming the Trees*

Opposite page right: *Death of Orpheus*

ORPHEUS CHARMING THE TREES

Owner: Dominick Reyntiens

Date: 1984

Size: 80x44.2cm (31 1/2x17 1/4in), stained, acided and painted glass panel with rounded top

Literature: AISG, p36

Reproduced: *Patrick Reyntiens, Glass Painted and Stained, Visions in Light*, Bruton Gallery, 1985, p7, 8, back cover; Reyntiens Patrick, *The Beauty of Stained Glass*, London: Herbert Press, 1990, front cover, p211; *Stained Glass*, Winter 1994, Volume 89, Number 4, '1994 Excellence in Education Awards', p276; *Register of Artists and Craftsmen in Architecture, Patrick Reyntiens*, undated; AISG, p36

Exhibited: *Patrick Reyntiens, Glass Painted and Stained, Visions in Light*, Bruton Gallery, Bruton, Somerset, 1985, #1; *Images of Myth and Love. Stained glass panels for the collector and the connoisseur, Patrick Reyntiens. Exhibition of stained glass*, Bernard Becker and Partners, Clerkenwell, London, 16 June – 1 September 1994, #14 (£3,000) titled *He Charms the Trees*

Notes: The small red clad figure of Orpheus, playing his golden lyre, is almost swamped in a green ravine of trees. The red figure is another example of Reyntiens adding 'la tache' – a spot of completely different colour for no particular reason.

DEATH OF ORPHEUS (ORPHEUS TORN TO PIECES BY MAENADS)

Owner: Reyntiens Trust

Date: 1984

Size: 91.4x71.1cm (36x28in), panel with rounded top

Literature: AISG, p37 titled *Death of Orpheus* (£17,955)

Reproduced: *Stained Glass*, Winter 1994, Volume 89, Number 4, '1994 Excellence in Education Awards', p276; AISG, p37

Exhibited: *Images of Myth and Love. Stained glass panels for the collector and the connoisseur, Patrick Reyntiens. Exhibition of stained glass*, Bernard Becker and Partners, Clerkenwell, London, 16 June – 1 September 1994, #15 (£7,000) titled *He is torn to pieces by Maenads*

Notes: A rather confusing panel heaving with figures against a background of big mauve coloured hills. The Maenads were female followers of Dionysius, hysterical and drunken creatures – their name translates as 'raving ones'. They became peeved because Orpheus refused their attentions after the death of his wife Eurydice and threw sticks and stones at the musician, but the sticks and stones refused to harm Orpheus so the infuriated Maenads tore him to pieces.

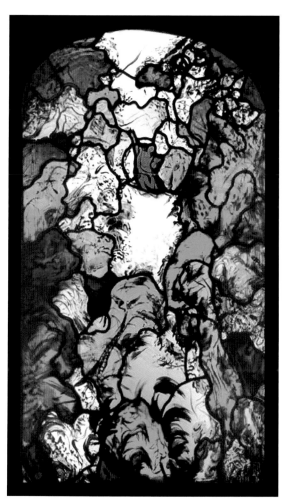

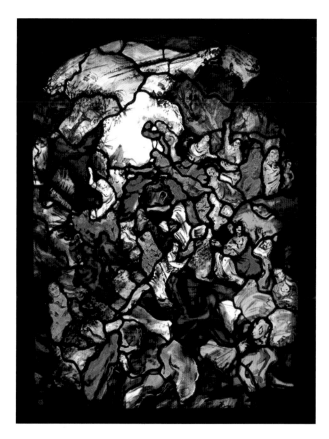

OVID'S METAMORPHOSES

General: Reyntiens notes that the wonderful stories created by the Roman poet Ovid and completed in 8AD would have been lost were it not for the 'dogged persistence' of Carolingian monks who copied down the works. He refreshingly notes that he is 'not the least worried about being thought or dubbed "literary" or "illustrational" – those are terms considered pejorative only by a culture that itself is illiterate and unillumined'. Grimshaw states that these panels resulted from a commission for a series of Stations of the Cross, 'from these emerged the elements of time-sequence, memory scale and the human figure'.

Literature: Reyntiens Patrick, 'Visions of Classical Life', *Patrick Reyntiens, Glass Painted and Stained, Visions in Light*, Bruton Gallery, 1985, p33; Stamp Gavin, 'Patrick Reyntiens and the Ovid Glass Panels', *Patrick Reyntiens, Glass Painted and Stained, Visions in Light*, Bruton Gallery, 1985, p2-3; *Green Book The, A Quarterly Review of the Visual and Literary Arts*, Grimshaw Rosalind, 'Patrick Reyntiens. Visions of Classical Life. Metamorphoses', Autumn 1985, p11; *Spectator The*, Harrod Tanya, 'Talking about angels', 18/25 December 1993, p85; Neiswander Judith & Swash Caroline, *Stained & Art Glass*, London: The Intelligent Layman Publishers Ltd, 2005, p260; *Decorative Arts Society The, Omnium Gatherum*, Horner Libby, 'Patrick Reyntiens' Autonomous Panels. Myth, music and theatre', Journal 35, 2011, p73, 74

APOLLO AND DAPHNE

Date: 1984

Size: 59x54cm (23 1/4x21 1/4in)

Literature: *Green Book The, A Quarterly Review of the Visual and Literary Arts*, Grimshaw Rosalind, 'Patrick Reyntiens. Visions of Classical Life. Metamorphoses', Autumn 1985, p10

Reproduced: *Patrick Reyntiens, Glass Painted and Stained, Visions in Light*, Bruton Gallery, 1985, p9; *Working With Light. A look at contemporary STAINED GLASS in architecture*, Andrew Moor Associates and Derix Glass Studios, April 1987

Exhibited: *Patrick Reyntiens, Glass Painted and Stained, Visions in Light*, Bruton Gallery, Bruton, Somerset, 1985, #2; *Working With Light. A look at contemporary STAINED GLASS in architecture*, Andrew Moor Associates and Derix Glass Studios, RIBA, London, April 1987

Notes: Apollo insulted Cupid who, in revenge, took two arrows and shot the gold one through Apollo's heart causing him to fall in love with Daphne, but Cupid shot Daphne with a lead arrow which made her hate Apollo. When Apollo was about to embrace her she turned into a bay tree which is the incident depicted in this panel, the white body of Apollo contrasting with the shrinking blue and green form of the nymph/tree. Grimshaw considers that the figure of Daphne has a similar feel and patina to the Christ in the 15th century Pieta at Long Melford.

APOLLO FLAYING MARSYAS

Owner: Reyntiens Trust

Date: 1984

Size: 59x46.3cm (23 1/4x18 1/4in)

Literature: AISG, p33 titled *Flaying of Marsyas* (£7,374); *Decorative Arts Society The, Omnium Gatherum*, Horner Libby, 'Patrick Reyntiens' Autonomous Panels. Myth, music and theatre', Journal 35, 2011, p75

Reproduced: *Patrick Reyntiens, Glass Painted and Stained, Visions in Light*, Bruton Gallery, 1985, p21; AISG, p33

Exhibited: *Patrick Reyntiens, Glass Painted and Stained, Visions in Light*, Bruton Gallery, Bruton, Somerset, 1985, #13

Notes: Apollo is shown skinning the satyr Marsyas who had dared to pretend he could play the flute better than the God. The satyr's green/grey body is strung upside down and a river of blood flows out on to the ground – a cheerful subject!

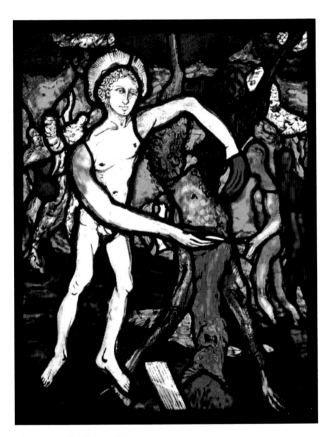

Above: *Apollo Flaying Marsyas*

CUPID AND PSYCHE

Owner: private collection (sold May 2011 for £10,000)

Date: 1984

Size: 59x62.2cm (23 1/4x24 1/2in)

Inscription: signed b.r.: 'Reyntiens 84'

Literature: AISG, p34 (£10,687); *Decorative Arts Society The, Omnium Gatherum*, Horner Libby, 'Patrick Reyntiens' Autonomous Panels. Myth, music and theatre', Journal 35, 2011, p74

Reproduced: *Patrick Reyntiens, Glass Painted and Stained, Visions in Light*, Bruton Gallery, 1985, p18; *Leadline 1990, Patrick Reyntiens & the Burleighfield Experience*, Goodden Ted (Ed),1990, cover; AISG, p34; *Decorative Arts Society The, Omnium Gatherum*, Horner Libby, 'Patrick Reyntiens' Autonomous Panels. Myth, music and theatre', Journal 35, 2011, p74

Exhibited: *Patrick Reyntiens, Glass Painted and Stained, Visions in Light*, Bruton Gallery, Bruton, Somerset, 1985, #10

Notes: Psyche boasted that she was more beautiful than Venus, who sent her son Cupid to transfix Psyche with an arrow of desire and make her fall in love with the nearest person or thing available. But even Cupid fell in love with her. Reyntiens appears to be depicting the moment when Psyche, thinking she has been impregnated by a monster, lights her oil lamp and to her delight discovers Cupid. The dark abstract background lends mystery to the scene.

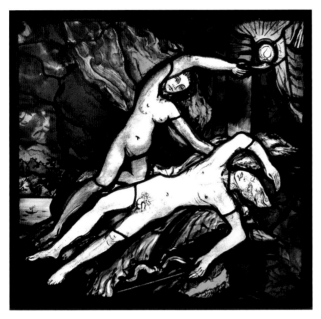

Above: *Cupid and Psyche*

DANAE AND THE SHOWER OF GOLD

Owner: Reyntiens Trust

Date: c1985

Size: 56.5x56.2cm (22 1/4x22in)

Literature: AISG, p41 £8,621)

Reproduced: *Patrick Reyntiens, Glass Painted and Stained, Visions in Light*, Bruton Gallery, 1985, p20; AISG, p41

Exhibited: *Patrick Reyntiens, Glass Painted and Stained, Visions in Light*, Bruton Gallery, Bruton, Somerset, 1985, #12

Notes: Danae was locked up in a bronze tower or cave and Zeus came to her in a shower of golden rain and impregnated her. She gave birth to Perseus. Danae looks like she's been struck by a bolt of lightning.

DIANA AND ACTAEON

Date: 1983-1984

Size: 51.2x82.0cm (20 1/4x32 1/4in) acided, stained and painted lunette

Reproduced: *Patrick Reyntiens, Glass Painted and Stained, Visions in Light*, Bruton Gallery, 1985, p10; *Green Book The,*

A Quarterly Review of the Visual and Literary Arts, Grimshaw Rosalind, 'Patrick Reyntiens. Visions of Classical Life. Metamorphoses', Autumn 1985, p11; *Leadline 1990, Patrick Reyntiens & the Burleighfield Experience*, Goodden Ted (Ed), 1990, p11; *Register of Artists and Craftsmen in Architecture, Patrick Reyntiens*, undated

Exhibited: *Patrick Reyntiens, Glass Painted and Stained, Visions in Light*, Bruton Gallery, Bruton, Somerset, 1985, #3; *Retrospective Exhibition*, Ontario Crafts Council Gallery, Dundas St, Toronto (17 May – 30 June 1990)

Notes: Actaeon was a hunter who accidentally surprised the chaste goddess Diana bathing with her nymphs. She splashed him with water, whereupon he turned into a deer and was run down and killed by his own hounds. This lunette appears to illustrate all the story, the white body of Diana surrounded by her nymphs in a watery glade on the left, whilst Actaeon, half man, half deer, is surrounded by suitably bloodthirsty red and orange dogs.

EUROPA AND THE BULL

Date: 1984

Size: 54.8x58.7cm (21 1/4x23in)

Reproduced: *Patrick Reyntiens, Glass Painted and Stained, Visions in Light*, Bruton Gallery, 1985, p14, 31

Exhibited: *Patrick Reyntiens, Glass Painted and Stained, Visions in Light*, Bruton Gallery, Bruton, Somerset, 1985, #7

Notes: Zeus wanted to deflower Europa and disguised himself as a beautiful placid white bull. Europa lost her fear of the animal and mounted him at which stage the god flew away over the sea with her. The panel shows the bull moving away with a distressed Europa on his back, leaving behind her Garden of Eden, its green pastures strewn with red and blue flowers, and a calm blue sea in the distance.

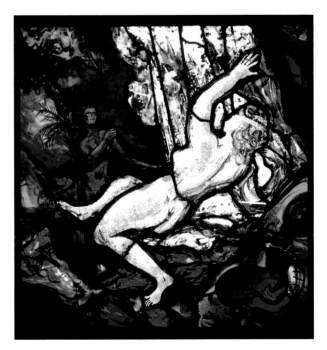

Above: *Danae and the Shower of Gold*

LETO AND THE PEASANTS (LETO AND THE FROGS)

Owner: Private collection

Date: 1984

Size: 51.2x82cm (20 1/4x32 1/4in) lunette

Reproduced: *Patrick Reyntiens, Glass Painted and Stained, Visions in Light*, Bruton Gallery, 1985, p11; Reyntiens Patrick, *The Beauty of Stained Glass*, London: Herbert Press, 1990, p210 (tiled *Leto and the Frogs*)

Exhibited: *Patrick Reyntiens, Glass Painted and Stained, Visions in Light*, Bruton Gallery, Bruton, Somerset, 1985, #4

Notes: Having given birth to Apollo and Artemis, Leto travelled to Lycia and tried to drink water from a pond. However the peasants refused to let her drink the water and even stirred it up into a muddy mess. In retaliation Leto turned the peasants into frogs, the image shown here, the goddess holding one child in her arms whilst pointing at the peasants with the other. The peasants are caught mid-way between human being and frog.

PERSEUS AND THE GORGON'S HEAD

Owner: Reyntiens Trust

Size: 67.0x60.5cm (26 1/4x23 3/4in)

Literature: AISG, p42 (£10,651)

Reproduced: *Patrick Reyntiens, Glass Painted and Stained, Visions in Light*, Bruton Gallery, 1985, p15 (titled *Perseus and Atlas*); AISG, p42

Exhibited: *Patrick Reyntiens, Glass Painted and Stained, Visions in Light*, Bruton Gallery, Bruton, Somerset, 1985, #8 (titled *Perseus and Atlas*)

Notes: This shows Perseus approaching Medusa (one of the Gorgon sisters) whose gaze turned people to stone, but he held his brightly burnished shield before his face as a mirror thus protecting himself and thereby succeeded in striking off the Gorgon's head. Pegasus sprang from the Gorgon's neck and the horse can be seen on the left.

PALAESTRA

General: In ancient Greece the palaestra was a rectangular enclosure for boxing and wrestling, often attached to a gymnasium.

COMPETITIVE SPORT

Owner: Reyntiens Trust

Date: 1988

Size: 55.9x55.9cm (22x22in), mounted on marble base

Inscription: signed b.r.: 'Reyntiens 88'

Literature: Moor Andrew, *Contemporary Stained Glass. A Guide to the Potential of Modern Stained Glass in Architecture*, London, Mitchell Beazley International Ltd, 1989, p121; *Leadline 1990, Patrick Reyntiens & the Burleighfield Experience* , Goodden Ted (Ed), Moor Andrew, 'Introduction to the Recent Work of Patrick Reyntiens', 1990, p9; AISG, p22 (£8,621)

Reproduced: Moor Andrew, *Contemporary Stained Glass. A Guide to the Potential of Modern Stained Glass in Architecture*, London, Mitchell Beazley International Ltd, 1989, p121; *Leadline 1990, Patrick Reyntiens & the Burleighfield Experience*, Goodden Ted (Ed), 1990; AISG, p22

Exhibited: *Retrospective Exhibition*, Ontario Crafts Council Gallery, Dundas St, Toronto (17 May – 30 June 1990)

Notes: The panel shows three nude men in pugilistic stances, some with blue arms or legs, standing in a stream, against an abstract background in red, mauve and green colouring. Moor (1989) considers this panel displays the 'incomparable style' of Reyntiens' work and his defiance of the 'graphic structures of lead, so that form is not automatically separated by colour and by line'. Moor (1990) notes the 'quality of narcissism to [the figures] but it is primarily the grace and fluidity of each figure, and the wonderful interlocking of line and colour, that gives the panel its magical appeal'.

PALAESTRA 1

Date: 1987

Size: 30x30in, almost semi-circular panel

Literature: AISG, p75 titled *Palestra 1* [sic] (£16.031)

Reproduced: AISG, p75

Notes: This shows two wrestling figures against a blue-green background. The aisg website categorises the work as *Erotica Palestra* (sic).

PALAESTRA 2

Owner: Reyntiens Trust

Date: 1987

Size: 76.2x76.2cm (30x30in), roundel

Inscription: signed r.h.s: 'Reyntiens 87'

Literature: AISG, p76 titled *Palestra 2* (sic) (£16,031)

Reproduced: AISG, p76

Notes: In this panel one man has the other on the ground whilst in the background various figures with towels draped round their loins stand watching. The aisg website categorises the work as *Erotica Palestra* [sic]

PALAESTRA 3

Date: 1986

Reproduced: *Leadline 1990, Patrick Reyntiens & the Burleighfield Experience*, Goodden Ted (Ed), 1990
Exhibited: *Retrospective Exhibition*, Ontario Crafts Council Gallery, Dundas St, Toronto (17 May – 30 June 1990)

Notes: This circular panel shows one nude man on the left standing on one leg and holding the other leg out in front of him at right angles

Far left: *Perseus and the Gorgon's Head*

Left: *Competitive Sport*

Right (from top to bottom): *Palaestra 1, Palaestra 2*

THEOCRITUS

Theocritus hailed from Sicily and wrote Greek poetry in the 3rd century BC. Much of the poetry is as relevant today as it was then and Reyntiens adores reciting the works in a dramatic fashion.

LANDSCAPE FROM THEOCRITUS

Date: 1984

Size: 35.5x48cm (14x18 7/8in)

Reproduced: *Patrick Reyntiens, Glass Painted and Stained, Visions in Light*, Bruton Gallery, 1985, p25

Exhibited: *Patrick Reyntiens, Glass Painted and Stained, Visions in Light*, Bruton Gallery, Bruton, Somerset, 1985, #16

Notes: This panel was produced in a limited edition of four. It is a largely abstract work, with what appears to be a white vase on the left with cream and red flowers and green foliage, against a vivid turquoise background with a darker blue column on the right.

PORTRAIT FROM THEOCRITUS (MELANCHOLY PORTRAIT)

Owner: Reyntiens Trust and Private Collections

Size: 35.5x31cm (14x12 1/4in)

Literature: AISG, p64 titled *Melancholy Portraits 1* (£2,992)

Reproduced: *Patrick Reyntiens, Glass Painted and Stained, Visions in Light*, Bruton Gallery, 1985, p24; AISG, p64

Exhibited: *Patrick Reyntiens, Glass Painted and Stained, Visions in Light*, Bruton Gallery, Bruton, Somerset, 1985, #15

Notes: The panel was produced as a limited edition of four and shows a sad looking female face with red roses round her hair. The AISG website includes the work under the *commedia dell'arte* series.

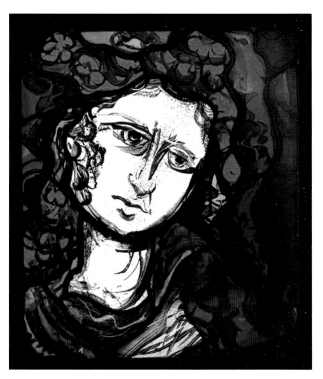

Top of page: *Landscape from Theocritus*

Above: *Portrait from Theocritus*

MOSAIC

Date: c1960

Size: 20.3x27.3cm (8x10 3/4in)

Exhibited: *Modern Stained Glass*, Arts Council, London, 1960-1961, #15

MOURNING FIGURES

Date: c1955

Exhibited: *A Small Anthology of Modern Stained Glass*, Aldeburgh Festival, The Arts Council of Great Britain, 1955, #18

MUSIC

CAESURA

Exhibited: *Patrick Reyntiens*, The Arthur Jeffress Gallery, London, 10 January-27 January 1961, #1

Notes: In musical notation, caesura denotes a brief, silent pause, during which metrical time is not counted.

MUSICAL HOMMAGES

General: Reytiens' conversation is peppered with analogies to music and he produced ten panels dedicated to various composers. Although apparently similar in form and conception, being in the main oval panels illustrating large bowls of flowers, each work is strikingly different and Reyntiens has delved into the distinctive characteristics of the composers, interpreting them into lyrical floral arrangements which bring forth entirely different emotional responses, in the same way that listening to the music of each composer would produce different reactions.

Literature: *Decorative Arts Society The, Omnium Gatherum*, Horner Libby, 'Patrick Reyntiens' Autonomous Panels. Myth, music and theatre', Journal 35, 2011, p76, 77

HOMMAGE 1 (HOMMAGE A BERLIOZ)

Owner: Reyntiens Trust

Date: 1986-1988

Size: 76.2x111.8cm (30x44in), landscape oval panel

Inscription: 'Tribute to Berlioz' and 'Reyntiens'

Literature: *Leadline 1990, Patrick Reyntiens & the Burleighfield Experience*, Goodden Ted (Ed), Moor Andrew, 'Introduction to the Recent Work of Patrick Reyntiens', 1990, p10; AISG, p7 titled *Homages 1*, (£23,512)

Reproduced: Reyntiens Patrick, *The Beauty of Stained Glass*, London: Herbert Press, 1990, p210 ; *Leadline 1990, Patrick Reyntiens & the Burleighfield Experience*, Goodden Ted (Ed), 1990, p11; AISG, p7; *Decorative Arts Society The, Omnium Gatherum*, Horner Libby, 'Patrick Reyntiens' Autonomous Panels. Myth, music and theatre', Journal 35, 2011, p76

Film: Mapleston Charles, Horner Libby, *From Coventry to Cochem, the Art of Patrick Reyntiens*, Reyntiens/Malachite, 2011

Exhibited: *Retrospective Exhibition*, Ontario Crafts Council Gallery, Dundas St, Toronto (17 May – 30 June 1990)

Notes: This floral panel is dedicated to the French romantic composer Hector Berlioz and shows flowers in a pink vase, a large sunflower right of centre.

HOMMAGE 2 (HOMMAGE A WEBER)

Owner: Reyntiens Trust

Size: 76.2x111.8cm (30x44in), landscape oval panel

Inscription: lower right, but too dark to identify

Literature: *Leadline 1990, Patrick Reyntiens & the Burleighfield Experience*, Goodden Ted (Ed), Moor Andrew, 'Introduction to the Recent Work of Patrick Reyntiens', 1990, p10; AISG, p8 titled *Homages 2* (£23,512)

Reproduced: *AISG*, p8

Exhibited: *Retrospective Exhibition*, Ontario Crafts Council Gallery, Dundas St, Toronto (17 May – 30 June 1990)

Notes: Dedicated to Carl Maria von Weber, the German composer, this panel shows flowers in a blue vase ranged right of centre.

Above: *Hommage à Weber*

Below: *Hommage à Berlioz*

HOMMAGE 3 (HOMMAGE A TARTINI)

Owner: Reyntiens Trust

Date: 1987

Size: 111.8x76.2cm (44x30in), portrait oval panel

Inscription: signed t.l.: 'Reyntiens 87', inscribed b.l.: 'Hommage à Tartini'

Study: Reyntiens Trust, pencil on paper

Literature: *Leadline 1990, Patrick Reyntiens & the Burleighfield Experience*, Gooden Ted (Ed), Moor Andrew, 'Introduction to the Recent Work of Patrick Reyntiens', 1990, p10; AISG, p9 titled *Homages 3* (£23,512)

Reproduced: AISG, p9

Exhibited: *Retrospective Exhibition*, Ontario Crafts Council Gallery, Dundas St, Toronto (17 May – 30 June 1990)

Film: Mapleston Charles, Horner Libby, *From Coventry to Cochem, the Art of Patrick Reyntiens*, Reyntiens/Malachite, 2011

Notes: Flowers in a tall white 18th century looking vase make an hommage to the 17th century Venetian composer and violinist Guiseppe Tartini.

Left: *Hommage à Tartini study*

Below: *Hommage à Tartini*

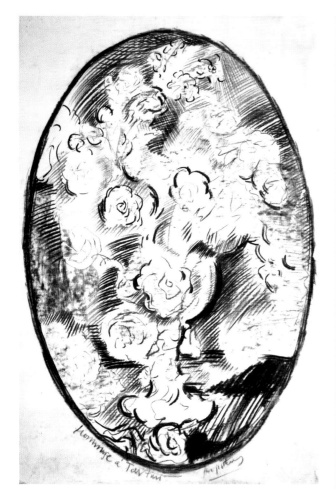

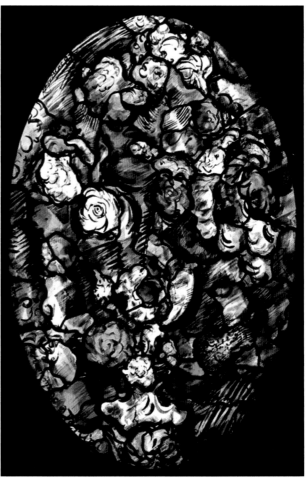

HOMMAGE 4 (HOMMAGE A BRAHMS)

Owner: Reyntiens Trust

Date: c1987

Size: 111x73cm (43.7x28.7in), portrait oval panel

Inscription: signed b.r.: 'Reyntiens' and titled t.r.: 'Brahms'

Study: 111x76cm, pencil on paper, inscribed 'Hommage à Brahms. Reyntiens', Reyntiens Trust. Reproduced: *Decorative Arts Society The, Omnium Gatherum*, Horner Libby, 'Patrick Reyntiens' Autonomous Panels. Myth, music and theatre', Journal 35, 2011, p70. Exhibited: *The Painter in Glass, Catalogue of Works*, Swansea Festival Exhibition, 1992, #50, p19 (lent by the Artist)

Literature: *The Painter in Glass, Catalogue of Works*, Swansea Festival Exhibition, 1992, p19; *BSMGP*, Corrin Adelle, 'Images of Myth and Love. An exhibition of stained glass panels by Patrick Reyntiens', Autumn/Winter 1994, p9; AISG, p10 titled *Homages 4* [sic] (£23,512); *Decorative Arts Society The, Omnium Gatherum*, Horner Libby, 'Patrick Reyntiens' Autonomous Panels. Myth, music and theatre', Journal 35, 2011, p67

Reproduced: AISG, p10; *Decorative Arts Society The, Omnium Gatherum*, Horner Libby, 'Patrick Reyntiens' Autonomous Panels. Myth, music and theatre', Journal 35, 2011, p67

Exhibited: *The Painter in Glass, Catalogue of Works*, Swansea Festival Exhibition, 1992, #49 (lent by the Artist); *Images of Myth and Love. Stained glass panels for the collector and the connoisseur, Patrick Reyntiens. Exhibition of stained glass*, Bernard Becker and Partners, Clerkenwell, London, 16 June – 1 September 1994, #12 (£4,000)

Notes: The panel shows flowers including white lilies in tall white container, an hommage to Johannes Brahms, the 19th century German composer and pianist. The Swansea catalogue entry notes Reyntiens 'virtuosity at handling paint and lead. Reyntiens has developed an approach to painting which involves working with the paint in a wet state to achieve the results he requires. This approach requires a decisive hand as the paint dries rapidly. As a consequence the resulting effect is one of spontaneity, not unlike the "action" painters of the 1950s.' It also notes his approach to the medium in that his designs 'have little or no indication of lead lines as the artist's intention was to create a work in which the paint is worked across the leads, rather than with them as is usually the case'.

Below: *Hommage à Brahms study*

Right: *Hommage à Brahms*

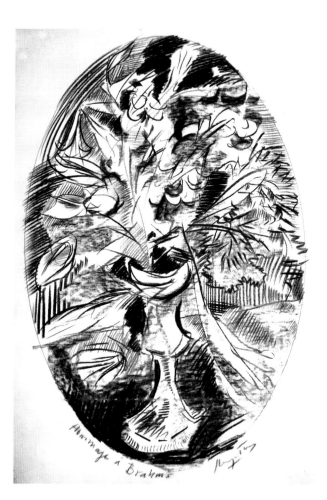

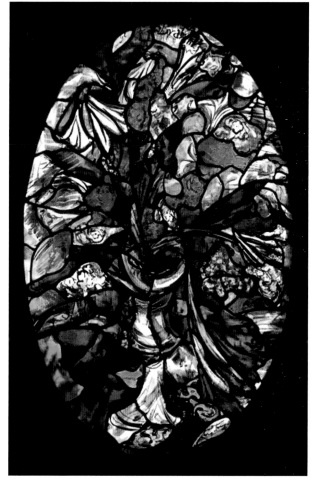

HOMMAGE 5 (HOMMAGE A FAURE)

Owner: Reyntiens Trust

Date: 1988-1989

Size: 111.8x76.2cm (44x30in), portrait oval panel

Inscription: signed b.l.: 'Reyntiens' and titled b.r.: 'Hommage à Fauré'

Study: Pencil on paper, inscribed 'Hommage à Fauré. Reyntiens', Reyntiens Trust

Literature: *Leadline 1990, Patrick Reyntiens & the Burleighfield Experience*, Goodden Ted (Ed), Moor Andrew, 'Introduction to the Recent Work of Patrick Reyntiens', 1990, p10; *The Painter in Glass, Catalogue of Works*, Swansea Festival Exhibition, 1992, p19; *BSMGP*, Swash Caroline, 'The Painter in Glass', Spring/Summer 1993, p17; *BSMGP*, Corrin Adelle, 'Images of Myth and Love. An exhibition of stained glass panels by Patrick Reyntiens', Autumn/Winter 1994, p9; AISG, p11 titled *Homage 5 [sic]* (£23,512)

Reproduced: *Leadline 1990, Patrick Reyntiens & the Burleighfield Experience*, Goodden Ted (Ed), 1990, p14; Lloyd Alison (Ed), *The Painter in Glass*, Dyfed: Gomer Press, 1992, p68; *BSMGP*, Swash Caroline, 'The Painter in Glass', Spring/Summer 1993, p16; AISG, p11

Film: Mapleston Charles, Horner Libby, *From Coventry to Cochem, the Art of Patrick Reyntiens*, Reyntiens/Malachite, 2011

Exhibited: *Retrospective Exhibition*, Ontario Crafts Council Gallery, Dundas St, Toronto (17 May – 30 June 1990); *The Painter in Glass, Catalogue of Works*, Swansea Festival Exhibition, 1992, #51; *Images of Myth and Love. Stained glass panels for the collector and the connoisseur, Patrick Reyntiens. Exhibition of stained glass*, Bernard Becker and Partners, Clerkenwell, London, 16 June – 1 September 1994, #13 (£4,000)

Notes: Flowers in a yellow vase create an hommage to Gabriel Urbain Fauré, the 19th century French composer, organist, pianist and teacher and a great favourite of Reyntiens. The artist hoped that the composition would inspire one to listen to Fauré's music.

Left: *Hommage à Fauré study*

Below: *Hommage à Fauré*

HOMMAGE A WAGNER (LANDSCAPE 'INTO WINTER')

Owner: Reyntiens Trust

Size: 94x45.7cm (37x18in)

Inscription: titled b.l.: 'Hommage to Wagner'

Literature: AISG, p13 titled *Landscape 'Into Winter'* (£11,893); *Decorative Arts Society The, Omnium Gatherum*, Horner Libby, 'Patrick Reyntiens' Autonomous Panels. Myth, music and theatre', Journal 35, 2011, p70, 77

Reproduced: AISG, p13; *Decorative Arts Society The, Omnium Gatherum*, Horner Libby, 'Patrick Reyntiens' Autonomous Panels. Myth, music and theatre', Journal 35, 2011, p77

Film: Mapleston Charles, Horner Libby, *From Coventry to Cochem, the Art of Patrick Reyntiens*, Reyntiens/Malachite, 2011

Notes: Unlike the other hommages, this panel is rectangular and semi-abstract in pale green/yellow/cream colours with a sun upper right and a small blue bird centre reminiscent of Venerable Bede's bird flying through the thane's hall. Reyntiens likes adding what Fragonard called 'la tache' – an individual spot of colour which bears no relationship to the surrounding colours but is perfectly placed – and you see this here with the little blue bird in the middle of the verdant landscape. The artist observed that 'The blue bird is just spring and the bird is flying down and it is the only colour in the whole composition which is unique and it takes your attention like the notes in a symphony or indeed the taste of lemon in a pudding'. The work is an hommage to Richard Wagner, the 19th century German composer, conductor and theatre director – perhaps that is the small male figure centre-bottom of the panel. Alternatively the figure may be one of Wagner's heroes - Siegfried for example. Reyntiens thinks the panel foreshadows the work he and Graham Jones did in Cochem, providing a 'totality of experience' and there is a completeness and unity about the work, an aesthetic atmosphere, perhaps symbolising the *gesamptkunstwerk*, total work of art, of Wagner's operas of which Reyntiens is a great admirer.

Above: Hommage à Wagner

Below: Penelope's Panel

NIGHT SHADOWS

Exhibited: *Patrick Reyntiens*, The Arthur Jeffress Gallery, 10 January-27 January 1961, #15

PENELOPE'S PANEL

Owner: Private collection

Date: 1995

Size: 31x21.5cm (12x8 1/2in)

Glass Maker: John Reyntiens

Notes: This is a small abstract panel in blues and greens and was made from offcuts from the Henry Moore window in Much Hadham, Hertfordshire.

POLITICIANS

Exhibited: I*mages of Myth and Love. Stained glass panels for the collector and the connoisseur, Patrick Reyntiens. Exhibition of stained glass*, Bernard Becker and Partners, Clerkenwell, 16 June – 1 September 1994, #25 (£500)

RELIGIOUS THEMES

ADAM AND EVE

Owner: private collection

Notes: This is a large backlit triptych made for a private house in London. The two figures are seen in various stages of their relationship in the outer panels, whilst in the central panel the white body of Eve appears to collapse into the tanned Adam's arms. There are bursts of green and yellow colouring and blue meteorite looking blobs.

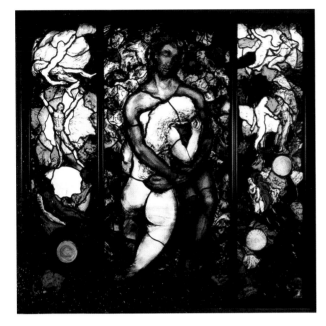

Above: *Adam and Eve*

ANNUNCIATION

Date: c1955

Exhibited: *A Small Anthology of Modern Stained Glass*, Aldeburgh Festival, The Arts Council of Great Britain, 1955, #17

LIFE OF ST PAUL 'FROM THE BAROQUE'

General: Five panels of the life of St Paul, four in upright oval panels and one round-headed retablo-piece measuring 117x72cm (46x28 1/4in) were shown at the Becker Gallery in 1994 – presumably this group included *Conversion of St Paul* and *Stoning of St Stephen*.

Exhibited: *Images of Myth and Love. Stained glass panels for the collector and the connoisseur, Patrick Reyntiens. Exhibition of stained glass*, Bernard Becker and Partners, Clerkenwell, London, 16 June – 1 September 1994, #17 (£30,000 for the whole group, indivisible)

CONVERSION OF ST PAUL

Owner: Reyntiens Trust

Date: 1991

Size: 114.3x73.7cm (45x29in), portrait oval panel

Inscription: signed b.r.: 'Reyntiens 91'

Literature: AISG, p17 (£23,245)

Reproduced: AISG, p17

Notes: This is a dramatic portrayal of Saul on the road to Damascus, falling from his horse and being blinded by the bright sun at the top of the panel, one half of his face blue, the other red.

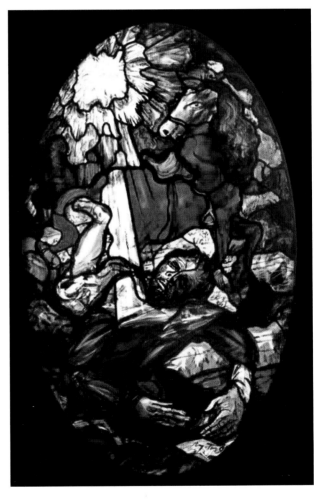

Above: *Conversion of St Paul*

STONING OF ST STEPHEN

Owner: Reyntiens Trust

Date: 1990

Size: 114.3x73.7cm (45x29in), portrait oval panel

Inscription: signed c.r.: 'Reyntiens 90'

Literature: AISG, p16 (£23,245)

Reproduced: AISG, p16

Notes: A rather fey looking Stephen in pink stands in the centre holding his hands up whilst others hurl stones at him. Paul is presumably the man bottom left, guarding the clothes of the assailants.

RAISING OF LAZARUS

Owner: Reyntiens Trust

Date: 1991

Size: 43.2x40.6cm (17x16in) irregular shaped panel

Inscription: signed b.l.: 'Reyntiens 91'

Literature: AISG, p18 (£4,845)

Reproduced: AISG, p18

Exhibited: *Images of Myth and Love. Stained glass panels for the collector and the connoisseur, Patrick Reyntiens. Exhibition of stained glass*, Bernard Becker and Partners, Clerkenwell, London, 16 June – 1 September 1994, #21 (£1,000) – possibly, no dimensions or description given in fly list

Notes: This illustrates the moment when, at the orders of Jesus, Lazarus wakes from the dead and walks out of his tomb, to then be unwrapped from his grave cloths. The panel shows a white swaddled figure centre with faces either side, possibly his sisters Martha and Mary, and dark red chunks suggesting the tomb.

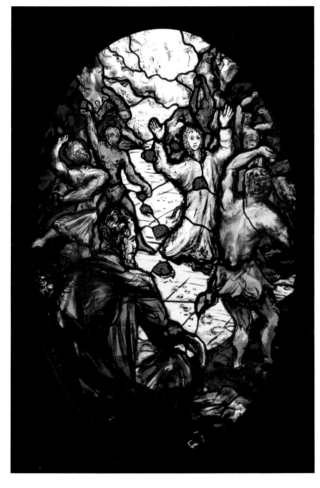

Above: Stoning of St Stephen

Right: Raising of Lazarus

THREE SACRED MOUNTAINS

General: Reyntiens produced three panels under this title, dated 1974.

THREE SACRED MOUNTAINS: CALVARY

Date: 1974

Reproduced: *Reyntiens Patrick, The Beauty of Stained Glass*, London: Herbert Press, 1990, frontispiece (detail)

VISIONS OF EZEKIEL

General: Reyntiens produced four inter-related panels illustrating the story of Ezekiel's prophecy (*Ezekiel* 37: 7-10) whereby God, in the form of the four winds, restored life to the slain. The panels may all have been round headed and showed skeletons in a landscape.

Reproduced: *BSMGP*, Corrin Adelle, 'Images of Myth and Love. An exhibition of stained glass panels by Patrick Reyntiens', Autumn/Winter 1994, p9; *Stained Glass*, Winter 1994, Volume 89, Number 4, '1994 Excellence in Education Awards', p276

VISION OF EZEKIEL 1

Date: c1994

Size: 56x57cm (22x22 1/2in)

Exhibited: *Images of Myth and Love. Stained glass panels for the collector and the connoisseur, Patrick Reyntiens. Exhibition of stained glass*, Bernard Becker and Partners, Clerkenwell, London, 16 June – 1 September 1994, #5 (£3,000)

VISION OF EZEKIEL 2

Date: c1994

Size: 56x57cm

Exhibited: *Images of Myth and Love. Stained glass panels for the collector and the connoisseur, Patrick Reyntiens. Exhibition of stained glass*, Bernard Becker and Partners, Clerkenwell, London, 16 June – 1 September 1994, #6 (£3,000)

VISON OF EZEKIEL 3

Date: c1994

Size: 56x57cm (22x22 1/2in)

Exhibited: *Images of Myth and Love. Stained glass panels for the collector and the connoisseur, Patrick Reyntiens. Exhibition of stained glass*, Bernard Becker and Partners, Clerkenwell, London, 16 June – 1 September 1994, #7 (£3,000)

VISION OF EZEKIEL 4

Date: c1994

Size: 56x57cm (22x22 1/2in)

Exhibited: *Images of Myth and Love. Stained glass panels for the collector and the connoisseur, Patrick Reyntiens. Exhibition of stained glass*, Bernard Becker and Partners, Clerkenwell, London, 16 June – 1 September 1994, #8 (£3,000)

RENAISSANCE JUSTE DE JUSTE

Size: 101.5x68.5cm (40x27in)

Literature: AISG, p21 (£19,237)

Reproduced: AISG, p21

Notes: This depicts rather skeletal nude male bodies balancing on each other to form an upright rectangular shape which appears to echo a dark archway behind them silhouetted against a brilliant turquoise blue.

RESTLESS SEA

Date: 1960

Reproduced: Reyntiens Patrick, *The Technique of Stained Glass*, London: B T Batsford Ltd, 1967, facing p80

Exhibited: *Patrick Reyntiens*, The Arthur Jeffress Gallery, London, 10 January-27 January 1961, #14

Notes: The panel is made of blue and purple coloured glass with a twisted knot of colours centre.

SCAPE

Exhibited: *Patrick Reyntiens*, The Arthur Jeffress Gallery, London, 10 January-27 January 1961, #5

SCARLET AND BLACK

Exhibited: *Patrick Reyntiens*, The Arthur Jeffress Gallery, London, 10 January-27 January 1961, #6

SECTION OF LEADED GLASS MURAL

Date: c1959

Size: 116.7x89cm (42x35in)

Exhibited: *British Artist Craftsmen*, Smithsonian Institution, Washington DC, 1959-1960, #160

SHIP OF FOOLS

Literature: *BSMGP*, Corrin Adelle, 'Images of Myth and Love. An exhibition of stained glass panels by Patrick Reyntiens', Autumn/Winter 1994, p9

Exhibited: *Images of Myth and Love. Stained glass panels for the collector and the connoisseur, Patrick Reyntiens. Exhibition of stained glass*, Bernard Becker and Partners, Clerkenwell, London, 16 June – 1 September 1994, #24 (£500)

SILENCE

Exhibited: *Patrick Reyntiens*, The Arthur Jeffress Gallery, London, 10 January-27 January 1961, #17

STANDING PIECE

Date: 1967

Size: 213x213cm (84x84in)

Reproduced: *House and Garden*, Levi Peta, 'Springboard from Piper and Reyntiens: or the brave new world of the stained-glass designers', April 1983, p147

Notes: This consists of a cross shape within a green diamond, the cross being pale orange with red balloons in two of the arms and yellow diamonds in the other two. Black blobs like ink drops separate the arms and the centre has a further collection of circles, ovals and diamonds.

STILL LIFE

Date: c1959

Size: 103x162.5cm (40 ½x64in)

Literature: *Spectator The*, Harrod Tanya, 'Talking about angels', 18/25 December 1993, p85

Reproduced: *British Artist Craftsmen*, Smithsonian Institution, Washington DC, 1959-1960, #159

Exhibited: *British Artist Craftsmen*, Smithsonian, 1959-1960, #159

Notes: This is an abstract panel with crowded soft forms in the centre surrounded by larger straight edged areas and with a border of four dots on the left.

SPECULUM

Exhibited: *Patrick Reyntiens*, The Arthur Jeffress Gallery, London, 10 January-27 January 1961, #18

STRUCTURE AND FLIGHT

Exhibited: *Patrick Reyntiens*, The Arthur Jeffress Gallery, London, 10 January-27 January 1961, #13

THE SEASONS TURN

Date: 1960

Size: 99x117cm (39x46in)

Reproduced: *Art News and Review*, Lucie-Smith Edward, 'Patrick Reyntiens and Pictures of Fantasy and Sentiment', 28 January to 11 February 1961, p7

Exhibited: *Patrick Reyntiens*, The Arthur Jeffress Gallery, London, 10 January-27 January 1961, #7

Notes: Writing about the exhibition as a whole, Lucie-Smith was less than enthusiastic, considering that Reyntiens was unable to resist the influence of contemporary painting, with the result that 'there is something very laborious about the transfer of free abstraction into the stained-glass medium'.
The panel is oval with a strong vertical lead and two strong horizontal leads at a slight angle to each other, the remaining leading curving round these forms.

TREE OF LIFE

Owner: private collection

Size: 21.6x36.8cm (8.5x14.5in)

Notes: This is a predominantly blue panel with a swirling tree and leaves and a small bird centre.

Above: *Tree of Life*

TRIUMPH OF DAME EDNA EVERAGE

General: Reyntiens made two panels, each consisting of six images of Dame Edna, inspired by Hokusai's *Twelve Views of Mount Fuji* – Reyntiens calls them *Twelve Views of Dame Edna Everage*. He also claims they were inspired by Andy Warhol's use of colour, and considers that Warhol's multiple, variously coloured images might have been influenced by the stamps printed by the Belgians after the death of Queen Astrid in 1935, said stamps bearing the Queen's face in a variety of colours. The panels are a wonderful example of Reyntiens taking a stuffy, boring static medium and instilling huge life and energy into it. In the BSMGP 1991 article Reyntiens states that he was fascinated with the persona as projected by Barry Humphries and considers that Edna has much in common with commedia dell'arte and also with medieval jesters who were allowed to blurt out the truth. Reyntiens considers the panels rather a joke and thinks they'd make a humorous decoration for the men's toilets in the Garrick Club. He recalls that Dame Edna interviewed Nureyev once and said, 'Oh Rudi, do tell me about Margot Fonteyn' and Nureyev just looked at Edna chillingly and said 'Margot was a real Dame' and for once Dame Edna was speechless!

Literature: *BSMPG*, Williams Rachel, 'Patrick Reyntiens', Spring 1991, p14, 15; *BSMGP*, Corrin Adelle, 'Images of Myth and Love. An exhibition of stained glass panels by Patrick Reyntiens', Autumn/Winter 1994, p9; Neiswander Judith & Swash Caroline, *Stained & Art Glass*, London: The Intelligent Layman Publishers Ltd, 2005, p260; *Times The*, 'Happy Birthday Patrick Reyntiens, 85', 11 December 2010; *Decorative Arts Society The, Omnium Gatherum*, Horner Libby, 'Patrick Reyntiens' Autonomous Panels. Myth, music and theatre', Journal 35, 2011, p79

Exhibited: *Images of Myth and Love. Stained glass panels for the collector and the connoisseur, Patrick Reyntiens. Exhibition of stained glass*, Bernard Becker and Partners, Clerkenwell, London, 16 June – 1 September 1994. It is not known which of the two panels was exhibited.

TRIUMPH OF DAME EDNA EVERAGE 1

Owner: Reyntiens Trust

Date: 1990

Size: 137.2x73.7cm (54x29in)

Inscriptions: Top left, middle right, bottom left and bottom right panels all signed: 'Reyntiens 90'

Literature: AISG, p4 (£27,894 each panel but sold as a pair)

Reproduced: *Country Life*, 'Living National Treasure: Artist in Glass', 2 June 1994, p36; *BSMGP*, Caroline Swash, 'On Contemporary Glass', Vol XXIII, 1999, p67; Neiswander Judith & Swash Caroline, *Stained & Art Glass*, London: The Intelligent Layman Publishers Ltd, 2005, p265; AISG, p4; *Decorative Arts Society The, Omnium Gatherum*, Horner Libby, 'Patrick Reyntiens' Autonomous Panels. Myth, music and theatre', Journal 35, 2011, p81

Exhibited: *Patrick Reyntiens. Theatre. Commedia Dell'Arte. Circus*, The Fine Art Society, London, 26 November-21 December 1990

Notes: Reyntiens considers this panel the better of the two although he describes the colour in each as 'rather worrying and horrifying'.

TRIUMPH OF DAME EDNA EVERAGE 2

Date: 1990

Size: 137.2x73.7cm (54x29in)

Inscriptions: Middle left and bottom left panels signed: 'Reyntiens', middle right panel signed: 'Reyntiens 90'

Literature: AISG, p5 (£27,894 each panel but sold as a pair)

Reproduced: *BSMPG*, Williams Rachel, 'Patrick Reyntiens', Spring 1991, p15; *Stained Glass*, Spring 1995, Volume 90, Number 1, 'Debora Coombs, 'British Stained Glass', p20; *BSMGP*, Caroline Swash, 'On Contemporary Glass', Vol XXIII, 1999, p67; Neiswander Judith & Swash Caroline, *Stained & Art Glass*, London: The Intelligent Layman Publishers Ltd, 2005, p265; AISG, p5

Film: Mapleston Charles, Horner Libby, *From Coventry to Cochem, the Art of Patrick Reyntiens*, Reyntiens/Malachite, 2011

Exhibited: *Patrick Reyntiens. Theatre. Commedia Dell'Arte. Circus*, The Fine Art Society, London, 26 November-21 December 1990

Far left: *Triumph of Dame Edna Everage 1*
Left: *Triumph of Dame Edna Everage 2*
Below: *Winter Landscape*

TWO BAGATELLES

Exhibited: *Patrick Reyntiens*, The Arthur Jeffress Gallery, London, 10 January-27 January 1961, #16

TWO VARIATIONS (two works)

Date: c1960

Size: both 50x80cm (19 3/4x31 1/2in)

Exhibited: *Modern Stained Glass*, Arts Council, London, 1960-1961, #14

WINTER LANDSCAPE

Size: 45.7x91.4cm (18x36in)

Literature: AISG, p14 (£11,542)

Reproduced: AISG, p14

Notes: This is an abstract panel in greens, mauves and browns with an almost anthropomorphic head and two eyes, one red and one blue, described on the aisg website as 'experimental'.

'In presenting these visions I am not in the least worried about being thought or dubbed 'literary' or 'illustrational' - those are terms considered pejorative only by a culture that itself is illiterate and unillumined.'

Reyntiens Patrick 'Visions of Classical Life', *Patrick Reyntiens, Glass Painted and Stained, Visions in Light*, Bruton Gallery, 1985, p33

Above: Light transmitted from Reyntiens' windows in Memorial Chapel, Abbey Church of St Laurence, Ampleforth

LIMITED EDITION
AND
GOLDMARK GALLERY
SERIES

LIMITED EDITION PANELS

First Edition: In 2009 and 2010 Reyntiens made 200 small painted stained glass panels which were leaded by his son John. Each work was signed and dated by the artist. These panels are just a representative selection.

Second Edition: The first edition was so successful that a second edition of **100** was created, many using more than one piece of glass and 16 with borders.

From top to bottom:
Smoking Fish, 23x35cm, private collection

Sky High, 32x24cm, private collection

It's my Brighter, Whiter Smile!, 23x23cm, Theodore Bell

It's a Long Way Down, 32x18cm, Theodore Bell

From top to bottom:
Lady Gaga with Aga, **25.5x36.5cm**, private collection

Wherefore Art Thou?, 27.3x30.5cm , Theodore Bell

Goldmark Edition 1: The Goldmark Gallery in Uppingham then commissioned Reyntiens to produce a further 75 unique panels, each numbered, dated and signed by the artist. These panels involved three or more pieces of coloured glass, many with borders, and as Dr Grant notes, 'each numbered panel is unique, the hand-blown antique glass selected and painted by Patrick. Each tells a small story, a testament to an exceptional talent.' The titles and numerous exclamation marks alone are an indication of the sense of the absurd which Reyntiens possesses in no small measure.

Literature: *Stained Glass. Patrick Reyntiens*, Goldmark Gallery, 2011 (Introduction by Dr Charlotte Grant)

Goldmark Edition 2: On 3 December 2011 the Gallery held a one-day exhibition of 108 panels, all signed and dated by the artist.

Photographs courtesy of Goldmark Gallery

Above: *A Pure Cool Day*

Below: *A Really Good Meal, If Someone Doesn't Steal It*

Goldmark Edition 1:

A Beautiful Day, Let's Go And Plunge
Size: 24.5x34.5cm
Cost: £495
Reproduced: *Stained Glass. Patrick Reyntiens*, Goldmark Gallery, 2011, p8, #1.52

A Castle Far Away
Size: 20x35cm
Cost: £395
Reproduced: *Stained Glass. Patrick Reyntiens*, Goldmark Gallery, 2011, p19, #1.17

A Dream Of The Sea
Size: 25.5x30.5cm
Cost: £395
Reproduced: *Stained Glass. Patrick Reyntiens*, Goldmark Gallery, 2011, p30, #1.56

A Horrid Dream
Size: 28x31cm
Cost: £495
Reproduced: *Stained Glass. Patrick Reyntiens*, Goldmark Gallery, 2011, p19, #1.16

A Perfect Meal For Friends
Size: 23x34cm
Cost: £495
Reproduced: *Stained Glass. Patrick Reyntiens*, Goldmark Gallery, 2011, p24, #1.40

A Pure Cool Day
Size: 32.5x40cm
Cost: £595
Reproduced: *Stained Glass. Patrick Reyntiens*, Goldmark Gallery, 2011, p6, #2.02

A Really Good Meal, If Someone Doesn't Steal It
Size: 35.5x42cm
Cost: £595
Reproduced: *Stained Glass. Patrick Reyntiens*, Goldmark Gallery, 2011, p22, #2.07
Exhibited: *Patrick Reyntiens*, 3 December 2011, Goldmark Gallery, #35 (£695)

A Sudden Storm
Size: 27x34.5cm
Cost: £395
Reproduced: *Stained Glass. Patrick Reyntiens*, Goldmark Gallery, 2011, p20, #1.27

A Vision Of The Universe
Size: 22.5x31.5cm
Cost: £395
Reproduced: *Stained Glass. Patrick Reyntiens*, Goldmark Gallery, 2011, p30, #1.58

A Yorkshire Ruin
Size: 23x32.5cm
Cost: £495
Reproduced: *Stained Glass. Patrick Reyntiens*, Goldmark Gallery, 2011, p24, #1.39

After Autumn
Size: 24.5x32cm
Cost: £395
Reproduced: *Stained Glass.*
Patrick Reyntiens, Goldmark Gallery,
2011, p9, #1.25

Away And Away, How Free
Size: 24x33cm
Cost: £395
Reproduced: *Stained Glass.*
Patrick Reyntiens, Goldmark Gallery,
2011, p15, #1.06

Away, Away, So Far Away
Size: 27.5x35.5cm
Cost: £395
Reproduced: *Stained Glass.*
Patrick Reyntiens, Goldmark Gallery,
2011, p26, #1.46

Away In The North
Size: 21.5x29.5cm
Cost: £495
Reproduced: *Stained Glass.*
Patrick Reyntiens, Goldmark Gallery,
2011, p20, #1.28

Beautiful Bounty We'll Never Forget You
Size: 30x40.5cm
Cost: £695
Reproduced: *Stained Glass.*
Patrick Reyntiens, Goldmark Gallery,
2011, p10, #2.04

Big Bang Beginning!
Size: 25x29cm
Cost: £295
Reproduced: *Stained Glass.*
Patrick Reyntiens, Goldmark Gallery,
2011, p21, #1.34

Darling, It's You
Size: 25.5x35.5cm
Cost: £495
Reproduced: *Stained Glass.*
Patrick Reyntiens, Goldmark Gallery,
2011, p14, #1.01

Don't Touch It Yet!
Size: 30x37.5cm
Cost: £695
Reproduced: *Stained Glass.*
Patrick Reyntiens, Goldmark Gallery,
2011, p11, #2.05

Flowers
Size: 27x32.5cm
Cost: £395
Reproduced: *Stained Glass.*
Patrick Reyntiens, Goldmark Gallery,
2011, p31, #1.54

Gee What Booze!
Size: 23x33.5cm
Cost: £395
Reproduced: *Stained Glass.*
Patrick Reyntiens, Goldmark Gallery,
2011, p25, #1.35

Grape Pickin' All The Time!
Size: 27x33.5cm
Cost: £495
Reproduced: *Stained Glass.*
Patrick Reyntiens, Goldmark Gallery,
2011, p21, #1.32

In The Wild
Size: 26.5x37cm
Cost: £495
Reproduced: *Stained Glass.*
Patrick Reyntiens, Goldmark Gallery,
2011, p32, #1.47

It's called Inspiration, Darling!
Size: 34.5x37cm
Cost: £695
Reproduced: *Stained Glass.*
Patrick Reyntiens, Goldmark Gallery,
2011, p29, #2.12

It's Easy to Know How
Size: 29x39cm
Cost: £595
Reproduced: *Stained Glass.*
Patrick Reyntiens, Goldmark Gallery,
2011, p7, #2.03

It's Only Them Again!
Size: 21.5x37cm
Cost: £495
Reproduced: *Stained Glass.*
Patrick Reyntiens, Goldmark Gallery,
2011, p13, #1.12

Let's have Some Peace!
Size: 23x32cm
Cost: £495
Reproduced: *Stained Glass.*
Patrick Reyntiens, Goldmark Gallery,
2011, p14, #1.02

Life In Its Variety
Size: 24x30.5cm
Cost: £395
Reproduced: *Stained Glass.*
Patrick Reyntiens, Goldmark Gallery,
2011, p9, #1.24

Lovely Grub
Size: 25x34cm
Cost: £495
Reproduced: *Stained Glass.*
Patrick Reyntiens, Goldmark Gallery,
2011, p27, #1.44
Exhibited: *Patrick Reyntiens*,
3 December 2011,
Goldmark Gallery, #13

Memories Of Puglia
Size: 21.5x34cm
Cost: £395
Reproduced: *Stained Glass.*
Patrick Reyntiens, Goldmark Gallery,
2011, p21, #1.31

Nice to See Ya
Size: 24x31cm
Cost: £495
Reproduced: *Stained Glass.*
Patrick Reyntiens, Goldmark Gallery,
2011, p5, #1.22

Oh Boosy – Snoozy – Snoozy
Size: 25.5x38cm
Cost: £495
Reproduced: *Stained Glass.*
Patrick Reyntiens, Goldmark Gallery,
2011, p18, #1.13

Oh! Middle Ages!
Size: 23x35.5cm
Cost: £495
Reproduced: *Stained Glass.*
Patrick Reyntiens, Goldmark Gallery,
2011, p12, #1.09

Oh, New South Wales
Size: 27x32.5cm
Cost: £495
Reproduced: *Stained Glass.*
Patrick Reyntiens, Goldmark Gallery,
2011, p32, #1.60

Oh! Sleepy, Sleepy!
Size: 21.5x33cm
Cost: £395
Reproduced: *Stained Glass.*
Patrick Reyntiens, Goldmark Gallery,
2011, p15, #1.04
Exhibited: *Patrick Reyntiens*,
3 December 2011, Goldmark Gallery, #11

Oh So Rested
Size: 22x39cm
Cost: £495
Reproduced: *Stained Glass.*
Patrick Reyntiens, Goldmark Gallery,
2011, p8, #1.50

Oh Spring, Oh Spring
Size: 24.5x32.5cm
Cost: £395
Reproduced: *Stained Glass.*
Patrick Reyntiens, Goldmark Gallery,
2011, p26, #1.45

Oh, The Scottish Islands
Size: 27x33cm
Cost: £395
Reproduced: *Stained Glass.*
Patrick Reyntiens, Goldmark Gallery,
2011, p9, #1.26

Oh! What A Nasty Dream!
Size: 24x32cm
Cost: £495
Reproduced: *Stained Glass.*
Patrick Reyntiens, Goldmark Gallery,
2011, p25, #1.36

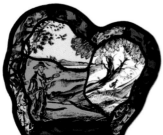

Oz Seriously. Oz Seriously
Size: 35x39.5cm
Cost: £695
Reproduced: *Stained Glass. Patrick Reyntiens*, Goldmark
Gallery, 2011, p2, #2.09

Perhaps We Could Go To France?
Size: 25.5x34.5cm
Cost: £495
Reproduced: *Stained Glass.*
Patrick Reyntiens, Goldmark Gallery,
2011, p15, #1.03

Rural England
Size: 24.5x35cm
Cost: £495
Reproduced: *Stained Glass.*
Patrick Reyntiens, Goldmark Gallery,
2011, p12, #1.10

Scrumpety – Dee. What a Dream for Me
Size: 26.5x37cm
Cost: £495
Reproduced: *Stained Glass.*
Patrick Reyntiens, Goldmark Gallery,
2011, p13, #1.11

Smell Smell! The Perfume
Size: 35x37cm
Cost: £595
Reproduced: *Stained Glass.*
Patrick Reyntiens, Goldmark Gallery,
2011, p10, #2.06

So Far Away, So Far Away
Size: 27x33cm
Cost: £495
Reproduced: *Stained Glass.*
Patrick Reyntiens, Goldmark Gallery,
2011, p27, #1.43

Spring Comes
Size: 29.5x26cm
Cost: £295
Reproduced: *Stained Glass.*
Patrick Reyntiens, Goldmark Gallery,
2011, p30, #1.57

Stags in Scotland
Size: 26x33.5cm
Cost: £495
Reproduced: *Stained Glass.*
Patrick Reyntiens, Goldmark Gallery,
2011, p20, #1.29

Stormy Weather!
Size: 24x32cm
Cost: £395
Reproduced: *Stained Glass.*
Patrick Reyntiens, Goldmark Gallery,
2011, p5, #1.21

Swimmin's So Healthy!
Size: 20x35.5cm
Cost: £395
Reproduced: *Stained Glass.*
Patrick Reyntiens, Goldmark Gallery,
2011, p12, #1.07

Swimmin' Swimmin' All The Time
Size: 22x36cm
Cost: £395
Reproduced: *Stained Glass.*
Patrick Reyntiens, Goldmark Gallery,
2011, p21, #1.33

The Beautiful Trees
Size: 30x37.5cm
Cost: £595
Reproduced: *Stained Glass.*
Patrick Reyntiens, Goldmark Gallery,
2011, p28, #2.13

The Beginning of Life
Size: 25x33cm
Cost: £295
Reproduced: *Stained Glass.*
Patrick Reyntiens, Goldmark Gallery,
2011, p19, #1.14

The Birds
Size: 24.5x35.5cm
Cost: £395
Reproduced: *Stained Glass.*
Patrick Reyntiens, Goldmark Gallery,
2011, p30, #1.55

The Clever Boys
Size: 25.5x32cm
Cost: £495
Reproduced: *Stained Glass.*
Patrick Reyntiens, Goldmark Gallery,
2011, p19, #1.18

The Desert Lands. Alone, Alone!
Size: 28x42.5cm
Cost: £595
Reproduced: *Stained Glass.*
Patrick Reyntiens, Goldmark Gallery,
2011, p6, #2.01

The English Landscape
Size: 23x34.5cm
Cost: £395
Reproduced: *Stained Glass.*
Patrick Reyntiens, Goldmark Gallery,
2011, p5, #1.19

The Far West
Size: 25.5x33.5cm
Cost: £495
Reproduced: *Stained Glass.*
Patrick Reyntiens, Goldmark Gallery,
2011, p20, #1.30

The Flowers Of Spring
Size: 24x25.5cm
Cost: £395
Reproduced: *Stained Glass.*
Patrick Reyntiens, Goldmark Gallery,
2011, p26, #1.41

The Growth Of Trees
Size: 20x35.5cm
Cost: £395
Reproduced: *Stained Glass.*
Patrick Reyntiens, Goldmark Gallery,
2011, p32, #1.48

The Land Of Freedom
Size: 24.5x32.5cm
Cost: £395
Reproduced: *Stained Glass.*
Patrick Reyntiens, Goldmark Gallery,
2011, p25, #1.37

The Pilgrim's Progress
Size: 30.5x37cm
Cost: £695
Reproduced: *Stained Glass. Patrick Reyntiens*, Goldmark
Gallery, 2011, cover and p17, #2.15

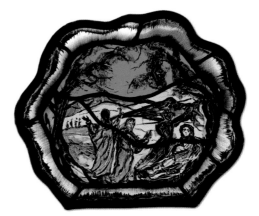

The Silver Sea
Size: 24.5x33.5cm
Cost: £395
Reproduced: *Stained Glass.*
Patrick Reyntiens, Goldmark Gallery,
2011, p9, #1.23

The Sky, The Sky. Oh Run! Oh Run!
Size: 32.5x37.5cm
Cost: £595
Reproduced: *Stained Glass.*
Patrick Reyntiens, Goldmark Gallery,
2011, p28, #2.11

The Trees, The Trees
Size: 27.5x32cm
Cost: £495
Reproduced: *Stained Glass.*
Patrick Reyntiens, Goldmark Gallery,
2011, p31, #1.53

The Waves! The Rock of Western Ireland
Size: 33.5x38cm
Cost: £595
Reproduced: *Stained Glass.*
Patrick Reyntiens, Goldmark Gallery,
2011, p16, #2.14

There's A Bird In The Trees
Size: 25.5x33cm
Cost: £495
Reproduced: *Stained Glass.*
Patrick Reyntiens, Goldmark Gallery,
2011, p15, #1.05

They're There! They're There! We've Found Them
Size: 32.5x39.5cm
Cost: £595
Reproduced: *Stained Glass.*
Patrick Reyntiens, Goldmark Gallery,
2011, p23, #2.08

Three Trees
Size: 25.5x35.5cm
Cost: £395
Reproduced: *Stained Glass.*
Patrick Reyntiens, Goldmark Gallery,
2011, p12, #1.08

Through The Desert
Size: 21x31.5cm
Cost: £395
Reproduced: *Stained Glass.*
Patrick Reyntiens, Goldmark Gallery,
2011, p8, #1.49
Exhibited: *Patrick Reyntiens*,
3 December 2011, Goldmark Gallery, #7

To The North, So Quickly
Size: 24.5x29cm
Cost: £495
Reproduced: *Stained Glass.*
Patrick Reyntiens, Goldmark Gallery,
2011, p4, 32, #1.59

Up And Down The Trees
Size: 25.5x33.5cm
Cost: £395
Reproduced: *Stained Glass.*
Patrick Reyntiens, Goldmark Gallery,
2011, p18, #1.15

Vulcan Wakes Up
Size: 22.5x36.5cm
Cost: £395
Reproduced: *Stained Glass.*
Patrick Reyntiens, Goldmark Gallery,
2011, p26, #1.42

We Grow All The Time
Size: 37x39.5cm
Cost: £595
Reproduced: *Stained Glass.*
Patrick Reyntiens, Goldmark Gallery,
2011, p23, #2.10

We're Here Quite Alone
Size: 25.5x32.5cm
Cost: £395
Reproduced: *Stained Glass.*
Patrick Reyntiens, Goldmark Gallery,
2011, p25, #1.38

We've Seen You Now
Size: 25.5x34.5cm
Cost: £395
Reproduced: *Stained Glass.*
Patrick Reyntiens, Goldmark Gallery,
2011, p8, #1.51

What A Mountain to Climb
Size: 23.5x33cm
Cost: £395
Reproduced: *Stained Glass. Patrick Reyntiens*, Goldmark
Gallery, 2011, p5, #1.20

Goldmark Edition 2:

A Beautiful Bay, Away Away!
Date: 2011
Size: 31.0x36.0cm
Cost: £695
Exhibited: *Patrick Reyntiens*,
3 December 2011,
Goldmark Gallery, #36

A Church in the Country
Date: 2011
Size: 32.0x40.0cm
Cost: £795
Exhibited: *Patrick Reyntiens*,
3 December 2011,
Goldmark Gallery, #26

A Good Bridge!
Date: 2011
Size: 32.0x35.0cm
Cost: £695
Exhibited: *Patrick Reyntiens*,
3 December 2011,
Goldmark Gallery, #23

A Lonely Land
Date: 2011
Size: 25.5x33.0cm
Cost: £495
Exhibited: *Patrick Reyntiens*,
3 December 2011,
Goldmark Gallery. #80

A Modest Living
Date: 2009
Size: 19.3x26.5cm
Cost: £395
Exhibited: *Patrick Reyntiens*,
3 December 2011,
Goldmark Gallery, #74

A Pilgrimage – So Far Away
Date: 2011
Size: 22.0x31.0cm
Cost: £595
Exhibited: *Patrick Reyntiens*,
3 December 2011,
Goldmark Gallery, #63

A Poem's Coming
Date: 2010
Size: 24.5x22.0cm
Cost: £395
Exhibited: *Patrick Reyntiens*,
3 December 2011,
Goldmark Gallery, #92

A Pretty Welsh Village
Date: 2010
Size: 15.7x31.0cm

A Real Medieval Castle!
Date: 2011
Size: 31.0x35.0cm
Cost: £795
Exhibited: *Patrick Reyntiens*,
3 December 2011,
Goldmark Gallery, #98

A Walk in the Park
Date: 2011
Cost: £495
Exhibited: *Patrick Reyntiens*,
3 December 2011,
Goldmark Gallery, #88

A Wild Country
Date: 2011
Size: 30.5x40.0cm
Cost: £695
Exhibited: *Patrick Reyntiens*, 3 December 2011, Goldmark
Gallery, #46

All's OK!
Date: 2011
Size: 24.0x31.0cm
Cost: £495
Exhibited: *Patrick Reyntiens*,
3 December 2011,
Goldmark Gallery, #89

An Awful Nightmare
Date: 2011
Size: 23.0x39.0cm
Cost: £495
Exhibited: *Patrick Reyntiens*,
3 December 2011,
Goldmark Gallery, #103

Auntie's Treasures!
Date: 2010
Size: 15.5x28.0cm

Away! Away! A Beautiful View!
Date: 2011
Size: 35.5x34.5cm
Cost: £795
Exhibited: *Patrick Reyntiens*, 3 December 2011, Goldmark
Gallery, #83

Away in Africa
Date: 2011
Size: 24.5x30.5cm
Cost: £495
Exhibited: *Patrick Reyntiens*,
3 December 2011,
Goldmark Gallery, #30

A Wild Way in the North!
Date: 2011
Size: 24.0x29.5cm
Cost: £495
Exhibited: *Patrick Reyntiens*, 3 December 2011, Goldmark
Gallery, #67

Balloons, Balloons
Date: 2010
Size: 20.0x26.0cm
Cost: £395
Exhibited: *Patrick Reyntiens*,
3 December 2011,
Goldmark Gallery, #79

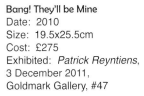

Bang! They'll be Mine
Date: 2010
Size: 19.5x25.5cm
Cost: £275
Exhibited: *Patrick Reyntiens*,
3 December 2011,
Goldmark Gallery, #47

Beautiful Bay!
Date: 2011
Size: 29.5x35.5cm
Cost: £595
Exhibited: *Patrick Reyntiens*, 3 December 2011, Goldmark
Gallery, #48

Bunny or Pussy or Fox?
Date: 2010
Size: 17.0x28.0cm
Cost: £395
Exhibited: *Patrick Reyntiens*,
3 December 2011,
Goldmark Gallery, #94

Chinese Gardens
Date: 2010
Size: 28.5x21.0cm
Cost: £495
Exhibited: *Patrick Reyntiens*,
3 December 2011,
Goldmark Gallery, #102

Country Sheep
Date: 2009
Size: 21.0x28.0cm
Cost: £395
Exhibited: *Patrick Reyntiens*,
3 December 2011,
Goldmark Gallery, #82

Creation Began with the Stars!
Date: 2011
Size: 32.5x34.0cm
Cost: £595
Exhibited: *Patrick Reyntiens*,
3 December 2011,
Goldmark Gallery, #69

Don't 'Barrier Reef' Me
Date: 2009
Size: 24.5x26.5cm
Cost: £395
Exhibited: *Patrick Reyntiens*,
3 December 2011,
Goldmark Gallery, #71

Do They Deserve This?
Date: 2010
Size: 18.5x27.5cm

Exercise Tires (unsigned)
Date: 2010
Size: 29.0x38.0cm
Cost: £695
Exhibited: *Patrick Reyntiens*,
3 December 2011,
Goldmark Gallery, #101

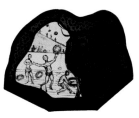

Fish, Fish, Fish! (And a Lobster)
Date: 2011
Size: 31.0x37.0cm
Cost: £595
Exhibited: *Patrick Reyntiens*,
3 December 2011,
Goldmark Gallery, #29

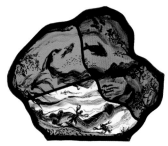

Go all the way: in Somerset
Date: 2011
Size: 32.5x33.5cm
Cost: £795
Exhibited: *Patrick Reyntiens*,
3 December 2011,
Goldmark Gallery, #60

Goodbye Goodbye
Date: 2010
Size: 18.0x26.5cm
Cost: £395
Exhibited: *Patrick Reyntiens*,
3 December 2011,
Goldmark Gallery, #28

Hadrian's at it Again
Date: 2010
Size: 19.7x30.0cm
Cost: £395
Exhibited: *Patrick Reyntiens,*
3 December 2011,
Goldmark Gallery, #100

He'll Not Come Back
Cost: £495
Exhibited: *Patrick Reyntiens,*
3 December 2011,
Goldmark Gallery, #22

Hick, Hack, Hock!
Date: 2010
Size: 16.5x28.5cm
Cost: £395
Exhibited: *Patrick Reyntiens*, 3 December 2011, Goldmark
Gallery, #104

Hills in the North!
Date: 2011
Size: 37.0x40.0cm
Cost: £795
Exhibited: *Patrick Reyntiens,*
3 December 2011,
Goldmark Gallery, #108

Horrible Dreams
Date: 2011
Size: 25.0x33.0cm
Cost: £495
Exhibited: *Patrick Reyntiens,*
3 December 2011,
Goldmark Gallery, #64

Horrible Monsters!
Date: 2011
Size: 24.0x28.5cm
Cost: £395
Exhibited: *Patrick Reyntiens,*
3 December 2011,
Goldmark Gallery, #99

I Keep my Eyes Wide Open all the
Date: 2010
Size: 20.5x28.0cm
Cost: £275

I'll See You in Three Months
Date: 2010
Size: 21.5x30.5cm

In Goodge Street
Date: 2010
Size: 17.0x29.0cm

In the Middle of the Coral
Date: 2011
Size: 24.0x28.0cm
Cost: £495
Exhibited: *Patrick Reyntiens*,
3 December 2011,
Goldmark Gallery, #42

Into the Cave with the Cows!
Date: 2011
Size: 25.5x34.0cm
Cost: £595
Exhibited: *Patrick Reyntiens*,
3 December 2011,
Goldmark Gallery,#51

Into the Desert!
Date: 2011
Size: 26.5x26.5cm
Cost: £495
Exhibited: *Patrick Reyntiens*,
3 December 2011,
Goldmark Gallery, #24

Is this a Chinese Restaurant?
Date: 2011
Size: 24.0x28.0cm
Cost: £495
Exhibited: *Patrick Reyntiens*,
3 December 2011,
Goldmark Gallery. #55

It's a Nice Sort of Garden!
Date: 2011
Size: 24.5x27.5cm
Cost: £495
Exhibited: *Patrick Reyntiens*,
3 December 2011,
Goldmark Gallery, #54

It's a Ocean isn't it?
Date: 2011
Size: 30.0x27.0cm
Cost: £495
Exhibited: *Patrick Reyntiens*,
3 December 2011,
Goldmark Gallery, #31

It's Fertile in Somerset
Date: 2011
Size: 25.0x25.5cm
Cost: £495
Exhibited: *Patrick Reyntiens*, 3 December 2011, Goldmark
Gallery, #56

It's Four Thirty You Know
Date: 2010
Size: 20.0x31.5cm
Cost: £395

I've Slipped, I've Slipped!
Date: 2011
Size: 25.0x28.0cm
Cost: £395
Exhibited: *Patrick Reyntiens*
3 December 2011,
Goldmark Gallery, #2

Jewellery on the Tube
Date: 2010
Size: 29.0x28.0cm
Cost: £395
Exhibited: *Patrick Reyntiens*,
3 December 2011,
Goldmark Gallery, #25

Jurassic Coast
Date: 2010
Size: 19.0x36.0cm

Just Smell My Flowers!
Date: 2011
Size: 43.0x39.0cm
Cost: £795
Exhibited: *Patrick Reyntiens*,
3 December 2011,
Goldmark Gallery, #107

Let Him Sleep
Date: 2010
Size: 17.3x25.5cm
Cost: £275
Exhibited: *Patrick Reyntiens*,
3 December 2011,
Goldmark Gallery, #72

Lets have some more Vodka
Date: 2010
Size: 20.5x30.5cm

Let's Straighten your Tie
Date: 2010
Size: 25.5x34.0
Cost: £595
Exhibited: *Patrick Reyntiens*,
3 December 2011,
Goldmark Gallery, #96

Little Old Town: So Far Away
Date: 2011
Size: 23.0x31.0cm
Cost: £495
Exhibited: *Patrick Reyntiens*,
3 December 2011,
Goldmark Gallery, #75

Martha's Sausage Roll
Date: 2010
Size: 23.0x25.0cm
Cost: £395
Exhibited: *Patrick Reyntiens*,
3 December 2011,
Goldmark Gallery, #97

Mother Julian
Date: 2010
Size: 18.0x28.0cm

No Harness; No harness!
Date: 2010
Size: 19.2x28.0cm
Cost: 395
Exhibited: *Patrick Reyntiens*,
3 December 2011,
Goldmark Gallery, #4

Not quite The Owl or The Pussycat
Date: 2009
Size: 26.2x22.0cm
Cost: £395
Exhibited: Patrick Reyntiens,
3 December 2011,
Goldmark Gallery, #49

Oh, Flowers!
Date: 2011
Size: 28.0x28.0cm
Cost: £395
Exhibited: *Patrick Reyntiens*,
3 December 2011,
Goldmark Gallery, #91

Oh Listen to me Pilgrims
Date: 2011
Size: 30.0x28.5cm
Cost: £495
Exhibited: *Patrick Reyntiens*,
3 December 2011,
Goldmark Gallery, #5

Oh Lumme is this the Hand of God!
Date: 2011
Size: 24.5x30.5cm
Cost: £395
Exhibited: *Patrick Reyntiens*,
3 December 2011,
Goldmark Gallery, #3

Oh Relax, Relax!
Date: 2009
Size: 16.0x28.0cm
Cost: £395
Exhibited: *Patrick Reyntiens*,
3 December 2011,
Goldmark Gallery, #21

Oh the Freedom of the Air
Date: 2009
Size: 22.0x25.0cm
Cost: £395
Exhibited: *Patrick Reyntiens*,
3 December 2011,
Goldmark Gallery, #78

Oh! The Seas, The Seas
Date: 2011
Size: 29.0x29.0cm
Cost: £495
Exhibited: *Patrick Reyntiens*,
3 December 2011,
Goldmark Gallery, #86

Oh! The Tsunami
Date: 2011
Size: 21.0x31.0cm
Cost: £395
Exhibited: *Patrick Reyntiens*,
3 December 2011,
Goldmark Gallery, #33

Oh! What a Dream!
Date: 2011
Size: 25.0x31.0cm
Cost: £495
Exhibited: *Patrick Reyntiens*,
3 December 2011,
Goldmark Gallery, #37

Oh! You Devils!
Date: 2011
Size: 29.0x26.0cm
Cost: £395
Exhibited: *Patrick Reyntiens,*
3 December 2011,
Goldmark Gallery, #53

Ooh! The Fish!
Date: 2011
Size: 23.0x30.5cm
Cost: £495
Exhibited: *Patrick Reyntiens,*
3 December 2011,
Goldmark Gallery, #6

Ooh! What a Monument
Date: 2011
Size: 25.5x38.8cm
Cost: £495
Exhibited: *Patrick Reyntiens,*
3 December 2011,
Goldmark Gallery, #65

Ooh What a River: Away it Goes
Date: 2011
Size: 36.5x39.0cm
Cost: £695
Exhibited: *Patrick Reyntiens,* 3 December 2011, Goldmark
Gallery, 90

Over the River and Into The trees
Date: 2011
Size: 27.5x28.5

Pretty Pony
Date: 2009
Size: 18.0x31.0cm
Cost: £395
Exhibited: *Patrick Reyntiens,*
3 December 2011,
Goldmark Gallery, #84

Put it up! Put it Up!
Date: 2010
Size: 24x26.5cm
Cost: £395
Exhibited: *Patrick Reyntiens,*
3 December 2011,
Goldmark Gallery, #14

Puzzled in the Tube
Date: 2010
Size: 30.5x24.0cm
Cost: £495
Exhibited: *Patrick Reyntiens,*
3 December 2011,
Goldmark Gallery, #8

Rabbit in the Rhubarb
Date: 2010
Size: 19.0x26.8cm
Cost: £395
Exhibited: *Patrick Reyntiens,*
3 December 2011,
Goldmark Gallery, #12

Rely on the Coiffeur
Date: 2010
Size: 20.0x27.0cm
Cost: £350

Romantic and Dangerous
Date: 2010
Size: 20.2x36.0cm
Cost: £395
Exhibited: *Patrick Reyntiens,*
3 December 2011,
Goldmark Gallery, #20

So Flat and Perfect. Pity about the Cloud!
Date: 2011
Size: 31.0x30.0cm
Cost: £695
Exhibited: *Patrick Reyntiens,*
3 December 2011,
Goldmark Gallery, #73

So High, and Uninhabited
Date: 2011
Size: 31.0x33.0cm
Cost: £495
Exhibited: *Patrick Reyntiens,*
3 December 2011,
Goldmark Gallery, #93

So lovely; relaxing in the Summer!
Date: 2011
Size: 29.5x36.0cm
Cost: £595
Exhibited: *Patrick Reyntiens,*
3 December 2011,
Goldmark Gallery, #39

Something Fishy Here
Date: 2009
Size: 25.5x28.0cm
Cost: £395
Exhibited: *Patrick Reyntiens,*
3 December 2011,
Goldmark Gallery, #105

Somewhere in Arizona?
Date: 2011
Size: 21.0x30.0cm
Cost: £495
Exhibited: *Patrick Reyntiens,*
3 December 2011,
Goldmark Gallery, #76

Swim baby as You Only Know How
Date: 2009
Size: 21.5x24.0cm
Cost: £395
Exhibited: *Patrick Reyntiens,*
3 December 2011,
Goldmark Gallery, #19

The Best I can do at Carnival
Date: 2009
Size: 25.0x21.0cm

The Big Stones, Standing
Date: 2011
Size: 21.5x33.0cm
Cost: £595
Exhibited: *Patrick Reyntiens,*
3 December 2011,
Goldmark Gallery, #87

The Birds, The Birds!
Date: 2011
Size: 32.0x26.5cm
Cost: £495
Exhibited: *Patrick Reyntiens*,
3 December 2011,
Goldmark Gallery, #57

The Brain's Alive: and Well?
Date: 2011
Size: 30.0x29.0cm
Cost: £495
Exhibited: *Patrick Reyntiens*,
3 December 2011,
Goldmark Gallery, #61

The Earthquake
Date: 2011
Size: 25.5x28.5cm
Cost: £495
Exhibited: *Patrick Reyntiens*,
3 December 2011,
Goldmark Gallery, #43

The Gothic!
Date: 2011
Size: 32.0x22.5cm
Cost: £495
Exhibited: *Patrick Reyntiens*,
3 December 2011,
Goldmark Gallery, #1

The Insects in One's Life!
Date: 2011
Size: 24.0x29.0cm
Cost: £495
Exhibited: *Patrick Reyntiens*,
3 December 2011,
Goldmark Gallery, #41

The Music of the Spheres
Date: 2011
Size: 23.0x30.5cm
Cost: £395
Exhibited: *Patrick Reyntiens*,
3 December 2011,
Goldmark Gallery, #106

The Sacred Mountain
Date: 2010
Size: 18.0x26.0
Cost: £395
Exhibited: *Patrick Reyntiens*,
3 December 2011,
Goldmark Gallery, #34

The Tree and the Hill
Date: 2011
Size: 24.0x27.0cm
Cost: £395
Exhibited: *Patrick Reyntiens*,
3 December 2011,
Goldmark Gallery, #58

The Waves!
Date: 2011
Size: 25.5x27.0cm
Cost: £495
Exhibited: *Patrick Reyntiens*,
3 December 2011,
Goldmark Gallery, #85

The Wind in the Willows!
Date: 2011
Size: 27.5x34.5cm
Cost: £395
Exhibited: *Patrick Reyntiens*,
3 December 2011,
Goldmark Gallery, #32

The Wilds & The Weather
Date: 2010
Size: 21.5x28.5cm
Cost: £395
Exhibited: *Patrick Reyntiens*,
3 December 2011,
Goldmark Gallery, #70

They'll Save us from Atoms!!
Date: 2011
Size: 26.5x31.0cm
Cost: £595
Exhibited: *Patrick Reyntiens*,
3 December 2011,
Goldmark Gallery, #66

They're There: They're There!
Date: 2011
Size: 22.0x31.0cm
Cost: £495
Exhibited: *Patrick Reyntiens*,
3 December 2011,
Goldmark Gallery, #68

This isn't Club Behaviour
Date: 2010
Size: 20.0x33.0cm

This Is the Place I Told You Of!
Date: 2011
Size: 26.5x37.0cm
Cost: £595
Exhibited: *Patrick Reyntiens*,
3 December 2011,
Goldmark Gallery, #81

This Land has Never Produced Food!
Date: 2011
Size: 28.0x33.0cm
Cost: £695
Exhibited: *Patrick Reyntiens*, 3 December 2011, Goldmark
Gallery, #50

Too Wild to Swim
Date: 2010
Size: 18.0x37.0cm
Cost: £395
Exhibited: *Patrick Reyntiens*,
3 December 2011,
Goldmark Gallery, #59

Under the Ocean
Date: 2011
Size: 23.0x31.0cm
Cost: £495
Exhibited: *Patrick Reyntiens*,
3 December 2011,
Goldmark Gallery, #44

Untitled (Funny Face)
Date: 2010
Size: 17.0x28.0cm
Cost: £275
Exhibited: *Patrick Reyntiens*,
3 December 2011,
Goldmark Gallery, #40

Untitled (Romantic Countryside)
Date: 2010
Size: 30.0x33.5cm
Cost: £595
Exhibited: Patrick Reyntiens,
3 December 2011,
Goldmark Gallery, #95

We Go to the South!
Date: 2011
Size: 24.0x28.0cm

We'll go Everywhere!
Date: 2011
Size: 23.0x32.0cm
Cost: £495
Exhibited: *Patrick Reyntiens*,
3 December 2011,
Goldmark Gallery, #45

We'll wait for the Dawn
Date: 2009
Size: 17.5x33.0

Wet Weather; Let's Swim!
Date: 2010
Size: 25.5x25.0cm
Cost: £395
Exhibited: *Patrick Reyntiens*,
3 December 2011,
Goldmark Gallery, #10

What a Menacing Old Castle
Date: 2011
Size: 29.5x24.5cm
Cost: £595
Exhibited: *Patrick Reyntiens*,
3 December 2011,
Goldmark Gallery, #18

What's in My Mind
Date: 2010
Size: 20.0x28.0cm

Where Have We Come From? Where Are We Going?
Date: 2011
Size: 27.0x30.0cm
Cost: £495
Exhibited: *Patrick Reyntiens*,
3 December 2011,
Goldmark Gallery, #77

Wild Birds in the Wet
Date: 2009
Size: 24.0x28.0cm
Cost: £395
Exhibited: *Patrick Reyntiens*,
3 December 2011,
Goldmark Gallery, #62

Wild Wood in the Country
Date: 2011
Size: 26.0x30.0cm
Cost: £395
Exhibited: *Patrick Reyntiens*, 3 December 2011, Goldmark
Gallery, #52

Woman Asleep
Date: 2010
Size: 22.5x33.5cm
Cost: £395
Exhibited: *Patrick Reyntiens*,
3 December 2011,
Goldmark Gallery, #38

Woods, Woods, Woods!!
Date: 2011
Size: 28.0x29.0cm
Cost: £495
Exhibited: *Patrick Reyntiens*,
3 December 2011,
Goldmark Gallery, #16

Woody Hills. All Around
Date: 2011
Size: 22.5x30.0cm
Cost: £495
Exhibited: *Patrick Reyntiens*,
3 December 2011,
Goldmark Gallery, #27

You Must believe Me!
Date: 2010
Size: 23.0x28.5cm
Cost: £395
Exhibited: *Patrick Reyntiens*,
3 December 2011,
Goldmark Gallery, #17

You Messed Ma Bet!
Date: 2010
Size: 18.0x26.0

You're all Welcome here, Pilgrims
Date: 2011
Size: 31.5x32.0cm
Cost: £795
Exhibited: *Patrick Reyntiens*, 3 December 2011, Goldmark
Gallery, #15

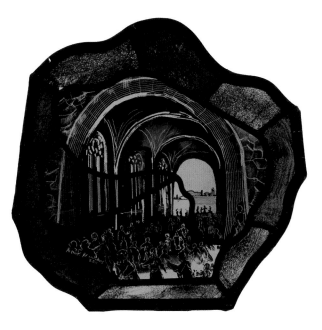

PATRICK

The voice

The eloquence

The elocution

The elan

The eccentricity

A godfather never to be underestimated, an exciting, educated mind, provocative, deeply contemplative, ecstatic at the elevation of the eucharist.

The father of new romanticism in English glass, the most lyrical painter of his generation (who captured the elegance of eighteenth century brush strokes and Chinese calligraphy alike). His brooding colours smouldering through the paint.

Leadline 1990, Patrick Reyntiens & the Burleighfield Experience, Goodden Ted (Ed), Prest Cedar, 'Burleighfield', 1990

TABULATED
BIOGRAPHY

PR = Patrick Reyntiens
AB = Anne Bruce JB = John Betjeman JP = John Piper JR = John Reyntiens
V&A = Victoria and Albert Museum, London
The start and finish dates of each collaborative project are recorded rather than the production dates because PR was frequently consulted by JP at the design stage.
Autonomous panels are marked in green

Date	Private Life	PR Commissions (Reyntiens Studio), Exhibitions and Public Life	Collaborations - Commissions and Exhibitions
1925	Nicholas Patrick Reyntiens born in 63 Cadogan Square, London, mother Janet MacRae		
1927	Anne Mary Bruce born 8 March		
1928	PR lived in Brussels until 1938 – father a diplomat		
1938	Father retired, moved to Stonelands, Dawlish, Devon		
1939	Studied at Ampleforth College (or 1940?) (until 1943)		
1943	Scots Guards (until 1947)		
1947	Studied at St Marylebone School of Art (to 1950) Travelled extensively in Italy, France, Spain, Portugal (until 1953)		
1948	Family sells Stonelands		
1950s	Met Betjeman through Anne Bruce's family Studied at Edinburgh College of Art (until 1951)		
1952	Worked in Eddie Nuttgens' studio for £3 a week (until 1954) Living at Flat 8, 231 Sussex Gardens, Hyde Park, W2		Worked on waterproofing glass for St Ethelreda's, Ely Place, London
1953	Married the artist Anne Bruce 9 September 1953. Lived on £8 a week. Their house, White House, Flackwell Heath, Buckinghamshire, cost £1000 and was completely redecorated for £300.	Wantage, Oxfordshire - panel for JB?	Oundle School, Oundle, Northamptonshire with JP (completed 1956)
1954	Andrew Grant Travelling Fellowship awarded by Edinburgh, travelled France Edith Mary Isabel Reyntiens born 3 October 1954 PR motor bike accident, shoulder hurt, arm in sling		*Heads of Two Kings* with JP
	Bought Burleighfield mid 1950s. Living in The White House, Flackwell Heath, Bucks in April 1955		

1955		*Annunciation*	Eton College, Windsor, Berkshire (completed 1964) *Christ between St Peter and St Paul* with JP (V&A) (completed 1960) *Christ between St Peter and St Paul* with JP (smaller version of V&A panel) *A Small Anthology of Modern Stained Glass*, Aldeburgh Festival, The Arts Council of Great Britain (organised by JP and PR)
1956			Minster Church of St Andrew, Plymouth, Devon with JP (completed 1968) *Experimental panel* with JP (Ely Stained Glass Museum, Cambridgeshire)
1957	Dominick Percival Ian Reyntiens born 8 January	St Leonard's, St Leonards-on-Sea, Sussex	
1958	Spent time in Ireland, studying Irish glass	Derek White starts supervising studio work Bishop's Palace, Peterborough, Cambridgeshire St Mary's, Hound, Hampshire (completed 1959) 2 one-man shows in Edinburgh	Coventry Cathedral of St Michael, West Midlands with JP (completed 1961)
1959	Lucy Mary Anne Reyntiens born 17 July	Elected member of the Art-Workers' Guild, London *Section of Leaded Glass Mural* *Still Life*	Sanderson, City of Westminster, London with JP (completed 1960) Nuffield College, Oxford with JP (completed 1961) Cathedral Church of Saints Peter and Paul, Dyfrig, Teilo and Euddogwy, Lland-aff, South Glamorgan with JP *British Artists Craftsmen*, Smithsonian, 1959-1960
1960		Holy Cross, Hucknall, Nottinghamshire Mylnhurst Preparatory School, Sheffield, Yorkshire (completed 1962) *Beckett's Bones* (V&A) *Beckett's Bones 2* *Mosaic* *Restless Sea* *The Seasons Turn* *Two Variations panels*	All Hallows, Wellingborough, Northamptonshire, with JP (completed 1961) All Saints, Misterton, Nottinghamshire with JP (completed 1965) *Le Cathedrale Engloutie* with Ceri Richards (Pallant House, Chichester, Sussex) *Abstract* with Anthony Curtis *Elect and the Damned* with JP *Nude* with Philip Sutton *Mural Art Today*, Victoria and Albert Museum *Modern Stained Glass*, Arts Council (Venues: Hull, Ferens Art Gallery, 24 September-15 October 1960; Leicester, Art Gallery, 19 November-10 December 1960; Cardiff, National Museum of Wales, 17 December-7 January 1961; Newcastle-on-Tyne, Hatton Art Gallery, 14 January-4 February 1961; Liverpool, Walker Art Gallery, 11 February-4 March 1961; Truro, County Museum and Art Gallery, 11 March-1 April 1961; Coventry, Herbert Art Gallery, 8 April-29 April, 1961; Cambridge, Arts Council Gallery, 6 May-27 May 1961; Southampton, Art Gallery, 3 June-24 June 1961; Newport, Art Gallery, 1 July-22 July 1961; Bristol, City Art Gallery, 29 July-19 August 1961; London, Arts Council Gallery, 5 October-4 November 1961)

1961		Christ Church, Flackwell Heath, Buckinghamshire Abbey Church of St Laurence, Ampleforth, Yorkshire *Patrick Reyntiens*, The Arthur Jeffress Gallery, London, 10 January-27 January 1961	St Mark's Church, Sheffield, Yorkshire with JP (completed 1963) *Brittany Beach Scene 1* with JP *Brittany Beach Scene II* with JP *An Exhibition of GLASS or Glass-making as a creative art through the ages*, Temple Newsam House, Leeds, 6 October – 12 November
1962		St Peter's, Tewin, Hertfordshire (completed 1963) St Michael and All Angels, Marden, Kent (completed 1963) Good Shepherd, Nottingham (completed 1964) Cathedral Church of St Peter and St Paul, Washington DC, USA (completed 1969)	St Peter's, Babraham, Cambridgeshire with JP (completed 1966) Derby Cathedral Church of All Saints, Derbyshire with Ceri Richards St Woolo's Cathedral, Newport, Gwent with JP (completed 1963)
1963		St Mary of the Assumption, Leyland, Lancashire (completed 1964)	St Margaret's, City of Westminster, London with JP (completed 1967) Metropolitan Cathedral of Christ the King, Merseyside with JP (completed 1967) All Hallows, Wellingborough, Northamptonshire, with JP (completed 1964) St Mary's, Swansea, West Glamorgan with JP (completed 1965)
1964	John Patrick Reyntiens born 23 June	Set up Burleighfield (until 1976) On behalf of the BSMGP replied to the speaker Sir Thomas Kendrick at Annual Dinner St Mary's Nursing Home, Ednaston, Derbyshire St Andrew's, Scole, Norfolk Goring Preparatory School, Goring Heath, Oxfordshire Clifton College, Bristol, Somerset	Wessex Hotel, Winchester, Hampshire with JP Ripon College, Cuddesdon, Oxfordshire with JP Christ's College, Christchurch, New Zealand with JP (completed 1969) *Anglesey Beach* with JP *Stained Glass Composition* with JP
1965		St Gregory the Great, London Borough of Hillingdon (completed 1967) St Leonard's, Telford, Shropshire	*Brittany Beach Scene* with JP (V&A) *John Piper*, Baukunst, Cologne, September 1965
1966		St Joseph and St Benildus, Waterford, Ireland Cross (V&A)	Metropolitan Cathedral of Christ the King, Merseyside with Ceri Richards (completed 1967) St Andrew's, Wolverhampton, West Midlands with JP (completed 1970) Malsis School Keighley, Yorkshire with JP (completed 1967) *Metamorphosis, Figure into Abstract*, Herbert Art Gallery, Coventry, 3 September-2 October
1967		Publishes *Technique of Stained Glass* Société Internationale des Artistes Chrétien (SIAC) held 5 day course titled *The Artist – Creator of the Environment* at Spode House, Staffordshire, 5-10 April – speakers included PR St John the Baptist, London Borough of Redbridge Church of the Sacred Heart, Waterford, Ireland (completed 1969) *Standing Piece*	St Paul's, Bledlow Ridge, Buckinghamshire with JP (completed 1968) Churchill College, Cambridge with JP (completed 1970) Bakers' Hall, City of London with JP (completed 1969) *John Piper, Ceri Richards*, Marlborough Fine Art Ltd, London, April 1967
1968		SIAC one day fact finding conference held at Burleighfield House London Oratory School, London Borough of Hammersmith and Fulham (completed 1970) All Saints, Odiham, Hampshire (completed 1969) Unicorn House, Johannesburg, South Africa *Herbin's Tomb* (V&A)	St Giles of Provence, Totternhoe, Bedfordshire with JP (completed 1971) St George's Chapel, King George VI Memorial Chapel, Windsor Castle, Berkshire with JP (completed 1969) St Paul's, Pishill, Oxfordshire with JP

1969		St Margaret of Scotland, London Borough of Richmond Upon Thames (completed 1970) All Saints, Hinton Ampner, Hampshire Christopher Grange, Knotty Ash, Merseyside (completed 1972)	All Hallows, Wellingborough, Northamptonshire with JP St Bartholomew's, Nettlebed, Oxfordshire with JP (completed 1970)
1970	Council member BSMGP (until 1974)	58 Holland Park, Royal Borough of Kensington and Chelsea Cathedral Church of St Peter and St Paul, Washington DC, USA (completed 1975) *Archimboldo*	May Fair Theatre, City of Westminster, London with JP (completed 1971)
1971		St Anselm, London Borough of Ealing	
1972		The Reyntiens Trust Ltd Trustees - Roy Fullick (Chairman), The Lady Norman, JP, administrators PR and AB. Exhibition at Burleighfield with works by JP, Ceri Richards and PR, July	St Martin's, Sandford St Martin, Oxfordshire with JP (completed 1973) Cathedral Church of St Peter and St Paul, Washington DC, USA with JP (completed 1974)
1973		Reyntiens Trust - Mrs Jeanette Jackson made Trustee. *Craftsman's Art*, V&A	
1974		Yoshiro Ohyama assistant until 1975 Reyntiens Trust - JP a Patron, also Michael Hattrell MA Cantab FRIBA. Trustees - John Hastings (Chairman), John Hocknell, Geoffrey Marshall, Directors PR and AB Holy Family, Southport, Merseyside (completed 1975) *Three Sacred Mountains panels* *Visions of Ezekiel panels*	St Mary the Virgin, Turville, Buckinghamshire with JP (completed 1975) St Bartholomew's, Nettlebed, Oxfordshire with JP (completed 1976)
1975		David Wasley starts working for PR, Ray King acts as assistant Sion Community, Brentwood, Essex (completed 1976) St Ambrose, Speke, Merseyside (completed 1977)	Church of St Peter, Wolvercote, Oxfordshire with JP (completed 1976)
1976	Awarded OBE for Services to Art Rents Old Church School, Windsor End, Beaconsfield for studio – work completed 1977	Head of Fine Art, St Martins School of Art and Central School of Art and Design, London (until 1986) Senior Tutor, Pilchuk School of Glass, USA *Transfiguration*, Cowley Fathers School, Oxford	
1977		Burleighfield moved to Old Church School, Windsor End, Beaconsfield All Saints, Lowesby, Leicestershire	St Mary's, Fawley, Buckinghamshire with JP (completed 1978) Charing Cross Hospital, London Borough of Hammersmith and Fulham with JP (completed 1978) Thorpe Tilney Hall, Timberland, Lincolnshire with JP (completed 1980)
1978		Christopher Grange, Knotty Ash, Merseyside (completed 1979)	Robinson College, Cambridge with JP (completed 1980) *Glass/Light*, The Royal Exchange, 18 July-12 August 1978
1979		Assistants Joe A Nuttgens (manager until 1982), Gregory Norman from Detroit, Phil Kenchatt and David Williams Sledmere House, Sledmere, Yorkshire with David Wasley	St Peter and St Paul, Aldeburgh, Suffolk with JP (completed 1980) Ipswich School, Ipswich, Suffolk with JP (completed 1981) *Das Bild in Glas*, Hessisches Landesmuseum Darmstadt, 4 October – 11 November 1979
1980	Family moved to Ilford Bridges Farm in Somerset	Christ Church College, Oxford (completed 1984)	St Peter & St Paul, Northampton with JP (completed 1982)

Year			
1981		Senior Tutor, Pilchuk School of Glass, USA St Lawrence College, Ramsgate, Kent (completed 1982)	Charing Cross Hospital, London Borough of Hammersmith and Fulham with JP Rayne House, Royal Borough of Kensington and Chelsea with JP St Paul's Church, Jarrow, Tyne and Wear with JP *Benedict Biscop* with JP
1982		David Wasley leaves to form own studio Cathedral Church of St Marie, Sheffield, Yorkshire	*Four Seasons*, with JP made for Chatres Exhibition *New British Glass & Vitrail Francais Contemporain* *Archaeological Finds*, Wiltshire Archaeological & Natural History Museum, Devizes with JP *John Piper painting in coloured light*, Kettle's Yard Gallery, 3 December 1982-9 January 1983
1983		Holy Trinity, Lyne, Surrey (completed 1985) *Male Figure in a Wooded Landscape*, Canadian Clay and Glass Gallery, Ontario, Canada *Ovid's Metamorphoses panels* (completed 1985)	*John Piper*, The Tate Gallery, London, 30 November 1983 -22 January 1984
1984		St John Fisher, London Borough of Merton *Temptation of St Anthony* (Ely Stained Glass Museum, Cambridgeshire) *Homer's Iliad and Odyssey panels* *Landscape from Theocritus* *Orpheus panels*	Hospital of St John Baptist, Lichfield, Staffordshire with JP
1985		*Greek Anthology* *Patrick Reyntiens, Glass Painted and Stained, Visions in Light*, Bruton Gallery (venues: London, Bruton, New York)	All Saints, Basingstoke, Hampshire with Cecil Collins (completed 1988)
1986		St Theodore of Canterbury, London Borough of Richmond Upon Thames Good Shepherd, Borough Green, Kent (completed 1987) *Fool's Paradise* (Derix Glasstudios, Germany) *Musical Hommages panels* (completed 1989) *Palaestra panels* (completed 1987) *Working With Light*. RIBA, organised by Andrew Moor and Bronson Shaw and sponsored by Andrew Moor Associates and Derix Glasstudios, April 1986	
1987		*Hercules as Harlequin* (completed 1988)	*To Build a Cathedral, 1945-1962, Coventry Cathedral*, University of Warwick, 1987
1988		*Abstract 2* *Competitive Sport*	
1989		Holy Trinity, Lyne, Surrey (completed 1980) *Goodbye Pantaloon* *Gymnasts*	
1990	Visited Canada	Publishes *Beauty of Stained Glass* Royal Surrey County Hospital, Guildford, Surrey *Branagh as Quince panels* *Circus characters and Commedia dell'arte panels* *Hercules' Twelve Labours panels* *Life of St Paul 'From the Baroque' panels* (completed 1991) *Triumph of Dame Edna Everage panels* *Retrospective Exhibition*, Ontario Crafts Council Gallery, Dundas St, Toronto (17 May – 30 June) *Patrick Reyntiens. Theatre. Commedia Dell'Arte. Circus*, The Fine Art Society, 26 November-21 December 1990	*John Piper in Wales*, Davis Memorial Gallery, Welshpool, 1990
1991		St Bernadette's Church, Lancaster *Catullus panels*	

1992		*Confrontation panels*	*The Painter in Glass*, Swansea Festival Exhibition, 1992
1993		Dellow Centre, London Borough of Tower Hamlets with Bernard Becker & Partners	
1994	Recipient of Excellence in Education Award, presented by the Stained Glass Association of America	John Reyntiens starts working with PR St Andrew, Much Hadham, Hertfordshire with JR (completed 1995) *Bosnia-Herzogovina panels* *Images of Myth and Love. Stained glass panels for the collector and the connoisseur, Patrick Reyntiens. Exhibition of stained glass*, Bernard Becker Gallery, Clerkenwell, London, 16 June – 1 September 1994	
1995		Minster and Cathedral Church of St Mary the Virgin, Southwell, Nottinghamshire with JR and Keith Barley (completed 1996) *Penelope's Panel*	
1996		Heathfield School, Ascot, Berkshire with JR St Peter's, Goytre, Monmouthshire	
1997		St George, Anstey, Hertfordshire with JR (completed 2000)	
1999		Heathfield School, Ascot, Berkshire with JR St Mary's, East Knoyle, Wiltshire with JR (completed 2000)	*Pleasure of Peace: Light, Art and Design in Britain1939-1968*, The Sainsbury Centre for Visual Arts, 1 February-18 April and Brighton Museum and Art Gallery, 1 May-20 June.
2000	*Rather Good at Blue*, NTV West film about PR	*George Club*, City of Westminster, London with JR St Mary's, Stoke St Mary, Somerset with JR (completed 2003)	
2002		St Alban, Promartyr, London Borough of Havering (completed 2004) Abbey Church of St Laurence, Ampleforth, Yorkshire with JR (completed 2004)	
2004		St Mary the Virgin, Shipton-under-Whychwood, Oxfordshire with JR	St Martin's, Cochem, Germany with Graham Jones (completed 2009)
2006	Anne Bruce dies, 18 October	The Frances Bardsley School for Girls, London Borough of Havering Abbey Church of St Laurence, Ampleforth, Yorkshire with JR (completed 2007)	
2007	Visits India		
2009		St George, Taunton, Somerset with JR (completed 2010) 200 small autonomous panels (completed 2010)	
2011	*From Coventry to Cochem, the Art of Patrick Reyntiens*, Reyntiens/Malachite film about PR	75 limited edition panels for Goldmark Gallery *Stained Glass. Patrick Reyntiens*, 3 December 2011, Goldmark Gallery, Uppingham (1 day one-man show)	

'About nine years ago I had a funny dream about 5 o'clock in the morning, those sorts of dreams you can remember late in your sleeping pattern and my guardian angel came to me and said "You'll live 'til you're 96" and I said "Oh how wonderful" and he said "You'll have to work for it". So there we are, I'm still working.'

Interview with Patrick Reyntiens, 29 April 2010

BIBLIOGRAPHY
AND
RED HERRINGS

BIBLIOGRAPHY

Altet Xavier Barral I, *Stained Glass Masterpieces of the Modern Era*, London: Thames & Hudson, 2007

Angus Mark, *Modern Stained Glass in British Churches*, London & Oxford: Mowbray, 1984

Archer Michael, 'John Piper and the Stained Glass of the King George VI Memorial Chapel 1967-9', in Brown Sarah, *A History of the Stained Glass of St George's Chapel, Windsor Castle, Windsor*: Dean and Canons of Windsor, 2005

Ayers Tim, Brown Sarah, Neiswander Judy, *The Stained Glass Museum Gallery Guide*, Lowestoft: The Stained Glass Museum, 2004

Baden Fuller Kate, *Contemporary Stained Glass Artists. A Selection of Artists Worldwide*, London: A&C Black Publishers Ltd, 2006

Bender Rodney, 'The Painter in Glass 19th and 20th Centuries', in Lloyd Alison (Ed), *The Painter in Glass*, Dyfed: Gomer Press, 1992

Betjeman John (Ed), *Collins Guide to English Parish Churches*, London: Collins, 1959 (1958)

Bettley James, Pevsner Nikolaus, *The Buildings of England, Essex, London*: Yale University Press, 2007 (1954)

Bradley Simon and Pevsner Nikolaus, *The Buildings of England, London 1: The City of London,* London: Penguin Books, 1997

Bradley Simon and Pevsner Nikolaus, *The Buildings of England, London 6: Westminster,* London: Yale University Press, 2003

Bullen Michael, Crook John, Hubbuck Rodney and Pevsner Nikolaus, *The Buildings of England, Hampshire: Winchester and the North*, London: Yale University Press, 2010 (1968)

Campbell Louise, *Coventry Cathedral. Art and Architecture in Post-War Britain*, Oxford: Clarendon Press, 1996

Catholic Blind Institute & St Vincent's School for the Blind and Partially Sighted, Annual Report & Statement of Accounts 1969-1970

CBRN, 'Church of St Ambrose, Speke, Liverpool', 1961

CBRN, 'Metropolitan Cathedral of Christ the King, Liverpool. The Final Design', 1961

CBRN, 'Metropolitan Cathedral of Christ the King, Liverpool', 1962

CBRN 'Mylnhurst Convent Chapel, Sheffield', 1962

CBRN, 'St Mary's Church, Sacristy and Priory, Leyland, Lancs', 1962

CBRN, 'Metropolitan Cathedral of Christ the King Liverpool', 1963

CBRN, 'St Mary's Priory Church, Sacristy and Priory, Broadfield Drive, Leyland, Lancs', 1963

CBRN, 'Metropolitan Cathedral of Christ the King, Liverpool', 1964

CBRN, 'St Mary's Church, Sacristy and Priory, Leyland, Lancs', 1964

CBRN, 'Foreword by The Most Reverend George Andrew Beck, Archbishop of Liverpool', 1967

CBRN, 'Christopher Grange, West Derby, Liverpool', 1969

CBRS, 'Proposed Church of the Holy Cross, Hucknall, Nottinghamshire', 1957

CBRS, 'Proposed Church of The Holy Cross, Hucknall', 1958

CBRS, 'Church of The Holy Cross, Hucknall, Nottinghamshire', 1960

CBRS, Monsignor Cyril Taylor, 'Liverpool's New Metropolitan Cathedral', 1960

CBRS, Rt Revd George Andrew Beck, Bishop of Salford, 'Design, Price and Value', 1960

CBRS, 'Church of The Good Shepherd, Thackeray's Lane, Woodthorpe, Nottingham', 1961

CBRS, 'Canon Hill Church of St John Fisher', 1962

CBRS, 'Church of the Good Shepherd, Thackeray's Lane, Woodthorpe, Nottingham', 1963

CBRS, 'Church of The Good Shepherd, Thackeray's Lane,

Woodthorpe, Nottingham', 1964

CBRS, 'New Presbytery, Church and Parish Rooms, Southall, Middlesex', 1964

CBRS, 'Church of St Gregory the Great, South Ruislip, Middlesex', 1965

CBRS, 'St Margaret of Scotland, East Twickenham', 1966

CBRS, 'Church of St Gregory The Great, Victoria Road, South Ruislip, Middlesex', 1967

CBRS, 'St John The Baptist Church, Wanstead Park Road, Ilford, Essex', 1967

CBRS, 'St Margaret's Church, 130 St Margaret's Road, East Twickenham', 1969

CBRS, 'St George's Church, Taunton', 1970

CBRS, 'New Convent for the Sisters of Mercy, Brentwood', 1974

CBRS, 'Convent of Mercy, Brentwood for the Sisters of Mercy, Brentwood', 1975

Caudwell Hugo, *The John Piper Windows Executed for Oundle School Chapel by Patrick Reyntiens*, 1956

Cherry Bridget, Pevsner Nikolaus, *The Buildings of England, Devon*, Harmondsworth: Penguin Books, 1991 (1952)

Cherry Bridget and Pevsner Nikolaus, *The Buildings of England, London 2: South*, Harmondsworth: Penguin Books, 1983

Cherry Bridget and Pevsner Nikolaus, *The Buildings of England, London 3: North West*, Yale University Press, 2002 (1991)

Cherry Bridget, O'Brien Charles and Pevsner Nikolaus, *The Buildings of England, London 5: East*, London: Yale University Press, 2005

Cherry Bridget, Pevsner Nikolaus, *The Buildings of England, Northamptonshire*, Harmondsworth: Penguin Books, 1973 (1961)

Christopher Grange Centre for Adult Blind, 1972

Ciarán Fiona, *Stained Glass Windows of Canterbury, New Zealand: a catalogue raisonne*, Dunedin: University of Otago Press, 1998

Ciarán Fiona & Teal Jane, *The Stained Glass Windows of Christ's College Chapel,* Christchurch: Christ's College, 2001

Clarke Brian (Ed), *Architectural Stained Glass*, London: John Murray, 1979

Cowen Painton, *A Guide to Stained Glass in Britain*, London: Michael Joseph Ltd, 1985

Crimi Elody and New Diane, *Jewels of Light. The Stained Glass of Washington National Cathedral*, Washington National Cathedral, 2004

Dutton Ralph, *Hinton Ampner. A Hampshire Manor*, National Trust, 2010 (1968)

Elrington C R (Ed), *The Victoria History of the County of Oxford, Volume 11*, London: Oxford University Press, 1983

Farmer David, *Oxford Dictionary of Saints*, Oxford University Press, 1997 (1978)

Gibberd Frederick, *Metropolitan Cathedral of Christ the King Liverpool*, London: The Architectural Press, 1968

Goldie Mark, *God's bordello: storm over a chapel. A history of the chapel at Churchill College Cambridge*, Cambridge, 2007

Greeves Lydia, 'Introduction' in Dutton Ralph, *Hinton Ampner. A Hampshire Manor*, National Trust, 2010 (1968)

Harman Ruth and Minnis John, *Pevsner Architectural Guides, Sheffield*, London: Yale University Press, 2004

Harrison Martin, 'Introduction', *Glass/Light*, London, 1978

Harrison Martin, 'Introduction', in Compton Ann (Ed), *John Piper painting in coloured light*, Kettle's Yard Gallery, 1982, unpaginated

Harrod Wilhelmine, *The Norfolk Guide*, Bury St Edmunds: The Alastair Press, 1988 (1958)

Hartwell Clare, Pevsner Nikolaus, *The Buildings of England, Lancashire: North*, Yale University Press, 2009

Harwood Elaine, *England. A Guide to Post-War Listed Buildings*, London: B T Batsford, 2003 (2000)

Haward Birkin, *Nineteenth Century Suffolk Stained Glass*, Suffolk: Boydell Press, 1989

Healey R M, *A Shell Guide to Hertfordshire*, London: Faber and Faber, 1982

Heard Kate, *Light in the East. A Guide to Stained Glass in Cambridgeshire and The Fens*, Stained Glass Museum, 2004

Heenan John C, *A Crown of Thorns. An Autobiography 1951-1963*, London: Hodder and Stoughton, 1974

Hicks Carola, *Cambridgeshire Churches*, Stamford: Paul Watkins, 1997

Hughes Pennethorne, *Kent Shell Guide*, London: Faber & Faber, 1969

Ingrams Richard and Piper John, *Piper's Places. John Piper in England & Wales*, London: Chatto & Windus. The Hogarth Press, 1983

Jenkins Simon, *England's Thousand Best Churches*, London: Allen Lane The Penguin Press, 1999

Leach Peter and Pevsner Nikolaus, *The Buildings of England, Yorkshire: West Riding. Leeds, Bradford and the North*, Yale University Press, 2009

Lee Lawrence, Seddon George, Stephens Francis, *Stained Glass*, London: Mitchell Beazley, 1976

Lee Lawrence, *The Appreciation of Stained Glass*, Oxford University Press, 1977

Lewis David, *The Churches of Liverpool*, Liverpool: Bluecoat Press, 2001

Little Bryan, *Catholic Churches since 1923*, London: Robert Hale, 1966

Lloyd Alison (Ed), *The Painter in Glass*, Dyfed: Gomer Press, 1992

Lycett Green Candida (Ed), *John Betjeman. Letters Volume Two: 1951 to 1984*, London: Methuen, 1995

Martin Christopher, *A Glimpse of Heaven. Catholic Churches of England and Wales*, Swindon: English Heritage, 2006

Moor Andrew, *Contemporary Stained Glass. A Guide to the Potential of Modern Stained Glass in Architecture*, London, Mitchell Beazley International Ltd, 1989

Moor Andrew, *Architectural Glass Art. Form and technique in contemporary glass*, London: Mitchell Beazley, 1997

Morris Elizabeth, *Stained and Decorative Glass*, Baldock: Apple Press Ltd, 1988

Mortlock D P, *The Popular Guide to Suffolk Churches, No 3 East Suffolk*, Cambridge: Acorn Editions, 1992

Mortlock D P and Roberts C V, *The Guide to Norfolk Churches*, Cambridge: Lutterworth Press, 2007 (1981 and 1985)

NADFAS, *Nadfas Church Record, St Paul's Church, Bledlow Ridge, Bucks*, 1974

NADFAS, *Nadfas Church Record, Fawley, St Mary the Virgin*, 1977 (1973)

NADFAS, *Record of Church Furnishings, St Bartholemew's, Nettlebed, Oxfordshire*, 1978

NADFAS, *Record of Church Furnishings, St Peter's, Tewin, Herts*, 1985

NADFAS, *Nadfas Church Record, St Margaret's Westminster Abbey*, 1993

NADFAS, *Record of Church Furnishings, St Peter and St Paul, Aldeburgh, Suffolk*, 2006

NADFAS, *Record of Church Furnishings, St Mark's, Broomhill, Sheffield, S Yorkshire*, 2010

NADFAS, *Nadfas Church Record, Christ Church, Flackwell Heath*, undated

Neiswander Judith & Swash Caroline, *Stained & Art Glass*, London: The Intelligent Layman Publishers Ltd, 2005

Newman John, *The Buildings of England, West Kent and the Weald*, Harmondsworth: Penguin Books, 1969

Newman John, *The Buildings of England, Glamorgan*, London: Penguin Books, 1995

Newman John, *The Buildings of England, North East and East Kent*, London: Penguin Books, 1998 (1969)

Newman John, *The Buildings of England, Gwent/Monmouthshire*, Harmondsworth: Penguin Books, 2000

Newman John and Nikolaus Pevsner, *The Buildings of England, Shropshire*, Yale University Press, 2006

Osborne June, *John Piper and Stained Glass*, Stroud: Sutton Publishing, 1997

Pace Peter, *The Architecture of George Pace*, London: B T Batsford, 1990

Pevsner Nikolaus and Wedgewood Alexandra, *The Buildings of England. Warwickshire*, Harmondsworth: Penguin Books, 1966

Pevsner Nikolaus, Lloyd David, *The Buildings of England, Hampshire and the Isle of Wight*, Harmondsworth, Penguin Books, 1967

Pevsner Nikolaus, *The Buildings of England, Bedfordshire and the County of Huntingdon and Peterborough*, Harmondsworth: Penguin Books, 1968

Pevsner Nikolaus, 2nd edition revised by Cherry Bridget, *The Buildings of England, Northamptonshire*, Harmondsworth: Penguin Books, 1973 (1961)

Pevsner Nikolaus, *The Buildings of England, Staffordshire*, Harmondsworth: Penguin Books, 1974

Pevsner Nikolaus, 2nd edition revised by Cherry Bridget, *The Buildings of England, Hertfordshire*, Harmondsworth: Penguin Books, 1977 (1953)

Pevsner Nikolaus, 2nd edition revised by Williamson Elizabeth, *The Buildings of England, Nottinghamshire*, Harmondsworth: Penguin Books, 1979 (1951)

Pevsner Nikolaus, revised by Williamson Elizabeth, *The Buildings of England, Leicestershire and Rutland*, Harmondsworth: Penguin Books, 1984 (1960)

Pevsner Nikolaus, Harris John, revised by Antram Nicholas, *The Buildings of England, Lincolnshire*, Harmondsworth: Penguin Books, 1990 (1964)

Pevsner Nikolaus and Williamson Elizabeth, *The Buildings of England, Buckinghamshire*, London: Penguin books, 1994 (1960)

Pevsner Nikolaus, *The Buildings of England, Yorkshire: The North Riding*, London: Penguin Books, 1997 (1966)

Pevsner Nikolaus, revised by Williamson Elizabeth, *The Buildings of England, Derbyshire*, Yale University Press, 2002 (1953)

Pevsner Nikolaus and Wilson Bill, *The Buildings of England, Norfolk 2: North-West and South*, Yale University Press, 2002 (1962)

Pevsner Nikolaus and Neave David, *The Buildings of England, Yorkshire: York and the East Riding*, Yale University Press, 2002 (1972)

Pollard Richard, Pevsner Nikolaus, *The Buildings of England, Lancashire, Liverpool and the South-West*, London: Yale University Press, 2006

Powell Kenneth, *Nottingham Transformed. Architecture and Regeneration for the New Millennium*, London: Merrell Publishers Ltd, 2006

Raguin Virginia Chieffo, t*he history of stained glass. The Art of Light Medieval to Contemporary*, London: Thames and Hudson Ltd, 2003

Reyntiens Patrick, *The Technique of Stained Glass*, London: B T Batsford Ltd, 1967

Reyntiens Patrick, 'Fawley in the Fifties', London, 1983

Reyntiens Patrick, *The Beauty of Stained Glass*, London: Herbert Press, 1990

Reyntiens Patrick, 'Since 1945 … The Art Of Interpretation in Stained Glass', in Lloyd Alison (Ed), *The Painter in Glass*, Dyfed: Gomer Press, 1992

Scarfe Norman, *Cambridgeshire. A Shell Guide*, London: Faber and Faber Limited, 1983

Sherwood Jennifer and Pevsner Nikolaus, *The Buildings of England, Oxfordshire*, Harmondsworth: Penguin Books, 1974

Sherwood Jennifer, *A Guide to the Churches of Oxfordshire*,

Oxford: Robert Dugdale, 1989
Sledmere, Norfolk: Jarrold Publishing, 2008
Spalding Frances, *John Piper Myfanwy Piper. Lives in Art*, Oxford: Oxford University Press, 2009
Spence Basil, *Phoenix at Coventry. The Building of a Cathedral – by its Architect*, London and Glasgow: Fontana Books, 1964 (1962)
Stained Glass Windows and Master Glass Painters 1930-1972, Bristol: Morris & Juliet Venables, 2003

Taylor Nicholas and Booth Philip, *Cambridge New Architecture*, London: Leonard Hill, 1970
The Christian Heritage of Ryedale. 2000 Years of Living Faith, Ryedale Christian Community, undated
Thorold Henry, *Collins Guide to Cathedrals, Abbeys and Priories*, Collins: London, 1986
Thorold Henry, *Lincolnshire Houses*, Wilby: Michael Russell (Publishing) Ltd, 1999
Trevor-Roper Hugh, *Christ Church Oxford. The Portrait of a College*, Governing Body of Christ Church
Tyack Geoffrey, Bradley Simon and Pevsner Nikolaus, *The Buildings of England, Berkshire*, London: Yale University Press, 2010

West Anthony, *John Piper*, London: Secker & Warburg, 1979
Wright Carolyn, *Exploring Cambridgeshire Churches*, Stamford: Cambridgeshire Historic Churches Trust, 1991

JOURNALS, MAGAZINES AND NEWSPAPERS

American Glass Guild, Reyntiens Patrick, 'A letter from Senior Advisor, Patrick Reyntiens', 20 January 2010
Ampleforth Journal, Corbould Father Edward, 'Ampleforth Abbey Church', 1961, #66
Architect and Building News The, Scott Keith 'Liverpool Cathedral – a criticism', 31 August 1960
Architect & Building News, 'Church, Nottingham', 23 September 1964
Architects' Journal, 'Art of the informal', 17 December 1980, Vol 172
Architects' Journal, 'Robinson College, Cambridge', 5 August 1981, Vol 174, #31
Architectural Review, 'New Windsor Chapel', February 1970
Architectural Review, Peter Davey, 'Cambridge Castle', August 1981, Vol CLXX, #1014
Architecture East Midlands, Stone John, 'Roman Catholic Church of the Good Shepherd, Woodthorpe', No 10, October/November 1966
Art News and Review, Lucie-Smith Edward, 'Patrick Reyntiens and Pictures of Fantasy and Sentiment', Jan 28-Feb 11 1961
Art New Zealand 37, Ciarán Fiona, 'The Piper-Reyntiens Window in New Zealand', Summer 1985
Berks and Bucks Countryside, Coomer Norman, 'Exciting new future for Beaconsfield school', Vol 20, No 157, September 1980

Building, 'A New College for Cambridge', 29 November 1974, Vol CCXXVII, #6860
Building, Spring Martin, 'College Collage', 19/26 December 1980, VolCCXXXIX, #7170
BSMGP, 'News and Notes', Volume 12, No 2, 1957
BSMGP, Lowe John, 'Stained Glass at Coventry Cathedral', Vol 13, no 4, 1963
BSMGP, Autumn 1982
BSMGP, Spring 1986
BSMGP, 'Working with Light', Autumn 1986
BSMPG, Williams Rachel, 'Patrick Reyntiens', Spring 1991
BSMGP, Swash Caroline, 'Peter Young', Autumn/Winter 1992
BSMGP, 'current events', Spring/Summer 1993
BSMGP, Swash Caroline, 'The Painter in Glass', Spring/Summer 1993
BSMGP, 'New Work', Spring/Summer 1994
BSMGP, Corrin Adelle, 'Images of Myth and Love. An exhibition of stained glass panels by Patrick Reyntiens', Autumn/Winter 1994

BSMGP, Ferrell Ginger, 'New Work Graham Jones', Autumn/Winter 1994
BSMGP, Barley Keith, 'Southwell Minster: The Great West Window', 1996, Issue 2
BSMGP, Swash Caroline, 'On Contemporary Glass', Vol XXIII, 1999
BSMGP, Cormack Peter, 'Crimi Elodi R and Ney Diane, Jewels of Light. The Stained Glass of Washington National Cathedral', Vol XXIX, 2005
BSMGP, '"C R Wyard, Aspects of 20th-Century Stained Glass": BSMGP International Conference 2008', Vol XXXII, 2008
BSMGP, Crichton-Miller Emma, 'The Great Glass Elevator', Vol XXXIV, 2010
Builder The, 'St Mary's Priory Church, Leyland, Lancashire', 2 May 1964
Builder The, 'St Mark's Church, Sheffield', 23 October 1964
Building, 'King George VI Chapel in St George's Chapel, Windsor', 29 March 1968
Building, 'King George VI Memorial Chapel, Windsor', 12 September 1969
Building, 'Convent of Mercy, Brentwood', 23 April 1976
Burlington Magazine The, Spalding Frances, 'John Piper and Coventry, in war and peace', CXLV, July 2003

Cambridge Evening News, 'Generous knight dies in seclusion', 12 January 1987
Chiltern Society's News, Gayner Richard, 'St Mary's Restored', August 1975
churchbuilding, Corbould Edward O.S.B., St Mary's Priory Church, Leyland, October 1964, no 13 (the article was also published in *Ampleforth Journal*, June 1964)
churchbuilding, Sheppard Richard and Duckworth Canon, 'Churchill College Chapel', October 1968, no 25
Church Building, 'Re-ordering of St John Fisher, Morden. Roman Catholic Diocese of Southwark', Whitsun 1985
Church Building, Reyntiens Patrick, 'Re-ordering of St John Fisher, Morden. Roman Catholic Diocese of Southwark', Whitsun 1985
Cornerstone, RS, '… but then there was John Piper', Vol 25, No 4, 2004
Country Life, Caudwell Hugo, 'New Windows at Oundle', 2 August 1956
Country Life, Dunlop Ian, 'Alice in Stained Glass. The Reyntiens Windows at Christ Church, Oxford', 15 November 1984
Country Life, 'Living National Treasure: Artist in Glass', 2 June 1994
Crafts, Margetts Martina, 'A Piper Portfolio', No 36, January/February 1979

Decorative Arts Society The, Omnium Gatherum, Horner Libby, 'Patrick Reyntiens' Autonomous Panels. Myth, music and theatre', Journal 35, 2011
Derby Evening Telegraph, 'Derby Diocese's Scheme. £200,000 Cathedral extensions and repairs, Church House redevelopment', 10 February 1966
Derby Evening Telegraph, 'Permanent Memorial', 15 November 1971
Derby Evening Telegraph, Flint Fred, 'Renovations Complete: Cathedral Reopening Sunday', 2 March 1972
Derby Evening Telegraph, 'Advertisement Feature', 7 March 1972
Derbyshire Advertiser The, 'Restored Cathedral Re-Opens on Sunday', 3 March 1972
Derbyshire Life and Countryside, 'The restoration of Derby Cathedral', May 1972
Derby Trader, 'Cathedral reopens for worship on Sunday', 1 March 1972

Green Book The, A Quarterly Review of the Visual and Literary Arts, Grimshaw Rosalind, 'Patrick Reyntiens. Visions of Classical Life. Metamorphoses', Autumn 1985
Guardian The, 'The house that Robinson built', 8 December 1980
Guardian The, Bell Julian, 'Seeing the Light', 13 June 2009

Heathfield Magazine The, 'Headmistress's Letter', 1996

Heathfield Magazine The, 'Headmistress's Letter', 1999
Hound Chronicle The, June 1959
House and Garden, Levi Peta, 'Springboard from Piper and Reyntiens: or the brave new world of the stained-glass designers', April 1983

Independent Magazine The, Fuller Peter, 'An English Romantic', 10 December 1988
Lawrentian The, Binfield John H, 'The Memorial Window – An Appreciation', Summer Term 1981
Lawrentian The, 'College Notes', Summer Term 1981
Lawrentian The, Binfield John H, 'The President's Window', Summer Term 1982

Leadline = the Annual publication of AiSG (Artists in Stained Glass)
Leadline 1990, Patrick Reyntiens & the Burleighfield Experience, Goodden Ted (Ed), 1990
Leadline 1990, Patrick Reyntiens & the Burleighfield Experience, Goodden Ted (Ed), 'Preface', 1990
Leadline 1990, Patrick Reyntiens & the Burleighfield Experience, Goodden Ted (Ed), Moor Andrew, 'Introduction to the Recent Work of Patrick Reyntiens', 1990
Leadline 1990, *Patrick Reyntiens & the Burleighfield Experience*, Goodden Ted (Ed), Stannard Meryl, 1990
Leadline 1990, Patrick Reyntiens & the Burleighfield Experience, Goodden Ted (Ed), Prest Cedar, 'Burleighfield', 1990
Leicester Mercury, 'Memorial window splendid addition to church of All Saints', 30 December 1977
Listener The, Dodd Philip, 'Fertile Imaginings' 15 Nov 1990

Nottinghamshire Guardian, 20 July 1963
Nottinghamshire Guardian, 18 April 1964

Oldie The, McEwen John, 'DVD Reviews', February 2010
One More Peek. June 2006. Big Friends and Little Friends, Friends of the 398th, 2006

Register of Artists and Craftsmen in Architecture, Patrick Reyntiens, undated

Somerset Magazine The, Philips Lionel, 'Artists in Somerset No. 1. Patrick Reyntiens and Anne Bruce', July 1993
Spectator The, Harrod Tanya, 'Talking about angels', 18/25 December 1993
Stained Glass = the quarterly of The Stained Glass Association of America
Stained Glass, Spring 1985, Volume 80, Number 1, Millard Richard, 'Richard T Feller. Aesthetic Beacon of Washington Cathedral'
Stained Glass, Winter 1994, Volume 89, Number 4, '1994 Excellence in Education Awards'
Stained Glass, Spring 1995, Volume 90, Number 1, Coombs Debora, 'British Stained Glass'
Studies in Church History: The Church and The Arts, Tarn John Nelson, 'Liverpool's Two Cathedrals', Oxford: Blackwell Publishers, 1992
Studio International, Piper John, 'The Liverpool Lantern', Volume 173, Number 890, June 1967
Sunday Telegraph The, Faulkes Sebastian, 'Romantic vision of a pagan believer', 1 July 1984
SundayTimes The, Colour Section, 'Coventry Cathedral', 20 May 1962

Telegraph The, 'The Angel Awards: The Good Shepherd, Woodthorpe, Nottinghamshire', 17 September 2011
Times The, 'Brilliant Design for Church Window. Mr John Piper's Work on View', 8 November 1957
Times The, 'Obituaries John Piper', 30 June 1992
Times The, Wasley David, 27 March 2002
Times The, 'Happy Birthday Patrick Reyntiens, 85', 11 December 2010
Twentieth Century Architecture, Harwood Elaine, 'Liturgy and Architecture: The Development of the Centralised Eucharistic Space', No 3, 1988
Wiltshire Archaeological and Natural History Magazine The, 'Inauguration of New Galleries and John Piper Stained Glass Window, 19 June 1982', 1983, Vol 77
Wiltshire Archaeological and Natural History Magazine The, Sykes Bonar, 'John Piper' in Obituaries, 1994, Vol 87

EXHIBITION CATALOGUES – these are in order of date

A Small Anthology of Modern Stained Glass, Aldeburgh Festival, The Arts Council of Great Britain, 1955
British Artist Craftsmen, Smithsonian Institution, 1959-1960
mural art today, Victoria and Albert Museum, 1960
Modern Stained Glass, Arts Council, 1960-1961
(Venues: Hull, Ferens Art Gallery, 24 September-15 October 1960; Leicester, Art Gallery, 19 November-10 December 1960; Cardiff, National Museum of Wales, 17 December-7 January 1961; Newcastle-on-Tyne, Hatton Art Gallery, 14 January-4 February 1961; Liverpool, Walker Art Gallery, 11 February-4 March 1961; Truro, County Museum and Art Gallery, 11 March-1 April 1961; Coventry, Herbert Art Gallery, 8 April-29 April, 1961; Cambridge, Arts Council Gallery, 6 May-27 May 1961; Southampton, Art Gallery, 3 June-24 June 1961; Newport, Art Gallery, 1 July-22 July 1961; Bristol, City Art Gallery, 29 July-19 August 1961; London, Arts Council Gallery, 5 October-4 November 1961)
Patrick Reyntiens, The Arthur Jeffress Gallery, London, 10 January-27 January 1961
An Exhibition of GLASS or Glass-making as a creative art through the ages, Temple Newsam House, Leeds, 6 October-12 November 1961
The English Eye, Marlborough-Gerson Gallery Inc, New York, November-December 1965
Metamorphosis, Figure into Abstract, Herbert Art Gallery, Coventry, 3 September-2 October 1966
John Piper, Ceri Richards, Marlborough Fine Art Ltd, London, April 1967
Glass/Light, The Royal Exchange, London, 18 July-12 August 1978
Das Bild in Glas, Hessisches Landesmuseum Darmstadt, 4 October-11 November 1979
Compton Ann (Ed), *John Piper painting in coloured light*, Kettle's Yard Gallery, 3 December 1982-9 January 1983
John Piper, The Tate Gallery, London, 30 November 1983 -22 January 1984
Patrick Reyntiens, Glass Painted and Stained, Visions in Light, Bruton Gallery, 1985 (London, Bruton, New York)
Reyntiens Patrick 'Visions of Classical Life', *Patrick Reyntiens, Glass Painted and Stained, Visions in Light*, Bruton Gallery, 1985
Stamp Gavin, 'Patrick Reyntiens and the Ovid Glass Panels', *Patrick Reyntiens, Glass Painted and Stained, Visions in Light*, Bruton Gallery, 1985
Working With Light. RIBA, organised by Andrew Moor and Bronson Shaw and sponsored by Andrew Moor Associates and Derix Glass Studios, April 1986
Working With Light. A look at contemporary STAINED GLASS in architecture, Andrew Moor Associates and Derix Glass Studios, April 1987
Campbell Louise, *To Build a Cathedral, 1945-1962*, Coventry Cathedral, University of Warwick, 1987
Retrospective Exhibition, Ontario Crafts Council Gallery, Dundas St, Toronto (17 May – 30 June 1990)
Patrick Reyntiens. Theatre. Commedia Dell'Arte. Circus, The Fine Art Society, 26 November-21 December 1990
Jenkins David Fraser, *John Piper in Wales*, Davis Memorial Gallery, Welshpool, 1990
The Painter in Glass, Catalogue of Works, Swansea Festival Exhibition, 1992
Images of Myth and Love. Stained glass panels for the collector and the connoisseur, Patrick Reyntiens. Exhibition of stained glass, Bernard Becker and Partners, Clerkenwell, London, 16 June-1 September 1994
Stained Glass. Patrick Reyntiens, Goldmark Gallery, Uppingham, 2011 (Introduction by Dr Charlotte Grant)

CHURCH and other GUIDES, DEDICATION LEAFLETS and NEWSLETTERS

All Saints' Church in the Basingstoke Team Ministry, leaflet
Ampleforth Abbey, Visitor's Guide 4, 2004
Ampleforth Abbey, Visitors Guide & History, 2012
A Guide to & Tour of the Parish Church of ALL SAINTS, Misterton, 2006
A Guide to Nuffield College Chapel, 2012
A Guide to the Parish Church of St Andrew, Much Hadham, Hertfordshire, 1997 (1986)
A Walk around the Church of St Andrew, Plymouth, undated
Ambit, Wolvercote Parish Magazine, May 1976
Ambit, Wolvercote Parish Magazine, August 1976
Arts & Windows in Coventry Cathedral The, undated

Bakers' Hall flier, undated
Berrill Shirley, *Wellingborough Parish Church, All Hallows, Notes on the Stained Glass Windows*, 1995
Berrill Shirley, *Wellingborough Parish Church, All Hallows, guide*, 2012
Blythe Ronald, *The Parish Church of St Peter & St Paul, Aldeburgh, Suffolk*, 1998 (1957)
Brice Alan, S*t Leonard's Malinslee, Bicentenary 2005, A Telford Church*, 2006
Burleigh Revd Bill and Mather Eileen, *Cathedral Church of Saint Marie Diocese of Hallam. A Simple Guide*, 2003

Christ Church Oxford, Guide to College and Cathedral, undated
Church of St Andrew. Plymouth, undated
Church of the Good Shepherd, Woodthorpe, Nottingham, undated
Church of The Good Shepherd, undated
Churchill Porch and Window dedication leaflet, Washington Cathedral, 29 September 1974
Corten Anthony G, *John Piper and Newport Cathedral*, undated

Dale Ernest, *A History of the Parish of The Good Shepherd Woodthorpe*, 2011
Davies Dr Chrystal, *Around and About Llandaff Cathedral*, Much Wenlock: R J L Smith and Associates, 2006
Die Neuen Kirchenfester in der Pfarrkircher St Martin, Cochem, 2009
Dixon Philip and Coates Nigel, *Southwell Minster, A History and Guide*, undated
Dry Mavis and Smart Reverend Ian Hunter, *The Royal Ancient & Monastic Parish Church of St Paul*, undated

Earl Chris, *St Andrews Church, Scole, Norfolk. A history of Scole and its Church*, 2007

Friends of Llandaff Cathedral, 27th Annual Report, May 1959-March 1960, Merchant Moelwyn William, 'Supper at Emmaus'

Gosling Mari, *The Parish Church of St Michael and All Angels, Marden*, 2009

Hill Revd Roger, *A Telford Church. St Leonard's, Malinslee, a history and guide*, 1980, unpaginated
Humphries Michael, *Pishill Church, Pishill, Henley-on-Thames, Oxon. A Brief History*, 2011

It's time to help, St Margaret's Church Appeal, 2009

Langley John D, *A Short History and Guide To the Parish Church of St Peter and St Paul, Abington*, 4th edition, 2000
Lansberger James, *Derby Cathedral, official guide*, Derbyshire Countryside Ltd, 2002

Mallender Margaret A, *The Great Church. A Short History of the Cathedral Church of All Saints Derby*, Mallender, 1977
Murray Paul & Helen (Eds), *A Short Guide to the Stained Glass Windows in St Mary's Parish Church Swansea*, 2003 (2001)

Pace George G, *St Mark's Church Broomhill Sheffield*, undated

Padley Kenneth, *Our Ladye Church of Swanesey a History of St Mary's*, The Friends of Swansea St Mary, 2007
Padley Kenneth, *there the heaven espy – a guide to swansea st mary by those who worship in it*, The Friends of Swansea St Mary, 2007
Parish News, East Knoyle, Sedgehill, Semley, April 1998
Parish News, East Knoyle, Sedgehill, Semley, May 1998
Parish News, East Knoyle, Sedgehill, Semley, July 1998
Parish News, East Knoyle, Sedgehill, Semley, January 2000
Parish News, East Knoyle, Sedgehill, Semley, March 2000
Parish News, East Knoyle, Sedgehill, Semley, June 2000
Parish News, East Knoyle, Sedgehill, Semley, July 2000
Parish News, East Knoyle, Sedgehill, Semley, August 2000
Parish News, East Knoyle, Sedgehill, Semley, November 2000
Pearce John and George Revd Elizabeth, *All Saints Church Basingstoke. A Guide*, 1998
Presentation of Windows in memory of Sir John Douglas Cockcroft, O.M. First Master of Churchill College Cambridge, Sunday 4 October 1970

St George's Church Anstey, undated
St George's Church Anstey, a brief guide, undated
St Giles' Church, Totternhoe. Visitor's Guide, undated
St Leonard's Parish Church, St Leonards-on-Sea. A Short Guide, undated
St Margaret's Church A Souvenir Guide, Dean and Chapter of Westminster, 2006
St Martin's Church, Sandford St Martin. A guide to the Church and Churchyard, Sandford St Martin PCC, 2009
St Peter's Church, Babraham, guidebook, undated
St Peter's Church, Tewin, A Visitor's Guide, 2009
St Woolos Cathedral Newport. The Cathedral Church of the Diocese of Monmouth, 2012
Servants of God dedication leaflet, Washington Cathedral, March 1976 (with description by R T Feller, Clerk of Works)
Southwell Minster. The Cathedral and Parish Church of the Blessed Virgin Mary. The Cathedral Companion, undated
Southwell Minster, The Great West Window, undated
Spruce Derek, *The Church in the Bury. A Thousand Years of All Saints, Odiham*, Odiham Parochial Church Council, 2001
Spruce Derek, *Illustrated Guide to the Church of All Saints*, 2006
Storer Patrick Anthony, *A History of St George's Catholic Church, Taunton*, 1990

The Cathedral Age, Summer 1976
The Cathedral Age, Winter 1969
The Chapel at Churchill College, 40th Anniversay Appeal, 2007
The Metropolitan Cathedral of Christ the King, Liverpool. Authorised Cathedral Guide, 2005
The Minster Church of St Andrew, Plymouth. The Windows, undated
The Parish Church of Saint Alban, Promartyr, Romford, Essex, appeal leaflet, 2002
Tyack Geoffrey, *Fawley Buckinghamshire. A short history of the Church and Parish*, Fawley Parochial Church Council, 1986

Williams Canon Roger, *St John's Hospital LICHFIELD*, Ziggurat Design, undated
Willie Revd Andrew, *St Woolos Cathedral Newport. Illustrated Guide Book*, 2002(1979)
Windows in St Leonard's Parish Church, undated
Wolvercote Parish Magazine, January 1974
Wolvercote Parish Magazine, June 1975
Woollen Hannah, Lethbridge Richard, *John Piper and the Church. A Stained-Glass Tour of selected local churches, in conjunction with the exhibition at Dorchester Abbey from 21 April to 10 June 2012*, 2012

FILMS

Burder John, *Great Artists Rediscovered: John Piper, John Hutton*, John Burder Films, c1967

Heckford Michael, *Crown of Glass*, Shell Film Unit, 1967

Mapleston Charles, Horner Libby, *An Empty Stage. John Piper's romantic vision of spirit, place and time*, Goldmark/Malachite, 2009

Mapleston Charles, Horner Libby, *From Coventry to Cochem, the Art of Patrick Reyntiens*, Reyntiens/Malachite, 2011

Pow Rebecca, *Rather Good at Blue. A Portrait of Patrick Reyntiens*, HTV West, 2000

WEBSITES

Artefacts website - http://www.artefacts.co.za/main/Buildings/bldgframes.php?bldgid=360

Herschel-Shorland Cassie, http://www.c20society.org.uk/botm/archive/2002/coventry-cathedral

'Male Figure in a Wooded Landscape', http://www.aisg.on.ca/stained_glass_publications/new_articles/reyntiens.htm, 15 January 2003

Artists in Stained Glass, Patrick Reyntiens Individual Glass Panels, 7 November 2008, http://www.aisg.on.ca

'Coventry Cathedral stained glass painter returns to talk about masterpiece', http://www.coventrytelegraph.net/news/coventry-news/2011/06/22/

Cranfield Nicholas, 'Vision of glory for the citizens of Romford', December 2006, http://www.churchtimes.co.uk/content.asp?id=29809

Gardom Anne, 'Surprised by angels, St Alban, Promartyr', Romford, November 2006, http://www.trushare.com/0138NOV06/21Reviews.htm

Procter Robert, http://www.c20society.org.uk/botm/archive/2008/st-marys-leyland-ne

www.grasshopper-hosting.co.uk/Diocese/02_Admin/AHP/Finalreport(PDF)NottinghamEastDeanery/Nottingham,Woodthorpe,theGoodShepherd

www.grasshopper-hosting.co.uk/Diocese/02_Admin/AHP/Finalreport(PDF)NottinghamWestDeanery/Nottingham, Holy Cross

Financial Times, Foyle Jonathan, April 2012, http://www.ft.com/cms/s/2/e4ba737c-8aee-11e1-912d-00144feab49a.html#axzz1tPvZkOeO

Patrick Reyntiens in his library amusing the author with his recital of Theocritus, November 2007

RED HERRINGS

St George's, Parktown, Johannesburg, South Africa

Date: 1963-1964
Location: 4-light east window
Designer: Brian Young
Technical Supervisor: Derek White
Architect in charge: Fleming, Cooke and Walker
Documentation: TGA 200410/2/1/11/74, 75, 77; private correspondence
Literature: *Stained Glass Windows and Master Glass Painters 1930-1972*, Bristol: Morris & Juliet Venables, 2003, p87

Notes: This project has previously been attributed to Reyntiens. In fact the architects were in correspondence with John Piper in 1962 but he refused the commission, handing it over to Brian Young who made the panels at Reyntiens' Burghlefield Studios.

Blessed Sacrament Chapel, Waterford, Ireland

Date: 1968-1969
Location: north and south windows
Designer, Glass Painter and Maker: Patrick Reyntiens
Architect in charge: O'Neill Flanagan
Literature: *Stained Glass Windows and Master Glass Painters 1930-1972*, Bristol: Morris & Juliet Venables, 2003, p87

Notes: I have been unable to identify this chapel. It was suggested that the windows might have been in the Blessed Sacrament church at Mount Sion, the location of the founding of the Irish Christian Brothers and the tomb of the Blessed Edmund Rice but these windows were designed by George Walsh.

St Philip & All Saints (the Barn Church), Atwood Avenue, Kew, London, TW9

Date: 1985
Location: East window
Designer: Meryl Stannard

Notes: This window has been attributed to Reyntiens but in fact was designed by Meryl Stannard who was a pupil of Reyntiens at Burghlefield.

Berkeley Square, City of Westminster, London

Notes: In a letter from Reyntiens to Piper dated about 1985 (mention is made of the large Cecil Collins window in All Saints, Basingstoke, Hampshire) Reyntiens observed: 'I have just finished eight large panels of sand blasted glass NOT like L. Whistler OR that chap at Coventry) for the [?] building on the S. side of Berkeley Square (site of the old Colony club)'. It is not known whether the panels are extant.

The TGA archive contains a vast number of letters from churches and parishioners who desperately wanted Piper/Reyntiens windows and the following gives a flavour of how popular their stained glass was. In some instances a polite refusal (usually due to the limited funds available) forms part of the archive. Since the following projects have not been flagged up by Harrison, Osborne or Spalding it is assumed that they were not accepted by the artists. They are listed in date order. Information about possible commissions from other sources is marked accordingly.

TGA 200410/2/1/11/30 Letter from Secretary to chapel council, Royal Military Academy, Sandhurst, 10 March 1959 asking for window for Memorial chapel 4'6"x12'6" – 'to the memory of young officers who have given their lives in war before reaching mans estate' – name put forward by Sir Hugh Casson

TGA 200410/2/1/11/35 letter from St Agatha's Vicarage, Sparkbrook, Birmingham, 13 July 1959, regarding east window, £2,400 to spare, War Damage Commission

TGA 200410/2/1/11/50 letter from Desmond [?], Ardington House, Wantage, 5 June 1961 regarding High Beach Church, Betjeman says Piper willing to design windows for south transept

TGA 200410/2/1/11/51 letter from vicar, St Anne's, Letchworth Rd, Leicester, 6 June 1961, legacy of £250 in memory of late husband, churchwarden, circular window above altar in new lady chapel – not enough money

TGA 200410/2/1/11/52 and 200410/2/1/11/63 letters from Humphreys and Hurst, Architects, Dorset St, London W1, 18 August 1961 and 9 March 1962, regarding St Augustine's, Whitton, doesn't think it necessary to glaze all 5 windows

TGA 200410/2/1/11/60 and TGA 200410/2/1/11/72 dated 1962 from Rev N T L McKittrick, St Benedict's Vicarage, Glastonbury, east window, Pevsner suggested Piper! Piper quoted £5,000 but they only had £1,000

TGA 200410/2/1/11/83 letter from George Pace to Piper, 12 October 1962 about central lancet in east apse of Pershore Abbey, and maybe other lancets in apse. Also TGA 200410/2/1/11/104 dated 30 October 1963 commission still hopeful. Another letter to Reyntiens dated 8 October 1964 stating Piper reckoned completion by early March 1965 provided Reyntiens has the time – Windsor Castle, St George's Chapel, King George VI Memorial Chapel

TGA 200410/2/1/11/93 letter from W M Cunningham dated 27 June 1963 for Knox Presbyterian church in Dunedin regarding 3-light north gothic window, plain quarry at present, 17'x6'

1964
Piper was asked by Revd Harry Williams of St Mary's, Swansea, to design a screen across the western arch of St Anne chapel within the church. Piper refused.
Literature: Padley Kenneth, *there the heaven espy – a guide to swansea st mary by those who worship in it*, The Friends of Swansea St Mary, 2007, p27

TGA200410/2/1/11/125 letter from Rev H O Duncan of Stadhampton Vicarage, Oxford, 24 September 1964 about a Mrs Davies at Chiselhampton who wanted a window to commemorate her 14 year old son John killed on the farm, but Piper considered it inappropriate

TGA200410/2/1/11/139 letter from Marshall Sisson FRIBA dated 27 January 1965 regarding Upwood Church, figure of St Peter, 1ft 6" widex8ft high, single light of east window

Letters in TGA 200410/2/1/6/1, 2 and 3 from Rev Dr C J S Sergel, St Martins-in-the-Veld, P O Box 139, Saxonwold, Johannesburg dated May and August 1966, building new church, wanted something by Piper, visited him in Fawley Bottom. Latter suggested polyester resin on fibre glass and £2/sq ft

TGA200410/2/1/12/105 letter from Pat Redlich [?], 26 Dec 1966 regarding windows in porch at Little Bowden Church, Market Harborough – how is Piper getting on with them? Also TGA200410/2/1/12/150 dated 13 August 1967 and TGA200410/2/1/12/161 dated 18 November 1967 from Revd L F Bowles, PCC approved idea Piper designing the window. TGA200410/2/1/12/174 dated 21 December 1967 idea turned down after all. Sigurd Christensen also involved.

TGA200410/2/1/12/175 from Miss Dorothy Tungear [?], 8 July 1967, regarding cost for small lancet in lady chapel, Holy Trinity, Oswestry, 3ft 6"x18" – representation of Our Lady

TGA200410/1/1OUN/OXF letter from J N Jacobs, Jesus College, Oxford, 23 October 1978 asking if Piper would design commemorative glass for the Hall, Piper interested. He and Reyntiens to visit. Still in contact 1980. Piper submitted designs but Governing Body rejected them May 1980

TGA 200410/2/1/11/27 letter from V W Hiller OBE of National Archives Building Trust, Salisbury, S Rhodesia – wants a window for the building

TGA200410/2/1/11/91 letter from Revd Canon D H Curtis, The Vicarage, Towcester, Mrs Hesketh lost her husband, Major John Hesketh, and would like a window to right of sanctuary, 20ftx6ft plus maybe another smaller stained glass window opposite to the tune of £2,000

TGA200410/2/1/11/143,144 letters from Mary Behrend, Grey House, Machynlleth, September regarding a window commemorating Sylvan Evans, a previous rector who compiled the first Welsh dictionary – Piper referred them to Reyntiens

The V&A file on Reyntiens includes a letter from his brother Michael suggesting that there is an offertory window in a church (RC) in Dorney, Buckinghamshire by Reyntiens, but I have been unable to trace such a window.

AFTER THOUGHT

To remember the vital details of a career that has lasted some fifty or sixty years is not particularly difficult if one has done the training needed for any visual art. Drawing is the most important activity – from the beginning till the end. This was fully understood before the arrival of photography; because it was the only way anything could be accurately remembered and defined, so as to be able to pass it on to further generations. Drawing stimulated memory – and it still stimulates. It is in the act of drawing, either with visual accuracy or with imaginative vision that the memory is stimulated. This is one of the major results of drawing 'from life', i.e. from a nude model. The formation of the body and its parts in relation to each other, is enclosed in the memory, but the act of drawing results in the memory being attached to anything seen – landscapes, architecture, animals, vegetation, flowers and mechanical paraphernalia. You name it, and the memory can deal with it, digest it, and keep it available for the length of the life of the artist.

And for stained glass, the subject matter of much of the art is, in fact, the dogmatic teaching of the church. The character of stained glass should be decorative and stimulative, but the subject is, in most cases historic. It reminds the eye that experiences it of the truth, of sacrifices, the loyalty and the love experienced in time far gone, but still of vital importance for the following of a life of goodness, invention, imagination, and a feeling of surety in its continued relevance and importance.

Stained glass is not simply a craft, as is so frequently thought and expressed. It is an art. And the first step towards a real feeling in the medium is that of an art training, and having been the recipient of instruction in drawing, painting, modelling and the various arts of etching, and other forms of reproducing and printing. A mind trained in these visual, imaginative and technical accomplishments is one fully equipped for a switch of vision towards the difficult art of stained glass.

As is well known, it is difficult, at the end of four or five years training in an art school, to find a particular job which may support one's life until the art that one is capable of becomes known – well known – famous – and possibly becomes the activity which will produce enough cash to live on – even if only modestly. I found this so, having left Edinburgh College of Art, that great college, where you were taught everything with certainty and hard work. (We were expected to draw from the life -from six in the evening till nine o'clock, after a day's work in the studios, for up to four days in the week) I had no job, and a friend of mine studying architecture at the same college, said to me "My father has a stained glass studio in Buckinghamshire, and needs an assistant at the moment. Would you like to work in his studio?" I immediately said 'yes' , since I had nothing else possible to do , and I needed a job desperately, having just got engaged to be married to another student in the Edinburgh College. That was the beginning of my life, whose activity is perpetuated in the pages of this book that may just have been read.

There is a major difficulty in stained glass and that is contained in its physical permanence of setting. Where does this difficulty come from? The finished work of a stained glass artist has only one setting and that is permanent. It is in the architectural position it occupies for ever. Then we remember that the life of an artist is in debt to the amount of publicity that can be drawn to the art produced. This is obvious when the publicity of all painters in Europe and America is considered. The urge for publicity only becomes effective if the particular work of art can be exchanged, hand to hand, at a profit. Art dealers know this; they live by it. But, since stained glass, however beautiful it may be, is always static when attached to a building and it cannot be moved on at a profit – it therefore is a waste of time and money in having any

publicity attached to it. The only stained glass to gain publicity and public interest is that designed by artists who already have won full public acclaim, by their previous art of painting, drawing and design. Such was that of John Piper, and for thirty-five years I helped Piper to express a marvellous variety of beautiful works in glass, which will have all been seen in the illustrations of this book.

I should say something of the nature of stained glass activity which is not fully understood. The psychological relationship between design and making – between art and craft if you like – is far more reminiscent of music than of other forms of visual art. The designer and maker of glass can help other artists in their design as well as, and at the same time as, continuing to design in their own visual way. The collaboration of artists in stained glass is directly similar to that of music. To take an example; a composer can be fully expressive of his own imaginative, creative vision; but if he or she plays any other composer's work – on piano, or organ or violin, it does not detract from the expressiveness and originality of that composer's original work. Something of this sort is to be found in all the work that I, and my studio, produced in collaboration with John Piper, Henry Moore, Cecil Collins, Ceri Richards and others, as well as my working on a multitude of small and large work in stained glass which were my own invention and were things expressive of my sense of design, colour and subjective relevance. I loved the great artists I worked with, but I kept my own individuality when on my own work.

It is the memory of the diversification of a lifetime, dedicated to a certain form of art that has enhanced my memory and inventiveness and continuous creativity. I am, as the Catalogue comes out, nearly ninety years of age – but then I remember that Titian went on painting till he was ninety-one. That is a great encouragement. The only worry about age is that others are apt to forget you and one's continuing invention and ability of expression although still available, tends to be forgotten and ignored. And then we are reminded that stained glass is an art of commission, and those commissioning tend to look for artists who may be younger than themselves, and help them. This is an admirable state of mind, and helps younger artists enormously, as it helped me when I began. But the art of invention and vision and expression of a visual identity still exists, given one's health, for as long as one's life proceeds. I still hope to be in good form for the experience of more inventive beauty in the medium of stained glass. I only have to be asked and I will do it! What a memorable and beautiful experience the vision of stained glass can be – and will be, in the future, by many coming after me.

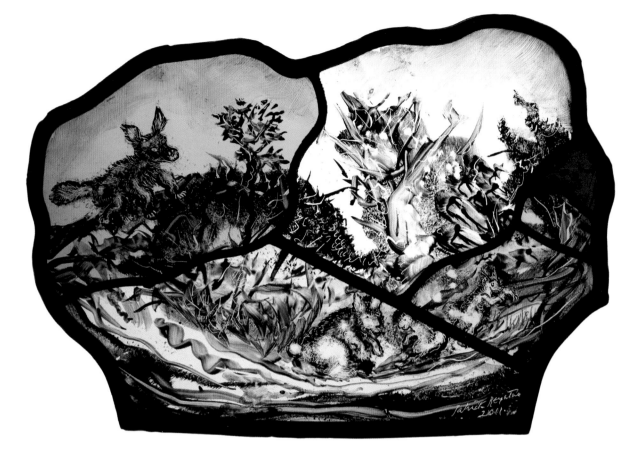

Run Rabbit, Run, 31.5x45.5cm, private collection